SEEING & WRITING

SEEIN
WR

G &

ITING

Donald McQuade
University of California, Berkeley

Christine McQuade

Bedford / St. Martin's
Boston ◆ New York

FOR BEDFORD/ST. MARTIN'S

Developmental Editor: Alanya Harter
Senior Production Editor: Michael Weber
Senior Production Supervisor: Dennis J. Conroy
Marketing Manager: Brian Wheel
Editorial Assistant: Ellen Thibault/Amy Thomas
Text and Cover Design: 2x4
Copyeditor: Alice Vigliani
Photo Research: Esin Goknar
Chapter Divider Photos: Richard Caldicott
Composition: Pine Tree Composition, Inc.
Printing and Binding: R.R. Donnelly & Sons, Inc.

President: Charles H. Christensen
Editorial Director: Joan E. Feinberg
Editor in Chief: Karen Henry
Director of Marketing: Karen Melton
Director of Editing, Design, and Production: Marcia Cohen
Managing Editor: Erica T. Appel

Library of Congress Catalog Card Number: 99-65526

For information, contact: Bedford/St. Martin's,
75 Arlington Street, Boston, MA 02116
617-399-4000
www.bedfordstmartins.com

ISBN: 0-312-18016-0

ACKNOWLEDGMENTS

Introduction
Verbal Texts

Annie Dillard. "Dumbstruck." From *Pilgrim at Tinker Creek* by Annie Dillard. Copyright © 1974 by Annie Dillard. Reprinted by permission of HarperCollins Publishers, Inc.

William Carlos Williams. "The Red Wheelbarrow." From *Collected Poems: 1909–1939*, Volume 1. Copyright © 1938 by New Directions Publishing Corp. Reprinted by permission of New Directions Publishing Corp.

Visual Texts

Warren Avenue at 23rd Street, Detroit, Michigan, October 1993. Copyright Joel Sternfeld. Courtesy Pace/MacGill Gallery, New York.

Chapter 1
Verbal Texts

Nicholson Baker. "Shoelaces." From *The Mezzanine* by Nicholson Baker. Copyright © 1988 by Nicholson Baker. Used by permission of Grove/Atlantic, Inc.

K.C. Cole. "A Matter of Scale." From *The Universe and the Teacup: The Mathematics of Truth and Beauty.* Copyright © 1998 by K.C. Cole. Reprinted by permission of Harcourt Brace & Company.

Annie Dillard. "Seeing." From *Pilgrim at Tinker Creek* by Annie Dillard. Copyright © 1974 by Annie Dillard. Reprinted by permission of HarperCollins Publishers, Inc.

Felice Frankel and George Whitesides. "Tears of Wine." From *On the Surface of Things* by Felice Frankel and George Whitesides. © 1997 by Felice Frankel and George Whitesides. Reprinted by permission of Chronicle Books, San Francisco.

Linda F. Magyar. "A Turn of the SKU." From *The New York Times*, April 6, 1997. Copyright © 1997 by The New York Times Company. Reprinted by permission.

William Carlos Williams. "The Great Figure." From *Collected Poems: 1909–1939*, Volume 1. Copyright © 1938 by New Directions Publishing Corp. Reprinted by permission of New Directions Publishing Corp.

Larry Woiwode. "Ode to an Orange." Copyright 1985 by Larry Woiwode. Reprinted by permission of Donadio & Ashworth, Inc.

Visual Texts

Roadmaster Bicycles. © 1999 Brunswick Corporation. *Roadmaster* is a registered trademark which is used by the express permission of Brunswick Corporation. 1953 ad Courtesy Gaslight Ad Arichves, Commack, NY.

April 1990–91 & April (detail), Chuck Close. From The Eli and Edythe L. Broad Collection, Los Angeles. Photograph by Bill Jacobson. Courtesy of PaceWildenstein.

Goldfish. Photograph © Davis & Starr.

The Figure 5 in Gold. Charles Henry Demuth. The Metropolitan Museum of Art, Alfred Stieglitz Collection, 1949. (49.59.1). Photograph © 1986 The Metropolitan Museum of Art.

Acknowledgments and copyrights are continued at the back of the book on pp. 553–56, which constitute an extension of the copyright page. It is a violation of the law to reproduce these selections by any means whatsoever without the written permission of the copyright holder.

For Susanne and Marc

Preface for Instructors

Effective writing is a product of clear thinking, and clear thinking begins with careful observation. Accurate and insightful observations about daily—and seemingly ordinary—experiences enable students to think and write confidently about important and complex aspects of American culture and their own lives. Learning to see well helps students to write well.

Seeing & Writing provides an unprecedented opportunity in first-year composition courses to help students improve their analytic and compositional skills by treating seriously the connection between the verbal and the visual in today's culture. It is the first composition reader to introduce the skills students need to read both kinds of texts and then to write effectively about them. Grounded in our decades of experience on both sides of the instructional desk, this book expresses our commitment to the pedagogical principle that instructors ought to start where students are able. And our experience suggests that undergraduates are thoroughly familiar—although often in a passive and uncritical way—with the myriad visual elements of contemporary American experience.

Whether they realize it or not, most students are well versed in the effects of visual texts, and many are at least acquainted with the basic workings of sophisticated visual processes such as those involved in advertising, film, and the Internet. Such materials offer opportunities for students to practice the verbal skills of critical analysis. As authors we believe that cultivating students' abilities to move fluently within and between the visual and verbal worlds will improve their analytical skills.

Consider, for example, the extent to which information technologies promote the visual in enabling people to communicate as well as to inform and entertain themselves. Increasingly, the sources as well as the processes used to envision, receive, and react to information depend on visual frames of reference. Moreover, the amount of information, its nature,

and the media and speed with which it is conveyed have intensified the pressures to respond promptly and decisively to the seemingly countless appeals to our attention made each day by individual and corporate interests. Rather than yielding to or trying to ignore these pressures, instructors should prepare students to respond to such demands by practicing the same analytic skills and applying the same rigorous intellectual standards to the visual as they do to the verbal dimensions of their lives. Practicing these skills will also enable students to articulate with greater confidence their own views of themselves and of their interactions with different subjects and contexts.

Seeing and Writing: Interrelations of the Visual and Verbal

Each of the eight chapters in this book concentrates on a visible and focused aspect of contemporary American life. Each chapter presents a series of carefully chosen visual and verbal texts exploring such topics as observing the ordinary, coming to terms with a sense of place, capturing memorable moments, figuring the body, engendering difference, constructing race, reading icons, and writing in the age of the image. The chapters present a wide range of visual images (including advertisements, photographs, paintings, and comic art) and related nonfiction prose, short stories, and poems. We believe that undergraduates are sufficiently conversant with the subjects and strategies of these types of materials to want to write about them—and the questions and issues they prompt—in original, coherent, and convincing terms.

The contents of *Seeing & Writing* feature a wealth of material with an impressive track record for teaching writing effectively. We have placed these materials in unique instructional contexts by juxtaposing them with an array of new visual and verbal sources. The blend of both types of texts in each chapter balances attention to analytic readings with conversational and compositional prompts for students to express their responses to the material. Our own classroom experiences with these materials, subjects, and themes suggest that they provide engaging opportunities for practicing composition skills.

We have designed *Seeing & Writing* to help students improve their writing by sharpening their perception. This pedagogical principle informs the book's three goals: (1) to provide opportunities for composition students to think perceptively and critically about compelling visual and verbal aspects of American culture, (2) to help students write effectively about how they perceive themselves, especially in relation to the images and words that compete for their attention, and (3) to give instructors the flexibility to work with these materials in ways best suited to the interests and abilities of their students. The nature and range of visual and verbal selections reprinted here, the way the selections are organized, and the supporting materials in the instructor's manual make this collection unique and timely.

A Flexible Organization

Each chapter opens with an illustration and a brief overview of the thematic scope of the chapter; this is followed by a reading and writing exercise that invites students to observe and draw reasonable, verifiable inferences from the visual material that opens the chapter. The exercise helps students relate their initial perceptions and interpretations of this material to their own life experiences and to the materials that follow in the chapter. Generally, we have designed each chapter to progress from the concrete to the abstract, from shorter to longer texts, and from a limited and readily accessible frame of reference to more wide-ranging and interconnected ones.

The overall organization of the book reflects a similar progression—from practicing the skills of observation and inference, to working with description and narration, and then to applying rhetorical forms such as exposition and argumentation. Yet because each chapter is self-contained and begins with an exercise in observation and inference, instructors can sequence subjects and themes to best address their own instructional needs as well as the interests and background of their students.

Additional Features

We have interspersed throughout each chapter several instructionally self-contained images that extend the scope of a given topic or theme. These

photographs, cartoons, advertisements, and other visual artifacts will stimulate discussion and prompt further thinking and writing.

Seeing & Writing includes additional features in each chapter:

Chapter dividers: Striking photographs preceding each chapter serve as visual introductions to the subject under consideration. Commissioned especially for *Seeing & Writing*, these photographs not only function as engaging chapter dividers but also represent one artist's interpretation of the eight thematic units of the book.

Paired visual and verbal texts: Each chapter includes visual and verbal texts that are linked. In some instances the image and the verbal text address the same topic or theme; in others one text has inspired the other. By juxtaposing two texts we invite students to explore the similarities and differences between communicating an idea visually and verbally.

Portfolios: This feature presents several examples of the work of a selected visual artist. The intent is to illustrate that most artists, like most writers, have an individual style and focus of vision. Each portfolio of images is accompanied by a brief biographical headnote about the artist as well as insights into his or her thematic and stylistic vision. "Seeing" and "Writing" questions conclude each portfolio, encouraging students to think and write productively about the study of multiple images by a single artist.

Retrospects: These "visual timelines" demonstrate in graphic terms the fact that cultural artifacts—such as advertisements, everyday objects, portraits, and cover art for popular magazines—are products of specific historical moments. The graphic selections constitute a comparative and historical lens through which to re-examine a particular aspect of the subject or issue being studied in the chapter. It's important for students to notice that the things people take for granted haven't always been presented in the same way. For example, in the chapter on gender stereotypes we offer a series of changing images of women in the military over several decades, and in the chapter on icons we reprint the changing images projected in the advertising and on the packaging for Betty Crocker products. We let the images speak for themselves, providing simply the title and date of each one.

Looking Closer: The terms of this feature reflect the focus of our pedagogical interests: to help students improve their writing by showing them how to take a second, more careful and detailed look at certain aspects of American culture that may be familiar to them already. In the chapter on icons, for example, students examine their assumptions about and attitudes toward one of the most commonplace yet highly charged images in American life: the flag. "Looking Closer" invites students to do more than recognize something out of the ordinary in the ordinary. In effect, it reinforces the pedagogical aims highlighted in the title *Seeing & Writing*. It invites students to analyze images and words related to a theme without our editorial comments and guidance. It also engages them in a reflective "double take" as they re-examine the familiar from a fresh angle of vision and with a more inquiring and analytical eye. Within the context of composition, a double take consists of a purposeful delayed reaction— an intentional rereading (that is, reviewing a visual or verbal text from a different perspective) and a deliberate revising (that is, thoughtful rewriting and careful editing), especially when the text is one's own prose.

Re: Searching the Web and **Talking Pictures**: We encourage students to use the World Wide Web—and to analyze its effectiveness—as a research tool to explore further visual and verbal resources related to the subjects and issues presented in each chapter. A boxed exercise, "Re: Searching the Web" appears in every chapter; its name summarizes its purpose. The instructions and questions that appear here encourage students to learn to use the web as a research tool by directing them to web sites where they can find additional images and prose material about the subject or issue being studied. This exercise also invites students to analyze the ways in which information is presented on the web and evaluate the reliability of that information.

We have included an additional boxed exercise in each chapter— "Talking Pictures"—to sharpen students' awareness of the roles and effects of television shows and movies on American culture.

Supportive and Inconspicuous Apparatus

We have deliberately kept to a mimimum the amount of apparatus that introduces and follows each selection. For each one, brief biographical headnotes

provide background information about the writer or artist and his or her creative goals and practices. Focused discussion questions and writing exercises follow each selection under the headings "Seeing" and "Writing."

"Seeing" questions engage students in focused and sustained ways with the subject of each selection, the compositional strategies used, and the overall organization of the selection and its interconnections with other texts in the book. "Writing" exercises often invite the student to write about the subject in a personal experience essay, an expository/analytic essay, or an argumentative essay. (We also occasionally include the opportunity for students to write a poem or story about the subject.) These writing exercises are linked to class discussion and in-class writing.

A Note about the Design

The design of *Seeing & Writing* creates an attractive and engaging environment in which students can reflect on—and see reflections of—contemporary American culture. The double purpose of the design reinforces our goals: to prompt further inquiry into the similarities and differences between the attractions and effects of images and verbal texts, and to encourage conversation about the ways in which such texts can be more productively connected. By integrating visual and verbal texts, juxtaposing them, and giving both equal positional importance on a page, the book's design facilitates that discussion while also reflecting the complex nature of the multimedia in which we all function.

Teaching *Seeing & Writing*

A comprehensive instructor's manual—*Teaching* SEEING & WRITING—offers suggestions on how to teach the material in *Seeing & Writing,* paying respectful attention to different institutional settings and instructional purposes. Pages from *Seeing & Writing* are reproduced in the manual in thumbnail style. This compendium of teaching resources includes generous attention to such useful elements as:

> **Generating Class Discussion and In-Class Writing:** A thorough assessment of how to work imaginatively and productively with the text in class to stimulate discussion and in-class writing, which may motivate students to write

engaging, coherent, and convincing essays about the text and the issues and themes it articulates.

Additional Writing Topics: A group of additional topics for each selection that includes informal and personal writing, descriptive and narrative essays, expository and argumentative papers, and research assignments.

Connections with Other Texts: For each selection, suggestions for additional connections within the chapter and within the book, along with suggestions about how to encourage students to discover these interconnections on their own, thicken the range of thematic and stylistic interconnections in *Seeing & Writing*.

Suggestions for Further Reading, Thinking, and Writing: A compendium of supplemental material designed for classroom use—including print, video, audio, and digital sources—along with recommendations on how to use them to reinforce your instructional goals.

Additionally, **Seeing & Writing Online,** a book-related web site at <www.bedfordstmartins.com/seeingwriting>, includes guided exercises on reading visual images and web-based research activities; annotated research links about the artists, writers, and thematic and compositional issues in the book; and doorways to visual resources, virtual museums, and much more.

Acknowledgments

Two converging stories account for the origins of *Seeing & Writing*. The genesis of what is in several respects an unprecedented book for the teaching of writing can be traced to innumerable conversations Don McQuade has had over the past twenty years with Charles H. Christensen, an extraordinary patron and developer of teachable ideas. Throughout this long collaboration and friendship, Chuck Christensen and Don McQuade have talked about creating a book that draws on undergraduates' familiarity with the visual dimensions of American culture to develop their skills as effective readers, thinkers, and writers.

There is a more recent impetus for launching what has been a memorable two-year adventure in both *creating* this unique instructional tool and

re-creating a father-daughter relationship. *Seeing & Writing* first took shape during an extended series of family dinner conversations over the course of a few evenings in late December 1996. The participants in that conversation included Don and Susanne McQuade and their two children, Christine and Marc. Christine had returned home for the holidays from New York City, where she had completed the fall season dancing with the STREB modern dance company. Marc was home for the winter holidays from the University of California, Berkeley, where he had finished his first semester.

Marc started the conversation—and what ultimately became the book— by talking about the writing course he had just completed, a course on writing about art. Marc carried from that class to the dinner table a nagging question: Which has a more powerful impact on people—an image or a word? Here's what he wrote about the family conversation that night:

> I was annoyed because in my History of Art class people were equating images with a single word, and I thought that was a false comparison. I compared images not with a single word but rather with a paragraph or some longer text. I believe an image is a composition of a visual vocabulary. An image has a range of meaning similar to a paragraph.... We were discussing the idea of an image replacing text or whether images or words were more efficient at conveying an idea.

Marc's classroom experience with and thoughts on the relationship between word and image within academic settings were—and continue to be—at the center of both the impetus for and the successful development of the book.

Having studied American popular culture as a history major and served as a writing tutor at Berkeley's Student Learning Center, Christine was eager to investigate and re-envision the teaching of writing in the visual age. Her ideas about relating the visual and verbal immediately drew her father's attention and encouragement. What began as an engaging conversation soon developed into a collaborative effort to create a book designed to improve the analytical and compositional skills of students by having them see, read, think, and write about the verbal and visual dimensions of American culture.

Don and Christine's work began together spontaneously and grew organically. In this sense there is another, more personal dimension to the story

about *Seeing & Writing*. The working relationship that evolved between Christine and her father became a process of negotiating differences: in location, gender, age, perspective, and family role.

Christine and Don—and their editor, Alanya Harter—rarely saw eye-to-eye on *Seeing & Writing*. That is to say, only rarely were they in the same place at the same time to work on the book. The logistical difficulties of living and working on different coasts with a three-hour difference were frequently compounded by Christine's touring schedule with the dance company, which traveled not only back and forth across the United States but also to Australia, France, Switzerland, and England. E-mail helped bridge these distances but couldn't address the urgent need to exchange images quickly between distant parts of the world. Marc engineered a partial solution to the problem by designing and building a very effective and attractive web site where the family members posted images for discussion and possible inclusion in the book.

Crowded schedules as well as physical distance—and the mediating presence of e-mail and a web site—only occasionally encumbered the work. And the fact that each member of the team approached the interrelations of the verbal and the visual from different compositional perspectives—those of professional literary study and professional dance—positioned them in a "neutral" space where they could recognize their differences as well as listen to and learn from each other. The contrasting disciplinary frames of reference were further enhanced by different gender and generational perspectives as well as by their familial relationship.

We'd like to emphasize that the relationship we have developed through our collaborative work has been immeasurably enriched by the differences between us, our world views, and the ways in which we approach learning, doing, thinking, and writing. We have grown closer to each other through an increasing awareness of—and mutual respect for—just how risky teaching and dancing can be.

Begun in conversation, *Seeing & Writing* has grown and developed through a series of conversations with each other, friends, colleagues, and the professional staff at Bedford/St. Martin's. Behind this collaborative effort stands a large number of friends and colleagues who graciously allowed us into their already crowded lives to seek advice, encouragement, and assistance.

For helping us by asking important questions and offering generous advice, we would like to add a special note of thanks to Austin Bunn, Eileen O'Malley Callahan of the University of California, Berkeley, Beth Chimera, Mia Chung, Lee Dembart, Kathy Gin, Justin Greene, Eli Kaufman, Laura Lanzerotti, Greg Mullins of Evergreen College, Anjum Salam, Shayna Samuels, Matthew Stromberg, and Elizabeth Streb and the dancers of STREB. Sandra and Yuen Gin provided us an inspiring place to work. With a rare blend of intelligence, imagination, and energy, Lee Dembart, Greg Mullins, and Barbara Roether assisted us in doing biographical research on the writers and artists and in drafting headnotes.

In addition to creating a life-saving indexing system for our web site and introducing us to Michael Rock and Susan Sellars at the design firm 2×4, Irwin Chen—someone who moves seamlessly between word and image— has contributed a lively and invaluable presence in the development of this book. We're grateful for his insightful suggestions and generous assistance.

We are also grateful to the instructors who offered critiques of the book during various stages of its development: Thomas Clemens, Heartland Community College; Wayne Crawford, Western Illinois University; Stephen Donatelli, Harvard University; Kathryn Flannery, Indiana University; Laurie Glover, University of California, Davis; Paul Heilker, Virginia Tech; Anne Kress, Santa Fe Community College; Jon A. Leydens, California School of Mines; Sonia Maasik, University of California, Los Angeles; Michael Mackey, Community College of Denver; Anthony Petruzzi, Bentley College; Dawn Skorscewski, Emerson College; and Todd Taylor, University of North Carolina, Chapel Hill; and Anne Frances Wysocki, Michigan Technological University.

Anne Kress and Suellyn Winkle, both of Santa Fe Community College, skillfully prepared *Teaching* SEEING & WRITING.

It quickly became clear that *Seeing & Writing* would be a book that needed a particularly sophisticated designer's eye. Michael Rock and Katie Andresen of 2×4 have been invaluable in helping us not only to expand our imaginations of how this book could look and function but also to sharpen our own abilities to think visually. They have turned a collection of chaotic materials into an elegant and useful instructional tool. We are delighted that Richard Caldicott accepted our invitation to prepare eight distinctive and memorable photographs for *Seeing & Writing* to precede the chapters. Commis-

sioned specifically for this book, these photographs provide an eminently teachable series of artistic views of contemporary American culture. We are grateful to Esin Goknar for opening the door to new sources of photography and other visual media.

We'd like to extend special thanks to the kind people of Bedford/St. Martin's. Alice Vigliani copyedited the manuscript with truly outstanding skill and judgment as well as with great sensitivity and respect for our instructional purposes. Sandy Schecter, assisted by Eva Pettersson, managed the complex project of securing permissions to reprint the visual and verbal materials presented in the book, and Ellen Thibault and Amy Thomas deftly assisted us with research and manuscript preparation. Terry Govan imaginatively designed a first-rate advertising program for the book. Marcia Cohen and Erica Appel helped us figure out the logistics of such a complicated production process; and Michael Weber took up where they left off, guiding the manuscript through a maze of production problems with an admirable blend of energy, intelligence, and patience. We continue to be indebted to Joan Feinberg, a perceptive, encouraging, and compelling voice of reason and sound judgment. Her vision of the book's potential and her critique of earlier drafts stand as models of intellectual and professional integrity. Chuck Christensen continually offered wise and energizing support as well as the kind of encouragement and confidence that made each sentence easier for us to write.

We would also like to thank our editor, Alanya Harter. She is a remarkably skillful and accomplished reader and writer, someone who balances good judgment, tact, and taste with knowledge and resourcefulness. She is the kind of editor every author hopes to work with and write for. Her animating and rigorous intellectual presence is everywhere evident to us in this "final," published version of *Seeing & Writing*; and we remain grateful for her hard work, dedication, and patience. Without her engaging intelligence, *Seeing & Writing* would be less than it is.

Finally, we would like to acknowledge Susanne and Marc McQuade. This project would never have been possible without their encouragement, patience, and most important, their inspiring intellectual curiosity. "Merci vu mou!"

Donald McQuade and Christine McQuade

Contents

No method nor discipline can supersede the
necessity of being forever on the alert.
What is a course of history, or philosophy, or poetry,
or the most admirable routine of life,
compared with the discipline of looking always
at what is to be seen? Will you be a reader,
a student merely, or a seer?

—Henry David Thoreau,

Introduction

Seeing & Writing provides a compilation of a wide range of visual and verbal "snapshots" of American culture—to enable you to practice the skills of careful and critical *seeing* and thoughtful and articulate *writing*. As authors we have designed this book to encourage you to engage with what you see in the world around you—to read actively and to write incisively about the texts that surround you. In effect, the book will help you improve your writing by improving your perception.

In preparing this material we have been guided by the wisdom and encouragement Thoreau offers in *Walden* (1854), the book documenting his year-long experiment with the simple life. Today, almost a century and a half later, the distinctions he draws in the epigraph on the previous page—between and among *reader, student,* and *seer*—endure. Following Thoreau's lead, we encourage you to be a seer, "looking always at what is to be seen." In addition to reminding you of "the necessity of being forever on the alert," we urge you to think about *how* you see, that is, to consider how your unique perspective shapes the meaning you make from whatever passes before your eyes. We encourage you to consider to what extent—and in what ways—your background, attitudes, and personality shape what and how you see.

When we say that we would like to encourage you to read the texts that surround you, we do not mean only the kind of writing you encounter in most college courses. We hope you will consider virtually everything around you to be a potential text for serious reading, discussion, and writing—from a movie poster for the latest box-office hit to a wall with graffiti scrawled on it; from an advertisement for building a stronger body to an essay about growing up in a Korean American community; from the clothes you buy to the personal ads you read in your local newspaper. We believe, for example, that the Vietnam War Memorial, with its black reflective surface and thou-

sands of names punctuated by flowers and mementos of the dead, is as engaging a text for study as is Mark Twain's *The Adventures of Huckleberry Finn.*

Advances in technology have made the production and circulation of images and words exponentially faster than was possible even twenty years ago, and they appear in many more different—and far more widespread—venues. Images and words flash by everywhere—on television, movie, and computer screens, as well as on the pages of books, newspapers, and magazines. Thoreau's words still resonate today, though our visual landscape has changed.

Many of the texts that seek to capture your attention have both verbal and visual components. *Seeing & Writing* presents an assortment of these commonplace texts, ones with which you no doubt are familiar: advertisements, CD covers, billboards, brochures, and posters. Many use words and images in combination to construct meaning. Increasingly as well, many "traditional" texts encountered today (e.g., textbooks, magazines, novels) use verbal and visual elements in artful combination. This is even true of the two examples just cited: The Vietnam War Memorial, a visual structure, also incorporates writing; and *The Adventures of Huckleberry Finn,* a verbal work, includes illustrations.

The page from Scott McCloud's "Show and Tell" (see facing page) combines the visual and verbal to construct an artful exploration of visual history and theory as well as an argument about the effectiveness of that combination. (See pages 526–50 for the complete text.) McCloud makes his argument especially effective by mixing words and images: sometimes showing the reader one point and telling the reader another, sometimes using words and images to express the same idea, and sometimes letting the images do most of the talking. Because McCloud makes his points in a format using comic art, some readers might argue that it's easy to respond to—and other readers might argue that his message thereby becomes less serious. In either case, the way he's chosen to put the text together is worth discussing as much as the message he's delivering.

The differences between the perceived seriousness of words and images are narrowing. In today's world where texts compete insistently for everyone's attention, being memorable has a great advantage. Much of today's public language functions at a level comparable to that of a simple

The word *image* derives from the Latin *imago*, "imitation, copy, likeness." In this sense we use *image* to mean a thing that represents something else; a symbol, an emblem, a representation.

looking at and what we have a right to observe. They are a grammar and, even more importantly, an ethics of seeing.–*Susan Sontag, 1977*

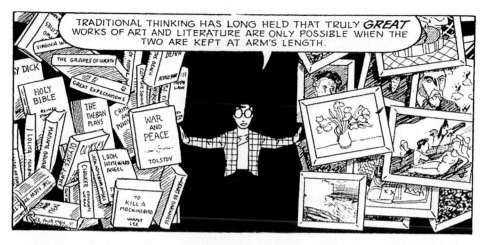

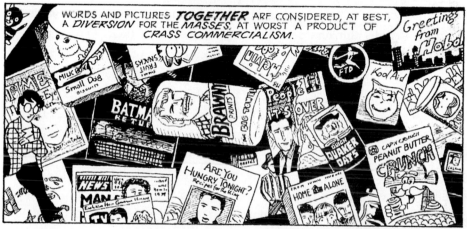

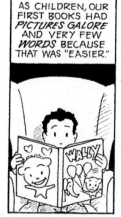

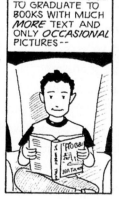

image: an immediately digestible sound bite. Often people absorb these words and images passively, without paying careful attention to them or looking beyond their immediate effect. Yet many words and images have very sophisticated relationships to each other. Sometimes the words are stronger than the image that accompanies them; sometimes the other way around; sometimes the combination does something neither could do alone, as the excerpt from McCloud's combination of comic art and essay illustrates. Some of you may be more comfortable with words than with images, others more comfortable using and reading images than words. We hope that you will think and talk about—and draw on—the advantages of each to communicate your ideas as clearly and effectively as possible.

We believe that anyone interested in becoming an articulate and confident writer needs to "cross train," that is, to learn from the different ways in which serious thinkers see the world and express their distinct perspectives on it. You will encounter the work of some of the most accomplished writers, painters, poets, artists, and photographers of this century in the pages that follow; each has used admirable and observable skills to articulate a unique vision through a particular medium. The strategies the artists and photographers employ to capture and direct the viewer's attention, make a point, or create an effect are not very different from the strategies the writers use to achieve the same effects, albeit in a different medium. For example, you might think of a writer's choice of word to be akin to a painter's brushstroke. A dot of bright color (say, red), like a single word (say, *smash*), doesn't do much on its own—it's the combination of different elements, the composition of a text, that gives the audience something to read, respond to, admire, and remember.

Thinking carefully about visual and verbal strategies will enable you to improve your own skills as readers and writers. We seek to assist you in becoming more aware of—and developing more practiced confidence in—the skills identified with both verbal and visual literacy. These skills will enable you to learn, recognize, understand, and create compelling and convincing messages that will be understood by many people within and beyond the halls of higher education. You are already a member of several distinct communities; mastering the skills of critical reading and writing will enable you to contribute your ideas—and posit your voice—in these and other communities with which you choose to associate.

The ability to read and write in a purely visual medium; the ability to decode the meaning delivered by visual texts, as through design, typography, and images.

Seeing

When we use the word *seeing*, we mean going beyond the surface features of a text and trying to articulate an understanding of what an image might mean. Everyday language is filled with visual metaphors , some of which are printed on this page. These idioms help people articulate their ability to read a situation, person, or event as well as to express their understanding of something that is not necessarily clear on the surface. To say someone sees something always has at least two possible meanings: one literal, the other figurative. You may see many images each day, meaning that they physically cross your line of vision, but you don't necessarily really see them—to actively read them for what's not explicitly shown and to think about what they mean.

I see the writing on the wall.

I'll believe it when I see it.

I see the light.

Wait and see.

Picture this . . .

I see what you mean.

Let me show you.

Seeing is believing.

When we talk about seeing a text, we mean reading it critically. *Seeing & Writing* provides opportunities to sharpen your skills of active seeing and critical reading—whether you're looking at an advertisement for a Mercedes-Benz, studying a photograph, or reading an essay. *Critical reading* is a term you will often hear invoked in your courses. Many students think it requires them to engage in elaborate "fault-finding" exercises while reading and writing. However, the etymology of the word *critical* suggests a different kind of intellectual activity. The word derives from the Latin *criticare*, meaning "to analyze, to take apart." All your college courses will ask you to "take apart" the subject you're studying, whether it's biology, political science, literature, or any other subject. We use the phrase *critical reading* here in this sense— to take a closer look, to see actively beyond the surface of the words and images you encounter in this book, in your college courses, and in your everyday life.

Critical reading involves carefully analyzing a text for overall meanings and effects, as well as breaking down its structure in order to better understand each part and to explore the relationship of each part to the whole. Critical reading also involves a willingness to question what exactly in the text prompts you to respond in a certain way. In effect, critical reading requires us to verify each of our assertions about a text with detailed references to specific evidence in it. You might think of critical reading as a

process of asking yourself a series of increasingly complex questions, such as the following:

What response does this text evoke in me? And why?

What are the strategies that the author or artist has used to create these effects?

What might this text—and the strategies used in it—say about contemporary American culture?

As you think through each question you will find yourself verifying your assertions with specific evidence. This kind of critical reading constitutes an intellectual "double take," an effort to be far more rigorous than simply recognizing something out of the ordinary in a text. Critical reading requires taking a step back—to re-examine a text from a fresh angle, with a more inquiring and analytical eye, and with sustained attention to detail. Like a double take in ordinary experience, critical reading involves a more thoughtful and purposeful delayed reaction. It consists of intentional rereading (i.e., reviewing the details of a visual or verbal text from different perspectives) and deliberate rewriting (i.e., thoughtful revising and careful editing), especially when the text is one's own prose.

Questions about Texts

One of the most productive ways to approach any text is to start with a two-step process: Make observations, and then draw reasonable and verifiable inferences from those observations. Working with this pattern of observation and inference—what we regard to be the cornerstone skills of seeing actively and reading analytically—can be applied to any question you ask about a text in terms of its structure, point of view, tone, purpose, audience, or the context within which it was written or produced.

MAKING OBSERVATIONS

When you encounter any image or piece of writing in and outside of this book, first ask yourself quite simply: What do I see? What details attract your attention as you look carefully at a text? For pedagogical purposes, we define an observation as a statement that can be verified by pointing to

1. (a) The act, practice, or power of noticing. (b) something noticed. 2. (a) The fact of being seen or noticed; the act or practice of noting and recording facts and events, as for some scientific study. (b) The data so noted and recorded. 3. A comment or remark based on something observed.

specific evidence in the text. An observation is, in effect, a neutral, nonjudg-mental, and verifiable statement. It's easy to make assumptions about something you're looking at or reading without taking the time to base your statements on what you can actually see. Each person's social, economic, and cultural backgrounds constitute the lens through which he or she sees the world, and it is often truly remarkable that two people can look at the same image and see something completely different. What's essential is that you train yourself to base your observations about a text on evidence in it. And one of the easiest ways to do this is to say, "I notice that . . ."

One of the first steps in critical analysis is to gather reliable information about the text. What do you notice about it? Take a few moments to consider carefully the observations you might make about the image on the next page. What exactly do you see here? Making initial observations when responding to any text will enable you to build confidence in your ability to read it carefully and insightfully. Reading with an eye on making observations also best pre-pares you to write effectively about what you see in a text.

We urge you to write down as many observations as possible about whatever you are observing. You might begin by writing out your thoughts—either by taking notes with pen and paper or by entering them on a keyboard—from the moment you encounter a new text.

Here are some observations a student made about a photograph: Joel Sternfeld's "Warren Avenue at 23rd Street, Detroit, Michigan, October 1993." How do they compare with your observations?

1 I notice that this is a photograph of a two-story building with a sidewalk and part of a street visible in front of it. The color of most of the building is light green.

2 I notice that there are three large windows on the second floor. The pane in the lower right corner of each of these three windows has the same appearance. The middle window is partially boarded up.

3 I notice that the words "When you take someones life you forfeit your own" appear under these three windows.

4 I notice that there are photos and notes on the wall on the first floor.

5 I notice that there is a "sold" sign and text on the door.

6 I notice that a brightly colored image of a person has been painted on the wall.

7 I notice that there are flowers on the sidewalk in front of the building.

8 I notice that there is a cross with flowers on it on the left side of the sidewalk.

9 I notice that there is an orange cone on the sidewalk in front of the building.

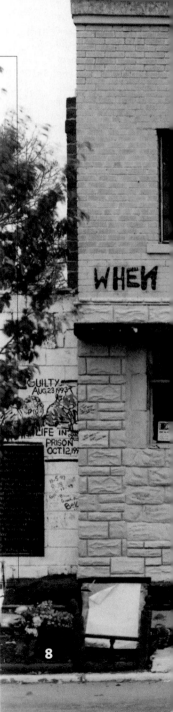

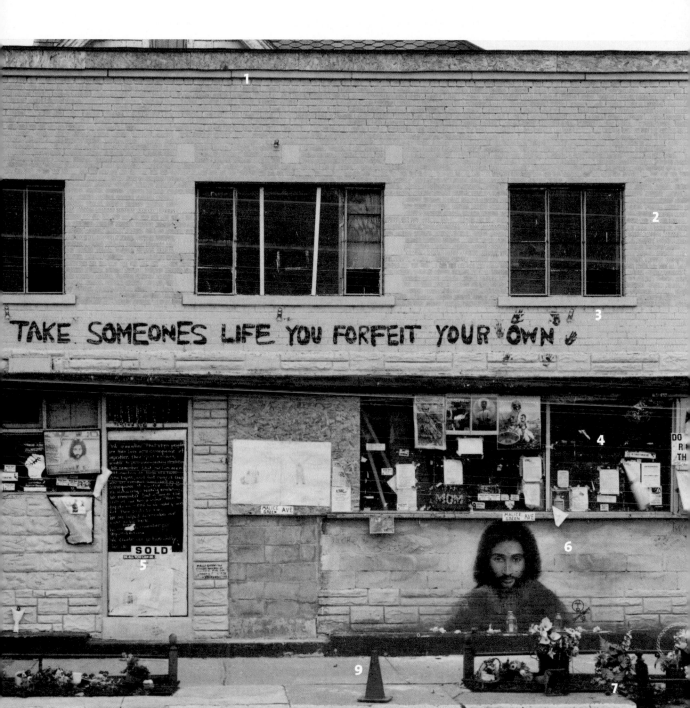

Now, consider how you might apply the same process of making careful observations to a verbal text. Take a few moments to read the following nonfiction "snapshot" from Annie Dillard's *Pilgrim at Tinker Creek,* a Pulitzer Prize–winning collection of observations of nature. What do you notice about it? Here are some observations a student made about this passage:

Annie Dillard

1 I notice that Dillard uses the first person ("I") to tell the story of her experience of witnessing a frog being eaten by a "giant water bug."

2 I notice that the writer repeats the idea of being amused by the sight she sees.

3 I notice that the writer uses a metaphor in the passage "Frogs were flying all around me."

4 I notice that the writer repeats the phrase "he didn't jump" in paragraphs 1 and 2.

5 I notice that the writer uses several similes to describe the frog: "like a schematic diagram of an amphibian," "like a kicked tent," "like a deflating football," "like bright scum on top of the water."

6 I notice that the writer shifts her attention— and her readers'—from the frog to the giant water bug in paragraph 3.

7 I notice that the writer doesn't reveal until paragraph 3 the information that the frog is being eaten alive by the giant water bug.

DUMBSTF

UCK

1

A couple of summers ago I was walking along the edge of the island to see what I could see in the water, and mainly to scare frogs. Frogs have an inelegant way of taking off from invisible positions on the bank just ahead of your feet, in dire panic, emitting a froggy "Yike!" and splashing into the water. Incredibly, this amused me, and, incredibly, it amuses me still. As I walked along the grassy edge of the island, I got better and better at seeing frogs both in and out of the water. I learned to recognize, slowing down, the difference in texture of the light reflected from mudbank, water, grass, or frog. Frogs were flying all around me. At the end of the island I noticed a small green frog. He was exactly half in and half out of the water, looking like a schematic diagram of an amphibian, and he didn't jump.

He didn't jump; I crept closer. At last I knelt on the island's winter-killed grass, lost, dumbstruck, staring at the frog in the creek just four feet away. He was a very small frog with wide, dull eyes. And just as I looked at him, he slowly crumpled and began to sag. The spirit vanished from his eyes as if snuffed. His skin emptied and drooped; his very skull seemed to collapse and settle like a kicked tent. He was shrinking before my eyes like a deflating football. I watched the taut, glistening skin on his shoulders ruck, and rumple, and fall. Soon, part of his skin, formless as a pricked balloon, lay in floating folds like bright scum on top of the water: it was a monstrous and terrifying thing. I gaped bewildered, appalled. An oval shadow hung in the water behind the drained frog; then the shadow glided away. The frog skin bag started to sink.

I had read about the giant water bug, but never seen one. "Giant water bug" is really the name of the creature, which is an enormous, heavy-bodied brown beetle. It eats insects, tadpoles, fish, and frogs. Its grasping forelegs are mighty and hooked inward. It seizes a victim with these legs, hugs it tight, and paralyzes it with enzymes injected during a vicious bite. That one bite is the only bite it ever takes. Through the puncture shoot the poisons that dissolve the victim's muscles and bones and organs—all but the skin—and through it the giant water bug sucks out the victim's body, reduced to a juice. This event is quite common in warm fresh water. The frog I saw was being sucked by a giant water bug. I had been kneeling on the island grass; when the unrecognizable flap of frog skin settled on the creek bottom, swaying, I stood up and brushed the knees of my pants. I couldn't catch my breath.

DRAWING REASONABLE AND VERIFIABLE INFERENCES

After you have made a set of detailed observations, ask yourself: What can I reasonably infer from what I have noticed about the text? How can you know whether the inferences you have drawn from your observations are reasonable ones? What makes an inference reasonable is whether specific evidence in the text warrants the intellectual leap you've made. When drawing an inference, be careful not to rush to judgment and formulate a conclusion, even if it's provisional, before you have carefully examined the details of the evidence under consideration.

An intellectual leap — from what one sees to what those details might suggest.

What you infer from a text will depend, at least in part, on what you bring to it. Whenever you read anything, you bring to that experience the sum total of your past experiences and how you define yourself—in terms of such matters as race, class, gender, sexuality, and political disposition. You should also acknowledge your own predispositions to—or prejudices about—the text in question. It's important to remember, however, to restrict your inferences to what the evidence of the verbal or visual text "authorizes" you to say. You might ask, for example, why a writer chose to introduce a subject with a description of a room, or why a photographer cropped out (i.e., eliminated) the head of a subject in a portrait. Your answers in both cases would be inferences, because you don't know the answers with certainty. In such instances you are basing your inferences on observations that anyone else who sees the image would also recognize.

Here are some inferences a student drew based on her observations about Joel Sternfeld's photograph and the prose passage by Annie Dillard:

> Based on the observations I have made, I infer that this is a place where someone has been killed:

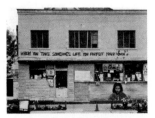

> — An event has provoked public expression in this particular place.

> — The inscription written on the wall—"When you take someones life you forfeit your own"—sends a direct message to anyone who sees it.

> — The arrangement of flowers as well as the cross on the sidewalk function as a memorial to the person killed.

— The person whose image is painted on the wall of the building is depicted with a celestial background.

Based on the observation I made, I infer that Dillard brings her readers closer to (1) her state of mind when she experienced the event she describes, than to (2) the event as she relived it through writing about it:

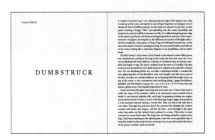

— Dillard's use of simile in paragraph 2 conveys a powerful sense of her fascination with the horror of witnessing the death of a frog.

— Dillard doesn't say that the frog was killed by a giant water bug; instead she tells us that the frog "crumpled and began to sag. The spirit vanished from his eyes as if snuffed. His skin emptied and drooped; his very skull seemed to collapse and settle like a kicked tent."

— It's almost as if the experience and the abstract knowledge of the frog's death exist independently until they merge in a moment of memorable inference.

Please remember to verify each interpretive claim you make with specific detail from the text in question. Providing ample—and detailed—evidence to support each of your assertions also ensures that you don't develop the habit of believing you are entitled to say whatever you want about a text and that you can read, as one student put it, "almost anything into a text."

Additional Questions about Texts

The following questions can help you develop your analytical reading of a visual or verbal text as you move from observation to inference.

What do I notice about the structure of the text—the way in which it's put together—and how important is the relationship of the parts to the whole? Whether you're looking at a photograph of Hillary Clinton or an academic essay about the dangers of smoking, every text is *composed* and has a shape of its own. Images are built through subject, use of color, texture, light, line, and focus, to name just a few structural variables; written texts use ideas, words, details, and narrative voice as their structural building

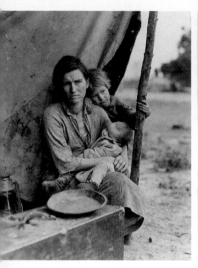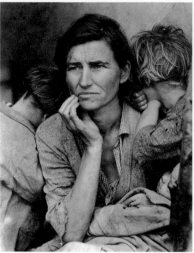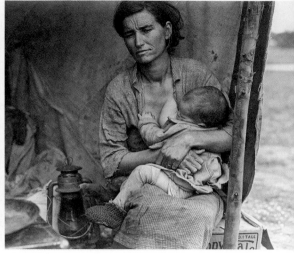

blocks, among others. The most polished texts are hard to pull apart, and if you're having trouble you might want to try to make a list of all the constituent parts and only then think about how they contribute to the whole.

What do I notice about the format of the text—the way in which it's presented—and whether it is important? Most of the texts reprinted in this book are presented in a consistent manner: one style for visual texts and another for verbal texts. As a result, you will not need to contend with the complicated fact that different typefaces and other visual markers (e.g., the size of an image or its placement in a layout) can affect how you read a text and the meaning you see in it. Yet you might ask yourself why any given author or artist chooses to present a verbal or visual text in a certain way.

To construct by fitting parts into a whole; to design, shape, construct; to put into words, to formulate; to contrive the evidence against an innocent person; to enclose in a frame, or as if in a frame.

How is the image or text framed? What's included within the frame? What's been left out? What is the point of view from which the subject is seen? It can be difficult to determine what is not included in an image or an essay, but occasionally what is excluded can be more important than what you see. Consider, for example, Dorothea Lange's famous photograph of a migrant mother and her children. Notice what happens when the same image is framed in a different way. What are the effects of Lange's decision to focus on the faces of her subjects rather than to take their picture from farther away? How do these framing choices change Lange's point of view ?

The angle of vision, the perspective, from which writers and artists see—and present—a subject. This perspective may be expressed—simply and literally—as the physical stance they establish in viewing a subject. In writing, point of view may also be revealed through the tone of voice, or attitude, that the writer expresses in addressing a subject.

Likewise, if you are reading a classmate's essay about going to college that talks about the friendship she developed with her roommate, you might reasonably ask why the writer chose this event to describe her university days rather than discuss the classes she took or what she learned in them. Sometimes readers frame or see a text in a way that omits something, as when you read a text without thinking about the context within which it functions.

Questions about Context

Other questions you might ask of any text focus on the sociocultural and historical contexts within which it was produced and viewed or read.

Where was this text published, and where was it placed in that publication? Texts do not appear in a vacuum. They function within specific contexts. The next time you encounter a text in its original publication, ask yourself how that text would read if you were to see it somewhere else—for example, on a billboard, on the wall of a museum, on a computer screen, or on the pages of a literature anthology.

The part of a text or statement that surrounds a particular word or image and helps to determine its meaning; the interrelated conditions within which something exists or occurs (environment or setting). One way to understand the importance of $\boxed{\text{context}}$ is to see where and how a text is placed within a publication. Examine carefully, for example, the front page of your local newspaper. Be aware that editors rank news reports by virtue of their overall importance. Accordingly, the stories the editors want most people to read are placed on or near the front page. The most important stories or images of the day usually appear on the front page and over the fold.

What comes before and after a text can make a difference too. Placing an article about nuclear weapons next to an advertisement for the latest action movie, for example, might prompt you to read the essay differently than if it were placed next to a photo of the victims of war. Each of the eight chapters in *Seeing & Writing* focuses on a theme in American culture. How does reading a text within a particular thematic grouping affect your response to it? If, for example, Joel Sternfeld's photograph were included in Chapter 2, "Coming to Terms with Place," how might you

read it in light of your response to David Guterson's insightful essay on the manicured streets of a master-planned community in suburbia?

Different publications have different personalities. If you're not sure of the identity a certain publication has established for itself, you might work your way through it and characterize the articles, photos, and overall look of the publication. You might also do some research on the publication in the library or examine its home page for a statement of the scope of its interests and editorial content. This information will help you infer something about the kind of publication you're looking at and who the assumed audience might be.

Who wrote this text or produced it? What do I know about this person? The more you know about the person who produced a particular text, the more information you'll have about it to inform your analysis and interpretation. For example, knowing that William Carlos Williams was a doctor who was treating a seriously ill child when he looked out the window and saw the now much-celebrated red wheelbarrow might make a difference in how you read his poem.

What compositional purpose does this particular text serve? Does the text explain? describe? tell a story? entertain? convince you of an argument? persuade you to engage in an action? move you to laughter or tears? something else? These questions may be difficult to answer quickly, and you will no doubt need to work closely and carefully with details in the text and then infer what reasonable answers might be. Likewise, when you sit down to write your own text, we hope that you'll be motivated to draft a paper with a clear purpose in mind—rather than aiming solely at earning a decent grade.

Who is the audience for this particular text, and how would that influence the way in which the author or artist created the text? Identifying the audience for a specific text is important, because certain audiences bring certain expectations to it. For example, a television

THE RED
WHEELBARROW
(1923)
William Carlos Williams

so much depends
upon

a red wheel
barrow

glazed with rain
water

beside the white
chickens.

show such as *Buffy the Vampire Slayer* is written and performed for one group of people, and the *NBC Nightly News with Tom Brokaw* is produced for a different group. Both shows reflect elements of the larger contexts of the networks on which they appear: the WB Network with its dancing frog mascot, and the more serious National Broadcasting Company with its assertions of public-spiritedness.

What response does the image or text seek to invoke in me in relation to its announced subject? In what ways does the text attempt to convince you of an argument or summon you to action? What kind of person does the text want you to be as you approach it? as you leave it? What values and code(s) of conduct does the writer of the text encourage his or her readers to adopt? Likewise, what kind of ideological theory and practice does the text promote?

The preceding text and context questions—tools for seeing and writing—can be used as you encounter the visual and verbal texts within and beyond this book. The questions will enable you to lay the groundwork for writing as you move from carefully observing what you see to making reasonable inferences about what is not necessarily shown.

Writing

You may still be asking yourself (and us) a very simple question: What does seeing have to do with writing, and why are we talking about reading visual images and thinking about visual strategies in a book for a course on writing? We think seeing and writing have everything to do with each other; careful seeing leads to effective writing.

We believe that all effective writing begins with careful observation—"being forever on the alert" and "looking always at what is to be seen"—and that composing is a recursive **process of seeing and writing.** Opening your eyes and taking a closer look around you not only gives you subjects and ideas to write about (which are the necessary initial ingredients in writing)

From the Latin *recursus*, to run back. A term adapted from mathematics to describe a process of writing in which the writer loops back to a preceding point in order to move forward with an idea.

but also leads to effective writing. We believe that practicing your powers of observation and sharpening your skills of drawing reasonable and verifiable inferences will enable you to become more accomplished writers.

Writers usually start by searching for and then deciding on a subject to write about, developing their ideas about the subject, clarifying their purpose in writing, organizing their thoughts, and considering the audience they want to address. In the drafting phase, they usually carry out the detailed plan they have developed. In the revising phase, they shift their focus to reading and studying what they have written and determining how to improve it. These phases are not a rigid series of stages that writers work through in exactly the same manner each time. They are simply patterns of activities that describe what happens when writers write. As every writer knows, at least intuitively, writing is not a linear but a recursive process. Writing rarely proceeds neatly from one phase to the next. Rather, the phases often overlap, making the process somewhat messy. Many writers, for example, revise what they have written as soon as they see the word or sentence on the page. Others wait until they have a complete draft and only then go back through it. Each writer participates in the writing process in a different way, at a different pace, and with a different result.

We believe that there is no single way to write, no fail-proof formula to produce successful essays. Anyone who is seriously interested in learning to write can benefit not only from listening carefully to what other writers and artists have to say about the challenges and pleasures of the composing process but also, and more importantly, from a willingness to practice the skills regularly. Writing is, after all, a skill; and skills develop over time with frequency of practice. Making writing a habitual, daily activity will reduce the anxiety and tension about whether you're writing correctly. Too many people focus on avoiding mistakes rather than on articulating the ideas they want to convey.

Getting Started

In the first phase of the writing process, a writer usually chooses a subject to write about (or one may have been assigned), identifies a purpose for writing about that subject, develops observations and inferences about the

text(s) in question, generates a thesis—a controlling idea—about the subject, considers the audience to be addressed, and then expands that idea in brainstorming or freewriting exercises, in an outline, or in some other form that provides the basis for a first draft of the essay.

Brainstorming involves recording thoughts as they occur, with no regard for their relation to each other. When writers brainstorm, they often leap from one thought to another without stopping to explore the connections between what may be two completely unrelated ideas.

Exercises like freewriting and brainstorming help writers search for and then decide on a subject to write about. These exercises are excellent confidence builders, especially if you are a relatively inexperienced writer, because they can help you produce a great deal of writing in a short time. They also enable you to see rather quickly just how much you have to say about a subject while resisting the urge to edit your work prematurely.

Also called nonstop writing, a strategy in which the writer puts pen or pencil to paper (or hands on a computer keyboard) to write without pausing between words or sentences to consider grammar, sentence structure, word choice, and spelling.

Deciding on a Purpose

Determining your purpose means making decisions about what to say and how to say it. The first of these concerns establishes the general content and overall goal of the essay. The second focuses on its structure and tone. For many writers, the principal purpose can be as simple as wanting to narrate or describe an experience, record a personal anecdote, recall a concert, remember a family story, or recover the pleasure of reading a book or seeing a film or a play. Just as there is no sure-fire way to succeed at writing, there is no single definition of an appropriate subject or purpose in writing.

Envisioning an Audience

Trying to picture the intended audience helps writers articulate what they want to say and how to say it. Student writers invariably speak of the problems and pleasures of struggling to convey a clear sense of their ideas to an audience. Successful writers usually ask some version of the following questions: Who is my reader? What do I have to do to help that person understand what I want to say about my particular subject? The first question addresses the knowledge, background, and predispositions of the reader toward the subject. The second points to the kinds of information or appeals to which the reader is most likely to respond.

Thinking about their readers helps writers make decisions about appropriate subjects, the kinds of examples to include, the type and level of dic-

tion and tone to use, and the overall organization of the essay. Every writer wants to be clear and convincing.

Drafting an Essay

It would not be practical for us to enumerate each of the strikingly different ways writers work during the second phase of the writing process—completing a full draft of an essay. Instead, we'd like to present a few general observations about how writers view their different styles of drafting. Some writers write to discover what they want to say. In one sense, they must see their ideas on paper in order to explore, develop, and revise them. In effect, they must write in order to discover and shape their own meaning.

Some writers proceed at a very deliberate pace. They think carefully about what they are going to say before they commit themselves to writing it out. These writers generally are more comfortable composing in their heads than on paper. They usually regard thinking and writing as separate and, in fact, sequential intellectual activities. Many other writers feel most comfortable creating their own distinctive blends of the write/rewrite and the think/write approaches to drafting an essay.

Revising an Essay

Many writers appreciate the power and permanence that revision can give to the act of writing. When writers revise, they reexamine what they have written with an eye to strengthening their control over ideas. As they revise, they expand or delete, substitute or reorder. In some cases they revise to clarify or emphasize. In others they revise to tone down or reinforce particular points. And more generally, they revise either to simplify what they have written or to make it more complex. Revising gives writers an opportunity to rethink their essays, to help them accomplish their intentions more clearly and fully. Revising also includes such larger concerns as determining whether the essay is logically consistent, whether its main idea is supported adequately, whether it is organized clearly, and whether it satisfies the audience's needs or demands in engaging and accessible terms. Revising enables writers to make sure that their essays are as clear, concise, precise, and effective as possible.

Revising also allows writers to distance themselves from their work and to see more clearly its strengths and weaknesses. This helps them make constructive, effective decisions about the best ways to produce a final draft. Some writers revise after they have written a very quick and very rough draft. Once they have something on paper, they revise for as long as they have time and energy. Still other writers require more distance from their first draft to revise effectively.

Thinking about an audience also helps writers revise, edit, and proofread their essays. When writers proofread, they reread their final drafts to detect any errors—misspellings, omitted lines, inaccurate information, and the like. In general, more experienced writers concentrate on the larger concerns of writing—purpose, ideas, evidence, and structure—before they give attention to such matters as strengthening syntax and looking for exactly the right word.

We believe that you have something important to say. The motivations for writing vary widely—from the reasonable desire to earn a good grade, to the understandable need to discover more about oneself and one's relation to the world that is larger than the self. But most importantly, writers write because they have something to say. Perhaps the most enduring satisfaction that writing affords is gaining authority over the ideas that one values and wants to express to others. And many writers have faith in their own ability to surprise themselves, to be able to express something they did not previously think they knew or could express. The possibility of expressing something original causes many writers to find the composing process highly satisfying, both within and beyond the academic environment. These writers recognize the power of writing to transform the world—which in a sense has already been formed by the words and images of others—into a world of possibility, the world they create with the words they craft on a blank page.

We have designed *Seeing & Writing* to help you improve your writing by improving your perception. We have created opportunities for you to think and write perceptively and critically about compelling visual and verbal aspects of American culture, and we have designed exercises to enable you to write more effectively about how you perceive yourself and your relations to the visual images and words that compete for your attention.

How the Book Works

Seeing & Writing offers you a wide range of verbal and visual texts to prompt you to read carefully and to write thoughtfully and convincingly about subjects and issues in contemporary American culture.

Each of the selections and exercises included in this book asks you to take a closer look at the objects, people, places, identities, and experiences that make up the varied expressions of American culture—to pay closer attention to, interpret, and then write about what you see.

The eight chapters that follow are filled with images and words that will help you think critically and write convincingly about increasingly complex themes and issues: observing the "ordinary" objects in everyday life; making a space a place; using technology to record personal and public memory; reconceiving the body as a cultural text; scripting gender; constructing race; assessing the cultural impact of American icons; and trying to make meaning as a writer in the age of the image.

Chapter Divider

In each of the eight chapters we've gathered an assortment of verbal and visual texts. We encourage you to read each of these selections as a text in its own right or in conjunction with other selections in the chapter. These texts include essays, short stories, poems, cartoons, photographs, paintings, sculpture, and graphic art, as well as a generous blend of advertisements, film posters, and CD covers.

Accompanying each selection are a headnote that provides background information about the writer or artist and text, and suggested questions for "Seeing" and "Writing." The Seeing and Writing questions will help you focus carefully on each of the selections. Seeing questions help you generate careful observations and think through your initial response; writing questions help you consider compositional issues such as how the author or artist has chosen to assemble the elements of the piece.

We have designed each page to help you see more clearly and write more effectively. In addition to full color elements and scores of "stand alone" verbal and visual texts, there are several recurring features in every chapter:

Verbal Text

NICHOLSON BAKER

"Some people think I'm a weird nut case with some sort of strange filing system," Nicholson Baker recently told an interviewer, responding to readers who are caught off guard by his seemingly unrelenting attention to detail, his love of the literal and metaphoric possibilities of language, and especially by, as the interviewer put it, his "tendency to go off on long, serpentine tangents that reflect [his] catholic and often abstruse interests." A brilliant observer and describer of the commonplace (he writes with equal gusto and insight about lumber as he does about punctuation and the destruction of library card catalogues, Baker has been called "the best American writer of his generation" who is, as he says, "interested in anything" and writes about everything – from the internal workings of a movie projector to the nature and syntax of dirty talk and the manufacture of the fingernail clipper.

Born in 1957, Nicholson Baker was educated at the Eastman School of Music and Haverford College. He is the author of five novels – *The Mezzanine* (1988), *Room Temperature* (1990), *Vox* (1992), *The Fermata* (1994), and, most recently, *The Everlasting Story of Nory* (1998), which recounts the relatively uneventful life of a 9-year-old American girl living in England. His essays have been published in many periodicals, including

The New Yorker, and have been collected in *The Size of Thoughts* (1996). "Every book I've written I've tried to make very different from the one before. I'd like to have all my books make the same point – and it's kind of a stupid point, really – that a single human being can think about a lot of different things. There can be nerdy parts and sordid parts and, with some luck, noble parts and morally nuanced parts."

This surprising and witty account of tying one's shoes is the second chapter of Baker's remarkable first novel, *The Mezzanine*.

Shoelaces

Nicholson Baker

MY LEFT SHOELACE HAD SNAPPED JUST BEFORE LUNCH. At some earlier point in the morning, my left shoe had become untied, and as I had sat at my desk working on a memo, my foot had sensed its potential freedom and slipped out of the sauna of black cordovan to soothe itself with rhythmic movements over an area of wall-to-wall carpeting under my desk, which, unlike the tamped-down areas of public traffic, was still almost as soft and fibrous as it had been when first installed. Only under the desks and in the little-used conference rooms was the pile still plush enough to hold the beautiful Ms and Vs the night crew left as strokes of their vacuum cleaners' wands made swaths of dustless tufting lean in directions that alternately absorbed and reflected the light. The nearly universal carpeting of offices must have come about in my lifetime, judging from black-and-white movies and Hopper paintings: since the pervasion of carpeting, all you hear when people walk by are their own noises – the flap of their raincoats, the jingle of their change, the squeak of their shoes, the efficient little sniffs they make to signal to us and to themselves that they are busy and walking somewhere for a very good reason, as well as the almost sonic whoosh of receptionists' staggering and misguided perfumes, and the covert chokings and showings of tongues and placing of braceleted hands to windpipes that more tastefully scented secretaries exchange in their wake. One or two individuals in every office (Dave in mine), who have special pounding styles of walking, may still manage to get their footfalls heard; but in general now we all glide at work: a major improvement, as anyone knows who has visited those areas of offices that are still for various reasons linoleum-squared – cafeterias, mailrooms, computer rooms. Linoleum was bearable back when incandescent light was there to counteract it with a softening glow, but the combination of fluorescence and linoleum, which must have been widespread for several years as the two trends overlapped, is not good.

As I had worked, then, my foot had, without any sanction from my conscious will, slipped from the untied shoe and sought out the texture of the carpeting; although now, as I reconstruct the moment, I realize that a more specialized desire was at work as well: when you slide a socked foot over a carpeted surface, the fibers of carpet and sock mesh and lock, so that though you think you are enjoying the texture of the carpeting, you are really enjoying the slippage of the inner surface of the sock against the underside of your foot, something you normally get to experience only in the morning when you first pull the sock on.[1]

A few minutes before twelve, I stopped working, threw out my earplugs and, more carefully, the remainder of my morning coffee – placing it upright within the converging spinnakers of the trash can liner on the base of the receptacle itself. I stapled a copy of a memo someone had cc:'d me on to a copy of an earlier memo I had written on the same subject, and wrote at the top to my manager, in my best casual scrawl, "Abe – should I keep hammering on these people or drop it?" I put the stapled papers in one of my Eldon trays, not sure whether I would forward them to Abelardo or not. Then I slipped my shoe back on by flipping it on its side, hooking it with my foot, and shaking it into place. I accomplished all this by foot-feel; and when I crouched forward, over the papers on my desk, to reach the untied shoelace, I experienced a faint surge of pride in being able to tie a shoe without looking at it. At that moment, Dave, Sue, and Steve, on their way to lunch, waved as they passed by my office. Right in the middle of tying a shoe as I was, I couldn't wave nonchalantly back, so I called out a startled, overhearty "Have a good one, guys!" They disappeared; I pulled the left shoelace tight, and bingo, it broke.

1. When I pull a sock on, I no longer pre-bunch, that is, I don't gather the sock up into telescoped folds over my thumbs and then position the resultant donut over my toes, even though I believed for some years that this was a clever trick, taught by admirable, fresh-faced kindergarten teachers, and that I revealed my laziness and my inability to plan ahead by instead bunching the sock by the ankle rim and jamming my foot to its destination, working the ankle a few times to properly seat the heel. Why?

The more elegant pre-bunching can leave in place any pieces of grit that have embedded themselves in your sole from the imperfectly swept floor you walked on to get from the shower to your room; while the cruder, more direct method, though it risks tearing an older sock, does detach this grit during the foot's downward passage, so that you seldom later feel irritating particles rolling around under your arch as you depart for the subway.

Chapter dividers. Striking photographs that precede each chapter serve as visual introductions to the subject being studied. Commissioned especially for *Seeing & Writing*, these photographs represent one artist's interpretation of the eight thematic units in the book.

Paired visual and verbal texts. Each chapter opens with a visual and verbal text that are linked. In some cases the text and image deal with exactly the same topic; in others they address the same theme; and in still others one text has inspired the other. By presenting two texts back to back, we're inviting you to focus on the differences and similarities between communicating an idea visually and verbally.

Portfolios. These show several examples of the work of a selected visual artist. This feature reinforces the fact that few artists have a single take on a topic or issue and that other artists create images in groups or series. In the Portfolio sections we provide biographical information about the artist in a headnote as well as insights into his or her particular the-

GIRL
Jamaica Kincaid

WASH THE WHITE CLOTHES ON MONDAY AND put them on the stone heap; wash the color clothes on Tuesday and put them on the clothesline to dry; don't walk barehead in the hot sun; cook pumpkin fritters in very hot sweet oil; soak your little cloths right after you take them off; when buying cotton to make yourself a nice blouse, be sure that it doesn't have gum on it, because that way it won't hold up well after a wash; soak salt fish overnight before you cook it; is it true that you sing benna[1] in Sunday school?; always eat your food in such a way that it won't turn someone else's stomach; on Sundays try to walk like a lady and not like the slut you are so bent on becoming; don't sing benna in Sunday school; you mustn't speak to wharf-rat boys, not even to give directions; don't eat fruits on the street—flies will follow you; *but I don't sing benna on Sundays at all and never in Sunday school*; this is how to sew on a button; this is how to make a buttonhole for the button you have just sewed on; this is how to hem a dress when you see the hem coming down and so to prevent yourself from looking like the slut I know you are so bent on becoming; this is how you iron your father's khaki shirt so that it doesn't have a crease; this is how you iron your father's khaki pants so that they don't have a crease; this is how you grow okra—far from the house, because okra tree harbors red ants; when you are growing dasheen,[2] make sure it gets plenty of water or else it makes your throat itch when you are eating it; this is how you sweep a corner; this is how you sweep a whole house; this is how you sweep a yard; this is how you smile to someone you don't like too much; this is

how you smile to someone you don't like at all; this is how you smile to someone you like completely; this is how you set a table for tea; this is how you set a table for dinner; this is how you set a table for dinner with an important guest; this is how you set a table for lunch; this is how you set a table for breakfast; this is how to behave in the presence of men who don't know you very well, and this way they won't recognize immediately the slut I have warned you against becoming; be sure to wash every day, even if it is with your own spit; don't squat down to play marbles—you are not a boy, you know; don't pick people's flowers—you might catch something; don't throw stones at blackbirds, because it might not be a blackbird at all; this is how to make a bread pudding; this is how to make doukona;[3] this is how to make pepper pot;[4] this is how to make a good medicine for a cold; this is how to make a good medicine to throw away a child before it even becomes a child; this is how to catch a fish; this is how to throw back a fish you don't like, and that way something bad won't fall on you; this is how to bully a man; this is how a man bullies you; this is how to love a man, and if this doesn't work there are other ways, and if they don't work don't feel too bad about giving up; this is how to spit up in the air if you feel like it, and this is how to move quick so that it doesn't fall on you; this is how to make ends meet; always squeeze bread to make sure it's fresh; *but what if the baker won't let me feel the bread?*; you mean to say that after all you are really going to be the kind of woman who the baker won't let near the bread? ○

1. *benna: Calypso music.*
2. *dasheen: the edible rootstock of taro, a tropical plant.*

3. *doukona: a spicy plantain pudding.*
4. *pepper pot: a stew.*

264 ENGENDERING DIFFERENCE

William H. Johnson, **Li'l Sis**

Pair: Kincaid & Johnson 265

matic and stylistic vision. Seeing and Writing questions following each Portfolio prompt you to think and write productively about reading multiple works by a single artist.

Retrospects. These "visual timelines" demonstrate in graphic terms the fact that cultural artifacts—such as advertisements, everyday objects, portraits, and pages of popular magazines—are products of particular historical moments. The things people take for granted haven't always been presented in the same way. You'll find the images in each Retrospect set on a black background. We let the images speak for themselves, providing you simply with the title and date of each one.

When you encounter a Retrospect, you might ask yourself the following questions: How is each image a product of a specific historical period? What patterns can be inferred from the series of images? Each Retrospect provides an opportunity for outside research. What examples might you put on a timeline that would complicate your reading of change?

Portfolio

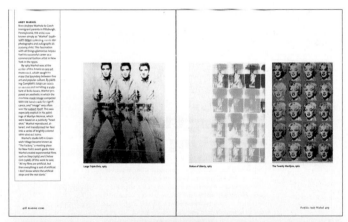

Retrospect

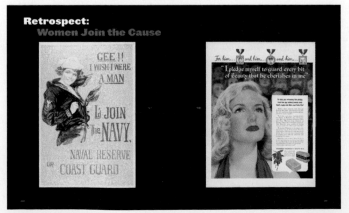

Looking Closer. These units at the end of each chapter consist of a carefully selected collection of materials that invite you to think about a specific, more focused aspect of the theme or issue presented in that chapter. Looking Closer units pose such questions as: How does changing one's scale of vision change what one sees? What does it mean to go home? How does the nature of photography shape one's private histories? How do people use fashion to announce their identities? How are children schooled in gender roles? How does the notion of "double consciousness" surface in contemporary American social life? What is the impact of the American flag as a national icon? To what extent can you believe what you see?

We have deliberately kept our editorial presence to a minimum in these Looking Closer units because we want you to look closely at the materials and think about the issues before shifting your focus to the author headnotes and the seeing and writing questions about selections.

Looking Closer in Chapter 3

Talking Pictures and **Re: Searching the Web.** Two boxed writing exercises appear in a dark column in every chapter. These exercises provide you with the opportunity to explore how some of the chapter's issues are treated online or on screen. In Talking Pictures we invite you to sharpen your awareness of the roles and effects of television shows and movies in American culture. In Re: Searching the Web we offer you the opportunity to use the Internet (whether you're beginning to explore the web or have already been using it regularly) as a research tool to enhance not only your understanding of particular questions, issues, or themes but also your ability to analyze the ways in which information is presented on the web.

Every page of *Seeing & Writing* has been designed to help you see more clearly and write more effectively. Given the fact that we're asking you to look closely at verbal and visual texts within and beyond this book, we also invite you to turn your attention to the content and design of the

Re: Searching the Web

pages of this book. What choices have the editors and designers made in presenting the material in this way? We encourage you to view this book as a text to be studied. What do you make of its visual and verbal "landscape"? Please share your responses and experiences of working with *Seeing & Writing* by writing to us at our web site.

Seeing & Writing Online, our book-related web site, can be reached at <http://www.bedfordstmartins.com/seeingwriting>. This site allows you to practice observation and inference with guided visual exercises; and to do Re: Searching the Web and Talking Pictures exercises online. It also provides links to other visual resources and virtual museums, and to annotated research links for the many authors, artists, and issues in this book.

Homepage

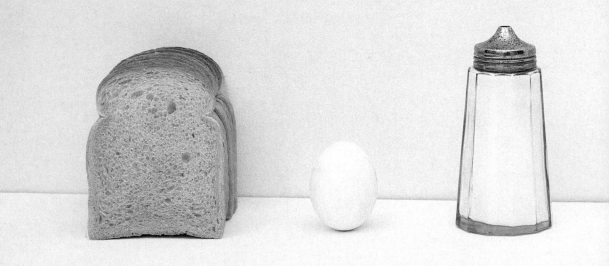

Observing the Ordinary

Imagine the following scene: It's Thanksgiving, well into the second night of a long holiday weekend visiting your parents. You have two papers due on Monday and an exam on Tuesday. It's been only two hours since you savored the delights of a home-cooked alternative to dorm food. Yet for the third time tonight, you stand at the open refrigerator door and stare blankly inside.

Such moments involve looking without actually noticing, the kind of attention many of us give to the ordinary in our lives. Staring into the refrigerator is a common example of what might be called passive looking—seeing without recognizing, looking without being aware of what we're looking at. How clearly, and accurately, for example, can you describe

Wolfgang Tillmans, **Grid A—Ordinary Objects**

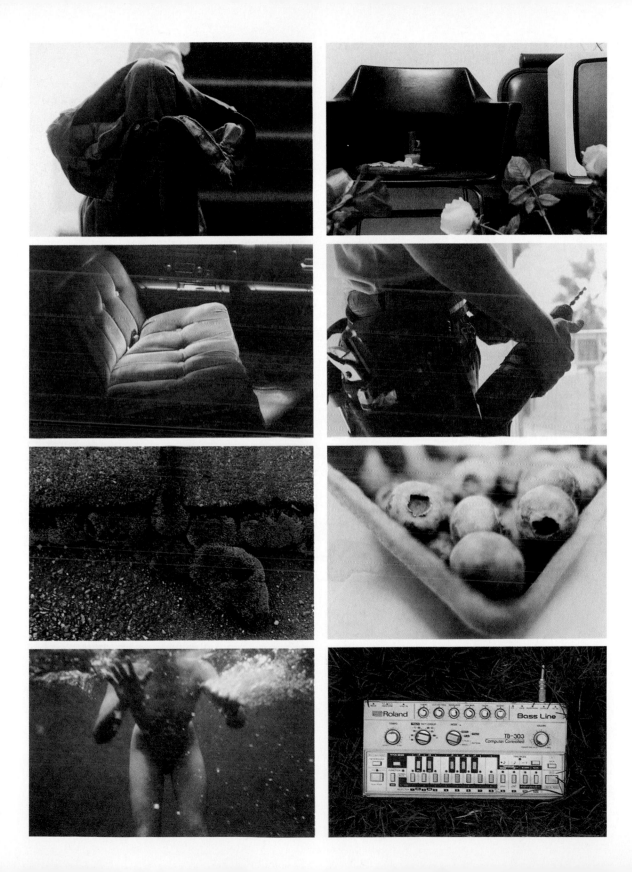

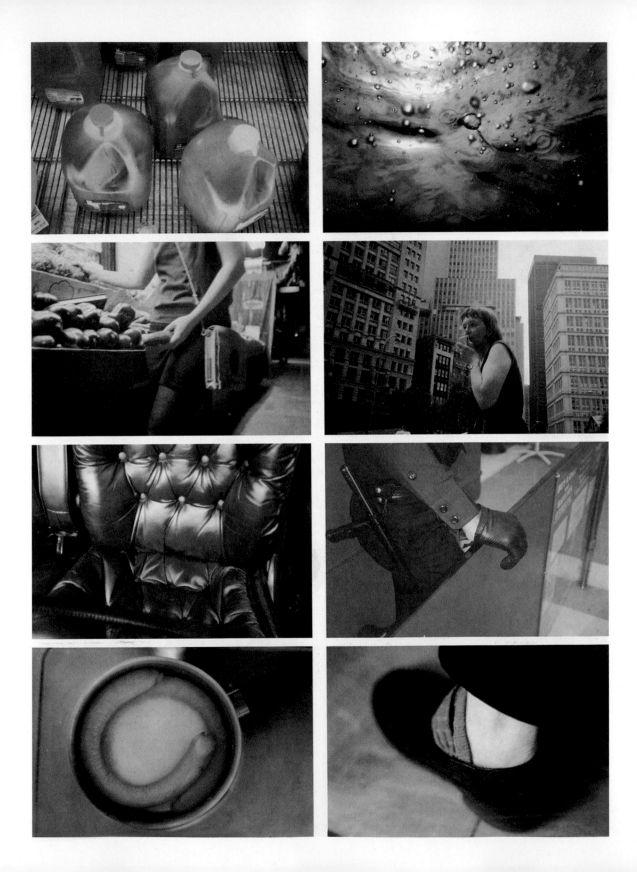

the objects most familiar to you: a penny; your favorite pair of shoes; the blanket on your bed; the food you ate this morning for breakfast? Most of us need to have such ordinary things physically in front of us in order to give a detailed, accurate description. Even if we all had the same object before us, each of our descriptions of it would likely be different, depending on who we are, the perspective from which we view the object, and the details we find important in it. If we practice examining commonplace objects with attention to both careful observation and an awareness of what makes every individual's perspective unique, we can begin to characterize more precisely for ourselves and others who we are and what we're like. By *actively seeing* the details of the ordinary we hone our skills of observation, the first step toward becoming a confident writer.

We see things as we are, not as they are.
– Jennifer Stone, 1997

Observing the ordinary with fresh eyes not only sharpens our skills of description, it also helps develop our ability to draw inferences. Indeed, drawing reasonable inferences from accurate observations involves seeing more than what is actually visible. Inferences are discoveries—of something we can't immediately see from what we can see. Consider, for example, the following scene: Two men sitting on a couch watching an NFL game on television at the same time that each is having considerable difficulty maneuvering the chips and salsa along a less-than-manicured path between bowl and mouth. By observing the men carefully, we can push beyond the stereotype they are projecting and reasonably infer from the clothes they are wearing or from other details some reliable information about what they do when they are not watching football on television.

Observing the ordinary is both the simplest skill to start exercising as a writer and a practical means of training ourselves to think and write analytically. When we are actively looking at the "ordinary," we realize it is a more complicated concept than we might at first have recognized. What might be regarded as ordinary by some of us may well be viewed as exceptional by others. Consider, for example, a car. Some people take owning a car for granted; others regard it as a luxury they can't afford. (Can you identify things that you view as ordinary in your own life that certain classmates would likely regard as exceptional?) We also invest ordinary objects

with private and public meanings. Each of us might personally relate to an ordinary object —a toothbrush, a coffee cup, a pencil—in different ways, yet we are likely to share at least some of the public significance attributed to ordinary objects in American culture such as a nickel, a cell phone, a hamburger, or a television set.

As you practice writing descriptions that will make your readers see what is extraordinary in your everyday life, you'll also be practicing active seeing—that is, seeing the world around you more carefully. To be an effective thinker and writer, you need to bring all of your sight—and insight—to bear on what is around you. If you notice and attend to the ordinary, if you devote focused and sustained attention to it, you increase the likelihood that you will become one of those on whom, as the novelist Henry James once said, "nothing is lost."

Each of the selections in this chapter presents the ordinary in some extra-ordinary way. The work of Wolfgang Tillmans and of other photographers throughout the chapter conveys the clarity of attention a photographer gives an object through the lens of a camera; the essays by Larry Woiwode, Linda Magyar, Nicholson Baker, and Annie Dillard demonstrate how writing can make us clearly see something that we would not otherwise have noticed.

All objects, all phases of culture are alive. They have voices. They speak of their history and interrelatedness. And they are talking at once!
– Camille Paglia, 1992

WOLFGANG TILLMANS

German-born Wolfgang Tillmans first gained notoriety with his stark and intense photographs of the "club scene" in his native Hamburg in the late 1980s. Although success as a lifestyle and fashion photographer for Europe's trendiest magazines followed, his aesthetic vision has developed as an antidote to the highly polished images of popular media. His photographs are imbued with a gritty authenticity and an informality often associated with amateur work.

Making portraits that go beyond simple stereotyping of members of his generation (he was born in 1968), Tillmans presents people, whether skinheads or gay activists, in all their striking tawdriness and beauty. One critic writes that his work "presents the unfolding of a new inclusive definition of beauty that . . . is ultimately closer to any concept of truth-telling than the codified images of the mainstream will ever be."

Fascinated by the shifting narratives created by a photo's context (where, how, and why a photo is placed where it is), Tillmans writes that he is "searching for applications and places that question the institutionalization of the image within both the gallery and the magazine." The first collection and study of Tillmans's work, entitled *Wolfgang Tillmans,* was published in 1994.

SEEING

1. What is your overall impression of these photographs? What about them seems ordinary to you? What seems unusual? Which photographs catch your attention more than others? Why? Can you identify the object in each photograph? What details do you notice about each of the scenes or objects? What stories does each photograph suggest to you?

2. Each of Tillmans's photographs reveals only a portion of a scene or object. What similarities and differences do you see in his approach to framing each scene or object? Which textures, colors, or shapes stand out the most to you? Why? Comment on what Tillmans includes and leaves out when framing each of the objects or scenes in the grids. What happens when you look at the ordinary out of context?

WRITING

1. Consider both grids of objects as one artist's statement. What is Tillmans trying to say? How would you characterize these objects as a group? Who are the people? Where are these places? Choose two or three words that you think describe Tillmans's "vision," and write a page or so using evidence from the photographs to defend your choices.

2. Tillmans describes himself as challenging "the institutionalization of the image within both the gallery and the magazine." Look through any two mainstream magazines, making notes about the kinds of images you find (what is photographed, for what purpose, and how images are presented). Write an essay comparing the way objects are presented (1) in the mainstream magazines you chose, and (2) in Tillmans's work shown here.

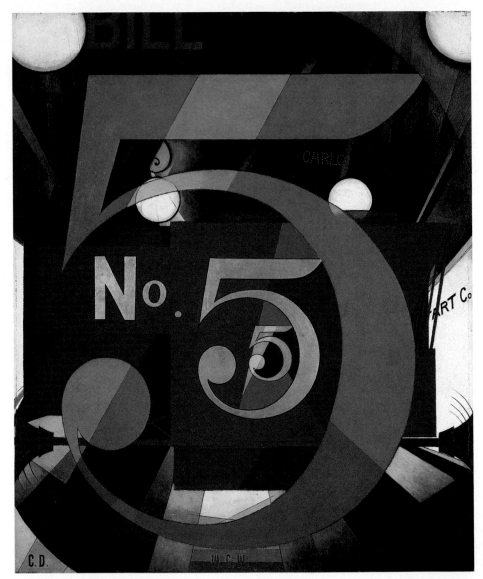

Charles Demuth, **The Figure 5 in Gold**

THE GREAT FIGURE

William Carlos Williams

Among the rain
and lights
I saw the figure 5
in gold
on a red 5
firetruck
moving
tense
unheeded
to gong clangs 10
siren howls
and wheels rumbling
through the dark city.

CHARLES DEMUTH

Born to a well-to-do family in 1883, in Lancaster, Pennsylvania, Charles Demuth studied at the Pennsylvania Academy of the Fine Arts, where he met William Carlos Williams. While in Europe, Demuth was influenced by Cubism, but on returning to America he synthesized his own style of abstract art, which has been called "abstract realism." Demuth applied his precise and hard-edged vision to the developing industrial landscape of America, depicting its structures and designs as monumental icons of American life.

Demuth painted *The Figure 5 in Gold* in 1928, after William Carlos Williams's poem was published, as part of a series of poster-portraits Demuth undertook to honor his friends. Parts of Williams's name—Bill, Carlos, etc.—are visible in the picture. Some critics see the name Carlos "in lights" as Demuth's statement that William Carlos Williams's name would be famous.

Demuth, who suffered from diabetes for most of his life, died in 1935. His paintings are in the collections of the Whitney Museum of American Art and the Metropolitan Museum of Art in New York.

A nonobjective school of painting and sculpture that presents the reduction and fragmentation of natural forms into abstract, often geometric, structures.

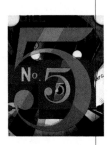

WILLIAM CARLOS WILLIAMS

Perhaps more than any other poet, William Carlos Williams helped to define the American modernist sensibility. By insisting on the integrity of his own experience, by speaking of visible objects close at hand, and by using language marked by the cadences of everyday speech, Williams opened a vein of American writing that has continued to flow through later generations of poets.

When asked in 1929 what he considered his strongest characteristic, Williams answered, "my sight": "I like most my ability to be drunk with a sudden realization of value in things others never notice." "Sudden" was a key word, for in Williams's quick-witted poems, language moves seamlessly from the observed world to the internal world.

Born in Rutherford in 1883 of an English father and Basque/Jewish mother from Puerto Rico, Williams studied medicine at the University of Pennsylvania from 1902 to 1909, where he met the painter Charles Demuth. Throughout his life, Williams acted as essayist, reviewer and mentor for the artists and writers who shared his vision of a uniquely American art. His books include *The Tempers* (1913), *Kora in Hell: Improvisations* (1920), *Spring and All* (1923), *The Great American Novel* (1923), and *In the American Grain* (1925), an exploration of American history and culture. In the 1940s Williams began to publish his long poem *Paterson*. His final book, *Pictures from Brueghel*, was published in 1962. Williams died the following year.

Any art that is not concerned with representing its subject realistically, that emphasizes form rather than subject.

THE GREAT FIGURE
William Carlos Williams

Among the rain
and lights
I saw the figure 5
in gold
on a red
firetruck
moving
tense
unheeded
to gong clangs
siren howls
and wheels rumbling
through the dark city

SEEING

1. What senses—in addition to sight—does William Carlos Williams draw on to describe the fire truck? Point to specific words and phrases to verify your reading. To what extent has Williams described the fire truck effectively? What do you make of his use of the details presented in lines 1–2 of the poem? What effects does Williams try to create through introducing so much movement in the poem? To what extent would you agree with the claim that this poem is Williams's attempt to create with words a compelling image of a fire truck?

2. Now, please turn your attention to Charles Demuth's painting. What was your first impression of this painting? As you examine it more carefully, what additional details do you see? What senses, in addition to sight, does Demuth draw on in this painting? What inferences might you make about Demuth's artistic presence in the painting? What features of the fire truck does Demuth seem to emphasize?

3. Compare the description of the fire truck presented in Williams's poem and in Demuth's painting. Which representation do you find more engaging and compelling? Why? What can descriptive writing accomplish that painting cannot? Alternatively, what can a painting describe more effectively than writing?

WRITING

1. William Carlos Williams's poem and Charles Demuth's painting offer two very different renditions of a red fire truck. Choose an object in the contemporary world—an automobile, a ripe avocado, a brand-name mountain bike, a succulent blueberry—that has roused your senses of sight and smell. Write the first draft of an essay in which you make as many observations about the object as possible, using description as a basis for drawing inferences about its distinctive "character."

2. The title and imagery of *The Figure 5 in Gold* were inspired by William Carlos Williams's "The Great Figure"—but Demuth was recording an abstract impression of a fire truck rather than a realistic representation. If you weren't told in a title or a headnote that this painting describes the effect of the No. 5 fire engine clanging through a rainy dark night, how would you have known? Write an expository essay in which you analyze the nature and extent of the different effects produced by a poem and a painting. Use *The Great Figure* and *The Figure 5 in Gold* as evidence, as well as any contemporary painting or poem.

LARRY WOIWODE

Larry Woiwode (b. 1941) grew up in North Dakota and Illinois. After moving to New York City in his twenties, he began to publish poems and stories in the *New Yorker, Atlantic Monthly, Harper's,* and other prestigious magazines. Among his books are the highly acclaimed novels *What I'm Going to Do, I Think* (1969) and *Beyond the Bedroom Wall* (1975). In 1978 he moved back to North Dakota, where he lives on a small farm and continues to write.

Woiwode uses precise observation and a sense of place to open up his fictional worlds. He notes that there "seems to be a paradox in writing fiction. For some reason the purest and simplest sentences permit the most meaning to adhere to them. In other words, the more specific a simple sentence is about a place in North Dakota, let us say, the more someone from outside that region seems to read universality into it." Although "Ode to an Orange" focuses on an object rather than a place, the same principle applies. In engagingly detailed sentences, Woiwode remembers specific experiences but evokes a universal romance with an ideal orange. This selection first appeared in *Paris Review* in 1985.

Ode to an Orange

Larry Woiwode

OH, THOSE ORANGES ARRIVING IN THE MIDST OF the North Dakota winters of the forties—the mere color of them, carried through the door in a net bag or a crate from out of the white winter landscape. Their appearance was enough to set my brother and me to thinking that it might be about time to develop an illness, which was the surest way of receiving a steady supply of them.

"Mom, we think we're getting a cold."

"*We?* You mean, you two want an orange?"

This was difficult for us to answer or dispute; the matter seemed moved beyond our mere wanting.

"If you want an orange," she would say, "why don't 5 you ask for one?"

"We want an orange."

"'We' again. *'We want an orange.'*"

"May we have an orange, please.*"*

"That's the way you know I like you to ask for one. Now, why don't each of you ask for one in that same way, but separately?"

"Mom ..." And so on. There was no depth of 10 degradation that we wouldn't descend to in order to get one. If the oranges hadn't wended their way northward by Thanksgiving, they were sure to arrive before the Christmas season, stacked first in crates at the depot, filling that musty place, where pews sat back to back, with a springtime acidity, as if the building had been rinsed with a renewing elixir that set it right for yet another year. Then the crates would appear at the local grocery store, often with the top slats pried back on a few of them, so that we were aware of a resinous smell of fresh wood in addition to the already orangy atmosphere that foretold the season more explicitly than any calendar.

And in the broken-open crates (as if burst by the power of the oranges themselves), one or two of the lovely spheres would lie free of the tissue they came wrapped in—always purple tissue, as if that were the only color that could contain the populations of them in their nestled positions. The crates bore paper labels at one end—of an orange against a blue background, or of a blue goose against an orange background— signifying the colorful otherworld (unlike our wintry

one) that these phenomena had arisen from. Each orange, stripped of its protective wrapping, as vivid in your vision as a pebbled sun, encouraged you to picture a whole pyramid of them in a bowl on your dining room table, glowing in the light, as if giving off the warmth that came through the windows from the real winter sun. And all of them came stamped with a blue-purple name as foreign as the otherworld that you might imagine as their place of origin, so that on Christmas day you would find yourself digging past everything else in your Christmas stocking, as if tunneling down to the country of China, in order to reach the rounded bulge at the tip of the toe which meant that you had received a personal reminder of another state of existence, wholly separate from your own.

The packed heft and texture, finally, of an orange in your hand—this is it!—and the eruption of smell and the watery fireworks as a knife, in the hand of someone skilled, like our mother, goes slicing through the skin so perfect for slicing. This gaseous spray can form a mist like smoke, which can then be lit with a match to create actual fireworks if there is a chance to hide alone with a match (matches being forbidden) and the peel from one. Sputtery ignitions can also be produced by squeezing a peel near a candle (at least one candle is generally always going at Christmastime), and the leftover peels are set on the stove top to scent the house.

And the ingenious way in which oranges come packed into their globes! The green nib at the top, like a detonator, can be bitten off, as if disarming the orange, in order to clear a place for you to sink a tooth under the peel. This is the best way to start. If you bite at the peel too much, your front teeth will feel scraped, like dry bone, and your lips will begin to burn from the bitter oil. Better to sink a tooth into this greenish or creamy depression, and then pick at that point with the nail of your thumb, removing a little piece of the peel at a time. Later, you might want to practice to see how large a piece you can remove intact. The peel can also be undone in one continuous ribbon, a feat which maybe your father is

able to perform, so that after the orange is freed, looking yellowish, the peel, rewound, will stand in its original shape, although empty.

The yellowish whole of the orange can now be divided into sections, usually about a dozen, by beginning with a division down the middle; after this, each section, enclosed in its papery skin, will be able to be lifted and torn loose more easily. There is a stem up the center of the sections like a mushroom stalk, but tougher; this can be eaten. A special variety of orange, without any pits, has an extra growth, or nubbin, like half of a tiny orange, tucked into its bottom. This nubbin is nearly as bitter as the peel, but it can be eaten, too; don't worry. Some of the sections will have miniature sections embedded in them and clinging as if for life, giving the impression that babies are being hatched, and should you happen to find some of these you've found the sweetest morsels of any.

If you prefer to have your orange sliced in half, as some people do, the edges of the peel will abrade the corners of your mouth, making them feel raw, as you eat down into the white of the rind (which is the only way to do it) until you can see daylight through the orangy bubbles composing its outside. Your eyes might burn; there is no proper way to eat an orange. If there are pits, they can get in the way, and the slower you eat an orange, the more you'll find your fingers sticking together. And no matter how carefully you eat one, or bite into a quarter, juice can always fly or slip from a corner of your mouth; this happens to everyone. Close your eyes to be on the safe side, and for the eruption in your mouth of the slivers of watery meat, which should be broken and rolled fine over your tongue for the essence of orange. And if indeed you have sensed yourself coming down with a cold, there is a chance that you will feel it driven from your head—your nose and sinuses suddenly opening—in the midst of the scent of a peel and eating an orange.

And oranges can also be eaten whole—rolled into a spongy mass and punctured with a pencil (if you don't find this offensive) or a knife, and then sucked upon. Then, once the juice is gone, you can disembowel the orange as you wish and eat away its pulpy remains, and eat once more into the whitish interior of the peel, which scours the coating from your teeth and makes your numbing lips and tip of your tongue start to tingle and swell up from behind, until, in the light from the windows (shining through an empty glass bowl), you see orange again from the inside. Oh, oranges, solid *o*'s, light from afar in the midst of the freeze, and not unlike that unspherical fruit which first went from Eve to Adam and from there (to abbreviate matters) to my brother and me.

"Mom, we think we're getting a cold."

"You mean, you want an orange?"

This is difficult to answer or dispute or even to acknowledge, finally, with the fullness that the subject deserves, and that each orange bears, within its own makeup, into this hard-edged yet insubstantial, incomplete, cold, wintry world. ○

1. Larry Woiwode takes great pleasure in lingering on the special qualities of what most of us would view as an altogether ordinary piece of fruit. What impression of an orange does Woiwode create? When, how, and why does he draw on each of the five senses to create this overall effect?

2. In addition to description, what other techniques does Woiwode use to evoke such a vibrant orange? What does he mean when he says that the oranges of his youth signified "the colorful otherworld"? What range of associations do the oranges of his youth evoke in Woiwode now? He was a child in the 1940s and 1950s, the same time that labels such as "Have One" (p. 16) were used to promote the fruit. If you consider the essay and the crate label together, does the way you see each one change? Why or why not?

1. Consider Woiwode's title: "Ode to an Orange." How does his essay satisfy the expectations usually associated with the word *ode*? Write your own ode to a piece of fruit; the goal is to evoke longing in your readers.

2. Woiwode uses each of the five senses—touch, sound, sight, smell, and taste—to convey the appeal of an orange. Imagine that you have to give up one of the five senses and that it will be taken away arbitrarily if you cannot argue convincingly for one over the others. Write the first draft of an essay, using Woiwode for support, about which of the five senses is least important to you.

Pepperidge Farm, **Smiley Goldfish Cracker**

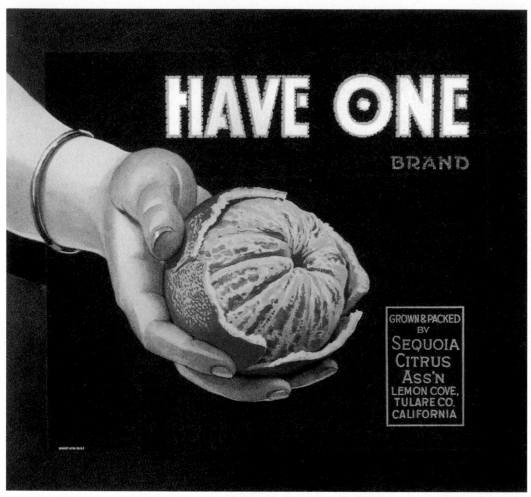

Sequoia Citrus Association, **Have One**

California Orange Growers, **Orange Crate Labels**

SEQUOIA CITRUS ASSOCIATION

From the late 1880s through the 1950s, California citrus growers and farmers relied on colorful paper labels to promote the fruits and vegetables they shipped in wooden crates throughout the United States. Designed primarily to attract wholesale buyers in distant markets, these distinctive examples of commercial art also helped to promote idealized images of California and to transplant seekers of sunshine and fortune. Many early labels accentuated the image of California as a land of plenty, innocence, and beauty; but such pastoral images and allegorical scenes soon yielded to the accelerated pace and more sophisticated look of urban life: bolder typography, darker colors, and billboard-like graphics associated with automobile advertisements.

The use of paper labels ended when corporate interests overshadowed individual and family enterprises, when small private groves were consumed by cooperatives or plowed into sites for tract-home communities, and when cardboard cartons replaced wooden crates.

The orange crate label for the Have One brand, which appeared in the 1920s, and the other labels reprinted here from the early twentieth century offer striking examples of the graphics and themes used to identify brand names through easily remembered images.

SEEING

1. The label used by the Sequoia Citrus Association to identify its oranges looks simple: a hand, an orange, a statement. But as you examine the label more carefully, do you notice anything that makes the image more complicated? What about the hand makes it distinct? How does its placement reinforce—or subvert—the invitation to "have" an orange? What are the advantages—and the disadvantages—of using an imperative in the headline ("Have One")? Is anything being sold here besides an orange?

2. Consider each of the graphic elements in the label. What do you notice about the placement of the hand and forearm? What effects does the artist achieve by superimposing the forearm and hand on the image? What aspects of the appearance of the orange does the artist highlight in order to call attention to the orange? What other graphic elements help to focus the viewer's attention on the orange and its succulence? In what ways does the typography used in the name of the brand reinforce—or detract from—the effectiveness of this graphic design?

WRITING

1. What products are most often identified with the community in which you live or attend college? Choose one product that interests you, and conduct some preliminary research on the earliest commercial representations of it. (You might check the holdings in the periodical and rare book sections of your library, or you might visit the local historical society.) Focusing on one example of commercial art used to promote this product, write an essay in which you analyze the way in which the graphic elements and language borrow from or help reinforce the identity of this particular community.

2. Cryptic advertising imperatives that never explicitly name the product they are promoting (e.g., "Just do it" or "Enjoy the ride") are used in many contemporary ads and commercials. What is more effective—the image or the language—in ads like these? Choose one such advertisement or commercial—whether the product is an orange, an automobile, or a sneaker—and write an essay in which you explain why you think the ad or commercial does or does not "work."

WILLIAM EGGLESTON

Born in 1939 in Memphis, Tennessee, not far from his family's Mississippi cotton farm, William Eggleston attended several colleges in the South. While he was a student at Vanderbilt University he was inspired by the work of Henri Cartier-Bresson, the French photographer celebrated for his spontaneously captured, black and white images of everyday life.

Like Cartier-Bresson, Eggleston focuses on the everyday and the private; in spirit his work invokes the practice of taking snapshots. In his book *A Guide,* published by the Museum of Modern Art in 1976, the photos are like those in any family album, suggesting stories or meanings seemingly visible only to those who know the subject. An Eggleston "snapshot" of objects under a bed might lead us to wonder, "What was he looking for?" or "Whose shoes are those?" However slight such images may seem on the surface, as a whole they demonstrate the possibilities of viewing domestic detail as rich material for a photographic diary. These powerfully simple images subvert our expectations of art; they document dull and ordinary aspects of our environment with wit and imagination.

Eggleston has been the recipient of a Guggenheim fellowship and a National Endowment for the Arts fellowship, among many other awards.

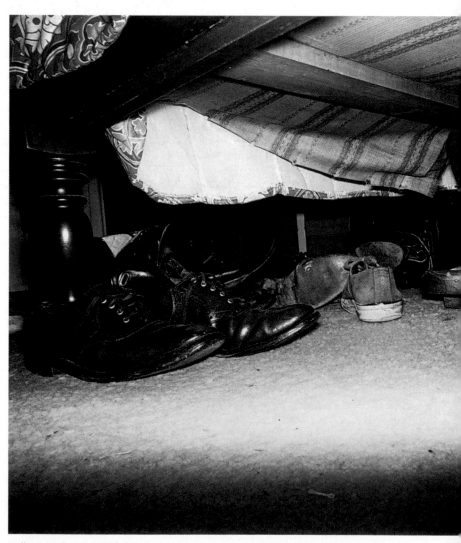

William Eggleston, **Untitled**

1. William Eggleston's photographs transform the most ordinary objects and scenes into inviting occasions for discovering the unrecognized dimensions of the most homely objects and locations. Identify each of the objects you see in this image. Which attracts your attention first? Which holds your attention the longest? What are the advantages—and disadvantages—of Eggleston having chosen not to show all of the bed and what's underneath it?

2. Consider the angle from which the photograph is taken. How does this perspective enable Eggleston to create a presence for himself in the photograph without being literally present in it? Comment on the composition—the overall organization—of this image. What do you notice, for example, about the relation of the carpet to the shoes? to the bed? to the walls beyond it? What do you notice about Eggleston's use of light and shadows? Eggleston names this moment "Untitled." Given the observations you've made about the image, what would you call it?

1. One way to gain important new awareness of the ordinary is to look for those things that are most often hidden, like Eggleston's space under the bed. Photography provides an important opportunity to explore such spaces; writing offers another. Choose a hidden space in the place where you live—under the bed, inside a closet, behind a bookshelf—and describe what you see there. Did seeking out a hidden space change how you see what's there?

2. This photograph appears in a collection entitled *The Pleasures and Terrors of Domestic Comfort.* Which emotion does this image most make you feel—pleasure or terror? or something else? Write an essay in two parts: First, explain what you think the collection title means and how it fits your own experience of "domestic comfort"; second, evaluate how well Eggleston's photograph fits that title.

Retrospect:
Changing Gears

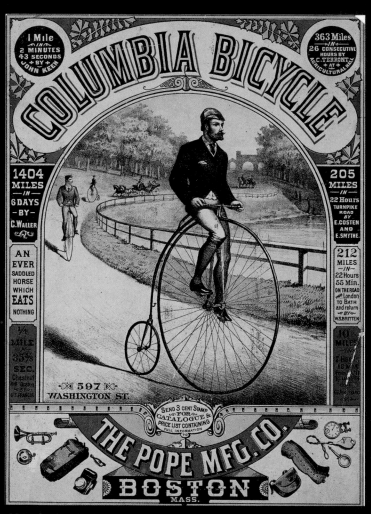

1886 Columbia Bicycle

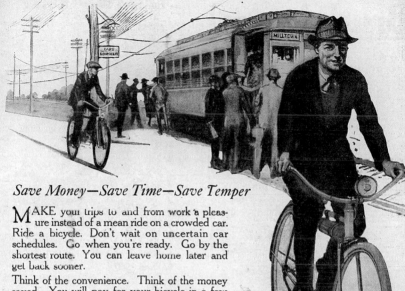

Save Money—Save Time—Save Temper

MAKE your trips to and from work a pleasure instead of a mean ride on a crowded car. Ride a bicycle. Don't wait on uncertain car schedules. Go when you're ready. Go by the shortest route. You can leave home later and get back sooner.

Think of the convenience. Think of the money saved. You will pay for your bicycle in a few months. Is it any wonder that more people are riding bicycles today than ever before?

How good it makes you feel! The red blood sings thru your veins, driving away those morning headaches and that old sluggish feeling! You get to work feeling like taking that old job and fairly "eating it up!" Health and a clear brain go a long way towards making a successful man. A bicycle goes nearly all the way towards making a healthy man!

The bicycle is the most economical mode of transportation. It is the most healthful. It is a pleasant benefit for every member of your family.

See Your Dealer Today

CYCLE TRADES OF AMERICA, Inc., 35 Warren Street, New York, U. S. A.

Ride a Bicycle

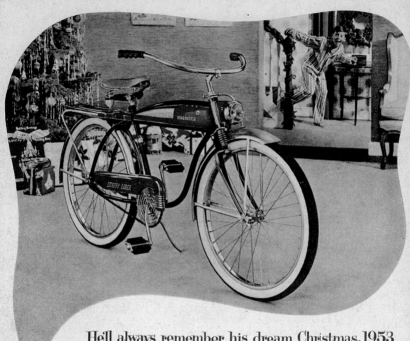

He'll always remember his dream Christmas, 1953

There it stands—his dream bicycle come true—the AMF Roadmaster Luxury Liner. What a sturdy beauty—and with all those extra features he especially wants! Mile-measuring Roadometer, Shockmaster coil-spring fork. Far-seeing Searchbeam headlight and electric horn, too. And you, Mom and Dad, can be satisfied he's safe—thanks to AMF engineering and Roadmaster experience. He gets safety bumper bars and an electronically-welded frame. See the full line of AMF Roadmasters at your dealer's and fine stores.

★ **ROADOMETER** automatically measures and records the miles you ride from 1/10 mile up to 10,000 miles.

Oh! for the small fry

here's the 20" De Luxe. Can be fitted with SAF-T-RIDER attachment. Balances him while he's learning.

 products ARE BETTER...by design
AMERICAN MACHINE & FOUNDRY COMPANY

Tune in **OMNIBUS** Sunday afternoons for America's most unusual TV entertainment. See local paper for time and channel. See smooth-riding AMF Roadmasters on Nov. 8th and Dec. 6th programs.

1953 Roadmaster

YOU SHOULD NEVER RUN AWAY
FROM YOUR PROBLEMS.
PEDALING IS MUCH FASTER.

Presenting the
Rockhopper A1
Comp FS with an
aluminum frame,
Manitou Spyder R
fork, race-ready
components and a
price that's right.
Ride hard.
Pedal fast.
Aim for puddles.

www.specialized.com

1998 Specialized Bicycles

LINDA MAGYAR

The universal product code—the black and white parallel lines on almost every product on sale in American stores—is used by manufacturers and retailers to register product prices, track inventory, and document sales preferences of consumers. The "bar codes" are read by scanners, which translate the light reflected by the codes' white surfaces into electrical signals that are converted into digital information sent to the retailer's computer system.

A recent article described the nature and extent of the different bar code "languages," which are called *symbologies*. These are used "to identify different types of products, like groceries, clothing and electronics. The central group for bar code *symbologies* is the Uniform Code Council, an independent organization that assigns and regulates all bar codes used in this country. The council cooperates with similar groups in Europe and Japan." Indeed, manufacturers and retailers have become so dependent on the universal product code that it has become increasingly difficult for cashiers to process purchases if a product doesn't have a bar code on it. Many states are adapting the code for use on drivers' licenses and other forms of official identification.

Linda Magyar, a staff writer at the *New York Times,* often writes about contemporary American consumer culture.

A Turn of the SKU

A step-by-step guide to the machinery set in motion when you buy a bottle of mouthwash

IT MAY BE TECHNOLOGY'S MOST DAZZLING effect on retailing, but you're only likely to notice it if there's a snag. As your purchase is checked out of any major store, a laser beam registers the bar code stamped on the label. In it is encrypted the numbers assigned to your item—or stock-keeping unit (SKU, pronounced skew) in store-speak. A price and description appear on a screen above the cash register. You pay up and you're done.

But inside the store a chain reaction is taking place that has revolutionized one of the most vexing problems in business: how to keep inventory and demand in balance.

This once meant manual counts, meticulous workbook entries, educated guesses—and a perilous wait while the data reach suppliers, a wait that could result in lost sales or pileups of unpopular merchandise. But now this single step at the point of purchase can provide a continuous stream of information to store, warehouse, shipper and manufacturer. Wal-Mart Stores, the world's largest retailer, is a leader in automated inventory management, having invested $500 million in technology annually for the past three years.

The result: The right merchandise at the right place at the right time.

—LINDA F. MAGYAR

1. SCAN

When the Universal Product Code on your Listerine bottle is scanned, the following information is registered into Wal-Mart's database: SKU No. 4279874; Listerine original; 1.5 liters; the retail price and cost to Wal-Mart. The data are used to manage inventory. Is an Oklahoma outlet sold out? Are sales low in Maine? Is the reason geography? Shipping? The brand? Wal-Mart can monitor Listerine's status instantly—and take corrective action.

4. RETAIL LINK

Retail Link is the database Wal-Mart shares with 2,500 of its 10,000 suppliers, including Warner-Lambert, Listerine's manufacturer. The 65 weeks of 4279874's sales history always available to Warner-Lambert can help the company adjust its production schedule to meet Wal-Mart's needs as they change.

2. LOCATOR PROGRAM

If a store runs out of 4279874, managers, and even clerks, can pick up one of Wal-Mart's 90,000 Telxon hand-held computers and tap into the company's Item Locator Program to find the closest Wal-Mart with inventory of 4279874 to spare. After a phone call to that store, the merchandise will be sent where it is needed.

5. FORECASTING

To improve coordination between retailer and manufacturer, Wal-Mart and Warner-Lambert are testing a collaborative forecasting and replenishment program that factors in seasonal trends like pollen counts to sales history. So far, this program has cut 427984's supply cycle—from Warner-Lambert's production line to Wal-Mart's shelves—from 12 weeks to 6.

3. DATA TRANSMISSION

The Telxons also communicate by satellite with Wal-Mart headquarters in Bentonville, Ark., transmitting and receiving data several times a day. Store managers, as well as company executives, track 4279874 and can order display changes when, say, Rosie O'-Donnell plugs Listerine on her show.

4279874

SEEING

1. Linda Magyar divides the process of keeping "inventory and demand in balance" into five steps. To what extent is this effective in presenting her central points? What information do the five points leave out? How might your reading of Magyar's piece change if it were written as an unbroken paragraph and did not include the image?

2. It is virtually impossible to buy a product without the little rectangle of black lines called a UPC (universal product code). Does the information Magyar provides about its use surprise you? Do you find the bar code more troubling as a means of keeping inventory than, say, keeping records with pen and pencil? Why or why not?

WRITING

1. Magyar focuses on the meaning of a UPC or bar code for store owners and manufacturers. Extend your analysis of the UPC, and consider the range of cultural meanings the bar code evokes for Americans. Write down as many associations as come to mind. What, for example, does the artist suggest in "Man Turning into a Barcode" about the nature of the UPC and contemporary culture? Write a short essay in which you explore how "Man Turning into a Barcode" illustrates the perceived and/or real functions of the bar code in contemporary American culture.

2. Imagine a future world when, instead of being issued a Social Security card, all people are marked at birth with an identity code. Write an essay in which you compare the benefits and liabilities of such a system.

Graphis Student Design,
Man Turning into a Barcode

 Re: Searching the Web

Choose a common commercial product that you would be likely to find in anyone's home: A carton of milk, a jar of peanut butter or jelly, a vacuum cleaner, a toaster, a radio, a CD player are a few examples. (Please do not restrict yourself to these examples. You might, for instance, choose one of the objects depicted in the portfolio of photographic images presented by Neil Winokur on pp. 28–29.)

What ordinary object piques your interest in knowing about its origins? Using a search engine to explore the World Wide Web, gather as much information as possible on the history of this product's origins and commercial development. At what point—and in what circumstances—was an image (a drawing or a photograph) of this product important to its gaining corporate and, eventually, public acceptance? Spend some time analyzing the drawing or photograph. Then use it as the focal point for a first draft of a narrative essay that weaves together details of the history and commercial development of this ordinary object, one that remains a testament to individual ingenuity and technological progress.

NEIL WINOKUR

Neil Winokur uses the traditional medium of photographic portraiture to explore the ways in which we see ourselves and the objects around us. Often posing his human, animal, or mineral subjects against brightly colored backgrounds and using very large formats, Winokur's work mimics the look of the promotional product shots common to catalogues and other forms of advertising.

In a series of portraits from the mid-1980s entitled *Totems*, Winokur paired headshot photos of friends with photographs of their important objects. Arranged together, these composite portraits read like a visual biography for an age of materialism, suggesting that the objects we accumulate are in some way a reflection of ourselves. Winokur turned the same vision on his own life, producing *Self Portrait: An Installation* (1991) with 40 images that included a few of his favorite things (e.g., cigarettes, baseball glove) and people.

Winokur's work in portraits goes far beyond flat depictions of people or things; he likes to examine how we portray or disguise the world around us. His work is included in collections at the Museum of Modern Art in New York and the Los Angeles County Museum of Art. His larger-than-life dog portraits and object portraits (e.g., a flag, a high-heeled shoe) are, in the words of one critic, "influenced by the Hollywood glamour portrait yet decidedly unglamorous."

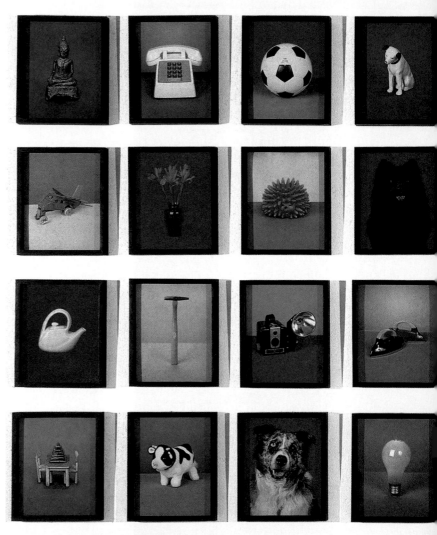

Neil Winokur, **Homage to Outerbridge**

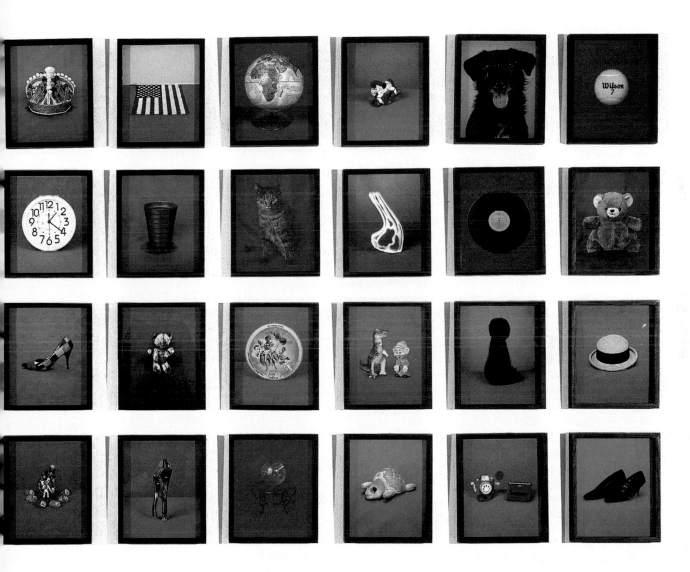

Portfolio: Neil Winokur 29

SEEING

1. What do you notice when you examine the portfolio of photographs presented by Neil Winokur's *Homage to Outerbridge*? Which image attracts your attention first? Which holds your attention the longest? Explain why. What relationship(s) does Winokur establish between and among the photographs? For example, does he express any sense of order or hierarchy in arranging the images, or does he place them randomly? What effects does he establish by repeating certain kinds of images? What perspective and attitude does Winokur establish by using color and by positioning each object within a frame and in relation to the other objects? What "statement(s)" does he make by doing so?

2. Now that you've had time to observe Winokur's images, think about the ways in which you viewed the overall portfolio. For example, how did your eye move as you viewed the images? At what point in the process did you begin to draw inferences from what you observed? What were those inferences? How would you characterize the overall impression(s) created by Winokur's images? With the portfolio in mind, examine the use of icons in the advertisement for Mercedes-Benz on page 398. Which objects depicted in Winokur's portfolio could be incorporated into the sequence in the Mercedes ad? Why? Where would you place each one in the ad?

WRITING

1. Make a list of the objects that are most important to you, and explain the significance of each. If you were to produce a composite portrait of yourself, as Winokur does, how would you arrange these objects? Taken as a whole, what would they suggest about you to someone who doesn't know you?

2. The next time you open the door to the place where you live, try to re-see it—and the ordinary objects inside—with the same powerful simplicity that Winokur displays in his grid of images. Choose one object on which to focus your attention. You might want to photograph it. Make a series of observations that demonstrate your responsiveness to the object and enable you to convey the sense that you see it in changed ways. Write the first draft of an essay in which you describe the object in order to markedly change your readers' appreciation of it.

NICHOLSON BAKER

"Some people think I'm a weird nut case with some sort of strange filing system," Nicholson Baker recently told an interviewer, responding to readers who are caught off guard by his unrelenting attention to detail, his love of the literal and metaphoric possibilities of language, and especially, as the interviewer put it, his "tendency to go off on long, serpentine tangents that reflect [his] catholic and often abstruse interests." A brilliant observer and describer of the commonplace, Baker writes with equal gusto and insight about everything from the internal workings of a movie projector to the nature and syntax of dirty talk and the manufacture of the fingernail clipper.

Born in 1957, Baker was educated at the Eastman School of Music and Haverford College. He is the author of five novels—*The Mezzanine* (1988), *Room Temperature* (1990), *Vox* (1992), *The Fermata* (1994), and *The Everlasting Story of Nory* (1998). His widely published essays have been collected in *The Size of Thoughts* (1996).

"Shoelaces" is the second chapter of Baker's remarkable first novel, *The Mezzanine*.

Shoelaces

Nicholson Baker

MY LEFT SHOELACE HAD SNAPPED JUST BEFORE lunch. At some earlier point in the morning, my left shoe had become untied, and as I had sat at my desk working on a memo, my foot had sensed its potential freedom and slipped out of the sauna of black cordovan to soothe itself with rhythmic movements over an area of wall-to-wall carpeting under my desk, which, unlike the tamped-down areas of public traffic, was still almost as soft and fibrous as it had been when first installed. Only under the desks and in the little-used conference rooms was the pile still plush enough to hold the beautiful Ms and Vs the night crew left as strokes of their vacuum cleaners' wands made swaths of dustless tufting lean in directions that alternately absorbed and reflected the light. The nearly universal carpeting of offices must have come about in my lifetime, judging from black-and-white movies and Hopper paintings: since the pervasion of carpeting, all you hear when people walk by are their own noises—the flap of their raincoats, the jingle of their change, the squeak of their shoes, the efficient little sniffs they make to signal to us and to themselves that they are busy and walking somewhere for a very good reason, as well as the almost sonic whoosh of receptionists' staggering and misguided perfumes, and the covert chokings and showings of tongues and placing of braceleted hands to windpipes that more tastefully scented secretaries exchange in their wake. One or two individuals in every office (Dave in mine), who have special pounding styles of walking, may still manage to get their footfalls heard; but in general now we all glide at work: a major improvement, as anyone knows who has visited those areas of offices that are still for various reasons linoleum-squared—cafeterias, mailrooms, computer rooms. Linoleum was bearable back when incandescent light was there to counteract it with a softening glow, but the combination of fluorescence and linoleum, which must have been widespread for several years as the two trends overlapped, is not good.

As I had worked, then, my foot had, without any sanction from my conscious will, slipped from the untied shoe and sought out the texture of the carpeting; although now, as I reconstruct the moment, I realize that a more specialized desire was at work as well: when you slide a socked foot over a carpeted surface, the fibers of sock and carpet mesh and lock, so that though you think you are enjoying the texture of the carpeting, you are really enjoying the slippage of the inner surface of the sock against the underside of your foot, something you normally get to experience only in the morning when you first pull the sock on.[1]

1. When I pull a sock on, I no longer *pre-bunch*, that is, I don't gather the sock up into telescoped folds over my thumbs and then position the resultant donut over my toes, even though I believed for some years that this was a clever trick, taught by admirable, fresh-faced kindergarten teachers, and that I revealed my laziness and my inability to plan ahead by instead holding the sock by the ankle rim and jamming my foot to its destination, working the ankle a few times to properly seat the heel. Why? The more elegant prebunching can leave in place any pieces of grit that have embedded themselves in your sole from the imperfectly swept floor you walked on to get from the shower to your room; while the cruder, more direct method, though it risks tearing an older sock, does detach this grit during the foot's downward passage, so that you seldom later feel irritating particles rolling around under your arch as you depart for the subway.

At a few minutes before twelve, I stopped working, threw out my earplugs and, more carefully, the remainder of my morning coffee—placing it upright within the converging spinnakers of the trash can liner on the base of the receptacle itself. I stapled a copy of a memo someone had cc:'d me on to a copy of an earlier memo I had written on the same subject, and wrote at the top to my manager, in my best casual scrawl, "Abe—should I keep hammering on these people or drop it?" I put the stapled papers in one of my Eldon trays, not sure whether I would forward them to Abelardo or not. Then I slipped my shoe back on by flipping it on its side, hooking it with my foot, and shaking it into place. I accomplished all this by foot-feel; and when I crouched forward, over the papers on my desk, to reach the untied shoelace, I experienced a faint surge of pride in being able to tie a shoe without looking at it. At that moment, Dave, Sue, and Steve, on their way to lunch, waved as they passed by my office. Right in the middle of tying a shoe as I was, I couldn't wave nonchalantly back, so I called out a startled, overhearty "Have a good one, guys!" They disappeared; I pulled the left shoelace tight, and *bingo,* it broke.

The curve of incredulousness and resignation I rode out at that moment was a kind caused in life by a certain class of events, disruptions of physical routines, such as:

 a. reaching a top step but thinking there is another step there, and stamping down on the landing;

 b. pulling on the red thread that is supposed to butterfly a Band-Aid and having it wrest free from the wrapper without tearing it;

 c. drawing a piece of Scotch tape from the roll that resides half sunk in its black, weighted Duesenberg of a dispenser, hearing the slightly descending whisper of adhesive-coated plastic detaching itself from the back of the tape to come (descending in pitch because the strip, while amplifying the sound, is also getting longer as you pull on it),[2] and then, just as you are intending to break the piece off over the metal serration, reaching the innermost end of the roll, so that the segment you have been pulling wafts unexpectedly free. Especially now, with the rise of Post-it notes, which have made the massive black tape-dispensers seem even more grandiose and Biedermeier and tragically defunct, you almost believe that you will never come to the end of a roll of tape; and when you do, there is a feeling, nearly, though very briefly, of shock and grief;

 d. attempting to staple a thick memo, and looking forward, as you begin to lean on the brontosaural head of the stapler arm,[3] to the three phases of the act—

first, before the stapler arm makes contact with the paper, the resistance of the spring that keeps the arm held up; then, *second,* the moment when the small independent unit in the stapler arm noses into the paper and begins to force the two points of the staple into and through it; and, *third,* the felt crunch, like the chewing of an ice cube, as the twin tines of the staple emerge from the underside of the paper and are bent by the two troughs of the template in the stapler's base, curving inward in a crab's embrace of your memo, and finally disengaging from the machine completely—

2. When I was little I thought it was called Scotch tape because the word "scotch" imitated the descending screech of early cellophane tapes. As incandescence gave way before fluorescence in office lighting, Scotch tape, once yellowish-transparent, became bluish-transparent, as well as superbly quiet.

3. Staplers have followed, lagging by about ten years, the broad stylistic changes we have witnessed in train locomotives and phonograph tonearms, both of which they resemble. The oldest staplers are cast-ironic and upright, like coal-fired locomotives and Edison wax-cylinder players. Then, in mid-century, as locomotive manufacturers discovered the word "streamlined," and as tonearm designers housed the stylus in aerodynamic ribbed plastic hoods that looked like trains curving around a mountain, the people at Swingline and Bates tagged along, instinctively sensing that staplers were like locomotives in that the two prongs of the staple make contact with a pair of metal hollows, which, like the paired rails under the wheels of the train, forces them to follow a preset path, and that they were like phonograph tonearms in that both machines, roughly the same size, make sharp points of contact with their respective media of informational storage. (In the case of the tonearm, the stylus retrieves the information, while in the case of the stapler, the staple binds it together as a unit—the order, the shipping paper, the invoice: *boom,* stapled, a unit; the letter of complaint, the copies of canceled checks and receipts, the letter of apologetic response: *boom,* stapled, a unit; a sequence of memos and telexes holding the history of some interdepartmental controversy: *boom,* stapled, one controversy. In old stapled problems, you can see the TB vaccine marks in the upper left corner where staples have been removed and replaced, removed and replaced, as the problem—even the staple holes of the problem—was copied and sent on to other departments for further action, copying, and stapling.) And then the great era of squareness set in: BART was the ideal for trains, while AR and Bang & Olufsen turntables became angular—no more cream-colored bulbs of plastic! The people at Bates and Swingline again were drawn along, ridding their devices of all softening curvatures and offering black rather than the interestingly textured tan. And now, of course, the high-speed trains of France and Japan have reverted to aerodynamic profiles reminiscent of *Popular Science* cities-of-the-future covers of the fifties; and soon the stapler will incorporate a toned-down pompadour swoop as well. Sadly, the tonearm's stylistic progress has slowed, because all the buyers who would appreciate an up-to-date Soviet Realism in the design are buying CD players: its inspirational era is over.

but finding, as you lean on the stapler with your elbow locked and your breath held and it slumps toothlessly to the paper, that it has run out of staples. How could something this consistent, this incremental, betray you? (But then you are consoled: you get to reload it, laying bare the stapler arm and dropping a long zithering row of staples into place; and later, on the phone, you get to toy with the piece of the staples you couldn't fit into the stapler, breaking it into smaller segments, making them dangle on a hinge of glue.)

In the aftermath of the broken-shoelace disappointment, irrationally, I pictured Dave, Sue, and Steve as I had just seen them and thought, "Cheerful assholes!" because I had probably broken the shoelace by transferring the social energy that I had had to muster in order to deliver a chummy "Have a good one!" to them from my awkward shoe-tier's crouch into the force I had used in pulling on the shoelace. Of course, it would have worn out sooner or later anyway. It was the original shoelace, and the shoes were the very ones my father had bought me two years earlier, just after I had started this job, my first out of college—so the breakage was a sentimental milestone of sorts. I rolled back in my chair to study the damage, imagining the smiles on my three co-workers' faces suddenly vanishing if I had really called them cheerful assholes, and regretting this burst of ill feeling toward them.

As soon as my gaze fell to my shoes, however, I was reminded of something that should have struck me the instant the shoelace had first snapped. The day before, as I had been getting ready for work, my *other* shoelace, the right one, had snapped, too, as I was yanking it tight to tie it, under very similar circumstances. I repaired it with a knot, just as I was planning to do now with the left. I was surprised—more than surprised—to think that after almost two years my right and left shoelaces could fail less than two days apart. Apparently my shoe-tying routine was so unvarying and robotic that over those hundreds of mornings I had inflicted identical levels of wear on both laces. The near simultaneity was very exciting— it made the variables of private life seem suddenly graspable and law-abiding.

I moistened the splayed threads of the snapped-off piece and twirled them gently into a damp, unwholesome minaret. Breathing steadily and softly through my nose, I was able to guide the saliva-sharpened leader thread through the eyelet without too much trouble. And then I grew uncertain. In order for the shoelaces to have worn to the breaking point on almost the same day, they would have had to be tied almost exactly the same number of times. But when Dave, Sue, and Steve passed my office door, I had been in the middle of tying one shoe—*one shoe only*. And in the course of a normal day it wasn't at all unusual for one shoe to come untied independent of the other. In the morning, of course, you always tied both shoes, but random midday comings-undone would have to have constituted a significant proportion of the total wear on both of these broken laces, I felt possibly thirty percent. And how could I be positive that this thirty percent was equally distributed—that right and left shoes had come randomly undone over the last two years with the same frequency?

I tried to call up some sample memories of shoe-tying to determine whether one shoe tended to come untied more often than another. What I found was that I did not retain a single specific engram of tying a shoe, or a pair of shoes, that dated from any later than when I was four or five years old, the age at which I had first learned the skill. Over twenty years of empirical data were lost forever, a complete blank. But I suppose this is often true of moments of life that are remembered as major advances: the discovery is the crucial thing, not its repeated later applications. As it happened, the first *three* major advances in my life—and I will list all the advances here—

1. shoe-tying
2. pulling up on Xs
3. steadying hand against sneaker when tying
4. brushing tongue as well as teeth
5. putting on deodorant after I was fully dressed
6. discovering that sweeping was fun
7. ordering a rubber stamp with my address on it to make bill-paying more efficient
8. deciding that brain cells ought to die

—have to do with shoe-tying, but I don't think that this fact is very unusual. Shoes are the first adult machines we are given to master. Being taught to tie them was not like watching some adult fill the dishwasher and then being asked in a kind voice if you would like to clamp the dishwasher door shut and advance the selector knob (with its uncomfortable grinding sound) to Wash. That was artificial, whereas you knew that adults wanted you to learn how to tie your shoes; it was no fun for them to kneel. I made several attempts to learn the skill, but it was not until my mother placed a lamp on the floor so that I could clearly see the dark laces of a pair of new dress shoes that I really mastered it; she explained again how to form the introductory platform knot, which began high in the air as a frail, heart-shaped loop, and shrunk as you pulled the plastic lace-tips down to a short twisted kernel three-eighths of an inch long, and she showed me how to progress from that base to the main cotyledonary string figure, which was, as it turned out, not a true knot but an illusion, a trick that you performed on the lace-string by bending segments of it back on themselves and tightening other temporary bends around them: it looked like a knot and functioned like a knot, but the whole thing was really an amazing interdependent pyramid scheme, which much later I connected with a couplet of Pope's:

Man, like the gen'rous vine, supported lives;
The strength he gains is from th'embrace he gives.

Only a few weeks after I learned the basic skill, my father helped me to my second major advance, when he demonstrated thoroughness by showing me how to tighten the rungs of the shoelaces one by one, beginning down at the toe and working up, hooking an index finger under each X, so that by the time you reached the top you were rewarded with surprising lengths of lace to use in tying the knot, and at the same time your foot felt tightly papoosed and alert.

The third advance I made by myself in the middle of a playground, when I halted, out of breath, to tie a sneaker,[4] my mouth on my interesting-smelling knee, a close-up view of anthills and the tread marks of other sneakers before me (the best kind, Keds, I think, or Red Ball Flyers, had a perimeter of asymmetrical triangles, and a few concavities in the center which printed perfect domes of dust), and found as I retied the shoe that I was doing it automatically, without having to concentrate on it as I had done at first, and, more important, that somewhere over the past year since I had first learned the basic moves, I had evidently evolved two little substeps of my own *that nobody had showed me*. In one I held down a temporarily taut stretch of shoelace with the side of my thumb; in the other I stabilized my hand with a middle finger propped against the side of the sneaker during some final manipulations. The advance here was my recognition that I had independently developed refinements of technique in an area where nobody had indicated there were refinements to be found: I had personalized an already adult procedure. ○

4. Sneaker knots were quite different from dress knots—when you pulled the two loops tight at the end, the logic of the knot you had just created became untraceable; while in the case of dress-lace knots, you could, even after tightening, follow the path of the knot around with your mind, as if riding a roller coaster. You could imagine a sneaker-shoelace knot and a dress-shoelace knot standing side by side saying the Pledge of Allegiance: the dress-shoelace knot would pronounce each word as a grammatical unit, understanding it as more than a sound; the sneaker-shoelace knot would run the words together. The great advantage of sneakers, though, one of the many advantages, was that when you had tied them tightly, without wearing socks, and worn them all day, and gotten them wet, and you took them off before bed, your feet would display the impression of the chrome eyelets in red rows down the sides of your foot, like the portholes in a Jules Verne submarine.

SEEING

1. Nicholson Baker uses the simple act of breaking his shoelaces as an occasion to reappraise everyday objects and rituals. As his thoughts about shoelaces unfold, what other aspects of ordinary experience do his eye and his mind seem drawn to? What ties these thoughts together? To what extent—and on what terms—do people enter his thoughts?

2. Does Baker's use of footnotes add to—or detract from—the order, pace, and effect of his fiction? Cite examples to verify your response. Compare and contrast what Baker accomplishes in any two footnotes— for example, the one about pulling on a sock (para. 2) and the one in which he describes "a certain class of events, disruptions of physical routines" (para. 4). Explain what you find effective in each. What advantages and effects does Baker establish by using footnotes rather than incorporating these points into the main body of his fiction?

WRITING

1. Following Baker's lead (but not necessarily his examples), make a list of your own top ten "moments of life that are remembered as major advances" (para. 7). Prioritize the list, placing the most important "major advances" in your life at the top. What do these advances have in common? Choose one, and write an essay in which you concentrate your attention—and your readers'—on the details of an everyday ritual to explain what you learned as you "personalized an already adult procedure" (para. 8).

2. Footnotes are often used in academic writing to explain something that is subordinate to—but that significantly adds to—a larger argument. Write an essay in which you explain how to do something you know well, using footnotes to reinforce your points or provide background information when appropriate. In a paragraph at the end, explain how using footnotes affected your explanation of the process.

 Talking Pictures

Few of us are as relentlessly attentive to observing the details of everyday life as the character in Nicholson Baker's "Shoelaces" (p. 31), yet each of us inevitably spends a great deal of time dealing with the mundane. In *Seinfeld*, one of the most popular television series in history, the routines of daily life preoccupy the characters of this self-described "show about nothing."

Choose an episode of *Seinfeld* to watch, or locate a script on one of the numerous web sites devoted to the show. As you watch or read the episode, list the aspects of everyday life that are portrayed. What does the episode reveal about the daily life of these single, "30-something" New Yorkers? What strategies do the writers and director use to achieve these effects? What approach do the characters in *Seinfeld* take to daily life? What details of ordinary life do you find more or less convincingly portrayed?

Now choose an episode of another television sitcom, and list as many observations as you can about its portrayal of everyday objects and tasks. How does *Seinfeld* differ from other sitcoms in this regard? Write an essay in which you compare and contrast the portrayal of the mundane in *Seinfeld* with that of another sitcom. To what extent does either show represent your own life?

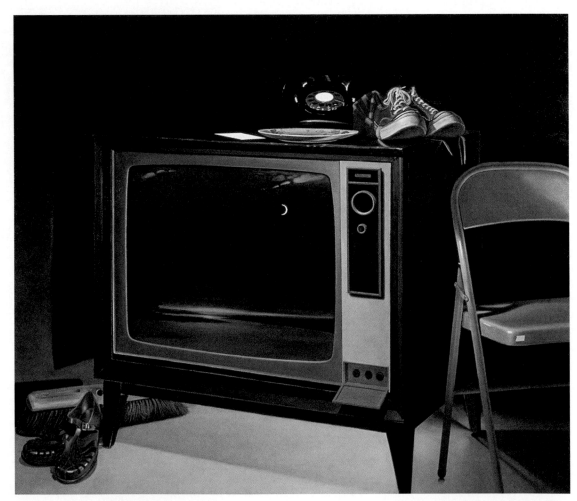

Alfred Leslie, **Television Moon**

ALFRED LESLIE

Alfred Leslie's eye for sharp, some-times hyperrealistic detail and his technical mastery suggest a career steeped in the conventions of realist painting. Interestingly, Leslie first made his mark in the art world in the late 1940s, as a young member of the abstract expressionist generation. In the 1950s he turned increasingly to narrative forms, first in flim, then in his art. In fact, the stories related by many of his paintings contain a moral, in the sense that he challenges viewers to consider ethical interpretations of scenes and events. Leslie once expressed his desire to create "an art like the art of David, Caravaggio, and Rubens, meant to influence the conduct of people."

Born in New York City in 1927, Leslie studied briefly at New York University and has been an independent painter since 1946. His work has been included in numerous prestigious exhibitions, and his awards include a Guggenheim fellowship (1969). He lives and paints in New York City and is represented by the Oil and Steel Gallery.

SEEING

1. Alfred Leslie's painting *Television Moon* subtly disrupts a centuries-old artistic tradition: the still life. Traditional still-life painters use simplicity and clarity to call attention to objects their audience knows well. Make a series of observations about this painting. Where does your eye rest as you look carefully at *Television Moon*? How many objects do you see? What details do you notice about each? Look again at the television. What additional details do you now notice about it? What reasonable inferences can you draw from these details and their relation to the other objects depicted?

2. In one sense, still-life paintings simply describe objects in the material world. In another sense, the artists who create still-life scenes often do so in order to interpret and comment on them. In what ways can Leslie's painting be said to interpret or serve as a commentary on contemporary American life and culture?

WRITING

1. Using precise description, translate Leslie's *Television Moon* into a one-page, verbal still life. The goal is for your readers to be able to sketch the painting on the basis of your description. (You might want to ask someone to try this after you've finished to see how close you've come.)

2. Antidrug campaigns have used an unusual version of the still life: an egg in a frying pan to represent the dangers of drugs to our brains. Choose an object (e.g., a dollar bill, a syringe, a remote control, a mountain bike) that represents something you believe should be changed in contemporary American life. Write an essay in two parts. First, provide a description, either verbal or visual, of how you would convey a moral message about the object through a still life. Second, write an analysis of how effective you expect this approach to be, and explain why.

ANNIE DILLARD

Annie Dillard was born Annie Doak in Pittsburgh in 1945. She attended Hollins College near Roanoke, Virginia, where she studied English, theology, and creative writing; married her writing teacher, Richard Dillard; and earned a master's degree with a thesis on Henry David Thoreau and Walden Pond. Before publishing her first book, *Pilgrim at Tinker Creek* (1974), she spent four seasons living near Tinker Creek in the Blue Ridge Mountains of Virginia and filled more than 20 volumes of journals with notes about her experiences and thoughts on the violence and beauty of nature, often in religious terms. Fearing that a work of theology written by a woman would not be successful, she was reluctant to publish the book. But she did, and it won the Pulitzer Prize in 1975.

Subsequently Dillard has published poetry, fiction, essays, memoirs, literary criticism, and autobiography, returning repeatedly to the themes of the mysteries of nature, the quest for meaning, and religious faith. *The Annie Dillard Reader,* a collection of her writing, was published in 1994.

"Seeing" speaks to Dillard's concern that a writer be "careful of what he reads, for that is what he will write . . . careful of what he learns, because that is what he will know."

Seeing

Annie Dillard

WHEN I WAS SIX OR SEVEN YEARS OLD, GROWING up in Pittsburgh, I used to take a precious penny of my own and hide it for someone else to find. It was a curious compulsion; sadly, I've never been seized by it since. For some reason I always "hid" the penny along the same stretch of sidewalk up the street. I would cradle it at the roots of a sycamore, say, or in a hole left by a chipped-off piece of sidewalk. Then I would take a piece of chalk, and, starting at either end of the block, draw huge arrows leading up to the penny from both directions. After I learned to write I labeled the arrows: SURPRISE AHEAD or MONEY THIS WAY. I was greatly excited, during all this arrow-drawing, at the thought of the first lucky passer-by who would receive in this way, regardless of merit, a free gift from the universe. But I never lurked about. I would go straight home and not give the matter another thought, until, some months later, I would be gripped again by the impulse to hide another penny.

It is still the first week in January, and I've got great plans. I've been thinking about seeing. There are lots of things to see, unwrapped gifts and free surprises. The world is fairly studded and strewn with pennies cast broadside from a generous hand. But—and this is the point—who gets excited by a mere penny? If you follow one arrow, if you crouch motionless on a bank to watch a tremulous ripple thrill on the water and are rewarded by the sight of a muskrat kit paddling from its den, will you count that sight a chip of copper only, and go your rueful way? It is dire poverty indeed when a man is so malnourished and fatigued that he won't stoop to pick up a penny. But if you cultivate a healthy poverty and simplicity, so that finding a penny will literally make your day, then, since the world is in fact planted in pennies, you have with your poverty bought a lifetime of days. It is that simple. What you see is what you get.

I used to be able to see flying insects in the air. I'd look ahead and see, not the row of hemlocks across the road, but the air in front of it. My eyes would focus along that column of air, picking out flying insects. But I lost interest, I guess, for I dropped the habit. Now I can see birds. Probably some people can look at the grass at their feet and discover all the crawling creatures. I would like to know grasses and sedges—and care. Then my least journey into the world would be a field trip, a series of happy recognitions. Thoreau, in an expansive mood, exulted, "What a rich book might be made about buds, including, perhaps, sprouts!" It would be nice to think so. I cherish mental images I have of three perfectly happy people. One collects stones. Another—an Englishman, say—watches clouds. The third lives on a coast and collects drops of seawater which he examines microscopically and mounts. But I don't see what the specialist sees, and so I cut myself off, not only from the total picture, but from the various forms of happiness.

Unfortunately, nature is very much a now-you-see-it, now-you-don't affair. A fish flashes, then dissolves in the water before my eyes like so much salt. Deer apparently ascend bodily into heaven; the brightest oriole fades into leaves. These disappearances stun me into stillness and concentration; they say of nature that it conceals with a grand nonchalance, and they say of vision that it is a deliberate gift, the revelation of a dancer who for my eyes only flings away her seven veils. For nature does reveal as well as conceal: now-you-don't-see-it, now-you-do. For a week last September migrating red-winged blackbirds were feeding heavily down by the creek at the back of the house. One day I went out to investigate the racket; I walked up to a tree, an Osage orange, and a hundred birds flew away. They simply materialized out of the tree. I saw a tree, then a whisk of color, then a tree again. I walked closer and another hundred blackbirds took flight. Not a branch, not a twig budged: The birds were apparently weightless as well as invisible. Or, it was as if the leaves of the Osage orange had been freed from a spell in the form of red-winged blackbirds; they flew from the tree, caught my eye in the sky, and vanished. When I looked again at the tree the leaves had reassembled as if nothing had happened. Finally I walked directly to the trunk of the tree and a final hundred, the real diehards, appeared,

spread, and vanished. How could so many hide in the tree without my seeing them? The Osage orange, unruffled, looked just as it had looked from the house, when three hundred red-winged blackbirds cried from its crown. I looked downstream where they flew, and they were gone. Searching, I couldn't spot one. I wandered downstream to force them to play their hand, but they'd crossed the creek and scattered. One show to a customer. These appearances catch at my throat; they are the free gifts, the bright coppers at the roots of trees.

It's all a matter of keeping my eyes open. Nature is 5 like one of those line drawings of a tree that are puzzles for children: Can you find hidden in the leaves a duck, a house, a boy, a bucket, a zebra, and a boot? Specialists can find the most incredibly well-hidden things. A book I read when I was young recommended an easy way to find caterpillars to rear: You simply find some fresh caterpillar droppings, look up, and there's your caterpillar. More recently an author advised me to set my mind at ease about those piles of cut stems on the ground in grassy fields. Field mice make them; they cut the grass down by degrees to reach the seeds at the head. It seems that when the grass is tightly packed, as in a field of ripe grain, the blade won't topple at a single cut through the stem; instead, the cut stem simply drops vertically, held in the crush of grain. The mouse severs the bottom again and again, the stem keeps dropping an inch at a time, and finally the head is low enough for the mouse to reach the seeds. Meanwhile, the mouse is positively littering the field with its little piles of cut stems into which, presumably, the author of the book is constantly stumbling.

If I can't see these minutiae, I still try to keep my eyes open. I'm always on the lookout for antlion traps in sandy soil, monarch pupae near milkweed, skipper larvae in locust leaves. These things are utterly common, and I've not seen one. I bang on hollow trees near water, but so far no flying squirrels have appeared. In flat country I watch every sunset in hopes of seeing the green ray. The green ray is a seldom-seen streak of light that rises from the sun like a spurting fountain at the moment of sunset; it throbs into the sky for two seconds and disappears. One more reason to keep my eyes open. A photography professor at the University of Florida just happened to see a bird die in midflight; it jerked, died, dropped, and smashed on the ground. I squint at the wind because I read Stewart Edward White: "I have always maintained that if you looked closely enough you could *see* the wind—the dim, hardly-made-out, fine débris fleeing high in the air." White was an excellent observer, and devoted an entire chapter of *The Mountains* to the subject of seeing deer: "As soon as you can forget the naturally obvious and construct an artificial obvious, then you too will see deer."

But the artificial obvious is hard to see. My eyes account for less than one percent of the weight of my head; I'm bony and dense; I see what I expect. I once spent a full three minutes looking at a bullfrog that was so unexpectedly large I couldn't see it even though a dozen enthusiastic campers were shouting directions. Finally I asked, "What color am I looking for?" and a fellow said, "Green." When at last I picked out the frog, I saw what painters are up against: The thing wasn't green at all, but the color of wet hickory bark.

The lover can see, and the knowledgeable. I visited an aunt and uncle at a quarter-horse ranch in Cody, Wyoming. I couldn't do much of anything useful, but I could, I thought, draw. So, as we all sat around the kitchen table after supper, I produced a sheet of paper and drew a horse. "That's one lame horse," my aunt volunteered. The rest of the family joined in: "Only place to saddle that one is his neck"; "Looks like we better shoot the poor thing, on account of those terrible growths." Meekly, I slid the pencil and paper down the table. Everyone in that family, including my three young cousins, could draw a horse. Beautifully. When the paper came back it looked as though five shining, real quarter horses had been corraled by mistake with a papier-mâché moose; the real horses seemed to gaze at the monster with a steady, puzzled air. I stay away from

horses now, but I can do a creditable goldfish. The point is that I just don't know what the lover knows; I just can't see the artificial obvious that those in the know construct. The herpetologist asks the native, "Are there snakes in that ravine?" "Nosir." And the herpetologist comes home with, yessir, three bags full. Are there butterflies on that mountain? Are the bluets in bloom, are there arrowheads here, or fossil shells in the shale?

Peeping through my keyhole I see within the range of only about thirty percent of the light that comes from the sun; the rest is infrared and some little ultraviolet, perfectly apparent to many animals, but invisible to me. A nightmare network of ganglia, charged and firing without my knowledge, cuts and splices what I do see, editing it for my brain. Donald E. Carr points out that the sense impressions of one celled animals are *not* edited for the brain: "This is philosophically interesting in a rather mournful way, since it means that only the simplest animals perceive the universe as it is."

A fog that won't burn away drifts and flows across my field of vision. When you see fog move against a backdrop of deep pines, you don't see the fog itself, but streaks of clearness floating across the air in dark shreds. So I see only tatters of clearness through a pervading obscurity. I can't distinguish the fog from the overcast sky; I can't be sure if the light is direct or reflected. Everywhere darkness and the presence of the unseen appalls. We estimate now that only one atom dances alone in every cubic meter of intergalactic space. I blink and squint. What planet or power yanks Halley's Comet out of orbit? We haven't seen that force yet; it's a question of distance, density, and the pallor of reflected light. We rock, cradled in the swaddling band of darkness. Even the simple darkness of night whispers suggestions to the mind. Last summer, in August, I stayed at the creek too late.

Where Tinker Creek flows under the sycamore log bridge to the tear-shaped island, it is slow and shallow, fringed thinly in cattail marsh. At this spot an astonishing bloom of life supports vast breeding populations of insects, fish, reptiles, birds, and mammals. On windless summer evenings I stalk along the creek bank or straddle the sycamore log in absolute stillness, watching for muskrats. The night I stayed too late I was hunched on the log staring spellbound at spreading, reflected stains of lilac on the water. A cloud in the sky suddenly lighted as if turned on by a switch; its reflection just as suddenly materialized on the water upstream, flat and floating, so that I couldn't see the creek bottom, or life in the water under the cloud. Downstream, away from the cloud on the water, water turtles smooth as beans were gliding down with the current in a series of easy, weightless push-offs, as men bound on the moon. I didn't know whether to trace the progress of one turtle I was sure of, risking sticking my face in one of the bridge's spider webs made invisible by the gathering dark, or take a chance on seeing the carp, or scan the mudbank in hope of seeing a muskrat, or follow the last of the swallows who caught at my heart and trailed it after them like streamers as they appeared from directly below, under the log, flying upstream with the tails forked, so fast.

But shadows spread, and deepened, and stayed. After thousands of years we're still strangers to darkness, fearful aliens in an enemy camp with our arms crossed over our chests. I stirred. A land turtle on the bank, startled, hissed the air from its lungs and withdrew into its shell. An uneasy pink here, an unfathomable blue there, gave great suggestion of lurking beings. Things were going on. I couldn't see whether that sere rustle I heard was a distant rattlesnake, slit-eyed, or a nearby sparrow kicking in the dry flood debris slung at the foot of a willow. Tremendous action roiled the water everywhere I looked, big action, inexplicable. A tremor welled up beside a gaping muskrat burrow in the bank and I caught my breath, but no muskrat appeared. The ripples continued to fan upstream with a steady, powerful thrust. Night was knitting over my face an eyeless mask, and I still sat transfixed. A distant airplane, a delta wing out of nightmare, made a gliding shadow on the creek's bottom that looked like a

stingray cruising upstream. At once a black fin slit the pink cloud on the water, shearing it in two. The two halves merged together and seemed to dissolve before my eyes. Darkness pooled in the cleft of the creek and rose, as water collects in a well. Untamed, dreaming lights flickered over the sky. I saw hints of hulking underwater shadows, two pale splashes out of the water, and round ripples rolling close together from a blackened center.

At last I stared upstream where only the deepest violet remained of the cloud, a cloud so high its underbelly still glowed feeble color reflected from a hidden sky lighted in turn by a sun halfway to China. And out of that violet, a sudden enormous black body arced over the water. I saw only a cylindrical sleekness. Head and tail, if there was a head and tail, were both submerged in cloud. I saw only one ebony fling, a headlong dive to darkness; then the waters closed, and the lights went out.

I walked home in a shivering daze, up hill and down. Later I lay open-mouthed in bed, my arms flung wide at my sides to steady the whirling darkness. At this latitude I'm spinning 836 miles an hour round the earth's axis; I often fancy I feel my sweeping fall as a break-neck arc like the dive of dolphins, and the hollow rushing of wind raises hair on my neck and the side of my face. In orbit around the sun I'm moving 64,800 miles an hour. The solar system as a whole, like a merry-go-round unhinged, spins, bobs, and blinks at the speed of 43,200 miles an hour along a course set east of Hercules. Someone has piped, and we are dancing a tarantella until the sweat pours. I open my eyes and I see dark, muscled forms curl out of water, with flapping gills and flattened eyes. I close my eyes and I see stars, deep stars giving way to deeper stars, deeper stars bowing to deepest stars at the crown of an infinite cone.

"Still," wrote van Gogh in a letter, "a great deal of 15 light falls on everything." If we are blinded by darkness, we are also blinded by light. When too much light falls on everything, a special terror results. Peter Freuchen describes the notorious kayak sickness to which Greenland Eskimos are prone. "The Greenland fjords are peculiar for the spells of completely quiet weather, when there is not enough wind to blow out a match and the water is like a sheet of glass. The kayak hunter must sit in his boat without stirring a finger so as not to scare the shy seals away. . . . The sun, low in the sky, sends a glare into his eyes, and the landscape around moves into the realm of the unreal. The reflex from the mirrorlike water hypnotizes him, he seems to be unable to move, and all of a sudden it is as if he were floating in a bottomless void, sinking, sinking, and sinking. . . . Horror-stricken, he tries to stir, to cry out, but he cannot, he is completely paralyzed, he just falls and falls." Some hunters are especially cursed with this panic, and bring ruin and sometimes starvation to their families.

Sometimes here in Virginia at sunset low clouds on the southern or northern horizon are completely invisible in the lighted sky. I only know one is there because I can see its reflection in still water. The first time I discovered this mystery I looked from cloud to no-cloud in bewilderment, checking my bearings over and over, thinking maybe the ark of the covenant was just passing by south of Dead Man Mountain. Only much later did I read the explanation: Polarized light from the sky is very much weakened by reflection, but the light in clouds isn't polarized. So invisible clouds pass among visible clouds, till all slide over the mountains; so a greater light extinguishes a lesser as though it didn't exist.

In the great meteor shower of August, the Perseid, I wail all day for the shooting stars I miss. They're out there showering down, committing hara-kiri in a flame of fatal attraction, and hissing perhaps at last into the ocean. But at dawn what looks like a blue dome clamps down over me like a lid on a pot. The stars and planets could smash and I'd never know. Only a piece of ashen moon occasionally climbs up or down the inside of the dome, and our local star without surcease explodes on our heads. We have really only that one light, one source for all power, and yet we must turn away from it by universal decree. Nobody here on the planet seems aware of this

strange, powerful taboo, that we all walk about carefully averting our faces, this way and that, lest our eyes be blasted forever.

Darkness appalls and light dazzles; the scrap of visible light that doesn't hurt my eyes hurts my brain. What I see sets me swaying. Size and distance and the sudden swelling of meanings confuse me, bowl me over. I straddle the sycamore log bridge over Tinker Creek in the summer. I look at the lighted creek bottom: Snail tracks tunnel the mud in quavering curves. A crayfish jerks, but by the time I absorb what has happened, he's gone in a billowing smoke-screen of silt. I look at the water: minnows and shiners. If I'm thinking minnows, a carp will fill my brain till I scream. I look at the water's surface: skaters, bubbles, and leaves sliding down. Suddenly, my own face, reflected, startles me witless. Those snails have been tracking my face! Finally, with a shuddering wrench of the will, I see clouds, cirrus clouds. I'm dizzy, I fall in. This looking business is risky.

Once I stood on a humped rock on nearby Purgatory Mountain, watching through binoculars the great autumn hawk migration below, until I discovered that I was in danger of joining the hawks on a vertical migration of my own. I was used to binoculars, but not, apparently, to balancing on humped rocks while looking through them. I staggered. Everything advanced and receded by turns; the world was full of unexplained foreshortenings and depths. A distant huge tan object, a hawk the size of an elephant, turned out to be the browned bough of a nearby loblolly pine. I followed a sharp-shinned hawk against a featureless sky, rotating my head unawares as it flew, and when I lowered the glass a glimpse of my own looming shoulder sent me staggering. What prevents the men on Palomar from falling, voiceless and blinded, from their tiny, vaulted chairs?

I reel in confusion; I don't understand what I see. 20 With the naked eye I can see two million light-years to the Andromeda galaxy. Often I slop some creek water in a jar and when I get home I dump it in a white china bowl. After the silt settles I return and see tracings of minute snails on the bottom, a planarian or two winding round the rim of water, roundworms shimmying frantically, and finally, when my eyes have adjusted to these dimensions, amoebae. At first the amoebae look like muscae volitantes, those curled moving spots you seem to see in your eyes when you stare at a distant wall. Then I see the amoebae as drops of water congealed, bluish, translucent, like chips of sky in the bowl. At length I choose one individual and give myself over to its idea of an evening. I see it dribble a grainy foot before it on its wet, unfathomable way. Do its unedited sense impressions include the fierce focus of my eyes? Shall I take it outside and show it Andromeda, and blow its little endoplasm? I stir the water with a finger, in case it's running out of oxygen. Maybe I should get a tropical aquarium with motorized bubblers and lights, and keep this one for a pet. Yes, it would tell its fissioned descendants, the universe is two feet by five, and if you listen closely you can hear the buzzing music of the spheres.

Oh, it's mysterious lamplit evenings, here in the galaxy, one after the other. It's one of those nights when I wander from window to window, looking for a sign. But I can't see. Terror and a beauty insoluble are a ribband of blue woven into the fringes of garments of things both great and small. No culture explains, no bivouac offers real haven or rest. But it could be that we are not seeing something. Galileo thought comets were an optical illusion. This is fertile ground: Since we are certain that they're not, we can look at what our scientists have been saying with fresh hope. What if there are *really* gleaming, castellated cities hung upside-down over the desert sand? What limpid lakes and cool date palms have our caravans always passed untried? Until, one by one, by the blindest of leaps, we light on the road to these places, we must stumble in darkness and hunger. I turn from the window. I'm blind as a bat, sensing only from every direction the echo of my own thin cries.

I chanced on a wonderful book by Marius von Senden, called *Space and Light.* When Western surgeons discovered how to perform safe cataract operations, they ranged across Europe and America

operating on dozens of men and women of all ages who had been blinded by cataracts since birth. Von Senden collected accounts of such cases; the histories are fascinating. Many doctors had tested their patients' sense perceptions and ideas of space both before and after the operations. The vast majority of patients, of both sexes and all ages, had, in von Senden's opinion, no idea of space whatsoever. Form, distance, and size were so many meaningless syllables. A patient "had no idea of depth, confusing it with roundness." Before the operation a doctor would give a blind patient a cube and a sphere; the patient would tongue it or feel it with his hands, and name it correctly. After the operation the doctor would show the same objects to the patient without letting him touch them; now he had no clue whatsoever what he was seeing. One patient called lemonade "square" because it pricked on his tongue as a square shape pricked on the touch of his hands. Of another postoperative patient, the doctor writes, "I have found in her no notion of size, for example, not even within the narrow limits which she might have encompassed with the aid of touch. Thus when I asked her to show me how big her mother was, she did not stretch out her hands, but set her two index-fingers a few inches apart." Other doctors reported their patients' own statements to similar effect. "The room he was in . . . he knew to be but part of the house, yet he could not conceive that the whole house could look bigger"; "Those who are blind from birth . . . have no real conception of height or distance. A house that is a mile away is thought of as nearby, but requiring the taking of a lot of steps. . . . The elevator that whizzes him up and down gives no more sense of vertical distance than does the train of horizontal."

For the newly sighted, vision is pure sensation unencumbered by meaning: "The girl went through the experience that we all go through and forget, the moment we are born. She saw, but it did not mean anything but a lot of different kinds of brightness." Again, "I asked the patient what he could see; he answered that he saw an extensive field of light, in which everything appeared dull, confused, and in motion. He could not distinguish objects." Another patient saw "nothing but a confusion of forms and colours." When a newly sighted girl saw photographs and paintings, she asked, " 'Why do they put those dark marks all over them?' 'Those aren't dark marks,' her mother explained, 'those are shadows. That is one of the ways the eye knows that things have shape. If it were not for shadows many things would look flat.' 'Well, that's how things do look,' Joan answered. 'Everything looks flat with dark patches.' "

But it is the patients' concepts of space that are most revealing. One patient, according to his doctor, "practiced his vision in a strange fashion; thus he takes off one of his boots, throws it some way off in front of him, and then attempts to gauge the distance at which it lies; he takes a few steps toward the boot and tries to grasp it; on failing to reach it, he moves on a step or two and gropes for the boot until he finally gets hold of it." "But even at this stage, after three weeks' experience of seeing," von Senden goes on, " 'space,' as he conceives it, ends with visual space, i.e., with color-patches that happen to bound his view. He does not yet have the notion that a larger object (a chair) can mask a smaller one (a dog), or that the latter can still be present even though it is not directly seen."

In general the newly sighted see the world as a dazzle of color-patches. They are pleased by the sensation of color, and learn quickly to name the colors, but the rest of seeing is tormentingly difficult. Soon after his operation a patient "generally bumps into one of these color-patches and observes them to be substantial, since they resist him as tactual objects do. In walking about it also strikes him—or can if he pays attention—that he is continually passing in between the colors he sees, that he can go past a visual object, that a part of it then steadily disappears from view; and that in spite of this, however he twists and turns—whether entering the room from the door, for example, or returning back to it—he always has a visual space in front of him. Thus he gradually comes

to realize that there is also a space behind him, which he does not see."

The mental effort involved in these reasonings proves overwhelming for many patients. It oppresses them to realize, if they ever do at all, the tremendous size of the world, which they had previously conceived of as something touchingly manageable. It oppresses them to realize that they have been visible to people all along, perhaps unattractively so, without their knowledge or consent. A disheartening number of them refuse to use their new vision, continuing to go over objects with their tongues, and lapsing into apathy and despair. "The child can see, but will not make use of his sight. Only when pressed can he with difficulty be brought to look at objects in his neighborhood; but more than a foot away it is impossible to bestir him to the necessary effort." Of a twenty-one-year-old girl, the doctor relates, "Her unfortunate father, who had hoped for so much from this operation, wrote that his daughter carefully shuts her eyes whenever she wishes to go about the house, especially when she comes to a staircase, and that she is never happier or more at ease than when, by closing her eyelids, she relapses into her former state of total blindness." A fifteen-year-old boy, who was also in love with a girl at the asylum for the blind, finally blurted out, "No, really, I can't stand it any more; I want to be sent back to the asylum again. If things aren't altered, I'll tear my eyes out."

Some do learn to see, especially the young ones. But it changes their lives. One doctor comments on "the rapid and complete loss of that striking and wonderful serenity which is characteristic only of those who have never yet seen." A blind man who learns to see is ashamed of his old habits. He dresses up, grooms himself, and tries to make a good impression. While he was blind he was indifferent to objects unless they were edible; now, "a sifting of values sets in . . . his thoughts and wishes are mightily stirred and some few of the patients are thereby led into dissimulation, envy, theft and fraud."

On the other hand, many newly sighted people speak well of the world, and teach us how dull is our own vision. To one patient, a human hand, unrecognized, is "something bright and then holes." Shown a bunch of grapes, a boy calls out, "It is dark, blue and shiny. . . . It isn't smooth, it has bumps and hollows." A little girl visits a garden. "She is greatly astonished, and can scarcely be persuaded to answer, stands speechless in front of the tree, which she only names on taking hold of it, and then as 'the tree with the lights in it.'" Some delight in their sight and give themselves over to the visual world. Of a patient just after her bandages were removed, her doctor writes, "The first things to attract her attention were her own hands; she looked at them very closely, moved them repeatedly to and fro, bent and stretched the fingers, and seemed greatly astonished at the sight." One girl was eager to tell her blind friend that "men do not really look like trees at all," and astounded to discover that her every visitor had an utterly different face. Finally, a twenty-two-year-old girl was dazzled by the world's brightness and kept her eyes shut for two weeks. When at the end of that time she opened her eyes again, she did not recognize any objects, but, "the more she now directed her gaze upon everything about her, the more it could be seen how an expression of gratification and astonishment overspread her features; she repeatedly exclaimed: 'Oh God! How beautiful!'"

I saw color-patches for weeks after I read this wonderful book. It was summer; the peaches were ripe in the valley orchards. When I woke in the morning, color-patches wrapped round my eyes, intricately, leaving not one unfilled spot. All day long I walked among shifting color-patches that parted before me like the Red Sea and closed again in silence, transfigured, wherever I looked back. Some patches swelled and loomed, while others vanished utterly, and dark marks flitted at random over the whole dazzling sweep. But I couldn't sustain the illusion of flatness. I've been around for too long. Form is condemned to an eternal danse macabre with meaning: I couldn't unpeach the peaches. Nor can I remember ever having seen without understanding; the color-patches of

infancy are lost. My brain then must have been smooth as any balloon. I'm told I reached for the moon; many babies do. But the color-patches of infancy swelled as meaning filled them; they arrayed themselves in solemn ranks down distance which unrolled and stretched before me like a plain. The moon rocketed away. I live now in a world of shadows that shape and distance color, a world where space makes a kind of terrible sense. What gnosticism is this, and what physics? The fluttering patch I saw in my nursery window—silver and green and shape-shifting blue—is gone; a row of Lombardy poplars takes its place, mute, across the distant lawn. That humming oblong creature pale as light that stole along the walls of my room at night, stretching exhilaratingly around the corners, is gone, too, gone the night I ate of the bittersweet fruit, put two and two together and puckered forever my brain. Martin Buber tells this tale: "Rabbi Mendel once boasted to his teacher Rabbi Elimelekh that evenings he saw the angel who rolls away the light before the darkness, and mornings the angel who rolls away the darkness before the light. 'Yes,' said Rabbi Elimelekh, 'in my youth I saw that too. Later on you don't see these things any more.'"

Why didn't someone hand those newly sighted 30 people paints and brushes from the start, when they still didn't know what anything was? Then maybe we all could see color-patches too, the world unraveled from reason, Eden before Adam gave names. The scales would drop from my eyes; I'd see trees like men walking; I'd run down the road against all orders, hallooing and leaping.

Seeing is of course very much a matter of verbalization. Unless I call my attention to what passes before my eyes, I simply won't see it. It is, as Ruskin says, "not merely unnoticed, but in the full, clear sense of the word, unseen." My eyes alone can't solve analogy tests using figures, the ones which show, with increasing elaborations, a big square, then a small square in a big square, then a big triangle, and expect me to find a small triangle in a big triangle. I have to say the words, describe what I'm seeing. If Tinker Mountain erupted, I'd be likely to notice. But if I want to notice the lesser cataclysms of valley life, I have to maintain in my head a running description of the present. It's not that I'm observant; it's just that I talk too much. Otherwise, especially in a strange place, I'll never know what's happening. Like a blind man at the ball game, I need a radio.

When I see this way I analyze and pry. I hurl over logs and roll away stones; I study the bank a square foot at a time, probing and tilting my head. Some days when a mist covers the mountains, when the muskrats won't show and the microscope's mirror shatters, I want to climb up the blank blue dome as a man would storm the inside of a circus tent, wildly, dangling, and with a steel knife claw a rent in the top, peep, and, if I must, fall.

But there is another kind of seeing that involves a letting go. When I see this way I sway transfixed and emptied. The difference between the two ways of seeing is the difference between walking with and without a camera. When I walk with a camera I walk from shot to shot, reading the light on a calibrated meter. When I walk without a camera, my own shutter opens, and the moment's light prints on my own silver gut. When I see this second way I am above all an unscrupulous observer.

It was sunny one evening last summer at Tinker Creek; the sun was low in the sky, upstream. I was sitting on the sycamore log bridge with the sunset at my back, watching the shiners the size of minnows who were feeding over the muddy sand in skittery schools. Again and again, one fish, then another, turned for a split second across the current and flash! the sun shot out from its silver side. I couldn't watch for it. It was always just happening somewhere else, and it drew my vision just as it disappeared: flash, like a sudden dazzle of the thinnest blade, a sparking over a dun and olive ground at chance intervals from every direction. Then I noticed white specks, some sort of pale petals, small,

floating from under my feet on the creek's surface, very slow and steady. So I blurred my eyes and gazed toward the brim of my hat and saw a new world. I saw the pale white circles roll up, roll up, like the world's turning, mute and perfect, and I saw the linear flashes, gleaming silver, like stars being born at random down a rolling scroll of time. Something broke and something opened. I filled up like a new wineskin. I breathed an air like light; I saw a light like water. I was the lip of a fountain the creek filled forever; I was ether, the leaf in the zephyr; I was flesh-flake, feather, bone.

When I see this way I see truly. As Thoreau says, I return to my senses. I am the man who watches the baseball game in silence in an empty stadium. I see the game purely; I'm abstracted and dazed. When it's all over and the white-suited players lope off the green field to their shadowed dugouts, I leap to my feet; I cheer and cheer.

But I can't go out and try to see this way. I'll fail, I'll go mad. All I can do is try to gag the commentator, to hush the noise of useless interior babble that keeps me from seeing just as surely as a newspaper dangled before my eyes. The effort is really a discipline requiring a lifetime of dedicated struggle; it marks the literature of saints and monks of every order East and West, under every rule and no rule, discalced and shod. The world's spiritual geniuses seem to discover universally that the mind's muddy river, this ceaseless flow of trivia and trash, cannot be dammed, and that trying to dam it is a waste of effort that might lead to madness. Instead you must allow the muddy river to flow unheeded in the dim channels of consciousness; you raise your sights; you look along it, mildly, acknowledging its presence without interest and gazing beyond it into the realm of the real where subjects and objects act and rest purely, without utterance. "Launch into the deep," says Jacques Ellul, "and you shall see."

The secret of seeing is, then, the pearl of great price. If I thought he could teach me to find it and keep it forever I would stagger barefoot across a hundred deserts after any lunatic at all. But although the pearl may be found, it may not be sought. The literature of illumination reveals this above all: Although it comes to those who wait for it, it is always, even to the most practiced and adept, a gift and a total surprise. I return from one walk knowing where the killdeer nests in the field by the creek and the hour the laurel blooms. I return from the same walk a day later scarcely knowing my own name. Litanies hum in my ears; my tongue flaps in my mouth Ailinon, alleluia! I cannot cause light; the most I can do is try to put myself in the path of its beam. It is possible, in deep space, to sail on solar wind. Light, be it particle or wave, has force: you rig a giant sail and go. The secret of seeing is to sail on solar wind. Hone and spread your spirit till you yourself are a sail, whetted, translucent, broadside to the merest puff.

When her doctor took her bandages off and led her into the garden, the girl who was no longer blind saw "the tree with the lights in it." It was for this tree I searched through the peach orchards of summer, in the forests of fall and down winter and spring for years. Then one day I was walking along Tinker Creek thinking of nothing at all and I saw the tree with the lights in it. I saw the backyard cedar where the mourning doves roost charged and transfigured, each cell buzzing with flame. I stood on the grass with the lights in it, grass that was wholly fire, utterly focused and utterly dreamed. It was less like seeing than like being for the first time seen, knocked breathless by a powerful glance. The flood of fire abated, but I'm still spending the power. Gradually the lights went out in the cedar, the colors died, the cells unflamed and disappeared. I was still ringing. I had been my whole life a bell, and never knew it until at that moment I was lifted and struck. I have since only very rarely seen the tree with the lights in it. The vision comes and goes, mostly goes, but I live for it, for the moment when the mountains open and a new light roars in spate through the crack, and the mountains slam. ○

SEEING

1. Near the end of her essay Annie Dillard observes, "Seeing is of course very much a matter of verbalization" (para. 31). Reread "Seeing" and make a list of every idiom she uses to talk about seeing "truly." Consider, for example, the last line of paragraph 2: "What you see is what you get." Identify other, similar idiomatic expressions. Explain how Dillard plays with the literal and figurative dimensions of each one. With what effects? What does she mean when she says, "This looking business is risky" (para. 18)? One of the strongest elements of Dillard's style is her effective use of metaphor. Identify two or three especially striking examples of her command of metaphor, and explain the effects of each.

2. Near the end of paragraph 6, Dillard quotes the naturalist Stewart Edward White on seeing deer: "As soon as you can forget the naturally obvious and construct an artificial obvious, then you too will see deer." Dillard immediately observes, "But the artificial obvious is hard to see" (para. 7). What does "the artificial obvious" mean here, how do people construct it, and why is it "hard to see"? Later, Dillard describes another kind of seeing, "a letting go" (para. 33). What does she mean when she says, "when I see this . . . way I am above all an unscrupulous observer"?

WRITING

1. Most of us at one time or another, have succumbed to the impulse to hide something and then either to lead people to it or to make it as difficult as possible for others to locate. Recall one such impulse that you had, and develop detailed notes about not only the circumstances but also the consequences of your yielding to the impulse. Draft an essay in which you recount this story and then use it as a harbinger of other, more important events or behavior in your life.

2. Reread Larry Woiwode's "Ode to an Orange" (p. 12). What do you think he would say about the nature of seeing? Using Woiwode's or any other work in this chapter, write an essay in which you compare the author's philosophy about seeing with Dillard's—and argue that one is more compelling than the other.

Seeing

Annie Dillard

JEFF KOONS

Jeff Koons (b. 1955) first took drawing lessons at age 5. His father began selling his paintings for hundreds of dollars when Jeff was 9 years old. After studying art and design at the Maryland Institute College of Art in Baltimore and the School of the Art Institute in Chicago, Koons moved to New York City, where he sold memberships at the Museum of Modern Art and commodities on Wall Street in order to support himself and, as he says, "to remain independent from the commercial art world system."

His commitment to communicating "with as wide an audience as possible" led Koons to work with the ordinary objects of daily experience and with the popular images and icons promoted on television and in advertising, film, and the entertainment industries. "If art is not directed toward the social," Koons explains, "it becomes purely self-indulgent. . . . But if art is functioning in the social sphere and helping to define social order, it's working purely as a tool of philosophy, enhancing the quality of individual life and re-directing social and political attitudes. Art can define an individual's aspirations and goals just as other systems— economics, for instance—are defining them now. Art can define ultimate states of being in a more responsible way than economics because art is concerned with philosophy as well as the marketplace."

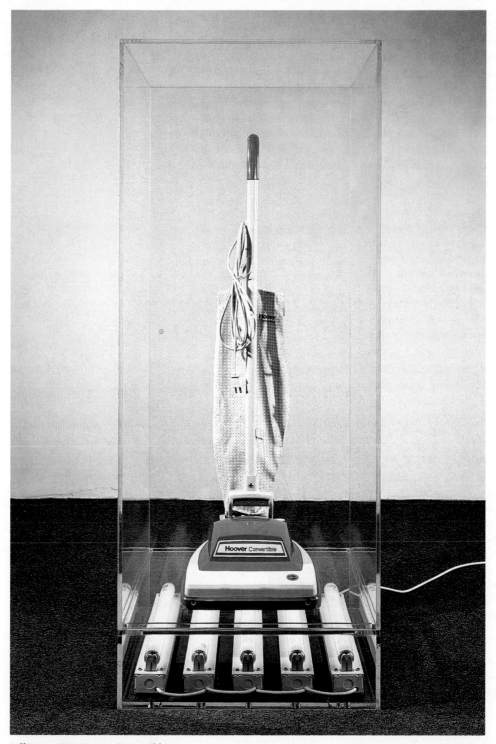

Jeff Koons, **New Hoover Convertible**

SEEING

1. Jeff Koons's *New Hoover Convertible*, 1980 illustrates his impressive ability to make ordinary objects into engaging and enduring subjects of art. What, in your view, happens to such a commonplace object as a vacuum cleaner when it is encased in Plexiglass and put on display above fluorescent lights? Examine this image carefully. What do you notice about it? about the Hoover Convertible? about the fluorescent lights? about the Plexiglass display case? about the wires evident within and extending beyond the display case? What do these objects—and the materials they are made of—have in common?

2. What effect(s) and significance does Koons establish through the use of fluorescent lights? With what uses and contexts is fluorescent lighting usually associated? What are the effects of positioning the fluorescent lights in front of and underneath the Hoover Convertible? What effects does Koons achieve by lighting the vacuum cleaner at all? In what ways does he reinforce these effects and significance through the use of other materials presented in the image?

WRITING

1. Imagine yourself in a museum viewing Jeff Koons's *New Hoover Convertible, 1980*. How would the context within which you view this work of art affect your understanding and appreciation of it? How would the materials Koons uses—especially his use of plexiglass—"reflect" your reading of his artistic purposes?

2. Now imagine yourself as the artist writing a response to a critic's statement, "Interesting—but is it really art?" Write the first draft of an essay in which you argue that *New Hoover Convertible* is indeed art; as you do so, try to anticipate all the reasons that someone might claim that the image fails as an example of artistic expression.

Looking Closer:
Seeing Is Believing

Size matters—or so advertisers claim when they promote certain products or services. Scientists make much the same point: A photograph of a single living cell or of a distant star would be so small that it would be difficult to identify the subject without some indication of its size and scale.

Each of the essays and images on the following pages invites us to explore our understanding of ordinary objects when we magnify our attention and discover the richness and complexity in what appears to be the superficial. Several photos—from David Scharf's **"Kitchen Scouring Pad"** to Harold Edgerton's **"Milk Drop Coronet"** to a **Post-it® note**—reveal how a changed scale of vision can transform the nondescript. K. C. Cole's essay **"A Matter of Scale"** provides a vocabulary and frame of reference with which to appreciate what is extraordinary about the ordinary; Felice Frankel and George M. Whitesides's **"Tears of Wine"** examines forces that cause wine to cling to a glass; and two perspectives of Chuck Close's *April* graphically prove that what we see depends on how closely we're looking.

A Matter of Scale
K. C. Cole

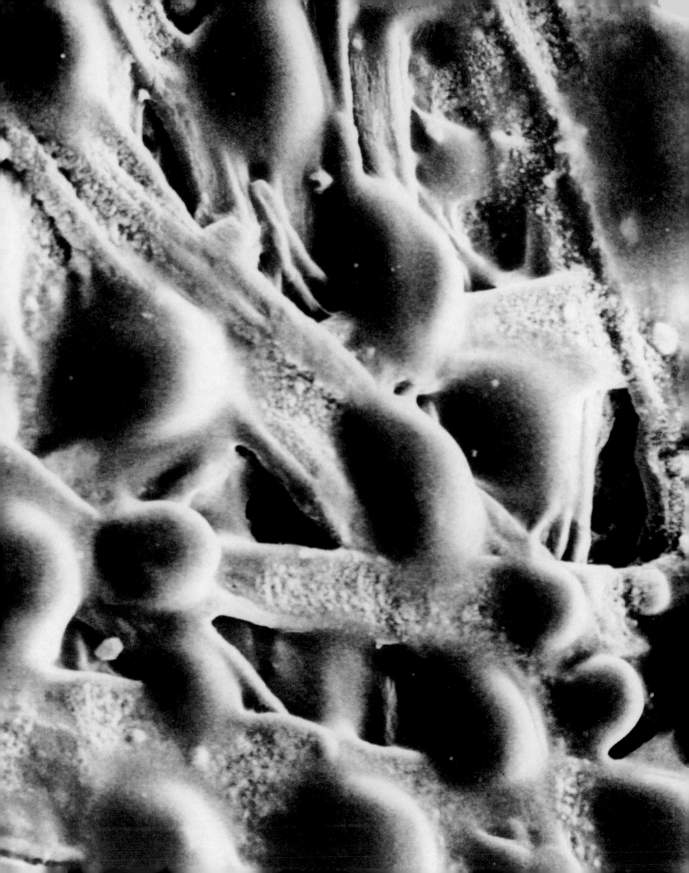

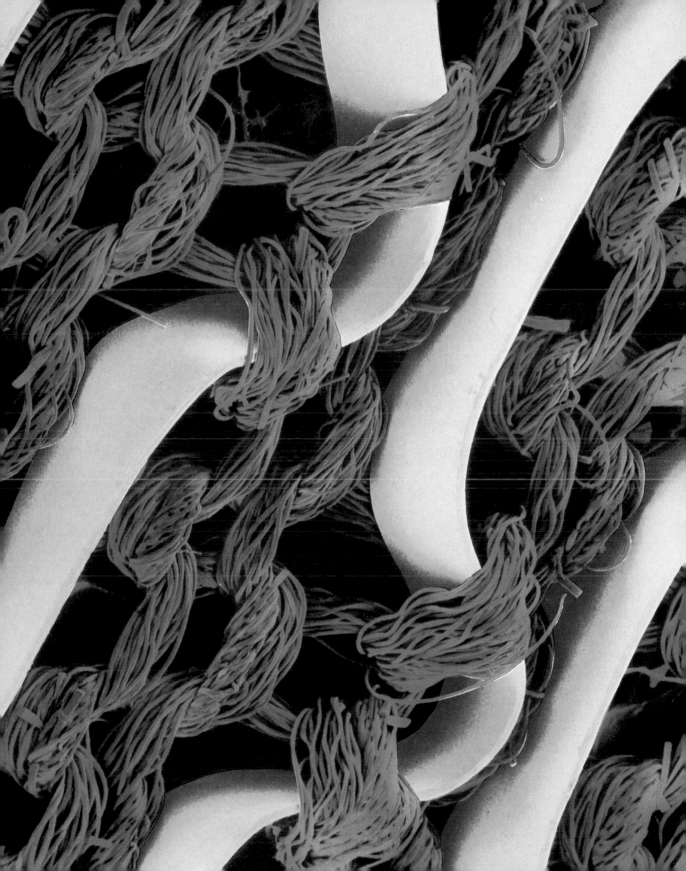

A Matter of Scale

K. C. Cole

*How would you suspend 500,000 pounds of water in the
air with no visible means of support? (Answer: build a cloud.)
—artist Bob Miller*

THERE IS SOMETHING MAGICALLY SEDUCTIVE about an invitation to a world where everything measures much bigger or smaller than ourselves. To contemplate the vast expanse of ocean or sky, to look at pond scum under a microscope, to imagine the intimate inner life of atoms, all cast spells that take us far beyond the realm of everyday living into exotic landscapes accessible only through the imagination. What would it be like to grow as big as a giant? As small as a bug? Alice ate a mushroom and puffed up like a Macy's Thanksgiving Day balloon, bursting out of her house; she ate some more and shrank like the Incredible Shrinking Woman, forever in fear of falling down the drain. From Stuart Little to King Kong, from *Honey, I Shrunk the Kids* to Thumbelina, the notion of changing size seems to have a powerful pull on our psyches.

There are good reasons to think a world that's different in scale will also be different in kind. More or less of something very often adds up to more than simply more or less; quantitative changes can make huge qualitative differences.

When the size of things changes radically, different laws of nature rule, time ticks according to different clocks, new worlds appear out of nowhere while old ones dissolve into invisibility. Consider the strange situation of a giant, for example. Big and strong to be sure, but size comes with distinct disadvantages. According to J. B. S. Haldane in his classic essay, "On Being the Right Size," a sixty-foot giant would break his thighbones at every step. The reason is simple geometry. Height increases only in one dimension, area in two, volume in three. If you doubled the height of a man, the cross section, or thickness, of muscle that supports him against gravity would quadruple (two times two) and his volume—and therefore weight—would increase by a factor of eight. If you made him ten times taller, his weight would be a thousand times greater, but the cross section of bones and muscles to support him would only increase by a factor of one hundred. Result: shattered bones.

To bear such weight would require stout, thick legs—think elephant or rhino. Leaping would be out of the question. Superman must have been a flea.

Fleas, of course, perform superhuman feats routinely (which is part of the science behind the now nearly extinct art of the flea circus). These puny critters can pull 160,000 times their own weight, and jump a hundred times their own height. Small creatures have so little mass compared to the area of their muscles that they seem enormously strong. While their muscles are many orders of magnitude weaker than ours, the mass they have to push around is so much smaller that it makes each ant and flea into a superbeing. Leaping over tall buildings does not pose a problem.[1]

Neither does falling. The old saying is true: The bigger they come, the harder they fall. And the smaller they come, the softer their landings. Again, the reason is geometry. If an elephant falls from a building, gravity pulls strongly on its huge mass while its comparatively small surface area offers little resistance. A mouse, on the other hand, is so small in volume (and therefore mass) that gravity has little to attract; at the same time, its relative surface area is so huge that it serves as a built-in parachute.

A mouse, writes Haldane, could be dropped from a thousand-yard-high cliff and walk away unharmed. A rat would probably suffer enough damage to be killed. A person would certainly be killed. And a horse, he tells us, "splashes."

The same relationships apply to inanimate falling objects—say, drops of water. The atmosphere is drenched with water vapor, even when we can't see it in the form of clouds. However, once a tiny particle begins to attract water molecules to its sides, things change rapidly. As the diameter of the growing droplet

1. According to Exploratorium physicist Tom Humphrey, all animals jump to the same height, roughly speaking. Both fleas and humans can jump about a meter off the ground—an interesting invariant.

increases by a hundred, the surface area increases by ten thousand, and its volume a millionfold. The larger surface area reflects far more light—making the cloud visible. The enormously increased volume gives the drops the gravitational pull they need to splash down to the ground as rain.

According to cloud experts, water droplets in the air are simultaneously pulled on by electrical forces of attraction—which keep them herded together in the cloud—and gravity, which pulls them down. When the drops are small, their surface area is huge compared to volume; electrical (molecular) forces rule and the drops stay suspended in midair. Once the drops get big enough, however, gravity always wins.

Pint-size objects barely feel gravity—a force that only makes itself felt on large scales. The electrical forces that hold molecules together are trillions of times stronger. That's why even the slightest bit of electrical static in the air can make your hair stand on end.

These electrical forces would present major problems to flea-size Superman. For one thing, he'd have a hard time flying faster than a speeding bullet, because the air would be a thick soup of sticky molecules grasping him from all directions; it would be like swimming through molasses.

Flies have no problem walking on the ceiling because the molecular glue that holds their feet to the moldings is stronger than the puny weight pulling them down. The electrical pull of water, however, attracts the insects like magnets. As Haldane points out, the electrical attraction of water molecules makes going for a drink a dangerous endeavor for an insect. A bug leaning over a puddle to take a sip of water would be in the same position as a person leaning out over a cliff to pluck a berry off a bush.

Water is one of the stickiest substances around. A person coming out of the shower carries about a pound of extra weight, scarcely a burden. But a mouse coming out of the shower would have to lift its weight in water, according to Haldane. For a fly, water is as powerful as flypaper; once it gets wet, it's

stuck for life. That's one reason, writes Haldane, that most insects have a long proboscis.

In fact, once you get down to bug size, almost everything is different. An ant-size person could never write a book: the keys to an ant-size typewriter would stick together; so would the pages of a manuscript. An ant couldn't build a fire because the smallest possible flame is larger than its body.

Shrinking down to atom size alters reality beyond recognition, opening doors into new and wholly unexpected vistas. Atom-size things do not behave like molecule-size things or human-size things. Atomic particles are ruled by the probabilistic laws of quantum mechanics. Physicists have to be very clever to lure these quantum mechanical attributes out in the open, because they simply don't exist on the scales of human instrumentation. We do not perceive that energy comes in precisely defined clumps or that clouds of electrons buzz around atoms in a permanent state of probabilistic uncertainty. These behaviors become perceptible macroscopically only in exotic situations—for example, superconductivity—a superordered state where pairs of loose electrons in a material line up like a row of Rockettes. With electrons moving in lockstep, electricity can flow through superconductors without resistance.

Scale up to molecule-size matter, and electrical forces take over; scale up further and gravity rules. As Philip and Phylis Morrison point out in the classic *Powers of Ten*, if you stick your hand in a sugar bowl, your fingers will emerge covered with tiny grains that stick to them due to electrical forces. However, if you stick your hand into a bowl of sugar cubes, you would be very surprised if a cube stuck to your fingers—unless you purposely set out to grasp one.

We know that gravity takes over in large-scale matters because everything in the universe larger than an asteroid is round or roundish—the result of gravity pulling matter in toward a common center. Everyday objects like houses and mountains come in every old shape, but mountains can only get so high

before gravity pulls them down. They can get larger on Mars because gravity is less. Large things lose their rough edges in the fight against gravity. "No such thing as a teacup the diameter of Jupiter is possible in our world," say the Morrisons. As a teacup grew to Jupiter size, its handle and sides would be pulled into the center by the planet's huge gravity until it resembled a sphere.

Add more matter still, and the squeeze of gravity ignites nuclear fires; stars exist in a continual tug-of-war between gravitational collapse and the outward pressure of nuclear fire. Over time, gravity wins again. A giant star eventually collapses into a black hole. It doesn't matter whether the star had planets orbiting its periphery or what globs of gas and dust went into making the star in the first place. Gravity is very democratic. Anything can grow up to be a black hole.

Even time ticks faster in the universe of the small. Small animals move faster, metabolize food faster (and eat more); their hearts beat faster; their life spans are short. In his book *About Time,* Paul Davis raises the interesting question: Does the life of a mouse feel shorter to a mouse than our life feels to us?

Biologist Stephen Jay Gould has answered this [20] question in the negative. "Small mammals tick fast, burn rapidly, and live for a short time; large mammals live long at a stately pace. Measured by their own internal clocks, mammals of different sizes tend to live for the same amount of time."

We all march to our own metronomes. Yet Davis suggests that all life shares the same beat because all life on Earth relies on chemical reactions—and chemical reactions take place in a sharply limited frame of time. In physicist Robert Forward's science fiction saga *Dragon's Egg,* creatures living on a neutron star are fueled by nuclear reactions; on their world, everything takes place millions of times faster. Many generations could be born and die before a minute passes on Earth.

And think how Earth would seem if we could slow our metabolism down. If our time ticked slowly enough, we could watch mountains grow and continental plates shift and come crashing together. The heavens would be bursting with supernovas, and comets would come smashing onto our shores with the regularity of shooting stars. Every day would be the Fourth of July.

An artist friend likes to imagine that if we could stand back far enough from Earth, but still see people, we would see enormous waves sweeping the globe every morning as people stood up from bed, and another huge wave of toothbrushing as people got ready to bed down for the night—one time zone after another, a tide of toothbrushing waxing and waning, following the shadow of the Sun across the land.

We miss a great deal because we perceive only things on our own scale. Exploring the invisible worlds beneath our skin can be a terrifying experience. I know because I tried it with a flexible microscope attached to a video camera on display at the Exploratorium in San Francisco. The skin on your arm reveals a dizzy landscape of nicks, creases, folds, and dewy transparent hairs the size of redwood trees—all embedded with giant boulders of dirt. Whiskers and eyelashes are disgusting—mascara dripping off like mud on a dog's tail. It is rather overwhelming to look through your own skin at blood cells coursing through capillaries. It's like looking at yourself without clothes. We forget the extent to which our view of the world is airbrushed, that we see things through a shroud of size, a blissfully out-of-focus blur.

An even more powerful microscope would reveal [25] all the creatures that live on your face, dangling from tiny hairs or hiding out in your eyelashes. Not to mention the billions that share your bed every night and nest in your dish towels. How many bacteria can stand on the pointy end of a pin? You don't want to know.[2]

2. For an eye-opening view, read *The Secret House,* by David Bodanis.

We're so hung up on our own scale of life that we miss most of life's diversity, says Berkeley microbiologist Norman Pace. "Who's in the ocean? People think of whales and seals, but 90 percent of organisms in the ocean are less than two micrometers."

In their enchanting journey *Microcosmos,* microbiologist Lynn Margulis and Dorion Sagan point out the fallacy of thinking that large beings are somehow supreme. Billions of years before creatures composed of cells with nuclei (like ourselves) appeared on Earth, simple bacteria transformed the surface of the planet and invented many high-tech processes that humans are still trying to understand—including the transformation of sunlight into energy with close to a 100 percent efficiency (green plants do it all the time). Indeed, they point out that fully 10 percent of our body weight (minus the water) consists of bacteria—most of which we couldn't live without.

Zoom in smaller than life-size, and solid tables become airy expanses of space, with an occasional nut of an atomic nucleus lost in the center, surrounded by furious clouds of electrons. As you zoom in, or out, the world looks simple, then complex, then simple again. Earth from far enough away would be a small blue dot; come in closer and you see weather patterns and ocean; closer still and humanity comes into view; closer still and it all fades away, and you're back inside the landscape of matter—mostly empty space.

So complexity, too, changes with scale. Is an egg complex? On the outside, it's a plain enough oval, like Jupiter's giant red spot. On the inside, it's white and yolk and blood vessels and DNA and squawking and pecking order and potential chocolate mousse or crème caramel.

The universe of the extremely small is so strange and rich that we can't begin to grasp it. No one said it better than Erwin Schrödinger himself:

> As our mental eye penetrates into smaller and smaller distances and shorter and shorter times, we find nature behaving so entirely differently from what we observe in visible and palpable bodies of our surroundings that no model shaped after our large-scale experiences can ever be "true." A complete satisfactory model of this type is not only practically inaccessible, but not even thinkable. Or, to be precise, we can, of course, think of it, but however we think it, it is wrong; not perhaps quite as meaningless as a "triangular circle," but more so than a "winged lion." ○

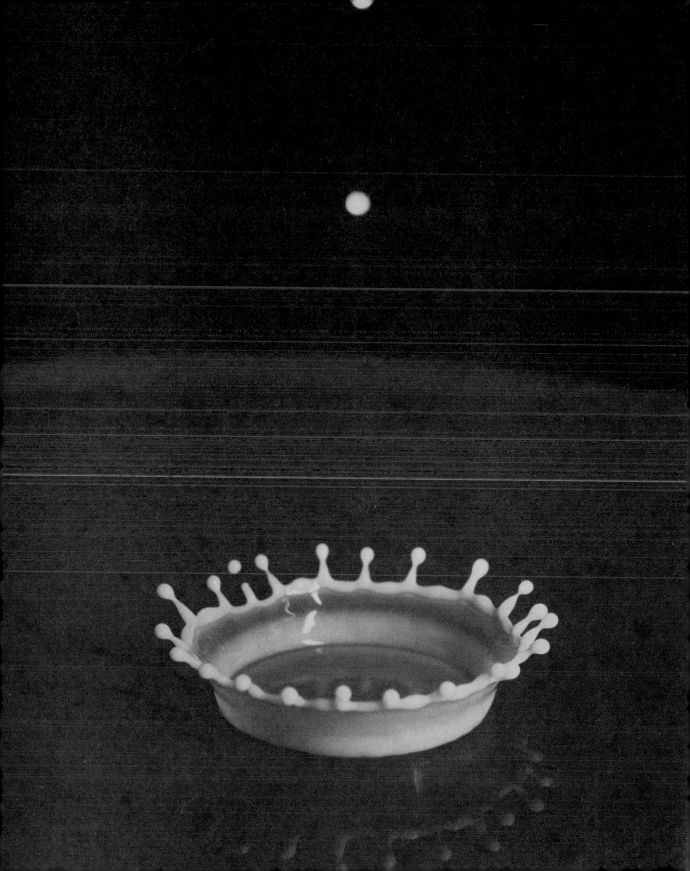

Tears of Wine

Felice Frankel and George M. Whitesides

SWIRL WINE IN A GLASS AND WATCH: A FILM OF liquid creeps up the wall of the glass, pauses, collects itself into drops along the top of the film, and slides back down into the wine. The motion evokes the fluidity of whales breaching or the changing shape of fog condensing into rain. It is an astonishing amount of independent activity for a simple liquid: a kind of levitation followed by lateral condensation. It smacks of water running uphill.

The invisible hand that pulls the wine up the side of the glass is surface tension: the tendency of a liquid surface to contract and to minimize the number of its molecules that are at a surface exposed to air. On the wall of the wine glass there is a competition. The solid surface of the glass tries to minimize its exposed surface by covering itself with wine; the pull of the glass on the wine generates a thin liquid film and increases the exposed surface of the liquid. The wine meanwhile tries to shrink its surface.

The competition between stretching and shrinking is complicated by the fact that the wine's eagerness to contract is different at different points. Wine is a mixture of alcohol and water. Water by itself does not tolerate being spread as a thin film—it has a very high surface tension and strongly resists having its surface stretched—but the alcohol in the wine weakens this resistance. The molecules of alcohol at the surface of the liquid attract their neighbors only weakly, so stretching a film of water containing ethanol is easier than stretching pure water.

The alcohol is also volatile: it evaporates from the wine and escapes into the air. This evaporation is most rapid at the lip of the film of liquid that covers the wall of the wine glass, since this lip is closest to the open top of the glass. When the alcohol evaporates, the proportion of water in the remaining wine increases, and its surface tension increases. This wine enriched in water collects itself into drops, pulled together by its increased surface tension. These drops slide back down the wall of the glass into the wine.

Phenomena related to tears of wine are important in many technologies that involve thin fluid films, especially if these films have components with different volatilities, or are exposed to different temperatures, as in distillation, or the spreading of paints containing volatile solvents. ○

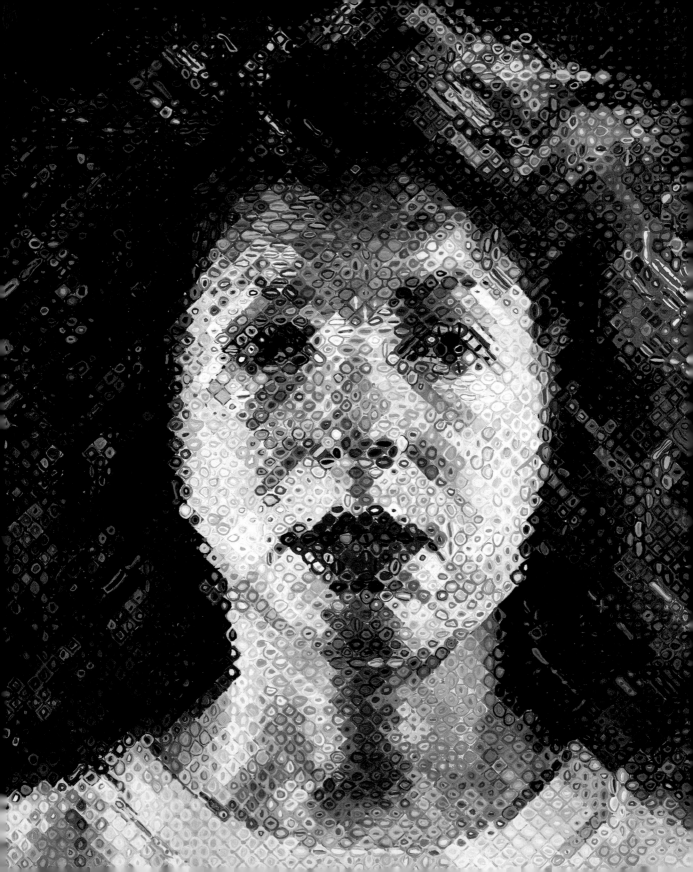

ARTHUR L. FRY

The ubiquitous "Post-it"® note was invented by Arthur L. Fry, who began to work part-time for 3M Corporation when he was a chemical engineering student at the University of Minnesota. Now semiretired from his position as corporate scientist, Fry continues to work as a 3M spokesman. "Post-it" is a registered trademark of 3M Corporation.

DAVID SCHARF

David Scharf's remarkable photographs of scientific subjects can be found among the more than 124,000 images available through the Science Photo Library, one of the world's largest photo agencies specializing in science. With contributors worldwide, the Science Photo Library aims "to make science imagery more accessible to the media and to increase public awareness of the wonders of science and nature."

K. C. COLE

K. C. Cole has commented that her "writing career has changed gear many times." After graduating from Columbia University, she was pursuing an interest in Eastern European affairs when she "stumbled upon the Exploratorium"—a hands-on science museum in San Francisco—and soon thereafter began a career as a science and health writer. "A Matter of Scale" is one of a series of essays in *The Universe and the Teacup: The Mathematics of Truth and Beauty* (1998), Cole's recently published book on the relevance of mathematics to everyday life and on the ways in which math provides insight into social, political, and natural phenomena as diverse as calculating the risks of smoking to understanding election outcomes. Awarded the American Institute of Physics Award for Best Science Writer in 1995, Cole writes regularly on science for the *Los Angeles Times*.

HAROLD EDGERTON

Harold Edgerton (1903–1990) developed and popularized the use of the stroboscope, a controlled pulsating light that enables a camera to "freeze" precise moments on film. The technology he developed while teaching at the Massachusetts Institute of Technology found applications in countless fields of science and industry, but he may be most famous for creating artistic images such as this milk drop (1938).

A Matter of Scale
K. C. Cole

FELICE FRANKEL AND GEORGE M. WHITESIDES

A Guggenheim fellow, Felice Frankel is an artist-in-residence and research scientist at the Massachusetts Institute of Technology. Her work in scientific imaging and visual expression has earned funding from the National Science Foundation as well as awards from the National Endowment for the Arts and several foundations. She is author of the award-winning book *Modern Landscape Architecture: Redefining the Garden* (1991).

George M. Whitesides is Mallinckrodt Professor of Chemistry at Harvard University as well as a member of the National Academy of Sciences and the American Academy of Arts and Sciences. Author of more than 500 research and technical articles and numerous scholarly books, Whitesides continues to teach—and take great pleasure in—introductory courses in molecular biology and chemistry.

CHUCK CLOSE

Since the 1970s, Chuck Close has worked with a painting style known as photorealism or super-realism, which attempts to re-create in paint the aesthetic and representational experience of photography. Close paints enormous canvases of people's faces that duplicate photographic images in precise detail, such as *April*.

Born in Monroe, Washington, in 1940, Close has lived in New York since 1967. In December 1988 he became paralyzed below his shoulders after a spinal artery suddenly collapsed, but he continues to paint colossal and powerful portraits using a brush held in his mouth.

SEEING

1. A masterful exercise in observation and inference about aspects of the natural world we normally cannot see, K. C. Cole's essay stimulates and sustains our interest in the most common creatures and daily events. Reread Cole's essay and identify one or two paragraphs that you think are especially effective. What techniques does she use to capture your attention in these paragraphs? What is memorable and convincing about them? What does Cole identify that is so "magically seductive" about observing "a world where everything measures much bigger or smaller than ourselves" (para. 1)?

2. Examine the visual images included in this section: the magnification of a Post-it® note; Felice Frankel's photograph of a glass of wine; Harold Edgerton's photograph "Milk Drop Coronet"; David Scharf's image of a kitchen scouring pad; and Chuck Close's *April*. Where does your eye linger as you view each image? Comment on the role(s) that color, light, and shadow play in enhancing the effects of the image. Describe your overall impression of each image. How would you describe each one to someone who has never seen these images before? Try writing a paragraph or two about two images. Swap drafts with one or more students. How are your drafts different?

WRITING

1. Early in Cole's essay "A Matter of Scale," when she speaks of the difference scale can make in the natural world, she declares that "quantitative changes can make huge qualitative differences" (para. 2). Cole then offers compelling and convincing examples to demonstrate this assertion. As you reflect on your own experience and that of people you know, to what extent do you think that the same, or a similar, assertion can be made about aspects of the ordinary world? Draft an essay that seeks to validate or challenge the reasonableness of Cole's assertion—if it were applied to the scale of our everyday lives. Following her lead, reinforce each assertion you make with a detailed analysis of examples that your readers will find compelling and convincing.

2. Review the images gathered in "Seeing Is Believing." Which one interests you most? Why? What range of associations and metaphors does this image elicit from you? Using George Whitesides's "Tears of Wine" as a model, draft an essay in which you describe what you imagine to be the process here. What metaphors and other figurative language can you summon to describe this process?

Coming to Terms with Place

"Place" is a fundamental component of everyday life, the "where" that locates each event and experience in our lives. Place in this sense evokes public identity, the often easily recognized characteristics of behavior that inform our accents, our clothes, and our behavior.

"Where are you from?" This question invariably arises when two Americans meet for the first time—especially when traveling. "I'm from the South," "I'm from L.A.," "I'm from Cody, Wyoming"—each response conjures different cultural assumptions and associations. In fact, the meaning we invest in the responses we hear suggests that growing up in a particular place leaves a deep, if not indelible, mark on a person's character. As the popular saying goes, "You

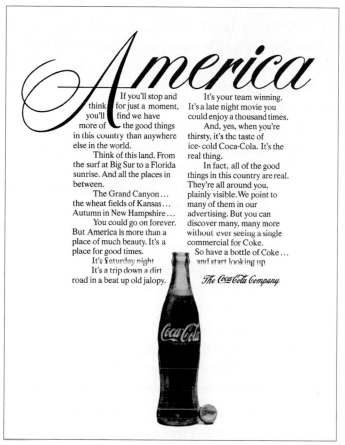

Coca-Cola Company, **Advertisement**

The advertisement text reads:

America

If you'll stop and think for just a moment, you'll find we have more of the good things in this country than anywhere else in the world.

Think of this land. From the surf at Big Sur to a Florida sunrise. And all the places in between.

The Grand Canyon ... the wheat fields of Kansas ... Autumn in New Hampshire ...

You could go on forever. But America is more than a place of much beauty. It's a place for good times.

It's Saturday night. It's a trip down a dirt road in a beat up old jalopy.

It's your team winning. It's a late night movie you could enjoy a thousand times.

And, yes, when you're thirsty, it's the taste of ice- cold Coca-Cola. It's the real thing.

In fact, all of the good things in this country are real. They're all around you, plainly visible. We point to many of them in our advertising. But you can discover many, many more without ever seeing a single commercial for Coke.

So have a bottle of Coke ... and start looking up

The Coca-Cola Company

can take the kid out of Brooklyn, but you can't take Brooklyn out of the kid." Think of a place—a town, a city, or America itself, for example. If asked to describe a sense of that place, what comes immediately to mind: people? buildings? landscapes? landmarks? a "feeling" about the place? Americans often classify people by where they are from, and in this we are encouraged by film and television; just think of *Young Guns, Hoosiers, L.A. Confidential, Beverly Hills 90210, Cheers, Seinfeld.*

Even as Americans invest meaning in geographical roots, fewer of us remain in the same place for long. According to the U.S. Census Bureau, 16 percent of the American public moved between March 1996 and March 1997. Indeed, answering the question "Where are you from?" has become

It's a nice place to visit, but I wouldn't want to live there.
— Anonymous American saying

increasingly difficult for many Americans, given the range of places where they have lived. Airplane travel, mass transit, and freeways reduce the distances between places. And when we arrive at our destinations, we realize that American places look increasingly alike. Few communities across the nation are without the familiar fast-food chains and shopping malls. Likewise, the borders between regions continue to dissolve. Consider the number of restaurants in different parts of the country, each boasting "authentic" regional cuisine. No matter where you find yourself, you can probably enjoy "down-home" Cajun cooking, Chicago pizza, New York bagels, or New England clam chowder.

Our sense of place is no longer limited to the physical realm. The Internet now offers its own electronic landscape, a virtual world in which we can frequent certain "spots" and form communities on particular "sites." Advertisers try to convince us that we can reach any place in the real or virtual world within seconds, without leaving "the privacy of your own home."

In contemporary American culture, the centuries-old distinctions between "place" and "space" seem to be disappearing. Jerry Brown, a former governor of California, candidate for president, and now mayor of Oakland, California, recently drew the following distinction between "place" and "space":

> People don't live in place, they live in space. The media used to accuse me of that—living in space. But it wasn't true. Now too many people just live in their minds, not in communities. They garage themselves in their homes and live in market space. It's an alienated way for human beings to live. It's the difference between a native and an immigrant. A native lives in place, not space.

For most people, coming to terms with place is ultimately a personal matter: It can mean the smell of chicken roasting in the oven, the sound of traffic or a certain song, the sight of a familiar stretch of land. In many respects, place is also about relationships, both (1) among people, and (2) between us and our experiences and associations with a particular time and space.

The essays and images in this chapter represent an attempt to map out the ways we connect socially and culturally with others—and to understand how geographical location, or a sense of place, shapes our outlook on the world and who we are.

There are things you just can't do in life. You can't beat the phone company . . . and you can't go home again.
— *Bill Bryson, 1999*

COCA-COLA

When Dr. John Stith Pemberton of Atlanta, Georgia, brewed a batch of fountain syrup in his backyard in 1886, he sold the drink, which he called Coca-Cola, at the drugstore soda fountain. An immediate success, it began to sell at the rate of nine drinks per day. Today, Coca-Cola sells one billion soft drinks daily in over two hundred countries. Defining the presence of American commerce wherever it is seen, the Coca-Cola trademark is the most recognized corporate logo in the world.

The logo's distinctive white script was custom designed in 1894 for one of the company's early owners. The letter forms were created with the designer's conviction that "the large C's would look well in advertising." From electric billboards in San Francisco to the tiniest store-fronts of Katmandu, the symbol of Coca-Cola remains potent.

Nearly all sub-Saharan African nations sell Coca-Cola. France and Belgium boast the largest European consumption, and the Japanese market grows annually, fueled in part by the presence of 930,000 vending machines dispensing the soft drink. With headquarters in Atlanta, the Coca-Cola Company now owns a wide range of other industries. Because the soft drink is made and bottled in the countries where it is consumed, the recipe for Coca-Cola varies slightly by region. The exact flavorings used are a closely guarded secret.

SEEING

1. What are the effects of the advertiser's emphasis on the virtues of America as a place rather than the virtues of the soft drink? What associations is the ad encouraging between place and product? Comment on the effectiveness of this promotional strategy. What details in the language of the text enable you to determine the audience for this advertisement? What kind of person is addressed in this way? What words and phrases can you identify in the ad that indicate the probable age group, level of education, socioeconomic background, and political beliefs of the audience?

2. Reread the paragraph beginning "In fact, all of the good things in this country are real." What point(s) is the copywriter making here? What response does he or she elicit by referring to other Coca-Cola advertisements? What is meant by "looking up" in the last line? How is this phrase literally and figuratively related to Coca-Cola?

WRITING

1. Imagine that you have been asked to rewrite this advertisement for an audience of senior citizens. Please keep in mind that the ad should seek to capitalize on the traditional American values and ideals associated with place. What changes would you make in the language of the ad? in its use and placement of visual material and in its overall layout (the relation between the visual and verbal elements)? Prepare a new draft of the language of the ad, along with a rough sketch of its layout.

2. Consider the ways in which a sense of place is used in television advertising to sell certain products. Choose one such advertisement, and write an essay in which you analyze the strategies the advertiser uses to promote the product by evoking a sense of place. Because you will be analyzing a television commercial (which may prove difficult to record for the purpose of studying it), you might want to examine the award-winning commercials that are gathered into video collections—such as the Clio Awards.

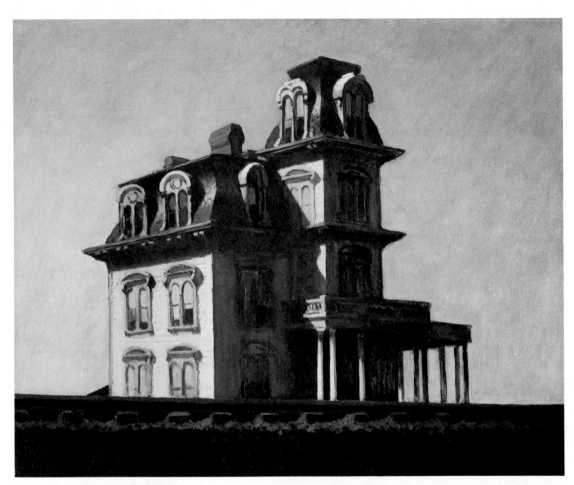

Edward Hopper, **House by the Railroad**

EDWARD HOPPER AND THE
HOUSE BY THE RAILROAD (1925)
Edward Hirsch

Out here in the exact middle of the day,
This strange, gawky house has the expression
Of someone being stared at, someone holding
His breath underwater, hushed and expectant;

This house is ashamed of itself, ashamed 5
Of its fantastic mansard rooftop
And its pseudo-Gothic porch, ashamed
Of its shoulders and large, awkward hands.

But the man behind the easel is relentless;
He is as brutal as sunlight, and believes 10
The house must have done something horrible
To the people who once lived here

Because now it is so desperately empty,
It must have done something to the sky
Because the sky, too, is utterly vacant 15
And devoid of meaning. There are no

Trees or shrubs anywhere—the house
Must have done something against the earth.
All that is present is a single pair of tracks
Straightening into the distance. No trains pass. 20

Now the stranger returns to this place daily
Until the house begins to suspect
That the man, too, is desolate, desolate
And even ashamed. Soon the house starts

To stare frankly at the man. And somehow 25
The empty white canvas slowly takes on
The expression of someone who is unnerved,
Someone holding his breath underwater.

And then one day the man simply disappears.
He is a last afternoon shadow moving 30
Across the tracks, making its way
Through the vast, darkening fields.

This man will paint other abandoned mansions,
And faded cafeteria windows, and poorly lettered
Storefronts on the edges of small towns. 35
Always they will have this same expression.

The utterly naked look of someone
Being stared at, someone American and gawky,
Someone who is about to be left alone
Again, and can no longer stand it. 40

EDWARD HOPPER

Edward Hopper's signature vision is expressed in virtually all his paintings, which capture a wide array of American scenes ranging from rural landscapes and seascapes to street scenes, isolated buildings, and domestic interiors. Hopper masterfully expressed the isolation, boredom, and vacuity of modern life. Even his most colorful, luminous scenes are stripped of joy through an extreme spareness of composition and detail. His Depression-era work in particular evokes the mood of that time. However, Hopper claimed that his work expressed personal rather than national truths: "I don't think I ever tried to paint the American scene," he once said; "I'm trying to paint myself."

Born in 1882, Hopper grew up in Nyack, New York, and received his training in New York City and in Europe. He was still a young man when his work was included in the Armory Show of 1913, a New York City exhibition that featured what would become known as modernist paintings. But in spite of success among critics he had to work as a commercial illustrator in order to support himself. His career turned around when, in his forties, he married the artist Josephine Nivison (1883–1968). Through several decades of an emotionally turbulent but artistically productive marriage, Hopper created his most memorable paintings. He died in 1967.

EDWARD HIRSCH

The poet, critic, and teacher Edward Hirsch was born in 1950 in Chicago and attended Grinnell College and the University of Pennsylvania. Currently a professor of creative writing at the University of Houston, Hirsch has published poems and reviews in the *New Yorker,* the *Nation,* and the *New York Times Book Review,* among other leading journals. He has also published five volumes of poetry, including *Wild Gratitude* (1986), which won the National Book Critics Award, and his most recent collection, *On Love* (1998). He has received numerous awards, including a MacArthur Foundation "genius" award and fellowships from the Guggenheim Foundation, the National Endowment for the Arts, and the Ingram Merrill Foundation.

Hirsch also edited *Transforming Vision: Writers on Art* (1994), a book he produced by asking a number of prominent writers to visit the Art Institute of Chicago and write short, reflective responses to any painting, sculpture, or photograph they saw there. Hirsch argues that "the proper response to a work of visual art may well be an ode or an elegy, a meditative lyric, a lyrical meditation" because poetic descriptions of art "teach us to look and look again more closely" and "dramatize with great intensity the actual experience of encounter." The poem *Edward Hopper and the House by the Railroad (1925)* dramatizes his own encounter with Hopper's famous painting.

SEEING

1. As you examine Edward Hopper's *House by the Railroad*, where does he direct your attention? What details do you notice about the house, its structure, and its relation to the railroad track and the sky? Where does your eye linger as you study the painting more carefully? How does each aspect of its presentation reinforce the overall effect of the painting?

2. What features of Hopper's painting does Edward Hirsch focus on in his poem? What effects does Hirsch create through personification of the house? Explain how his use of repetition (of words, phrases, and structural elements) reinforces—or detracts from—the overall impression or mood created in the poem. In what ways does Hirsch's poem change or enhance your initial reactions to Hopper's painting?

Often used as a poetic device, personifying means giving human qualities to an object or an idea.

WRITING

1. Write a page—in any form you prefer—in which you dramatize *your* encounter with Hopper's *House by the Railroad*. Do you agree with Hirsch that the house has the look of "someone American and gawky" (l. 38)?

2. Reread *Edward Hopper and the House by the Railroad* (1925) several times, until you feel comfortable describing and characterizing Hirsch's shifts in subject and tone. Based on your rereading of the poem, would you agree—or disagree—with the assertion that Hirsch seems more interested in Hopper the artist than in the scene he paints? How is the artist characterized in the poem? With what effects? At what point do the terms used to characterize house and artist seem to merge? What characteristics do the house and the artist share? What overall impression does Hirsch create in this comparison? Write the first draft of an essay in which you use evidence from the poem and the painting to validate your own response to the assertion that Hirsch is far more interested in Hopper as artist than in the scene he paints.

DAVID GRAHAM

The wonder of what can be found in one's backyard, and in the metaphorical backyard of America, has inspired much of David Graham's photographic work. Motivation for his book *American Beauty* (1987) came when he looked out the back window of a friend's house to discover "a perfect, formal, color, informational arrangement, of junk." Then Graham went looking. "When I saw something in a backyard that looked promising, I would simply knock at the door and ask if I could take a picture; if there were people in the yard all the better. It's that spontaneous relationship between the person, and the things around them. It's the way they relate to their things, and the objects relate to them, that sets up a multi-layered and very dense sort of language."

This approach to photography, known as environmental portraiture, is explored further in Graham's latest book, *The Land of the Free* (1999), in which he captures Americans in their environments "at home, at work, and at large."

Graham (b. 1952) grew up in a Philadelphia suburb in what he describes as a typical American family. In fact, his sister was chosen as the subject of a 1962 CBS documentary entitled "The Typical Teenager." He has explored more atypical Americana in his book of unusual roadside attractions, *Only in America* (1991).

David Graham, **Matthew Demo, Elridge, New York**

1. At or near the center of David Graham's photograph are two large round shapes: a satellite dish and a hill where a young boy is playing with toys. What qualities besides shape do the hill and the satellite dish share? What do you notice about the mailboxes? about the automobiles? about the boy's relationship to the toys on the hill and, more generally, to this space? Do you think the space depicted is suburban or rural?

2. Consider the contrasts that Graham captures in this photograph, among different shapes, lines, colors, and surfaces. Now consider the contrast between what is seen inside and outside the wire mesh fence. Do you think the fence is meant to keep the child in or strangers out? Both? Something else? Please cite evidence from the photograph as you formulate a response.

1. Graham's photograph provides an insightful view of the play area in a young boy's yard. In what ways did the play area of your childhood differ from this boy's? Write a descriptive account of the space you played in as a child. To what extent did the toys in that space help define it—and your identity?

2. Consider carefully the gender conventions displayed in this photograph. In what ways do the objects in the play area reinforce basic assumptions about gender training in American culture? (For additional views on the issue of gender training, see pages 256–323.) Write the first draft of an essay in which you compare toys marketed for little boys to those marketed for little girls.

The Little Store

Eudora Welty

TWO BLOCKS AWAY FROM THE MISSISSIPPI STATE Capitol, and on the same street with it, where our house was when I was a child growing up in Jackson, it was possible to have a little pasture behind your backyard where you could keep a Jersey cow, which we did. My mother herself milked her. A thrifty homemaker, wife, mother of three, she also did all her own cooking. And as far as I can recall, she never set foot inside a grocery store. It wasn't necessary.

For her regular needs, she stood at the telephone in our front hall and consulted with Mr. Lemly, of Lemly's Market and Grocery downtown, who took her order and sent it out on his next delivery. And since Jackson at the heart of it was still within very near reach of the open country, the blackberry lady clanged on her bucket with a quart measure at your front door in June without fail, the watermelon man rolled up to your house exactly on time for the Fourth of July, and down through the summer, the quiet of the early-morning streets was pierced by the calls of farmers driving in with their plenty. One brought his with a song, so plaintive we would sing it with him:

> "Milk, milk,
> Buttermilk,
> Snap beans—butterbeans—
> Tender okra—fresh greens . . .
> And buttermilk."

My mother considered herself pretty well prepared in her kitchen and pantry for any emergency that, in her words, might choose to present itself. But if she

should, all of a sudden, need another lemon or find she was out of bread, all she had to do was call out, "Quick! Who'd like to run to the Little Store for me?"

I would.

She'd count out the change into my hand, and I was away. I'll bet the nickel that would be left over that all over the country, for those of my day, the neighborhood grocery played a similar part in our growing up.

Our store had its name—it was that of the grocer who owned it, whom I'll call Mr. Sessions—but "the Little Store" is what we called it at home. It was a block down our street toward the capitol and half a block further, around the corner, toward the cemetery. I knew even the sidewalk to it as well as I knew my own skin. I'd skipped my jumping-rope up and down it, hopped its length through mazes of hopscotch, played jacks in its islands of shade, serpentined along it on my Princess bicycle, skated it backward and forward. In the twilight I had dragged my steamboat by its string (this was homemade out of every new shoebox, with candle in the bottom lighted and shining through colored tissue paper pasted over windows scissored out in the shapes of the sun, moon and stars) across every crack of the walk without letting it bump or catch fire. I'd "played out" on that street after supper with my brothers and friends as long as "first-dark" lasted; I'd caught its lightning bugs. On the first Armistice Day (and this will set the time I'm speaking of) we made our own parade down that walk on a single velocipede—my brother pedaling, our little brother riding the handlebars, and myself standing on the back, all with arms wide, flying flags in each hand. (My father snapped that picture as we raced by. It came out blurred.)

As I set forth for the Little Store, a tune would float toward me from the house where there lived three sisters, girls in their teens, who ratted their hair over their ears, wore headbands like gladiators, and were considered to be very popular. They practiced for this in the daytime; they'd wind up the Victrola, leave the same record on they'd played before, and you'd see them bobbing past their dining-room windows while they danced with each other. Being three, they could go all day, cutting in:

"Everybody ought to know-oh
How to do the Tickle-Toe
(how to do the Tickle-Toe)"—

They sang it and danced to it, and as I went by to the same song, I believed it.

A little further on, across the street, was the house where the principal of our grade school lived—lived on, even while we were having vacation. What if she would come out? She would halt me in my tracks—she had a very carrying and well-known voice in Jackson, where she'd taught almost everybody—saying, "Eudora Alice Welty, spell OBLIGE." OBLIGE was the word that she of course knew had kept me from making 100 on my spelling exam. She'd make me miss it again now, by boring her eyes through me from across the street. This was my vacation fantasy, one good way to scare myself on the way to the store.

Down near the corner waited the house of a little boy named Lindsey. The sidewalk here was old brick, which the roots of a giant chinaberry had humped up and tilted this way and that. On skates, you took it fast, in a series of skittering hops, trying not to touch ground anywhere. If the chinaberries had fallen and rolled in the cracks, it was like skating through a whole shooting match of marbles. I crossed my fingers that Lindsey wouldn't be looking.

During the big flu epidemic he and I, as it happened, were being nursed through our sieges at the same time. I'd hear my father and mother murmuring to each other, at the end of a long day, "And I wonder how poor little *Lindsey* got along today?" Just as, down the street, he no doubt would have to hear his family saying, "And I wonder how is poor *Eudora* by now?" I got the idea that a choice was going to be made soon between poor little Lindsey and poor Eudora, and I came up with a funny poem. I wasn't prepared for it when my father told me it wasn't funny and my mother cried that if I couldn't be ashamed for myself, she'd have to be ashamed for me:

> There was a little boy and his name was Lindsey.
> He went to heaven with the influinzy.

He didn't, he survived it, poem and all, the same as I did. But his chinaberries could have brought me down in my skates in a flying act of contrition before his eyes, looking pretty funny myself, right in front of his house.

Setting out in this world, a child feels so indelible. He only comes to find out later that it's all the others along his way who are making themselves indelible to him. 10

Our Little Store rose right up from the sidewalk; standing in a street of family houses, it alone hadn't any yard in front, any tree or flowerbed. It was a plain frame building covered over with brick. Above the door, a little railed porch ran across on an upstairs level and four windows with shades were looking out. But I didn't catch on to those.

Running in out of the sun, you met what seemed total obscurity inside. There were almost tangible smells—licorice recently sucked in a child's cheek, dill-pickle brine that had leaked through a paper sack in a fresh trail across the wooden floor, ammonia-loaded ice that had been hoisted from wet croker sacks and slammed into the icebox with its sweet butter at the door, and perhaps the smell of still-untrapped mice.

Then through the motes of cracker dust, cornmeal dust, the Gold Dust of the Gold Dust Twins that the floor had been swept out with, the realities emerged. Shelves climbed to high reach all the way around, set out with not too much of any one thing but a lot of things—lard, molasses, vinegar, starch, matches, kerosene, Octagon soap (about a year's worth of octagon-shaped coupons cut out and saved brought a signet ring addressed to you in the mail. Furthermore, when the postman arrived at your door, he blew a whistle). It was up to you to remember what you came for, while your eye traveled from cans of sardines to ice cream salt to harmonicas to flypaper (over your head, batting around on a thread beneath the blades of the ceiling fan, stuck with its testimonial catch).

Its confusion may have been in the eye of its beholder. Enchantment is cast upon you by all those things you weren't supposed to have need for, it lures you close to wooden tops you'd outgrown, boy's marbles and agates in little net pouches, small rubber balls that wouldn't bounce straight, frazzly kitestring, clay bubble-pipes that would snap off in your teeth, the stiffest scissors. You could contemplate those long narrow boxes of sparklers gathering dust while you waited for it to be the Fourth of July or Christmas, and noisemakers in the shape of tin frogs for somebody's birthday party you hadn't been invited to yet, and see that they were all marvelous.

You might not have even looked for Mr. Sessions when he came around his store cheese (as big as a doll's house) and in front of the counter looking for you. When you'd finally asked him for, and received from him in its paper bag, whatever single thing it was that you had been sent for, the nickel that was left over was yours to spend. 15

Down at a child's eye level, inside those glass jars with mouths in their sides through which the grocer could run his scoop or a child's hand might be invited to reach for a choice, were wineballs, all-day suckers, gumdrops, peppermints. Making a row under the glass of a counter were the Tootsie Rolls, Hershey Bars, Goo-Goo Clusters, Baby Ruths. And whatever was the name of those pastilles that came stacked in a cardboard cylinder with a cardboard lid? They were thin and dry, about the size of tiddlywinks, and in the shape of twisted rosettes. A kind of chocolate dust came out with them when you shook them out in your hand. Were they chocolate? I'd say rather they were brown. They didn't taste of anything at all, unless it was wood. Their attraction was the number you got for a nickel.

Making up your mind, you circled the store around and around, around the pickle barrel, around the tower of Cracker Jack boxes; Mr. Sessions had built it for us himself on top of a packing case, like a house of cards.

If it seemed too hot for Cracker Jacks, I might get a cold drink. Mr. Sessions might have already stationed

himself by the cold-drinks barrel, like a mind reader. Deep in ice water that looked black as ink, murky shapes that would come up as Coca-Colas, Orange Crushes, and various flavors of pop, were all swimming around together. When you gave the word, Mr. Sessions plunged his bare arm in to the elbow and fished out your choice, first try. I favored a locally bottled concoction called Lake's Celery. (What else could it be called? It was made by a Mr. Lake out of celery. It was a popular drink here for years but was not known universally, as I found out when I arrived in New York and ordered one in the Astor bar.) You drank on the premises, with feet set wide apart to miss the drip, and gave him back his bottle.

But he didn't hurry you off. A standing scales was by the door, with a stack of iron weights and a brass slide on the balance arm, that would weigh you up to three hundred pounds. Mr. Sessions, whose hands were gentle and smelled of carbolic, would lift you up and set your feet on the platform, hold your loaf of bread for you, and taking his time while you stood still for him, he would make certain of what you weighed today. He could even remember what you weighed the last time, so you could subtract and announce how much you'd gained. That was goodbye.

Is there always a hard way to go home? From the Little Store, you could go partway through the sewer. If your brothers had called you a scarecat, then across the next street beyond the Little Store, it was possible to enter this sewer by passing through a privet hedge, climbing down into the bed of a creek, and going into its mouth on your knees. The sewer—it might have been no more than a "storm sewer"—came out and emptied here, where Town Creek, a sandy, most often shallow little stream that ambled through Jackson on its way to the Pearl River, ran along the edge of the cemetery. You could go in darkness through this tunnel to where you next saw light (if you ever did) and climb out through the culvert at your own street corner.

I was a scarecat, all right, but I was a reader with my own refuge in storybooks. Making my way under the sidewalk, under the street and the streetcar track, under the Little Store, down there in the wet dark by myself, I could be Persephone entering into my six-month sojourn underground—though I didn't suppose Persephone had to crawl, hanging onto a loaf of bread, and come out through the teeth of an iron grating. Mother Ceres would indeed be wondering where she could find me, and mad when she knew. "Now am I going to have to start marching to the Little Store for *myself?*"

I couldn't picture it. Indeed, I'm unable today to picture the Little Store with a grown person in it, except for Mr. Sessions and the lady who helped him, who belonged there. We children thought it was ours. The happiness of errands was in part that of running for the moment away from home, a free spirit. I believed the Little Store to be a center of the outside world, and hence of happiness—as I believed what I found in the Cracker Jack box to be a genuine prize, which was as simply as I believed in the Golden Fleece.

But a day came when I ran to the store to discover, sitting on the front step, a grown person, after all—more than a grown person. It was the Monkey Man, together with his monkey. His grinding-organ was lowered to the step beside him. In my whole life so far, I must have laid eyes on the Monkey Man no more than five or six times. An itinerant of rare and wayward appearances, he was not punctual like the Gipsies, who every year with the first cool days of fall showed up in the aisles of Woolworth's. You never knew when the Monkey Man might decide to favor Jackson, or which way he'd go. Sometimes you heard him as close as the next street, and then he didn't come up yours.

But now I saw the Monkey Man at the Little Store, where I'd never seen him before. I'd never seen him sitting down. Low on that familiar doorstep, he was not the same any longer, and neither was his monkey. They looked just like an old man and an old friend of his that wore a fez, meeting quietly together, tired, and resting with their eyes fixed on some place far away, and not the same place. Yet their romance for

me didn't have it in its power to waver. I wavered. I simply didn't know how to step around them, to proceed on into the Little Store for my mother's emergency as if nothing had happened. If I could have gone in there after it, whatever it was, I would have given it to them—putting it into the monkey's cool little fingers. I would have given them the Little Store itself.

In my memory they are still attached to the store— so are all the others. Everyone I saw on my way seemed to me then part of my errand, and in a way they were. As I myself, the free spirit, was part of it too.

All the years we lived in that house where we children were born, the same people lived in the other houses on our street too. People changed through the arithmetic of birth, marriage and death, but not by going away. So families just accrued stories, which through the fullness of time, in those times, their own lives made. And I grew up in those.

But I didn't know there'd ever been a story at the Little Store, one that was going on while I was there. Of course, all the time the Sessions family had been living right overhead there, in the upstairs rooms behind the little railed porch and the shaded windows; but I think we children never thought of that. Did I fail to see them as a family because they weren't living in an ordinary house? Because I so seldom saw them close together, or having anything to say to each other? She sat in the back of the store, her pencil over a ledger, while he stood and waited on children to make up their minds. They worked in twin black eyeshades, held on their gray heads by elastic bands. It may be harder to recognize kindness—or unkindness, either—in a face whose eyes are in shadow. His face underneath his shade was as round as the little wooden wheels in the Tinker Toy box. So

was her face. I didn't know, perhaps didn't even wonder: were they husband and wife or brother and sister? Were they father and mother? There were a few other persons, of various ages, wandering singly in by the back door and out. But none of their relationships could I imagine, when I'd never seen them sitting down together around their own table.

The possibility that they had any other life at all, anything beyond what we could see within the four walls of the Little Store, occurred to me only when tragedy struck their family. There was some act of violence. The shock to the neighborhood traveled to the children, of course; but I couldn't find out from my parents what had happened. They held it back from me, as they'd already held back many things, "until the time comes for you to know."

You could find out some of these things by looking in the unabridged dictionary and the encyclopedia—kept to hand in our dining room—but you couldn't find out there what had happened to the family who for all the years of your life had lived upstairs over the Little Store, who had never been anything but patient and kind to you, who never once had sent you away. All I ever knew was its aftermath: they were the only people ever known to me who simply vanished. At the point where their life overlapped into ours, the story broke off.

We weren't being sent to the neighborhood grocery for facts of life, or death. But of course those are what we were on the track of, anyway. With the loaf of bread and the Cracker Jack prize, I was bringing home the intimations of pride and disgrace, and rumors and early news of people coming to hurt one another, while others practiced for joy—storing up a portion for myself of the human mystery. ○

Eudora Welty, **Storekeeper, 1935**

SEEING

1. What principles of selection and order does Eudora Welty use to organize her reminiscences of running errands to the local grocery store? Reread the opening paragraphs in which she affectionately recounts some of the games she played as a child. How do these moments express her feelings toward the store? What are the effects of presenting these paragraphs before she describes the store? To which senses does she appeal in describing "the Little Store"? What techniques does she use to reinforce the childlike perspective recaptured in the essay? In each instance, point to specific evidence to verify your points.

2. Eudora Welty is an accomplished photographer as well as a renowned writer. (Her photographs of people and places in the South are collected in *Eudora Welty Photographs*.) She seeks to capture "the moment in which people reveal themselves." After examining the photograph of the storekeeper, what do you think he reveals about himself? Take notes on as many details of the photograph as you can. What, for example, do you notice about this man's stance, body language, and facial expression? How does lighting affect your impression of him? How has Welty chosen to frame her subject? What has she included in the photograph? What has she omitted?

WRITING

1. In an interview about her photography, Welty suggested that both the writer and the photographer must learn about "accuracy of the eye, about observation, and about sympathy towards what is in front of you." Consider the meaning of each of the three components of her statement, and make a list of the ways in which you can apply them to writing and taking photographs. To what extent do writing and photography capture "accuracy of the eye," "observation," and "sympathy towards what is in front of you"? Write an essay in which you explore Welty's statement about the similarities between writing and taking pictures, using her own visual and verbal takes on similar subjects as the basis for your analysis.

2. Examine Welty's observation that she strives to capture in her photographs "the moment in which people reveal themselves." What assumptions about the relationship between photographs and spontaneity are embedded in the point she makes? Draft an essay in which you defend or challenge the assertion that the recognized presence of a photographer precludes the possibility of capturing a spontaneous, non-posed moment. Whichever side you argue, please be sure to support your claims with evidence as well as to anticipate—and rebut—the point(s) of view of those arguing the other side.

I'm not very eloquent about things like this, but I think that writing and photography go together. I don't mean that they are related arts, because they're not. But the person doing it, I think, learns from both things about accuracy of the eye, about observation and about sympathy toward what is in front of you. It's about trying to see into the essence of reality. It's about honesty, or truth telling, and a way to find it in yourself, how to need it and learn from it.

I still go back to a paragraph of mine from *One Time, One Place* as the best expression I was ever able to manage about what I did or was trying to do in both fields. It's still the truth:

> I learned quickly enough when to click the shutter, but what I was becoming aware of more slowly was a story-writer's truth: The thing to wait on, to reach for, is the moment in which people reveal themselves. . . . I learned from my own pictures, one by one, and had to; for I think we are the breakers of our own hearts.

– Eudora Welty, from "Storekeeper, 1935"

ALBERT BIERSTADT

Albert Bierstadt (1830–1902) was a preeminent painter of nineteenth-century American landscapes. At age 2 he immigrated to the United States with his family and settled in Massachusetts. His parents tried to dissuade him from pursuing a career in art, but Bierstadt persisted and by 1853, had sold enough of his work to pay for four years of travel and education in Europe.

After returning to the United States in 1857, Bierstadt joined the expedition of General F. W. Lander that was sent to explore the Rocky Mountains. Bierstadt is best remembered for his paintings that resulted from this and other travels through the American West. Throughout his long career he celebrated the sublime beauty and power of romanticized landscapes. During the nineteenth century he was one of the leading interpreters of the West for sedentary easterners, who often built their aspirations for national expansion on romantic visions of pristine nature.

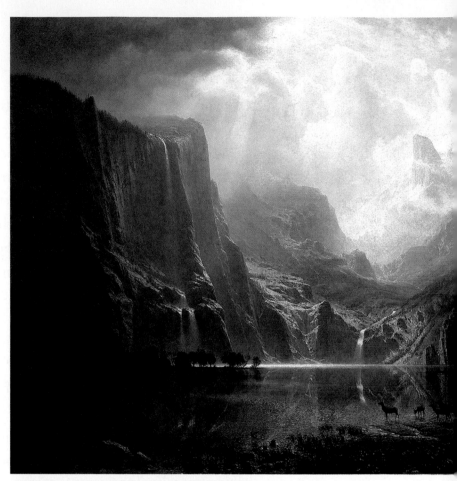

Albert Bierstadt, **Among the Sierra Nevada Mountains, California, 1868**

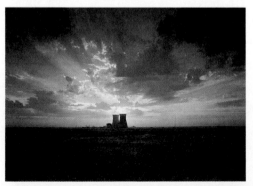

John Pfahl, **Rancho Seco Nuclear Plant, Sacramento, California, 1983**

Pfahl's collection of photographs, *A Distanced Land* (1990), presents industrial power plants in the context of natural scenic wonders. "By making the landscape appear so romantic," he asks, "would it promote the naive impression that these power plants were living in blissful harmony with nature? Would my work be co-opted by industry?"

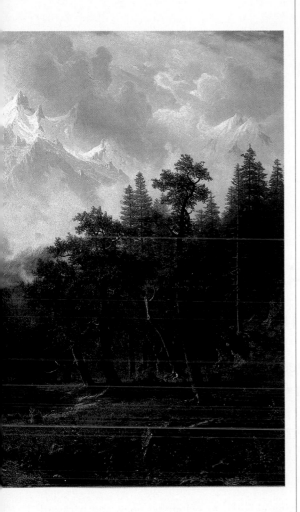

SEEING

1. Albert Bierstadt traveled extensively through the Rocky Mountains and Sierra Nevada making drawings and oil sketches, from which he later painted large canvases. What is the dominant impression created by Bierstadt in this famous painting of a scene in the Sierra Nevada Mountains? What artistic choices—such as the use of color, light, perspective, and scale—does he make that account for this effect and for the popularity of this painting as an artistic rendition of the American West?

2. What is the dominant impression created by John Pfahl's photograph of the nuclear power plant at Rancho Seco in California? How do the elements of light and darkness reinforce this impression? In what ways might we say (and admiringly so) that Pfahl's photograph is "composed"? Consider, for example, his use of perspective. This photograph appeared as the cover illustration for an issue of *Aperture*, a prominent photography magazine, entitled "Beyond Wilderness." In what ways does the title of that issue serve as an apt—or ironic—gloss on Pfahl's photograph? Compare Bierstadt's painting with Pfahl's photograph. In what ways is the overall effect of each image similar? different?

WRITING

1. In an essay entitled "The Loss of the Creature," the renowned physician and writer Walker Percy talks about the difficulties of seeing the natural world around us. He asks: "Why is it almost impossible to gaze directly at the Grand Canyon . . . and see it for what it is? The Grand Canyon has been appropriated by the symbolic complex which has already been formed in the sightseer's mind." Write the first draft of an essay in which you account for the ways in which Albert Bierstadt's painting *Among the Sierra Nevada Mountains* has contributed to the "symbolic complex which has already been formed in the sightseer's mind" when he or she travels to the American West for the first time. In what ways has Bierstadt's painting helped determine the American public's vision of the West?

2. What would you say and do if you were asked to state your position—and to vote—on the uses of nuclear energy in the twenty-first century? Enumerate, and then consider carefully, the advantages and disadvantages of nuclear energy in the coming decades. Draft an argumentative essay in which you articulate and defend your position that the federal and state governments ought to promote (increased or decreased) reliance on nuclear energy.

DAVID GUTERSON

In both his fiction and essays, David Guterson's craft reminds one of an ornate tapestry: Intense focus on detail builds toward a complex and compelling portrait. He engages his readers on multiple levels—philosophical, psychological, and ethical—because, in his words, "I feel responsible to tell stories that inspire readers to consider more deeply who they are." In "No Place Like Home," which appeared in *Harper's* in November 1991, Guterson invites us to consider the kind of society we are producing as planned and gated communities proliferate. No matter where we live or aspire to live, Guterson asks us to reflect on our dreams of utopia and our apparently contradictory needs for freedom and security.

Guterson (b. 1956) lives near Seattle on Bainbridge Island, where he works as a high school English teacher. His publications include a collection of short stories, *The Country Ahead of Us, the Country Behind Us* (1989); an argument in favor of home schooling, *Family Matters* (1993); the celebrated novel *Snow Falling on Cedars* (1994); and *East of the Mountains* (1999).

No Place Like Home

On the Manicured Streets of a Master-Planned Community

David Guterson

TO THE CASUAL EYE, GREEN VALLEY, NEVADA, A corporate master-planned community just south of Las Vegas, would appear to be a pleasant place to live. On a Sunday last April—a week before the riots in Los Angeles and related disturbances in Las Vegas—the golf carts were lined up three abreast at the upscale "Legacy" course; people in golf outfits on the clubhouse veranda were eating three-cheese omelets and strawberry waffles and looking out over the palm trees and fairways, talking business and reading Sunday newspapers. In nearby Parkside Village, one of Green Valley's thirty-five developments, a few homeowners washed cars or boats or pulled up weeds in the sun. Cars wound slowly over clean broad streets,

ferrying children to swimming pools and backyard barbecues and Cineplex matinees. At the Silver Springs tennis courts, a well-tanned teenage boy in tennis togs pummeled his sweating father. Two twelve-year-old daredevils on expensive mountain bikes, decked out in Chicago Bulls caps and matching tank tops, watched and ate chocolate candies.

Green Valley is as much a verb as a noun, a place in the process of becoming what it purports to be. Everywhere on the fringes of its 8,400 acres one finds homes going up, developments going in (another twenty-one developments are under way), the desert in the throes of being transformed in accordance with the master plan of Green Valley's designer and

builder, the American Nevada Corporation. The colors of its homes are muted in the Southwest manner: beiges, tans, dun browns, burnt reds, olive grays, rusts, and cinnamons. Its graceful, palm-lined boulevards and parkways are conspicuously devoid of gas stations, convenience stores, and fast-food restaurants, presenting instead a seamless facade of interminable, well-manicured developments punctuated only by golf courses and an occasional shopping plaza done in stucco. Within the high walls lining Green Valley's expansive parkways lie homes so similar they appear as uncanny mirror reflections of one another—and, as it turns out, they are. In most neighborhoods a prospective homeowner must choose from among a limited set of models with names like "Greenbriar," "Innisbrook," and "Tammaron" (or, absurdly, in a development called Heartland, "Beginnings," "Memories," and "Reflections"), each of which is merely a variation on a theme: Spanish, Moorish, Mexican, Territorial, Mediterranean, Italian Country, Mission. Each development inhabits a planned socioeconomic niche—$99,000, $113,900, $260,000 homes, and on into the stratosphere for custom models if a wealthy buyer desires. Neighborhoods are labyrinthine, confusing in their sameness; each block looks eerily like the next. On a spring evening after eight o'clock it is possible to drive through miles of them without seeing a single human being. Corners are marked with signs a visitor finds more than a little disconcerting: WARNING, they read, NEIGHBORHOOD WATCH PROGRAM IN FORCE. WE IMMEDIATELY REPORT ALL SUSPICIOUS PERSONS AND ACTIVITIES TO OUR POLICE DEPARTMENT. The signs on garages don't make me feel any better. WARNING, they read, YOUR NEIGHBORS ARE WATCHING.

I'd come to Green Valley because I was curious to meet the citizens of a community in which everything is designed, orchestrated, and executed by a corporation. More and more Americans, millions of them—singles, families, retirees—are living in such places. Often proximate to beltway interchanges and self-contained office parks of boxy glass buildings, these communities are everywhere now, although far more common in the West than elsewhere: its vast terrain, apparently, still lends itself to dreamers with grand designs. Irvine, California—the master-planned product of the Irvine Company, populated by 110,000 people and one of the fastest-growing *cities* in America—is widely considered a prototype, as are Reston, Virginia, and Columbia, Maryland, two early East Coast versions. Fairfield Communities, Inc., owns fourteen "Fairfield Communities": Fairfield in the Foothills, Fairfield's La Cholla, Fairfield's River Farm, and so forth. The Walt Disney Co. has its entry—Celebration—under way not far from Florida's Disney World. Las Colinas, Inc., invented Las Colinas, Texas, "America's Premier Master Planned Community," "America's Premier Development," and "America's Corporate Headquarters." The proliferation of planned communities is most visible in areas of rapid growth, which would certainly include the Las Vegas valley, the population of which has nearly doubled, to 799,381, since 1982.

That Sunday afternoon I made my way along peaceful boulevards to Green Valley's civic center, presumably a place where people congregate. A promotional brochure describes its plaza as "the perfect size for public gatherings and all types of social events," but on that balmy day, the desert in bloom just a few miles off, no one had, in fact, gathered here. The plaza had the desultory ambience of an architectural mistake—deserted, useless, and irrelevant to Green Valley's citizens, who had, however, gathered in large numbers at stucco shopping centers not far off—at Spotlight Video, Wallpaper World, Record City, and Bicycle Depot, Rapunzel's Den Hair Salon, Enzo's Pizza and Ristorante, A Basket of Joy, and K-Mart.

Above the civic center, one after another, flew airplanes only seconds from touching down at nearby McCarran International Airport, which services Las Vegas casinogoers. Low enough that the rivets in their wings could be discerned, the planes descended at sixty-second intervals, ferrying fresh loads of gamblers into port. To the northeast, beyond a billboard put up by a developer—WATCH US BUILD THE NEW LAS

5

VEGAS—lay a rectangle of desert as yet not built upon but useful as a dumping ground: scraps of plastic, bits of stucco, heaps of wire mesh and lumber ends were all scattered in among low creosote bush. The corporate master plan, I later learned, calls for hauling these things away and replacing them with, among other things, cinemas, a complex of swimming pools, restaurants, and substantially more places to shop.

Inside the civic center were plenty of potted palms, walls of black glass, and red marble floors, but again, no congregating citizens. Instead, I found the offices of the Americana Group Realtors; Lawyer's Title of Nevada, Inc.; RANPAC Engineering Corporation; and Coleman Homes, a developer. A few real estate agents were gearing up for Sunday home tours, dressed to kill and shuffling manila folders, their BMWs parked outside. Kirk Warren, a marketing specialist with the Americana Group, listened patiently to my explanation: I came to the civic center to talk to people; I wanted to know what brought them to a corporate-planned community and why they decided to stay.

"It's safe here," Warren explained, handing me a business card with his photograph on it. "And clean. And nice. The schools are good and the crime rate low. It's what buyers are looking for."

Outside the building, in the forlorn-looking plaza, six concrete benches had been fixed astride lawns, offering citizens twenty-four seats. Teenagers had scrawled their graffiti on the pavement (DARREN WAS HERE, JASON IS AWESOME), and a footlight beneath a miniature obelisk had been smashed by someone devoted to its destruction. Someone had recently driven past on a motorcycle, leaving telltale skid marks.

The history of suburbia is a history of gradual dysfunction, says Brian Greenspun, whose family owns the American Nevada Corporation (ANC), the entity that created Green Valley. Americans, he explains, moved to the suburbs in search of escape from the more undesirable aspects of the city and from undesirable people in particular. Time passed and undesirables showed up anyway; suburbia had no means to prevent this. But in the end, that was all right, Green-

spun points out, because master planners recognized the problem as an enormously lucrative market opportunity and began building places like Green Valley.

Rutgers history professor Robert Fishman, author of *Bourgeois Utopias: The Rise and Fall of Suburbia,* would agree that suburbia hasn't worked. Suburbia, he argues, appeared in America in the middle of the nineteenth century, offering escape from the squalor and stench of the new industrial cities. The history of suburbia reached a climax, he says, with the rise of Los Angeles as a city that is in fact one enormous suburb. Today, writes Fishman, "the original concept of suburbia as an unspoiled synthesis of city and countryside has lost its meaning." Suburbia "has become what even the greatest advocates of suburban growth never desired—a new form of city." These new suburb-cities have, of course, inevitably developed the kinds of problems—congestion, crime, pollution, tawdriness—that the middle class left cities to avoid. Now, in the Nineties, developers and corporate master planners, recognizing an opportunity, have stepped in to supply the middle class, once again, with the promise of a bourgeois utopia.

As a product of the American Nevada Corporation, Green Valley is a community with its own marketing logo: the letters G and V intertwined quite cleverly to create a fanciful optical illusion—two leaves and a truncated plant stem. It is also a community with an advertising slogan: ALL THAT A COMMUNITY CAN BE. Like other master-planned communities in America, it is designed to embody a corporate ideal not only of streets and houses but of image and feeling. Green Valley's crisp lawns, culs-de-sac, and stucco walls suggest an amiable suburban existence where, as an advertising brochure tells us, people can enjoy life *more than they ever did before.* And, apparently, they do enjoy it. Thirty-four thousand people have filled Green Valley's homes in a mere fourteen years—the place is literally a boomtown. . . .

On weekday mornings, familiar yellow buses amble through Green Valley toward public schools built on acreage set aside in a 1971 land-sale agreement

between ANC and Henderson, a blue-collar town just south of Vegas that was initially hostile to its new upscale neighbor but that now willingly participates in Green Valley's prosperity. Many parents prefer to drive their children to these schools before moving on to jobs, shopping, tennis, or aerobics classes. (Most Green Valley residents work in Las Vegas, commuting downtown in under twenty minutes.) The characteristic Green Valley family—a married couple with two children under twelve—has an average annual income of $55,000; about one in five are members of the Green Valley Athletic Club, described by master planners as "the focal point of the community" (family initiation fee: $1,000). The club's lavish swimming pools and air-conditioned tennis courts are, I was told, especially popular in summer, when Green Valley temperatures can reach 115 degrees and when whole caravans of Porsches and BMWs make their way toward its shimmering parking lots.

Inside is a state-of-the-art body-sculpting palace with Gravitron Upper Body Systems in its weight room, $3.99 protein drinks at its Health Bar, complimentary mouthwash in its locker rooms (swilled liberally by well-preserved tennis aficionados primping their thinning hair at mirrors before heading upstairs to Café Brigette Deux), and employees trained "to create an experience that brings a smile to every Member at every opportunity." I was given a tour by Jill Johnson, a Membership Service Representative, who showed me the Cybex systems in the weight room, the Life-Circuit computerized resistance equipment, the aerobics studio, and the day-care center.

Upstairs, the bartender mixed an "Arnold Schwarzenegger" for an adolescent boy with a crisp haircut and a tennis racket: yogurt, banana, and weight-gain powder. Later, in the weight room, I met a man I'll call Phil Anderson, an accountant, who introduced me to his wife, Marie, and to his children, Jason and Sarah. Phil was ruddy, overweight, and sweat-soaked, and had a towel draped over his shoulders. Marie was trim, dressed for tennis; the kids looked bored. Phil had been playing racquetball that evening while Marie took lessons to improve her serve and the children watched television in the kids' lounge. Like most of the people I met in Green Valley, the Andersons were reluctant to have their real names used ("We don't want the reaction," was how some residents explained it, including Marie and Phil). I coaxed them by promising to protect their true identities, and the Andersons began to chat.

"We moved here because Jase was getting on toward junior high age," Marie explained between sets on a machine designed to strengthen her triceps. "And in San Diego, where we lived before, there were these . . . *forces,* if you know what I mean. There were too many things we couldn't control. Drugs and stuff. It wasn't healthy for our kids."

"I had a job offer," Phil said, "We looked for a house. Green Valley was . . . the obvious place—just sort of obvious, really. Our real estate agent sized us up and brought us out here right away."

"We found a house in Silver Springs," Marie said. "You can go ahead and put that in your notes. It's a big development. No one will figure it out."

"But just don't use our names, okay?" Phil pleaded. "I would really appreciate that."

"We don't need problems," Marie added.

Master planners have a penchant not just for slogans but for predictable advertising strategies. Their pamphlets, packets, and brochures wax reverent about venerable founding fathers of passionate vision, men of foresight who long ago—usually in the Fifties—dreamed of building cities in their own image. Next comes a text promising an upscale pastoral: golf courses, blissful shoppers, kindly security guards, pleasant walkways, goodly physicians, yeomanly fire fighters, proficient teachers. Finally—invariably—there is culture in paradise: an annual arts and crafts festival, a sculpture, a gallery, Shakespeare in the park. In Las Colinas's Williams Square, for example, a herd of bronze mustangs runs pell-mell across a plaza, symbolizing, a brochure explains, a "heritage of freedom in a free land." Perhaps in the interstices of some sophisticated market analysis, these unfettered mustangs

make perfectly good sense; in the context of a community whose dominant feature is walls, however, they make no sense whatsoever.

Walls are everywhere in Green Valley too; they're the first thing a visitor notices. Their message is subliminal and at the same time explicit; controlled access is as much metaphor as reality. Controlled access is also a two-way affair—both "ingress" and "egress" are influenced by it; both coming and going are made difficult. The gates at the thresholds of Green Valley's posher neighborhoods open with a macabre, mechanical slowness; their guards speak firmly and authoritatively to strangers and never smile in the manner of official greeters. One of them told me to take no pictures and to go directly to my destination "without stopping to look at anything." Another said that in an eight-hour shift he felt constantly nervous about going to the bathroom and feared that in abandoning his post to relieve himself he risked losing his job. A girl at the Taco Bell on nearby Sunset Road complained about Clark County's ten o'clock teen curfew—and about the guard at her neighborhood's gate who felt it was his duty to remind her of it. A ten-year-old pointed out that his friends beyond the wall couldn't join him inside without a telephone call to "security," which meant "the policeman in the guardhouse." Security, of course, can be achieved in many ways, but one implication of it, every time, is that security has insidious psychological consequences for those who contrive to feel secure.

"Before I built a wall," wrote Robert Frost, "I'd ask to know what I was walling in or walling out, and to whom I was like to give offense." The master planners have answers that are unassailably prosaic: "lot owners shall not change said walls in any manner"; "perimeter walls are required around all single family residential projects"; "side yard walls shall conform to the Guidelines for intersecting rear property walls." Their master plan weighs in with ponderous wall specifics, none of them in any way actionable: location, size, material, color, piers, pillars, openings. "Perimeter Project Walls," for example, "shall be made of gray colored, split face concrete masonry units, 8" by 16" by 6" in size, with a 4" high gray, split face, concrete block. . . . The block will be laid in a running bond pattern. . . . No openings are allowed from individual back yard lots into adjoining areas."

All of Green Valley is defined in this manner, by CC&Rs, as the planners call them—covenants, conditions, and restrictions embedded in deeds. Every community has some restrictions on matters such as the proper placement of septic tanks and the minimum distance allowed between homes, but in Green Valley the restrictions are detailed and pervasive, insuring the absence of individuality and suppressing the natural mess of humanity. Clotheslines and Winnebagos are not permitted, for example; no fowl, reptile, fish, or insect may be raised; there are to be no exterior speakers, horns, whistles, or bells. No debris of any kind, no open fires, no noise. Entries, signs, lights, mailboxes, sidewalks, driveways, rear yards, side yards, carports, sheds—the planners have had their say about each. All CC&Rs are inscribed into books of law that vary only slightly from development to development: the number of dogs and cats you can own (until recently, one master-planned community in Newport Beach, California, even limited the *weight* of dogs) as well as the placement of garbage cans, barbecue pits, satellite dishes, and utility boxes. The color of your home, the number of stories, the materials used, its accents and trim. The interior of your garage, the way to park your truck, the plants in your yard, the angle of your flagpole, the size of your address numbers, the placement of mirrored glass balls and birdbaths, the grade of your lawn's slope, and the size of your FOR SALE sign should you decide you want to leave.

"These things," explained Brad Nelson, an ANC vice president, "are set up to protect property values." ANC owner Greenspun put it another way: "The public interest and ANC's interest are one." . . .

As a journalist, I may have preferred a telling answer [25] to my most frequent question—Why do you live here?—but the people of Green Valley, with disconcerting uniformity, were almost never entirely forthcoming. ("I moved here because of my job," they

would say, or "I moved here because we found a nice house in Heartland.") Many had never heard of the American Nevada Corporation; one man took me for a representative of it and asked me what I was selling. Most had only a vague awareness of the existence of a corporate master plan for every detail of their community. The covenants, conditions, and restrictions of their lives were background matters of which they were cognizant but about which they were yawningly unconcerned. It did not seem strange to anyone I spoke with that a corporation should have final say about their mailboxes. When I explained that there were CC&Rs for nearly everything, most people merely shrugged and pointed out in return that it seemed a great way to protect property values. A woman in a grocery store checkout line explained that she'd come here from southern California because "even the good neighborhoods there aren't good anymore. You don't feel safe in L.A."

What the people of Green Valley want, explained a planner, is safety from threats both real and imagined and control over who moves in beside them. In this they are no different from the generation that preceded them in search of the suburban dream. The difference this time is that nothing has been left to chance and that everything has been left to the American Nevada Corporation, which gives Green Valley its contemporary twist: to achieve at least the illusion of safety, residents must buy in to an enormous measure of corporate domination. Suburbia in the Nineties has a logo.

But even Eden—planned by God—had serpents, and so, apparently, does Green Valley. Last year a rapist ran loose in its neighborhoods; police suspected the man was a resident and responsible for three rapes and five robberies. George Hennard, killer of twenty-three people in a Killeen, Texas, cafeteria in October 1991, was a resident of Green Valley only months before his rampage and bought two of his murder weapons here in a private transaction. Joseph Weldon Smith, featured on the television series *Unsolved Mysteries,* strangled to death his wife and two stepdaughters in a posh Green Valley development called The Fountains.

The list of utopia's outrages also includes a November 1991 heist in which two armed robbers took a handcuffed hostage and more than $100,000 from a Green Valley bank, then fled and fired military-assault-rifle rounds at officers in hot pursuit. The same week police arrested a suspected child molester who had been playing football with Green Valley children and allegedly touching their genitals.

"You can run but you can't hide," one Green Valley resident told me when I mentioned a few of these incidents. "People are coming here from all over the place and bringing their problems with them." Perhaps she was referring to the gangs frequenting a Sunset Road fast-food restaurant—Sunset Road forms one fringe of Green Valley—where in the summer of 1991, according to the restaurant's manager, "the dining room was set on fire and there were fights every weekend." Perhaps she had talked to the teenagers who told me that LSD and crystal meth are the narcotics of choice at Green Valley High School, or to the doctor who simply rolled his eyes when I asked if he thought AIDS had arrived here.

Walls might separate paradise from heavy industry, 30 but the protection they provide is an illusion. In May 1991 a leak at the nearby Pioneer Chlor Alkali plant spread a blanket of chlorine gas over Green Valley; nearly a hundred area residents were treated at hospitals for respiratory problems. The leak came three years after another nearby plant—this one producing rocket-fuel oxidizer for the space shuttle and nuclear missiles—exploded powerfully enough to register on earthquake seismographs 200 miles away. Two people were killed, 210 injured. Schools were closed and extra police officers called in to discourage the looting of area homes with doors and windows blown out.

And, finally, there is black comedy in utopia: a few days after Christmas last year, police arrested the Green Valley Community Association president for allegedly burglarizing a model home. Stolen items included pictures, cushions, bedspreads, and a gaudy brass figurine—a collection with no internal logic. A local newspaper described the civic leader running from the scene, dropping his loot piece by piece in his

wake as he was chased by police to his residence. At home he hid temporarily in his attic but ultimately to no avail. The plaster cracked and he fell through a panel into the midst of the arresting officers.

Is it a coincidence that the one truly anomalous soul I met roams furtively the last unpaved place in Green Valley, a short stretch of desert called Pittman Wash?

Pittman Wash winds through quiet subdivisions, undeveloped chiefly because it is useful for drainage and unbuildable anyway. Lesser washes have been filled in, built on, and forgotten, but Pittman remains full of sand and desert hollyhock, a few tamarisks, some clumps of creosote bush. Children prefer it to the manicured squares of park grass provided for them by the master planners; teenagers drink beer here and write graffiti on the storm-drain access pillars buried in the wash's channel: FUCK HENDERSON PK. DSTC., and the like. Used condoms, rusting oil filters, a wind-whipped old sleeping bag, a rock wren, a yellow swallowtail butterfly.

Here I met nine-year-old Jim Collins, whose name has been changed—at his fervent request—on the off chance his mother reads these words and punishes him for playing in Pittman Wash again. Jim struck me as a lonesome, Huck Finn sort, brown-skinned and soft-spoken, with grit beneath his nails and sun-bleached hair. I found him down on his dirty knees, lazily poking a stick into a hole.

"Lizards," he explained. "I'm looking for lizards. There's rattlers, chipmunks, coyote, mountain lion, black widows, and scorpions too." He regaled me with stories of parents in high dudgeon over creatures of the wash brought home. Then, unsolicited, he suddenly declared that "most of the time I'm bored out of my guts . . . the desert's all covered up with houses—that sucks."

He insisted, inexplicably, on showing me his back-yard, which he described as "just like the desert." So we trudged out of the wash and walked the concrete trail the master planners have placed here. Jim climbed the border wall and ran along its four-inch top with the unconscious facility of a mountain goat. We looked at his yard, which had not yet been land-scaped, a rectangle of cracked desert caliche. Next door three children dressed fashionably in sporting attire shot baskets on a Michael Jordan Air Attack hoop. "We don't get along," Jim said. He didn't want me to go away in the end, and as I left he was still chattering hopefully. "My favorite store is Wild Kingdom of Pets," he called. "If you go there you can see Tasha the wildcat."

Some might call Green Valley a simulacrum[1] of a real place, Disneyland's Main Street done in Mediterranean hues, a city of haciendas with cardboard souls, a valley of the polished, packaged, and perfected, an empyrean of emptiness, a sanitized wasteland. They will note the Southwest's pastel palette coloring a community devoid of improvisation, of caprice, spontaneity, effusiveness, or the charm of error—a place where the process of commodification has at last leached life of the accidental and ecstatic, the divine, reckless, and enraged.

Still, many now reside in this corporate domain, driven here by insatiable fears. No class warfare here, no burning city. Green Valley beckons the American middle class like a fabulous and eternal dream. In the wake of our contemporary trembling and discontent, its pilgrims have sought out a corporate castle where in exchange for false security they pay with personal freedoms; where the corporation that does the job of walling others out also walls residents in. The principle, once political, is now economic. Just call your real estate agent. ○

1. *Simulacrum:* an insubstantial image of something real [ed.].

SEEING

1. "To the casual eye," writes David Guterson, "Green Valley, Nevada, . . . would appear to be a pleasant place to live" (para. 1). How does Guterson suggest the *critical* eye would see Green Valley? Find specific examples of the language Guterson uses and the details he focuses on to support your answer. What does he mean when he says that "Green Valley is as much a verb as a noun" (para. 2) or that Green Valley "is designed to embody a corporate ideal not only of streets and houses but of image and feeling" (para. 11)?

2. What principle of organization does Guterson employ in developing his analysis of planned communities? Do you think the organization is effective? What specific examples does he provide to illustrate his point that Green Valley is "a place where the process of commodification has at last leached life of the accidental and ecstatic, the divine, reckless, and enraged" (para. 37)? What sources and perspectives does he draw on to help paint a picture of suburban life in general? What opinions and perspectives does he omit? How would you characterize the tone of this piece? What passages, words, or phrases lead you to this characterization?

WRITING

1. "Walls are everywhere in Green Valley too," Guterson writes; "they're the first thing a visitor notices. Their message is subliminal and at the same time explicit; controlled access is as much metaphor as reality" (para. 21). Choose a wall, fence, or some other physical divider in your neighborhood or on campus. What purpose(s) does it serve? What does it keep in or out? Write the first draft of an essay in which you characterize the literal and metaphorical functions of the wall you have chosen.

2. "In the middle of the nineteenth century," according to Guterson, suburbia offered an "escape from the squalor and stench of the new industrial cities" (para. 10). Write an essay in which you identify and analyze the middle-class ideal of the suburban or planned community. Why has the ideal of living in such communities remained attractive to middle-class Americans for so long, and why do the sales of these houses continue to rise? Do you think the suburban "dream" is a myth or reality?

— A word or phrase that means one thing but is used to describe something else in order to suggest a relationship between the two.

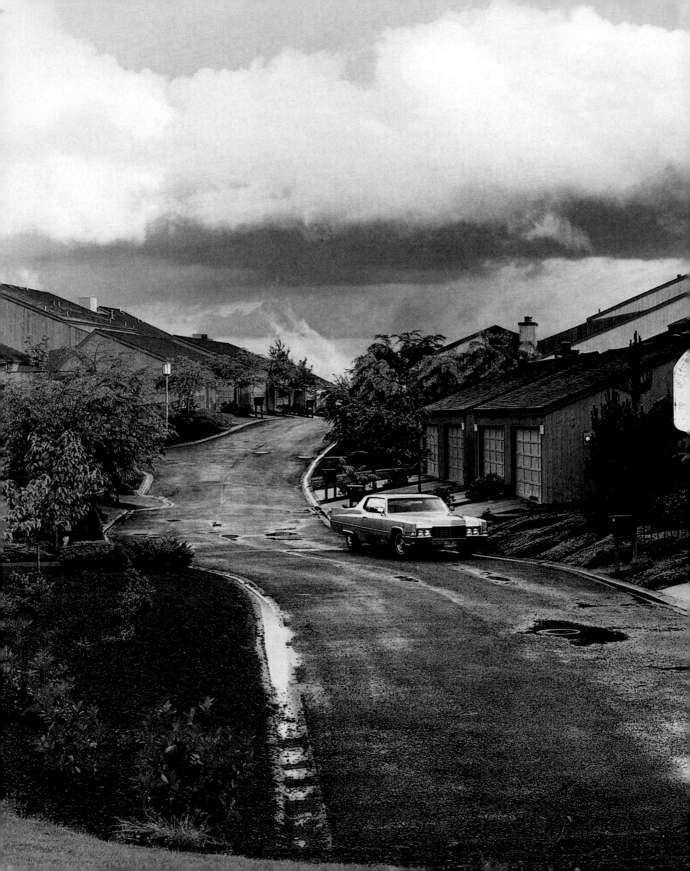

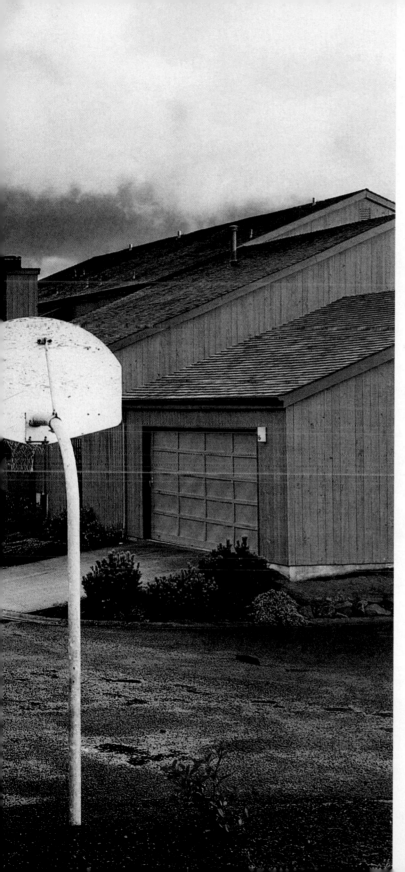

Joel Sternfeld, **Lake Oswego, Oregon**

Retrospect:
Camilo José Vergara's
Photographs of

December 1977

January 1980

November 1988

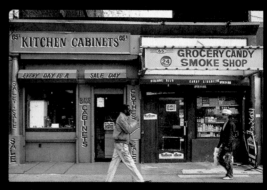

March 1990

February 1996

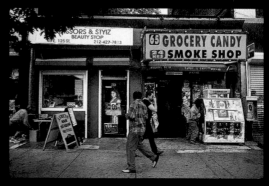

June 1997

65 East 125th St., Harlem

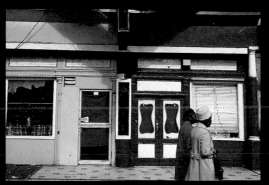

October 1980

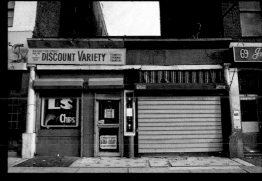

December 1983

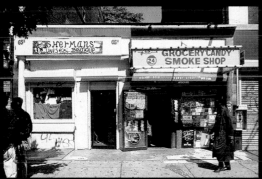

September 1992

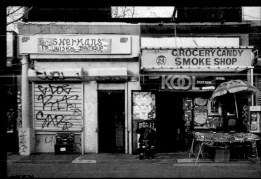

March 1994

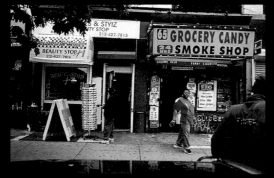

May 1998

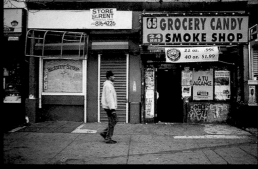

December 1998

THE FAR SIDE By GARY LARSON

"Well, this is just going from bad to worse."

SCOTT RUSSELL SANDERS
The value of staying put is a re-
curring theme in Scott Russell
Sanders's recent essays, which
are collected in *Secrets of the
Universe* (1991), *Staying Put: Mak-
ing a Home in a Restless World*
(1993), and *Writing from the Cen-
ter* (1995). Sanders interweaves
explorations of place with reflec-
tions on nature and the impor-
tance of the natural environment
for healthful living.

 Born in Memphis in 1945,
Sanders has lived since 1971 in
Bloomington, where he is a
professor of English at Indiana
University. Frequently compared
to Henry David Thoreau and
Wendell Berry, Sanders is devoted
to exploring the unique aspects
of nature and social life in the
Midwest. "Because there is no
true human existence apart from
family and community," says
Sanders, "I feel a deep commit-
ment to my region, to the land,
to the people and all other living
things with which I share this
place." This commitment, he
adds, is strengthened by "a re-
gard compounded of grief and
curiosity and love." The essay
"Homeplace" appeared in *Orion*
magazine in 1992.

Homeplace

Scott Russell Sanders

AS A BOY IN OHIO, I KNEW A FARM FAMILY, THE Millers, who suffered from three tornadoes. The father, mother, and two sons were pulling into their driveway after church when the first tornado hoisted up their mobile home, spun it around, and carried it off. With the insurance money, they built a small frame house on the same spot.

Several years later, a second tornado peeled off the roof, splintered the garage, and rustled two cows. The Millers rebuilt again, raising a new garage on the old foundation and adding another story to the house. That upper floor was reduced to kindling by a third tornado, which also pulled out half the apple trees and slurped water from the stock pond. Soon after that I left Ohio, snatched away by college as forcefully as by any cyclone. Last thing I heard, the family was preparing to rebuild yet again.

Why did the Millers refuse to move? I knew them well enough to say they were neither stupid nor crazy. Plain stubbornness was a factor. These were people who, once settled, might have remained at the foot of a volcano or on the bank of a flood-prone river or beside an earthquake fault. They had relatives nearby, helpful neighbors, jobs and stores and schools within a short drive, and those were all good reasons to stay. But the main reason, I believe, was that the Millers had invested so much of their lives in the land, planting orchards and gardens, spreading manure on the fields, digging ponds, building sheds, seeding pastures. Out back of the house were groves of walnuts, hickories, and oaks, all started by hand from acorns and nuts. April through October, perennial flowers in the yard pumped out a fountain of blossoms. This farm was not just so many acres of dirt, easily exchanged for an equal amount elsewhere; it was a particular place, intimately known, worked on, dreamed over, cherished.

Psychologists tell us that we answer trouble with one of two impulses, either fight or flight. I believe that the Millers exhibited a third instinct, that of staying put. They knew better than to fight a tornado, and they chose not to flee. Their commitment to the place may have been foolhardy, but it was also grand. I suspect that most human achievements worth admiring are the result of such devotion.

The Millers dramatize a choice we are faced with 5 constantly: whether to go or stay, whether to move to a situation that is safer, richer, easier, more attractive, or to stick where we are and make what we can of it. If the shine goes off our marriage, our house, our car, do we trade it for a new one? If the fertility leaches out of our soil, the creativity out of our job, the money out of our pocket, do we start over somewhere else? There are voices enough, both inner and outer, urging us to deal with difficulties by pulling up stakes and heading for new territory. I know

them well, for they have been calling to me all my days. I wish to raise here a contrary voice, to say a few words on behalf of staying put, learning the ground, going deeper.

Claims for the virtues of moving on are familiar and seductive to Americans, this nation founded by immigrants and shaped by restless seekers. From the beginning, our heroes have been sailors, explorers, cowboys, prospectors, speculators, backwoods ramblers, rainbow chasers, vagabonds of every stripe. Our Promised Land has always been over the next ridge or at the end of the trail, never under our feet. In our national mythology, the worst fate is to be trapped on a farm, in a village, in the sticks, in some dead-end job or unglamorous marriage or played-out game.

Stand still, we are warned, and you die. Americans have dug the most canals, laid the most rails, built the most roads and airports of any nation. In a newspaper I read that, even though our sprawling system of interstate highways is crumbling, politicians think we should triple its size. Only a populace drunk on driving, a populace infatuated with the myth of the open road, could hear such a proposal without hooting.

Novelist Salman Rushdie chose to leave his native India for England, where he has written a series of brilliant books from the perspective of a cultural immigrant. In his book of essays *Imaginary Homelands* he celebrates the migrant sensibility: "The effect of mass migrations has been the creation of radically new types of human being: people who root themselves in ideas rather than places, in memories as much as in material things." He goes on to say that "to be a migrant is, perhaps, to be the only species of human being free of the shackles of nationalism (to say nothing of its ugly sister, patriotism)." Lord knows we could do with less nationalism (to say nothing of its ugly siblings, racism, religious sectarianism, and class snobbery). But who would pretend that a history of migration has immunized the United States against bigotry? And even if, by uprooting ourselves, we shed our chauvinism, is that all we lose?

In this hemisphere, many of the worst abuses—of land, forests, animals, and communities—have been carried out by "people who root themselves in ideas rather than places." Migrants often pack up their visions and values with the rest of their baggage and carry them along. The Spaniards devastated Central and South America by imposing on this New World the religion, economics, and politics of the Old. Colonists brought slavery with them to North America, along with smallpox and Norway rats. The Dust Bowl of the 1930s was caused not by drought but by the transfer onto the Great Plains of farming methods that were suitable to wetter regions. The habit of our industry and commerce has been to force identical schemes onto differing locales, as though the mind were a cookie cutter and the land were dough.

I quarrel with Rushdie because he articulates as eloquently as anyone the orthodoxy that I wish to counter: the belief that movement is inherently good, staying put is bad; that uprooting brings tolerance, while rootedness breeds intolerance; that to be modern, enlightened, fully of our time is to be displaced. Wholesale displacement may be inevitable in today's world; but we should not suppose that it occurs without disastrous consequences for the earth and for ourselves. People who root themselves in places are likelier to know and care for those places than are people who root themselves in ideas. When we cease to be migrants and become inhabitants, we might begin to pay enough heed and respect to where we are. By settling in, we have a chance of making a durable home for ourselves, our fellow creatures, and our descendants.

The poet Gary Snyder writes frequently about our need to "inhabit" a place. One of the key problems in American society now, he points out, is people's lack of commitment to any given place:

> Neighborhoods are allowed to deteriorate, landscapes are allowed to be strip-mined, because there is nobody who will live there and take responsibility; they'll just move on. The reconstruction of a people and of a life in the United States depends in part on people, neighborhood

by neighborhood, county by county, deciding to stick it out and make it work where they are, rather than flee.

But if you stick in one place, won't you become a stick-in-the-mud? If you stay put, won't you be narrow, backward, dull? You might. I have met ignorant people who never moved; and I have also met ignorant people who never stood still. Committing yourself to a place does not guarantee that you will become wise, but neither does it guarantee that you will become parochial.

To become intimate with your home region, to know the territory as well as you can, to understand your life as woven into the local life does not prevent you from recognizing and honoring the diversity of other places, cultures, ways. On the contrary, how can you value other places if you do not have one of your own? If you are not yourself *placed*, then you wander the world like a sightseer, a collector of sensations, with no gauge for measuring what you see. Local knowledge is the grounding for global knowledge. Those who care about nothing beyond the confines of their parish are in truth parochial, and are at least mildly dangerous to their parish; on the other hand, those who *have* no parish, those who navigate ceaselessly among postal zones and area codes, those for whom the world is only a smear of highways and bank accounts and stores, are a danger not just to their parish but to the planet.

Since birth, my children have regularly seen images 15 of the earth as viewed from space, images that I first encountered when I was in my 20s. Those photographs show vividly what in our sanest moments we have always known—that the earth is a closed circle, lovely and rare. On the wall beside me as I write there is a poster of the big blue marble encased in its white swirl of clouds. That is one pole of my awareness; but the other pole is what I see through my window. I try to keep both in sight at once.

For all my convictions, I still have to wrestle with the fear—in myself, in my children, and even in some of my neighbors—that our place is too remote from the action. This fear drives many people to pack

their bags and move to some resort or burg they have seen on television, leaving behind what they learn to think of as the boondocks. I deal with my own unease by asking just what action I am remote *from*—a stock market? a debating chamber? a drive-in mortuary? The action that matters, the work of nature and community, goes on everywhere.

Since Copernicus, we have known better than to see the earth as the center of the universe. Since Einstein, we have learned that there is no center; or alternatively, that any point is as good as any other for observing the world. I find a kindred lesson in the words of the Zen master Thich Nhat Hanh: "This spot where you sit is your own spot. It is on this very spot and in this very moment that you can become enlightened. You don't have to sit beneath a special tree in a distant land." If you stay put, your place may become a holy center, not because it gives you special access to the divine, but because in your stillness you hear what might be heard anywhere.

I think of my home ground as a series of nested rings, with house and family and marriage at the center, surrounded by the wider and wider hoops of neighborhood and community, the bioregion within walking distance of my door, the wooded and rocky hills of southern Indiana, the watershed of the Ohio Valley, and so on outward—and inward—to the ultimate source.

The longing to become an inhabitant rather than a drifter sets me against the current of my culture, which nudges everyone into motion. Newton taught us that a body at rest tends to stay at rest, unless it is acted on by an outside force. We are acted on ceaselessly by outside forces—advertising, movies, magazines, speeches—and also by the inner force of biology. I am not immune to their pressure. Before settling in my present home, I lived in seven states and two countries, tugged from place to place in childhood by my father's work and in early adulthood by my own. This itinerant life is so common among the people I know that I have been slow to conceive of an alternative. Only by knocking against the golden calf of mobility, which looms so large and shines so

brightly, have I come to realize that it is hollow. Like all idols, it distracts us from what is truly divine.

I am encouraged by the words of a Crow elder, [20] quoted by Gary Snyder in *The Practice of the Wild:* "You know, I think if people stay somewhere long enough—even white people—the spirits will begin to speak to them. It's the power of the spirits coming up from the land. The spirits and the old powers aren't lost, they just need people to be around long enough and the spirits will begin to influence them."

As I write this, I hear the snarl of earth movers and chain saws a mile away destroying a farm to make way for another shopping strip. I would rather hear a tornado, whose damage can be undone. The elderly woman who owned the farm had it listed in the National Register, then willed it to her daughters on condition they preserve it. After her death, the daughters, who live out of state, had the will broken, so the land could be turned over to the chain saws and earth movers. The machines work around the clock. Their noise wakes me at midnight, at three in the morning, at dawn. The roaring abrades my dreams. The sound is a reminder that we are living in the midst of a holocaust. I do not use the word lightly. The earth is being pillaged, and every one of us, willingly or grudgingly, is taking part. We ask how sensible, educated, supposedly moral people could have tolerated slavery or the slaughter of Jews. Similar questions will be asked about us by our descendants, to whom we bequeath an impoverished planet. They will demand to know how we could have been party to such waste and ruin.

What does it mean to be alive in an era when the earth is being devoured, and in a country that has set the pattern for that devouring? What are we called to do? I think we are called to the work of healing, both inner and outer: healing of the mind through a change in consciousness, healing of the earth through a change in our lives. We can begin that work by learning how to inhabit a place.

"The man who is often thinking that it is better to be somewhere else than where he is excommunicates himself," we are cautioned by Thoreau, that notorious stay-at-home. The metaphor is religious: To withhold yourself from where you are is to be cut off from communion with the source. It has taken me half a lifetime of searching to realize that the likeliest path to the ultimate ground leads through my local ground. I mean the land itself, with its creeks and rivers, its weather, seasons, stone outcroppings, and all the plants and animals that share it. I cannot have a spiritual center without having a geographical one; I cannot live a grounded life without being grounded in a *place.*

In belonging to a landscape, one feels a rightness, an at-homeness, a knitting of self and world. This condition of clarity and focus, this being fully present, is akin to what the Buddhists call mindfulness, what Christian contemplatives refer to as recollection, what Quakers call centering down. I am suspicious of any philosophy that would separate this-worldly from other-worldly commitment. There is only one world, and we participate in it here and now, in our flesh and our place. ○

SEEING

1. Arguing against the "belief that movement is inherently good," Scott Russell Sanders asserts, "people who root themselves in places are likelier to know and care for those places than are people who root themselves in ideas" (para. 10). What strategies does Sanders use to build his argument on behalf of "staying put"? How, for example, does he define being "settled," being "placed," and being "an inhabitant rather than a drifter"? What factors does Sanders identify that prompt people to refuse to move? Comment on the nature and effectiveness of the examples he uses to illustrate each point. What additional sources and examples would strengthen his argument?

2. How does Gary Larson's cartoon "Entering the Middle of Nowhere" relate to Sanders's essay? What aspects of Sanders's discussion of the range of American notions of place does Larson address in this cartoon? To what extent, for example, does Larson's cartoon invoke the American fear of being "remote from the action" that Sanders describes?

WRITING

1. Sanders recounts the story of the Miller family, who refused to yield to the ravages of several tornadoes. He notes, "The Millers dramatize a choice we are faced with constantly: whether to go or stay, whether to move to a situation that is safer, richer, easier, more attractive, or to stick where we are and make what we can of it" (para. 5). Consider a difficult set of circumstances or a conflict that you, your family, or someone you know faced. Draft an essay in which you recount both the nature of the problem and whether you or someone else yielded, as Sanders notes, to voices "both inner and outer, urging us to deal with difficulties by pulling up stakes and heading for new territory" (para. 5).

2. Sanders claims that some of the "worst abuses" in this hemisphere have come about through "the habit of our industry and commerce . . . to force identical schemes onto differing locales" (para. 9). Select an example of this "habit" in contemporary American experience, and write an essay in which you consider equally whether it's better to move, as Salman Rushdie argues, or to stay, as Sanders contends (paras. 8–10). Please be sure to provide sufficient evidence to validate each point in your argument as well as to account for opposing points of view.

 Talking Pictures

Early in his essay "Homeplace," Scott Russell Sanders explains that "claims for the virtues of moving on are familiar and seductive to Americans, this nation founded by immigrants and shaped by restless seekers. . . . Our Promised Land has always been over the next ridge or at the end of the trail, never under our feet. In our national mythology, the worst fate is to be trapped on a farm, in a village, in the sticks, in some dead-end job or unglamorous marriage or played-out game" (para. 6). Consider the ways in which our "national mythology" continues to be enacted on contemporary American television. Choose one example of a recent television program or an advertisement, and show how—in specific terms—it promotes the virtues of moving on.

MARK PETERSON

Born and raised in Minneapolis, Mark Peterson began his career as a photographer while doing odd jobs for a photojournalist. "I was failing miserably as a writer," he said in a recent interview, "and thought photography would be easy. That was my first mistake in photography." After working in both Minneapolis and New York, Peterson moved to New Jersey to pursue freelance photography. His photographs, which he describes as "day in the life" reportage, have appeared in *Life, Newsweek, Fortune,* and the *New York Times Magazine.* In 1992 Peterson was awarded the W. Eugene Smith Support grant for his work with revolving-door alcoholics, during which he photographed a group of patients in Minneapolis over twelve years. Peterson's most recent projects include photographing teenagers in recovery from drug and alcohol addiction and capturing the lives of upper-class New Yorkers in a series entitled *The Highlife.* This photograph is from his series *Across the Street,* in which Peterson aimed to capture the divide between rich and poor living on and along Fifth Avenue in New York City.

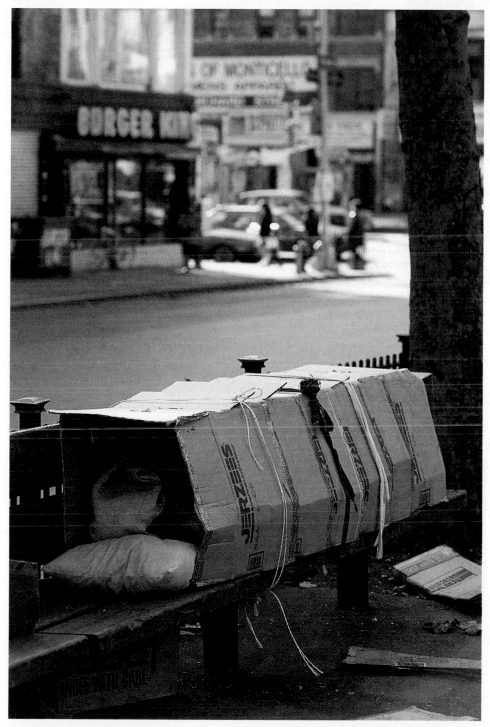

Mark Peterson, **Image of Homelessness**

SEEING

1. What exactly is the place captured by this photograph—the box? the park? the urban scene? How did the person sleeping inside the box create a sense of place? What features of the arrangement of the box mark it as a "place"? How can you tell whether there is—or was—someone inside?

2. What does the photographer gain—and lose—by positioning the "place" of the homeless person clearly in the foreground? Given what is visible in the picture, what changes— say, in perspective or focus— might you suggest to highlight the dramatic impact of this redefinition of place? What effect(s) does the photographer accentuate in the image by including the phrase "HANDLE WITH CARE"? by including the out-of-focus background of Burger King?

WRITING

1. Imagine the following scenario. Shortly before the Opening Ceremony at the Olympic Games in 2004, which will take place in your state, the City Council is debating the following resolution: that all homeless people in the city shall be removed to shelters for the duration of the Games. Now imagine yourself as the person charged with either advocating or challenging passage of the resolution. Write a draft of the remarks you would present to the City Council when this resolution is considered.

2. In an essay entitled "Distancing the Homeless," the writer and social critic Jonathan Kozol argues that the homeless are subject to many misconceptions. "A misconception . . . is not easy to uproot, particularly when it serves a useful social role. The notion that the homeless are largely psychotics who belong in institutions, rather than victims of displacements at the hands of enterprising realtors, spares us from the need to offer realistic solutions to the . . . extremes of wealth and poverty in the United States." Review the professional literature on the causes of homelessness published during the past eighteen months. Choose a still-popular misconception about homelessness—one that involves coming to terms with a sense of place—and write an argumentative essay in which you correct the mistaken or unexamined assumptions evident in this misconception.

RICHARD FORD

Richard Ford (b. 1944), like Eudora Welty, grew up in Jackson, Mississippi. Like Scott Russell Sanders, he came of age during the 1960s and began publishing in the 1970s. However, Ford thinks about place and writing in ways that set him far apart from Welty and Sanders. In "I Must Be Going" (first published in *Harper's* in 1992), Ford explains the personal value of moving frequently.

Elsewhere he has explained why it is important not to think of fiction in regional terms. "Categorization (women's writing, gay writing, Illinois writing) inflicts upon art exactly what art strives at its best never to inflict on itself: arbitrary and irrelevant limits, shelter from the widest consideration and judgment, exclusion from general excellence." Ford sets his novels and short stories in a range of locations, from Mississippi to Mexico to New Jersey. His fifth novel, *Independence Day* (1995), received both the Penn Faulkner Award and the Pulitzer Prize for fiction; more recently he has published *Women with Men: Three Stories* (1997).

I Must Be Going

Richard Ford

I'VE READ SOMEPLACE THAT IN OUR DESCENDING order of mighty and important human anxieties, Americans suffer the death of a spouse, the loss of a house by fire, and moving to be the worst three things that can happen to us.

So far, I've missed the worst of these—the first, unspeakable, and my house up in flames. Though like most of us, I've contemplated burning my house *myself*—prior to the spring fix-up season or during those grinding "on-the-market" periods when prices sag and interest rates "skyrocket" and I brood over the sign on my lawn bitterly demanding "make offer."

But moving. Moving's another matter. Moving's not so bad, I've done it a lot.

Twenty times, probably, in twenty years (I'm sure I've forgotten a move or two). And always for excellent reasons. St. Louis to New York, New York to California, California to Chicago, Chicago to Michigan, Michigan to New Jersey, New Jersey to Vermont, Vermont to Montana, Montana to Mississippi, Mississippi to Montana, Montana to Montana to here—New Orleans, land of dreamy dreams, where I doubt I'll stay much longer.

To speed the getaways I've sacrificed valuable mortgage points, valuable rent deposits, valuable realtors' commissions, valuable capital gains writeoffs. I've blown off exterminator contracts, forsaken new paint jobs, abandoned antique mirrors, oil paintings, ten-speeds, armoires, wedding presents, snow chains, and—unintentionally—my grandfather's gold-handled cane engraved with his name.

What are my excellent reasons? No different from the usual, I imagine. I've just put more of mine into motion. My wife got a better job, I got a better job, I needed to leave a bad job. I began to hate the suburbs and longed for the country, I began to hate New York and longed for the Berkshires, I got frightened of becoming a Californian and longed for the Middle West, I longed to live again in the place where I was born, then later I couldn't stand to live in the place where I was born. I missed the West. I missed the South. I missed the East Coast. I missed my pals. I got sick of their company.

Longing's at the heart of it, I guess. Longing that overtakes me like a fast car on the freeway and makes me willing to withstand a feeling of personal temporariness. Maybe, on a decidedly reduced scale, it's what a rock star feels, or a chewing-gum heiress, celebs who keep houses all over the globe, visit them often, but never fully live in any: a sense that life's short and profuse and mustn't be missed.

In the past, when people have asked me why I've moved so often, I've answered that if you were born in Mississippi you either believed you lived in the vivid center of a sunny universe, or you believed as I did that the world outside of there was the more magical,

exotic place and *that's* what you needed to see. Or else I've said it was because my father was a traveling salesman, and every Monday morning I would hear him whistling as he got ready to leave again: a happy weekend at home with his bag packed in the bedroom, then a happy workweek traveling, never seeming to suffer the wrench-pang of departure, never seeming to think life was disrupted or lonely.

I doubt now if either of those reasons is satisfactory. And, indeed, I'm suspicious of explanations that argue that any of us does anything because of a single reason, or two, or three.

Place, that old thorny-bush in our mind's back- 10 yard, is supposed to be important to us Southerners. It's supposed to hold us. But where I grew up was a bland, unadhesive place—Jackson, Mississippi—a city in love with the suburban Zeitgeist, a city whose inert character I could never much get interested in. I just never seemed like enough of a native, and Jackson just never meant as much to me as it did to others. Other places just interested me more.

My most enduring memories of childhood are mental snapshots not of my hometown streets or its summery lawns but of roads leading *out* of town. Highway 51 to New Orleans. Highway 49 to the delta and the coast. Highway 80 to Vicksburg and darkest Alabama. These were my father's customary routes, along which I was often his invited company—I and my mother together.

Why these should be what I now recollect most vividly, instead of, say, an odor of verbena or watermelons in a tub on the Fourth of July, I don't know, other than to conjecture that we were on the move a lot, and that it mattered to me that my parents were my parents and that they loved me, more than *where* they loved me.

Home—real home—the important place that holds you, always meant that: affection, love.

Once my wife and I were stranded with car trouble in the town of Kearney, Nebraska, on a blurry, hot midsummer day late in the '70s. And when we'd eaten our dinner in a little, home-cook place at the edge of town not far from the interstate, we walked out into the breezy, warm air and stood and watched the sun go down beyond the ocean of cornfields and the shining Platte River. And as the shadows widened on, my wife said to me, drowsily, "I've just gotten so sleepy now. I've got to go home and go to sleep." "Home?" I said. "How far is that from here?" "Oh, you know," she said and shook her head and laughed at the absurdity of that idea. "Just back to the motel. Where else?"

Oh, I've stayed places, plenty of times. I've owned 15 "homes," three or four, with likable landscapes, pleasant prospects, safe streets, folksy friends nearby. I've held down jobs, paid millages, served on juries, voted for mayors. As with all of us, some part of me is a stayer. *Transient* is a word of reproach; *impermanence* bears a taint, a suspicion that the gentleman in question isn't quite . . . well . . . solid, lacks a certain depth, can't be fully *known,* possibly has messy business left on the trail somewhere—another county, something hushed up.

Other people's permanences are certainly in our faces all the time; their lengthy lengths-of-stay at one address, their many-layered senses of place, their store of lorish, insider blab. Their commitment. Yet I don't for a minute concede their establishment to be any more established than mine, or their self-worth richer, or their savvy regarding risk management and reality any more meticulous. They don't know any more than I do. In fact, given where they've been and haven't been, they probably know less.

"But you," they might say, "you only get a superficial view of life living this way, skimming the top layer off things the way you do." And my answer is: Memory always needs replenishing, and anyway you misunderstand imagination and how it thrives in us by extending partial knowledge to complete any illusion of reality. "We live amid surfaces, and the true art of life is to skate well on them," Emerson wrote.

One never moves without an uneasiness that staying is the norm and that what you're after is something not just elusive but desperate, and that eventually

you'll fail and have to stop. But those who'll tell you what you *have to do* say so only because that's what they've done and are glad about it—or worse, are not so glad. Finally, I'll be the judge. It'll be on my bill, not theirs.

On the first night I ever spent in the first house I ever owned, I said to my wife as we were going to sleep on a mattress on the bedroom floor amid boxes and paper and disheveled furniture, "Owning feels a lot like renting, doesn't it? You just can't leave when you want to." This was in New Jersey, 15 years ago— a nice, brown three-story stucco of a vaguely Flemish vernacular, on a prizable double lot on a prizable oak-lined street named for President Jefferson—a home that cost $117,500, and that now probably runs above a half million if you could buy it, which you can't. This was a house I eventually grew to feel so trapped in that one night I got stirringly drunk, roared downstairs with a can of white paint, and flung paint on everything—all over the living room, the rugs, the furniture, the walls, my wife, even all over our novelist friend who was visiting and who hasn't been back since. I wanted, I think, to desanctify "the home," get the *joujou* out of permanence.

And, in fact, in two months' time we were gone from there, for good.

Today, when people ask me, people who banked [20] their fires and their equity, "Don't you wish you'd hung onto that house on Jefferson? You'd have it half paid for now. You'd be rich!" my answer is, "Holy Jesus no! Don't you realize I'd have had to *live* in that house all this time? Life's too short." It's an odd thing to ask a man like me.

It may simply and finally be that the way most people feel when they're settled is the way I feel when I move: safe and in possession of myself. So much so that when I'm driving along some ribbony highway over a distant and heat-miraged American landscape, and happen to spy, far across the median strip, a U-Haul van humping its cargo toward some pay dirt far away, its beetle-browed driver alone in the buzzing capsule of his own fears and hopes and silent explanations of the future, who I think of is . . . me. He's me. And my heart goes out to him. It's never a wasted effort to realize that what we do is what anybody does, all of us clinging to our little singularities, making it in the slow lane toward someplace we badly need to go. ○

1. Emphasizing the negative connotations of words associated with people who move frequently, Richard Ford declares that "*Transient* is a word of reproach; *impermanence* bears a taint, a suspicion that the gentleman in question isn't quite . . . well . . . solid, lacks a certain depth, can't be fully *known*, possibly has messy business left on the trail somewhere— another county, something hushed up" (para. 15). Develop a list of other travel-related words, phrases, or sayings. (Don't hesitate to use Scott Russell Sanders's "Homeplace" as another source for this kind of language.) Which of your words are descriptive of people who stay in place, and which ones characterize people who, like Ford, prefer to move around? Which ones were easier to come up with? Why? What cultural assumptions and values associated with place does each of your words and phrases reveal?

2. Characterize the tone of Ford's essay, citing specific words and phrases as examples. Imagine yourself directing someone to read this essay aloud. What tone of voice would you instruct the reader to use? Compare Ford's tone of voice with that of Sanders in "Homeplace." Which voice do you find more engaging? more convincing? Explain why.

1. Sanders warns that Americans are a "populace infatuated with the myth of the open road" (para. 7), whereas Ford laments that "other people's permanences are certainly in our faces all the time; their lengthy lengths-of-stay at one address, their many-layered senses of place, their store of lorish, insider blab. Their commitment" (para. 16). What evidence of these opposing associations with place do you see in contemporary American popular culture? Choose a document such as an advertisement, a song, a photograph, or a news report. Analyze the ways in which it demonstrates the value of "staying put" or the appeal of the open road. Draft an essay in which you analyze the cultural assumptions your text draws on, citing examples to support each of your assertions.

2. Ford anticipates that those who favor "staying put" would argue that life on "the open road" gives "a superficial view of life." He reinforces his own position—that "Memory always needs replenishing"—by quoting Ralph Waldo Emerson: "'We live amid surfaces, and the true art of life is to skate well on them'" (para. 17). Draft an essay in which you assess the appropriateness of applying Emerson's aphorism to contemporary American experience. As you prepare notes, consider the nature and extent of the ways in which contemporary Americans live "amid surfaces."

Catherine Opie, **Untitled #20**

RICHARD MISRACH >

Four of the five photographs on
the pages that follow are each
drawn from a different Canto of
Richard Misrach's portrait of the
desert. Misrach's *Desert Cantos*
is a book-length photographic
essay modeled on the traditional
literary form of the canto—a
section of a long song or poem.
In the "Afterword" to his volume,
Misrach explains that "my focus
has been the desert, or more
accurately, 'desertness,' as I have
tried to determine what makes
the desert the desert. Each
Canto—each series or subsec-
tion—although independent,
adds another dimension to the
understanding and definition
of desertness."

The fifth image is Misrach's
photograph of a diorama enti-
tled "Palm Oasis," which is on
display at the Palm Springs
Desert Museum.

"As interesting and provoca-
tive as the cultural geography
might be," Misrach explains,
"the desert may serve better as
the backdrop for the problematic
relationship between man and
the environment. The human
struggle, the successes and fail-
ures, the use and abuse, both
noble and foolish, are readily
apparent in the desert."

Born in Los Angeles in 1949,
Richard Misrach graduated from
the University of California,
Berkeley, with a degree in psy-
chology. He is the recipient of
numerous fellowships and awards,
including a Guggenheim fellow-
ship and several from the Na-
tional Endowment for the Arts.
His photographs have been
exhibited in the United States
and abroad.

Wind Mill Farm, San Gorgonio Pass

Waiting, Edwards Air Force Base

Diving Board, Salton Sea

Desert Fire #236

Palm Oasis

desert: (1) dry, often sandy region with little rainfall, extreme temperatures, and little greenery; (2) permanently cold region that is largely or entirely devoid of life; (3) area of seemingly lifeless water; (4) empty or forsaken place or wasteland, as in *an emotional desert.*

SEEING

1. The word desert usually means any area seemingly incapable of supporting life. What does the word mean to you? After studying the photographs by Richard Misrach, what do you think the word means to him? Use examples from his photos to support your answer.

2. What images of the desert come to mind when you think of such well-known areas as, say, Death Valley or Monument Valley? What's present—or absent—from Misrach's photographs that you associate with the desert? What details in his photographs reinforce or challenge your sense of what the desert should look like? What evidence do you find in these photographs that illustrates Misrach's stance on larger issues such as the relationship between people and the environment?

WRITING

1. In the "Afterword" to *Desert Cantos,* Misrach suggests that the desert represents the "'civilized' cultural landscape of America—the result of man's conquest of the last great physical and psychological barrier to Manifest Destiny. The Great American Wasteland is now [1984] the home of more than a million people, with all their usual accoutrements—swimming pools, golf courses, condominiums, air-conditioned motels, shopping centers, 7-11s, and Dairy Queens." Despite Misrach's account of the literal transformation of the desert, clichés and stereotypes about this "wasteland" still abound. Develop a list of such stereotypes and clichés, and then draft an essay in which you assess the nature and extent to which this long-standing identity of the desert persists in American culture. What reasonable inferences about the desert's "place" in contemporary culture can you draw from the research you conduct?

The policy of imperialistic expansion, expressed as necessary or benevolent. This phrase also refers to the nineteenth-century belief that the United States had the right and duty to expand on the North American continent.

2. Use one of Misrach's images as the basis for an essay in which you support or challenge his claim that "The human struggle, the successes and failures, the use and abuse, both noble and foolish, are readily apparent in the desert." Please be sure to validate each of your assertions with a detailed analysis of the photograph.

Re: Searching the Web

The language of the Internet is full of spatial metaphors. Individuals and organizations spend time in "cyberspace," create "web sites," and frequent "chat rooms" and "multi-user domains" (MUDs). If we view the web as a landscape to be explored, what similarities do cyber spaces have to physical spaces? In what ways is this comparison useful? Where does the analogy break down? If we treat the Internet as a global village, what evidence of national or regional communities can be found? How does the Internet affect our notions of place?

Choose a web site, a chat room, a newsgroup, or a MUD as a focus for your exploration of the use of spatial or place-related metaphors to describe the Internet experience. What, if anything, about this site reminds you of a physical place? How is the space defined visually and verbally? How does the movement from page to page through links compare to physical travel?

After you have reviewed the notes you've developed in response to these questions, prepare the first draft of an expository essay in which you analyze the aptness of spatial metaphors in describing the nature and workings of the Internet.

Looking Closer:
Going Home

In a nation founded by people who left their *homelands*, the word *home* soon became an obsession. Indeed, this parent word has generated more offspring than virtually any other in the lexicon. We speak of *homefries*, *homemakers*, the *homeless*, *homesteads*, *hometowns*, even being *homesick*. In fact, recent estimates suggest that one in eight Americans spends most of her Thanksgiving weekend traveling substantial distances to *home*.

Although the visual and verbal selections that follow are informed by certain dimensions of personal experience, they also include the presence of others and are infused with the emotional associations evoked by a sense of place. AT&T uses such emotions to their advantage in their ad ***Families Are Realizing Distance Doesn't Have to Keep Them Apart.*** For Chang-rae Lee, cooking for his dying mother made it possible to endure the anguish of **"Coming Home Again";** Lucille Clifton hears and smells "the tremors of that house" in ***When I Go Home;*** the kitchen table serves as the emotional hearth for Carmen Lomas Garza's painting ***Tamalada*** and Tina Barney's photograph **"Family in Kitchen."** Going home is never a one-sided matter. It is a ritual rooted in a search for the comforts of the familiar—experiences of a specific place and of the individuals who remain there, waiting for us to return.

Coming Home Again
Chang-rae Lee

WHEN I GO HOME
Lucille Clifton

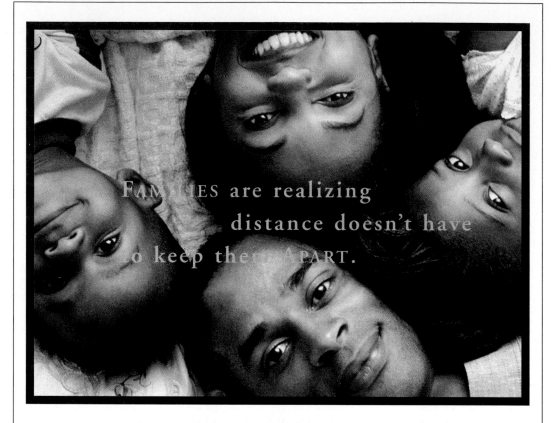

FAMILIES are realizing distance doesn't have to keep them APART.

Even when you're halfway around the world on business, you can still stay in touch with those who are near

Now that you've *checked in*, WHY NOT CHECK IN WITH THOSE *back home?*

For dialing instructions and **AT&T Direct** Access Numbers, look for this card by the phone in your hotel room or ask for it at check-in.

and dear to you back home—your family. Just make sure you stay at a hotel that offers **AT&T Direct**ˢᴹ Service in every room. **AT&T Direct** provides the fastest, clearest connections* on calls back to the U.S. from almost anywhere in the world your travels take you. It also makes calling to over 210 other countries quick and easy. All at affordable prices. If you would like to stay close to the

Any AT&T Card or most U.S. local phone company cards can make calling and billing easy.

ones you love even when you're far away, look for hotels that offer the convenient and reliable service of AT&T. A world of possibilities. *That's Your True Choice.*ˢᴹ AT&T.

Coming Home Again

Chang-rae Lee

WHEN MY MOTHER BEGAN USING THE ELECTRONIC pump that fed her liquids and medication, we moved her to the family room. The bedroom she shared with my father was upstairs, and it was impossible to carry the machine up and down all day and night. The pump itself was attached to a metal stand on casters, and she pulled it along wherever she went. From anywhere in the house, you could hear the sound of the wheels clicking out a steady time over the grout lines of the slate-tiled foyer, her main thoroughfare to the bathroom and the kitchen. Sometimes you would hear her halt after only a few steps, to catch her breath or steady her balance, and whatever you were doing was instantly suspended by a pall of silence.

I was usually in the kitchen, preparing lunch or dinner, poised over the butcher block with her favorite chef's knife in my hand and her old yellow apron slung around my neck. I'd be breathless in the sudden quiet, and, having ceased my mincing and chopping, would stare blankly at the brushed sheen of the blade. Eventually, she would clear her throat or call out to say she was fine, then begin to move again, starting her rhythmic *ka-jug;* and only then could I go on with my cooking, the world of our house turning once more, wheeling through the black.

I wasn't cooking for my mother but for the rest of us. When she first moved downstairs she was still eating, though scantily, more just to taste what we were having than from any genuine desire for food. The point was simply to sit together at the kitchen table and array ourselves like a family again. My mother would gently set herself down in her customary chair near the stove. I sat across from her, my father and sister to my left and right, and crammed in the center was all the food I had made—a spicy codfish stew, say, or a casserole of gingery beef, dishes that in my youth she had prepared for us a hundred times.

It had been ten years since we'd all lived together in the house, which at fifteen I had left to attend boarding school in New Hampshire. My mother would sometimes point this out, by speaking of our present time as being "just like before Exeter," which surprised me, given how proud she always was that I was a graduate of the school.

My going to such a place was part of my mother's 5 not so secret plan to change my character, which she worried was becoming too much like hers. I was clever and able enough, but without outside pressure I was readily given to sloth and vanity. The famous school—which none of us knew the first thing about—would prove my mettle. She was right, of course, and while I was there I would falter more than a few times, academically and otherwise. But I never thought that my leaving home then would ever be a problem for her, a private quarrel she would have even as her life waned.

Now her house was full again. My sister had just resigned from her job in New York City, and my father, who typically saw his psychiatric patients until eight or nine in the evening, was appearing in the driveway at four-thirty. I had been living at home for nearly a year and was in the final push of work on what would prove a dismal failure of a novel. When I wasn't struggling over my prose, I kept occupied with the things she usually did—the daily errands, the grocery shopping, the vacuuming and the cleaning, and, of course, all the cooking.

When I was six or seven years old, I used to watch my mother as she prepared our favorite meals. It was one of my daily pleasures. She shooed me away in the beginning, telling me that the kitchen wasn't my place, and adding, in her half-proud, half-deprecating way, that her kind of work would only serve to weaken me. "Go out and play with your friends," she'd snap in Korean, "or better yet, do your reading and homework." She knew that I had already done both, and that as the evening approached there was no place to go save her small and tidy kitchen, from which the clatter of her mixing bowls and pans would ring through the house.

I would enter the kitchen quietly and stand beside her, my chin lodging upon the point of her hip. Peering through the crook of her arm, I beheld the movements of her hands. For *kalbi*, she would take up a butchered short rib in her narrow hand, the flinty bone shaped like a section of an airplane wing and deeply embedded in gristle and flesh, and with the point of her knife cut so that the bone fell away, though not completely, leaving it connected to the meat by the barest opaque layer of tendon. Then she methodically butterflied the flesh, cutting and unfolding, repeating the action until the meat lay out on her board, glistening and ready for seasoning. She scored it diagonally, then sifted sugar into the crevices with her pinched fingers, gently rubbing in the crystals. The sugar would tenderize as well as sweeten the meat. She did this with each rib, and then set them all aside in a large shallow bowl. She minced a half-dozen cloves of garlic, a stub of gingerroot, sliced up a few scallions, and spread it all over the meat. She wiped her hands and took out a bottle of sesame oil, and, after pausing for a moment, streamed the dark oil in two swift circles around the bowl. After adding a few splashes of soy sauce, she thrust her hands in and kneaded the flesh, careful not to dislodge the bones. I asked her why it mattered that they remain connected. "The meat needs the bone nearby," she said, "to borrow its richness." She wiped her hands clean of the marinade, except for her little finger, which she would flick with her tongue from time to time, because she knew that the flavor of a good dish developed not at once but in stages.

Whenever I cook, I find myself working just as she would, readying the ingredients—a mash of garlic, a julienne of red peppers, fantails of shrimp—and piling them in little mounds about the cutting surface. My mother never left me any recipes, but this is how I learned to make her food, each dish coming not from a list or a card but from the aromatic spread of a board.

I've always thought it was particularly cruel that 10 the cancer was in her stomach, and that for a long time at the end she couldn't eat. The last meal I made for her was on New Year's Eve, 1990. My sister suggested that instead of a rib roast or a bird, or the usual overflow of Korean food, we make all sorts of finger dishes that our mother might fancy and pick at.

We set the meal out on the glass coffee table in the family room. I prepared a tray of smoked-salmon canapés, fried some Korean bean cakes, and made a few other dishes I thought she might enjoy. My sister supervised me, arranging the platters, and then with some pomp carried each dish in to our parents. Finally, I brought out a bottle of champagne in a bucket of ice. My mother had moved to the sofa and was sitting up, surveying the low table. "It looks pretty nice," she said. "I think I'm feeling hungry."

This made us all feel good, especially me, for I couldn't remember the last time she had felt any hunger or had eaten something I cooked. We began to eat. My mother picked up a piece of salmon toast and took a tiny corner in her mouth. She rolled it around for a moment and then pushed it out with the tip of her tongue, letting it fall back onto her plate. She swallowed hard, as if to quell a gag, then glanced up to see if we had noticed. Of course we all had. She attempted a bean cake, some cheese, and then a slice of fruit, but nothing was any use.

She nodded at me anyway, and said, "Oh, it's very good." But I was already feeling lost and I put down my plate abruptly, nearly shattering it on the thick glass. There was an ugly pause before my father asked me in a weary, gentle voice if anything was wrong, and I answered that it was nothing, it was the last night of a long year, and we were together, and I was simply relieved. At midnight, I poured out glasses of champagne, even one for my mother, who took a deep sip. Her manner grew playful and light, and I helped her shuffle to her mattress, and she lay down in the place where in a brief week she was dead.

My mother could whip up most anything, but during our first years of living in this country we ate only Korean foods. At my harangue-like behest, my mother set herself to learning how to cook exotic American dishes. Luckily, a kind neighbor, Mrs. Churchill, a tall florid young woman with flaxen hair, taught my mother her most trusted recipes.

Mrs. Churchill's two young sons, palish, weepy boys with identical crew cuts, always accompanied her, and though I liked them well enough, I would slip away from them after a few minutes, for I knew that the real action would be in the kitchen, where their mother was playing guide. Mrs. Churchill hailed from the state of Maine, where the finest Swedish meatballs and tuna casserole and angel food cake in America are made. She readily demonstrated certain techniques—how to layer wet sheets of pasta for a lasagna or whisk up a simple roux, for example. She often brought gift shoeboxes containing curious ingredients like dried oregano, instant yeast, and cream of mushroom soup. The two women, though at ease and jolly with each other, had difficulty communicating, and this was made worse by the often confusing terminology of Western cuisine ("corned beef," "deviled eggs"). Although I was just learning the language myself, I'd gladly play the interlocutor, jumping back and forth between their places at the counter, dipping my fingers into whatever sauce lay about.

I was an insistent child, and, being my mother's firstborn, much too prized. My mother could say no to me, and did often enough, but anyone who knew us—particularly my father and sister—could tell how much the denying pained her. And if I was overconscious of her indulgence even then, and suffered the rushing pangs of guilt that she could inflict upon me with the slightest wounded turn of her lip, I was too happily obtuse and venal to let her cease. She reminded me daily that I was her sole son, her reason for living, and that if she were to lose me, in either body or spirit, she wished that God would mercifully smite her, strike her down like a weak branch.

In the traditional fashion, she was the house accountant, the maid, the launderer, the disciplinarian, the driver, the secretary, and, of course, the cook. She was also my first basketball coach. In South Korea, where girls' high school basketball is a popular spectator sport, she had been a star, the point guard for the national high school team that

once won the all-Asia championships. I learned this one Saturday during the summer, when I asked my father if he would go down to the schoolyard and shoot some baskets with me. I had just finished the fifth grade, and wanted desperately to make the middle school team the coming fall. He called for my mother and sister to come along. When we arrived, my sister immediately ran off to the swings, and I recall being annoyed that my mother wasn't following her. I dribbled clumsily around the key, on the verge of losing control of the ball, and flung a flat shot that caromed wildly off the rim. The ball bounced to my father, who took a few not so graceful dribbles and made an easy layup. He dribbled out and then drove to the hoop for a layup on the other side. He rebounded his shot and passed the ball to my mother, who had been watching us from the foul line. She turned from the basket and began heading the other way.

"*Um-mah*," I cried at her, my exasperation already bubbling over, "the basket's over *here!*"

After a few steps she turned around, and from where the professional three-point line must be now, she effortlessly flipped the ball up in a two-handed set shot, its flight truer and higher than I'd witnessed from any boy or man. The ball arced cleanly into the hoop, stiffly popping the chain-link net. All afternoon, she rained in shot after shot, as my father and I scrambled after her.

When we got home from the playground, my mother showed me the photograph album of her team's championship run. For years I kept it in my room, on the same shelf that housed the scrapbooks I made of basketball stars, with magazine clippings of slick players like Bubbles Hawkins and Pistol Pete and George (the Iceman) Gervin.

It puzzled me how much she considered her own 20 history to be immaterial, and if she never patently diminished herself, she was able to finesse a kind of self-removal by speaking of my father whenever she could. She zealously recounted his excellence as a student in medical school and reminded me, each night before I started my homework, of how hard he

drove himself in his work to make a life for us. She said that because of his Asian face and imperfect English, he was "working two times the American doctors." I knew that she was building him up, buttressing him with both genuine admiration and her own brand of anxious braggadocio, and that her overarching concern was that I might fail to see him as she wished me to—in the most dawning light, his pose steadfast and solitary.

In the year before I left for Exeter, I became weary of her oft-repeated accounts of my father's success. I was a teenager, and so ever inclined to be dismissive and bitter toward anything that had to do with family and home. Often enough, my mother was the object of my derision. Suddenly, her life seemed so small to me. She was there, and sometimes, I thought, *always* there, as if she were confined to the four walls of our house. I would even complain about her cooking. Mostly, though, I was getting more and more impatient with the difficulty she encountered in doing everyday things. I was afraid for her. One day, we got into a terrible argument when she asked me to call the bank, to question a discrepancy she had discovered in the monthly statement. I asked her why she couldn't call herself. I was stupid and brutal, and I knew exactly how to wound her.

"Whom do I talk to?" she said. She would mostly speak to me in Korean, and I would answer in English.

"The bank manager, who else?"

"What do I say?"

"Whatever you want to say." 25

"Don't speak to me like that!" she cried.

"It's just that you should be able to do it yourself," I said.

"You know how I feel about this!"

"Well, maybe then you should consider it *practice*," I answered lightly, using the Korean word to make sure she understood.

Her face blanched, and her neck suddenly became 30 rigid, as if I were throttling her. She nearly struck me right then, but instead she bit her lip and ran upstairs. I followed her, pleading for forgiveness at her

door. But it was the one time in our life that I couldn't convince her, melt her resolve with the blandishments of a spoiled son.

When my mother was feeling strong enough, or was in particularly good spirits, she would roll her machine into the kitchen and sit at the table and watch me work. She wore pajamas day and night, mostly old pairs of mine.

She said, "I can't tell, what are you making?"

"*Mahn-doo* filling."

"You didn't salt the cabbage and squash."

"Was I supposed to?"

"Of course. Look, it's too wet. Now the skins will get soggy before you can fry them."

"What should I do?"

"It's too late. Maybe it'll be OK if you work quickly. Why didn't you ask me?"

"You were finally sleeping."

"You should have woken me."

"No way."

She sighed, as deeply as her weary lungs would allow.

"I don't know how you were going to make it without me."

"I don't know, either. I'll remember the salt next time."

"You better. And not too much."

We often talked like this, our tone decidedly matter-of-fact, chin up, just this side of being able to bear it. Once, while inspecting a potato fritter batter I was making, she asked me if she had ever done anything that I wished she hadn't done. I thought for a moment, and told her no. In the next breath, she wondered aloud if it was right of her to have let me go to Exeter, to live away from the house while I was so young. She tested the batter's thickness with her finger and called for more flour. Then she asked if, given a choice, I would go to Exeter again.

I wasn't sure what she was getting at, and I told her that I couldn't be certain, but probably yes, I would. She snorted at this and said it was my leaving home that had once so troubled our relationship.

"Remember how I had so much difficulty talking to you? Remember?"

She believed back then that I had found her more and more ignorant each time I came home. She said she never blamed me, for this was the way she knew it would be with my wonderful new education. Nothing I could say seemed to quell the notion. But I knew that the problem wasn't simply the *education;* the first time I saw her again after starting school, barely six weeks later, when she and my father visited me on Parents Day, she had already grown nervous and distant. After the usual campus events, we had gone to the motel where they were staying in a nearby town and sat on the beds in our room. She seemed to sneak looks at me, as though I might discover a horrible new truth if our eyes should meet.

My own secret feeling was that I had missed my parents greatly, my mother especially, and much more than I had anticipated. I couldn't tell them that these first weeks were a mere blur to me, that I felt completely overwhelmed by all the studies and my much brighter friends and the thousand irritating details of living alone, and that I had really learned nothing, save perhaps how to put on a necktie while sprinting to class. I felt as if I had plunged too deep into the world, which, to my great horror, was much larger than I had ever imagined.

I welcomed the lull of the motel room. My father and I had nearly dozed off when my mother jumped up excitedly, murmured how stupid she was, and hurried to the closet by the door. She pulled out our old metal cooler and dragged it between the beds. She lifted the top and began unpacking plastic containers, and I thought she would never stop. One after the other they came out, each with a dish that traveled well—a salted stewed meat, rolls of Korean-style sushi. I opened a container of radish kimchi and suddenly the room bloomed with its odor, and I reveled in the very peculiar sensation (which perhaps only true kimchi lovers know) of simultaneously drooling and gagging as I breathed it all in. For the next few minutes, they watched me eat. I'm not certain that I was even hungry. But after weeks of

pork parmigiana and chicken patties and wax beans, I suddenly realized that I had lost all the savor in my life. And it seemed I couldn't get enough of it back. I ate and I ate, so much and so fast that I actually went to the bathroom and vomited. I came out dizzy and sated with the phantom warmth of my binge.

And beneath the face of her worry, I thought, my mother was smiling.

From that day, my mother prepared a certain meal to welcome me home. It was always the same. Even as I rode the school's shuttle bus from Exeter to Logan airport, I could already see the exact arrangement of my mother's table.

I knew that we would eat in the kitchen, the table brimming with plates. There was the *kalbi*, of course, broiled or grilled depending on the season. Leaf lettuce, to wrap the meat with. Bowls of garlicky clam broth with miso and tofu and fresh spinach. Shavings of cod dusted in flour and then dipped in egg wash and fried. Glass noodles with onions and shiitake. Scallion-and-hot-pepper pancakes. Chilled steamed shrimp. Seasoned salads of bean sprouts, spinach, and white radish. Crispy squares of seaweed. Steamed rice with barley and red beans. Homemade kimchi. It was all there—the old flavors I knew, the beautiful salt, the sweet, the excellent taste.

After the meal, my father and I talked about school, but I could never say enough for it to make any sense. My father would often recall his high school principal, who had gone to England to study the methods and traditions of the public schools, and regaled students with stories of the great Eton man. My mother sat with us, paring fruit, not saying a word but taking everything in. When it was time to go to bed, my father said good night first. I usually watched television until the early morning. My mother would sit with me for an hour or two, perhaps until she was accustomed to me again, and only then would she kiss me and head upstairs to sleep.

During the following days, it was always the cook- 55 ing that started our conversations. She'd hold an inquest over the cold leftovers we ate at lunch, discussing each dish in terms of its balance of flavors or what might have been prepared differently. But mostly I begged her to leave the dishes alone. I wish I had paid more attention. After her death, when my father and I were the only ones left in the house, drifting through the rooms like ghosts, I sometimes tried to make that meal for him. Though it was too much for two, I made each dish anyway, taking as much care as I could. But nothing turned out quite right—not the color, not the smell. At the table, neither of us said much of anything. And we had to eat the food for days.

I remember washing rice in the kitchen one day and my mother's saying in English, from her usual seat, "I made a big mistake."

"About Exeter?"

"Yes. I made a big mistake. You should be with us for that time. I should never let you go there."

"So why did you?" I said.

"Because I didn't know I was going to die." 60

I let her words pass. For the first time in her life, she was letting herself speak her full mind, so what else could I do?

"But you know what?" she spoke up. "It was better for you. If you stayed home, you would not like me so much now."

I suggested that maybe I would like her even more.

She shook her head. "Impossible."

Sometimes I still think about what she said, about 65 having made a mistake. I would have left home for college, that was never in doubt, but those years I was away at boarding school grew more precious to her as her illness progressed. After many months of exhaustion and pain and the haze of the drugs, I thought that her mind was beginning to fade, for more and more it seemed that she was seeing me again as her fifteen-year-old boy, the one she had dropped off in New Hampshire on a cloudy September afternoon.

I remember the first person I met, another new student, named Zack, who walked to the welcome picnic with me. I had planned to eat with my parents—my mother had brought a coolerful of food even that first day—but I learned of the cookout and

told her that I should probably go. I wanted to go, of course. I was excited, and no doubt fearful and nervous, and I must have thought I was only thinking ahead. She agreed wholeheartedly, saying I certainly should. I walked them to the car, and perhaps I hugged them, before saying goodbye. One day, after she died, my father told me what happened on the long drive home to Syracuse.

He was driving the car, looking straight ahead. Traffic was light on the Massachusetts Turnpike, and the sky was nearly dark. They had driven for more than two hours and had not yet spoken a word. He then heard a strange sound from her, a kind of muffled chewing noise, as if something inside her were grinding its way out.

"So, what's the matter?" he said, trying to keep an edge to his voice.

She looked at him with her ashen face and she burst into tears. He began to cry himself, and pulled the car over onto the narrow shoulder of the turnpike, where they stayed for the next half hour or so, the blank-faced cars droning by them in the cold, onrushing night.

Every once in a while, when I think of her, I'm 70 driving alone somewhere on the highway. In the twilight, I see their car off to the side, a blue Olds coupe with a landau top, and as I pass them by I look back in the mirror and I see them again, the two figures huddling together in the front seat. Are they sleeping? Or kissing? Are they all right? ○

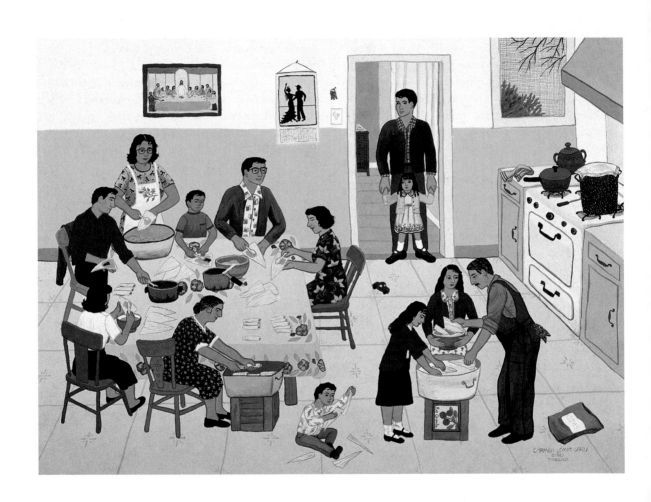

WHEN I GO HOME
Lucille Clifton

i go to where my mother is,
alive again and humming,
in a room
warm with the scent of dough
rising under damp towels, 5
and i walk
linoleum again, hard against
the splintered floorboards
that she held
together with her song. 10
i hear and smell and almost taste
the tremors of that house
and i am home, i have gone home
wherever i might find myself,
home 15
where the memory is.

Home is the place where you feel safe, where despite disquieting news that arrives by cable or optical fibre, you can leave the door on the latch and wander outside in your old terrycloth bathrobe and a pair of muddy clogs to check on whether or not the brave arrows of the crocuses are poking through the snow.

As a child, not knowing there is an alternative, you never really appreciate home. As a young adult, home is where you want to leave as soon as possible, brandishing a new driver's license and a boyfriend.

Only in midlife—our sexy new euphemism for dread old middle age—does home beckon seductively again, inviting you to pleasures running away can never supply. Home is where your books are. . . . Home is where you know all the quirks of the plumbing but they comfort rather than irritate you. Home is where you get out of bed at 3 A.M., wink at the full moon through the bathroom skylight, and go back to sleep perfectly contented, knowing no demons can follow you here.

– Erica Jong, from "Coming Home to Connecticut"

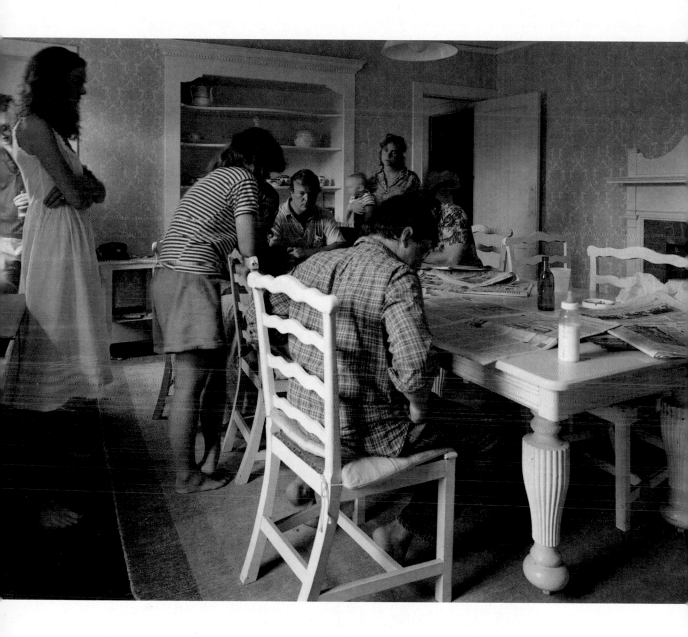

AT&T

AT&T was incorporated on March 3, 1885 in New York as the American Telephone and Telegraph company. It soon outgrew its original purpose—to manage and develop the long distance component of the American Bell Telephone Company.

From 1899 until the deregulation of the telecommunications industry in 1984, AT&T was responsible for much of the telecommunications in the United States. In 1995, AT&T split into three companies: AT&T, Lucent, and NCR Corp. With 109,000 employees and annual revenues of over $53 billion, AT&T currently focuses on long-distance, wireless, Internet, and consulting services. AT&T plans to offer integrated phone, entertainment, and internet access through its merger with cable television company Tele-Communications Inc. (TCI).

CHANG-RAE LEE

At age 3 Chang-rae Lee came to the United States with his family from South Korea. He graduated from Yale University and earned a Master of Fine Arts degree at the University of Oregon, where he now teaches creative writing. In 1996, Lee's novel *Native Speaker* won the Ernest Hemingway Foundation/Pen Award for first fiction. The novel tells the story of Henry Park, a native Korean who tries to become a "real" American but whose efforts only increase his cultural alienation.

CARMEN LOMAS GARZA

Carmen Lomas Garza (b. 1948) grew up in Texas with the pain and confusion of discrimination. In *A Piece of My Heart / Pedacito de mi Corazon* (1991), from which the painting *Tamalada (Making Tamales)* (1987) is reprinted, Lomas Garza explains that her paintings "helped heal the wounds inflicted by discrimination and racism. . . . I felt I had to start with my earliest recollections of my life and validate each event or incident by depicting it in a visual format." In *Tamalada* Lomas Garza takes us into the heart of the *familia* as several generations nurture a delectable tradition.

LUCILLE CLIFTON

Lucille Clifton is the author of several volumes of poetry, more than a dozen children's books, and a memoir, *Generations* (1976), that traces five generations of her family history. Among the themes that recur throughout her work, Clifton places special emphasis on the resilience and dignity of African American families and the importance of finding one's center "at home." Born in 1936 in Depew, New York, Clifton has taught poetry at colleges and universities in New York, California, and Maryland, where she was named state poet laureate in 1979.

TINA BARNEY

Photographer Tina Barney's book, *Theater of Manners* (1997), presents views of her extended family in intimate and candid scenes of daily life. Whether her subjects are getting dressed in the bathroom or reading the paper at the kitchen table, Barney presents them in what she calls "a very personal way." Reflecting the tradition of narrative storytelling, her photos often feature the telling details that surround a certain upper-class segment of East Coast society. Born in New York in 1946, Barney began taking photographs when she moved to Sun Valley, Idaho, in 1974. There have been several solo exhibits of her work in New York galleries.

WHEN I GO HOME
Lucille Clifton

Coming Home Again
Chang-rae Lee

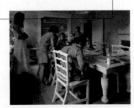

SEEING

1. Chang-rae Lee presents a poignant account of the personal pleasures and painful ironies associated with going home. As you reread his essay, pay special attention to the narrative and descriptive devices that he uses to both structure the story and build unity and coherence in it. What, for example, does Lee gain and lose by opening the narrative with his mother on the verge of death? Much of his story is organized around literal senses of place—a kitchen, a motel room, a boarding school. What descriptive details does Lee associate with each of these places, and how is each one related to his expectations of going home?

2. Examine the verbal and visual accounts of going home included in this section: the AT&T advertisement, Carmen Lomas Garza's painting *Tamalada (Making Tamales)*, Lucille Clifton's poem *When I Go Home,* and Tina Barney's photograph of a family in a kitchen. Show how each scene depicted in these artistic texts relates a sense of place with the expectations associated with going home. Write a set of detailed notes for class discussion that focus on the features in each text that establish this sense of place and convey the meanings of going home.

WRITING

1. Chang-rae Lee explains that the idea of coming home involves a specific sense of place—in this case, the kitchen table: "The point was simply to sit together at the kitchen table and array ourselves like a family again" (para. 3). What sense of place do you most associate with "coming home"? Draft an essay in which you describe this place in detail. Consider how you can incorporate events that normally occur in that space to evoke a range of emotions associated with going home. Because this exercise involves description and narration, please choose details that evoke the widest and deepest array of emotions in the reader.

2. Cooking is a theme that unifies Chang-rae Lee's account of his relations with his parents, and especially with his mother. Preparing food not only links mother and son emotionally but also provides an opportunity for her to "Americanize" herself. Yet when his parents visit him at boarding school, his mother brings special Korean delicacies. "From that day," Lee notes, "my mother prepared a certain meal to welcome me home" (para. 52). Consider what that meal would be when you want to be welcomed home. Draft an essay in which you not only describe this meal in sensuous detail but also explain why it reinforces your sense of personal, familial, and ethnic identity.

Capturing Memorable Moments

Each generation of Americans shares memorable moments. Most Americans over age 40, for example, remember precisely where they were and what they were doing when they heard the news that President John F. Kennedy had been assassinated. No matter what our age, we have all seen the film footage of JFK and Jackie waving from their car in Dallas the second before the fatal shots were fired.

Identifying a single memorable moment for younger generations of Americans may be more difficult. We might look first to certain news images. Many will never forget being glued to the television watching replays of the beating of Rodney King;

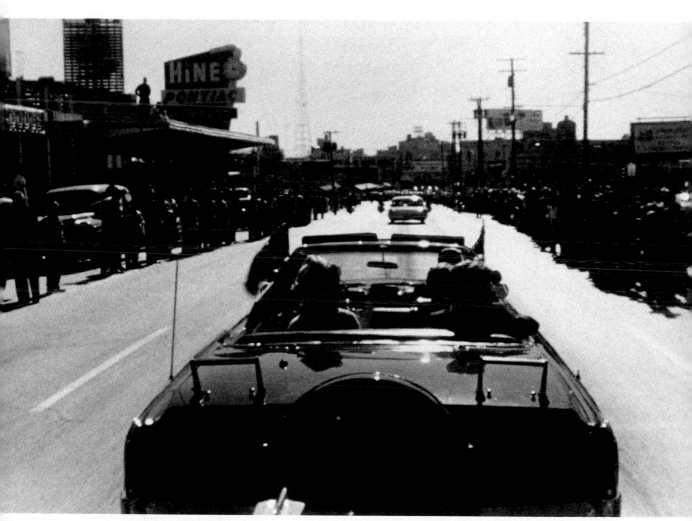

Dave Powers, **Dallas, November 22, 1963**

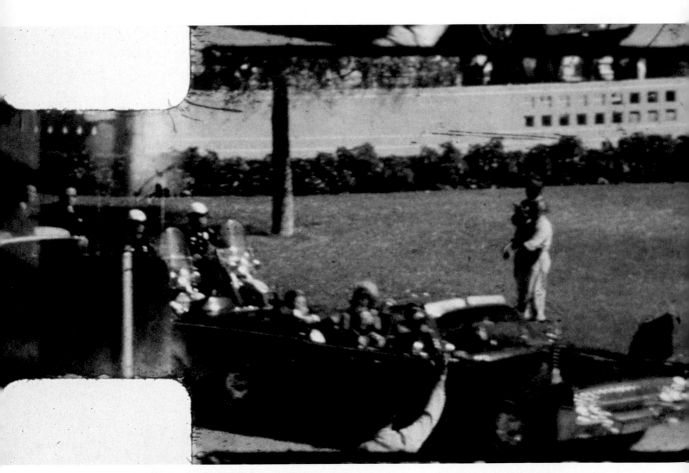

Abraham Zapruder, **Film Frame of Kennedy Assassination**

"live" helicopter shots of O. J. Simpson slumped across the back seat of a white Bronco; the shooting of rap artist Tupac Shakur; the image of wreckage in a Paris tunnel after the death of Princess Di; or the footage of Monica Lewinsky hugging President Clinton. But do any of these moments define today's generation?

According to Brian A. Gnatt, the student editor of the University of Michigan *Daily Arts*, the defining moments of his generation can be found in Hollywood rather than in the political realm. "While my parents' generation vividly remembers where they were when JFK was shot," Gnatt explains, "my generation has no single event of the same caliber."

> I remember where I was when I heard the Gulf War had begun. I remember Panama and Grenada, I remember seeing the space shuttle launches and the *Challenger's* demise. I also remember Reagan being shot, but I couldn't honestly say any of these events had a significant impact on my life, or better yet, defined my generation. But I do remember when, where and who I was with when I saw the *Star Wars* films. To my generation, nothing we have experienced together has been as huge a phenomenon as *Star Wars*. Luke Skywalker and Hans Solo are more than household names—they will be ingrained in all of our memories until the day we die.

Contemporary American culture is replete with striking and powerful images that compete for our attention and emotion. Gnatt argues that his generation has had more profound experiences in shared popular culture than in political culture; from this perspective, where might we find the most important events or shared experiences for this year's graduating seniors?

It is impossible to sift through diverse and idiosyncratic personal experiences to find a single answer to that question. After all, each of us has different personal rites of passage and ceremonies: confirmations or bat mitzvah ceremonies, the birth of a sibling, a first date, a first day at a first job, winning a championship game, or high school graduation. Moreover, the moments that we expect—or are expected—to remember, the events and ceremonies that we feel obliged to record in our photo albums and scrapbooks, are not always those that affect us the most. Often the most memorable experiences occur when we least expect them or are difficult to capture in a picture frame on a mantel: becoming blood sisters with a childhood friend; nervously finding a seat in your first college lecture class, only to find that you're in the wrong

**It all began so beautifully. After a drizzle in the morning, the sun came out bright and clear. We were driving into Dallas. In the lead car were President and Mrs. Kennedy.
– Lady Bird Johnson, 1963**

**History is the present. That's why every generation writes it anew. But what most people think of as history is its end product, myth.
– E. L. Doctorow, 1998**

building; struggling through a complex mathematical equation and finally "getting" it; or receiving the news that a loved one has died.

Telling stories about the most memorable moments in our lives often includes explaining *how* they have become etched into our minds. In fact, private moments, like public ones, are inextricably linked to the technologies with which we record them. Most of our special occasions involve cameras; for example, the video camera at a wedding, rather than the bride and groom, often commands everyone's attention and cooperation. It almost seems as though an event has not taken place if it hasn't been photographed or videotaped. Instant replay and stop-action photography allow us to relive, slow down, and freeze our most cherished or embarrassing moments. The success of shows like *TV's Funniest Home Videos,* as well as the popularity of web sites featuring 24-hour live feeds to "real life" living rooms, testify to the increasing importance of the video camera in Americans' private lives.

Whether we take photographs, create scrapbooks, use home-video cameras, keep journals, describe our experiences in letters or e-mails to friends, share family stories during the holidays, or simply replay memories in our minds, we are framing our experiences—for ourselves and often for others. As those memorable events drift into the past, we often revise and embellish our stories about them. Indeed, we continually reshape the nature and tone of our stories each time we recall them.

The selections that follow provide an opportunity for you to practice and develop your skills of narration and revision by noticing how other writers and artists capture memorable moments. From Isabel Allende's description of her highly emotional connection to a photograph by Frank Fournier of a dying girl, to Don DeLillo's exploration of videotape in contemporary American culture, each selection in this chapter conveys a public or personal moment of revelation. Pay attention to the techniques and methods each artist and writer employs to tell his or her story. As you read, observe, and write about these selections, consider the range of ways in which you capture the memorable moments in your own life. How does the process of transcribing (writing, photographing, painting, videotaping, etc.) shape or change your understanding of those moments? How can you as a writer enable readers to "get inside" your own experience—to understand the details and nuances that make each particular experience memorable?

DAVE POWERS

Dave Powers was a special assistant to President John F. Kennedy when he accompanied JFK to Dallas on November 22, 1963. Riding in a Secret Service car behind the presidential limousine, Powers recorded the ill-fated journey with his color home-movie camera. Powers's camera ran out of film at 12:17 P.M., about ten minutes before Kennedy was shot. Nevertheless, his casual record of the day's events has become a document of great historical significance.

ABRAHAM ZAPRUDER

Holding a home movie camera as the presidential motorcade went by, Dallas dressmaker Abraham Zapruder captured a 480-frame, 22-second record of the assassination of President Kennedy on November 22, 1963. Time-Life purchased the rights to the film on November 23, claiming that the film was too gruesome to ever be shown. In 1975 Geraldo Rivera first showed the film on television, and in 1998 a digitally enhanced video was made available to the general public. Many people have developed theories around the Zapruder film: Some think it proves there was more than one gunman; some think the film supports the theory of a lone assassin firing from behind; some think the film itself was faked; some claim there are missing frames, whereas others claim frames have been added. Still others believe that Abraham Zapruder (who died in 1970) himself was one of the conspirators.

SEEING

1. The story of John F. Kennedy's assassination has been told in innumerable ways for those born long after the momentous event—through eyewitness accounts, historians' interpretations, through the lens of Oliver Stone's 1991 movie on the subject, and through the controversial digitally enhanced version of Abraham Zapruder's film of the assassination, to name but a few. Each of these stories about the assassination contributes a new angle on one of the most contested moments in recent American history. What feelings does Dave Powers's photograph—taken moments before the first shot was fired—evoke? What details about the scene of the shooting does the image reveal? What does the photograph convey about the assassination itself as well as the direct and indirect effects of the event on the nation?

2. Compare Powers's photograph with the Zapruder film frame (pp. 139, 140). Comment on the positioning of the car within the frame of each photograph. How do the different camera angles produce two different "takes" on the assassination? How do they affect what you already knew about the event?

WRITING

1. What would your personal timeline of memorable moments include? Which moments have made an indelible impression on you? Why? Write down your most memorable moments, explaining the nature and significance of each event. What details do you remember about each one? What makes each one significant?

2. What would you call the defining moment of your generation so far? Write an essay in which you first explore in detail the circumstances of your personal experience with that event, and then explain its impact on your generation. You might explore some of the following questions: What makes an event significant to an entire nation? What constitutes a generation to you as an individual? What role did technology play in your event? To what extent are your notions of significant events mediated by the filters of print and visual media?

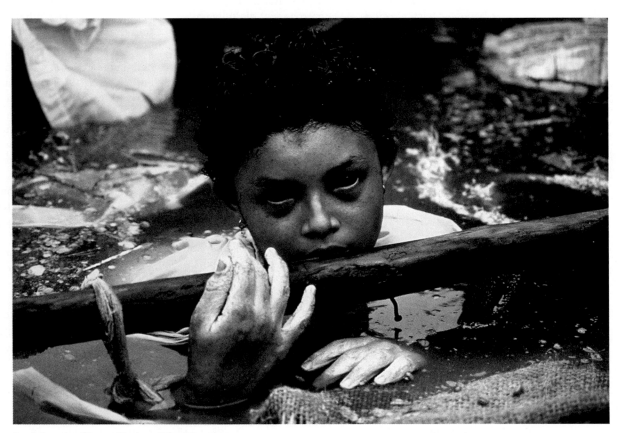

Frank Fournier, **Omayra Sanchez, Colombia, 1985**

OMAYRA SANCHEZ
Isabel Allende

WHEN I SAW THIS PICTURE IN 1985, I THOUGHT nothing like this could ever happen to my children, but I now have a daughter who's very ill and may die. Just as Omayra agonized trapped in the mud, so is my daughter trapped in a body that doesn't function anymore. For two years I have been at her bedside and often the memory of Omayra comes to me, she has never quite left me, really. She will always be with me. She brings the same message now as she did before: of endurance and the love of life, and, ironically, the acceptance of tragedy and death. When I first saw the picture I thought, "Maybe she's asking for help." Then I thought, "No, she has not died yet. She's still alive." It reminds me of how fragile life is. She demonstrates such passion, she never begged for help, never complained.

In all these years, I've become acquainted with her and I identify with her. In some ways I am her; she's inside me, there's something between us that's very strange. She's a ghost that haunts me. I often wonder about what she feels. I don't think she's thinking, she just *feels*. Later it was discovered that when her house had crumbled, she was stuck between two pieces of wood and the bodies of her brothers. Her body *feels* the cold, the fear, the stress. She looks so uncomfortable in the mud, so much in pain. And yet, look at her hands, they're so elegant.

The wonder of photography is that it does what no words can. I think in images. I remember my life in images. The earliest memory of my life, and the only memory I have of my father, is when I was two years old. My father and I are standing on the stairs of our house in Lima, where I was born. And I can see his legs and his shoes—back then, men wore shoes in two colors, black and white. And I remember my brother, who couldn't walk yet, wearing white pants and white shoes, and then, all of a sudden, he tumbled and fell, and there was blood. I have this image of my father's trousers stained with blood.

The lessons that Omayra has taught me are about life and about death. What I have learned, what she has taught me, is very complex. Every time I go back to this photograph, new things come up. This girl is alone. No one from her family is with her. I don't know if they were all dead at that time or if they had run away. The only people with her were cameramen, photographers, and people from the Red Cross who were strangers. She died alone, and I wish I had been there to hold her, the way I hold my daughter.

Western culture forces us to ignore anything that is inexplicable or uncontrollable, like poverty, death, sickness, or failure. But this is not so in the rest of the world, where people share pain more than they share happiness, because there is *more* pain than happiness most of the time. There's nothing surprising or horrifying about dying.

In this picture Omayra is not very afraid, maybe because she has seen so much death, and she has been poor all of her life. The life expectancy in Colombia isn't very high, so she walked around hand in hand with death, as most poor people do all over the world. Only people who live in very privileged bubbles think that they're going to live forever. This girl is dead, yet we're talking about her years later. We've never met her and are living at the other end of the world, but we've been brought together because of her. She never dies, this girl. She never dies. She's born every instant. ○

FRANK FOURNIER

Frank Fournier was born in France in 1948, attended the School of Graphic Design in Vevey, Switzerland, and moved to New York City in 1972. During his career as a commercial photographer he has covered a range of international events. His photographs have been featured in such publications as *Life, National Geographic,* and the French newspaper *Paris-Match,* and he has contributed to *Day in the Life* projects in America, the former Soviet Union, Spain, and Canada. His work documenting the lives of Romanian babies afflicted by HIV has been displayed in a solo exhibition that premiered at the Musée de l'Elysée in Switzerland.

Fournier received the 1985 World Press Photo of the Year award for his photograph of Omayra Sanchez, a young girl trapped in the mud caused by a volcanic eruption in Colombia. Her slow death was broadcast on news programs around the world. "Some thirty thousand people died," Fournier recalls. "Very few survived, some fought very hard but never made it. Among them an incredible and heroic person, a small little girl of 13, Omayra. . . . Her courage and dignity in death contrasted with the incredible cowardice of all the elected officials. . . . Anybody who saw her fight is now older and a lot more humble."

ISABEL ALLENDE

Isabel Allende was born in 1942 in Chile but left her native country after her uncle, President Salvador Allende, was assassinated. She had worked as a journalist in Chile, but after several years of exile she published *The House of the Spirits* (1982), which began as a letter to her 99-year-old grandfather. This novel established Allende's reputation as one of the most important contemporary Latin American authors. She has subsequently received literary awards in Latin America, Europe, and the United States. Among her other novels and stories are *Of Love and Shadows* (1987), *The Stories of Eva Luna* (1990), *Paula* (1994), a memoir about the illness and death of her daughter, and *Aphrodite: A Memoir of the Senses* (1998).

Commenting on her background as a journalist, Allende has said, "I work with emotions; language is the tool, the instrument. . . . When I write, I try to use language in an efficient way, the way a journalist does—you have little space and time and have to grab your reader by the neck and not let go. That's what I try to do with language: create tension. From journalism I also use practical things, like research and how to conduct an interview and how to talk to people in the streets. All that is useful for me as a writer."

SEEING

1. Over a decade ago, Isabel Allende encountered an image of Omayra Sanchez—first on television, and then in a magazine—that left an indelible impression on her. "The wonder of photography," Allende writes, "is that it does what no words can." In what ways has this image of a young girl Allende never met "spoken" to her since she first saw it?

2. What aspects of this photograph strike you the most? Consider Frank Fournier's framing of Omayra Sanchez in the photograph. What has he chosen to reveal about his subject? What has he left out? What aspects of Fournier's photograph does Allende draw our attention to? What details do you notice that Allende does not comment on?

WRITING

1. The plight of Omayra Sanchez deeply affected both Frank Fournier and Isabel Allende. Which representation of Omayra moves you the most—the photograph or the essay? Does reading one make the other more powerful? Write a page comparing the essay with the image.

2. Twentieth-century technology has made it possible to broadcast the most personal and private moments to global audiences. Television, magazines, and the web allow us to visit a family's living room after they've successfully delivered sextuplets, or witness a stranger's turmoil in the wake of a disaster, without ever leaving our hometowns. Choose a publicly printed photograph or image of a "memorable moment" that made a profound impression on you. Write an essay that, like Allende's, describes both your first impression and what that image or moment means to you today.

JUDY BUDNITZ
Born in Massachusetts, Judy
Budnitz grew up in Atlanta. After
graduating from Harvard in
1995, she was a writing fellow
at the Fine Arts Work Center
in Provincetown and obtained
her master's degree in creative
writing at New York University.
Flying Leap (1998), her first col-
lection of short stories, began
as her senior thesis in college.
Referring to her style as wry,
quirky, and even twisted, critics
have heralded Budnitz as an
exciting new fiction writer. She
has said that she relies more on
imagination than experience in
her writing. "There's not a lot I
can write about believably," she
remarked in a recent interview;
"I have a really ordinary life, so I
have to find new ways of seeing
things. Realistic fiction isn't
something I can do. But I don't
try to be off the wall; I try to get
at real human things from a
new angle." Budnitz is currently
living in New York, writing a
novel, and working as a free-
lance illustrator. "Park Bench"
originally appeared in *25 and
Under* (1997), an anthology of
previously unpublished fiction
by young American writers.

Park Bench

Judy Budnitz

THIS IS THE PARK BENCH WHERE I FELL IN LOVE
with Denise. It looks the same: wood slats, chipped
green paint, somebody's initials (not ours) carved
on the back. It was autumn when it happened, and
the trees were like traffic lights, going from green to
yellow and red. The air was crisp and smelled of
burning leaves.

This is also the park bench where I saw Denise for
the last time. It was autumn that time too, same de-
tails: chipped paint, initials, burning smell.

It happened like this. I was crossing through the
park during lunch hour, scuffling through the leaves
and holding a bag with a sandwich and a bottle of
pop in one hand while trying to loosen my tie with
the other, when I saw Denise sitting there. Only I
didn't know her name was Denise then.

She was sitting there reading a book. It was a big
thick book, I remember, with tiny print, and she was
almost done with it. She sat with her ankles together
and her knees together, kind of hunching forward like
she wanted to dive in and blast through the last pages.

I sat down on the bench next to her, but not too 5
close. Her hair was cut short, but it looked good on
her, she had the right sort of head for it. I waited for
her to look up. I rattled my bag around, cleared my
throat. She turned the page and her eyes flew back
and forth over it.

"Hi," I said.

She looked up and blinked. Her eyes were like swirled marbles, gray and green mixed. "Hi," she said.

"Jack," I said, introducing myself.

"Denise," she said, and that's when I knew, seeing her lips hissing out the end of her name; I knew she was a home run, a keeper, a real thing, a long-term plan, something worth hanging on to forever or for at least a month and a half. I can't explain how I knew. Call it intuition. Call it fate.

"So . . ." I said, trying to get started. I crossed one 10 ankle over the other knee. I stretched my arms out along the back of the bench. "So, what's a nice girl like you doing in a place like this?"

She laughed a polite, mechanical little laugh and went back to her book. We sat there a few minutes. She read. I stretched out and stared at the sky. We were quite companionable, really. I mean, some people have to be talking all the time; it's rare to find someone you can just be quiet with, you know, not need to say anything because you already understand each other. She was quite comfortable with me already, like she'd known me a long time. I could tell this by the way she wasn't at all self-conscious in front of me, she even picked at her nose a little as she read, as if she knew I liked her enough not to care.

It was good like that. But we needed to move on. We were neither of us getting any younger. The leaves were turning, turning. "Denise," I said, and "Denise . . ." I said again, my voice choked with longing, and she turned to me, and we locked eyes, we looked deep into each other's souls and knew each other, truly, deeply, and in that split second we smashed down all the barriers of gender and class and politics and age and sex that people write books and advice columns about. One brilliant flash, I swear to God it can happen even in this shabby old world, brilliant flashes, true communion, that's what I felt as I sat on that park bench and squashed my sandwich under my thigh in my excitement.

She gazed long and longingly at me and didn't say anything. There was nothing left to say. I took her in my arms, I kissed her, a deep probing kiss that plumbed her very depths; deliciously delirious, I nudged the base of her brain and tickled the backs of her eyeballs with my tongue. I didn't stop until I knew her insides the way a blind man knows the face of a loved one beneath his fingertips.

She pulled away, blushing, suddenly shy. She drew back to her end of the bench. She crossed her legs and laid her book on her lap. But in spite of her demurrings I knew she was as inflamed as I. This thing that had sprouted between us was growing unchecked, we could not resist it, we could only follow along.

I took off my jacket and tossed it over the back of 15 the bench. I took off my tie. I bent to unlace my shoes and pull them off. I took off my socks. She was watching me.

"So you're staying, then," she said. Her voice was cool.

I straightened up. "I thought you wanted me to," I said.

"It looks like you're planning to stay whether I want you to or not," she said, getting all defensive, like she was afraid to trust me.

"I'm only trying to do what you want—what we both want," I said. "I won't stay on your bench if you don't want me to." And I stood up.

"Yes, yes, I want you to. Please stay with me," she 20 said after a moment, holding herself as if she were cold.

So I stayed and we made love on the bench as only two people who are truly in love can make love, and we leaped and swooped and flew in a fantastic oneness surrounded by fireworks in slow motion and Vivaldi violins, and with love like that, who notices the hardness of the boards, or the splinters?

Afterward she cried and said I would leave her like they always did. She held me fast by a belt loop and prepared for a struggle. But I had no intention of leaving.

We set up a home there, on the park bench, and we started out the way all good idealistic unions begin: with lots of love and hope and few material possessions. We had all we needed: the ventilation was good, the facilities adequate, the provisions only slightly squashed.

We thought our love would sustain us, but unforeseen difficulties arose. She adored me. She was attentive—too attentive. She hovered over me constantly, tending to my clothes and the maintenance of my body. I am self-sufficient by nature. She was suffocating me. And she was dissatisfied with the place, she wanted to move; she thought a higher elevation would be healthier for the children, when they arrived.

Our lovemaking was still a glorious tumbling union through space, but I began to feel the roughness of the bench where I had not before. Her short hair tickled my nose, making me sneeze.

"I wish you wouldn't throw your clothes around," she said. "You know I hate it when you do that." She folded up my jacket, rolled the tie into a neat ball.

"And I hate it when you nag," I growled. She leaned over and untied my shoelace so that she could retie it in a neater knot. "Quit it," I said, jerking my foot away.

She turned away and sulked and opened her book. I had to coax and plead with the back of her neck to get her to turn around.

Our lovemaking grew less and less like gymnastics in zero gravity; it was becoming slow and ponderous like sumo wrestling.

I liked to sit still and watch the world go by. But she could not sit still. I watched the leaves fall in slow spirals; she fidgeted and stroked the hair at my temple. "Oh, look," she said. "A gray hair." I felt a *ping* of pain in my scalp as she pulled it out. Her fingers moved again, stopped again. "Oooh, here's another."

I slapped her hand away. "Pick, pick, pick. Nag, nag, nag. That's all you ever do. You're worse than your mother."

"You've never even met my mother."

"But I know what she's like, and I bet you're even worse than she is."

"You leave my mother out of this!" she screamed.

"You know she's just an old bag, a lonely old bag who does nothing but nag and pick the clothes up off the floor, and—"

"Stop it, stop it, stop it!" she screamed.

"—and one day you'll be just like her!" I finished. She beat at me with her fists. Boy, I'd really struck a nerve with the mother thing. But I couldn't stop myself, it was like I could see her turning into her mother before my eyes, I could see her growing old long before I did, and suddenly I was terrified of our future together.

"You don't know anything about it! What do you know! Insensitive clod!" she cried. She snatched up my clothes and things and flung them off her bench. "Get out! Get out! Get out!"

I stood up. "Don't worry, I'm leaving, and I'm not coming back. You'll be the one to regret this one day, not me. One day when you're all lonely and old, dragging around, you'll remember Jack. You'll remember the one that got down on his hands and knees and offered you true love and you just threw it away."

I was rather proud of that last part, about the hands and knees. I made it up on the spot. I stood there and tried to remember our happy times together, our immediate intimacy, but all that was gone, suddenly I didn't know her at all, and all I could think of was the way she'd nagged and smothered and held me down on that bench for so long. Resentment curdled the air between us.

That was that. I gathered up my clothes, and the sandwich in the paper bag, and the soda pop. I left her exactly the way I'd found her, with her legs tight together and her head bent. Only this time she was weeping with fury and (I'm sure) regret. She looked up and screamed: "Get out! Get *out*, I said!" So I did.

I was only a little late getting back to the office. I got right back to work on the accounts I'd begun earlier. I lost myself once again in the columns of numbers, and soon I felt like I had never left.

But I didn't forget Denise. I still haven't; she's stayed in my head all this time. I mean, here it is already Friday, and still I'm thinking about her. That's why I'm back at the park, looking at the same old bench, with this foolish kind of hope that maybe just maybe she'll still be here.

Of course she isn't. I sit on the bench gingerly and watch the leaves fall. I think of all the time I spent with her. Then I think of all the ways I might have used that time instead: golfing, learning Spanish, traveling the world, loving another woman.

But I think the time was well spent. These days it's hard to keep track of time once it's past and done and gone. Sure, some people take pictures, write it all down. But it's just paper, it doesn't mean anything. All you can do is try to hang on to those significant moments.

And that's what it was with Denise—the brilliant flash, the moment of communion. *That* moment I'll hang on to. And I can make it as long or as short as I want it. It is safe in the past just as I want it to be; no one can prove it is otherwise.

So this is how it will be: Denise and I sit on a park bench, eyes locked, lost in the brilliant flash, whirling in the celestial dance and squashed sandwiches, giving off sparks, knowing each other to the deepest and fullest, completely naked to each other, no, beyond naked, *skinned,* maybe, metaphorically of course, our inner workings exposed to each other, incredible intimacy, our insides dissected, centrifuged, laid out on microscope slides, numbered and labeled down to the last chromosome, *that's* how thoroughly we know and understand each other and ourselves and everything is clear and right in this one glorious melding moment that lasts a hundred thousand thousand years. ○

45

SEEING

1. How would you characterize the narrator, Jack, in this story? What kind of person is he? How will he remember his experience with Denise? What evidence does the story give that Jack's experience was different from Denise's?

2. How does the narrative of "Park Bench" remind you of—or differ from—a traditional romantic plot? In what ways does Budnitz play with our expectations of the passage of time? How much time really passes? With what effects?

WRITING

1. At the end of "Park Bench," the narrator reflects on the meaning of his experience with Denise. "All you can do is try to hang on to those significant moments. . . . *That* moment I'll hang on to. And I can make it as long or as short as I want it. It is safe in the past just as I want it to be; no one can prove it is otherwise" (paras. 45, 46). Has the narrator made this moment long or short? What do you think he means by "no one can prove it otherwise"? Write a page describing your responses to the ways in which Jack has remembered his experiences with Denise. Do you find his story funny or irritating? Why?

2. Choose a romantic experience in your life—one that seemed significant at the time—that is "safe in the past." Write a two- to three-page fictional "retelling" of that experience. Instead of limiting yourself to the facts, feel free to embellish your story for humor and maximum impact.

Retrospect:
Some Enchanted Evening

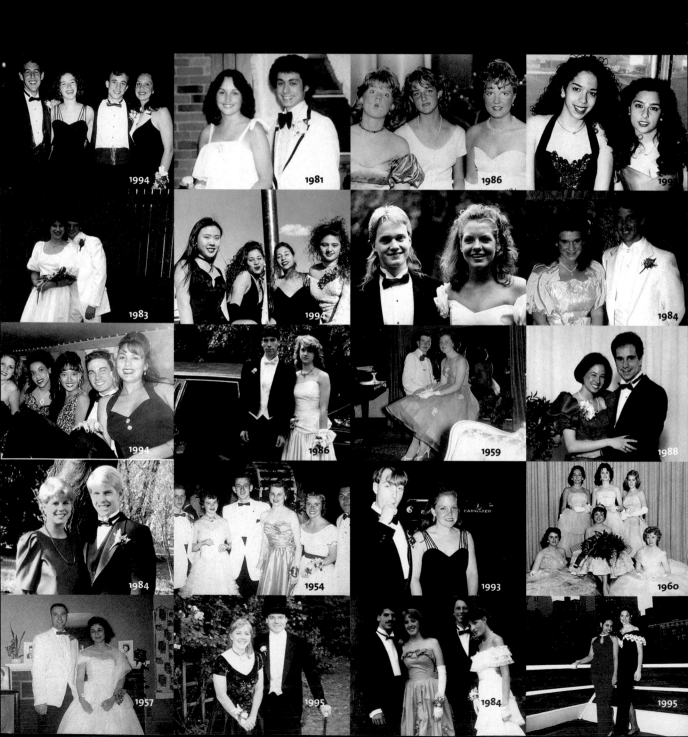

1994 1981 1986 1993

1983 1994 1984

1994 1986 1959 1988

1984 1954 1993 1960

1957 1995 1984 1995

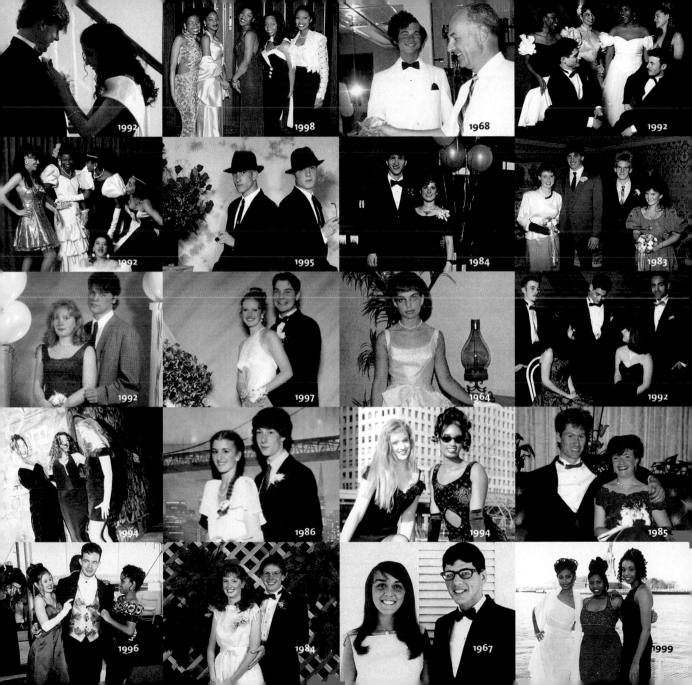

Front page of the *New York Times*, Wednesday, April 21, 1999

DOROTHY ALLISON

"I know in my bones that to write well you must inhabit your creations: male, female, whatever," says Dorothy Allison, a self-described "lesbian, feminist, Southern femme partnered to a self-defined butch musician, incest survivor, 46-year-old mother of a 3-year-old son, peri-menopausal, working-class escapee."

Born in Greenville, South Carolina, Allison grew up in a poor, working-class family. She says that she knew from her earliest years that she was an outsider, that she didn't fit in, but that not fitting in is one of her strengths as a writer. "Some days I think I have a unique advantage, an outsider's perspective that lets me see what others ignore." Her writing gives voice to her experience of the working-poor South, where her stepfather raped her when she was 5 years old. Her first novel, *Bastard Out of Carolina* (1992), which was a finalist for the National Book Award, is about escaping from that world. Her second novel, *Cavedweller* (1998), is about getting back to it.

"As a teacher I invariably require that my students write across their own barriers," she says, "forcing young lesbians to write as middle-aged men (straight or gay) and the most fervently macho men to speak as tender girls. Climbing into a stranger's skin is the core of the writer's experience, stretching the imagination to incorporate the unimagined."

This Is Our World

Dorothy Allison

THE FIRST PAINTING I EVER SAW UP CLOSE WAS at a Baptist church when I was seven years old. It was a few weeks before my mama was to be baptized. From it, I took the notion that art should surprise and astonish, and hopefully make you think something you had not thought until you saw it. The painting was a mural of Jesus at the Jordan River done on the wall behind the baptismal font. The font itself was a remarkable creation—a swimming pool with one glass side set into the wall above and behind the pulpit so that ordinarily you could not tell the font was there, seeing only the painting of Jesus. When the tank was flooded with water, little lights along the bottom came on, and anyone who stepped down the steps seemed to be walking past Jesus himself and descending into the Jordan River. Watching baptisms in that tank was like watching movies at the drive-in, my cousins had told me. From the moment the deacon walked us around the church, I knew what my cousin had meant. I could not take my eyes off the painting or the glass-fronted tank. It looked every moment as if Jesus were about to come alive, as if he were about to step out onto the water of the river. I think the way I stared at the painting made the deacon nervous.

The deacon boasted to my mama that there was nothing like that baptismal font in the whole state of South Carolina. It had been designed, he told her, by a nephew of the minister—a boy who had gone on to build a shopping center out in New Mexico. My mama was not sure that someone who built shopping centers was the kind of person who should have been designing baptismal fonts, and she was even more uncertain about the steep steps by Jesus' left hip. She asked the man to let her practice going up and down, but he warned her it would be different once the water poured in.

"It's quite safe though," he told her. "The water will hold you up. You won't fall."

I kept my attention on the painting of Jesus. He was much larger than I was, a little bit more than life-size, but the thick layer of shellac applied to protect the image acted like a magnifying glass, making him seem larger still. It was Jesus himself that fascinated me, though. He was all rouged and pale and pouty as Elvis Presley. This was not my idea of the Son of God, but I liked it. I liked it a lot.

"Jesus looks like a girl," I told my mama. 5

She looked up at the painted face. A little blush appeared on her cheekbones, and she looked as if she would have smiled if the deacon were not frowning so determinedly. "It's just the eyelashes," she said. The deacon nodded. They climbed back up the stairs. I stepped over close to Jesus and put my hand on the painted robe. The painting was sweaty and cool, slightly oily under my fingers.

"I liked that Jesus," I told my mama as we walked out of the church. "I wish we had something like that." To her credit, Mama did not laugh.

"If you want a picture of Jesus," she said, "we'll get you one. They have them in nice frames at Sears." I sighed. That was not what I had in mind. What I wanted was a life-size, sweaty painting, one in which Jesus looked as hopeful as a young girl—something other-worldly and peculiar, but kind of wonderful at the same time. After that, every time we went to church I asked to go up to see the painting, but the baptismal font was locked tight when not in use.

The Sunday Mama was to be baptized, I watched the minister step down into that pool past the Son of God. The preacher's gown was tailored with little weights carefully sewn into the hem to keep it from rising up in the water. The water pushed up at the fabric while the weights tugged it down. Once the minister was all the way down into the tank, the robe floated up a bit so that it seemed to have a shirred ruffle all along the bottom. That was almost enough to pull my eyes away from the face of Jesus, but not quite. With the lights on in the bottom of the tank, the eyes of the painting seemed to move and shine. I tried to point it out to my sisters, but they were uninterested. All they wanted to see was Mama.

Mama was to be baptized last, after three little boys, and their gowns had not had any weights attached. The white robes floated up around their necks so that their skinny boy bodies and white cotton underwear were perfectly visible to the congregation. The water that came up above the hips of the minister lapped their shoulders, and the shortest of the boys seemed panicky at the prospect of gulping water, no matter how holy. He paddled furiously to keep above the water's surface. The water started to rock violently at his struggles, sweeping the other boys off their feet. All of them pumped their knees to stay upright and the minister, realizing how the scene must appear to the congregation below, speeded up the baptismal process, praying over and dunking the boys at high speed.

Around me the congregation shifted in their seats. My little sister slid forward off the pew, and I quickly grabbed her around the waist and barely stopped myself from laughing out loud. A titter from the back of the church indicated that other people were having the same difficulty keeping from laughing. Other people shifted irritably and glared at the noisemakers. It was clear that no matter the provocation, we were to pretend nothing funny was happening. The minister frowned more fiercely and prayed louder. My mama's friend Louise, sitting at our left, whispered a soft "Look at that" and we all looked up in awe. One of the hastily blessed boys had dog-paddled over to the glass and was staring out at us, eyes wide and his hands pressed flat to the glass. He looked as if he hoped someone would rescue him. It was too much for me. I began to giggle helplessly, and not a few of the people around me joined in. Impatiently the minister hooked the boy's robe, pulled him back, and pushed him toward the stairs.

My mama, just visible on the staircase, hesitated briefly as the sodden boy climbed up past her. Then she set her lips tightly together, and reached down and pressed her robe to her thighs. She came down the steps slowly, holding down the skirt as she did so, giving one stern glance to the two boys climbing past her up the steps, and then turning her face deliberately up to the painting of Jesus. Every move she made communicated resolution and faith, and the congregation stilled in respect. She was baptized looking up stubbornly, both hands holding down that cotton robe while below, I fought so hard not to giggle, tears spilled down my face.

Over the pool, the face of Jesus watched solemnly with his pink, painted cheeks and thick, dark lashes. For all the absurdity of the event, his face seemed to me startlingly compassionate and wise. That face understood fidgety boys and stubborn women. It made me want the painting even more, and to this day I remember it with longing. It had the weight of art, that face. It had what I am sure art is supposed to have—the power to provoke, the authority of a heartfelt vision.

10

I imagine the artist who painted the baptismal font in that Baptist church so long ago was a man who did not think himself much of an artist. I have seen paintings like his many times since, so perhaps he worked from a model. Maybe he traced that face off another he had seen in some other church. For a while, I tried to imagine him a character out of a Flannery O'Connor short story, a man who traveled around the South in the fifties painting Jesus wherever he was needed, giving the Son of God the long lashes and pink cheeks of a young girl. He would be the kind of man who would see nothing blasphemous in painting eyes that followed the congregation as they moved up to the pulpit to receive a blessing and back to the pews to sit chastened and still for the benediction. Perhaps he had no sense of humor, or perhaps he had one too refined for intimidation. In my version of the story, he would have a case of whiskey in his van, right behind the gallon containers of shellac and buried notebooks of his own sketches. Sometimes, he would read thick journals of art criticism while sitting up late in cheap hotel rooms and then get roaring drunk and curse his fate.

"What I do is wallpaper," he would complain. 15 "Just wallpaper." But the work he so despised would grow more and more famous as time passed. After his death, one of those journals would publish a careful consideration of his murals, calling him a gifted primitive. Dealers would offer little churches large sums to take down his walls and sell them as installations to collectors. Maybe some of the churches would refuse to sell, but grow uncomfortable with the secular popularity of the paintings. Still, somewhere there would be a little girl like the girl I had been, a girl who would dream of putting her hand on the cool, sweaty painting while the Son of God blinked down at her in genuine sympathy. Is it a sin, she would wonder, to put together the sacred and the absurd? I would not answer her question, of course. I would leave it, like the art, to make everyone a little nervous and unsure.

I love black-and-white photographs, and I always have. I have cut photographs out of magazines to paste in books of my own, bought albums at yard sales, and kept collections that had one or two images I wanted near me always. Those pictures tell me stories—my own and others, scary stories sometimes, but more often simply everyday stories, what happened in that place at that time to those people. The pictures I collect leave me to puzzle out what I think about it later. Sometimes, I imagine my own life as a series of snapshots taken by some omniscient artist who is just keeping track—not interfering or saying anything, just capturing the moment for me to look back at it again later. The eye of God, as expressed in a Dorothea Lange or Wright Morris. This is the way it is, the photograph says, and I nod my head in appreciation. The power of art is in that nod of appreciation, though sometimes I puzzle nothing out, and the nod is more a shrug. No, I do not understand this one, but I see it. I take it in. I will think about it. If I sit with this image long enough, this story, I have the hope of understanding something I did not understand before. And that, too, is art, the best art.

My friend Jackie used to call my photographs sentimental. I had pinned them up all over the walls of my apartment, and Jackie liked a few of them but thought on the whole they were better suited to being tucked away in a book. On her walls, she had half a dozen bright prints in bottle-cap metal frames, most of them bought from Puerto Rican artists at street sales when she was working as a taxi driver and always had cash in her pockets. I thought her prints garish and told her so when she made fun of my photographs.

"They remind me of my mama," she told me. I had only seen one photograph of Jackie's mother, a wide-faced Italian matron from Queens with thick, black eyebrows and a perpetual squint.

"She liked bright colors?" I asked.

Jackie nodded. "And stuff you could buy on the 20 street. She was always buying stuff off tables on the street, saying that was the best stuff. Best prices. Cheap skirts that lost their dye after a couple of washes, shoes with cardboard insoles, those funky lit-

tle icons, weeping saints and long-faced Madonnas. She liked stuff to be really colorful. She painted all the ceilings in our apartment red and white. Red-red and white-white. Like blood on bone."

I looked up at my ceiling. The high tin ceiling was uniformly bloody when I moved in, with paint put on so thick, I could chip it off in lumps. I had climbed on stacks of boxes to paint it all cream white and pale blue.

"The Virgin's colors," Jackie told me. "You should put gold roses on the door posts."

"I'm no artist," I told her.

"I am," Jackie laughed. She took out a pencil and sketched a leafy vine above two of my framed photographs. She was good. It looked as if the frames were pinned to the vine. "I'll do it all," she said, looking at me to see if I was upset.

"Do it," I told her. 25

Jackie drew lilies and potato vines up the hall while I made tea and admired the details. Around the front door she put the Virgin's roses and curious little circles with crosses entwined in the middle. "It's beautiful," I told her.

"A blessing," she told me. "Like a bit of magic. My mama magic." Her face was so serious, I brought back a dish of salt and water, and we blessed the entrance. "Now the devil will pass you by," she promised me.

I laughed, but almost believed.

For a few months last spring I kept seeing an ad in all the magazines that showed a small child high in the air dropping toward the upraised arms of a waiting figure below. The image was grainy and distant. I could not tell if the child was laughing or crying. The copy at the bottom of the page read: "Your father always caught you."

"Look at this," I insisted the first time I saw the ad. 30 "Will you look at this?"

A friend of mine took the magazine, looked at the ad, and then up into my shocked and horrified face.

"They don't mean it that way," she said.

I looked at the ad again. They didn't mean it that way? They meant it innocently? I shuddered. It was supposed to make you feel safe, maybe make you buy insurance or something. It did not make me feel safe. I dreamed about the picture, and it was not a good dream.

I wonder how many other people see that ad the way I do. I wonder how many other people look at the constant images of happy families and make wry faces at most of them. It's as if all the illustrators have television sitcom imaginations. I do not believe in those families. I believe in the exhausted mothers, frightened children, numb and stubborn men. I believe in hard-pressed families, the child huddled in fear with his face hidden, the father and mother confronting each other with their emotions hidden, dispassionate passionate faces, and the unsettling sense of risk in the baby held close to that man's chest. These images make sense to me. They are about the world I know, the stories I tell. When they are accompanied by wry titles or copy that is slightly absurd or unexpected, I grin and know that I will puzzle it out later, sometimes a lot later.

I think that using art to provoke uncertainty is what 35 great writing and inspired images do most brilliantly. Art should provoke more questions than answers and, most of all, should make us think about what we rarely want to think about at all. Sitting down to write a novel, I refuse to consider if my work is seen as difficult or inappropriate or provocative. I choose my subjects to force the congregation to look at what they try so stubbornly to pretend is not happening at all, deliberately combining the horribly serious with the absurd or funny, because I know that if I am to reach my audience I must first seduce their attention and draw them into the world of my imagination. I know that I have to lay out my stories, my difficult people, each story layering on top of the one before it with care and craft, until my audience sees something they had not expected. Frailty—stubborn, human frailty—that is what I work to showcase. The wonder and astonishment of the despised and ignored, that is what I hope to find in art and in the books I write—my secret self, my vulnerable and

embattled heart, the child I was and the woman I have become, not Jesus at the Jordan but a woman with only her stubborn memories and passionate convictions to redeem her.

"You write such mean stories," a friend once told me. "Raped girls, brutal fathers, faithless mothers, and untrustworthy lovers—meaner than the world really is, don't you think?"

I just looked at her. Meaner than the world really is? No. I thought about showing her the box under my desk where I keep my clippings. Newspaper stories and black-and-white images—the woman who drowned her children, the man who shot first the babies in her arms and then his wife, the teenage boys who led the three-year-old away along the train track, the homeless family recovering from frostbite with their eyes glazed and indifferent while the doctor scowled over their shoulders. The world is meaner than we admit, larger and more astonishing. Strength appears in the most desperate figures, tragedy when we have no reason to expect it. Yes, some of my stories are fearful, but not as cruel as what I see in the world. I believe in redemption, just as I believe in the nobility of the despised, the dignity of the outcast, the intrinsic honor among misfits, pariahs, and queers. Artists—those of us who stand outside the city gates and look back at a society that tries to ignore us—we have an angle of vision denied to whole sectors of the sheltered and indifferent population within. It is our curse and our prize, and for everyone who will tell us our work is mean or fearful or unreal, there is another who will embrace us and say with tears in their eyes how wonderful it is to finally feel as if someone else has seen their truth and shown it in some part as it should be known.

"My story," they say. "You told my story. That is me, mine, us." And it is.

We are not the same. We are a nation of nations. Regions, social classes, economic circumstances, ethical systems, and political convictions—all separate us even as we pretend they do not. Art makes that plain. Those of us who have read the same books, eaten the same kinds of food as children, watched the same television shows, and listened to the same music, we believe ourselves part of the same nation—and we are continually startled to discover that our versions of reality do not match. If we were more the same, would we not see the same thing when we look at a painting? But what is it we see when we look at a work of art? What is it we fear will be revealed? The artist waits for us to say. It does not matter that each of us sees something slightly different. Most of us, confronted with the artist's creation, hesitate, stammer, or politely deflect the question of what it means to us. Even those of us from the same background, same region, same general economic and social class, come to "art" uncertain, suspicious, not wanting to embarrass ourselves by revealing what the work provokes in us. In fact, sometimes we are not sure. If we were to reveal what we see in each painting, sculpture, installation, or little book, we would run the risk of exposing our secret selves, what we know and what we fear we do not know, and of course incidentally what it is we truly fear. Art is the Rorschach test for all of us, the projective hologram of our secret lives. Our emotional and intellectual lives are laid bare. Do you like hologram roses? Big, bold, brightly painted canvases? Representational art? Little boxes with tiny figures posed precisely? Do you dare say what it is you like?

For those of us born into poor and working-class [40] families, these are not simple questions. For those of us who grew up hiding what our home life was like, the fear is omnipresent—particularly when that home life was scarred by physical and emotional violence. We know if we say anything about what we see in a work of art we will reveal more about ourselves than the artist. What do you see in this painting, in that one? I see a little girl, terrified, holding together the torn remnants of her clothing. I see a child, looking back at the mother for help and finding none. I see a mother, bruised and exhausted, unable to look up for help, unable to believe anyone in the world will help her. I see a man with his fists

raised, hating himself but making those fists tighter all the time. I see a little girl, uncertain and angry, looking down at her own body with hatred and contempt. I see that all the time, even when no one else sees what I see. I know I am not supposed to mention what it is I see. Perhaps no one else is seeing what I see. If they are, I am pretty sure there is some cryptic covenant that requires that we will not say what we see. Even when looking at an image of a terrified child, we know that to mention why that child might be so frightened would be a breach of social etiquette. The world requires that such children not be mentioned, even when so many of us are looking directly at her.

There seems to be a tacit agreement about what it is not polite to mention, what it is not appropriate to portray. For some of us, that polite behavior is set so deeply we truly do not see what seems outside that tacit agreement. We have lost the imagination for what our real lives have been or continue to be, what happens when we go home and close the door on the outside world. Since so many would like us to never mention anything unsettling anyway, the impulse to be quiet, the impulse to deny and pretend, becomes very strong. But the artist knows all about that impulse. The artist knows that it must be resisted. Art is not meant to be polite, secret, coded, or timid. Art is the sphere in which that impulse to hide and lie is the most dangerous. In art, transgression is holy, revelation a sacrament, and pursuing one's personal truth the only sure validation.

Does it matter if our art is canonized, if we become rich and successful, lauded and admired? Does it make any difference if our pictures become popular, our books made into movies, our creations win awards? What if we are the ones who wind up going from town to town with our notebooks, our dusty boxes of prints or Xeroxed sheets of music, never acknowledged, never paid for our work? As artists, we know how easily we could become a Flannery O'Connor character, reading those journals of criticism and burying our faces in our hands, staggering under the weight of what we see that the world does not. As artists, we also know that neither worldly praise nor critical disdain will ultimately prove the worth of our work.

Some nights I think of that sweating, girlish Jesus above my mother's determined features, those hands outspread to cast benediction on those giggling uncertain boys, me in the congregation struck full of wonder and love and helpless laughter. If no one else ever wept at that image, I did. I wished the artist who painted that image knew how powerfully it touched me, that after all these years his art still lives inside me. If I can wish for anything for my art, that is what I want—to live in some child forever—and if I can demand anything of other artists, it is that they attempt as much. ○

1. At several points in "This Is Our World," Dorothy Allison invokes the image of a magazine ad "that showed a small child high in the air dropping toward the upraised arms of a waiting figure below" (para. 29). What varying "versions of reality" does Allison see in this image? How does her description of each version exemplify her point that "if we were to reveal what we see in each painting, sculpture, installation, or little book, we would run the risk of exposing our secret selves" (para. 39)?

2. Allison begins her essay with a childhood anecdote of her reactions to the first painting she "ever saw up close." At what points—and with what effects—does she refer to this anecdote later in the essay? When does Allison shift from personal anecdotes to more general commentary? To what extent do you think these moves are successful?

1. "The world is meaner than we admit," Allison writes, referring to the stash of newspaper clippings she keeps under her desk (para. 37). Use a newspaper clipping of your choice—or the *New York Times* front page (p.154) with its cover story on the shootings in Littleton, Colorado—to agree or disagree with Allison's assertion. Use details from your text and your knowledge of school violence to support your points.

2. From the painting of Jesus she marveled at as a child, Allison writes, she "took the notion that art should surprise and astonish, and hopefully make you think something you had not thought until you saw it" (para. 1). Choose a piece of art—a visual image, an essay, or some other work—that surprised and astonished you, and use it to support or refute Allison's claim about what art should do. If you disagree with Allison, make sure you start with your own definition of the purpose of art.

NICK UT

Nick Ut was born in Long An, southwest of Saigon in Vietnam, in 1951. He began his career at the Associated Press (AP) in 1965, the same year that his older brother, also an AP photographer, was killed while on assignment during a battle in the Mekong Delta. In 1972 Ut captured the agony of a young girl and her brothers running from a napalm attack. His photograph was published throughout the United States, thrusting the image of a 9-year-old girl's anguish into the nation's consciousness and increasing public pressure to end the war. Ut won the World Press photo award for "Children Fleeing a Napalm Strike, Vietnam, 1972," a horrifying image that became a symbol of the Vietnam War. The photograph also earned him the Pulitzer Prize in 1973.

"As a photojournalist," Ut has stated, "one looks for the right moment that captures essentially the whole essence of the time and place." Ever since Ut captured this moment, the child who lived it, Kim Phuc, has remained in the public eye. After a series of painful operations, she moved to Cuba to study medicine and now lives in Toronto. In an act of reconciliation nearly twenty-five years after this photo was taken, she visited the United States to lay a wreath at the Vietnam Veterans' Memorial.

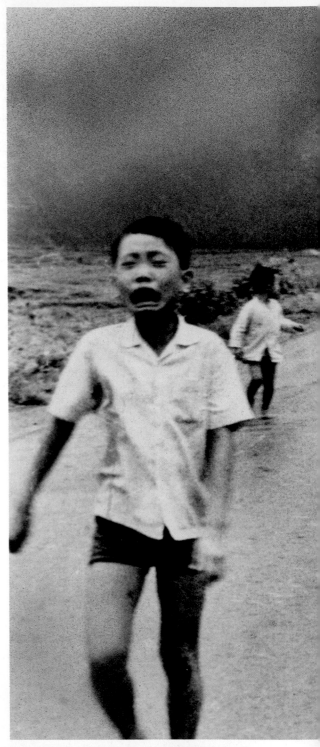

Nick Ut, **Children Fleeing a Napalm Strike, Vietnam, 1972**

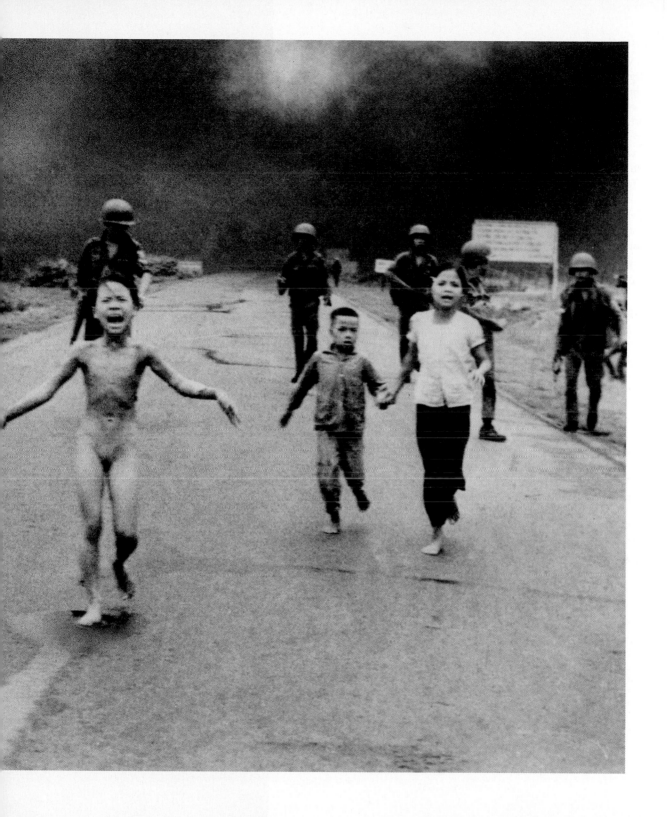

Ut / *Children Fleeing a Napalm Strike, Vietnam, 1972* 163

1. Where is your eye first drawn in this photograph? Consider the range of vision the photograph includes. What perspectives on this scene has Nick Ut's lens allowed us to view? What do we not see? Comment on the effect of scale and distance in this image. What effects does Ut produce by including both the foreground and background so visibly?

2. If the role of the photojournalist is, as Ut says, to search for "the right moment that captures essentially the whole essence of the time and place," what whole essence does this photograph capture? What details of this particular moment in the Vietnam War does it reveal? What makes the image so shocking and memorable? What characteristics made it have such a lasting impression on the collective American memory?

1. "Children Fleeing a Napalm Strike" is an extremely disturbing image. Yet Kim Phuc, the young girl who lived through the horror, has forgiven the men who dropped the bombs. Write a brief essay (one to two pages) about what it means to you that the woman has absolved the world for the pain caused to the child.

2. "When you look at war," remarked Vincent J. Alabiso, the executive photo editor of the Associated Press, "one image can somehow define a story and crystallize your feelings some way or another, and can force you to decide on a point of view you might take. That's different from looking at a hurricane picture." Choose an image of war that you have encountered in a newspaper or magazine, on television, or in film. Write an essay in which you explore the extent to which the image leads you "to decide on a point of view" about the conflict. Include a copy and a description of the image, as well as your reactions to it in vivid detail. If the image does not provoke a significant reaction, explain why not. You might also compare the image you've chosen with Nick Ut's photograph. How does each photograph evoke the "essence of the time and place"?

Re: Searching the Web

The photograph Nick Ut took of children fleeing a napalm strike (pp. 162-163) is one of the most searing images of the Vietnam War. It was viewed as a defining moment in the war and prompted antiwar activists to mobilize greater opposition to U.S. military policy. Kim Phuc, the girl in the middle of the picture, traveled to many parts of the United States in 1998, almost twenty-five years after her ordeal, to promote peace and reconciliation.

Some members of the American press criticized Phuc for participating in what they viewed as an antimilitary publicity tour. Using the resources of a search engine on the web, conduct research on the origins, purpose(s), and impact of Kim Phuc's visit to the United States. (You might use the web to connect to the newspaper accounts in the cities she visited.) Write an essay in which you provide an overview of her visit and then argue for — or against — the assertion that her trip was an antimilitary tour. As you develop your argument, be sure to anticipate the counter-arguments of those who support the opposite side.

I have suffered a lot from both physical and emotional pain. Sometimes I could not breathe. But God saved my life and gave me faith and hope. Even if I could talk face to face with the pilot who dropped the bombs, I would tell him, "We cannot change history, but we should try to do good things for the present and for the future to promote peace."

Kim Phuc

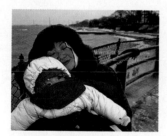

Joe McNally, **Kim Phuc, 1995**

ANDREW SAVULICH

Andrew Savulich worked as a landscape architect before turning to freelance photography and, fifteen years later, becoming a staff photographer for the *New York Daily News* (which, according to its masthead, is "New York's Picture Newspaper"). His work has been exhibited in the United States and abroad, and he has received numerous awards, including a National Endowment for the Arts fellowship grant in photography.

Savulich is a master of "spot news"—spontaneous photographs of the violence and accidents, the humorous and odd events of everyday life, especially in urban areas.... He explains his motivation: "We're at a point in our society where very weird things are happening in the streets, and I like taking pictures because I feel I'm recording something that's really *happening*." He thrives on the spontaneity of "hunting" for memorable pictures: "There's a kind of adrenaline rush when you're doing this work.... It's all spontaneous: you have to figure things out, and you never really know what you have. That uncertainty is attractive, I think."

Savulich adds a handwritten caption below each photograph he takes. "I felt that the pictures needed something to describe what was happening. And I thought the easiest way would be just to write a little description on the prints themselves. And I liked the way it looked."

PEOPLE WATCHING JUMPER ON HOTEL ROOF.

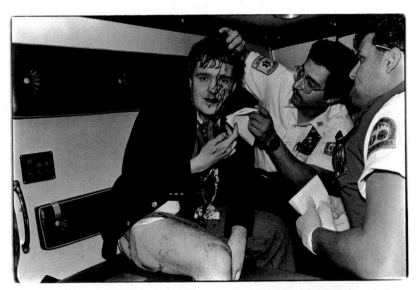

MAN COMPLAINING THAT HE WAS ATTACKED AFTER HE GAVE HIS MONEY TO ROBBERS.

TAXI DRIVER EXPLAINING HOW AN ARGUEMENT WITH HIS PASSENGER CAUSED HIM TO DRIVE INTO THE RESTAURANT.

WOMAN LAUGHING AFTER CAR WRECK.

1. What story does each of these photographs tell? What is especially striking and memorable about them? What similarities or differences do you see between and among the four photos?

2. Look carefully at each of the photographs for Andrew Savulich's artistic presence. Comment, for example, on the camera angle, the precise moment at which he chooses to take each photograph, as well as what he includes. What makes his style distinct from that of any of the other photographers whose work is presented in this chapter?

1. Much of the story in each of Savulich's photographs is conveyed by its caption. Think of alternate captions for each image. Would a different caption significantly change how you "read" the photograph? Why or why not?

2. Choose one of Savulich's photographs, and write a two-page journalistic account that you imagine would accompany the image in a newspaper. Include the sequence of events that led to the moment depicted in the photograph, conveying the emotional aspects of the event as you do so. Base as much of your report as possible on details you see in the image, and then embellish your report in any way you wish—with quotations, names, background information—to make your news story compelling.

PEOPLE WATCHING JUMPER ON HOTEL ROOF.

TAXI DRIVER EXPLAINING HOW AN ARGUMENT WITH HIS PASSENGER CAUSED HIM TO DRIVE INTO THE RESTAURANT.

MAN COMPLAINING THAT HE WAS ATTACKED AFTER HE GAVE HIS MONEY TO ROBBERS.

WOMAN LAUGHING AFTER CAR WRECK.

Andrew Savulich describes New York City as a place where "something is wrong," where daily life is a "no-mercy situation." "Anybody who's lived in New York for the last ten years, or even less, knows that." His photographs record everyday events there from an angle that delicately balances horror and humor.

The ubiquitous reruns of such television news and tabloid shows as *America's Most Wanted, Rescue 911, Cops,* and *Hard Copy* serve as the mundane stage on which dramatic slow-motion replays of real-life violence and crime are played out. These programs project the image that no one is safe on the nation's urban streets. Write the first draft of an essay in which you explain why so many Americans seem frightened on the streets and yet can't seem to get enough violence on television when they arrive home.

MICHAEL JORDAN

"Ever since I was a small boy, I dreamed of playing basketball at the highest level of competition," Michael Jordan reported in his 1999 retirement speech. "I dreamed of playing in college and winning a national championship. I dreamed of playing in the Olympics and winning a gold medal. I dreamed of playing in the National Basketball Association and winning a world championship." Six world championships later, the 6'6", 216-pound North Carolina guard has made a career of creating memorable sports moments. Often referred to as one of the greatest athletes in the history of team sports, Jordan helped the NBA and the sport of basketball attain unprecedented popularity.

During his 1996–97 season with the Chicago Bulls, Michael Jordan earned more income from endorsements ($40 million) than from playing basketball ($30 million). Since 1984, when Nike launched its first line of "Air Jordan's," Jordan's image has helped sell everything from Gatorade and Wheaties to his own line of cologne and underwear. When asked recently about his retirement, Jordan commented, "Hopefully I've put enough memories out there."

Sports Illustrated chose this photograph to memorialize the shot—made with only 40 seconds on the clock—that enabled the Chicago Bulls to win the NBA Championship in 1998.

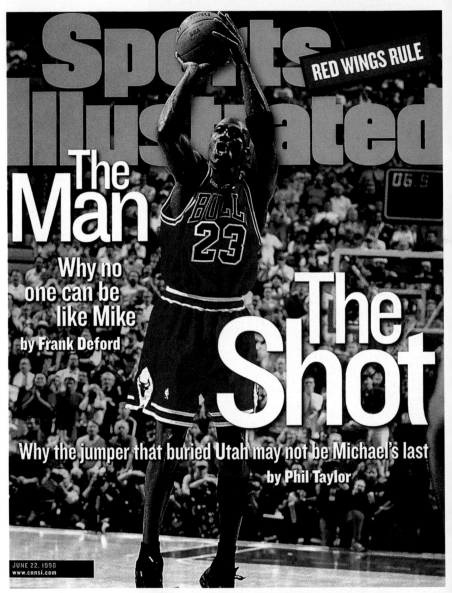

Sports Illustrated, **The Man / The Shot**

SEEING

1. Sports commentators, journalists, and fans alike have written volumes on Michael Jordan's extraordinary skill and grace. How would you describe Jordan's action and body language in this photograph? What does this photograph capture about the game and Michael Jordan's playing that we wouldn't be able to see without the aid of sophisticated photography and high-speed film? What does the photograph express that a sportscaster, narrating a play-by-play of the moment, could not, and vice versa?

2. How has *Sports Illustrated* chosen to capture the Chicago Bulls' victory on the cover of this issue? How have they framed this image? What have they included in this photograph? What have they left out? What aspects of this nationally recognized event do the headlines emphasize? How do these choices help frame our collective memory of the game?

The period of the end of the century.

WRITING

1. Write a two-page recollection of an equivalent of "The Shot" in your life—a crucial moment in which time seemed to stand still. You might choose a final play in a game you helped win or lose, or draw from any number of other experiences: passing a driver's test, giving a memorable performance in a school play, or a moment when you decided to speak for yourself rather than have others speak for you.

2. "Even allowing that we might overstate the point," wrote Frank Deford in the same issue of *Sports Illustrated*, "it is not uncommon for the most memorable of our athletes to reflect their times. Certainly, the Babe was at one with the Roaring Twenties, just as Jackie Robinson perfectly represented the grand societal advances of the postwar years, and as Ali and Billie Jean so symbolized the turmoil of their period. Likewise, Michael Jordan is not merely so extraordinary for what he does. He also has been the right, best athlete for us now, for this relatively serene and altogether prosperous fin de siècle, when the United States rules alone, as much superculture as superpower." Write an essay in which you use *Sports Illustrated*'s photograph of Michael Jordan as your departure point for responding to Deford's statement that Jordan is an athlete of our times. To what extent do you agree with Deford? How does the *Sports Illustrated* cover support or complicate Deford's claims?

Babe Ruth, the New York Yankee outfielder, was one of the greatest baseball stars of all time.

Jackie Robinson, the Brooklyn Dodger infielder, became in 1947 the first black major league player.

Eli Reed, **Damage from the LA Riots, Baldwin Hills, California, 1992**

Don DeLillo is one of the most acute observers of contemporary society who is writing fiction today. In ten novels and numerous short stories, he manages to capture the intangible essence of modern life in language that is at once direct, clear, and incisive. His novels focus on a range of subjects, including modern science in *Ratner's Star* (1976), terrorism in *Players* (1977), chemical accidents in *White Noise* (1985), religious fanaticism in *Mao II* (1991), and the cold war in *Underworld* (1997). Across this array of topics DeLillo explores the ways in which individuals cope with the pressures of technology, mass media, and depersonalizing institutions. His enduring fascination with the cultural function of film and video is apparent in "Videotape," which first appeared in *Antaeus* (1984).

Born in New York City in 1936, DeLillo is often linked with a group of contemporary writers whose focus is language, especially experimental language. His work is particularly celebrated for its crafted, hard edge. "What writing means to me," DeLillo explains, "is trying to make interesting, clear, beautiful language."

Videotape

Don DeLillo

IT SHOWS A MAN DRIVING A CAR. IT IS THE simplest sort of family video. You see a man at the wheel of a medium Dodge.

It is just a kid aiming her camera through the rear window of the family car at the windshield of the car behind her.

You know about families and their video cameras. You know how kids get involved, how the camera shows them that every subject is potentially charged, a million things they never see with the unaided eye. They investigate the meaning of inert objects and dumb pets and they poke at family privacy. They learn to see things twice.

It is the kid's own privacy that is being protected here. She is twelve years old and her name is being withheld even though she is neither the victim nor the perpetrator of the crime but only the means of recording it.

It shows a man in a sport shirt at the wheel of his 5 car. There is nothing else to see. The car approaches briefly, then falls back.

You know how children with cameras learn to work the exposed moments that define the family cluster. They break every trust, spy out the undefended space, catching mom coming out of the bathroom in her cumbrous robe and turbaned towel, looking bloodless and plucked. It is not a joke. They will shoot you sitting on the pot if they can manage a suitable vantage.

The tape has the jostled sort of noneventness that marks the family product. Of course the man in this case is not a member of the family but a stranger in a car, a random figure, someone who has happened along in the slow lane.

It shows a man in his forties wearing a pale shirt open at the throat, the image washed by reflections and sunglint, with many jostled moments.

It is not just another video homicide. It is a homicide recorded by a child who thought she was doing something simple and maybe halfway clever, shooting some tape of a man in a car.

He sees the girl and waves briefly, wagging a hand 10 without taking it off the wheel—an underplayed reaction that makes you like him.

It is unrelenting footage that rolls on and on. It has an aimless determination, a persistence that lives outside the subject matter. You are looking into the mind of home video. It is innocent, it is aimless, it is determined, it is real.

He is bald up the middle of his head, a nice guy in his forties whose whole life seems open to the hand-held camera.

But there is also an element of suspense. You keep on looking not because you know something is going to happen—of course you do know something is going to happen and you do look for that reason but you might also keep on looking if you came across

this footage for the first time without knowing the outcome. There is a crude power operating here. You keep on looking because things combine to hold you fast—a sense of the random, the amateurish, the accidental, the impending. You don't think of the tape as boring or interesting. It is crude, it is blunt, it is relentless. It is the jostled part of your mind, the film that runs through your hotel brain under all the thoughts you know you're thinking.

The world is lurking in the camera, already framed, waiting for the boy or girl who will come along and take up the device, learn the instrument, shooting old granddad at breakfast, all stroked out so his nostrils gape, the cereal spoon baby-gripped in his pale fist.

It shows a man alone in a medium Dodge. It seems 15 to go on forever.

There's something about the nature of the tape, the grain of the image, the sputtering black-and-white tones, the starkness—you think this is more real, truer to life than anything around you. The things around you have a rehearsed and layered and cosmetic look. The tape is superreal, or maybe underreal is the way you want to put it. It is what lies at the scraped bottom of all the layers you have added. And this is another reason why you keep on looking. The tape has a searing realness.

It shows him giving an abbreviated wave, stiff-palmed, like a signal flag at a siding.

You know how families make up games. This is just another game in which the child invents the rules as she goes along. She likes the idea of videotaping a man in his car. She has probably never done it before and she sees no reason to vary the format or terminate early or pan to another car. This is her game and she is learning it and playing it at the same time. She feels halfway clever and inventive and maybe slightly intrusive as well, a little bit of brazenness that spices any game.

And you keep on looking. You look because this is the nature of the footage, to make a channeled path through time, to give things a shape and a destiny.

Of course if she had panned to another car, the 20 right car at the precise time, she would have caught the gunman as he fired.

The chance quality of the encounter. The victim, the killer, and the child with a camera. Random energies that approach a common point. There's something here that speaks to you directly, saying terrible things about forces beyond your control, lines of intersection that cut through history and logic and every reasonable layer of human expectation.

She wandered into it. The girl got lost and wandered clear-eyed into horror. This is a children's story about straying too far from home. But it isn't the family car that serves as the instrument of the child's curiosity, her inclination to explore. It is the camera that puts her in the tale.

You know about holidays and family celebrations and how somebody shows up with a camcorder and the relatives stand around and barely react because they're numbingly accustomed to the process of being taped and decked and shown on the VCR with the coffee and cake.

He is hit soon after. If you've seen the tape many times you know from the handwave exactly when he will be hit. It is something, naturally, that you wait for. You say to your wife, if you're at home and she is there, Now here is where he gets it. You say, Janet, hurry up, this is where it happens.

Now here is where he gets it. You see him jolted, 25 sort of wireshocked—then he seizes up and falls toward the door or maybe leans or slides into the door is the proper way to put it. It is awful and unremarkable at the same time. The car stays in the slow lane. It approaches briefly, then falls back.

You don't usually call your wife over to the TV set. She has her programs, you have yours. But there's a certain urgency here. You want her to see how it looks. The tape has been running forever and now the thing is finally going to happen and you want her to be here when he's shot.

Here it comes, all right. He is shot, head-shot, and the camera reacts, the child reacts—there is a jolting movement but she keeps on taping, there is a sympathetic response, a nerve response, her heart is beating faster but she keeps the camera trained on the subject as he slides into the door and even as you see him die

you're thinking of the girl. At some level the girl has to be present here, watching what you're watching, unprepared—the girl is seeing this cold and you have to marvel at the fact that she keeps the tape rolling.

It shows something awful and unaccompanied. You want your wife to see it because it is real this time, not fancy movie violence—the realness beneath the layers of cosmetic perception. Hurry up, Janet, here it comes. He dies so fast. There is no accompaniment of any kind. It is very stripped. You want to tell her it is realer than real but then she will ask what that means.

The way the camera reacts to the gunshot—a startle reaction that brings pity and terror into the frame, the girl's own shock, the girl's identification with the victim.

You don't see the blood, which is probably trickling behind his ear and down the back of his neck. The way his head is twisted away from the door, the twist of the head gives you only a partial profile and it's the wrong side, it's not the side where he was hit.

And maybe you're being a little aggressive here, practically forcing your wife to watch. Why? What are you telling her? Are you making a little statement? Like I'm going to ruin your day out of ordinary spite. Or a big statement? Like this is the risk of existing. Either way you're rubbing her face in this tape and you don't know why.

It shows the car drifting toward the guardrail and then there's a jostling sense of two other lanes and part of another car, a split-second blur, and the tape ends here, either because the girl stopped shooting or because some central authority, the police or the district attorney or the TV station, decided there was nothing else you had to see.

This is either the tenth or eleventh homicide committed by the Texas Highway Killer. The number is uncertain because the police believe that one of the shootings may have been a copycat crime.

And there is something about videotape, isn't there, and this particular kind of serial crime? This is a crime designed for random taping and immediate playing. You sit there and wonder if this kind of crime became more possible when the means of taping an event and playing it immediately, without a neutral interval, a balancing space and time, became widely available. Taping-and-playing intensifies and compresses the event. It dangles a need to do it again. You sit there thinking that the serial murder has found its medium, or vice versa—an act of shadow technology, of compressed time and repeated images, stark and glary and unremarkable.

It shows very little in the end. It is a famous murder because it is on tape and because the murderer has done it many times and because the crime was recorded by a child. So the child is involved, the Video Kid as she is sometimes called because they have to call her something. The tape is famous and so is she. She is famous in the modern manner of people whose names are strategically withheld. They are famous without names or faces, spirits living apart from their bodies, the victims and witnesses, the underage criminals, out there somewhere at the edges of perception.

Seeing someone at the moment he dies, dying unexpectedly. This is reason alone to stay fixed to the screen. It is instructional, watching a man shot dead as he drives along on a sunny day. It demonstrates an elemental truth, that every breath you take has two possible endings. And that's another thing. There's a joke locked away here, a note of cruel slapstick that you are willing to appreciate even if it makes you feel a little guilty. Maybe the victim's a chump, a sort of silent-movie dupe, classically unlucky. He had it coming in a sense, for letting himself be caught on camera. Because once the tape starts rolling it can only end one way. This is what the context requires.

You don't want Janet to give you any crap about it's on all the time, they show it a thousand times a day. They show it because it exists, because they have to show it, because this is why they're out there, to provide our entertainment.

The more you watch the tape, the deader and colder and more relentless it becomes. The tape sucks the air right out of your chest but you watch it every time. ○

1. What does DeLillo mean when he writes that home videos are "more real, truer to life than anything around you" (para. 16)? Consider his descriptions of this particular videotape. What, according to DeLillo, makes it "realer than real"? In what ways does his exploration of the nature of home videos resonate with—or seem at odds with—your own experience with home videos?

2. Don DeLillo describes the Video Kid as "famous in the modern manner of people whose names are strategically withheld" (para. 35). Which names does DeLillo reveal or withhold in this story? With what effect? Who is the "you" in this story? What effect do you think DeLillo's use of the second person has on the tone of his essay? How would the essay change if he had given the protagonist a name and an identity? Who is the "they" referred to at the end of the piece? How do DeLillo's choices of withholding or revealing names relate to his commentary on fame and anonymity?

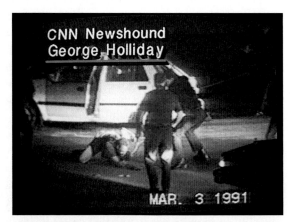

Stills from Videotape of Rodney King Beating

1. DeLillo argues that crimes such as the one videotaped by the girl in this story "are designed for random taping and immediate playing" (para. 34). How has the notion of "taping and playing" changed the ways in which Americans experience and record significant events? Choose a recent event covered in the media. Write the first draft of an essay in which you explore the role of videotape in the proceedings as well as the coverage of the event. To what extent and in what specific ways was videotape an essential component of the event?

2. Compare the images of Rodney King from the 1991 videotape with Eli Reed's photograph (p. 172) of the aftermath of the riots in Los Angeles, "Damage from the LA Riots, Baldwin Hills, California, 1992." What is the role of the video camera in each picture? Write an essay in which you agree or disagree with DeLillo's claim that video is "realer than real" (para. 28).

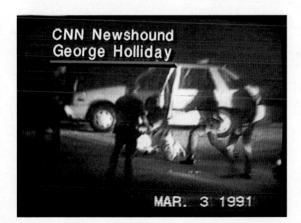 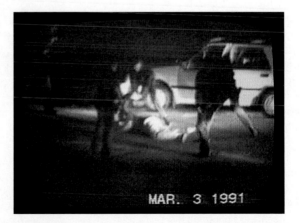

LAUREN GREENFIELD

Freelance photographer Lauren Greenfield was born in Boston in 1966 and grew up in Venice, California. Greenfield attended Harvard University and returned to Los Angeles to launch a career with her photographic documentary *Fast Forward: Growing Up in the Shadow of Hollywood* (1997). In her colorful and disquieting photographs Greenfield captures a wide range of Los Angeles youth, from Beverly Hills debutantes to gang members. Reviewing Greenfield's photographs, Richard Rodriguez notes that "What L.A. sells America, what L.A. sells the entire world, is a dream of adolescence." Greenfield underscores the extent to which that dream can become nightmarish for those who live it. She considers this documentary series to be autobiographical insofar as the images convey a sense of her own experience growing up in L.A. She offers unremitting criticism of a culture that measures success by how closely individuals conform to stereotypical images of power, wealth, and beauty.

Fast Forward, the collection from which this photo of "Ashleigh" is reproduced, received the Community Awareness Award from the National Press Photographers' Pictures of the Year competition and the 1997 International Center of Photography Infinity Award for Young Photographers. Greenfield's photographs have appeared in *Time, Newsweek, Vanity Fair, Life,* and the *New York Times Magazine.*

Lauren Greenfield, **Ashleigh, 13, with Her Friend and Parents, Santa Monica**

1. How would you describe the moment that Lauren Greenfield has captured in this photograph? While Ashleigh is looking intently down at the scale, where are each of the other figures in the photograph looking? What do you imagine each of these figures is "saying" with his or her facial expression and body language?

2. If each of the figures in Greenfield's photograph is looking intently at something or someone, what photographic angle has Greenfield chosen from which to view and capture this scene? What aspects of this scene does the framing reveal about the subject or its author? What does it conceal? With what effects?

1. Write a one-paragraph character sketch on each of the figures in Greenfield's photograph—as if they were characters in a play or movie. What revealing details do you notice about their postures, facial expressions, and clothes, as well as the objects around them? Given your observations, what might you infer about each of their personalities, their reactions to this moment, and their relationships to each other? Now write a brief dialogue for the moments before, during, and after this photograph was taken.

2. Richard Rodriguez writes that Greenfield's photographs reveal "what L.A. sells the entire world is a dream of adolescence." Do you think "Ashleigh, 13, with Her Friend and Parents, Santa Monica" has this effect? Write an essay that starts with what you know about Hollywood, L.A., and movie culture and ends by arguing either that Rodriguez is right (based on this photograph) or that the photograph offers something else entirely.

Looking Closer:
Taking Pictures

When George Eastman introduced the simple and inexpensive box camera in 1888, the medium of photography came within the reach of most Americans. Anyone could buy the pre-loaded "Kodak #1," take 100 exposures, and then send the camera back to Kodak to develop the film. "You press the button, we do the rest" was the slogan that enticed generations of Americans to take snapshots.

The writers and photographers whose work is presented on the following pages explore the ways in which pictures and picture taking have become part of American culture. Susan Sontag speculates about the significance of photographs in an excerpt from her now-classic essay **"On Photography."** The ad **"Keep the story with a *KODAK*"** provides a glimpse into the language and imagery used to familiarize Americans with the "point and shoot" process. Ethan Canin uses a family snapshot called **"Vivian, Fort Barnwell"** to imagine the very short story in "Viewfinder" and N. Scott Momaday uses a snapshot as an occasion for a short essay in "The Photograph." Catherine Wagner's **"Monica and Jack P., Mill Valley, California, 1990,"** draws attention to the central role photographs occupy in our homes, while Martin Parr's **"Kalkan, Turkey"** and Duane Hanson's **"Tourists"** offer ironic views of tourists in search of unique experience.

On Photography
Susan Sontag

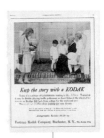

On Photography

Susan Sontag

RECENTLY, PHOTOGRAPHY HAS BECOME ALMOST as widely practiced an amusement as sex and dancing—which means that, like every mass art form, photography is not practiced by most people as an art. It is mainly a social rite, a defense against anxiety, and a tool of power.

Memorializing the achievements of individuals considered as members of families (as well as of other groups) is the earliest popular use of photography. For at least a century, the wedding photograph has been as much a part of the ceremony as the prescribed verbal formulas. Cameras go with family life. According to a sociological study done in France, most households have a camera, but a household with children is twice as likely to have at least one camera as a household in which there are no children. Not to take pictures of one's children, particularly when they are small, is a sign of parental indifference, just as not turning up for one's graduation picture is a gesture of adolescent rebellion.

Through photographs, each family constructs a portrait-chronicle of itself—a portable kit of images that bears witness to its connectedness. It hardly matters what activities are photographed so long as photographs get taken and are cherished. Photography becomes a rite of family life just when, in the industrializing countries of Europe and America, the very institution of the family starts undergoing radical surgery. As that claustrophobic unit, the nuclear family, was being carved out of a much larger family aggregate, photography came along to memorialize, to restate symbolically, the imperiled continuity and vanishing extendedness of family life. Those ghostly traces, photographs, supply the token presence of the dispersed relatives. A family's photograph album is generally about the extended family—and, often, is all that remains of it.

As photographs give people an imaginary possession of a past that is unreal, they also help people to take possession of space in which they are insecure. Thus, photography develops in tandem with one of the most characteristic of modern activities: tourism. For the first time in history, large numbers of people regularly travel out of their habitual environments for short periods of time. It seems positively unnatural to travel for pleasure without taking a camera along. Photographs will offer indisputable evidence that the trip was made, that the program was carried out, that fun was had. Photographs document sequences of consumption carried on outside the view of family, friends, neighbors. But dependence on the camera, as the device that makes real what one is experiencing, doesn't fade when people travel more. Taking photographs fills the same need for the cosmopolitans accumulating photograph-trophies of their boat trip up the Albert Nile or their fourteen days in China as it does for lower-middle-class vacationers taking snapshots of the Eiffel Tower or Niagara Falls.

A way of certifying experience, taking photographs is also a way of refusing it—by limiting experience to a search for the photogenic, by converting experience into an image, a souvenir. Travel becomes a strategy for accumulating photographs. The very activity of taking pictures is soothing, and assuages general feelings of disorientation that are likely to be exacerbated by travel. Most tourists feel compelled to put the camera between themselves and whatever is remarkable that they encounter. Unsure of other responses, they take a picture. This gives shape to experience: stop, take a photograph, and move on. The method especially appeals to people handicapped by a ruthless work ethic—Germans, Japanese, and Americans. Using a camera appeases the anxiety which the work-driven feel about not working when they are on vacation and supposed to be having fun. They have something to do that is like a friendly imitation of work: they can take pictures.

People robbed of their past seem to make the most fervent picture takers, at home and abroad. Everyone who lives in an industrialized society is obliged gradually to give up the past, but in certain countries, such as the United States and Japan, the break with the past has been particularly traumatic. In the early 1970s, the fable of the brash American tourist of the 1950s and 1960s, rich with dollars and

Babbittry,[1] was replaced by the mystery of the group-minded Japanese tourist, newly released from his island prison by the miracle of overvalued yen, who is generally armed with two cameras, one on each hip.

Photography has become one of the principal devices for experiencing something, for giving an appearance of participation. One full-page ad shows a small group of people standing pressed together, peering out of the photograph, all but one looking stunned, excited, upset. The one who wears a different expression holds a camera to his eye; he seems self-possessed, is almost smiling. While the others are passive, clearly alarmed spectators, having a camera has transformed one person into something active, a voyeur: only he has mastered the situation. What do these people see? We don't know. And it doesn't matter. It is an Event: something worth seeing—and therefore worth photographing. The ad copy, white letters across the dark lower third of the photograph like news coming over a teletype machine, consists of just six words: ". . . Prague . . . Woodstock . . . Vietnam . . . Sapporo . . . Londonderry . . . LEICA." Crushed hopes, youth antics, colonial wars, and winter sports are alike—are equalized by the camera. Taking photographs has set up a chronic voyeuristic relation to the world which levels the meaning of all events.

A photograph is not just the result of an encounter between an event and a photographer; picture-taking is an event in itself, and one with ever more peremptory rights—to interfere with, to invade, or to ignore whatever is going on. Our very sense of situation is now articulated by the camera's interventions. The omnipresence of cameras persuasively suggests that time consists of interesting events, events worth photographing. This, in turn, makes it easy to feel that any event, once underway, and whatever its moral character, should be allowed to complete itself—so that something else can be brought into the world, the photograph. After the event has ended, the picture will still exist, conferring on the event a kind of immortality (and importance) it would never otherwise have enjoyed. While real people are out there killing themselves or other real people, the photographer stays behind his or her camera, creating a tiny element of another world: the image-world that bids to outlast us all.

Photographing is essentially an act of non-intervention. Part of the horror of such memorable coups of contemporary photojournalism as the pictures of a Vietnamese bonze[2] reaching for the gasoline can, of a Bengali guerrilla in the act of bayoneting a trussed-up collaborator, comes from the awareness of how plausible it has become, in situations where the photographer has the choice between a photograph and a life, to choose the photograph. The person who intervenes cannot record; the person who is recording cannot intervene. Dziga Vertov's great film, *Man with a Movie Camera* (1929), gives the ideal image of the photographer as someone in perpetual movement, someone moving through a panorama of disparate events with such agility and speed that any intervention is out of the question. Hitchcock's *Rear Window* (1954) gives the complementary image: the photographer played by James Stewart has an intensified relation to one event, through his camera, precisely because he has a broken leg and is confined to a wheelchair; being temporarily immobilized prevents him from acting on what he sees, and makes it even more important to take pictures. Even if incompatible with intervention in a physical sense, using a camera is still a form of participation. Although the camera is an observation station, the act of photographing is more than passive observing. Like sexual voyeurism, it is a way of at least tacitly, often explicitly, encouraging whatever is going on to keep on happening. To take a picture is to have an interest in things as they are, in the status quo remaining unchanged (at least for as long as it takes to get a "good" picture), to be in complicity with whatever makes a subject interesting, worth photographing—including, when that is the interest, another person's pain or misfortune. ○

1. *Babbittry* is a term, based on Sinclair Lewis's novel *Babbit* (1925), for Americans who define themselves by ready-made products and opinions. [ed.]

2. A *bonze* is a Buddhist monk. [ed.]

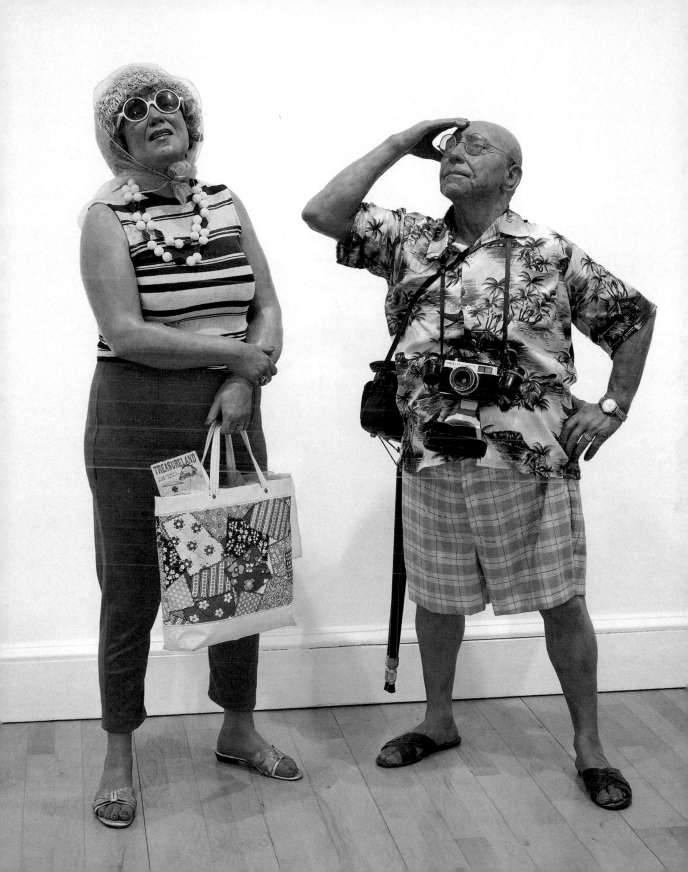

Viewfinder

Ethan Canin

I TELL MY WIFE, I'LL ALWAYS REMEMBER THIS photograph of my mother. She's out in back, hanging the blankets to dry on our backyard lines after one of our picnics, and she looks so young, the way I remember her before we moved to California. I was ten, I think. We used to have picnics out there under the water tower when my father got home from work, out in back on the grass on a set of big gray movers' blankets. My father and the man next door had built a pool from a truck tire set in concrete, and they filled it with water for my brother and me to splash in. I remember the day this picture was taken, because my mother had to hang the blankets to dry after we'd soaked them from the pool. My father was mad but she wasn't. She was never mad at us. I haven't seen that picture in years, I tell my wife. But I remember it.

And then one day, for no reason I can fathom, my wife is looking through the old cardboard-sided valise where my mother had kept her pictures, and she says, Here? Is this the one you're always talking about? And I say, Yes, I can't believe you found it. And she says, Those aren't movers' blankets, those are some kind of leaves up in the foreground. They look like something tropical, maybe rubber leaves. She's not hanging laundry at all. I say, Wait a minute—let me see. And I laugh and say, You're right. How can that be? My whole life I've remembered that picture of her hanging those blankets after we'd soaked them. I can even remember the picnic. She says, That's funny, isn't it? I say, My mother was so beautiful.

Our own children are out back in our own yard. It's too cool here for a pool, but I've built them a swingset from redwood, and I take a look out the window at them climbing it the way I've told them not to.

And then a few minutes later my wife says, Look at this, and she hands me the picture again, turned over. On the back it says, Vivian, Fort Barnwell, 1931. That's not your mother at all, she says. That's your grandmother. I say, Let me see that. I say, My God, you're right. How could that have happened? ○

Keep the story with a KODAK

Today it's a picture of Grandmother reading to the children. Tomorrow
it may be Bobbie playing traffic policeman or Aunt Edna at the wheel of her
new car or Brother Bill back from college for the week-end or—
There's always another story waiting for your Kodak.

Free at your dealer's or from us—"At Home with the Kodak," a well
illustrated little book that will help in picture-making at your house.

Autographic Kodaks $6.50 up

Eastman Kodak Company, Rochester, N. Y., *The Kodak City*

THE PHOTOGRAPH

N. Scott Momaday

WHEN I FIRST LIVED ON THE NAVAJO RESERVATION there were no cars, except those that were government property or that belonged to the Indian Service employees. The Navajos went about in wagons and on horseback, everywhere. My father worked for the Roads Department on the Navajo reservation. I lived for those trips, for he would often take me with him. I got a sense of the country then; it was wild and unending. In rainy weather the roads became channels of running water, and sometimes a flash flood would simply wash them away altogether, and we would have to dig ourselves out of the mud or wait for the ground to freeze. And then the wagons would pass us by or, if we were lucky, some old man would unhitch his team and pull us out to firm ground.

"Ya'at'eeh," the old man would say.

"Ya'at'eeh, shicheii," my father would reply.

"Hagosha' diniya?"

"Nowhere," my father would say, "we are going nowhere."

"Aoo', atiin ayoo hastlish." Yes, the road is very muddy, the old man would answer, laughing, and we knew then that we were at his mercy, held fast in the groove of his humor and goodwill. My father learned to speak the Navajo language in connection with his work, and I learned something of it, too—a little. Later, after I had been away from the Navajo country for many years, I returned and studied the language formally in order to understand not only the meaning but the formation of it as well. It is a beautiful language, intricate and full of subtlety, and very difficult to learn.

There were sheep camps in the remote canyons and mountains. When we ventured out into those areas, we saw a lot of people, but they were always off by themselves, it seemed, living a life of their own, each one having an individual existence in that huge landscape. Later, when I was learning to fly an airplane, I saw the land as a hawk or an eagle sees it, immense and wild and all of a piece. Once I flew with a friend to the trading post at Low Mountain where we landed on a dirt road in the very middle of the reservation. It was like going backward in time, for Low Mountain has remained virtually undiscovered in the course of years, and there you can still see the old people coming in their wagons to get water and to trade. It is like Kayenta was in my earliest time on the reservation, so remote as to be almost legendary in the mind.

My father had a little box camera with which he liked to take photographs now and then. One day an old Navajo crone came to our house and asked to have her picture taken. She was a gnarled old woman with gray hair and fine pronounced features. She made a wonderful subject, and I have always thought very well of the photograph that my father made of her. Every day thereafter she would come to the house and ask to see the print, and every day my father had to tell her that it had not yet come back in the mail. Having photographs processed was a slow business then in that part of the world. At last the day came when the print arrived. And when the old woman came, my father presented it to her proudly. But when she took a look at it, she was deeply disturbed, and she would have nothing to do with it. She set up such a jabber, indeed, that no one could understand her, and she left in a great huff. I have often wondered that she objected so to her likeness, for it was a true likeness, as far as I could tell. It is quite possible, I think, that she had never seen her likeness before, not even in a mirror, and that the photograph was a far cry from what she imagined herself to be. Or perhaps she saw, in a way that we could not, that the photograph misrepresented her in some crucial respect, that in its dim, mechanical eye it had failed to see into her real being. ○

SUSAN SONTAG

From the 1960s through the 1980s, Susan Sontag was one of America's foremost intellectuals, cultural commentators, and provocateurs. Her essays brilliantly explained the country and its culture, especially the avant garde. In *Notes on Camp* (1964) she accurately described the absurdity of attributes of taste; in *Against Interpretation* (1966) she limned Anglo-American fiction; in *Illness as Metaphor* (1978), which grew out of her own battle with breast cancer, she cast a fresh eye on disease, a subject that she revisited in *AIDS and Its Metaphors* (1988). Her novel *The Volcano Lover* (1992) was a bestseller: "No book I ever wrote came near to selling as many copies or reaching as many readers," she has said.

Sontag was born in New York City in 1933 but was raised in Tucson, Arizona, and Los Angeles.

On Photography
Susan Sontag

DUANE HANSON

Sculptor Duane Hanson (1926–1996) made his mark on the art world in the 1970s with true-to-life, cast fiberglass people. The unattractive, the elderly, the ordinary people whom we overlook every day are transformed by Hanson's sculpture into art objects worthy of our close inspection. Dressed in real clothing and equipped with accessories, Hanson's models are shocking in their "aliveness."

Born in Minnesota, Hanson spent much of his life in Miami. The Whitney Museum of American Art, in New York, held a retrospective of his work in 1999.

ETHAN CANIN

Ethan Canin was born in 1960 in Ann Arbor, Michigan, and grew up in California. He studied engineering at Stanford University and then earned a Master of Fine Arts degree from the University of Iowa in 1984. Never expecting that he could earn a living from writing, he attended medical school at Harvard University and earned his M.D. in 1991. Canin's career plans were changed permanently when his first collection of short stories, *Emperor of the Air* (1989), became a critically acclaimed bestseller. Since then he has published a second collection of short stories, *The Palace Thief* (1994), and two novels, *Blue River* (1991) and *For Kings and Planets* (1998).

CATHERINE WAGNER

Catherine Wagner is a highly acclaimed photographer who is celebrated for her ability to record and develop a sense of place in photographs. In addition to domestic interiors, Wagner has pursued projects at sites as varied as school classrooms, science laboratories, and Disney theme parks. Born in San Francisco in 1953, Wagner teaches art and photography at Mills College in Oakland, California.

MARTIN PARR

"The best way to describe my work," says Martin Parr, "is subjective documentary." Over the past twenty-five years the British-born photographer has established an international reputation for making photographs that document the social foibles, stereotypes, and iconography of various places and people. A member of the prestigious photographers' collective Magnum Photos since 1992, he is the recipient of numerous awards and has published fourteen books and catalogues to date. In *A Small World* (1995), Parr captures with wit and irony the discovery made by many tourists—seeking unique experiences in unison, they invariably find each other.

KODAK

George Eastman's first "photographic outfit," which he purchased in 1875, weighed about 100 pounds and required the use of wet glass plates and a crate of chemicals. In 1878 Eastman founded the Kodak Company with the intention of "making photography as convenient as a pencil." The invention of roll film in 1889, portable hand-held cameras, home movie cameras, sound-sensitive movie film, color-slide film, automated film development, photo billboards, and digital cameras are just a few of Kodak's developments. One of the twenty-five largest companies in the United States, Kodak continues to pioneer new "image technologies" that affect the visual content of our daily lives.

N. SCOTT MOMADAY

N. Scott Momaday was born on a Kiowa reservation in Oklahoma in 1934. His father was Kiowa; his mother was Cherokee, French, and English. He has spent his life and his career reconstructing the story of the Kiowa tribe—its myths, its history, and, most important, its oral tradition. His first novel, *House Made of Dawn* (1968), focuses on the clash between the Native American world and the white world; it won a Pulitzer Prize. Momaday has since written essays, poetry, autobiography, and fiction, almost all of which draws on and explores the story of his people and their land.

SEEING

1. Susan Sontag observes that "photography is not practiced by most people as an art. It is mainly a social rite, a defense against anxiety, and a tool of power" (para. 1). Given your own experience taking pictures, would you agree or disagree with her assertion? Now examine each of the visual images and prose selections included in this section. To what extent do you think each writer and photographer represented here would agree or disagree with Sontag? Are family photos like the one shown in Catherine Wagner's "Monica and Jack P." merely a "defense against anxiety"? If so, anxiety about what? Does Ethan Canin's short story treat the photograph as a "tool of power"? If so, what kind of power?

2. Sontag declares that "a photograph is not just the result of an encounter between an event and a photographer; picture-taking is an event in itself, and one with ever more peremptory rights—to interfere with, to invade, or to ignore whatever is going on. Our very sense of situation is now articulated by the camera's interventions" (para. 8). Sontag seems to be saying that the camera or act of taking pictures is more important than either the photographer or the event. Use any of the selections in this section as support for explaining why you do or do not agree with her.

WRITING

1. Sontag writes: "For at least a century, the wedding photograph has been as much a part of the ceremony as the prescribed verbal formulas" (para. 2). Write an essay in which you compare the differences between (1) the function—and the visibility—of photography in your parents' wedding and (2) its presence and role in a wedding you attended in the past year or two. Draw inferences about the extent to which the role of photography in the more recent wedding has become analogous to what Sontag calls "prescribed verbal formulas."

2. Sontag observes that "A family's photograph album is generally about the extended family—and, often, is all that remains of it" (para. 3). How important are photographs to your sense of family? Write an essay in which you describe your extended family—grandparents, aunts, uncles, cousins—using the role of family photographs as a way to frame your argument.

Figuring the Body

Images of the body are everywhere to be seen in American popular culture: on billboards along the side of the road, on computer and TV screens, on the pages of magazines and newspapers, in museums, galleries, and libraries. It's difficult to believe that a hundred years ago the American public was shocked by the glimpse of a woman's naked ankle. Today we're all accustomed to advertisers using bulging biceps and bare necks to sell everything from cigarettes and cars to cereal and cell phones.

Magazine headlines entice readers with the keys to achieving "The Perfect Body." The language surrounding the shaping of the body is commonplace; *toning, nipping, tucking, shaping,* and *figuring* are all terms in the public discourse.

An entire industry of products promoting beauty and well-being reveals a health-obsessed culture. Gyms and fitness clubs are ubiquitous in cities and small towns across America. Infomercials, self-help manuals, talk shows, and dieting centers all cater to—and perpetuate—Americans' obsession with weight and fat. Food packaging caters to health-conscious consumers, highlighting the terms *natural, low-fat, low-cholesterol,* and *healthy.* The athletic look has seeped into the realm of fashion to such an extent that even if you've never shot a basket or lifted a dumbbell, you can look like you've just come from the gym.

To judge from consumer culture, the body is the celebrated center of public life. However, the private body is often a source of shame and fear, something to be controlled and yet beyond control. Whether it's "heroin chic" or the healthy athletic look, few Americans actually reflect the latest trend in body type represented in fashion and advertising; nevertheless more and more Americans—and young Americans in particular—see themselves through the lenses of popular images of the body. It is no surprise that the incidence of anorexia and bulimia among teenage girls is on the rise.

Artists and writers are reimagining the body, and scientists and engineers are redesigning and rebuilding it. Body parts are now transferable, the genetic code alterable. Childbirth can be contracted to surrogate mothers, and life prolonged far beyond the brain's ceasing to function. The body can be transformed even after death; an endless supply of digital cadavers are now available "on line" and in "living color." "At the end of the twentieth century," writes historian Joan Jacobs Brumberg in her book *The Body Project* (1997), "the body is regarded as something to be managed and maintained, usually through expenditures on clothes and personal grooming items, with special attention to exterior surfaces—skin, hair, and contours. In adolescent girls' private diaries and journals, the body is a consistent preoccupation, second only to peer relationships. 'I'm so fat, [hence] I'm so ugly,' is as common a comment today as are classic adolescent ruminations about whether Jennifer is a true friend or if Scott likes Amy."

Even as we regard the body as something to be mastered and shaped, it is also a site of identity—our bodies shape who we are, how we see ourselves, and how we are perceived. We inherit our mother's hands or our

Mario Testino, **Shalom and Linda, Paris**

grandfather's eyes. We communicate through body language: posture, facial expression, gesture, speech, accent, height, skin color. If the body can be the site of torment and pain, it can also be the vehicle for achieving artistic and athletic excellence. We are in awe of the athletic mastery of great athletes such as Michael Jordan and the graceful power of skilled dancers such as Mikhail Barishnikov. Indeed, dancers and athletes focus countless hours on making their bodies the sites of perfect motion, while politicians and actors study how to communicate compassion, strength, or determination through simple gesture and facial expression.

Although the terms and the images have changed over the decades, Americans continue to be obsessed with the body. A recent study revealed that by age 13, "53 percent of American girls are unhappy with their bodies; by age 17, 78 percent are dissatisfied." But this sense of unease is long-standing in American culture. From turn-of-the-century hygiene manuals that proclaimed physical fitness as a "sign" of moral purity, to the latest trends in cosmetic surgery, piercing, and tattooing, the body continues to serve as a display board for what is *en vogue* and as a locus for expressing ourselves and fashioning an identity.

Now equally the province of anthropologists, historians, writers, psychologists, philosophers, sociologists, physicians, and artists, the body has been so analyzed and scrutinized that it is at once an anatomical object and a social construction. In the public eye, the body has been reconceived as both a playground and a battleground, a site for what the sociologist Carol Gilligan calls "a repository of experience and desire."

MARIO TESTINO

Born in Peru in 1954, Mario Testino is one of the world's premier fashion photographers. A flamboyant lifestyle and well-publicized friendships with celebrities make him an integral part of the fashionable world he photographs. Although most of his subjects are models, they are not always shot in model poses. His dressing-room photos of "supermodels" reveal the private emotions behind the scenes of the fashion industry.

Testino's photographs of the late Princess Diana in the July 1997 issue of *Vanity Fair* are among his most famous, exemplifying his glamorous vision of richly saturated colors and dramatic settings. In 1998 Testino published a book of photographs entitled *Any Objections,* from which these two images are drawn. In this compilation, Testino ventures outside the fashion world and explores a wide range of subjects from high and low culture around the globe.

"For his first book," writes Patrick Kinmouth in the introduction to *Any Objections,* "he did not choose to assemble the kind of pictures that have made him famous. . . . Instead he has selected largely unseen pictures . . . and made them into a documentary. . . . This process he describes as distinct from the business of taking fashion pictures. There his role is carefully to construct the image; here, his role is immediately to trap it as it flashes by."

SEEING

1. What do you notice first about the photograph of the two men? of the two women? How would you characterize the depiction of their bodies in each photograph (the way the photos are cropped, the amount of body exposed, etc.)? In what ways do the people in each photograph acknowledge the presence of the photographer? What additional points of comparison and contrast do you notice in the two photographs?

2. Testino's photograph of the two women could easily be placed in any fashion magazine. Would you be surprised to find the photo of the two men in *Allure* or *Elle?* Why or why not? What would be the effect of reversing the order of these images? What is the overall effect of juxtaposing the two very different images? (Does it change the way you perceive one or the other?)

WRITING

1. Which of Testino's photographs do you like better? Write an informal essay in two parts: In the first part, carefully describe the figures in each photograph, what's in the background, and the mood evoked by each; in the second part, try to articulate why you respond more positively to one than the other.

2. In the Preface to his beautifully illustrated and insightful study *The Body,* author and photo curator William Ewing asks: "Why is it today that the human body is at the centre of so much attention? Why are magazines, newspapers, television, and advertisements saturated with images of naked, or virtually naked, bodies? Why are so many writers, artists and photographers so profoundly concerned with the subject?" Write the first draft of a cause-and-effect essay in which you answer Ewing's question and try to account for the preoccupation with the body in contemporary American culture.

PORTRAIT OF MY BODY
Phillip Lopate

I AM A MAN WHO TILTS. WHEN SITTING, MY HEAD slants to the right; when walking, the upper part of my body reaches forward to catch a sneak preview of the street. One way or another, I seem to be off-center—or "uncentered," to use the jargon of holism. My lousy posture, a tendency to slump or put myself into lazy contorted misalignments, undoubtedly contributes to lower back pain. For a while I correct my bad habits, do morning exercises, sit straight, breathe deeply, but always an inner demon that insists on approaching the world askew resists perpendicularity.

I think if I had broader shoulders I would be more squarely anchored. But my shoulders are narrow, barely wider than my hips. This has always made shopping for suits an embarrassing business. (Françoise Gilot's *Life with Picasso* tells how Picasso was so touchy about his disproportionate body—in his case all shoulders, no legs—that he insisted the tailor fit him at home.) When I was growing up in Brooklyn, my hero was Sandy Koufax, the Dodgers' Jewish pitcher. In the doldrums of Hebrew choir practice at Feigenbaum's Mansion & Catering Hall, I would fantasize striking out the side, even whiffing twenty-seven batters in a row. Lack of shoulder development put an end to this identification; I became a writer instead of a Koufax.

It occurs to me that the restless angling of my head is an attempt to distract viewers' attention from its paltry base. I want people to look at my head, partly because I live in my head most of the time. My sister, a trained masseuse, often warns me of the penalties, like neck tension, which may arise from failing to integrate body and mind. Once, about ten years ago, she and I were at the beach, and she was scrutinizing my body with a sister's critical eye. "You're getting flabby," she

said. "You should exercise every day. I do—look at me, not an ounce of fat." She pulled at her midriff, celebrating (as is her wont) her physical attributes with the third-person enthusiasm of a carnival barker.

"But," she threw me a bone, "you do have a powerful head. There's an intensity. . . ." A graduate student of mine (who was slightly loony) told someone that she regularly saw an aura around my head in class. One reason I like to teach is that it focuses fifteen or so dependent gazes on me with such paranoiac intensity as cannot help but generate an aura in my behalf.

I also have a commanding stare, large sad brown eyes which can be read as either gentle or severe. Once I watched several hours of myself on videotape. I discovered to my horror that my face moved at different rates: sometimes my mouth would be laughing, eyebrows circumflexed in mirth, while my eyes coolly gauged the interviewer to see what effect I was making. I am something of an actor. And, like many performers, the mood I sense in myself is that of energy-conserving watchfulness; but this expression is often mistaken (perhaps because of the way brown eyes are read in our culture) for sympathy. I see myself as determined to the point of stubbornness, selfish, even a bit cruel—in any case, I am all too aware of the limits of my compassion, so that it puzzles me when people report a first impression of me as gentle, kind, solicitous. In my youth I felt obliged to come across as dynamic, intimidating, the life of the party; now, surer of myself, I hold back some energy, thereby winning time to gather information and make better judgments. This results sometimes in a misimpression of my being mildly depressed. Of course, the simple truth is that I have less energy than I once did, and that accumulated experiences have made me, almost against my will, kinder and sadder. ○

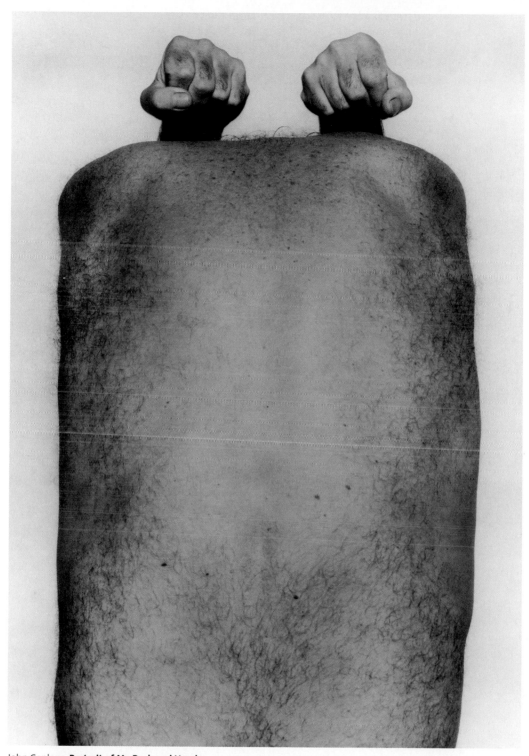

John Coplans, **Portrait of My Back and Hands**

PHILLIP LOPATE

"I am a man who tilts," writes Phillip Lopate (b. 1943) in his essay "Portrait of My Body"; although he is speaking literally about his neck, Lopate might well be metaphorically referring to his worldview in general. "I want to record how the world *comes at me,* because I think it is indicative of the way it comes at everyone. And to the degree that it is not, then my peculiarities should strengthen the reader's own sense of individuality."

As the author of more than seven books, Lopate has written essays on topics as diverse as raging landlords, teaching school, and his daughter's birth. As editor of the popular collection *The Art of the Personal Essay: An Anthology from the Classical Era to the Present* (1994) and several editions of the *Anchor Essay Annual,* he has done much to call attention to the essay as an important form in contemporary American literature.

An avid film fan and critic, he often superimposes the visual metaphors of the movies onto everyday life, finding his parents' marriage reflected in Cecil B. DeMille's epic *Samson and Delilah* and his own romantic fortunes foretold in the work of the German filmmaker Rainier Fassbinder. His collection *Totally, Tenderly, Tragically* (1998) focuses exclusively on film. Lopate is currently a professor of English at Hoftstra University.

JOHN COPLANS

Born in London in 1920, John Coplans first skirmished with the art world at age 13 when he was expelled from school for possessing pictures of nude women. At 16 he left school and by 1943 was leading a British Army brigade in Burma. Searching for a livelihood after World War II, Coplans discovered that "the educational requirements to become an artist are minimal."

After studying in London, Coplans had his first one-man show of abstract paintings in 1957. Sensing that "the future of Art was in America," he moved to San Francisco in 1960. Subsequently he became a key voice in the American art world, first as co-founder of *Artforum* magazine and then as director of the Pasadena Art Museum, where he staged some of this country's early pop art exhibits. In the late 1970s Coplans worked as a free-lance curator, critic, and writer. In 1980 a renewed interest in photography inspired him to return to creative work.

Using his own aging body, Coplans photographed hands, feet, back, and even genitals in styles and poses from various periods of art, to present his "personal" view of art history. Startling and deeply humorous, this work was widely exhibited and published—in *A Body of Work* (1987), *Hand* (1988), and *Foot* (1989)—and collected in *John Coplans: A Self-Portrait 1984–1997.*

SEEING

1. Which words and phrases do you find most engaging and memorable in Phillip Lopate's portrait of his body? Characterize the tone of voice he adopts in describing himself. What does he mean when he observes that he seems to be "off-center"? What distinctions can you draw between being "off-center" and being "uncentered"? How might Lopate's stance toward creating a prose portrait of his body be said to tilt?

2. Examine the photograph by John Coplans. Were it not for the clenched fists, would you recognize this photograph as someone's back? What is there in this picture that attracts—and holds—your attention? What, for example, does Coplans achieve by placing the clenched fists in this position rather than, say, on the sides of his body? Comment on the overall effect(s) of his self-portrait. Does it tilt?

3. In what ways does Coplans's portrait of a back remind you of Lopate's verbal portrait of his body? What similar techniques do Lopate and Coplans use to create their portraits of a body? What differences distinguish their approaches to the same subject? Which do you prefer? Why?

WRITING

1. Your goal is to create a prose portrait of your body. Which aspect(s) of your physical identity would you focus on in your description? Which would you downplay? How would you organize an essay about your own body? What tone of voice would you use to introduce your readers to the ways in which you see your body? What overall impression of yourself would you hope to create in this portrait? After you have settled on answers to these questions—and developed others of your own—draft a brief essay (five or six paragraphs) that gives readers a compelling "portrait" of your body.

2. In paragraph 5, Lopate introduces a new subject: the kinds of daily readings and misreadings each of us engages in as we decipher the meaning and significance of the body language of those with whom we are speaking. Choose some source of facial expression— a wink, a smile, a nod. Then conduct library research on the subject of body language and, more specifically, on the importance of this particular facial expression in conveying messages to those with whom we speak. Draft an expository essay in which you lay out the possible interpretations of this facial expression, testing that explanation against your experience and that of your friends or relatives.

To engage in a fight on horseback in which your aim is to knock your opponent off his horse by charging him with your lance; to slant; to incline toward an opinion, action, or one side of an argument.

KIKI SMITH

Kiki Smith says of her work: "I think I chose the body as a subject not consciously, but because it is the one form we all share; it's something that everyone has their own authentic experience with."

An adventurous sculptor whose work can be said to center on human anatomy, Smith gained an understanding of the body from first-hand experience. Trained as an emergency medical technician in New York City, she presents the body not always as a unified entity but as the site of many different processes and functions. Within that view Smith has constructed her work from a variety of methods and materials, including glass, embroidery, and quilting. *Lilith*, shown here, was sculpted in 1994 of silicon bronze and glass.

Kiki Smith was born in Germany in 1954; her father was the minimalist sculptor Tony Smith. She has lived in New York since 1976. Her works have been shown at the Whitney Biennials of 1991 and 1993 and are also in the collections of the Art Institute of Chicago, the Museum of Modern Art in New York, the Tate Gallery, and numerous European collections.

In Hebrew legend Lilith was the first wife of Adam, before Eve. Lilith and Adam were both created in the same way and were equals until Adam tried to use force to make her submit to his will; she uttered God's name and flew away.

SEEING

1. What are some of the ways in which a sculpture differs from a painting? How does it change your experience of *Lilith* to see it here as a photograph rather than as a sculpture? To what extent does the position of the figure influence your reaction to it? What do you think the figure is doing? What adjectives would you use to characterize this work of art? Explain your choices.

2. Great works of sculpture draw our eye to detail. We admire, for example, the care and sensitivity with which the sculptor handles the surface of the form. Which details in this sculpture are you drawn to—and with what effects? One of the most important aspects of appreciating a sculpture is light. The amount of light—and the direction it falls on the sculpture—accentuates the dramatic effects of details. How does the use of light in this photograph highlight particular dimensions of its composition? Does knowing Kiki Smith's title— Lilith —change the way you interpret this sculpture? Does it change the way you see it to know what it's composed of—bronze and glass?

WRITING

1. It is not attention to verisimilitude—realistic detail— alone that makes a sculpture truly memorable. If that were so, then the figures in wax museums would line the corridors of most museums. What aspect of sculpture makes it so memorable to observe? Write the first draft of an essay in which you identify what is unique about a three-dimensional work of art. What is special about the interaction between object and viewer when the object is a sculpture?

2. One of Smith's achievements is that her sculptures enable us to perceive new aspects of the human form. Compare and contrast the nature of Smith's presentation of this human form to John Coplans's photograph of his own back and hands (p. 203). Which do you find more engaging? surprising? What angle of vision is emphasized in each? with what effects? Which do you prefer? Why? Write an essay in which you explain why you find one of these works of art more artistically engaging and memorable than the other.

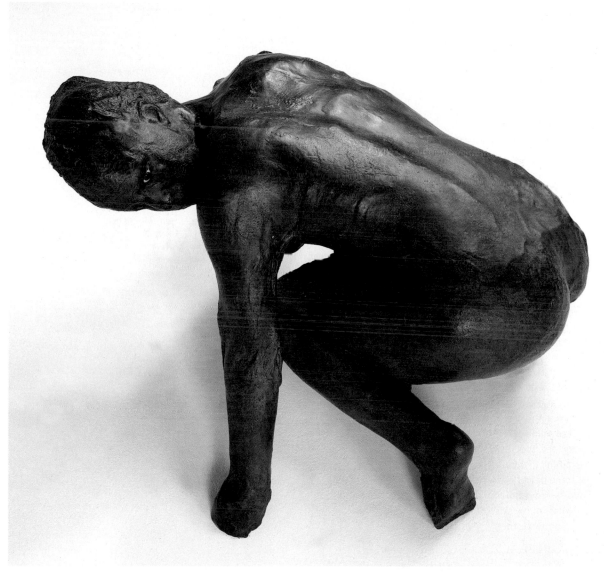

Kiki Smith, **Lilith**

JUDITH ORTIZ COFER

In an essay entitled "The Myth of the Latin Woman: I Just Met a Girl Named Maria," Judith Ortiz Cofer (b. 1952) talks of the prejudice she encountered as a youth: "As a Puerto Rican girl growing up in the United States and wanting like most children to 'belong,' I resented the stereotype that my Hispanic appearance called forth from many people I met."

Ortiz Cofer speaks with insight and eloquence about the costs of cultural transplantation and has established a reputation for writing finely crafted and deeply moving expressions of contemporary Puerto Rican experience. She first earned recognition for her literary talents through several collections of poetry. Her first novel, *The Line of the Sun* (1989), was nominated for a Pulitzer Prize and was followed by a compilation of poems and essays. More recently she has published prose and poetry in *The Latin Deli* (1993), *An Island Like You* (1995), and *The Year of Our Revolution* (1998).

Ortiz Cofer explains that "my personal goal in my public life is to replace the old pervasive stereotypes and myths about Latinas with a much more interesting set of realities.... I hope the stories I tell, the dreams and fears I examine in my work, can achieve some universal truth which will get my audience past the particulars of my skin color, my accent, or my clothes."

The Story of My Body

Judith Ortiz Cofer

Migration is the story of my body.
—Victor Hernández Cruz

SKIN

I was born a white girl in Puerto Rico but became a brown girl when I came to live in the United States. My Puerto Rican relatives called me tall; at the American school, some of my rougher classmates called me Skinny Bones, and the Shrimp because I was the smallest member of my classes all through grammar school until high school, when the midget Gladys was given the honorary post of front row center for class pictures and scorekeeper, bench warmer, in P.E. I reached my full stature of five feet in sixth grade.

I started out life as a pretty baby and learned to be a pretty girl from a pretty mother. Then at ten years of age I suffered one of the worst cases of chicken pox I have ever heard of. My entire body, including the inside of my ears and in between my toes, was covered with pustules which in a fit of panic at my appearance I scratched off my face, leaving permanent scars. A cruel school nurse told me I would always have them—tiny cuts that looked as if a mad cat had plunged its claws deep into my skin. I grew my hair long and hid behind it for the first years of my adolescence. This was when I learned to be invisible.

COLOR

In the animal world it indicates danger: the most colorful creatures are often the most poisonous. Color is also a way to attract and seduce a mate. In the human world color triggers many more complex and often deadly reactions. As a Puerto Rican girl born of "white" parents, I spent the first years of my life hearing people refer to me as *blanca*, white. My mother insisted that I protect myself from the intense island sun because I was more prone to sunburn than some of my darker, *trigueño* playmates. People were always commenting within my hearing about how my black hair contrasted so nicely with my "pale" skin. I did not think of the color of my skin consciously except when I heard the adults talking about complexion. It seems to me that the subject is much more common in the conversation of mixed-race peoples than in mainstream United States society, where it is a touchy and sometimes even embarrassing topic to discuss, except in a political context. In Puerto Rico I heard many conversations about skin color. A pregnant woman could say, "I hope my baby doesn't turn out *prieto*" (slang for "dark" or "black") "like my husband's grandmother, although she was a good-looking *negra* in her time." I am a combination of both, being olive-skinned—lighter than my mother yet darker than my fair-skinned father. In America, I am a person of color, obviously a Latina. On the Island I have been called everything from a *paloma blanca,* after the song (by a black suitor), to *la gringa.*

My first experience of color prejudice occurred in a supermarket in Paterson, New Jersey. It was Christmastime, and I was eight or nine years old. There was a display of toys in the store where I went two or three times a day to buy things for my mother, who never made lists but sent for milk, cigarettes, a can of this or that, as she remembered from hour to hour. I enjoyed being trusted with money and walking half a city block to the new, modern grocery store. It was owned by three good-looking Italian brothers. I liked the younger one with the crew-cut blond hair. The two older ones watched me and the other Puerto Rican kids as if they thought we were going to steal something. The oldest one would sometimes even try to hurry me with my purchases, although part of my pleasure in these expeditions came from looking at everything in the well-stocked aisles. I was also teaching myself to read English by sounding out the labels on packages: L&M cigarettes, Borden's homogenized milk, Red Devil potted ham, Nestle's chocolate mix, Quaker oats, Bustelo coffee, Wonder bread, Colgate toothpaste, Ivory soap, and Goya (makers of products used in Puerto Rican dishes) everything—these are some of the brand names that taught me nouns. Several times this man had come up to me, wearing his blood-stained butcher's apron, and towering over me had asked in a harsh voice whether there was something he could help me find. On the way out I would glance at the younger brother who ran one of the registers and he would often smile and wink at me.

It was the mean brother who first referred to me as "colored." It was a few days before Christmas, and my parents had already told my brother and me that since we were in Los Estados now, we would get our presents on December 25 instead of Los Reyes, Three Kings Day, when gifts are exchanged in Puerto Rico. We were to give them a wish list that they would take to Santa Claus, who apparently lived in the Macy's store downtown—at least that's where we had caught a glimpse of him when we went shopping. Since my parents were timid about entering the fancy store, we did not approach the huge man in the red suit. I was not interested in sitting on a stranger's lap anyway. But I did covet Susie, the talking schoolteacher doll that was displayed in the center aisle of the Italian brothers' supermarket. She talked when you pulled a string on her back. Susie had a limited repertoire of three sentences: I think she could say: "Hello, I'm Susie Schoolteacher," "Two plus two is four," and one other thing I cannot remember. The day the older brother chased me away, I was reaching to touch Susie's blonde curls. I had been told many times, as most children have, not to touch anything in a store that I was not buying. But I had been looking at Susie for weeks. In my mind, she was my doll. After all, I had put her on my Christmas wish list. The moment is frozen in my mind as if there were a photograph of it on file. It was not a turning point, a disaster, or an earth-shaking revelation. It was simply the first time I considered—if naively—the meaning of skin color in human relations.

I reached to touch Susie's hair. It seems to me that I had to get on tiptoe, since the toys were stacked on a table and she sat like a princess on top of the fancy box she came in. Then I heard the booming "Hey, kid, what do you think you're doing!" spoken very loudly from the meat counter. I felt caught, although I knew I was not doing anything criminal. I remember not looking at the man, but standing there, feeling humiliated because I knew everyone in the store must have heard him yell at me. I felt him approach, and when I knew he was behind me, I turned around to face the bloody butcher's apron. His large chest was at my eye level. He blocked my way. I started to run out of the place, but even as I reached the door I heard him shout after me: "Don't come in here unless you gonna buy something. You PR kids put your dirty hands on stuff. You always look dirty. But maybe dirty brown is your natural color." I heard him laugh and someone else too in the back. Outside in the sunlight I looked at my hands. My nails needed a little cleaning as they always did, since I liked to paint with watercolors, but I took a bath every night. I thought the man was dirtier than I was in his stained apron. He was also always sweaty—it showed in big yellow circles under his shirt-sleeves. I sat on the front steps of the apartment building where we lived and looked closely at my hands, which showed the only skin I could see, since it was bitter cold and I was wearing my quilted play coat, dungarees, and a knitted navy cap of my father's. I was not pink like my friend Charlene and her sister Kathy, who had blue eyes and light brown hair. My skin is the color of the coffee my grandmother made, which was half milk, *leche con café* rather than *café con leche*. My mother is the opposite mix. She has a lot of café in her color. I could not understand how my skin looked like dirt to the supermarket man.

I went in and washed my hands thoroughly with soap and hot water, and borrowing my mother's nail file, I cleaned the crusted watercolors from underneath my nails. I was pleased with the results. My skin was the same color as before, but I knew I was clean. Clean enough to run my fingers through Susie's fine gold hair when she came home to me.

SIZE

My mother is barely four feet eleven inches in height, which is average for women in her family. When I grew to five feet by age twelve, she was amazed and began to use the word tall to describe me, as in "Since you are tall, this dress will look good on you." As with the color of my skin, I didn't consciously think about my height or size until other people made an issue of it. It is around the preadolescent years that in America the games children play for fun

become fierce competitions where everyone is out to "prove" they are better than others. It was in the playground and sports fields that my size-related problems began. No matter how familiar the story is, every child who is the last chosen for a team knows the torment of waiting to be called up. At the Paterson, New Jersey, public schools that I attended, the volleyball or softball game was the metaphor for the battlefield of life to the inner city kids—the black kids versus the Puerto Rican kids, the whites versus the blacks versus the Puerto Rican kids; and I was 4F, skinny, short, bespectacled, and apparently impervious to the blood thirst that drove many of my classmates to play ball as if their lives depended on it. Perhaps they did. I would rather be reading a book than sweating, grunting, and running the risk of pain and injury. I simply did not see the point in competitive sports. My main form of exercise then was walking to the library, many city blocks away from my barrio.

Still, I wanted to be wanted. I wanted to be chosen for the teams. Physical education was compulsory, a class where you were actually given a grade. On my mainly all A report card, the C for compassion I always received from the P.E. teachers shamed me the same as a bad grade in a real class. Invariably, my father would say: "How can you make a low grade for *playing games?*" He did not understand. Even if I had managed to make a hit (it never happened) or get the ball over that ridiculously high net, I already had a reputation as a "shrimp," a hopeless nonathlete. It was an area where the girls who didn't like me for one reason or another—mainly because I did better than they in academic subjects—could lord it over me; the playing field was the place where even the smallest girl could make me feel powerless and inferior. I instinctively understood the politics even then; how the *not* choosing me until the teacher forced one of the team captains to call my name was a coup of sorts—there, you little show-off, tomorrow you can beat us in spelling and geography, but this afternoon you are the loser. Or perhaps those were only my own bitter thoughts as I sat or stood in the sidelines while the big girls were grabbed like fish and I, the little brown tadpole, was ignored until Teacher looked over in my general direction and shouted, "Call Ortiz," or, worse, "Somebody's *got* to take her."

No wonder I read Wonder Woman comics and 10 had Legion of Super Heroes daydreams. Although I wanted to think of myself as "intellectual," my body was demanding that I notice it. I saw the little swelling around my once-flat nipples, the fine hairs growing in secret places; but my knees were still bigger than my thighs, and I always wore long- or half-sleeve blouses to hide my bony upper arms. I wanted flesh on my bones—a thick layer of it. I saw a new product advertised on TV. Wate-On. They showed skinny men and women before and after taking the stuff, and it was a transformation like the ninety-seven-pound-weakling turned-into-Charles-Atlas ads that I saw on the back covers of my comic books. The Wate-On was very expensive. I tried to explain my need for it in Spanish to my mother, but it didn't translate very well, even to my ears—and she said with a tone of finality, eat more of my good food and you'll get fat—anybody can get fat. Right. Except me. I was going to have to join a circus someday as Skinny Bones, the woman without flesh.

Wonder Woman was stacked. She had a cleavage framed by the spread wings of a golden eagle and a muscular body that has become fashionable with women only recently. But since I wanted a body that would serve me in P.E., hers was my ideal. The breasts were an indulgence I allowed myself. Perhaps the daydreams of bigger girls were more glamorous, since our ambitions are filtered through our needs, but I wanted first a powerful body. I daydreamed of leaping up above the gray landscape of the city to where the sky was clear and blue, and in anger and self-pity, I fantasized about scooping my enemies up by their hair from the playing fields and dumping them on a barren asteroid. I would put the P.E. teachers each on their own rock in space too, where they would be the loneliest people in the universe, since I knew they had no "inner resources," no imagination, and in outer space, there would be no air for

them to fill their deflated volleyballs with. In my mind all P.E. teachers have blended into one large spiky-haired woman with a whistle on a string around her neck and a volleyball under one arm. My Wonder Woman fantasies of revenge were a source of comfort to me in my early career as a shrimp.

I was saved from more years of P.E. torment by the fact that in my sophomore year of high school I transferred to a school where the midget, Gladys, was the focal point of interest for the people who must rank according to size. Because her height was considered a handicap, there was an unspoken rule about mentioning size around Gladys, but of course, there was no need to say anything. Gladys knew her place: front row center in class photographs. I gladly moved to the left or to the right of her, as far as I could without leaving the picture completely.

LOOKS

Many photographs were taken of me as a baby by my mother to send to my father, who was stationed overseas during the first two years of my life. With the army in Panama when I was born, he later traveled often on tours of duty with the navy. I was a healthy, pretty baby. Recently, I read that people are drawn to big-eyed round-faced creatures, like puppies, kittens, and certain other mammals and marsupials, koalas, for example, and, of course, infants. I was all eyes, since my head and body, even as I grew older, remained thin and small-boned. As a young child I got a lot of attention from my relatives and many other people we met in our barrio. My mother's beauty may have had something to do with how much attention we got from strangers in stores and on the street. I can imagine it. In the pictures I have seen of us together, she is a stunning young woman by Latino standards: long, curly black hair, and round curves in a compact frame. From her I learned how to move, smile, and talk like an attractive woman. I remember going into a bodega for our groceries and being given candy by the proprietor as a reward for being *bonita,* pretty.

I can see in the photographs, and I also remember, that I was dressed in the pretty clothes, the stiff, frilly dresses, with layers of crinolines underneath, the glossy patent leather shoes, and, on special occasions, the skull-hugging little hats and the white gloves that were popular in the late fifties and early sixties. My mother was proud of my looks, although I was a bit too thin. She could dress me up like a doll and take me by the hand to visit relatives, or go to the Spanish mass at the Catholic church, and show me off. How was I to know that she and the others who called me "pretty" were representatives of an aesthetic that would not apply when I went out into the mainstream world of school?

In my Paterson, New Jersey, public schools there were still quite a few white children, although the demographics of the city were changing rapidly. The original waves of Italian and Irish immigrants, silk-mill workers, and laborers in the cloth industries had been "assimilated." Their children were now the middle-class parents of my peers. Many of them moved their children to the Catholic schools that proliferated enough to have leagues of basketball teams. The names I recall hearing still ring in my ears: Don Bosco High versus St. Mary's High, St. Joseph's versus St. John's. Later I too would be transferred to the safer environment of a Catholic school. But I started school at Public School Number 11. I came there from Puerto Rico, thinking myself a pretty girl, and found that the hierarchy for popularity was as follows: pretty white girl, pretty Jewish girl, pretty Puerto Rican girl, pretty black girl. Drop the last two categories; teachers were too busy to have more than one favorite per class, and it was simply understood that if there was a big part in the school play, or any competition where the main qualification was "presentability" (such as escorting a school visitor to or from the principal's office), the classroom's public address speaker would be requesting the pretty and/or nice-looking white boy or girl. By the time I was in the sixth grade, I was sometimes called by the principal to represent my class because I dressed neatly (I knew this from a progress report sent to my mother, which I translated for her) and because all the "presentable" white girls had moved

to the Catholic schools (I later surmised this part). But I was still not one of the popular girls with the boys. I remember one incident where I stepped out into the playground in my baggy gym shorts and one Puerto Rican boy said to the other: "What do you think?" The other one answered: "Her face is OK, but look at the toothpick legs." The next best thing to a compliment I got was when my favorite male teacher, while handing out the class pictures, commented that with my long neck and delicate features I resembled the movie star Audrey Hepburn. But the Puerto Rican boys had learned to respond to a fuller figure: long necks and a perfect little nose were not what they looked for in a girl. That is when I decided I was a "brain." I did not settle into the role easily. I was nearly devastated by what the chicken pox episode had done to my self-image. But I looked into the mirror less often after I was told that I would always have scars on my face, and I hid behind my long black hair and my books.

After the problems at the public school got to the point where even nonconfrontational little me got beaten up several times, my parents enrolled me at St. Joseph's High School. I was then a minority of one among the Italian and Irish kids. But I found several good friends there—other girls who took their studies seriously. We did our homework together and talked about the Jackies. The Jackies were two popular girls, one blonde and the other red-haired, who had women's bodies. Their curves showed even in the blue jumper uniforms with straps that we all wore. The blonde Jackie would often let one of the straps fall off her shoulder, and although she, like all of us, wore a white blouse underneath, all the boys stared at her arm. My friends and I talked about this and practiced letting our straps fall off our shoulders. But it wasn't the same without breasts or hips.

My final two and a half years of high school were spent in Augusta, Georgia, where my parents moved our family in search of a more peaceful environment. There we became part of a little community of our army-connected relatives and friends. School was yet another matter. I was enrolled in a huge school of

nearly two thousand students that had just that year been forced to integrate. There were two black girls and there was me. I did extremely well academically. As to my social life, it was, for the most part, uneventful—yet it is in my memory blighted by one incident. In my junior year, I became wildly infatuated with a pretty white boy. I'll call him Ted. Oh, he was pretty: yellow hair that fell over his forehead, a smile to die for—and he was a great dancer. I watched him at Teen Town, the youth center at the base where all the military brats gathered on Saturday nights. My father had retired from the navy, and we had all our base privileges—one other reason we had moved to Augusta. Ted looked like an angel to me. I worked on him for a year before he asked me out. This meant maneuvering to be within the periphery of his vision at every possible occasion. I took the long way to my classes in school just to pass by his locker, I went to football games, which I detested, and I danced (I too was a good dancer) in front of him at Teen Town—this took some fancy footwork, since it involved subtly moving my partner toward the right spot on the dance floor. When Ted finally approached me, "A Million to One" was playing on the jukebox, and when he took me into his arms, the odds suddenly turned in my favor. He asked me to go to a school dance the following Saturday. I said yes, breathlessly. I said yes, but there were obstacles to surmount at home. My father did not allow me to date casually. I was allowed to go to major events like a prom or a concert with a boy who had been properly screened. There was such a boy in my life, a neighbor who wanted to be a Baptist missionary and was practicing his anthropological skills on my family. If I was desperate to go somewhere and needed a date, I'd resort to Gary. This is the type of religious nut that Gary was: when the school bus did not show up one day, he put his hands over his face and prayed to Christ to get us a way to get to school. Within ten minutes a mother in a station wagon, on her way to town, stopped to ask why we weren't in school. Gary informed her that the Lord had sent her just in time to find us a way to get there in time for roll call. He as-

sumed that I was impressed. Gary was even good-looking in a bland sort of way, but he kissed me with his lips tightly pressed together. I think Gary probably ended up marrying a native woman from wherever he may have gone to preach the Gospel according to Paul. She probably believes that all white men pray to God for transportation and kiss with their mouths closed. But it was Ted's mouth, his whole beautiful self, that concerned me in those days. I knew my father would say no to our date, but I planned to run away from home if necessary. I told my mother how important this date was. I cajoled and pleaded with her from Sunday to Wednesday. She listened to my arguments and must have heard the note of desperation in my voice. She said very gently to me: "You better be ready for disappointment." I did not ask what she meant. I did not want her fears for me to taint my happiness. I asked her to tell my father about my date. Thursday at breakfast my father looked at me across the table with his eyebrows together. My mother looked at him with her mouth set in a straight line. I looked down at my bowl of cereal. Nobody said anything. Friday I tried on every dress in my closet. Ted would be picking me up at six on Saturday: dinner and then the sock hop at school. Friday night I was in my room doing my nails or something else in preparation for Saturday (I know I groomed myself nonstop all week) when the telephone rang. I ran to get it. It was Ted. His voice sounded funny when he said my name, so funny that I felt compelled to ask: "Is something wrong?" Ted blurted it all out without a preamble. His father had asked who he was going out with. Ted had told him my name. "Ortiz? That's

Spanish, isn't it?" the father had asked. Ted had told him yes, then shown him my picture in the yearbook. Ted's father had shaken his head. No. Ted would not be taking me out. Ted's father had known Puerto Ricans in the army. He had lived in New York City while studying architecture and had seen how the spics lived. Like rats. Ted repeated his father's words to me as if I should understand *his* predicament when I heard why he was breaking our date. I don't remember what I said before hanging up. I do recall the darkness of my room that sleepless night and the heaviness of my blanket in which I wrapped myself like a shroud. And I remember my parents' respect for my pain and their gentleness toward me that weekend. My mother did not say "I warned you," and I was grateful for her understanding silence.

In college, I suddenly became an "exotic" woman to the men who had survived the popularity wars in high school, who were now practicing to be worldly: they had to act liberal in their politics, in their lifestyles, and in the women they went out with. I dated heavily for a while, then married young. I had discovered that I needed stability more than social life. I had brains for sure and some talent in writing. These facts were a constant in my life. My skin color, my size, and my appearance were variables—things that were judged according to my current self-image, the aesthetic values of the times, the places I was in, and the people I met. My studies, later my writing, the respect of people who saw me as an individual person they cared about, these were the criteria for my sense of self-worth that I would concentrate on in my adult life. ○

SEEING

1. What are the features of the ideal body that Judith Ortiz Cofer imagines for herself? What kind of language does she use to describe her own, real body? Who are the figures she looks up to during her childhood? Why? From what aspects of the culture were these figures drawn? In what specific ways does Ortiz Cofer's memory of going to the local grocery store remind you of Eudora Welty's account of a similar experience? (See "The Little Store," p. 78.) In what ways is Ortiz Cofer's "portrait" of her body similar to—and different from—the concept of "double consciousness" defined by W. E. B. DuBois (p. 383)?

2. What principle of organization governs Ortiz Cofer's essay? What logical thread links one paragraph to another? Comment on the effectiveness of her use of metaphor and irony, and please support your response with specific examples. What does Cofer identify as the constant and the variables in her life? What conclusions do you draw from the "ending" of this essay? To what extent, for example, does our identity vary according to the context in which we find ourselves? Having reread the essay and thought about it carefully, what cultural implications can you identify in the title "The Story of My Body"?

WRITING

1. Ortiz Cofer's account of her childhood is punctuated by an oft-repeated admonition: "I had been told many times, as most children have, not to touch anything in a store that I was not buying" (para. 5). What repeated admonitions can you recall hearing as a child? Which ones do you associate with an especially memorable experience? Write the first draft of a narrative essay in which you recount how this maxim was invoked as a means of regulating your behavior.

2. At several points in her essay, Ortiz Cofer speaks of herself as "the Shrimp" and as "Skinny Bones." What nicknames have your peers applied to you, or what self-deprecating identity have you created for yourself? Write the first draft of an expository essay in which you account for the origins—and the personal consequences—of having taken on this nickname, willingly or not.

A usually humorous aspect of writing that calls attention to the difference between the actual result of a sequence of events and the expected result.

The Story of My Body

Judith Ortiz Cofer

TV Talking Pictures

Television and motion pictures are among the most powerful vehicles for establishing and distributing an ideal of physical beauty in American popular culture. Which television programs and recent films can you identify that capitalize on portraying such standards of beauty? Choose one television program or film. What visual and verbal strategies do the creators use to convey this standard of beauty? Which physical features do they focus on in order to promote it? What aspects of the body are given the most attention?

Review the research findings of Professors Langlois and Roggman as summarized in Bruce Bower's essay "Average Attractions" (see p. 222). What do you think their reaction would be to the standards promoted by the movie or television show you have chosen? Write an essay in which you analyze the features of physical beauty projected in the film or television show. Explain to what extent these features are the same as the standard "average" that Americans apply to themselves.

ANNIE LEIBOVITZ

Annie Leibovitz was a student at the San Francisco Art Institute in 1970 when she snapped a picture of poet Allen Ginsburg smoking marijuana, which found its way to *Rolling Stone* magazine. After joining their staff and photographing pop music icons such as Jerry Garcia and Mick Jagger, Leibovitz developed her signature high-contrast style: "I almost overlit everything, using several strobes and available light. I had to do this to get the contrast necessary to reproduce well on newsprint."

Leibovitz is well known for posing her subjects to illustrate their personalities, such as showing Roseanne Barr as a mud wrestler or Whoopi Goldberg in a tub of milk. Of her Olympic photographs Leibovitz writes, "I am not a sports photographer. I'm a portrait photographer . . . who has always been more interested in what people do than in the way they look. . . . There is nothing people do which is more intensely reflected in the way they look than athletics."

Leibovitz now works for *Vanity Fair* magazine. Her book *Photographs: Annie Leibovitz 1970–1990* was on the *New York Times* bestseller list in 1991. That same year she became the second living photographer to be given a solo exhibition at the National Portrait Gallery at the Smithsonian Institution in Washington, D.C. Unique among photographers, Leibovitz has become as much a public icon as her subjects.

Dennis Mitchell, Track

Lily Yip, Table Tennis

Jackie Joyner-Kersee, Track and Field

Gwen Torrence, Track

SEEING

1. Celebrity photographer Annie Leibovitz has earned an international reputation for being able to capture the essence of her subjects on film. What do you notice about the nature of the body depicted in these images from her book *Olympic Portraits?* What specifically links—and distinguishes—each of the four portraits? To what extent does each photograph satisfy the expectations associated with the word portrait?

2. Leibovitz has said, "There is nothing people do which is more intensely reflected in the way they look than athletics." Examine the images of Dennis Mitchell bursting out of the starting blocks and of Lily Yip returning a volley. What do you notice about the body position of each figure? What does Leibovitz enable us to see in these stop-action photographs that our eyes are rarely able to see in everyday life? Compare and contrast the sense of movement she presents in these images with the photograph of Jackie Joyner-Kersee holding a javelin. Finally, what do you notice about the close-up photograph of Gwen Torrence? How is what these athletes do reflected in the way they look?

WRITING

1. What is present—or absent—from Leibovitz's photographs that you associate with the Olympics? What details in the photographs reinforce or challenge your sense of the way bodies should look in this sporting spectacle? Write an expository essay in which you explain how Leibovitz's photographs do—or do not—satisfy your expectations of the physical nature of Olympic competition.

2. Check the sports section in a recent edition of your local newspaper. What are the features of the photographs you see there? Where is each photograph positioned in relation to the written account of the competition? How important do you think the photograph is in determining the impact of the story? Write the first draft of an essay in which

A picture or painting of a person, usually showing the face; historically, portraits have included objects, clothing, or other markers that help identify or categorize the person portrayed.

you discuss the role of photographs in sports reporting. What are the advantages and disadvantages of including a photograph in an account of an athletic competition?

BRUCE BOWER

Bruce Bower has been writing about behavioral science and other topics for *Science News* magazine since 1984. He compares the arena of behavioral sciences today to the Wild West, where many ideas vie for territory like so many settlers. "The problem with the field is that there is just no accurate way to measure many different human reactions," he remarks. In viewing scientific work, Bower urges that we look beyond our own cultural norms "not only at the evidence presented, but at the assumptions that underlie the evidence. Often scientists themselves are not aware of their assumptions."

Regarding the state of popular science research today, Bower suggests that the developments we read about may not always be the most critical issues. "People who can present simple 'sound bite' answers are often given attention over those who are doing work that is harder to summarize." The essay "Average Attractions" first appeared in *Science News* in 1990; in it, Bower reports on a study that attempts to define standards of beauty.

Among other topics covered in Bower's numerous articles are the relationship between sex and cigarettes, Western notions of the mind, and the basis of decision making and intuition. He attended Pepperdine University, where he studied psychology, as well as the University of Missouri School of Journalism.

Bruce Bower

Average Attractions

Here she comes, Miss America. Her demeanor exudes poise, her figure curves gracefully, her face is incredibly average.

That's right, average. And no, the computer did not jumble the judges' votes, at least not according to Judith H. Langlois of the University of Texas at Austin and Lori A. Roggman of the University of Arkansas at Fayetteville. These two psychologists have provided a scientific answer to a question that has puzzled philosophers for centuries: What constitutes physical beauty? Their surprising answer: The most attractive people are not blessed with rare physical qualities others can only dream about. A knockout face possesses features that approximate the mathematical average of all faces in a particular population.

In other words, Miss America's face is an extremely typical example of all faces, constituting what psychologists call a facial "prototype." Strictly speaking, her beauty is average. And the same goes for handsome male faces.

"This is a very exciting principle," says psychologist Ellen S. Berscheid of the University of Minnesota in Minneapolis. "We can get an empirical handle on facial beauty now."

Until seeing Langlois and Roggman's data, Berscheid, like most other investigators of physical attraction, contended that physical beauty was unmeasurable. Good looks were assumed to be perceived as a unified whole, a kind of "gestalt face" that could not be broken down or averaged in the laboratory. "We thought it was impossible to determine whether, say, Cary Grant's ears or Elizabeth Taylor's nose are attractive in an absolute sense," Berscheid remarks.

If Berscheid's about-face foreshadows a widespread adoption of the notion that attractive faces are average, the implications will extend beyond rating the raw beauty of movie stars. For instance, an analysis of groups of children's faces at different ages might provide surgeons with reliable guideposts for reconstructing craniofacial deformities resulting from accidents or inborn defects, Langlois says. Craniofacial surgeons currently operate with no standardized, age-based criteria for reshaping a disfigured face, she adds.

For now, the theory of "average beauty" rests on an intriguing facial analysis of 96 male and 96 female college students. Mug shots of the students—predominantly Caucasian, but including some Hispanics and Asians—were scanned by a video lens hooked up to a computer that converted each picture into a matrix of tiny digital units with numerical values.

Langlois and Roggman divided each group into three sets of 32 faces. In each set, the computer randomly chose two faces and mathematically averaged their digitized values. It then transformed this information into a composite face of the two individuals. Composite faces

Although these look like photographs of real-life women, they are actually computer-generated composite faces. The top image consists of four faces; the second from the top consists of eight faces; the third from the top combines sixteen faces; the bottom comprises thirty-two faces. When asked to rank faces like these, college students rated the bottom two composites as most attractive, even compared with the individual faces that made up the composites.

were then generated for four, eight, 16 and 32 members of each set.

Each set of individual faces and its corresponding composites was then judged by at least 65 college students, including both males and females. The students rated composite faces as more attractive than virtually any of the individual faces, Langlois and Roggman report in the March *Psychological Science*.

Student judges attributed the most [10] striking physical superiority to the 16- and 32-face composites. Composites made from eight or fewer faces did not receive attractiveness ratings significantly greater, in a statistical sense, than individual ratings.

Not only does the averaging of 16 or more faces produce a highly attractive composite image; it also seems to produce a prototypical face. The 16- and 32-face composites in each set looked very similar to each other, and also looked similar to the corresponding composites in the other two same-sex sets, the researchers note. It did not matter that some composites were randomly generated from individual faces rated more unattractive than attractive, while other composites consisted of a majority of faces judged as attractive.

Although a composite of a different racial group—say, 32 Asian faces—would surely look different from a predominantly Caucasian composite, Langlois predicts that both Asian and non-Asian judges would rate a composite Asian face as very attractive.

"We don't claim to have simulated what the human mind does," Langlois says. "Our digitized images only approximate the averaging process that is assumed to occur when humans form mental prototypes [of an attractive face]."

The finding helps explain numerous recent observations that both infants as young as 2 months old and adults perceive the same faces as attractive, regardless of the racial or cultural background of the person viewing a face. In the January *Developmental Psychology*, Langlois and her co-workers report that 1-year-olds are happier, less withdrawn and more likely to play with a female stranger judged as attractive by adults than with an equally unfamiliar female rated unattractive. The same infants play significantly longer with a doll possessing an attractive face as judged by adults than with a doll whose face is unattractive to adults.

Faces serve as a critical source of [15] social information, especially for babies, who may prefer an attractive or prototypical face because it is easier to classify as a face, Langlois suggests. In fact, she says, evolutionary pressures over the past several million years may have endowed humans with a built-in "beauty-detecting" mechanism that averages facial features. According to this scenario—which is admittedly difficult to test—humans have evolved to respond most strongly to the most prototypical faces, which most readily yield social information through such facial expressions as happiness or disgust.

On the other hand, people may acquire preferences for attractive faces early in infancy, when the ability to sort diverse stimuli into meaningful categories organized around prototypes is apparently already in place. For example, 6-month-olds respond most strongly to basic vowel sounds—the long "e" in the word "peep," for example—that adults perceive as the best examples of particular vowels. This suggests that specific speech sounds serve as "perceptual anchors" from infancy onward.

Whatever the case, the principle that averageness is a critical element of attractiveness probably applies to as many as nine out of 10 people whose countenances are considered alluring, Berscheid says. Most exceptions may be individuals in the public eye, such as movie stars, whose appeal sometimes lies largely in perceptions indirectly linked to facial beauty, such as glamour and fame.

Langlois agrees, citing Cher as one such exception. Cher's facial features are clearly not average, but many people view her as attractive, Langlois says. Opinions about Cher's facial beauty are undoubtedly affected by her expressions in photographs, the youthfulness of her face, her glamorous image and numerous media reports describing her younger boyfriends, the Texas psychologist points out.

For similar reasons, raters might judge a sample of movie stars as more attractive than student composites, Langlois asserts. Further research is needed to investigate attractiveness factors that lie beyond the bounds of an absolute measure of beauty, she says.

In the meantime, those of us who 20 muddle by without Cary Grant's ears or Elizabeth Taylor's nose can find solace in the suggestion that attractive faces are, in fact, only average.

And even Cher can take comfort. Neither Langlois nor anyone else has the faintest idea how to quantify charisma. ○

SEEING

1. What features does Bruce Bower focus on in defining physical beauty? What assumptions about physical beauty seemed to prevail in the American popular imagination prior to the study conducted by Professors Langlois and Roggman? To what useful purposes does Bower suggest that Langlois and Roggman's findings might be put? How does Bower define "average" in this essay? What information does he provide about the ethnic and racial makeup of the participants in Langlois and Roggman's study? What impact does this factor have on their findings? What claim(s) do they make about the adaptability of their findings to different races?

2. According to Bower, Langlois and Roggman suggest that exceptions to the rule of "average attractions" might be "individuals in the public eye, such as movie stars, whose appeal sometimes lies largely in perceptions indirectly linked to facial beauty, such as glamour and fame" (para. 17). If there can be so many exceptions, what then constitutes the nature of "average" attractions? Compare the computer-generated composite photographs of the faces of real-life women (p. 222) to the photograph of the altered body of Cindy Jackson (p. 231). Which image of beauty do you find more attractive? Why?

WRITING

1. In paragraph 17, Bower asserts the principle that "averageness is a critical element of attractiveness." What assumptions are embedded in this claim? What does your own experience suggest about the accuracy of this assertion? Write an essay in which you support—or refute—Bower's claim. Please be sure to include a detailed analysis of examples to verify each of your contentions.

2. Stop at the campus bookstore or local magazine stand. Which magazines trade on selling images of physical beauty? Choose the magazine you judge to be most visibly committed to capitalizing on its readers' interest in physical beauty. Examine that magazine carefully, paying special attention to the images that focus on features of the body that project beauty. Draft an essay in which you examine those images carefully and extrapolate from them the magazine's definition of beauty. How "average" is the attractiveness projected in the magazine?

Retrospect:
Building the Male Body

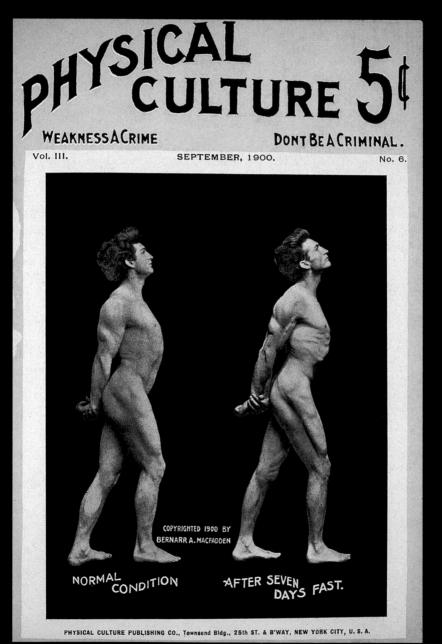

PHYSICAL CULTURE 5¢

WEAKNESS A CRIME DONT BE A CRIMINAL.

Vol. III. SEPTEMBER, 1900. No. 6.

COPYRIGHTED 1900 BY
BERNARR A. MACFADDEN

NORMAL CONDITION AFTER SEVEN DAYS FAST.

PHYSICAL CULTURE PUBLISHING CO., Townsend Bldg., 25th ST. & B'WAY, NEW YORK CITY, U.S.A.

1900

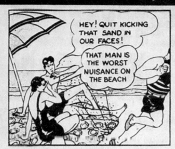
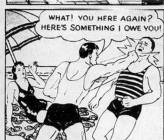
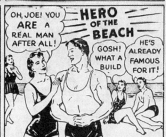

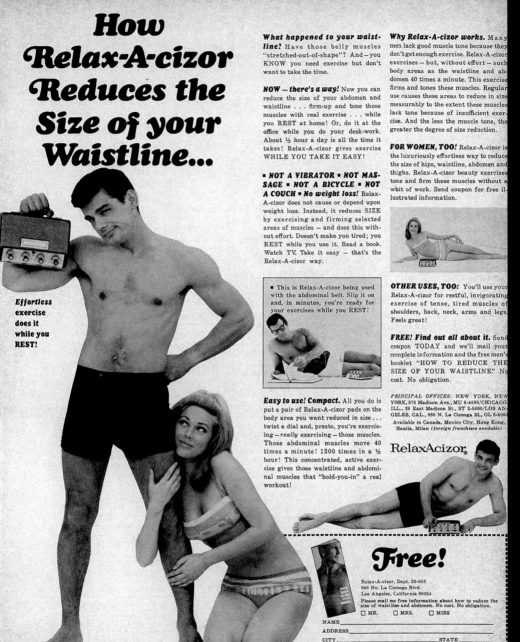

How Relax-A-cizor Reduces the Size of your Waistline...

Effortless exercise does it while you REST!

What happened to your waistline? Have those belly muscles "stretched-out-of-shape"? And—you KNOW you need exercise but don't want to take the time.

NOW — there's a way! Now you can reduce the size of your abdomen and waistline . . . firm-up and tone those muscles with real exercise . . . while you REST at home! Or, do it at the office while you do your desk-work. About ½ hour a day is all the time it takes! Relax-A-cizor gives exercise WHILE YOU TAKE IT EASY!

■ **NOT A VIBRATOR** ■ **NOT MASSAGE** ■ **NOT A BICYCLE** ■ **NOT A COUCH** ■ **No weight loss!** Relax-A-cizor does not cause or depend upon weight loss. Instead, it reduces SIZE by exercising and firming selected areas of muscles — and does this without effort. Doesn't make you tired; you REST while you use it. Read a book. Watch TV. Take it easy — that's the Relax-A-cizor way.

■ This is Relax-A-cizor being used with the abdominal belt. Slip it on and, in minutes, you're ready for your exercises while you REST!

Easy to use! Compact. All you do is put a pair of Relax-A-cizor pads on the body area you want reduced in size . . . twist a dial and, presto, you're exercising — really exercising — those muscles. Those abdominal muscles move 40 times a minute! 1200 times in a ½ hour! This concentrated, active exercise gives those waistline and abdominal muscles that "hold-you-in" a real workout!

Why Relax-A-cizor works. Many men lack good muscle tone because they don't get enough exercise. Relax-A-cizor exercises — but, without effort — such body areas as the waistline and abdomen 40 times a minute. This exercise firms and tones these muscles. Regular use causes these areas to reduce in size measurably to the extent these muscles lack tone because of insufficient exercise. And the less the muscle tone, the greater the degree of size reduction.

FOR WOMEN, TOO! Relax-A-cizor is the luxuriously effortless way to reduce the size of hips, waistline, abdomen and thighs. Relax-A-cizor beauty exercises tone and firm these muscles without a whit of work. Send coupon for free illustrated information.

OTHER USES, TOO: You'll use your Relax-A-cizor for restful, invigorating exercise of tense, tired muscles of shoulders, back, neck, arms and legs. Feels great!

FREE! Find out all about it. Send coupon TODAY and we'll mail your complete information and the free men's booklet "HOW TO REDUCE THE SIZE OF YOUR WAISTLINE." No cost. No obligation.

PRINCIPAL OFFICES: NEW YORK, NEW YORK, 575 Madison Ave., MU 8-4690/CHICAGO, ILL., 29 East Madison St., ST 2-5680/LOS ANGELES, CAL., 980 N. La Cienega Bl., OL 5-8000. Available in Canada, Mexico City, Hong Kong, Manila, Milan *(foreign franchises available)*

RelaxAcizor ®

Free!

Relax-A-cizor, Dept. 20-603
980 No. La Cienega Blvd.
Los Angeles, California 90054
Please mail me free information about how to reduce the size of waistline and abdomen. No cost. No obligation.
☐ MR. ☐ MRS. ☐ MISS

NAME_____
ADDRESS_____
CITY_____ STATE_____
ZIP_____ PHONE_____

☐ I am under 18. ☐ I am over 18. 20-603 707

© Relax-A-cizor 1967

1952

Let us ask you something. And tell us the truth.

1999

Does it
matter to you
that if you skip a day
of running,
only
one person
in the world
will ever know?
Or
is that
one person
too many?

One less excuse to skip a day: the GEL-140.™
Its substantial GEL® Cushioning System
can handle even the most mile-hungry feet.

asics

CINDY JACKSON

Cindy Jackson was, in her own words, "a homely, dumpy farm girl in Ohio," but with the help of cosmetic surgery she transformed herself into a close facsimile of her personal model of perfection, the Barbie Doll. Between her high school graduation in 1973 and her public debut in 1993, Jackson underwent over nineteen operations to alter her face, breasts, and other parts of her body. The unusually narrow waist, large bust, and high arched eyebrows of the classic Barbie Doll are trademarks of Jackson's "living doll" look.

"I was born in the United States but made in Britain," says Jackson, who lived in England during her transformations. By 1998 Cindy Jackson was a frequent guest on television talk shows and the "toast of London Society," a fact she attributes to her recently perfected beauty.

As the founder of the Cosmetic Surgery Network, Jackson now spends her days promoting the power of "surgical enhancements," urging women to gain power and influence through improved looks. In a culture defined by physical perfection, she argues, beauty is a commodity that can be purchased like any other.

Cindy Jackson, 1973

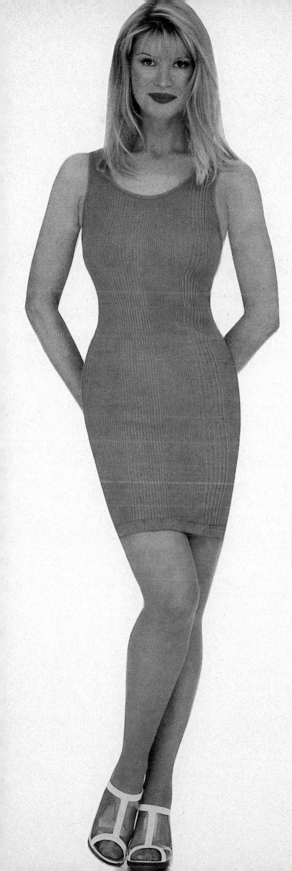

1. Examine the photograph of Cindy Jackson taken when she graduated from high school in 1973. What do you notice about the overall shape of her body? about her posture? Focus for a moment on her head. What do you notice about her hair? eyes? nose? mouth? neck? Turn your attention to the rest of her body. What do you notice about her breasts? waist? hips? legs? ankles? feet?

2. Cindy Jackson's nineteen operations can readily account for the radical alteration of her body. As you compare the two photographs, what do you think has been done to her body? Given her goal to look as much like a Barbie Doll as possible, in what order do you imagine those operations took place? What's next for Cindy Jackson? In your judgment, what aspects of her physical appearance are still in need of repair—in order for her to become a "real" doll?

1. Look through some family photographs. Choose one that you believe best reflects your recollection of yourself in adolescence. Write an essay in which you analyze that photograph in detail, showing how it is representative of the image you had of your body when you were an adolescent.

2. The case of Cindy Jackson illustrates the results as well as the complications of reshaping one's body through cosmetic surgery. In your opinion, what are the ethical issues involved in changing so substantially the nature of one's body and, presumably, one's identity? Jackson claims that she had these operations because our society demands physical perfection from women. Write an essay in which you argue for or against cosmetic surgery in general or, more specifically, in a case such as Cindy Jackson's.

Cindy Jackson, 1998

MARGE PIERCY

Marge Piercy is a novelist, essay-
ist, and poet, and much of her
writing has a political dimension
that stems from her hardscrab-
ble childhood in Detroit during
the Depression. She attended
the University of Michigan on a
scholarship, earned an M.A. at
Northwestern University, lived in
France for several years, and then
returned to Chicago, where she
supported herself with a variety
of low-paying, part-time jobs, in-
cluding secretary, department
store clerk, and artists' model.

All the while, she wrote novels
but could not get them published.
She says she knew two things
about her fiction: She wanted it
to be political, and she wanted
to write about working-class peo-
ple. After moving to Cape Cod
in 1971, Piercy took up gardening,
became active in the women's
movement, and found renewed
creative energy for writing poetry.

"Piercy doesn't understand
writers who complain about writ-
ing," states the biography on her
World Wide Web homepage, "not
because it is easy for her but be-
cause it is so absorbing that she
can imagine nothing more con-
suming and exciting. . . . So long
as she can make her living
at writing, she will consider her-
self lucky."

IMAGING

Marge Piercy

I am my body.
This is not a dress, a coat;
not a house I live in;
not a suit of armor for close fighting;
not a lump of meat in which I nuzzle like a worm. 5

I issue orders from the command tower;
I look out the twin windows staring,
reading the buzz from ears, hands, nose,
weighing, interpreting, forecasting.
Downstairs faceless crowds labor. 10

I am those mute crowds rushing.
I must glide down the ladder of bone,
I must slide down the silken ropes
of the nerves burning in their darkness.
I must ease into the warm egg of the limbic brain. 15

Like learning the chemical language of ants,
we enter and join to the body lying
down as if to a lover. We ourselves,
caves we must explore in the dark,
eyes shut tight and hands unclenched. 20

Estranged from ourselves to the point
where we scarcely credit the body's mind,
in we go reclaiming what once we knew.
We wrestle the dark angel of our hidden
selves, fighting all night for our lives. 25

Who is this angel I meet on my back,
radiant as molten steel pouring from the ladle,
dark as the inside of the moon?
Whose is this strength I wrestle?
—the other, my lost holy self. 30

1. Marge Piercy opens *Imaging* with a simple declarative sentence: "I am my body." What do you understand this assertion to mean? How is this claim illustrated in the lines that follow? Comment on the effects of Piercy's use of negatives in the first stanza. Explain how lines 2–5 reinforce or subvert her opening statement. How would you summarize the final two stanzas of the poem? How does the poem end differently from where it began? With what effects?

2. What organizational principles lend coherence to this poem? What kinds of movement can you identify in it? Examine the metaphors used in the final stanza. How has Piercy prepared her readers for the use of these metaphors? What effects do they have?

1. The artist Barbara Kruger presents a provocative metaphor for the female body, calling it a "battleground." What examples can you point to in Piercy's poem that either support or challenge Kruger's assertion? Write an essay in which you argue for or against Kruger's claim that a woman's body is a battleground. Please be sure to define the terms you use and to validate each of your claims with examples drawn from Piercy's poem or other sources.

2. Philosophers have struggled for centuries to come to terms with the question of who we are. The Western philosophical tradition, for example, holds that who we are is determined by our consciousness and rationality—and that this consciousness is separate from and transcends the physical body, which functions according to physical laws, needs, and desires. This classical distinction between subject and object helps us to understand what it is to be human. Reread *Imaging* carefully, several times, until you feel comfortable with thinking and writing about the poem. Then draft an essay in which you explain whether Piercy's poem endorses this distinction between subject and object.

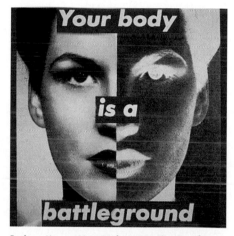

Barbara Kruger, **Your Body Is a Battleground**

CHRISTIAN MARCLAY

Recorded sound is dead sound, in the sense that it's not live anymore. Old records have this quality of time past," remarks Christian Marclay, an artist who has made a career of physically re-enlivening the discarded music of the past. The legendary "turntable wizard of NYC," Marclay makes music by operating multiple turntables at once, mixing and manipulating the recorded sounds to create assembled symphonies of dissonant splendor. He has cut records into pie shapes, glued them together to create new recordings, had crowds walk on them, and otherwise manipulated the vinyl of records in every way imaginable. His extensive discography includes collaborations with experimental composers such as Gunter Muller.

In the late 1980s Marclay began doing sculpture with records, mixing phonograph horns, album covers, and turntables into three-dimensional compositions. One famous piece was constructed of six album covers from *The Sound of Music* glued together to form a box that suggested it contained "the sound of music." A recent set of prints entitled "False Advertising" featured Marclay posed as a classical violinist, a folk singer, and a hard rocker.

Legend has it that Marclay's business card reads "Record Player," a fitting title for an artist who has brought interaction back to the realm of music listening.

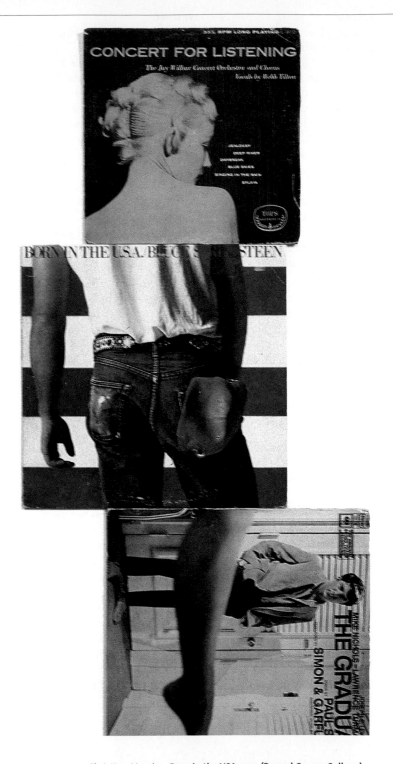

Christian Marclay, *Born in the USA, 1991* (Record Covers Collage)

SEEING

1. How is the body represented differently in each of the three album covers? What body parts are revealed and/or hidden? What is the effect of putting the three together?

2. What different kinds of music are represented by the three album covers, and what clues did you use to answer? What marketing strategies are evident in each of the covers? How does each of these features appeal to a different audience? What role does gender play in marketing each image? How successful do you think each image is in attracting its desired audience? Why?

WRITING

1. Stop by your local music store and examine the images of the male or female body used on the covers of CDs to promote such different kinds of music as rap, jazz, rock 'n roll, folk, and classical. What aspects or features of the body are emphasized in each of these categories of music? Which aspects or features seem to be de-emphasized or ignored? Write an essay in which you analyze the different depictions of the body in marketing CDs to audiences interested in two or three different kinds of music. To what extent are the images of the body used to promote the different kinds of music similar? different?

2. In a recent interview, Marclay observed that "Some people just listen to music, others just look at art, some do both but they don't do it in the same place. . . . We take a lot of our sound experiences for granted. We don't question sounds as much as images." Write an essay in which you agree or disagree with Marclay's assertion that "we don't question sounds as much as images." Please be sure to verify each of your assertions with a detailed analysis of a specific example.

SUSAN BORDO >

An archeologist of the culture of the body, Susan Bordo has helped bring "body studies" to the forefront of feminist intellectual debate. She writes, "The body is a powerful symbolic form, a surface on which the central rules, hierarchies and even metaphysical commitments of a culture are inscribed, and thus reinforced."

Bordo's best known book, *Unbearable Weight: Feminism, Western Culture and the Body,* was nominated for a Pulitzer Prize and named a notable book of 1993 by the *New York Times.* In it she explores women's relationships to food, desire, and power. She is also the author of *The Flight to Objectivity: Essays on Cartesianism and Culture* (1987) and the co-editor of a collection of essays entitled *Gender/Body/ Knowledge* (1989). The subjects of her numerous articles range from anorexia and cosmetic surgery to Hollywood's leading men and the impact of contemporary media. Her work on cultural analysis is exemplified by *Twilight Zones: The Hidden Life of Cultural Images from Plato to O.J.* (1997), from which the following essay is drawn. She turned her attention to the male body in *The Male Body: A New Look at Men in Public and Private* (1999), a work she describes as "a personal exploration of the male body from a woman's point of view."

Born in 1947, Bordo is Professor of English and Women's Studies at the University of Kentucky, where she holds the Singletary Chair of Humanities.

Never Just Pictures

Susan Bordo

BODIES AND FANTASIES

When Alicia Silverstone, the svelte nineteen-year-old star of *Clueless,* appeared at the Academy Awards just a smidge more substantial than she had been in the movie, the tabloids ribbed her cruelly, calling her "fatgirl" and "buttgirl" (her next movie role is Batgirl) and "more *Babe* than babe."[1] Our idolatry of the trim, tight body shows no signs of relinquishing its grip on our conceptions of beauty and normality. Since I began exploring this obsession it seems to have gathered momentum, like a spreading mass hysteria. Fat is the devil, and we are continually beating him—"eliminating" our stomachs, "busting" our thighs, "taming" our tummies—pummeling and purging our bodies, attempting to make them into something other than flesh. On television, infomercials hawking

Figure 1 *All our mothers needed to diet.*

1. I give great credit to Alicia Silverstone for her response to these taunts. In *Vanity Fair* she says, "I do my best. But it's much more important to me that my brain be working in the morning than getting up early and doing exercise. . . . The most important thing for me is that I eat and that I sleep and that I get the work done, but unfortunately . . . it's the perception that women in film should look a certain way" ("Hollywood Princess," September 1996, pp. 292–294). One wonders how long she will manage to retain such a sane attitude!

miracle diet pills and videos promising to turn our body parts into steel have become as commonplace as aspirin ads. There hasn't been a tabloid cover in the past few years that didn't boast of an inside scoop on some star's diet regime, a "fabulous" success story of weight loss, or a tragic relapse. (When they can't come up with a current one, they scrounge up an old one; a few weeks ago the *National Inquirer* ran a story on Joan Lunden's fifty-pound weight loss fifteen years ago!) Children in this culture grow up knowing that you can never be thin enough and that being fat is one of the worst things one can be. One study asked ten- and eleven-year-old boys and girls to rank drawings of children with various physical handicaps; drawings of fat children elicited the greatest disapproval and discomfort, over pictures of kids with facial disfigurements and missing hands.

Psychologists commonly believe that girls with eating disorders suffer from "body image disturbance syndrome": they are unable to see themselves as anything but fat, no matter how thin they become. If this is a disorder, it is one that has become a norm of cultural perception. Our ideas about what constitutes a body in need of a diet have become more and more pathologically trained on the slightest hint of excess. This ideal of the body beautiful has largely come from fashion designers and models. (Movie stars, who often used to embody a more voluptuous ideal, are now modeling themselves after the models.) They have taught us "to love a woman's pelvis, her hipbones jutting out through a bias-cut grown ... the clavicle in its role as a coat hanger from which clothes are suspended."[2] (An old fashion industry justification for skinniness in models was that clothes just don't "hang right" on heftier types.) The fashion industry has taught us to regard a perfectly healthy, nonobese body such as the one

depicted in figure 1 as an unsightly "before" ("Before CitraLean, no wonder they wore swimsuits like that"). In fact, those in the business have admitted that models have been getting thinner since 1993, when Kate Moss first repopularized the waif look. British models Trish Goff and Annie Morton make Moss look well fed by comparison,[3] and recent ad campaigns for Jil Sander go way beyond the thin-body-as-coat-hanger paradigm to a blatant glamorization of the cadaverous, starved look itself.* More and more ads featuring anorexic-looking young men are appearing too.

The main challenge to such images is a muscular aesthetic that *looks* more life-affirming but is no less punishing and compulsion-inducing in its demands on ordinary bodies. During the 1996 Summer Olympics—which were reported with unprecedented focus and hype on the fat-free beauty of muscular bodies—commentators celebrated the "health" of this aesthetic over anorexic glamour. But there is growing evidence of rampant eating disorders among female athletes, and it's hard to imagine that those taut and tiny Olympic gymnasts—the idols of preadolescents across the country—are having regular menstrual cycles. Their skimpy level of body fat just won't support it. During the Olympics I heard a commentator gushing about how great it was that the 1996 team was composed predominantly of eighteen- and nineteen-year-old women rather than little girls. To me it is far more disturbing that these nineteen-year-olds still *look* (and talk) like little girls! As I watched them vault and leap, my admiration for their tremendous skill and spirit was shadowed by thoughts of what was going on *inside* their bodies—the hormones unreleased because of insufficient body fat, the organ development delayed, perhaps halted.

2. Holly Brubach, "The Athletic Esthetic," *The New York Times Magazine,* June 23, 1996, p. 51.

3. In early 1996 the Swiss watch manufacturer Omega threatened to stop advertising in British *Vogue* because of *Vogue*'s use of such hyperthin models, but it later reversed this decision. The furor was reminiscent of boycotts that were threatened in 1994 when Calvin Klein and Coca-Cola first began to use photos of Kate Moss in

their ads. In neither case has the fashion industry acknowledged any validity to the charge that their imagery encourages eating disorders. Instead, they have responded with defensive "rebuttals."

* For reasons of copyright, we are unable to reproduce the Jil Sander advertisement shown in Bordo's essay [eds.].

Is it any wonder that despite media attention to the dangers of starvation dieting and habitual vomiting, eating disorders have spread throughout the culture?[4] In 1993 in *Unbearable Weight* I argued that the old clinical generalizations positing distinctive class, race, family, and "personality" profiles for the women most likely to develop an eating disorder were being blasted apart by the normalizing power of mass imagery. Some feminists complained that I had not sufficiently attended to racial and ethnic "difference" and was assuming the white, middle-class experience as the norm. Since then it has been widely acknowledged among medical professionals that the incidence of eating and body-image problems among African American, Hispanic, and Native American women has been grossly underestimated and is on the increase.[5] Even the gender gap is being narrowed, as more and more men are developing eating disorders and exercise compulsions too. (In the mid-eighties the men in my classes used to yawn and pass notes when we discussed the pressure to diet; in 1996 they are more apt to protest if the women in the class talk as though it's their problem alone.)

The spread of eating disorders, of course, is not just about images. The emergence of eating disorders is a complex, multilayered cultural "symptom," reflecting problems that are historical as well as contemporary, arising in our time because of the confluence of a number of factors.[6] Eating disorders are overdetermined in this culture. They have to do not only with new social expectations of women and ambivalence toward their bodies but also with more general anxieties about the body as the source of hungers, needs, and physical vulnerabilities not within our control. These anxieties are deep and long-standing in Western philosophy and religion, and they are especially acute in our own time. Eating disorders are also linked to the contradictions of consumer culture, which is continually encouraging us to binge on our desires at the same time as it glamorizes self-discipline and scorns fat as a symbol of laziness and lack of willpower. And these disorders reflect, too, our increasing fascination with the possibilities of reshaping our bodies and selves in radical ways, creating new bodies according to our mind's design.

The relationship between problems such as these and cultural images is complex. On the one hand, the idealization of certain kinds of bodies foments and perpetuates our anxieties and insecurities, that's clear. Glamorous images of hyperthin models certainly don't encourage a more relaxed or accepting attitude toward the body, particularly among those whose own bodies are far from that ideal. But, on the other hand, such images carry fantasized solutions *to* our anxieties and insecurities, and that's part of the reason why they are powerful. They speak to us not just about how to be beautiful or desirable but about how to get control of our lives, get safe, be cool, avoid hurt. When I look at the picture of a skeletal and seemingly barely breathing young woman in figure 2, for example, I do not see a vacuous fashion ideal. I see a visual embodiment of what novelist and ex-anorexic Stephanie Grant means when she says in her autobiographical novel, *The Passion of Alice*, "If I had to say my anorexia was about any single thing, I would have said it was about living without desire. Without longing of any kind."[7]

Now, this may not seem like a particularly attractive philosophy of life (or a particularly attractive body, for that matter). Why would anyone want to look like death, you might be asking. Why would anyone want to live without desire? But recent articles in

4. Despite media attention to eating disorders, an air of scornful impatience with "victim feminism" has infected attitudes toward women's body issues. Christina Hoff-Sommers charges Naomi Wolf (*The Beauty Myth*) with grossly inflating statistics on eating disorders and she poo-poos the notion that women are dying from dieting. Even if some particular set of statistics is inaccurate, why would Sommers want to deny the reality of the problem, which as a teacher she can surely see right before her eyes?

5. For the spread of eating disorders in minority groups, see, for example, "The Art of Integrating Diversity: Addressing Treatment Issues of Minority Women in the 90's," in *The Renfrew Perspective*, Winter 1994; see also Becky Thompson, *A Hunger So Wide and So Deep* (Minneapolis: University of Minnesota Press, 1994).
6. See my *Unbearable Weight* (Berkeley: University of California Press, 1993).
7. Stephanie Grant, *The Passion of Alice* (New York: Houghton Mifflin, 1995), 58.

both *The New Yorker* and the *New York Times* have noted a new aesthetic in contemporary ads, in which the models appear dislocated and withdrawn, with chipped black nail polish and greasy hair, staring out at the viewer in a deathlike trance, seeming to be "barely a person." Some have called this wasted look "heroin chic": ex-model Zoe Fleischauer recalls that "they wanted models that looked like junkies. The more skinny and fucked-up you look, the more everybody thinks you're fabulous."[8]

Hilton Als, in *The New Yorker*, interprets this trend as making the statement that fashion is dead and beauty is "trivial in relation to depression."[9] I read these ads very differently. Although the photographers may see themselves as ironically "deconstructing" fashion, the reality is that no fashion advertisement can declare fashion to be dead—it's virtually a grammatical impossibility. Put that frame around the image, whatever the content, and we are instructed to find it glamorous. These ads are not telling us that beauty is trivial in relation to depression, they are telling us that depression is beautiful, that being wasted is *cool*. The question then becomes not "Is fashion dead?" but "Why has death become glamorous?"

Freud tells us that in the psyche death represents not the destruction of the self but its return to a state prior to need, thus freedom from unfulfilled longing, from anxiety over not having one's needs met. Following Freud, I would argue that ghostly pallor and bodily disrepair, in "heroin chic" images, are about the allure, the safety, of being beyond needing, beyond caring, beyond desire. Should we be surprised at the appeal of being without desire in a culture that has invested our needs with anxiety, stress, and danger, that has made us craving and hungering machines, creatures of desire, and then repaid us with addictions, AIDS, shallow and unstable relationships, and cutthroat competition for jobs and mates? To have given up the quest for fulfillment, to be unconcerned

Figure 2 *Advertising anorexia?*

with the body or its needs—or its vulnerability—is much wiser than to care.

So, yes, the causes of eating disorders are "deeper"[10] than just obedience to images. But cultural images themselves *are* deep. And the way they become imbued and animated with such power is hardly mysterious. Far from being the purely aesthetic inventions that designers and photographers would like to have us believe they are—"It's just fashion, darling, nothing to get all politically steamed up about"—they reflect the designers' cultural savvy, their ability to sense and give form to flutters and quakes in the cultural psyche. These folks have a strong and simple motivation to hone their skills as cultural Geiger counters. It's called the profit motive. They want their images and the products associated with them to sell.

The profit motive can sometimes produce seemingly "transgressive" wrinkles in current norms. Recently

8. Zoe Fleischauer quoted in "Rockers, Models, and the New Allure of Heroin," *Newsweek*, August 26, 1996.

9. Hilton Als, "Buying the Fantasy," *The New Yorker*, October 10, 1996, p. 70.

designers such as Calvin Klein and Jil Sander have begun to use rather plain, ordinary-looking, un-madeup faces in their ad campaigns. Unlike the models in "heroin chic" ads, these men and women do not appear wasted so much as unadorned, unpolished, stripped of the glamorous veneer we have come to expect of fashion spreads. While many of them have interesting faces, few of them qualify as beautiful by any prevailing standards. They have rampant freckles, moles in unbeautiful places, oddly proportioned heads. Noticing these ads, I at first wondered whether we really were shifting into a new gear, more genuinely accepting of diversity and "flaws" in appearance. Then it suddenly hit me that these imperfect faces were showing up in clothing and perfume ads only and the *bodies* in these ads were as relentlessly normalizing as ever—not one plump body to complement the facial "diversity."

I now believe that what we are witnessing here is a commercial war. Clothing manufacturers, realizing that many people—particularly young people, at whom most of these ads are aimed—have limited resources and that encouraging them to spend all their money fixing up their faces rather than buying clothes is not in their best interests, are reasserting the importance of body over face as the "site" of our fantasies. In the new codes of these ads a too madeup look signifies a lack of cool, too much investment in how one looks. "Just Be," Calvin Klein tells us in a recent CK One ad. But looks—a lean body—still matter enormously in these ads, and we are still being told *how* to be—in the mode which best serves Calvin Klein. And all the while, of course, makeup and hair products continue to promote their own self-serving aesthetics of facial perfection. ○

1. Susan Bordo reports that "The spread of eating disorders . . . is not just about images. The emergence of eating disorders is a complex, multilayered cultural 'symptom,' reflecting problems that are historical as well as contemporary" (para. 5). Identify as many problems as possible that may have caused the spread of eating disorders. In what ways has the power of mass imagery exacerbated this problem?

Later in paragraph 5, Bordo links eating disorders to "the contradictions of consumer culture, which is continually encouraging us to binge on our desires at the same time as it glamorizes self-discipline and scorns fat as a symbol of laziness and lack of willpower." Read carefully the advertisements in several widely circulated women's magazines. What visual and verbal strategies do the advertisers use to encourage readers to fantasize about reshaping their bodies and selves in radically new ways?

2. In paragraph 7, Bordo discusses the "heroin chic" ads of recent years. Along with her own interpretation, she provides several different readings of the messages and the cultural significance projected in these ads. Which analysis do you find most convincing? Why? What is your reading of these ads? Where would you position your analysis in relation to the others? What aspects of the ads does your reading attend to that the others do not?

1. In the opening paragraph, Bordo reminds us that "On television, infomercials hawking miracle diet pills and videos promising to turn our body parts into steel have become as commonplace as aspirin ads." Choose an infomercial and examine it carefully. What appeals and promises does it trade on? What strategies do its producers use to induce viewers to buy the product? Write an expository essay in which you analyze the nature of the success of this infomercial. What recommendations, if any, would you offer to support— or resist—an effort to regulate more carefully the claims made by the promoters of these goods and services?

2. In the final paragraph, Bordo reports that clothing manufacturers are "reasserting the importance of body over face as the 'site' of our fantasies." Review some advertisements aimed at young people, especially those with limited financial resources. Write an essay in which you assess the "new codes" of values projected in these ads. What conclusions, however tentative, do you draw about the cultural implications of shifting the "site" of beauty from the face to the body?

Never Just Pictures

Susan Bordo

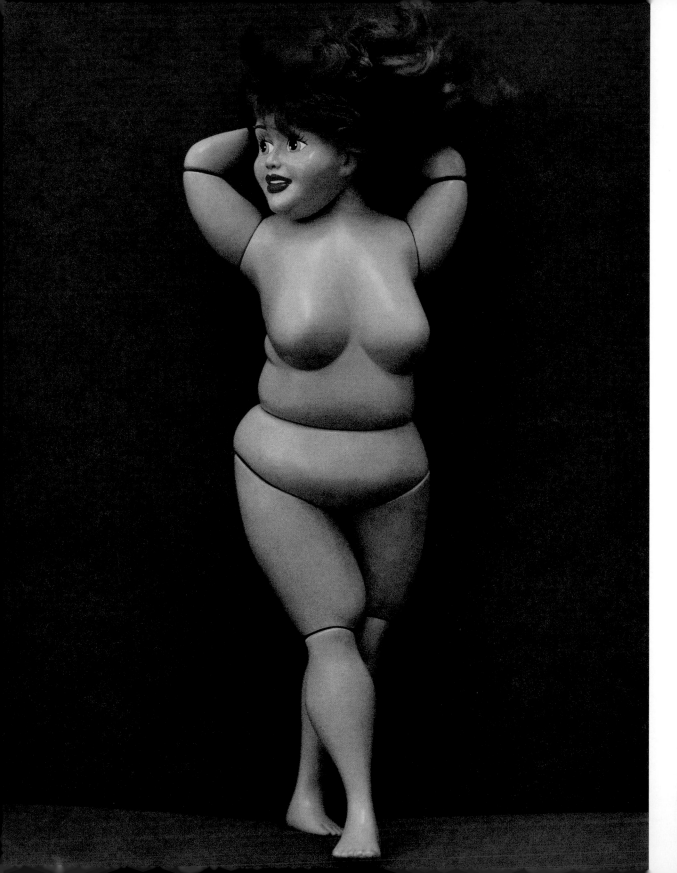

THE BODY SHOP

A cosmetics company with a social conscience, The Body Shop was founded by Anita Roddick in 1976 in Britain to provide high-quality body care products "that satisfy real needs without making false promises." Today the company has more than 1,600 stores in 48 countries.

By attaching values of ecological awareness, political activism, and global fair trade to its business operations, The Body Shop has worked to redefine "beauty" as a way of being, not simply looking. It has created a community trade program that promotes sustainable business in developing countries and has joined with Amnesty International in several human rights projects.

The marketing strategies of The Body Shop include a commitment neither to test its products on animals nor to deal with suppliers who do; to promote women's self-esteem; to pay a fair price for quality products; and to "dedicate its business to the pursuit of social and environmental change." In 1997 The Body Shop came under fire for its relationship with the Kayapo Indians in the Brazilian rain forest when exporting Brazil nut oil to make Brazil Nut Conditioner. Company representatives remain committed to their activism, although they acknowledge the difficulty of keeping commercial reality in line with social idealism.

The company's highly successful "anti-model" Ruby (shown in this photograph) exemplifies the "inner beauty" emphasized in the sales message "Know your mind. Love your body."

SEEING

1. What aspects of this photograph attract your attention? Why? With what effects? What image of the female body is projected in it? What do the creators of the photograph gain—and risk losing— by placing a plastic doll in this position? by showing her in the nude? What parts of the doll's body are accentuated in this position? What historical images do they invoke? Which contemporary female figure does she remind you of?

2. Another Body Shop ad shows a similar doll lounging nude on a couch with the copy, "There are 3 billion women who don't look like supermodels and only 8 who do." Does this photograph featuring the doll Ruby make the same point without verbal text? What ultimately makes this ad effective or not effective?

WRITING

1. In a recent essay entitled "The Female Body," novelist Margaret Atwood reports that "The Female Body has many uses. . . . It sells cars, beer, shaving lotion, cigarettes, hard liquor; it sells diet plans and diamonds, and desire in tiny crystal bottles. Is this the face that launched a thousand products? You bet it is, but don't get any funny big ideas, honey, that smile is a dime a dozen." Choose one such stereotypical depiction of the female body, and analyze the ways in which that stereotype serves as the persuasive focus for selling a specific product. Write the first draft of an expository essay in which you demonstrate the ways in which the copywriter draws on that stereotype to sell a particular good or service.

2. Choose a recent supermodel as the focal point for an essay in which you explain the phenomenon of the relation of the supermodel image to increased sales of a product. If so few women either do or can look like this figure, why are supermodels so popular and why do they command such high fees? What sexual and cultural values are projected by the supermodel image?

www. Re: Searching the Web

When we sit in front of a computer monitor, many of us slouch in our chairs and are drawn into a virtual world, leaving behind thoughts of our bodies. Eyes glued to the screen, fingers poised on a keyboard or a mouse, we require only a few physical movements to explore the Internet. Dislocated from our bodies, our minds are absorbed in cyberspace. Yet much of the language of the Internet suggests a physical presence. We speak, for example, of "navigating" through virtual space, "entering" chat rooms, and "establishing" a presence for ourselves online.

Consider, for example, The Palace (www.thepalace.com), developed by Electric Communities, which encourages users to "communicate interactively online in rich visual environments. You create personalized 'avatars' [personalized icons] that allow you to be 'seen' online. You can express yourself with sounds, space, and movement as well as text. Conversation appears in speech balloons next to avatars, making it much easier to follow than boring text-based chat."

Draft an essay in which you examine how the use of avatars changes the spirit and substance of conversations in a chat room. What are the advantages and disadvantages of conducting a conversation in a text-based chat room as opposed to one in a visually based space, such as in The Palace?

Looking Closer:
Fashioning an Identity

Americans are continually reinventing themselves, whether they are inspired by infomercials, makeovers on talk shows, or ads for the hottest line of clothes. Whether we consider ourselves "fashion victims" or "trend setters," each of us creates and expresses identities through physical appearance and clothing. As jazz saxophonist Joshua Redman says, "I'm attracted to a look that's a combination of hot and cool, that's casual and elegant at the same time, something that's subdued and understated but also intense." What does your appearance say about you? What is your personal style? How do you create an identity for yourself?

The selections that follow express different approaches to fashioning an identity. As both the subject and artist of his work portraying pop artists like **Madonna and Michael Jackson,** Yasumasa Morimura reinvents his identity through clothes, makeup, and body language. Two snapshots revealing **Bill Clinton's dress codes** suggest that every facet of the president's life is managed for its impact on public perceptions. And Natalie Kusz's **"Ring Leader"** and Lynn Johnson's **Nose Piercing** offer glimpses into body piercing and its meanings within personal and public life.

Ring Leader
Natalie Kusz

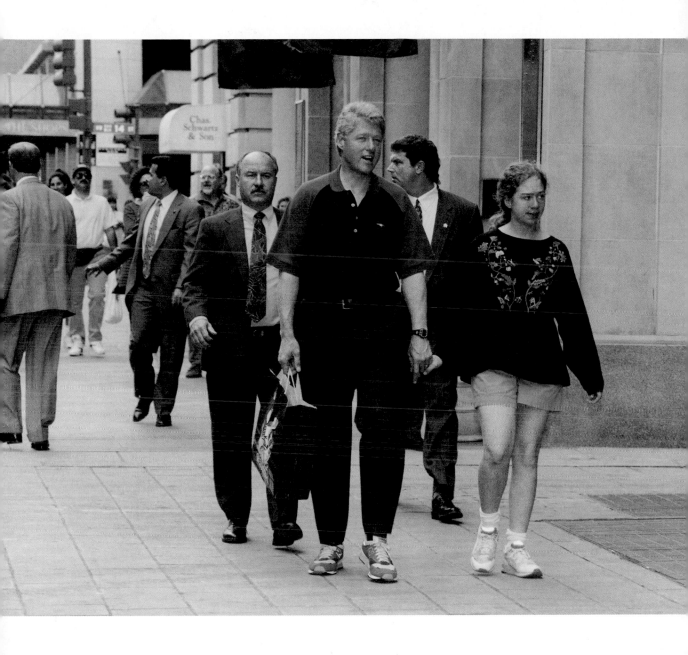

Ring Leader

Natalie Kusz

I WAS THIRTY YEARS OLD WHEN I HAD MY RIGHT nostril pierced, and back-home friends fell speechless at the news, lapsing into long telephone pauses of the sort that June Cleaver would employ if the Beave had ever called to report, "Mom, I'm married. His name's Eddie." Not that I resemble a Cleaver or have friends who wear pearls in the shower, but people who have known me the longest would say that for me to *draw* attention to my body rather than to work all out to *repel* it is at least as out of character as the Beave's abrupt urge for his-and-his golf ensembles. A nose ring, they might tell you, would be my last choice for a fashion accessory, way down on the list with a sag-enhancing specialty bra or a sign on my butt reading "Wide Load."

The fact is, I grew up ugly—no, worse than that, I grew up *unusual*, that unforgivable sin among youth. We lived in Alaska, where, despite what you might have heard about the Rugged Individualist, teenagers still adhere to the universal rules of conformity: if Popular Patty wears contact lenses, then you will by gum get contacts too, or else pocket those glasses and pray you can distinguish the girls' bathroom door from the boys'. The bad news was that I had only one eye, having lost the other in a dog attack at age seven; so although contacts, at half the two-eyed price, were easy to talk my parents into, I was still left with an eye patch and many facial scars, signs as gaudy as neon, telling everyone, "Here is a girl who is Not Like You." And Not Like Them, remember, was equivalent to Not from This Dimension, only half (maybe one third) as interesting.

The rest of my anatomy did nothing to help matters. I come from a long line of famine-surviving ancestors—on my father's side, Polish and Russian, on my mother's, everything from Irish to French Canadian—and thus I have an excellent, thrifty, Ebenezer Scrooge of a metabolism. I can ingest but a single calorie, and before quitting time at the Scrooge office, my system will have spent that calorie to replace an old blood cell, to secrete a vital hormone, to send a few chemicals around the old nervous system, and still have enough left over to deposit ten fat cells in my inner thigh—a nifty little investment for the future, in case the Irish potato famine ever recurs. These metabolic wonders are delightful if you are planning a move to central Africa, but for an American kid wiggling to Jane Fonda as if her life depended on it (which, in high school, it did), the luckiest people on earth seemed to be anorexics, those wispy and hollow-cheeked beings whose primary part in the locker room drama was to stand at the mirror and announce, "My God, I disgust myself, I am *so fat*." While the other girls recited their lines ("No, Samantha, don't talk like that, you're beautiful, you really *are!*"), I tried to pull on a gym shirt without removing any other shirt first, writhing inside the cloth like a cat trapped among the bedsheets.

Thus, if you add the oversized body to the disfigured face, and add again my family's low income and my secondhand wardrobe, you have a formula for pure, excruciating teenage angst. Hiding from public scrutiny became for me, as for many people like me, a way of life. I developed a bouncy sense of humor, the kind that makes people say, "That Natalie, she is always so *up*," and keeps them from probing for deep emotion. After teaching myself to sew, I made myself cheap versions of those Popular Patty clothes or at least the items (*never* halter tops, although this was the seventies) that a large girl could wear with any aplomb. And above all, I studied the other kids, their physical posture, their music, their methods of blow-dryer artistry, hoping one day to emerge from my body, invisible. I suppose I came as close to invisibility as my appearance would allow, for if you look at the yearbook photos from that time, you will find on my face the same "too cool to say 'cheese'" expression as on Popular Patty's eleven-man entourage.

But at age thirty, I found myself living in the (to me) incomprehensible politeness of America's Midwest, teaching at a small private college that I found suffocating, and anticipating the arrival of that all-affirming desire of college professors everywhere, that professional certification indicating you are now "one of the family": academic tenure. A first-time visitor to any college campus can easily differentiate between

tenured and nontenured faculty by keeping in mind a learning institution's two main expectations: (1) that a young professor will spend her first several years on the job proving herself indispensable (sucking up), working to advance the interests of the college (sucking up), and making a name for herself in her field of study (sucking up); and (2) that a senior, tenured professor, having achieved indispensability, institutional usefulness, and fame will thereafter lend her widely recognized name to the school's public relations office, which will use that name to attract prospective new students and faculty, who will in turn be encouraged to call on senior professors for the purpose of asking deep, scholarly questions (sucking up). Thus, a visitor touring any random campus can quickly distinguish tenured faculty persons from nontenured ones simply by noting the habitual shape and amount of chapping of their lips.

I anticipated a future of senior-faculty meetings with academia's own version of Popular Patty—not a nubile, cheerleading fashion plate, but a somber and scholarly denture wearer who, under the legal terms of tenure, cannot be fired except for the most grievous unprofessional behavior, such as igniting plastique under the dean's new Lexus. When that official notice landed in my In box, my sucking-up days would be over. I would have arrived. I would be family.

I couldn't bear it. In addition to the fact that I possessed all my own teeth, I was unsuited to Become As One with the other tenured beings because I was by nature boisterous, a collector of Elvis memorabilia, and given to not washing my car—in short, I was and always would be from Alaska.

Even in my leisure hours, my roots made my life of that period disorienting. Having moved to the immaculate Midwest from the far-from-immaculate wilderness, I found myself incapable of understanding, say, the nature of cul-de-sacs, those little circles of pristine homes where all the children were named Chris, and where all the parents got to vote on whether the Johnsons (they were all Johnsons) could paint their house beige. I would go to potluck suppers where the dishes were foreign to me, and twelve

people at my table would take a bite, savor it with closed eyes, and say, "Ah, Tater Tot casserole. Now *that* takes me back." It got to the point where I felt defensive all the time, professing my out-of-townness whenever I was mistaken for a local, someone who understood the conversational subtexts and genteel body language of a Minnesotan. Moreover, I could never be sure what I myself said to these people with my subtextual language or my body. For all I knew, my posture during one of those impossible kaffeeklatsches proclaimed to everyone, "I am about to steal the silverware," or "I subscribe to the beliefs of Reverend Sun Myung Moon."

I grew depressed. Before long, I was feeling nostalgic for Alaskan eccentricities I had avoided even when I had lived there—unshaven legs and armpits, for example, and automobiles held together entirely by duct tape. I began decorating my office with absurd and nonprofessional items: velvet paintings, Mr. Potato Head, and a growing collection of snow globes from each of the fifty states. Students took to coming by to play with Legos, or to blow bubbles from those little circular wands, and a wish started to grow in my brain, a yearning for some way to transport the paraphernalia around with me, to carry it along as an indication that I was truly unconventional at heart.

So the week that I received tenure, when they could no longer fire me and when a sore nose would not get bumped during the course of any future sucking-up maneuver, I entered a little shop in the black-leather part of town and emerged within minutes with my right nostril duly pierced. The gesture was, for me, a celebration, a visible statement that said, "Assume nothing. I might be a punk from Hennepin Avenue, or a belly dancer with brass knuckles in my purse." Polite as was the society of that region, my colleagues never referred to my nose, but I could see them looking and wondering a bit, which was exactly the thing I had wanted—a lingering question in the minds of the natives, the possibility of forces they had never fathomed.

After this, my comfort level changed some, and almost entirely for the better. I had warned my father, who lived with me those years, that I was thinking of piercing my nose. When I arrived home that day and the hole was through the side instead of the center—he had expected, I found out, a Maori-style bone beneath the nostrils—he looked at me, his color improved, and he asked if I wanted chicken for dinner. So that was all fine. At school, students got over their initial shock relatively quickly, having already seen the trailer-park ambience of my office, and they became less apt to question my judgment on their papers; I could hear them thinking, She looks like she must understand *something* about where I'm coming from. And my daughter—this is the best part of all—declared I was the hippest parent she knew, and decided it was O.K. to introduce me to her junior high friends; even Cool Chris—the Midwestern variety of Popular Patty—couldn't boast a body-pierced mom.

I have since moved away from Minnesota, and old friends (those of the aforementioned June Cleaver–type stunned silence) have begun to ask if I have decided to stop wearing a nose stud now that my initial reason for acquiring it has passed. And here, to me, is the interesting part: the answer, categorically, is no. Nonconformity, or something like it, may have been the initial reason behind shooting a new hole through my proboscis, but a whole set of side effects, a broad and unexpected brand of liberation, has provided me a reason for keeping it. Because the one-eyed fat girl who couldn't wear Popular Patty's clothes, much less aspire to steal her boyfriends, who was long accustomed to the grocery-store stares of adults and small children ("Mommy, what happened to that fat lady's face?"), who had learned over the years to hide whenever possible, slathering her facial scars with cover stick, is now—am I dreaming?—in charge. I have now, after all, deliberately chosen a "facial flaw," a remarkable aspect of appearance. Somehow now, the glances of strangers seem less invasive, nothing to incite me to nunhood; a long look is just that—a look—and what of it? I've invited it, I've made room for it, it is no longer inflicted upon me against my will. ○

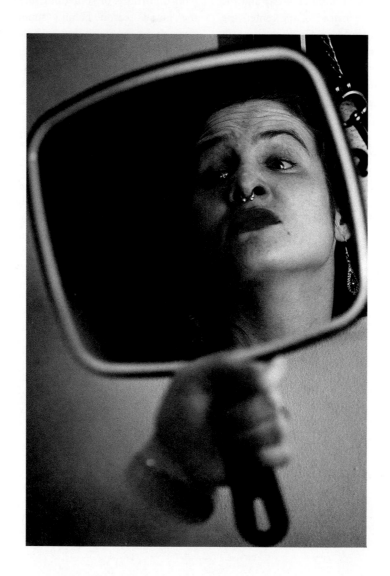

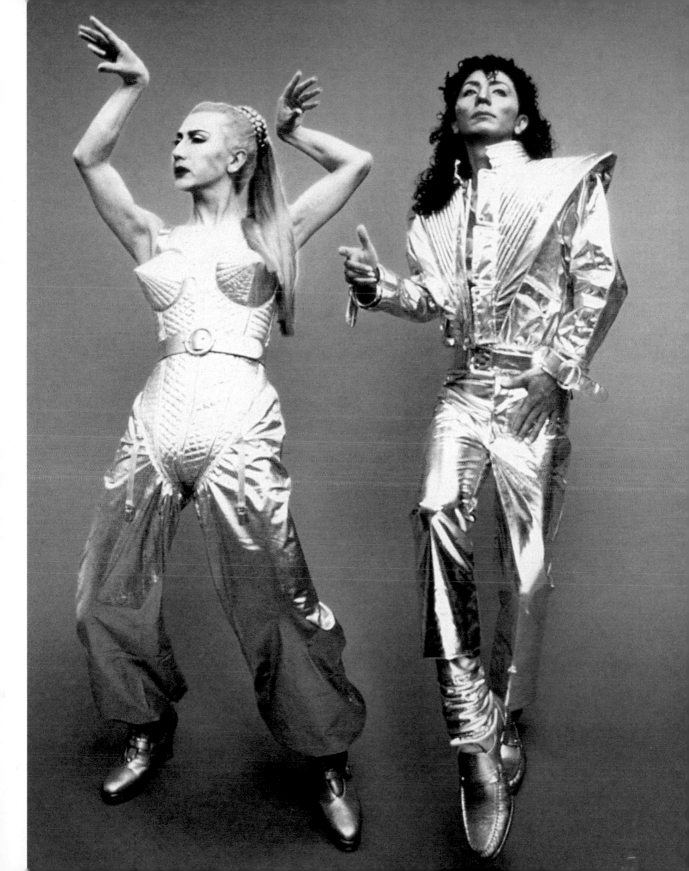

GREG GIBSON

Greg Gibson has been the Associated Press's White House photographer during the entire Clinton administration. He is a ten-year veteran of Washington journalism. In 1993 he was among the group of AP photographers who were awarded a Pulitzer Prize for their coverage of the 1992 presidential campaign. Gibson began his career in photojournalism at the *Raleigh News and Observer* in North Carolina.

NATALIE KUSZ

Natalie Kusz is the author of *Road Song* (1990), an autobiography set in the wilds of Alaska. It offers a dramatic account of her own and her family's heroic efforts to mend their lives after a brutal dog attack left Natalie blind in one eye and badly disfigured at the age of 7. Kusz (which is pronounced like "push") was the recipient of the Whiting Writers Award as well as a General Electric Foundation Award for Younger Writers. She was born in New York City in 1962 and currently teaches writing at Harvard University.

LYNN JOHNSON

Lynn Johnson's photographs appear regularly in *National Geographic, Life, Sports Illustrated,* and many other of the world's leading publications. She has traveled to the ends of the globe, "eating rats with Vietcong guerillas," recording the lives of monks in Tibet, and climbing the radio antenna on top of Chicago's Hancock Tower—though she writes that some of her favorite assignments have been capturing ordinary people in extraordinary circumstances (a family struggling with AIDS, an athlete learning to compete with artificial legs, or musicians volunteering to play for the dying). Whether turning her lens on the obscure or the famous, her intent remains simple: "To invite the viewer to find meaning in the frame."

Among her numerous books are *Pittsburgh Moments,* her first, and *We Remember: Women Born at the Turn of the Century,* her most recent (1999). She has contributed to many of the *Day in the Life* series of books and to the groundbreaking social commentaries *Material World* (1994) and *Women in the Material World* (1997).

Ring Leader

Natalie Kusz

YASUMASA MORIMURA

Born in Osaka, Japan (1951), the photographer Yasumasa Morimura has used photography to capture many different identities, each of them a version of his own. Working with photographs or paintings scanned into a computer, Morimura interweaves photos of his own face or body into images of famous historical figures and actresses such as Rembrandt, the Mona Lisa, and Madonna. This "original" is then printed onto canvas and covered with a layer of gel to make the pieces more closely resemble paintings. In Morimura's exhibitions, the images are often reproduced on a grand scale, approximating 6 × 10 feet.

SEEING

1. Natalie Kusz has written a remarkable account of her continuing struggles with alienation. What is the nature of the alienation she felt while growing up in Alaska? What challenges did she face, and how did she overcome them? What different kind of alienation did Kusz experience when she moved to a small town in the Midwest to teach at a private college? How did she overcome that challenge? In addition to piercing, in what other ways does Kusz fashion an identity for herself? In what other ways have you considered fashioning an identity for yourself?

2. Examine the additional visual accounts of two photographs of Bill Clinton in presidential and informal clothes, a photo of a woman with a pierced nose looking into a mirror, and two photographs of Yasumasa Morimura in which he has transformed his appearance to resemble that of Michael Jackson and Madonna. As you examine these selections, notice the specific ways in which each photographer fashions an identity.

WRITING

1. Natalie Kusz describes the ways in which she fashioned a new identity for herself in the face of alienation from the communities she inhabited. As she tells us, she hoped "one day to emerge from my body, invisible" (para 4). What experiences with alienation did you have during adolescence? What were the circumstances? How did you fashion an identity that enabled you to respond effectively to the situation? Write a narrative essay in which you recount the predicament you faced as well as how you succeeded in responding to that challenge.

2. How would you respond to those who claim that body piercing is a form of self-mutilation, a danger to the person's health, and an expression of antisocial behavior that ought to be prohibited by law? What points would you make in defense of the right to pierce any part of the body one chooses? Write an essay in which you summon as much evidence as possible to argue one side of this question.

Engendering Difference

From a very early age, we are taught to identify with one of the two most universally recognized icons: the abstract symbols 👨 and 👩 . Created in the early 1970s, the two-dimensional black-on-white figures signifying "male" and "female" have become so pervasive we take them for granted. Yet a more careful look raises numerous questions: What cultural assumptions are embedded in these icons? How exactly do they communicate gender difference? Why are differences in clothing such a clear communicator of gender identity and sex? How do these representations of difference relate to larger issues of the equality of the sexes and the social construction of gender?

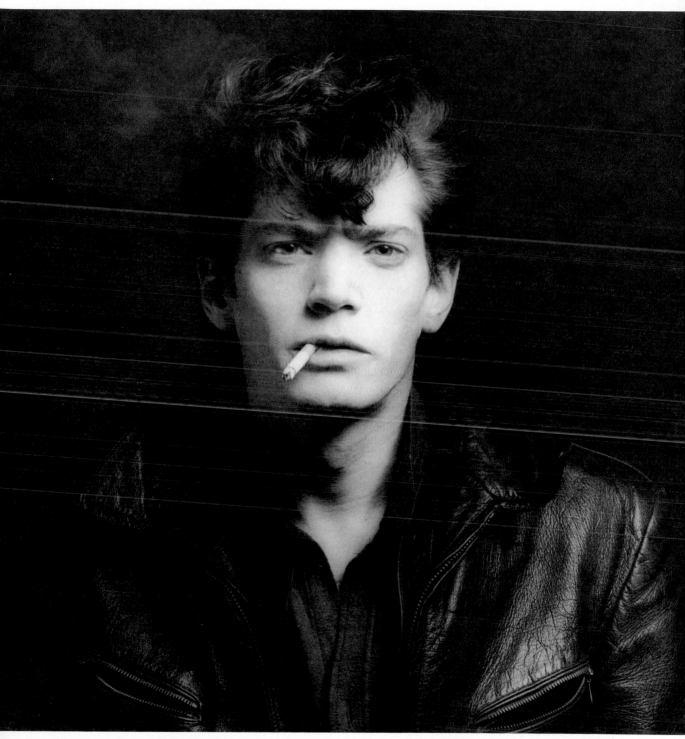

Robert Mapplethorpe, **Self-Portrait, 1980**

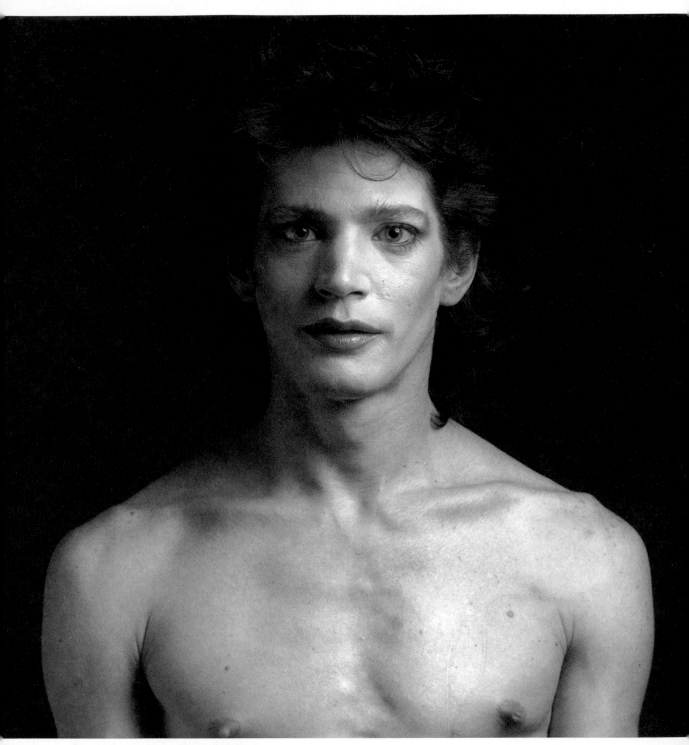

Robert Mapplethorpe, **Self-Portrait, 1980**

One hundred years ago the terms *sex* and *gender* were used interchangeably, but they mean different things today. *Sex* refers to a structural, functional, biological category—determined by birth with male or female genitalia. The chromosomes we inherit determine our sex. *Gender* refers to a cultural category—behavioral or psychological standards for masculine or feminine behavior. Gender expectations are articulated and often revised by any given historical and cultural moment. For example, vastly different expectations affect the lives of a 21-year-old woman living in San Francisco and a woman of the same age living in Beijing, just as a young man living in Ames, Iowa, has grown up with a concept of masculinity that is quite different from the one his counterpart fifty years earlier did.

We are all born with a biological sex, and we all soon learn about—and develop attitudes toward—gender roles: how men and women should act in private and public life, what we should wear, how we should talk, how we should interact with others, even what life choices we should make. What codes for gender behavior can you identify in your own life? on campus? in your family? among friends?

Magazine and advertising headlines insistently proclaim that men and women are different. Indeed, representations of these differences can be seen everywhere in popular culture. Advertisers, for example, make money by invoking such categories of essential difference. Smoking Virginia Slims is "a woman thing"; drinking Jim Beam helps you "get in touch with your masculine side." Men love beer, women love jewelry; men love watching sports, women love watching soaps: We "know" these things to be true because we read them and see such statements everywhere—and clearly many people still believe that anatomy is destiny.

> Men are from Mars, women are from Venus.
> *– John Gray, 1992*

Yet despite these messages about the essential differences between men and women, at the same time gender lines are breaking down. More women are working, for more money and at better jobs than thirty years ago; more men are staying home without feeling like failures. Women have the right to be in the military; gay men and lesbians may soon have the same right, even if they are asked to tell. Coming out is becoming mainstream, with sitcoms such as *Ellen* and *Will and Grace* featuring gay and lesbian characters

> Females have biological problems staying in a ditch for 30 days because they get infections.
> *– Newt Gingrich on women in combat, 1995*

who go beyond caricature, and drag queen supermodel RuPaul serving as a spokesman for Rockport Shoes and as a covergirl for ·MAC· makeup. Men and women can wear the same clothes, get the same education, work the same jobs, and behave the same way *in theory*—and many do in practice. Today the public discourse is focused both on the black-and-white question of the similarities and differences between men and women, and on the gray area in between.

How do you read the signs of gender difference at the beginning of this new century? Is the recent trend in super-spiky high heels a throwback to the traditional feminine code that feminists fought against, or does it reveal a more nuanced and ironic postmodern expression of femininity? Is it a myth that men are afraid of intimacy? How do *you* respond to public and private constructions of gender identity? The men and women whose work is represented in the following selections explore this question in uniquely individual ways, whether it be from the scientific as in Natalie Angier's "Men, Women, Sex, and Darwin," the social/cultural as in Daniel Harris's exploration of the concept of "Effeminacy," or the world of popular culture, as in Marilyn Manson's controversial album cover, *Mechanical Animals*.

[I have been] working in a male culture for a very long time, and I haven't met the first man who wants to go out and hunt a giraffe.
– Pat Schroeder's response to Newt Gingrich on women in combat, 1995

ROBERT MAPPLETHORPE

Robert Mapplethorpe, born in 1946 in New York, achieved celebrity status as a photographer in the years before his death in 1989. At the age of 16 he began to study art at Pratt Institute in Brooklyn, New York. Trained as a painter and sculptor, he approached photographic subjects with an acute sense of symmetrical composition. He was encouraged to pursue photography by Sam Wagstaff, a former museum curator. Mapplethorpe had his first solo exhibition in New York in 1976, and the first major museum retrospective of his work was presented by the Whitney Museum of American Art in 1988. He remains one of the most important figures in contemporary photography.

Whether photographing flowers, erotic scenes, or portraits, Mapplethorpe manipulated light, shadow, and setting in ways that often provoked tension between his subject matter and his characteristic formalist aesthetic. He summed up the effect when he said, "My work is about seeing things like they haven't been seen before."

SEEING

1. As you examine these two self-portraits carefully, what strikes you as masculine or feminine? Comment, for example, on Mapplethorpe's choice of hairstyle, facial expression, clothing, and accessories. What gender conventions and stereotypes does Mapplethorpe invoke in these images? Can you identify imagery of—or references to—past eras in American history?

2. Museum curator and writer Jennifer Blessing observes that Robert Mapplethorpe's portraits "are more frequently consciously contrived studio portraits. His images demonstrate the high value he placed on formal aesthetics. His portraits suggest the conventions of celebrity advertisements. Their flat backgrounds, tight cropping, iconic centrality, and minimal distracting detail focus all attention on the subject." What cropping choices has Mapplethorpe made in these images, and with what effect(s)? How might the tone and effect of the photographs change if Mapplethorpe had shot them in a more "realistic" or non-studio context?

WRITING

1. What do you like about being female? about being male? What do you see as the major differences between being a male and a female college student? Write an essay in which you imagine changing your sex for a day. How do you think your day might be different?

2. The dangling cigarette is a prominent part of Mapplethorpe's masculine self-portraits. Choose a cigarette ad that draws explicitly on gender conventions—Virginia Slims, Marlboro, or Camel, for example. Can smoking make you more of a man or more of a woman? Write an essay in which you answer that question, arguing for or against the claims made by the copy and image in your chosen ad.

Trimming a photograph, either when composing it (e.g., moving closer or farther away from the subject to include more or less of the background); or printing part of the negative rather than the whole image when developing a photograph (e.g., cutting away some of the background to obtain a new perspective on the subject).

GIRL

Jamaica Kincaid

WASH THE WHITE CLOTHES ON MONDAY AND put them on the stone heap; wash the color clothes on Tuesday and put them on the clothesline to dry; don't walk barehead in the hot sun; cook pumpkin fritters in very hot sweet oil; soak your little cloths right after you take them off; when buying cotton to make yourself a nice blouse, be sure that it doesn't have gum on it, because that way it won't hold up well after a wash; soak salt fish overnight before you cook it; is it true that you sing benna[1] in Sunday school?; always eat your food in such a way that it won't turn someone else's stomach; on Sundays try to walk like a lady and not like the slut you are so bent on becoming; don't sing benna in Sunday school; you mustn't speak to wharf-rat boys, not even to give directions; don't eat fruits on the street—flies will follow you; *but I don't sing benna on Sundays at all and never in Sunday school;* this is how to sew on a button; this is how to make a buttonhole for the button you have just sewed on; this is how to hem a dress when you see the hem coming down and so to prevent yourself from looking like the slut I know you are so bent on becoming; this is how you iron your father's khaki shirt so that it doesn't have a crease; this is how you iron your father's khaki pants so that they don't have a crease; this is how you grow okra—far from the house, because okra tree harbors red ants; when you are growing dasheen,[2] make sure it gets plenty of water or else it makes your throat itch when you are eating it; this is how you sweep a corner; this is how you sweep a whole house; this is how you sweep a yard; this is how you smile to someone you don't like too much; this is how you smile to someone you don't like at all; this is how you smile to someone you like completely; this is how you set a table for tea; this is how you set a table for dinner; this is how you set a table for dinner with an important guest; this is how you set a table for lunch; this is how you set a table for breakfast; this is how to behave in the presence of men who don't know you very well, and this way they won't recognize immediately the slut I have warned you against becoming; be sure to wash every day, even if it is with your own spit; don't squat down to play marbles—you are not a boy, you know; don't pick people's flowers—you might catch something; don't throw stones at blackbirds, because it might not be a blackbird at all; this is how to make a bread pudding; this is how to make doukona;[3] this is how to make pepper pot;[4] this is how to make a good medicine for a cold; this is how to make a good medicine to throw away a child before it even becomes a child; this is how to catch a fish; this is how to throw back a fish you don't like, and that way something bad won't fall on you; this is how to bully a man; this is how a man bullies you; this is how to love a man, and if this doesn't work there are other ways, and if they don't work don't feel too bad about giving up; this is how to spit up in the air if you feel like it, and this is how to move quick so that it doesn't fall on you; this is how to make ends meet; always squeeze bread to make sure it's fresh; *but what if the baker won't let me feel the bread?;* you mean to say that after all you are really going to be the kind of woman who the baker won't let near the bread? ○

1. *benna:* Calypso music.
2. *dasheen:* the edible rootstock of taro, a tropical plant.
3. *doukona:* a spicy plantain pudding.
4. *pepper pot:* a stew.

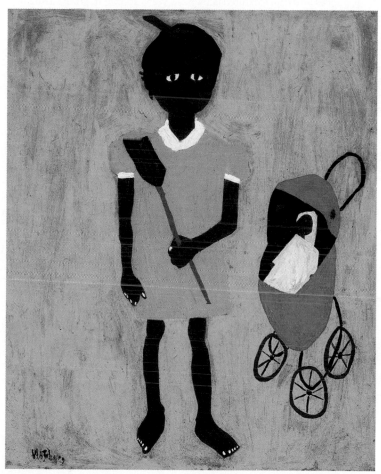

William H. Johnson, **Li'l Sis**

JAMAICA KINCAID

Jamaica Kincaid was born in Antigua in 1949 and immigrated to the United States at age 17. Her novel *Lucy* (1990) is loosely based on her own experience coming into adulthood in a foreign country. Kincaid has transformed other autobiographical experiences into richly textured fiction in her novels *Annie John* (1985) and *The Autobiography of My Mother* (1995). She has also published collections of short stories and essays. Her most recent book, *My Brother* (1997), is a powerful memoir of her brother's struggle against AIDS. Kincaid lives in Bennington, Vermont, and teaches at Harvard University.

Kincaid discovered her talent and passion for writing when, in her twenties, she was asked to contribute sketches on Caribbean and African American culture for *The New Yorker*'s "Talk of the Town" column. Before long she was invited to become a staff writer, and in 1978 "Girl," her first piece of published fiction, appeared in the magazine. "I'm someone who writes to save her life," Kincaid says. "I can't imagine what else I would do if I didn't write. I would be dead or I would be in jail because what else could I do? . . . All the things that were available to someone in my position involved being a subject person. And I'm very bad at being a subject person."

WILLIAM H. JOHNSON

William H. Johnson (1901–1970) developed as an artist on a path that included the rural South, New York, and Europe. Born in South Carolina, Johnson arrived in Harlem in 1918. After spending five years as a student at the National Academy of Design he went abroad to study, living in Paris, Tunisia, Norway, and Denmark—where he married a Danish weaver, Holcha Krake. His art developed in each place as he was influenced by studying the European masters. In 1938 Johnson and his wife returned to New York, where Johnson broke stylistically with the paintings he had studied during his European sojourn and began to concentrate on African American subjects and themes, using bright, flat colors to paint simplified figures. A number of his paintings celebrate his experience growing up in the South, with family members as subjects; *L'il Sis* (1944) is one of these.

Soon after Johnson returned to Denmark in 1946 he was diagnosed as having a disease that affected both his motor and mental functioning—which meant the end of his painting career. Today Johnson's work is recognized as having contributed to the acceptance of African American subjects within the tradition of Western art.

SEEING

1. Who is the speaker in Jamaica Kincaid's essay, and how would you describe that person? Who is the speaker addressing? What, according to the narrator, are the prescriptions for being a "girl"? If this is a portrait, who is being portrayed?

2. William H. Johnson's *Li'l Sis* is a portrait of the artist's younger sister, who grew up in the rural South in the early 1900s. What details can you identify in the painting that reveal what was expected from this girl? Support each of your responses with detailed references to the painting.

3. Compare the tone of "Girl" and *Li'l Sis*. What mood is evoked by these portraits? What techniques do Kincaid and Johnson use to create this mood? In what ways are such verbal and visual techniques alike—and different?

WRITING

1. Write an informal essay in which you "translate" Kincaid's "Girl" into a drawing. You can either sketch it out or describe that drawing in writing, but please be as detailed as possible. Then convert Johnson's painting *Li'l Sis* into prose. You can do this in the form of a monologue, a dialogue, or a description. After you have completed these two exercises, write an additional paragraph in which you sum up what you've learned about seeing and writing by completing the exercises.

2. Kincaid and Johnson both describe little girls whose growing up involved lessons of gender, obedience, and domesticity. Consider whether girls today are taught the same kinds of lessons. If so, how? Write the first draft of an essay in which you describe the lessons you think would be taught to a young girl in the early twenty-first century, and explain the cultural importance of each lesson. You might conclude by noting which little girl is better off—Kincaid's? Johnson's? or the millennial miss you've created?

MAVIS HARA

The unique expressions of race and ethnic identity in Hawaii—among Native Hawaiian, Asian, and American cultures—provide a rich backdrop to the fiction of Mavis Hara. Born in Honolulu in 1949, she graduated from the University of Hawaii and earned a master's degree from the University of California at Santa Barbara.

Hara's work has appeared in numerous collections and in the magazine *Bamboo Ridge*. She spent several years teaching English in Japan but subsequently returned to her native island. Hara describes herself as an "intensely shy and private person, who prefers not to talk about herself"; however, her fiction, which is often autobiographical, reveals a great deal about growing up Japanese American on the edge of Asia.

Carnival Queen

Mavis Hara

MY FRIEND TERRY AND I BOTH HAVE BOY'S NICK-names. But that's the only thing about us that is the same. Terry is beautiful. She is about 5′4″ tall, which is tall enough to be a stewardess. I am only 5 feet tall, which is too short, so I should know.

My mother keeps asking me why Terry is my friend. This makes me nervous, because I really don't know. Ever since we had the first senior class officers' meeting at my house and my mother found the empty tampax container in our wastebasket she has been really asking a lot of questions about Terry. Terry and I are the only girls who were elected to office. She's treasurer and I'm secretary. The president, the vice-president, and the sergeant-at-arms are all boys. I guess that's why Terry and I hang out together. Like when we have to go to class activities and meetings she picks me up. I never even knew her before we were elected. I don't know who she used to

hang around with, but it sure wasn't with me and my friends. We're too, Japanese girl, you know, plain. I mean, Terry has skin like a porcelain doll. She has cheekbones like Garbo, a body like Ann Margret, she has legs like, well, like not any Japanese girl I've ever seen. Like I said, she's beautiful. She always dresses perfectly, too. She always wears an outfit, a dress with matching straw bag and colored leather shoes. Her hair is always set, combed, and sprayed, she even wears nylon stockings under her jeans, even on really hot days. Terry is the only girl I know who has her own Liberty House charge card. Not that she ever goes shopping by herself. Whenever she goes near a store, her mother goes with her.

Funny, Terry has this beautiful face, perfect body, and nobody hates her. We hate Valerie Rosecrest. Valerie is the only girl in our P.E. class who can come out of the girls' showers, wrap a towel around herself

under her arms and have it stay up by itself. No hands. She always takes the longest time in the showers and walks back to her locker past the rest of us, who are already dry and fumbling with the one hook on the back of our bras. Valerie's bra has five hooks on the back of it and needs all of them to stay closed. I think she hangs that thing across the top of her locker door on purpose just so we can walk past it and be blinded by it shining in the afternoon sun. One time, my friend Tina got fed up and snatched Val's bra. She wore it on top of her head and ran around the locker room. I swear, she looked like an albino Mickey Mouse. Nobody did anything but laugh. Funny, it was Terry who took the bra away and put it back on Val's locker again.

I don't know why we're friends, but I wasn't surprised when we ended up together as contestants in the Carnival Queen contest. The Carnival Queen contest is a tradition at McKinley. They have pictures of every Carnival Queen ever chosen hanging in the auditorium corridor right next to the pictures of the senators, governors, politicians, and millionaires who graduated from the school. This year there are already five portraits of queens up there. All the girls are wearing long ball gowns and the same rhinestone crown which is placed on their heads by Mr. Harano, the principal. They have elbow length white gloves and they're carrying baby's breath and roses. The thing is, all the girls are hapa.[1] Every one.

Every year, it is the same tradition. A big bunch of girls gets nominated to run, but everybody knows from intermediate school on which girl in the class is actually going to win. She has to be hapa.

"They had to nominate me," I try to tell Terry. "I'm a class officer, but you, you actually have a chance to be the only Japanese girl to win." Terry had just won the American Legion essay contest the week before. You would think that being fashionable and coordinated all the time would take all her

energy and wear her out, but her mother wants her to be smart too. She looks at me with this sad face I don't understand.

"I doubt it," she says.

Our first orientation meeting for contestants is today in the library after school. I walk to the meeting actually glad to be there after class. The last after school meeting I went to was the one I was forced to attend. That one had no contestants. Just potential school dropouts. The first meeting, I didn't know anybody there. Nobody I know in the student government crowd is like me and has actually flunked chemistry. All the guys who were coming in the door were the ones who hang around the bathrooms that I'm too scared to use. Nobody ever threatened me though, and after a while, dropout class wasn't half bad, but I have to admit, I like this meeting better. I sit down and watch the other contestants come through the door. I know the first name of almost every girl who walks in. Terry, of course, who is wearing her blue suede jumper and silk blouse, navy stockings and navy patent leather shoes. My friend Trudye, who has a great figure for an Oriental girl but who wears braces, and coke bottle glasses. My friend Linda, who has a beautiful face but a basic musubi-shaped[2] body. The Yanagawa twins, who have beautiful hapa faces, but pretty tragic, they inherited their father's genes and have government-issue Japanese-girl legs. Songleaders, cheerleaders, ROTC sponsors, student government committee heads, I know them all. Krissie Clifford, who is small and blond, comes running in late. Krissie looks like a young version of Beaver's mother on the TV show. She's always running like she just fell out of the screen, and if she moves fast enough, she can catch up with the TV world and jump back in. Then she walks in. Leilani Jones. As soon as she walks in the door, everybody in the room turns to look at her. Everybody in the room knows that Leilani is the only girl who can possibly win.

1. *hapa:* Hawaiian word meaning half and half, or ethnically mixed.

2. *musubi:* rectangular riceball made from sticky rice and wrapped in a black sheet of dried seaweed.

Lani is hapa, Japanese-haole.[3] She inherited the best features from everybody. She is tall and slim, with light brown hair and butter frosting skin. I don't even know what she is wearing. Leilani is so beautiful it doesn't matter what she is wearing. She is smooth, and gracefully quiet. Her smile is soft and shiny. It's like looking at a pearl. Lani is not only beautiful, when you look at her all you hear is silence, like the air around her is stunned. We all know it. This is the only girl who can possibly win.

As soon as Leilani walks in, Mrs. Takahara, the teacher advisor, says, "Well, now, take your seats everyone. We can begin."

We each take a wooden chair on either side of two rows of long library tables. There is a make-up kit and mirror at each of the places. Some of Mrs. Takahara's friends who are teachers are also sitting in.

"This is Mrs. Chung, beauty consultant of Kamedo cosmetics," Mrs. Takahara says. "She will show us the proper routines of skin cleansing and make-up. The Carnival Queen contest is a very special event. All the girls who are contestants must be worthy representatives of McKinley High School. This means the proper make-up and attitude. Mrs. Chung . . ."

I have to admire the beauty consultant. Even though her make-up is obvious as scaffolding in front of a building, it is so well done, kinda like the men who dance the girls' parts in Kabuki[4] shows, you look at it and actually believe that what you are seeing is her face.

"First, we start with proper cleansing," she says. We stare into our own separate mirrors.

"First, we pin our hair so that it no longer hangs in our faces." All of the girls dig in handbags and come up with bobby pins. Hairstyles disappear as we pin our hair straight back. The teachers look funny, kind of young without their teased hair. Mrs. Chung walks around to each station. She squeezes a glop of pink liquid on a cotton ball for each of us.

"Clean all the skin well," she says. "Get all the dirt and impurities out." We scrub hard with that cotton ball, we all know that our skin is loaded with lots of stuff that is impure. My friend Trudye gets kinda carried away. She was scrubbing so hard around her eyes that she scrubbed off her Scotch tape. She hurries over to Mrs. Takahara's chair, mumbles something and excuses herself. I figure she'll be gone pretty long; the only bathroom that is safe for us to use is all the way over in the other building.

"Now we moisturize," Mrs. Chung is going on. "We use this step to correct defects in the tones of our skins." I look over at Terry. I can't see any defects in any of the tones of her skin.

"This mauve moisturizer corrects sallow undertones," Mrs. Chung says.

"What's shallow?" I whisper to Terry.

"SALLOW," she whispers back disgusted. "Yellow."

"Oh," I say and gratefully receive the large glop of purple stuff Mrs. Chung is squeezing on my new cotton ball. Mrs. Chung squeezes a little on Terry's cotton ball too. When she passes Lani, she smiles and squeezes white stuff out from a different tube.

I happily sponge the purple stuff on. Terry is sponging too but I notice she is beginning to look like she has the flu. "Next, foundation," says Mrs. Chung. She is walking around, narrowing her eyes at each of us and handing us each a tube that she is sure is the correct color to bring out the best in our skin. Mrs. Chung hands me a plastic tube of dark beige. She gives Terry a tube of lighter beige and gives Lani a different tube altogether.

"Just a little translucent creme," she smiles to Lani who smiles back rainbow bubbles and strands of pearls.

Trudye comes rushing back and Linda catches her up on all the steps she's missed. I gotta admit, without her glasses and with all that running, she has really pretty cheekbones and nice colored skin. I

3. *haole:* white, Caucasian.

4. *kabuki:* traditional Japanese theater, in which only male actors perform, with some specializing in playing female roles.

notice she has new Scotch tape on too, and is really concentrating on what Mrs. Chung is saying next.

"Now that we have the proper foundation, we con- 25 centrate on the eyes." She pulls out a rubber and chrome pincer machine. She stands in front of Linda with it. I become concerned.

"The eyelashes sometimes grow in the wrong direction," Mrs. Chung informs us. "They must be trained to bend correctly. We use the Eyelash Curler to do this." She hands the machine to Linda. I watch as Linda puts the metal pincer up to her eye and catches her straight, heavy black lashes between the rubber pincer blades.

"Must be sore if they do it wrong and squeeze the eyelid meat," I breathe to Terry. Terry says nothing. She looks upset, like she is trying not to bring up her lunch.

"Eyeshadow must be applied to give the illusion of depth," says Mrs. Chung. "Light on top of the lid, close to the lashes, luminescent color on the whole lid, a dot of white in the center of the iris, and brown below the browbone to accentuate the crease." Mrs. Chung is going pretty fast now. I wonder what the girls who have Oriental eyelids without a crease are going to do. I check out the room quickly, over the top of my make-up mirror. Sure enough, all the Oriental girls here have a nice crease in their lids. Those who don't are wearing Scotch tape. Mrs. Chung is passing out "pearlescent" eyeshadow.

"It's made of fish scales," Terry says. I have eyelids that are all right, but eyeshadow, especially sparking eyeshadow, makes me look like a gecko, you know, with protruding eye sockets that go in separate directions. Terry has beautiful deep-socketed eyes and browbones that don't need any help to look well defined. I put on the stuff in spite of my better judgment and spend the rest of the time trying not to move my eyeballs too much, just in case anybody notices. Lani is putting on all this make-up too. But in her case, it just increases the pearly glow that her skin is already producing.

"This ends the make-up session," Mrs. Chung is 30 saying. "Now our eyes and skins have the proper preparation for our roles as contestants for Carnival Queen."

"Ma, I running in the Carnival Queen contest," I was saying last night. My mother got that exasperated look on her face.

"You think you get chance!"

"No, but the teachers put in the names of all the student council guys." My mother is beginning to look like she is suffering again.

"When you were small, everybody used to tell me you should run for Cherry Blossom contest. But that was before you got so dark like your father. I always tell you no go out in the sun or wear lotion like me when you go out but you never listen."

"Yeah, Ma, but we get modeling lessons, make-up, 35 how to walk."

"Good, might make you stand up straight. I would get you a back brace, but when you were small, we paid so much money for your legs, to get special shoes connected to a bar. You only cried and never would wear them. That's why you still have crooked legs."

That was last night. Now I'm here and Mrs. Takahara is telling us about the walking and modeling lessons.

"Imagine a string coming out of the top of your skull and connected to the ceiling. Shorten the string and walk with your chin out and back erect. Float! Put one foot in front of the other, point your toes outward and glide forward on the balls of your feet. When you stop, place one foot slightly behind the other at a forty-five degree angle. Put your weight on the back foot ..." I should have worn the stupid shoes when I was small. I'm bow-legged. Just like my father. Leilani is not bow-legged. She looks great putting one long straight tibia in front of the other. I look kinda like a crab. We walk in circles around and around the room. Terry is definitely not happy. She's walking pretty far away from me. Once, when I pass her, I could swear she is crying.

"Wow, long practice, yeah?" I say as we walk across the lawn heading toward the bus. Terry, Trudye, Linda, and I are still together. A black Buick pulls up

to the curb. Terry's Mom has come to pick her up. Terry's Mom always picks her up. She must have just come back from the beauty shop. Her head is wrapped in a pink net wind bonnet. Kind of like the cake we always get at weddings that my mother keeps on top of the television and never lets anybody eat.

"I'll call you," Terry says. 40

"I'm so glad that you and Theresa do things together," Terry's mother says. "Theresa needs girlfriends like you, Sam." I'm looking at the pink net around her face. I wonder if Terry's father ever gets the urge to smash her hair down to feel the shape of her head. Terry looks really uncomfortable as they drive away.

I feel uncomfortable too. Trudye and Linda's make-up looks really weird in the afternoon sunlight. My eyeballs feel larger than tank turrets and they must be glittering brilliantly too. The Liliha Puunui bus comes and we all get on. The long center aisle of the bus gives me an idea. I put one foot in front of the other and practice walking down. Good thing it is late and the guys we go to school with are not getting on.

"You think Leilani is going to win?" Trudye asks.

"What?" I say as I almost lose my teeth against the metal pole I'm holding on to. The driver has just started up, and standing with your feet at a forty-five degree angle doesn't work on public transportation.

"Lani is probably going to win, yeah?" Trudye says 45 again. She can hide her eye make-up behind her glasses and looks pretty much OK. "I'm going to stay in for the experience. Plus, I'm going to the orthodontist and take my braces out, and I asked my mother if I could have contact lenses and she said OK." Trudye goes on, but I don't listen. I get a seat by the window and spend the whole trip looking out so nobody sees my fish-scale eyes.

I am not surprised when I get home and the phone begins to ring.

"Sam, it's Terry. You stay in the contest. But I decided I'm not going to run."

"That's nuts, Terry," I am half screaming at her, "you are the only one of us besides Lani that has a

chance to win. You could be the first Japanese Carnival Queen that McKinley ever has." I am going to argue this one.

"Do you know the real name of this contest?" Terry asks.

"I don't know, Carnival Queen. I've never thought 50 about it I guess."

"It's the Carnival Queen Scholarship Contest."

"Oh, so?" I'm still interested in arguing that only someone with legs like Terry even has a chance.

"Why are you running? How did you get nominated?" Terry asks.

"I'm Senior Class secretary, they had to nominate me, but you . . ."

"And WHY are you secretary," she cuts me off be- 55 fore I get another running start about chances.

"I don't know, I guess because I used to write poems for English class and they always got in the paper or the yearbook. And probably because Miss Chuck made me write a column for the newspaper for one year to bring up my social studies grade."

"See . . . and why am I running?"

"OK, you're class officer, and sponsor, and you won the American Legion essay contest . . ."

"And Krissy?"

"She's editor of the yearbook, and a sponsor and 60 the Yanagawa twins are songleaders and Trudye is prom committee chairman and Linda . . ." I am getting into it.

"And Lani," says Terry quietly.

"Well, she's a sponsor I think . . ." I've lost some momentum. I really don't know.

"I'm a sponsor, and I know she's not," Terry says.

"Student government? No . . . I don't think so . . . not cheering, her sister is the one in the honor society, not . . . hey, no, couldn't be . . ."

"That's right," Terry says, "the only reason she's 65 running is because she's supposed to win." It couldn't be true. "That means the rest of us are all running for nothing. The best we can do is second place." My ears are getting sore with the sense of what she says. "We're running because of what we did. But we're going to lose because of what we look

like. Look, it's still good experience and you can still run if you like."

"Nah . . ." I say, still dazed by it. "But what about Mrs. Takahara, what about your mother?" Terry is quiet.

"I think I can handle Mrs. Takahara," Terry finally says.

"I'll say I'm not running, too. If it's two of us, it won't be so bad." I am actually kind of relieved that this is the last day I'll have to put gecko eye make-up all over my face.

"Thanks, Sam . . ." Terry says.

"Yeah . . . my mother will actually be relieved. Ever since I forgot the ending at my piano recital in fifth grade, she gets really nervous if I'm in front of any audience."

"You want me to pick you up for the carnival Saturday night?" Terry asks.

"I'll ask my Mom," I say. "See you then . . ."

"Yeah . . ."

I think, "We're going to lose because of what we look like." I need a shower, my eyes are itching anyway. I'm glad my mother isn't home yet. I think best in the shower and sometimes I'm in there an hour or more.

Soon, with the world a small square of warm steam and tile walls, it all starts going through my head. The teachers looked so young in the make-up demonstration with their hair pinned back—they looked kind of like us. But we are going to lose because of what we look like. I soap the layers of make-up off my face. I guess they're tired of looking like us; musubi bodies, daikon legs, furoshiki-shaped, home-made dresses, bento tins to be packed in the early mornings, mud and sweat everywhere. The water is splashing down on my face and hair. But Krissy doesn't look like us, and she is going to lose too. Krissy looks like the Red Cross society lady from intermediate school. She looks like Beaver's mother on the television show. Too haole. She's going to lose because of the way she looks. Lani doesn't look anything like anything from the past. She looks like something that could only have been

born underwater where all motions are slow and all sounds are soft. I turn off the water and towel off. Showers always make me feel clean and secure. I guess I can't blame even the teachers, everyone wants to feel safe and secure.

My mother is sitting at the table peeling an orange. She does this almost every night and I already know what she's going to say.

"Eat this orange, good for you, lots of vitamin C."

"I don't want to eat orange now, Ma." I know it is useless, but I say it anyway. My mother is the kind of Japanese lady who will hunch down real small when she passes in front of you when you're watching TV. Makes you think she's quiet and easy going, but not on the subject of vitamin C.

"I peeled it already. Want it." Some people actually think that my mother is shy.

"I not running in the contest. Terry and I going quit."

"Why?" my mother asks, like she really doesn't need to know.

"Terry said that we running for nothing. Everybody already knows Lani going win." My mother looks like she just tasted some orange peel.

"That's not the real reason." She hands me the orange and starts washing the dishes.

There's lots of things I don't understand. Like why Terry hangs out with me. Why my mother is always so curious about her and now why she doesn't think this is the real reason that Terry is quitting the contest.

"What did the mother say about Terry quitting the contest?" my mother asks without turning around.

"I donno, nothing I guess."

"Hmmmmmm . . . that's not the real reason. That girl is different. The way the mother treats her is different." Gee, having a baby and being a mother must be really hard and it must really change a person because all I know is that my mother is really different from me.

Terry picks me up Saturday night in her brother's white Mustang. It's been a really busy week. I haven't even seen her since we quit the contest. We had to build the Senior Class Starch Throwing booth.

"Hi, Sam. We're working until ten o'clock on the first shift, OK?" Terry is wearing a triangle denim scarf in her hair, a workshirt and jeans. Her face is flushed from driving with the Mustang's top down and she looks really glamorous.

"Yeah, I thought we weren't going to finish the booth this afternoon. Lucky thing my Dad and Lenny's Dad helped us with the hammering and Valerie's committee got the cardboard painted in time. We kinda ran out of workers because most of the girls . . ." I don't have to finish. Most of the student council girls are getting dressed up for the contest.

"Mrs. Sato and the cafeteria ladies finished cooking the starch and Neal and his friends and some of the football guys are going to carry the big pots of starch over to the booth for us." Terry is in charge of the manpower because she knows everybody.

"Terry's mother is on the phone!" my mother is calling to us from the house. Terry runs in to answer the phone. Funny, her mother always calls my house when Terry is supposed to pick me up. My mother looks out at me from the door. The look on her face says, "Checking up." Terry runs past her and jumps back in the car.

"You're lucky, your mother is really nice," she says.

We go down Kuakini Street and turn onto Liliha. We pass School Street and head down the freeway on-ramp. Terry turns on K-POI and I settle down in my seat. Terry drives faster than my father. We weave in and out of cars as she guns the Mustang down H-1. I know this is not very safe, but I like the feeling in my stomach. It's like going down hills. My hair is flying wild and I feel so clean and good. Like the first day of algebra class before the symbols get mixed up. Like the first day of chemistry before we have to learn molar solutions. I feel like it's going to be the first day forever and I can make the clean feeling last and last. The ride is too short. We turn off by the Board of Water Supply station and we head down by the Art Academy and turn down Pensacola past Mr. Feiterra's green gardens and into the parking lot of the school.

"I wish you were still in the contest tonight," I tell Terry as we walk out toward the Carnival grounds. "I mean you are so perfect for the Carnival Queen. You were the only Japanese girl that was perfect enough to win."

"I thought you were my friend," Terry starts mumbling. "You sound like my mother. You only like me because of what you think I should be." She starts walking faster and is leaving me behind.

"Wait! What? How come you getting so mad?" I'm running to keep up with her.

"Perfect, perfect. What if I'm NOT perfect. What if I'm not what people think I am? What if I can't be what people think I am?" She's not making any sense to me and she's crying. "Why can't you just like me? I thought you were different. I thought you just liked me. I thought you were my friend because you just liked ME." I'm following her and I feel like it's exam time in chemistry. I'm flunking again and I don't understand.

We get to the Senior booth and Terry disappears behind the cardboard. Valerie Rosecrest is there and hands me a lot of paper cupcake cups and a cafeteria juice ladle.

"Quick, we need at least a hundred of these filled, we're going to be open in ten minutes."

"Try wait, I gotta find Terry." I look behind the cardboard back of the booth. Terry is not there. I run all around the booth. Terry is nowhere in sight. The senior booth is under a tent in the midway with all the games. There are lots of lightbulbs strung like kernels of corn on wires inside the tent. There's lots of game booths and rows and rows of stuffed animal prizes on clotheslines above each booth. I can't find Terry and I want to look around more, but all of a sudden the merry-go-round music starts and all the lights come on. The senior booth with its handpainted signs, "Starch Throw— three script" looks alive all of a sudden in the warm Carnival light.

"Come on, Sam!" Valerie is calling me. "We're opening. I need you to help!" I go back to the booth. Pretty soon Terry comes back and I look at her kind

of worried, but under the soft popcorn light, you cannot even tell she was crying.

"Terry, Mr. Miller said that you're supposed to watch the script can and take it to the cafeteria when it's full." Val's talking to her, blocking my view. Some teachers are arriving for first shift. They need to put on shower caps and stick their heads through holes in the cardboard so students can buy paper cupcake cups full of starch to throw to try to hit the teachers in the face. Terry goes in the back to help the teachers get ready. Lots of guys from my dropout class are lining up in the front of the booth.

"Eh, Sam, come on, take my money. Ogawa's back there. He gave me the F in math. Gimme the starch!" Business is getting better and better all night. Me, Val, and Terry are running around the booth, taking script, filling cupcake cups, and getting out of the way fast when the guys throw the starch. Pretty soon, the grass in the middle of the booth turns into a mess that looks like thrown-up starch, and we are trying not to slip as we run around trying to keep up with business.

"Ladies and gentlemen, McKinley High School is proud to present the 1966 Carnival Queen and her court." It comes over the loudspeaker. It must be the end of the contest, ten o'clock. All the guys stop buying starch and turn to look toward the tent. Pretty soon, everyone in the tent has cleared the center aisle. They clap as five girls in evening dresses walk our way.

"Oh, great," I think. "I have starch in my hair and I don't want to see them." The girls are all dressed in long gowns and are wearing white gloves. The first girl is Linda. She looks so pretty in a maroon velvet A-line gown. Cannot see her musubi-shaped body and her face is just glowing. The rhinestones in her tiara are sparkling under each of the hundreds of carnival lights. The ribbon on her chest says "Third Princess." It's neat! Just like my cousin Carolyn's wedding. My toes are tingling under their coating of starch. The next is Trudye. She's not wearing braces and she looks so pretty in her lavender gown. Some of the guys are going "Wow" under

their breath as she walks by. The first Princesses pass next. The Yanagawa twins. They're wearing matching pink gowns and have pink baby roses in their hair, which is in ringlets. Their tiaras look like lace snowflakes on their heads as they pass by. And last. Even though I know who this is going to be I really want to see her. Sure enough, everybody in the crowd gets quiet as she passes by. Lani looks like her white dress is made of sugar crystals. As she passes, her crown sparkles tiny rainbows under the hundreds of lightbulbs from the tent and flashbulbs popping like little suns.

The court walks through the crowd and stops at the senior booth. Mr. Harano, the principal, steps out.

"Your majesty," he's talking to Lani, who is really glowing. "I will become a target in the senior booth in your honor. Will you and your Princesses please take aim and do your best as royal representatives of our school?"

I look around at Terry. The principal is acting so stupid. I can't believe he really runs the whole school. Terry must be getting so sick. But I look at her and she's standing in front of Lani and smiling. This is weird. She's the one who said the contest was fixed. She's the one who said everyone knew who was supposed to win. She's smiling at Lani like my grandmother used to smile at me when I was five: Like I was a sweet mochi dumpling floating in red bean soup. I cannot stand it. I quit the contest so she wouldn't have to quit alone. And she yells at me and hasn't talked to me all night. All I wanted was for her to be standing there instead of Lani.

The Carnival Queen and four Princesses line up in front of the booth. Val, Terry, and I scramble around giving each of them three cupcake cups of starch. They get ready to throw. The guys from the newspaper and the yearbook get ready to take their picture. I lean as far back into the wall as I can. I know Trudye didn't have time to get contacts yet and she's not wearing any glasses. I wonder where Val is and if she can flatten out enough against the wall to get out of the way. Suddenly, a hand reaches out and grabs my ankle. I look down, and Terry,

who is sitting under the counter of the booth with Val, grabs my hand and pulls me down on the grass with them. The ground here is nice and clean. The Carnival Queen and Princesses and the rows of stuffed animals are behind and above us. The air is filled with pink cupcake cups and starch as they throw. Mr. Harano closes his eyes, the flashbulbs go off, but no one comes close to hitting his face. Up above us everyone is laughing and clapping. Down below, Terry, Val, and I are nice and clean.

"Lani looks so pretty, Sam." Terry is looking at me and smiling.

"Yeah, even though the contest was juice she looks really good. Like a storybook," I say, hoping it's not sounding too fake.

"Thanks for quitting with me." Terry's smile is like the water that comes out from between the rocks at Kunawai stream. I feel so clean in that smile.

"It would have been lonely if I had to quit by my-self," Terry says, looking down at our starch-covered shoes. She looks up at me and smiles again. And even if I'm covered with starch, I suddenly know that to her, I am beautiful. Her smile tells me that we're friends because I went to dropout class. It is a smile that can wash away all the F's that Mr. Low my chemistry teacher will ever give. I have been waiting all my life for my mother to give me that smile. I know it is a smile that Terry's mother has never smiled at her. I don't know where she learned it.

It's quiet now, the Carnival Queen and her 115 Princesses have walked away. Terry stands up first as she and Val and I start to crawl out from our safe place under the counter of the booth. She gives me her hand to pull me up and I can see her out in the bright Carnival light. Maybe every girl looks like a queen at one time in her life. ○

SEEING

1. Focus your attention on the "make-up training" scene in this story (para. 10 and following). How does this process enable these high school students to fashion a highly gendered identity for themselves? Mrs. Takahara says: "The Carnival Queen contest is a very special event. All the girls who are contestants must be worthy representatives of McKinley High School" (para. 12). What does it mean for a girl to be a "worthy representative" of this high school? How do the narrator's notions of beauty change over the course of this story? What does the narrator mean when she says, "I guess I can't blame even the teachers, everyone wants to feel safe and secure" (para. 75). How does Hara represent feeling "safe and secure" in this story?

2. Describe the point of view from which this story is told. How would you characterize the narrator's tone of voice? Point to specific words and phrases that establish the idiosyncrasies of this character. Comment on the voice of the mother in this story. How would you characterize her tone? What compositional techniques does Hara use to convey the mother's personality? Compare this mother's voice with the maternal voice in Jamaica Kincaid's story "Girl" (p. 264).

WRITING

1. We'd like to invite you to reflect for a few moments on your experiences with "beauty" and with your own version of the kind of beauty pageant represented in "Carnival Queen." What standard of "beauty" seemed to dominate your conversations with your high school peers at the time? What kinds of training and rituals did you experience (or hear about) as students prepared themselves for these beauty competitions or other special school events? How were the definitions of "beauty" different for girls and boys growing up in your high school? Write an essay in which you identify—and characterize—the standard of beauty that operated during your years in high school.

2. Examine carefully the photograph by Dana Lixenberg entitled "Practice Makes Perfect" (p. 315). Using your reading of "Carnival Queen" as a source, write the first draft of a story or an "inner dialogue" based on the Lixenberg photograph showing the young woman preparing for a beauty pageant. An alternate exercise would be to write an analytical essay in which you compare and contrast what the phrase "practice makes perfect" means in these two visual and verbal representations of beauty contests.

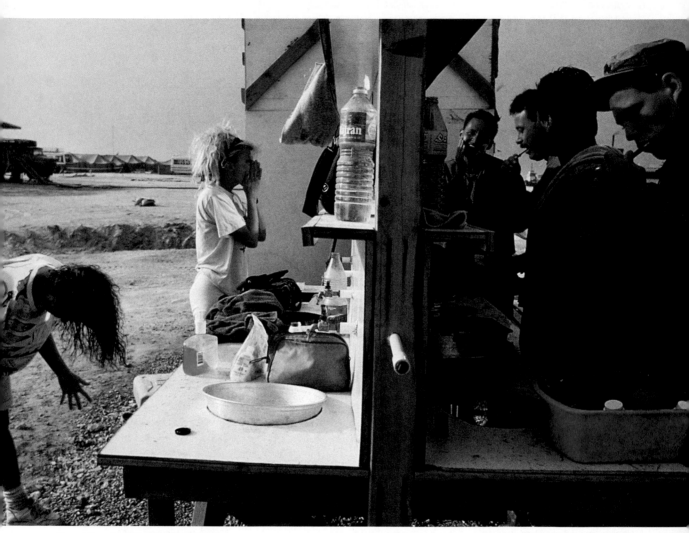

Donna Ferrato, **Operation Desert Storm**

DONNA FERRATO

A professional photographer for more than eighteen years, Donna Ferrato has covered subjects as various as Bruce Springsteen, the Persian Gulf War, and the movements for the rights of the gay/transgendered community. A co-founder of the Domestic Abuse Awareness Program in New York City, Ferrato has used photography to raise awareness and financial support for victims of domestic abuse. Her documentation of abuse victims has appeared in *Life, Time,* and the *New York Times Magazine* and has been collected in *Living with the Enemy* (1991). For this work Ferrato received the W. Eugene Smith Grant, the Kodak Crystal Eagle for Courage in Journalism, and the Robert F. Kennedy Award for Humanistic Photography.

SEEING

1. How would you characterize the similarities and differences between the spaces divided by the wall in this photograph? What different "cleaning up" rituals are these soldiers involved in? What products are they using? How do the soldiers relate to each other—on the same side and on the opposite side of the wall? What do you make of the military's decision to construct an actual wall in the middle of the desert? To what extremes has the military gone in order to preserve traditional social conventions? To what extent does the wall serve, in fact, as a divider? To what extent does this photograph remind you of or seem to diverge from single-sex spaces that you've experienced? What, if anything, about the photograph seems ironic or absurd to you?

2. How many different images within an image do you see here? How has Ferrato managed to convey multiple scenes in one photograph? Comment on her photographic choices here: the angle she chose, the precise moment to capture this image, as well as the role of the vertical line of the wall in the overall composition of the photograph.

WRITING

1. We have all experienced single-sex spaces, if only in public bathrooms. What other single-sex spaces (e.g., locker rooms, gyms, or single-sex schools) or groups (e.g., of friends, siblings, community groups, fraternities, and sororities) have you participated in? Write an essay in which you recollect a memorable experience in a single-sex group that conveys the particularly male- or female-oriented social dynamics of that group or space.

2. In an essay entitled "The Gender Blur," Nancy Blum, a professor of journalism at the University of Wisconsin, Madison and author of *Sex on the Brain: The Biological Differences between Men and Women* (1998), discusses the following statistics: "Crime reports in both the United States and Europe record between 10 and 15 robberies committed by men for every one by a woman. At one point, people argued that this was explained by size difference. Women weren't big enough to intimidate, but that would change, they predicted, with the availability of compact weapons. But just as little girls don't routinely make weapons out of toast, women—even criminal ones—don't seem drawn to weaponry in the same way that men are. Almost twice as many male thieves and robbers use guns as their female counterparts do." Write the first draft of an essay in which you speculate about an explanation for the statistical differences Blum reports.

NATALIE ANGIER

Pulitzer Prize–winning journalist Natalie Angier writes for the *New York Times* on science-related subjects as diverse as microbes and monogamy. "She knows all that scientists know and sometimes more," remarks one critic who counts Angier among the great nature writers of our time. First celebrated for her reporting work on cancer research, which was collected in her book *Natural Obsessions* (1988), she has since received many awards.

Angier is author of *The Beauty of the Beastly: New Views in the Nature of Life* (1995), which elucidates such topics as the erotic behavior of barn swallows and queen bees as well as the habits of invisible invertebrates.

Most recently Angier has turned her attention to evolutionary psychology and the views of the many (mostly male) scientists in that field who assert that the sexual nature and desires of men are innately different from those of women. Angier's compelling arguments against such assumptions are a major theme in her latest book, *Women, an Intimate Geography* (1999), from which "Men, Women, Sex, and Darwin" is adapted.

Angier (b. 1958) attended the University of Michigan and Barnard College in New York. Her work has been published in both scholarly and popular periodicals.

MEN, WOMEN, SEX, AND DARWIN

Natalie Angier

Life is short but jingles are forever. none more so, it seems, than the familiar ditty, variously attributed to William James, Ogden Nash and Dorothy Parker: "Hoggamus, higgamus,/Men are polygamous,/ Higgamus, hoggamus,/Women monogamous."

Lately the pith of that jingle has found new fodder and new fans, through the explosive growth of a field known as evolutionary psychology. Evolutionary psychology professes to have discovered the fundamental modules of human nature, most notably the essential nature of man and of woman. It makes sense to be curious about the evolutionary roots of human behavior. It's reasonable to try to understand our impulses and actions by applying Darwinian logic to the problem. We're animals. We're not above the rude little prods and jests of natural and sexual selection. But evolutionary psychology as it has been disseminated across mainstream consciousness is a cranky and despotic Cyclops, its single eye glaring through an overwhelmingly masculinist lens. I say "masculinist" rather than "male" because the view of male behavior promulgated by hard-core evolutionary psychologists is as narrow and inflexible as their view of womanhood is.

I'm not interested in explaining to men what they really want or how they should behave. If a fellow chooses to tell himself that his yen for the fetching young assistant in his office and his concomitant disgruntlement with his aging wife make perfect Darwinian sense, who am I to argue with him? I'm only proposing here that the hard-core evolutionary psychologists have got a lot about women wrong—about some of us, anyway—and that women want more and deserve better than the cartoon Olive Oyl handed down for popular consumption.

The cardinal premises of evolutionary psychology of interest to this discussion are as follows: 1. Men are more promiscuous and less sexually reserved than women are. 2. Women are inherently more interested in a stable relationship than men are. 3. Women are naturally attracted to high-status men with resources. 4. Men are naturally attracted to youth and beauty. 5. Humankind's core preferences and desires were hammered out long, long ago, a hundred thousand years or more, in the legendary Environment of Evolutionary Adaptation, or E.E.A., also known as the ancestral environment, also known as the Stone Age, and they have not changed appreciably since then, nor are they likely to change in the future.

In sum: Higgamus, hoggamus, 5 Pygmalionus, Playboy magazine, eternitas. Amen.

Hard-core evolutionary psychology types go to extremes to argue in favor of the yawning chasm that separates the innate desires of women and men. They declare ringing confirmation for their theories even in the face of feeble and amusingly contradictory data. For example: Among the cardinal principles of the evo-psycho set is that men are by nature more polygamous than women are, and much more accepting of casual, even anonymous, sex. Men can't help themselves, they say: they are always hungry for sex, bodies, novelty and nubility. Granted, men needn't act on such desires, but the drive to sow seed is there nonetheless, satyric and relentless, and women cannot fully understand its force. David Buss, a professor of psychology at the University of Texas at Austin and one of the most outspoken of the evolutionary psychologists, says that asking a man not to lust after a pretty young woman is like telling a carnivore not to like meat.

At the same time, they recognize that the overwhelming majority of men and women get married, and so their theories must extend to different innate mate preferences among men and women. Men look

for the hallmarks of youth, like smooth skin, full lips and perky breasts; they want a mate who has a long childbearing career ahead of her. Men also want women who are virginal and who seem as though they'll be faithful and not make cuckolds of them. The sexy, vampy types are fine for a Saturday romp, but when it comes to choosing a marital partner, men want modesty and fidelity.

Women want a provider, the theory goes. They want a man who seems rich, stable and ambitious. They want to know that they and their children will be cared for. They want a man who can take charge, maybe dominate them just a little, enough to reassure them that the man is genotypically, phenotypically, eternally, a king. Women's innate preference for a well-to-do man continues to this day, the evolutionary psychologists insist, even among financially independent and professionally successful women who don't need a man as a provider. It was adaptive in the past to look for the most resourceful man, they say, and adaptations can't be willed away in a generation or two of putative cultural change.

And what is the evidence for these male-female verities? For the difference in promiscuity quotas, the hard-cores love to raise the example of the differences between gay men and lesbians. Homosexuals are seen as a revealing population because they supposedly can behave according to the innermost impulses of their sex, untempered by the need to adjust to the demands and wishes of the opposite sex, as heterosexuals theoretically are. What do we see in this ideal study group? Just look at how gay men carry on! They are perfectly happy to have hundreds, thousands, of sexual partners, to have sex in bathhouses, in bathrooms, in Central Park. By contrast, lesbians are sexually sedate. They don't

cruise sex clubs. They couple up and stay coupled, and they like cuddling and hugging more than they do serious, genitally based sex.

In the hard-core rendering of inherent male-female discrepancies in promiscuity, gay men are offered up as true men, real men, men set free to be men, while lesbians are real women, ultra-women, acting out every woman's fantasy of love and commitment. Interestingly, though, in many neurobiology studies gay men are said to have somewhat feminized brains, with hypothalamic nuclei that are closer in size to a woman's than to a straight man's, and spatial-reasoning skills that are modest and ladylike rather than manfully robust. For their part, lesbians are posited to have somewhat masculinized brains and skills—to be sportier, more mechanically inclined, less likely to have played with dolls or tea sets when young—all as an ostensible result of exposure to prenatal androgens. And so gay men are sissy boys in some contexts and Stone Age manly men in others, while lesbians are battering rams one day and flower into the softest and most sexually divested girlish girls the next.

On the question of mate preferences, evo-psychos rely on surveys, most of them compiled by David Buss. His surveys are celebrated by some, derided by others, but in any event they are ambitious—performed in 37 countries, he says, on six continents. His surveys, and others emulating them, consistently find that men rate youth and beauty as important traits in a mate, while women give comparatively greater weight to ambition and financial success. Surveys show that surveys never lie. Lest you think that women's mate preferences change with their own mounting economic clout, surveys assure us that they do not. Surveys of female medical students, accord-

ing to John Marshall Townsend, of Syracuse University, indicate that they hope to marry men with an earning power and social status at least equal to and preferably greater than their own.

Perhaps all this means is that men can earn a living wage better, even now, than women can. Men make up about half the world's population, but they still own the vast majority of the world's wealth—the currency, the minerals, the timber, the gold, the stocks, the amber fields of grain. In her superb book "Why So Slow?" Virginia Valian, a professor of psychology at Hunter College, lays out the extent of lingering economic discrepancies between men and women in the United States. In 1978 there were two women heading Fortune 1000 companies; in 1994, there were still two; in 1996, the number had jumped all the way to four. In 1985, 2 percent of the Fortune 1000's senior-level executives were women; by 1992, that number had hardly budged, to 3 percent. A 1990 salary and compensation survey of 799 major companies showed that of the highest-paid officers and directors, less than one-half of 1 percent were women. Ask, and he shall receive. In the United States the possession of a bachelor's degree adds $28,000 to a man's salary but only $9,000 to a woman's. A degree from a high-prestige school contributes $11,500 to a man's income but subtracts $2,400 from a woman's. If women continue to worry that they need a man's money, because the playing field remains about as level as the surface of Mars, then we can't conclude anything about innate preferences. If women continue to suffer from bag-lady syndrome even as they become prosperous, if they still see their wealth as provisional and capsizable, and if they still hope to find a man with a de-

pendable income to supplement their own, then we can credit women with intelligence and acumen, for inequities abound.

There's another reason that smart, professional women might respond on surveys that they'd like a mate of their socioeconomic status or better. Smart, professional women are smart enough to know that men can be tender of ego—is it genetic?—and that it hurts a man to earn less money than his wife, and that resentment is a noxious chemical in a marriage and best avoided at any price. "A woman who is more successful than her mate threatens his position in the male hierarchy," Elizabeth Cashdan, of the University of Utah, has written. If women could be persuaded that men didn't mind their being high achievers, were in fact pleased and proud to be affiliated with them, we might predict that the women would stop caring about the particulars of their mates' income. The anthropologist Sarah Blaffer Hrdy writes that "when female status and access to resources do not depend on her mate's status, women will likely use a range of criteria, not primarily or even necessarily prestige and wealth, for mate selection." She cites a 1996 New York Times story about women from a wide range of professions—bankers, judges, teachers, journalists—who marry male convicts. The allure of such men is not their income, for you can't earn much when you make license plates for a living. Instead, it is the men's gratitude that proves irresistible. The women also like the fact that their husbands' fidelity is guaranteed. "Peculiar as it is," Hrdy writes, "this vignette of sex-reversed claustration makes a serious point about just how little we know about female choice in breeding systems where male interests are not paramount and patrilines are not making the rules."

Do women love older men? Do women find gray hair and wrinkles attractive on men—as attractive, that is, as a fine, full head of pigmented hair and a vigorous, firm complexion? The evolutionary psychologists suggest yes. They believe that women look for the signs of maturity in men because a mature man is likely to be a comparatively wealthy and resourceful man. That should logically include baldness, which generally comes with age and the higher status that it often confers. Yet, as Desmond Morris points out, a thinning hairline is not considered a particularly attractive state.

Assuming that women find older men attractive, is it the men's alpha status? Or could it be something less complimentary to the male, something like the following—that an older man is appealing not because he is powerful but because in his maturity he has lost some of his power, has become less marketable and desirable and potentially more grateful and gracious, more likely to make a younger woman feel that there is a balance of power in the relationship? The rude little calculation is simple: He is male, I am female—advantage, man. He is older, I am younger—advantage, woman. By the same token, a woman may place little value on a man's appearance because she values something else far more: room to breathe. Who can breathe in the presence of a handsome young man, whose ego, if expressed as a vapor, would fill Biosphere II? Not even, I'm afraid, a beautiful young woman.

In the end, what is important to question, and to hold to the fire of alternative interpretation, is the immutability and adaptive logic of the discrepancy, its basis in our genome rather than in the ecological circumstances in which a genome manages to express itself. Evolutionary psychologists insist on

the essential discordance between the strength of the sex drive in males and females. They admit that many nonhuman female primates gallivant about rather more than we might have predicted before primatologists began observing their behavior in the field—more, far more, than is necessary for the sake of reproduction. Nonetheless, the credo of the coy female persists. It is garlanded with qualifications and is admitted to be an imperfect portrayal of female mating strategies, but then, that little matter of etiquette attended to, the credo is stated once again.

"Amid the great variety of social structure in these species, the basic theme . . . stands out, at least in minimal form: males seem very eager for sex and work hard to find it; females work less hard," Robert Wright says in "The Moral Animal." "This isn't to say the females don't like sex. They love it, and may initiate it. And, intriguingly, the females of the species most closely related to humans—chimpanzees and bonobos—seem particularly amenable to a wild sex life, including a variety of partners. Still, female apes don't do what male apes do: search high and low, risking life and limb, to find sex, and to find as much of it, with as many different partners, as possible; it has a way of finding them." In fact female chimpanzees do search high and low and take great risks to find sex with partners other than the partners who have a way of finding them. DNA studies of chimpanzees in West Africa show that half the offspring in a group of closely scrutinized chimpanzees turned out not to be the offspring of the resident males. The females of the group didn't rely on sex "finding" its way to them; they proactively left the local environs, under such conditions of secrecy that not even their vigilant human observers knew they had gone, and

became impregnated by outside males. They did so even at the risk of life and limb—their own and those of their offspring. Male chimpanzees try to control the movements of fertile females. They'll scream at them and hit them if they think the females aren't listening. They may even kill an infant they think is not their own. We don't know why the females take such risks to philander, but they do, and to say that female chimpanzees "work less hard" than males do at finding sex does not appear to be supported by the data.

Evo-psychos pull us back and forth until we might want to sue for whiplash. On the one hand we are told that women have a lower sex drive than men do. On the other hand we are told that the madonna-whore dichotomy is a universal stereotype. In every culture, there is a tendency among both men and women to adjudge women as either chaste or trampy. The chaste ones are accorded esteem. The trampy ones are consigned to the basement, a notch or two below goats in social status. A woman can't sleep around without risking terrible retribution, to her reputation, to her prospects, to her life. "Can anyone find a single culture in which women with unrestrained sexual appetites aren't viewed as more aberrant than comparably libidinous men?" Wright asks rhetorically.

Women are said to have lower sex drives than men, yet they are universally punished if they display evidence to the contrary—if they disobey their "natural" inclination toward a stifled libido. Women supposedly have a lower sex drive than men do, yet it is not low enough. There is still just enough of a lingering female infidelity impulse that cultures everywhere have had to gird against it by articulating a rigid dichotomy with menacing implications for

those who fall on the wrong side of it. There is still enough lingering female infidelity to justify infibulation, purdah, claustration. Men have the naturally higher sex drive, yet all the laws, customs, punishments, shame, strictures, mystiques and antimystiques are aimed with full hominid fury at that tepid, sleepy, hypoactive creature, the female libido.

"It seems premature ... to attribute the relative lack of female interest in sexual variety to women's biological nature alone in the face of overwhelming evidence that women are consistently beaten for promiscuity and adultery," the primatologist Barbara Smuts has written. "If female sexuality is muted compared to that of men, then why must men the world over go to extreme lengths to control and contain it?"

Why indeed? Consider a brief evolutionary apologia for President Clinton's adulteries written by Steven Pinker, of the Massachusetts Institute of Technology. "Most human drives have ancient Darwinian rationales," he wrote. "A prehistoric man who slept with 50 women could have sired 50 children, and would have been more likely to have descendants who inherited his tastes. A woman who slept with fifty men would have no more descendants than a woman who slept with one. Thus, men should seek quantity in sexual partners; women, quality." And isn't it so, he says, everywhere and always so? "In our society," he continues, "most young men tell researchers that they would like eight sexual partners in the next two years; most women say that they would like one." Yet would a man find the prospect of a string of partners so appealing if the following rules were applied: that no matter how much he may like a particular woman and be pleased by her performance and want to sleep with her again, he will have

no say in the matter and will be dependent on her mood and good graces for all future contact; that each act of casual sex will cheapen his status and make him increasingly less attractive to other women; and that society will not wink at his randiness but rather sneer at him and think him pathetic, sullied, smaller than life? Until men are subjected to the same severe standards and threat of censure as women are, and until they are given the lower hand in a so-called casual encounter from the start, it is hard to insist with such self-satisfaction that, hey, it's natural, men like a lot of sex with a lot of people and women don't.

Reflect for a moment on Pinker's philandering caveman who slept with 50 women. Just how good a reproductive strategy is this chronic, random shooting of the gun? A woman is fertile only five or six days a month. Her ovulation is concealed. The man doesn't know when she's fertile. She might be in the early stages of pregnancy when he gets to her; she might still be lactating and thus not ovulating. Moreover, even if our hypothetical Don Juan hits a day on which a woman is ovulating, the chances are around 65 percent that his sperm will fail to fertilize her egg; human reproduction is complicated, and most eggs and sperm are not up to the demands of proper fusion. Even if conception occurs, the resulting embryo has about a 30 percent chance of miscarrying at some point in gestation. In sum, each episode of fleeting sex has a remarkably small probability of yielding a baby—no more than 1 or 2 percent at best.

And because the man is trysting and running, he isn't able to prevent any of his casual contacts from turning around and mating with other men. The poor fellow. He has to mate with many scores of women for his wham-bam strategy

to pay off. And where are all these women to be found, anyway? Population densities during that purportedly all-powerful psyche shaper the "ancestral environment" were quite low, and long-distance travel was dangerous and difficult.

There are alternatives to wantonness, as a numbers of theorists have emphasized. If, for example, a man were to spend more time with one woman rather than dashing breathlessly from sheet to sheet, if he were to feel compelled to engage in what animal behaviorists call mate guarding, he might be better off, reproductively speaking, than the wild Lothario, both because the odds of impregnating the woman would increase and because he'd be monopolizing her energy and keeping her from the advances of other sperm bearers. It takes the average couple three to four months of regular sexual intercourse to become pregnant. That number of days is approximately equal to the number of partners our hypothetical libertine needs to sleep with to have one encounter result in a "fertility unit," that is, a baby. The two strategies, then, shake out about the same. A man can sleep with a lot of women—the quantitative approach—or he can sleep with one woman for months at a time, and be madly in love with her—the qualitative tactic.

It's possible that these two reproductive strategies are distributed in discrete packets among the male population, with a result that some men are born philanderers and can never attach, while others are born romantics and perpetually in love with love; but it's also possible that men teeter back and forth from one impulse to the other, suffering an internal struggle between the desire to bond and the desire to retreat, with the circuits of attachment ever there to be toyed with, and their needs and desires difficult to understand, paradoxical,

fickle, treacherous and glorious. It is possible, then, and for perfectly good Darwinian reason, that casual sex for men is rarely as casual as it is billed.

It needn't be argued that men and women are exactly the same, or that humans are meta-evolutionary beings, removed from nature and slaves to culture, to reject the perpetually regurgitated model of the coy female and the ardent male. Conflicts of interest are always among us, and the outcomes of those conflicts are interesting, more interesting by far than what the ultra-evolutionary psychology line has handed us. Patricia Gowaty, of the University of Georgia, sees conflict between males and females as inevitable and pervasive. She calls it sexual dialectics. Her thesis is that females and males vie for control over the means of reproduction. Those means are the female body, for there is as yet no such beast as the parthenogenetic man.

Women are under selective pressure to maintain control over their reproduction, to choose with whom they will mate and with whom they will not—to exercise female choice. Men are under selective pressure to make sure they're chosen or, barring that, to subvert female choice and coerce the female to mate against her will. "But once you have this basic dialectic set in motion, it's going to be a constant push-me, pull-you," Gowaty says. "That dynamism cannot possibly result in a unitary response, the caricatured coy woman and ardent man. Instead there are going to be some coy, reluctantly mating males and some ardent females, and any number of variations in between.

"A female will choose to mate with a male whom she believes, consciously or otherwise, will confer some advantage on her and her offspring. If that's the case, then her decision is contingent on what she brings to the equation." For example, she says, "the 'good genes' model leads to oversimplified notions that there is a 'best male' out there, a top-of-the-line hunk whom all females would prefer to mate with if they had the wherewithal. But in the viability model, a female brings her own genetic complement to the equation, with the result that what looks good genetically to one woman might be a clash of colors for another."

Maybe the man's immune system doesn't complement her own, for example, Gowaty proposes. There's evidence that the search for immune variation is one of the subtle factors driving mate selection, which may be why we care about how our lovers smell; immune molecules may be volatilized and released in sweat, hair, the oil on our skin. We are each of us a chemistry set, and each of us has a distinctive mix of reagents. "What pleases me might not please somebody else," Gowaty says. "There is no one-brand great male out there. We're not all programmed to look for the alpha male and only willing to mate with the little guy or the less aggressive guy because we can't do any better. But the propaganda gives us a picture of the right man and the ideal woman, and the effect of the propaganda is insidious. It becomes self-reinforcing. People who don't fit the model think, I'm weird, I'll have to change my behavior." It is this danger, that the ostensible "discoveries" of evolutionary psychology will be used as propaganda, that makes the enterprise so disturbing.

Variation and flexibility are the key themes that get set aside in the breathless dissemination of evolutionary psychology. "The variation is tremendous, and is rooted in biology," Barbara Smuts said to me. "Flexibility itself is the adaptation." Smuts has studied olive baboons, and she has seen males pursuing all sorts of mating strate-

gies. "There are some whose primary strategy is dominating other males, and being able to gain access to more females because of their fighting ability," she says. "Then there is the type of male who avoids competition and cultivates long-term relationships with females and their infants. These are the nice, affiliative guys. There's a third type, who focuses on sexual relationships. He's the consorter. . . . And as far as we can tell, no one reproductive strategy has advantages over the others."

Women are said to need an investing male. We think we know the reason. Human babies are difficult and time consuming to raise. Stone Age mothers needed husbands to bring home the bison. Yet the age-old assumption that male parental investment lies at the heart of human evolution is now open to serious question. Men in traditional foraging cultures do not necessarily invest resources in their offspring. Among the Hadza of Africa, for example, the men hunt, but they share the bounty of that hunting widely, politically, strategically. They don't deliver it straight to the mouths of their progeny. Women rely on their senior female kin to help feed their children. The women and their children in a gathering-hunting society clearly benefit from the meat that hunters bring back to the group. But they benefit as a group, not as a collection of nuclear family units, each beholden to the father's personal pound of wildeburger.

This is a startling revelation, which upends many of our presumptions about the origins of marriage and what women want from men and men from women. If the environment of evolutionary adaptation is not defined primarily by male parental investment, the

bedrock of so much of evolutionary psychology's theories, then we can throw the door wide open and ask new questions, rather than endlessly repeating ditties and calling the female coy long after she has run her petticoats through the Presidential paper shredder.

For example: Nicholas Blurton Jones, of the University of California at Los Angeles, and others have proposed that marriage developed as an extension of men's efforts at mate guarding. If the cost of philandering becomes ludicrously high, the man might be better off trying to claim rights to one woman at a time. Regular sex with a fertile woman is at least likely to yield offspring at comparatively little risk to his life, particularly if sexual access to the woman is formalized through a public ceremony—a wedding. Looked at from this perspective, one must wonder why an ancestral woman bothered to get married, particularly if she and her female relatives did most of the work of keeping the family fed from year to year. Perhaps, Blurton Jones suggests, to limit the degree to which she was harassed. The cost of chronic male harassment may be too high to bear. Better to agree to a ritualized bond with a male and to benefit from whatever hands-off policy the marriage may bring, than to spend all of her time locked in one sexual dialectic or another.

Thus marriage may have arisen as a multifaceted social pact: between man and woman, between male and male and between the couple and the tribe. It is a reasonable solution to a series of cultural challenges that arose in concert with the expansion of the human neocortex. But its roots may not be what we think they are, nor may our contemporary mating behaviors stem from the pressures of an ancestral environment as it is commonly portrayed, in which a

woman needed a mate to help feed and clothe her young. Instead, our "deep" feelings about marriage may be more pragmatic, more contextual and, dare I say it, more egalitarian than we give them credit for being.

If marriage is a local compact, a mutual bid between man and woman to contrive a reasonably stable and agreeable microhabitat in a community of shrewd and well-armed members, then we can understand why, despite rhetoric to the contrary, men are as eager to marry as women are. A raft of epidemiological studies have shown that marriage adds more years to the life of a man than it does to that of a woman. Why should that be, if men are so "naturally" ill suited to matrimony?

What do women want? None of us can speak for all women, or for more than one woman, really, but we can hazard a mad guess that a desire for emotional parity is widespread and profound. It doesn't go away, although it often hibernates under duress, and it may be perverted by the restrictions of habitat or culture into something that looks like its opposite. The impulse for liberty is congenital. It is the ultimate manifestation of selfishness, which is why we can count on its endurance. ○

SEEING

1. What does Natalie Angier mean when she talks about "evolutionary psychology"? Look up the definitions of any terms she uses with which you are unfamiliar, such as *alpha status* and *genome*. In what ways do these terms add to—or detract from—your overall impression of the essay? What is Angier's thesis? When does she reveal it in the course of the essay? In what ways did reading this essay change (or not change) your views on the "Nature versus Nurture" debate?

2. What is the gist of the jingle with which Angier begins her essay? Why might she have chosen to weave variations on this jingle throughout the piece? What references does it evoke? What tone does it convey? This essay appeared in the *New York Times Magazine.* In what ways has Angier shaped the essay to meet the expectations of her audience? Who is her audience? How do you imagine she might revise her essay if it were to appear in another magazine—for example, a men's magazine such as *GQ* or a women's magazine such as *Elle?*

WRITING

1. How does Angier view the marriage ceremony in contemporary culture? Why does she speculate about the reasons men and women choose to get married? Do you agree with her speculations? Write an essay in which you explore the factors that you think contribute to the decision to get married.

2. In paragraph 29, Angier (initially quoting Patricia Gowaty) writes that " 'We're not all programmed to look for the alpha male and only willing to mate with the little guy or the less aggressive guy because we can't do any better. But the propaganda gives us a picture of the right man and the ideal woman, and the effect of the propaganda is insidious. . . . People who don't fit the model think, I'm weird, I'll have to change my behavior.' It is this danger, that the ostensible 'discoveries' of evolutionary psychology will be used as propaganda, that makes the enterprise so disturbing." Reread Angier's assertion several times until you are confident enough to think and write effectively about it. Do you agree or disagree with her claim? Cite evidence within—and beyond—Angier's essay to validate or refute the claim that the effect of the propaganda about "the right man and the ideal woman . . . is insidious." Write an essay in which you use the quotation to develop an argument that supports or refutes Angier's assertion.

MEN, WOMEN, SEX, AND DARWIN

Natalie Angier

"I had a nice time, Steve. Would you like to come in, settle down, and raise a family?"

Robert Mankoff, **Cartoon from** *The New Yorker*

Retrospect:
Women Join the Cause

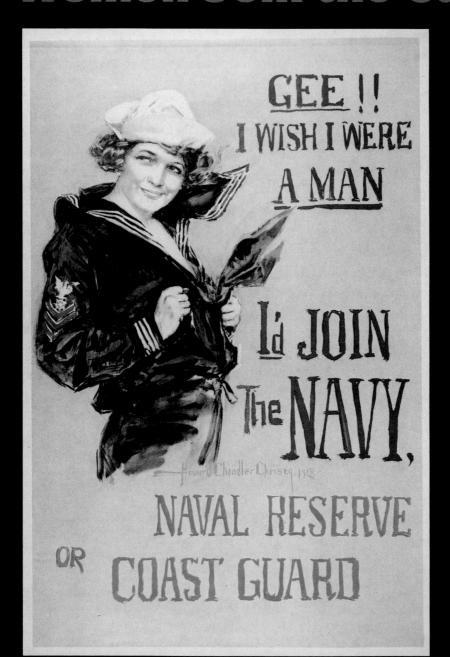

1917

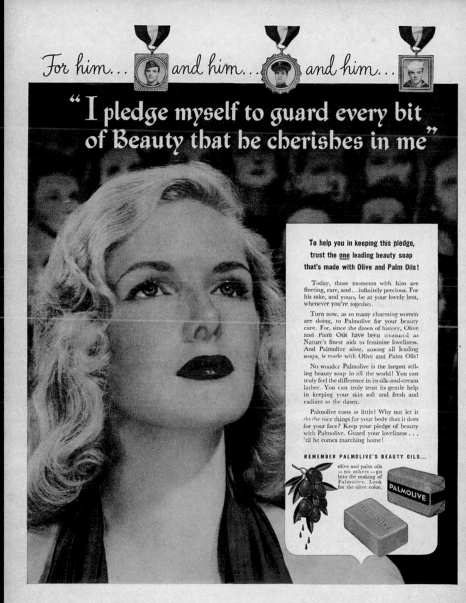

For him... and him... and him...

"I pledge myself to guard every bit of Beauty that he cherishes in me"

1943

To help you in keeping this pledge, trust the one leading beauty soap that's made with Olive and Palm Oils!

Today, those moments with him are fleeting, rare, and...infinitely precious. For his sake, and yours, be at your lovely best, whenever you're together.

Turn now, as so many charming women are doing, to Palmolive for your beauty care. For, since the dawn of history, Olive and Palm Oils have been treasured as Nature's finest aids to feminine loveliness. And Palmolive *alone*, among all leading soaps, is made with Olive and Palm Oils!

No wonder Palmolive is the largest selling beauty soap in all the world! You can truly feel the difference in its silk-and-cream lather. You can truly trust its gentle help in keeping your skin soft and fresh and radiant as the dawn.

Palmolive costs *so* little! Why not let it do the nice things for your body that it does for your face? Keep your pledge of beauty with Palmolive. Guard your loveliness . . . 'til he comes marching home!

REMEMBER PALMOLIVE'S BEAUTY OILS...

olive and palm oils — no others — go into the making of Palmolive. Look for the olive color.

PALMOLIVE

Molly Pitcher, 1944

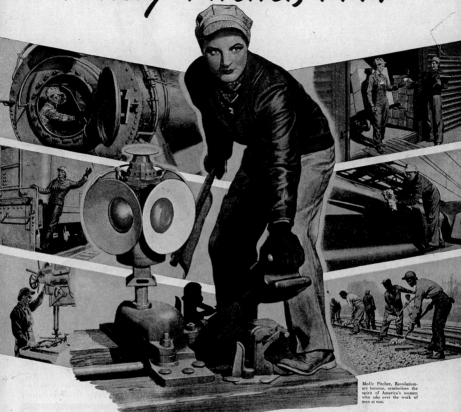

Molly Pitcher, Revolutionary heroine, symbolizes the spirit of America's women who take over the work of men at war.

Women are doing a big job on the Pennsylvania Railroad

More than 48,000 experienced Pennsylvania Railroad men have entered our armed forces. Yet, wartime's unusual needs for railroad service are being met . . . thanks in great part to more than 23,000 women who have rallied to the emergency. From colleges, high schools and homes, these women—after intensive training—are winning the wholehearted applause of the traveling public.

You see them working as trainmen, in ticket and station masters' offices and information bureaus, as platform ushers and train passenger representatives, in dining car service. Yes, even in baggage rooms, train dispatchers' offices, in shops and yards and as section hands. The Pennsylvania Railroad proudly salutes these "Molly Pitchers" who so gallantly fill the breach left by their fighting brothers-in-arms.

★ 48,128 in the Armed Forces
★ 248 have given their lives for their Country

Pennsylvania Railroad
Serving the Nation

BUY UNITED STATES
WAR BONDS AND STAMPS

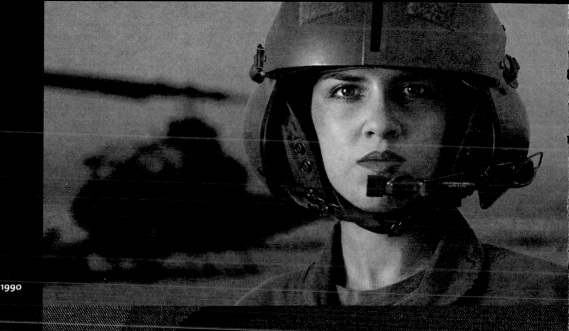

1990

There's something about a soldier.

Especially if you're a woman.

Because you'll find yourself doing the most amazing things. Like being a Flight Crew Chief or a Topographic Surveyor, or any one of over 200 skills the Army offers.

You'll also find yourself doing some very familiar things. Like getting into aerobics, going to the movies or just being with friends.

The point is, a woman in the Army is still a woman. You carry yourself with a little more confidence. And you may find yourself shouldering more responsibility than you ever dreamed, but that's because, in the Army, you'll gain experience you can't find anywhere else.

You could also find yourself earning as much as $25,200 for college, if you qualify, through the Montgomery G.I. Bill and the Army College Fund.

If you're looking for experience that could help you get an edge on life and be a success at whatever you do, call 1-800-USA-ARMY.

ARMY.
BE ALL YOU CAN BE.

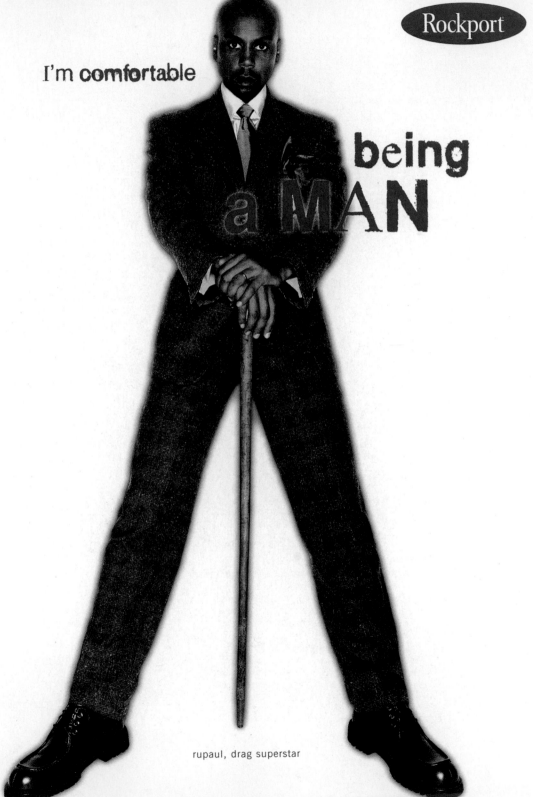

I'm **comfortable**

being
a MAN

Rockport

rupaul, drag superstar

be comfortable. uncompromise.® start with your feet.

RUPAUL

According to supermodel RuPaul, "Whether we are at work or at play we are all wearing masks and playing roles all the time. Like I've always said, 'you're born naked and the rest is drag.'" Born Andre Charles in San Diego, RuPaul is today's most popular man in woman's clothing. The self-named "Queen of All Media" is a celebrity whose talents include singing, modeling, acting, and hosting his own TV talk show.

RuPaul's first album, *Supermodel of the World* (1993), topped the charts for several months. In 1998 he recorded a Christmas album that included new versions of popular classics, such as "RuPaul the Red Nosed Drag Queen" and "I Saw Daddy Kissing Santa Claus."

His autobiography, *Lettin It All Hang Out* (1995), was also a popular success and is now in its third printing. In it he describes his mother as the person he most admired while growing up and as "the fiercest drag queen I've ever known." RuPaul's book was dedicated to the children of the country with his hope that "maybe the kids will see that if I can do it, they can do it. I wrote this book for the RuRu in everyone." With other celebrities, he has been instrumental in raising millions of dollars in the fight against AIDS.

SEEING

1. How would you characterize RuPaul's body language in this advertisement? Comment, for example, on his facial expression, stance, and posture, as well as on his choice of dress and accessories. What would you identify as masculine or feminine about his body language? On what notions of "being a man" does this advertisement capitalize?

2. Consider the use of the word "comfortable" in this ad. How do you read its meaning in the phrase, "I'm comfortable being a man"? How do you interpret it within the context of its placement near the image of RuPaul? What senses of the word "comfort" does this image convey or contradict? How important is the literal placement of the word comfortable at the top of the page? How would the effect of the word and the phrase change if it were positioned somewhere else on the page? What is the effect of the repetition of the word comfortable at the bottom of the page?

WRITING

1. How important to the overall effect of the ad is the audience's knowledge that RuPaul is a popular drag performer and American celebrity? Choose two alternate models—a celebrity and an ordinary person—and imagine them in exactly the same dress and stance as RuPaul. Write a few paragraphs for each that explore how using the different models would change the impact and meaning of the ad.

2. Choose a recent advertisement that either explicitly or implicitly invokes notions of masculinity to sell a product. You might, for example, look at an advertisement featuring a classic American male figure such as a male Ralph Lauren model or the Marlboro man. Write the first draft of an essay in which you compare and contrast that representation of masculinity with this Rockport ad.

www. Re: Searching the Web

Since its inception, the World Wide Web has been characterized as a male-dominated space. Recent surveys report, however, that the gender gap between online users is closing. In the summer of 1998, America Online (AOL), one of the nation's largest and most popular Internet service providers, announced that its women clients (52%) outnumbered its clients who are men. Only four years earlier, 16 percent of AOL members were women. Yet online usage statistics fail to speak to the male bias on the web, argues Dianne Lynch, chair of the Department of Journalism and Mass Communication at St. Michael's College in Burlington, Vermont. "The brave new digital world is no democracy," she writes in her online column "Wired Woman" (http://www.abcnews.go.com /sections/tech/WiredWomen), "and strength in numbers isn't buying us influence on the Web or employment in the corporate offices of the high-tech firms that increasingly control it. The prototypical computer geek . . . is a young, white male. And male sensibilities still dominate the technology industries, from the design of the lowliest laptop to the hiring practices of the largest conglomerates."

What signs of gender bias in content and design do you see on the web? Choose a news or information site. Write an essay in which you discuss the extent to which the content and design of that web site are male- or female-oriented.

DAPHNE SCHOLINSKI

At age 15, Daphne Scholinski was committed to a mental institution for consistently failing to "act like a girl." The tomboy daughter in a relatively affluent family with an abusive father and a largely absent mother, Scholinski showed signs of adolescent rebellion. In 1981 a therapist diagnosed her behavior as Gender Identity Disorder, a condition that according to her medical care providers warranted confinement in a mental hospital.

The harrowing story of Daphne's three-year involuntary incarceration is detailed in her book, *The Last Time I Wore a Dress* (1997). Ongoing treatments for her "serious failure to identify as a sexual female" included drugs, solitary confinement, and lessons on how to apply makeup, dress, and walk with her hips swinging back and forth.

Determined that "no one else should have their childhood taken away," Scholinski has presented her story on the television news shows *20/20* and *Dateline*. Although many people construe Scholinski's story as a glaring example of medical insurance fraud in which patients are institutionalized under false pretenses for monetary gain, others trace a more insidious cause. In the annals of psychiatry and mental health, gender roles are still very strictly defined and—although society may present an outwardly accepting face of tolerance for sexual expression—certain concepts of "normal" remain deeply inscribed in the official underpinnings of our culture.

THE LAST TIME I WORE A DRESS
Daphne Scholinski

EVEN NOW, IT'S ALWAYS THE SAME QUESTION: why don't you act more like a girl? Makeup, dresses, a little swing in my walk is what people mean. The millennium is upon us and this is the level of discussion.

The only thing I can say is, I tried.

It wasn't as simple as my doctors made it sound. In the hospital, I turned control of my face over to my roommate, Donna, a fluffy-haired girl with major depression. She wanted to help. She tried to pinpoint exactly why my 15-year-old girl's face looked boyish. This turned out to be a bigger question than we could answer.

So we settled for the superficial: A jawline that needed shading? Eyes that needed definition?

Donna wasn't given the strong drugs, at least not 5 early in the morning, so her aim was true. Every morning I lowered my eyelids and let her make me up. If I didn't emerge from my room with foundation, lip gloss, blush, mascara, eye-liner, eye shadow, and feathered hair, I lost points. Without points, I was not allowed to walk from the classroom back to the unit without an escort. Either choice I hated: makeup, or a man trailing in my shadow. It didn't take me long to figure out that a half-moon of blue on my eyelids was a better decision. This was how I learned what it means to be a woman.

The staff was under orders to scrutinize my femininity: the way I walked, the way I sat with my ankle on my knee, the clothes I wore, the way I kept my hair. Trivial matters, one might say, but trivial matters in which the soul reveals itself. Try changing these things. Try it. Wear an outfit that is utterly foreign—a narrow skirt when what you prefer is a loose shift of a dress. Torn-up black jeans when what you like are pin-striped wool trousers. See how far you can contradict your nature. Feel how your soul rebels.

One million dollars my treatment cost. Insurance money, but still. Three years in three mental hospitals for girlie lessons, from 1981 to 1984. A high school diploma from a psychiatric facility for adolescents, a document I never show anyone.

I met my psychiatrist, Dr. Browning, on my second day in the hospital. Dr. Browning had wire rimmed glasses that made his dark eyes look bigger than they were. I looked at his eyes but he didn't look at mine; if he caught my glance he turned away, and I knew that to him I was a specimen, a thing he was studying.

We sat down. He crossed his left knee over his right and balanced a yellow legal pad on his left thigh.

"Do you know why you're here, Daphne?" 10

"No," I said. Why should I make it easy for him? Besides, I wanted to hear him explain me to me. He started in about my problems at school, cutting class, miserable grades, threatening a teacher. He said I was failing school and a thought popped up: How come no one ever says school is failing me? I had a problem with authority figures, he said, and I thought, OK, this is cool, I can admit to this. I said, Yeah, yeah, I know.

He asked me about problems at home. I told him my father hit me, my mother doesn't want me around, and he scribbled away, flipping up pages as he went. We moved along to drugs and alcohol and I exaggerated my use, because doctors always like to hear about youth and drugs.

Once his pen had stopped scratching, I asked him what my diagnosis was. I knew this was a major deal; it was like being a Disciple or a Latin King; it was your identity in the hospital. When the doctor

looked at you, he didn't see *you*, he saw "paranoid" or "schizophrenic."

Dr. Browning said I had a multiple diagnosis because of the complexity of my situation. I liked the sound of that: the complexity of my situation. One of the diagnoses was conduct disorder, which made sense to me. He said another diagnosis was mixed substance abuse, which I knew to be a stretch, but what did I care if he thought I had a drug problem?

He rolled his pen between his fingers for a moment. He said the other diagnosis was something called gender identity disorder, which he said I'd had since third grade, according to my records. He said this meant that I wasn't an appropriate female, that I didn't act the way a female was supposed to act.

I looked at him. I didn't mind being called a delinquent, a truant, a hard kid who smoked and drank and ran around with a knife in her sock. But I didn't want to be called something I wasn't. Gender screwup or whatever wasn't cool. He was calling me a freak, not normal. I knew I walked tough and sat with my legs apart and did not defer to men, but I was a girl in the only way I knew how to be one.

Sometimes when we were bored, some of the other patients and I would go up to the nurses' station and borrow the *Diagnostic and Statistical Manual of Mental Disorders.* It was the third edition they were using back then, a green volume. Someone would ask, "What are you in for?" We looked up anorexia for Julie and Lisa. Manic depression? Borderline personality? Obsessive-compulsive? Then we'd flip to the entry for zoophilia. Sex with animals, ha ha.

Using the *DSM,* we placed bets that we could get a new diagnosis added on our charts. Danny, a Disciple gang member, handsome, the only black teenage boy on the unit, went for hallucinations. This was tricky. It had to be convincing, so he started out small. "Did you hear that?" he asked, and we shook our heads no.

Heather, the rich girl on the unit, tight Guess jeans and a pink Izod polo shirt, decided to go for split personalities. One second she was her usual spoiled self demanding her diet Sprite, and the next she was a mewling 3-year-old with her thumb in her mouth.

I bet I could get anorexia written on my chart. The anorexics were psyched. The more anorexics, the better—the less attention anyone would be paying to what they weren't eating.

Danny quit the hallucinations after a while. You didn't want to go too far with that or you'd end up swallowing a cupful of medication that might be more than you'd bargained for. Heather grew tired of being a 3-year-old. She shifted out of being a toddler gradually so the nurses would have to stay on edge, waiting for the other personality to come back.

We never did look up gender identity disorder. I didn't tell anyone about my gender thing. It was later, in college, after I'd been in and out of the hospitals and the damage was done, that I went back to the *DSM.* Here's how the fourth edition, the current one, describes someone like me, an ex–mental patient who never had a mental illness:

> Girls with Gender Identity Disorder display intense negative reactions to parental expectations or attempts to have them wear dresses or other feminine attire. Some may refuse to attend school or social events where such clothes may be required. They prefer boys' clothing and short hair, are often misidentified by strangers as boys, and may ask to be called by a boy's name. Their fantasy heroes are most often powerful male figures, such as Batman or Superman. These girls prefer boys as playmates, with whom they share interests in contact sports, rough-and-tumble play, and traditional boyhood games. They show little interest in dolls or any form of feminine dress up or role-play activity. A girl with this disorder may occasionally refuse to urinate in a sitting position. She may claim that she has or will grow a penis and may not want to grow breasts or menstruate. She may assert that she will grow up to be a man. Such girls typically reveal marked cross-gender identification in role-play, dreams, and fantasies.

The words are ludicrous, but not if it's you they're talking about, not if it's you they're locking up. Not ludicrous at all for the ones who continue to be diagnosed as mentally ill. Even if we'd looked up gender identity disorder, I don't think anyone would have tried to fake it. We knew the rules: Pacing, screaming, hallucinating, and vomiting were OK. Not OK was being like me, a girl who never felt comfortable in a dress. ○

1. It was as a patient in a psychiatric ward, Daphne Scholinski writes, that she "learned what it means to be a woman" (para. 5). What prescriptions for feminine behavior did Scholinski learn? How did her own behavior fall outside of those notions of femininity? With what effects?

2. How would you describe Scholinski's tone in this essay? What words or phrases reveal her tone most clearly? How does the tone of this piece compare with the narrator's tone in Mavis Hara's "Carnival Queen" (page 268)? Point to examples of the effects of specific words and phrases.

1. What do you think it means to "act like a girl"? Brainstorm a list of the behaviors, attitudes, and attributes that you associate with being "girlish," and write a paragraph on the meanings this phrase has for you. Exchange lists with a classmate. To what extent are your respective notions of the phrase "act like a girl" similar or different?

2. Reread the *Diagnostic and Statistical Manual of Mental Disorders* definition of Gender Identity Disorder that Scholinski includes at the end of her essay. How would you paraphrase the description of Gender Identity Disorder? What do you make of the examples of "abnormal" behavior? How would you characterize the language used to describe them? Scholinski refers to the words in this passage as "ludicrous." What aspects of this piece seem ludicrous to you? What aspects seem reasonable? Why? Point to specific words and phrases to verify your reading. Write the first draft of an essay in which you speculate on what this definition might suggest about the notions of normal gender behavior within the field of clinical psychiatry. As an additional exercise, you might conduct a search for "Gender Identity Disorder" on the Internet. What did you discover about changes in the definitions and usage of this term today? Write an essay in which you explore the cultural implications of these changes.

NANCY BURSON

Well known for her work with computer-composite photographs, Nancy Burson has had a career that spans the technical and artistic fields. Born in St. Louis in 1948, Burson was trained as a painter. Soon after moving to New York in 1968, she became interested in using computer technology to manipulate and transform the human face. Beginning with the acceptance of her project proposal "To Simulate the Aging Process" by MIT's Media Lab, Burson's collaborations with engineers and technicians resulted in developing computer software programs that are now used by the FBI, missing children organizations, and surgeons. She holds a patent on software best known as "morphing," which simulates the aging process based on a database of typical aging patterns. From a focus on manipulating images, Burson shifted to capturing realistic images of children and adults with startling craniofacial disorders and other facial deformities. These were cataloged in her book *Faces*, published in 1993.

The photographs here are untitled images from the *He/She Series* in which Burson took formal portraits of androgynous-looking people. Burson explains that, like her past work, the images in this series are "more about the commonality of people rather than about their differences or separateness. They're meant to challenge the individual's notions of self-perception and self-acceptance by allowing viewers to see beyond superficial sexual differences to our common humanity."

Nancy Burson is currently working with and photographing energy healers in creating a bridge between the alternative and traditional medical communities. "My work has always tried to have a bigger purpose," Burson explains, "I've always tried to explore ways of changing people's point of view, getting them to shift their vision so that they see differently, usually by showing them things they haven't seen before."

Untitled Images from the He/She Series

SEEING

1. Examine carefully each of Nancy Burson's photographs. In your judgment, which ones are portraits of a man? of a woman? What evidence can you point to in each instance to verify your reading? Do you find it easier to determine the subject's gender in some of these photographs than in others? Why? How do your choices compare with those of your classmates?

2. How has Burson complicated our ability to pinpoint the sex of each of these subjects through specific artistic choices? What aspects of each subject has she chosen to highlight? What does she conceal? What might these choices reveal about the ways in which we subconsciously differentiate between men and women?

WRITING

1. Choose one of Burson's portraits, and explain why you think it shows a man or a woman or why you cannot determine the sex of the subject. What about the portrait seems masculine to you? What about it seems feminine? Write a two-page analysis of the image in which you speculate about the kinds of visual information or facial "cues" we rely on to determine a person's sex.

2. Write an essay in which you compare and contrast Burson's portraits with Robert Mapplethorpe's two self-portraits (pp. 259-60). Recognizing the differences between a portrait and a self-portrait, what different statements about gender does each of these artists make? How would you compare their artistic techniques and styles? How do these portraits illustrate the social construction of masculinity and femininity?

DANIEL HARRIS

In the introduction to his book *The Rise and Fall of Gay Culture* (1997), Daniel Harris observes: "I came out in 1970 at the . . . age of 13. While my announcement coincided almost exactly with the Stonewall riots, they played no role in my decision to confront my parents with what should have been perfectly obvious to them ever since the third grade when, even as my peers were collecting baseball cards and winning merit badges in the Cub Scouts, I threw myself into a somewhat unconventional pastime: female impersonation."

In the essays collected in this volume, Harris examines the changing rituals and practices of gay culture, including drag (men dressing in women's clothing), pornography, personal ads, and reading habits. He argues that gay culture, which used to involve being separated and ostracized from the straight world, is now being abandoned for the rewards of belonging to the mainstream. In several energetic critiques of gay self-help literature, Harris traces the rewriting of gay relationships into the "normal" heterosexual model of courtship, betrothal, and marriage, a trend he sees as undercutting the actual nature of homosexual relationships.

Harris (b. 1957) grew up in Asheville, North Carolina, where he wore 4-inch platform shoes to junior high school. An award-winning essayist and book critic, he is a frequent contributor to *Harpers* magazine, *Salmagundi*, and *Newsday*.

Effeminacy

Daniel R. Harris

IN AN AGE IN WHICH ANDROGYNY HAS BECOME the essence of urban cool and radical chic, even the nattiest male trendsetter is still a good old boy in regard to the tribal imperative of masculinity. For all his *blasé,* he would undoubtedly bristle at the suggestion that his fashionable minimizing of gender is either coquettish or effeminate. Effeminacy, after all, has none of the cachet and all of the curse. Whereas androgyny creates its own mystique of sexual ambiguity and tasteful self-containment, effeminacy is animated, excessive, and engaged. Androgyny is tantalizingly withdrawn; effeminacy theatrical and extroverted, causing acute embarrassment and disgust not only among the intolerant but the socially progressive as well.

For this reason, some twenty years after gay liberation, neither a forum nor, for that matter, a *decorum* exists for the discussion of what amounts to an outlawed manner of walking and talking, a proscribed behavior that attracts few defenders at a time when activists of the boldest stripe have shown remarkable agility in flushing out new forms of prejudice and bigotry. Every gesture of the effeminate man, from his sinuous amble to the proverbial erect pinkie nervously sawing the air, is a direct affront to an unspoken ideology of the body. Written like a signature in the very register of the voice, in the gait, the demeanor, the sense of humor, and even the prose style, effeminacy is an unwilled form of radicalism, of unrepentant exaggeration, hands that rake the air rather than remaining clenched at the sides.

Is it possible to say that something as elusive and inconsequential as a walk that's too markedly feminine or laughter that tends to unravel into titters has a political dimension? In a society whose body language consists of firm grips and steely gazes, the gestural iconoclasm of effeminacy, its unconventional moves, sounds, and expressions, has more than just private and individual consequences. One has only to look at the media to appreciate the extent to which the quavering contralto of the effeminate voice and its accompanying mannerisms have been purged from public view on the grounds that they are untelegenic in comparison with the sanitized corporate physiques and monotonously melodic tenors and baritones of most newscasters. The media are allergic to effeminacy, as are the other most powerful professions in the country. Would a corporation, for instance, hire an effeminate C.E.O. whose grip melts into a glove of putty when he shakes the hand of an important client? Would a criminal hire an effeminate lawyer to defend him in court, or the electorate vote for an effeminate candidate in a major election? The absence of effeminacy and the predominance of such dour and conservative models of behavior in the masculine consortiums of power, our boardrooms,

courts, media, and legislative chambers, raise a number of troubling political issues, and yet the practical effect of this most evasive of chauvinisms passes virtually unacknowledged.

Why does an age so conscious of its victims turn a blind eye to the politics of the flaccid handshake and the insufficiently rigid swagger? For a culture accustomed to measuring victimhood entirely in terms of the lack of money, charges of active discrimination go up in smoke when you consider that the majority of effeminate men—homosexuals—are gainfully employed, swimming in disposable income, and thus, according to the accepted mythology of oppression, too rich to be victims. With no underclass to shore up its credentials for persecution, effeminacy challenges and redefines our whole notion of what constitutes both a minority and an appropriate political response to an unorthodox form of oppression, with hilarious images of an "effeminacy rights" movement—marches on Washington, impassioned testimonials before glowering Congressional subcommittees—inevitably leaping to mind. In the eyes of society, the effeminate have no political identity, in part because what distinguishes them from others, something as insubstantial as a husky resonance in the voice or a languorous posture, is too impalpable to set them apart as a distinct group. Their movements are considered so irrepressibly demonstrative, clownish, and marginal that the effeminate are often unwilling to admit to themselves, much less to others, that they are effeminate and therefore take solace in a self-ignorance that undercuts the very foundation of organized political action.

For obvious social and professional reasons, the effeminate also submit to a process of voluntary ghettoization that makes this most colorless of apartheids even more invisible, both to others and, more importantly, to themselves. When faced with the hostility they are likely to encounter in the staid sanctuaries of corporate America, they conveniently flee into an arty barrio of so-called "accepting" professions where their stylized mannerisms fade into a common idiom. Instead of being escorted out of the boardroom and into jobs less directly linked with the administration of power, they prefer to believe that they have skirted around these professions for personal reasons and misinterpret what is in fact a manly rebuff on the part of the business world as a conscious decision on their part to enter a special subdivision of the work force, the beauty and entertainment industries—interior decoration, cosmetics, floristry, the theater, the fine arts. Unaware of the barriers that limit their choices, so many effeminate men become shopkeepers, hairdressers, and manicurists because they know their place, a place traditionally occupied by women, and have intuitively sought out those careers society has decided are unimportant enough to provide a refuge (or quarantine) for their unacceptable behavior. The purging of effeminacy from the media, courts, or boardrooms is not interpreted as exclusion or discrimination because it occurs with the full complicity of the discriminated party, who willingly shuffles to the back of the bus. With neither victim nor villain, this non-racial jim crow, this *self-imposed* ghettoization defuses and depoliticizes an issue that is in fact deeply political.

In another category altogether, the calculated understatements of androgyny, so successfully exploited by rock musicians like Prince, David Byrne, Mick Jagger, or David Bowie, constitute little more than a stylized and well-groomed imperviousness that preserves intact the conventionally masculine man's sullen independence and detachment. Far from being a liability, androgyny is just the banal and essentially retrograde poetic license that we give to urban youth and the commercialized hedonists of the music industry, whose behavior represents an insignificant departure from rigid gender paradigms. Moreover, the behavioral impact on established sex roles of a more genuine androgyny is severely restricted from the outset by the fact that it is a fashion to which men and women have unequal access: It is much easier for a woman to be androgynous than a man. The venerable tradition of the hard-boiled actress and the manly chanteuse, from Marlene Dietrich and Joan Crawford to Sigourney Weaver, Laurie

Anderson, Patti Smith, and Annie Lennox, officially sanctions female experimentation with gender, whereas no comparable tradition exists in popular culture for men.

Unlike androgyny, effeminate behavior profoundly alters the hard and fast distinctions between the sexes, and, what's more, it does so in a way that is highly original and in no sense of the word imitative. Is effeminacy, as it is commonly understood, really an imitation of the opposite sex? Certainly, popular films and sitcoms construe it as such. In *The Odd Couple,* for instance, Tony Randall appears quite literally as a housewife in an apron furiously mowing the carpet with his Hoover or taking mad swipes with the feather duster in the wake of Jack Lemmon's exasperating masculinity. The effeminate man in both American public life and popular iconography is *always* a man impersonating a woman. He is allotted his marginal presence in TV and film only if he makes the terms of his impersonation abundantly clear, as Quentin Crisp does with his theatrical makeup and imperious capes or Boy George with his wide-brimmed bonnets and modish dresses. The only exception to this rule that comes immediately to mind is the conspicuously effeminate behavior of Michael Jackson, who is in no obvious way imitating the style and apparel of women but who is nonetheless poignantly, defenselessly effeminate. However much time, money, and effort his publicists have invested in burying the eccentric gestures and squeaking voice of the castrato under black shades and hoodish accoutrements, the embarrassing and unmarketable mannerisms of a real person, and not just a bland, pasteurized superstar, burn through the floodlights.

For the mass audience, effeminacy is comedy—the slapstick of *La Cage aux Folles* or the dizzy exaggerations of William Hurt in his mistakenly rapturous performance in *Kiss of the Spider Woman.* Because it is almost impossible for people to view effeminacy as an entirely separate form of behavior with an integrity of its own, it is pigeonholed in popular culture as a ridiculous waste product of gender conflicts, the province of endearing grotesques and colorful transsexuals who strive unavailingly, with all of the attendant absurdities, to transform themselves into the opposite sex. In reality, however, the effeminate man is not just a rowdy impostor of women and a favorite cinematic gag. In fact, he is not so much imitative of women as he is *non-imitative* of men, for the state of effeminacy is characterized by complete inattention to gender, a kind of forgetfulness of one's duty to uphold the rituals of the fellowship. It is so difficult to describe, not only because the embarrassment it causes interferes with our concentration on it and thus prevents us from fixing it in words, but also because it is defined by the *absence* rather than by the presence of specific qualities, by the lack of the preoccupying awareness most men have of their sex. The imitative view of effeminacy, the attempt to locate the analogue of every effeminate gesture in the body language of women, is fundamentally flawed because it presumes that these gestures are deliberate, however unconsciously, when in fact they are simply the outcome of total, anarchistic relaxation of one's vigilance in maintaining the masculine stance and demeanor. In short, effeminacy is nonrepresentational, an imitation of nothing. It is not a routine, a futile act of sexual plagiarism, but an absence of the absorption and single-mindedness with which we conform to the strict code of conduct that our culture mandates for both men and women. In this sense, conventional masculinity and femininity are much more imitative, because masculine men and feminine women, far from being oblivious to their sex, are constantly attempting to achieve a successful approximation of an abstract behavioral ideal considered appropriate to their gender, whereas the effeminate are heedless, if inadvertently so, of these often oppressive expectations.

One would have anticipated that gay liberation and the commercialization of the lives of gay men in inner-city neighborhoods like the Castro and Christopher Street would have significantly changed the way that our culture views effeminacy, providing a new protective environment in which to experiment

with unconventionally masculine forms of behavior. A central paradox of the birth of the subculture, however, is that in resisting the effeminate stereotypes and gestural paradigms that have tyrannized gay men in the past, we have created a new Frankenstein—the "good gay," masculine, assimilated, forceful, deliberate, his body no longer a boneless frenzy of threshing arms and legs but a militarized automaton patrolling his beat at a brisk goosestep. In liberating themselves from effeminacy, homosexuals have taken on yet another albatross, accepted more, not less rigid notions of how they should express their homosexuality, and essentially invented—to borrow a stereotype ridiculed in the black community—the gay oreo, effeminate on the inside, masculine without. In the final analysis, liberation has liberated homosexuals into a new totalitarian attitude toward their mannerisms, a new contempt for effeminacy, and above all a new body language, the masculine majority's depersonalizing Esperanto of frigid gestures and flinty smiles.

Nowhere is the resistance to effeminacy, the ultimatum to butch it up, seen more clearly than in the de-sexing of many men's lives. Since the gay community has by and large ceased to be our culture's effeminate avant-garde, the effeminate man must now contend with both his ostracism and his lack of sex appeal. The language of self-censorship and self-fascism one finds in gay personal ads, the epithets of "straight-appearing" and "straight-acting," expresses a new anxiety on the part of gay men to strip themselves of the demasculinizing traces of the subculture, an anxiety they once clothed and shod and sexed up with the dated accoutrements of hard-line homosexual machismo: the boots and keys of the hard hat, the chaps and Stetson of the cowpoke, the olive drab and dog tags of the soldier, the leather jacket and motorcycle of the cop, or even the Lacoste shirts and penny loafers of the preppie. The subculture we thought would enable us to be more ourselves has in fact encouraged us to be less so, with the unfortunate result that the rise of the gay ghetto and our attempt to escape from the demeaning stereotypes of the swish have put us more at the mercy of

heterosexual models for masculine behavior and sexual appeal than we have ever been before.

Which isn't to say that effeminate mannerisms— legs that involuntarily seek each other out and braid under the table or hands that oscillate like pendulums at the wrists—have been eradicated altogether, as anyone who has the most casual acquaintance with an inner-city ghetto can attest. Instead of disappearing entirely in the aftermath of the militarization of the gay libido, effeminacy is now governed by a new decorum: "camp," not "camp" in Susan Sontag's sense of the word but in the much more specific sense of "to camp," "camp it up," or "campy queen." These idioms are essential components of the vernacular of contemporary urban life, and they are part of a revolution in sensibility. The very fact that effeminate behavior has been given a name and, what's more, that one of the forms of the name is an intransitive verb, suggests that a major change has occurred in the way that gay men view themselves and their gestures. The verbal form "to camp" implies that effeminacy has become a specific kind of activity that one can choose to do, like "to sing" or "to dance" or "to laugh"—that is not, in other words, an all-embracing style over which the effeminate have no control but rather that it is an *action* that one can will oneself to perform and likewise *not* to perform. To be effeminate is no longer something one *is* but something one *does*. What was once a largely unconscious attitude toward the self, an obliviousness or immunity to the erect carriage and poker face of The Real Man, has now become a willed form of behavior, a social mask or party drag of which the effeminate man is not the victim but the impresario, the emcee.

Camp, unlike effeminacy, is an alternative form of the self, a routine, a shtick, a persona, something that can be donned like formal wear for occasions of state and similarly doffed when the situation demands a low profile, like dining with your parents or careering at the office. Camp is effeminacy empowered by gay liberation, not the pre-Stonewall straight jacket of the flouncing pansy, the slave of his own gestures, but a heavily monitored and site-specific style which we can

hide or flaunt as we choose. After twenty years of gay activism, our closets haven't really been ripped open, as those of us who have participated in gay liberation would like to believe, but simply equipped with swinging doors, slamming shut to enable the sober professional with his power suit and his attaché to embark for the office undetected, and then—after 6:00—swinging wide open again to reveal the master of the revels no longer in his three-piece but in harlequin tights and a cap with jingling bells.

Gay liberation has inspired a new self-consciousness about the way that effeminacy isolates the individual and has encouraged men to reserve their effeminate behavior for colorful intermezzos of short duration policed by a harsh decorum. Camp is a new expression of their unsparingly objective view of their own mannerisms, a form of monologuing, grandstanding, and self-display in which effeminacy becomes a cunning and deliberate ceremony, a highly detached street mime or self-theater with its own repertoire of stock moves, parts, phrases, gags, bits—all of the elements of the outlandish cartoon, the "queen." Camp transforms the effeminate titter into a booming bray and the effeminate mince into a vampish slink with the man who is "on" batting away the imaginary tidal-wave curl. Camp, in short, is effeminacy in quotation marks. It is "about" itself, involving the burlesque of a style that once dictated the appearance of virtually every move the effeminate man made. In this sense, rather than endorsing effeminacy, gay liberation has led to the institutionalization of its ridicule.

The major difference between genuinely effeminate men like Little Richard, Michael Jackson, or even Paul Lynde from *Hollywood Squares* and camp goddesses like Divine (the star of John Waters's cult films), Holly Woodlawn (the transsexual heroine of Paul Morrissey's *Trash*), or the late Charles Ludlum (the brilliant drag-queen performer from The Ridiculous Theater Company) is that the former are unconscious of the restraints of gender and therefore nonimitative of women, whereas the latter are preoccupied with the ribald effects of the paradox of the boy-girl. Far from being spontaneous and individual personalities with a *sui generis* style, the camp stars of the American underground—San Francisco's Sisters of Perpetual Indulgence (a group of gay men in full nuns' habits), the Trocadero (a dance company which performs full-length ballets in drag), or the late disco diva Sylvester—are imitative of at least three separate things: women, new media images of the female performer, and the effete mannerisms of the old-style homosexual. Unlike effeminacy, camp *is* representational. Whereas the effeminate man exists in solipsistic oblivion to masculinity, the campy queen is fully conscious, not only of his sex and the potential it offers for humorous paradoxes, but also of images of women disseminated by TV and film, the dense web of allusions to popular culture (to Judy Garland, Bette Davis, Marilyn Monroe, Barbara Stanwyck, Mae West, and any number of other celebrities) which constitutes the bedrock of camp, the sounding board off of which the queen is constantly bouncing his impersonations.

Why do men camp? While there is such a thing as 15 good camp and bad camp, camp that involves full-scale impersonations by men with an uncanny theatrical presence and camp that is as mundane and artless as a screeching falsetto, anyone who has ever seen quality camp knows how exhilarating it can be, both for the performer and for his audience. It is an indigenous style of stand-up comedy, and like many stand-up comedians, the most talented maintain a playfully mordant antagonism with members of their audiences, laughing at the way they're dressed or at their bashfulness in the face of his sour but ultimately good-natured intimidation. For the audience, the pleasure of such a performance is a good show and also the exciting sensation that you will be the next one singled out for inspection, the next sacrificial object of scorn. For the performer, the pleasure of camp is far more complex, involving feelings of power and superiority, of towering over your audience and being able to send them sprawling as you sweep past on a gust of outrageous barbs. Camp creates the illusion of incredible conversational

omnipotence, of an urbanity and self-control that make your audience cower before you, full of admiration, fear, and obedience.

Because of this short-lived power-fix, camp has a particularly seductive appeal for gay men in that it sponsors the illusion of having a sort of power they often lack in their daily lives, a spurious mastery over others which they achieve by means of their skills as pantomimists and wordsmiths. It thus functions as a form of false politics: it allows effeminate men to live out fantasies of being conversational champions in a restrictive and permissive environment, whereas in the less restrictive environment of the workplace, they are so often cast in the role of the victim—not the loud and imperious *femme fatale* of camp's portable stage but a man hemmed in by the constraints of the still largely homophobic office world.

Does this mean that camp is a good thing or a bad thing, politics or playacting, a real source of power or a placebo? As someone who finds camp one of the inescapable elements of his life, something I take for granted like the air I breathe, it would be ridiculous for me to shower reproaches on a style of behavior that is a rich example of ethnic culture, an authentic form of urban folk art that enshrines the divided sensibility of the homosexual, of someone who has kept quiet and yet observed, and consequently recognizes on a visceral level the value of irony and parody. Yet camp, like all great things, most notably effeminacy itself, carries with it both a license and a responsibility: Those who acquire its addictive taste are in constant danger of falling prey to its seductive false politics which, rather than enabling effeminate men to resist ghettoization, will ultimately turn them into clowns and harlequins, dancing bears and bearded ladies. ○

1. What, according to Harris, are the definitions of—and differences among—*effeminacy, androgyny,* and *camp?* How, according to Harris, is effeminacy "an unwilled form of radicalism"? What does effeminate behavior rebel against?

2. Signs of effeminacy are to be found, Harris argues, in "something as elusive and inconsequential as a walk." Notice when and how he includes descriptions of physical gesture. How effective are these descriptions? When do they fall short? Harris justifies his frequent references to body language and gestures by arguing that "in a society whose body language consists of firm grips and steely gazes, the gestural iconoclasm of effeminacy, its unconventional moves, sounds, and expressions, has more than just private and individual consequences" (para 3). What are some of these other consequences?

1. To what extent do you agree with Harris's statement that "it is much easier for a woman to be androgynous than a man" (para. 6)? What evidence within—and beyond—the essay can you identify in order to validate your claim? Why is it more unusual or threatening for a man to wear a dress than it is for a woman to wear a suit? Do you think Daphne Scholinski would agree with Harris? Write an essay in which you argue that it's more difficult for a man or a woman to be androgynous, using Harris and Scholinski to support your thesis.

2. Consider the image of Marilyn Manson on the *Mechanical Animals* album cover (p. 311). How would Daniel Harris analyze this artist's portrayal of himself? As effeminate? androgynous? campy? something else? Write an essay in which you explain how you think Harris would interpret Manson's CD cover, and then present your own reading of the image.

 Talking Pictures

Daniel Harris argues in his essay "Effeminacy" (p. 303) that "the media are allergic to effeminacy"—examples of a man exhibiting traditional feminine characteristics—but that the film world provides us with numerous examples of women who have transgressed traditional notions of American femininity. He writes, "the venerable tradition of the hard-boiled actress and the manly chanteuse, from Marlene Dietrich and Joan Crawford to Sigourney Weaver, Laurie Anderson, Patti Smith, and Annie Lennox, officially sanctions female experimentation with gender, whereas no comparable tradition exists in popular culture for men" (para. 6). What evidence of effeminate behavior do you see in contemporary television or movies? Choose a popular television or film celebrity such as Dennis Rodman or Nathan Lane, someone who in your opinion transgresses traditional gender roles. Collect some examples in the media—either "real-life" or scripted TV or film roles—of your celebrity challenging traditional gender roles. Using your examples, write an essay in which you document the extent to which this celebrity succeeds in calling traditional gender roles into question—and with what consequences.

MARILYN MANSON

Born in Ft. Lauderdale, Florida (1969), Brian Warner formed a hard-rock band in 1989 and adopted "Marilyn Manson" as his stage name, combining references to icon Marilyn Monroe and serial killer Charles Manson. The band's cult following grew at a steady pace, even as Manson's lyrics and stage practices have been the subject of increasing controversy.

Some critics decry his use of satanic symbols and language; others accuse him of inciting youth violence. He argues, however, that the violence routinely displayed on television is "much more intense than anything we've done." A 1997 show at the University of South Carolina Coliseum was cancelled when the university and the promoter agreed to pay him $40, 000 not to play.

Manson explained in a recent interview, "Some of my anger comes out of disappointment for the world, because so many people are close-minded about things. . . . I think growing up, anybody that has any little bit of creativity or intelligence is never going to be happy in a world like this, because it's not rewarded in any way." Manson is known as an astute self-promoter; his album *Antichrist Superstar* (1996) went platinum as did *Mechanical Animals* (1998). *The Long Hard Road Out of Hell* (1998) is his autobiography.

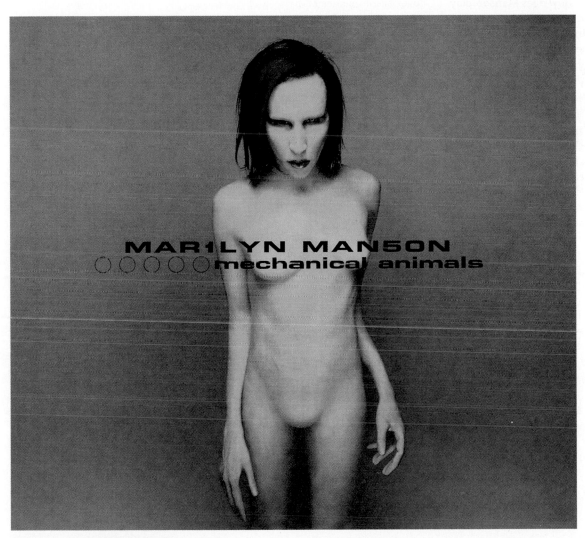

Marilyn Manson, **Mechanical Animals**

SEEING

1. Would you describe this image as surprising, shocking, or something else? Please explain. Does this image disgust you? engage you? make you want to look at it more? Why? What sort of body is this? How does Manson play with our expectations of masculinity and femininity? What is he "saying" with his body language? Comment, for example, on his facial expression, posture, skin quality, or use of color.

2. Consider the design choices that contribute to the tone of this album cover. What overall effects are produced, for example, from the choices of color and typeface, the positioning of text in relationship to image, the angle of the photograph, or the cropping of the image? Comment on the relationship of the title, *Mechanical Animals,* to the image of Manson. In what ways does the image reinforce or contradict the meanings of the terms *mechanical* and *animal*?

WRITING

1. When asked to characterize this image in a recent interview, Manson responded, "It's about getting completely sexual, completely sexless at the same time." To what extent do you think the album cover accomplishes Manson's vision? Write an analytical essay in which you explain whether you think this is simultaneously an asexual and a sexual image.

2. Although in vastly different realms of popular culture and in different ways, both Marilyn Manson and RuPaul incorporate gender transgression in their public personae and in their work. Write an essay in which you compare and contrast Manson's album cover with the image of RuPaul in the Rockport advertisement (p. 294). Through analyzing the details of body language in each image, you might explore some of the following questions: what aspects of gender bending do each of these images evoke? What assumptions about masculinity and femininity does each man draw on? Comment on posture, stance, facial expression. Is one more masculine than the other? Why?

Looking Closer:
Gender Training

Are we born with an innate gender identity, or does our culture
script one for us? In debating the source and nature of the
differences between men and women, virtually all researchers,
writers, artists, and cultural critics look to the childhood years.
Increasing attention is being paid to the social and play patterns
of children in and out of school, before they have had long-term
exposure to the socialization of parents, peers, and culture.

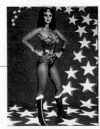

Why Boys Don't Play
With Dolls

 The "Nature versus Nurture" debate has strong advocates on
each side. In **"Why Boys Don't Play with Dolls,"** journalist Katha
Pollitt argues that after almost three decades since the inception
of the women's movement, we can't escape the assumption
that "boys still like trucks and girls still like dolls"; Dana Lixenberg's
Practice Makes Perfect suggests the kind of training involved
in beauty pageants. Art Spiegelman graphically asserts his position
in **"Nature vs. Nurture"**; **Wonder Woman** reminds us of the cultural
impact of superheroes and cartoon characters in our childhood
imaginations; and Jenny Holzer's art brings social messages into
everyday spaces in **"Raise Girls and Boys the Same Way"**; while
"The Human Animal" by Desmond Morris shows Russian
babies getting identical treatment—except in the color of their
swaddling cloth.

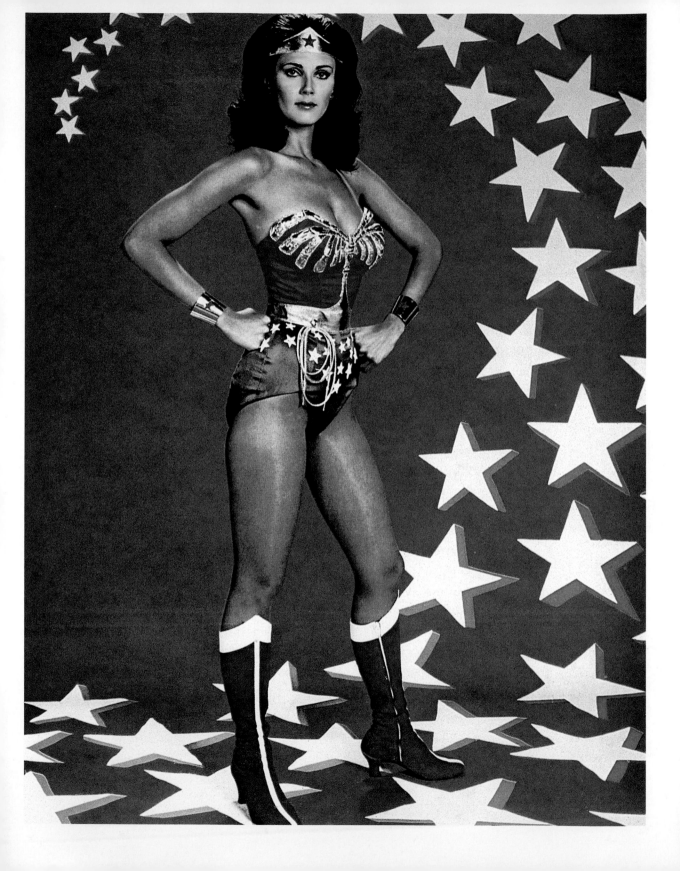

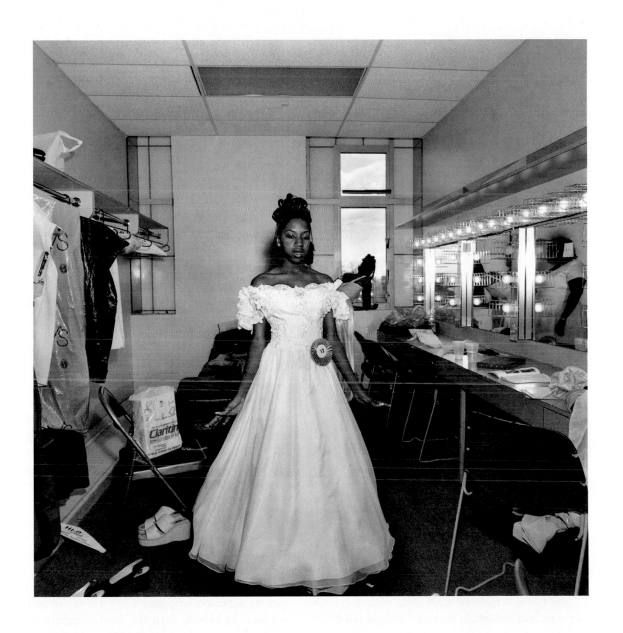

Why Boys Don't Play With Dolls

Katha Pollitt

IT'S TWENTY-EIGHT YEARS SINCE THE FOUNDING of NOW,[1] and boys still like trucks and girls still like dolls. Increasingly, we are told that the source of these robust preferences must lie outside society—in prenatal hormonal influences, brain chemistry, genes—and that feminism has reached its natural limits. What else could possibly explain the love of preschool girls for party dresses or the desire of toddler boys to own more guns than Mark from Michigan?

True, recent studies claim to show small cognitive differences between the sexes: He gets around by orienting himself in space; she does it by remembering landmarks. Time will tell if any deserve the hoopla with which each is invariably greeted, over the protests of the researchers themselves. But even if the results hold up (and the history of such research is not encouraging), we don't need studies of sex-differentiated brain activity in reading, say, to understand why boys and girls still seem so unalike.

The feminist movement has done much for some women, and something for every woman, but it has hardly turned America into a playground free of sex roles. It hasn't even got women to stop dieting or men to stop interrupting them.

Instead of looking at kids to "prove" that differences in behavior by sex are innate, we can look at the ways we raise kids as an index to how unfinished the feminist revolution really is, and how tentatively it is embraced even by adults who fully expect their daughters to enter previously male-dominated professions and their sons to change diapers.

I'm at a children's birthday party. "I'm sorry," one 5 mom silently mouths to the mother of the birthday girl, who has just torn open her present—Tropical Splash Barbie. Now, you can love Barbie or you can hate Barbie, and there are feminists in both camps. But *apologize* for Barbie? Inflict Barbie, against your own convictions, on the child of a friend you know will be none too pleased?

Every mother in that room had spent years becoming a person who had to be taken seriously, not least by herself. Even the most attractive, I'm

1. *NOW*: National Organization for Women.

willing to bet, had suffered over her body's failure to fit the impossible American ideal. Given all that, it seems crazy to transmit Barbie to the next generation. Yet to reject her is to say that what Barbie represents—being sexy, thin, stylish—is unimportant, which is obviously not true, and children know it's not true.

Women's looks matter terribly in this society, and so Barbie, however ambivalently, must be passed along. After all, there are worse toys. The Cut and Style Barbie styling head, for example, a grotesque object intended to encourage "hair play." The grown-ups who give that probably apologize, too.

How happy would most parents be to have a child who flouted sex conventions? I know a lot of women, feminists, who complain in a comical, eyeball-rolling way about their sons' passion for sports. the ruined weekends, obnoxious coaches, macho values. But they would not think of discouraging their sons from participating in this activity they find so foolish. Or do they? Their husbands are sports fans, too, and they like their husbands a lot.

Could it be that even sports-resistant moms see athletics as part of manliness? That if their sons wanted to spend the weekend writing up their diaries, or reading, or baking, they'd find it disturbing? Too anti-social? Too lonely? Too gay?

Theories of innate differences in behavior are appealing. They let parents off the hook—no small recommendation in a culture that holds moms, and sometimes even dads, responsible for their children's every misstep on the road to bliss and success.

They allow grown-ups to take the path of least resistance to the dominant culture, which always requires less psychic effort, even if it means more actual work: Just ask the working mother who comes home exhausted and nonetheless finds it easier to pick up her son's socks than make him do it himself. They let families buy for their children, without *too* much guilt, the unbelievably sexist junk that the kids, who have been watching commercials since birth, understandably crave.

But the thing the theories do most of all is tell adults that the *adult* world—in which moms and dads still play by many of the old rules even as they question and fidget and chafe against them—is the way it's supposed to be. A girl with a doll and a boy with a truck "explain" why men are from Mars and women are from Venus, why wives do housework and husbands just don't understand.

The paradox is that the world of rigid and hierarchical sex roles evoked by determinist theories is already passing away. Three-year-olds may indeed insist that doctors are male and nurses female, even if their own mother is a physician. Six-year-olds know better. These days, something like half of all medical students are female, and male applications to nursing school are inching upward. When tomorrow's three-year-olds play doctor, who's to say how they'll assign the roles?

With sex roles, as in every area of life, people aspire to what is possible, and conform to what is necessary. But these are not fixed, especially today. Biological determinism may reassure some adults about their present, but it is feminism, the ideology of flexible and converging sex roles, that fits our children's future. And the kids, somehow, know this.

That's why, if you look carefully, you'll find that for every kid who fits a stereotype, there's another who's breaking one down. Sometimes it's the same kid—the boy who skateboards *and* takes cooking in his afterschool program; the girl who collects stuffed animals *and* A-pluses in science.

Feminists are often accused of imposing their "agenda" on children. Isn't that what adults always do, consciously and unconsciously? Kids aren't born religious, or polite, or kind, or able to remember where they put their sneakers. Inculcating these behaviors, and the values behind them, is a tremendous amount of work, involving many adults. We don't have a choice, really, about *whether* we should give our children messages about what it means to be male and female—they're bombarded with them from morning till night. ○

Nature vs. Nurture

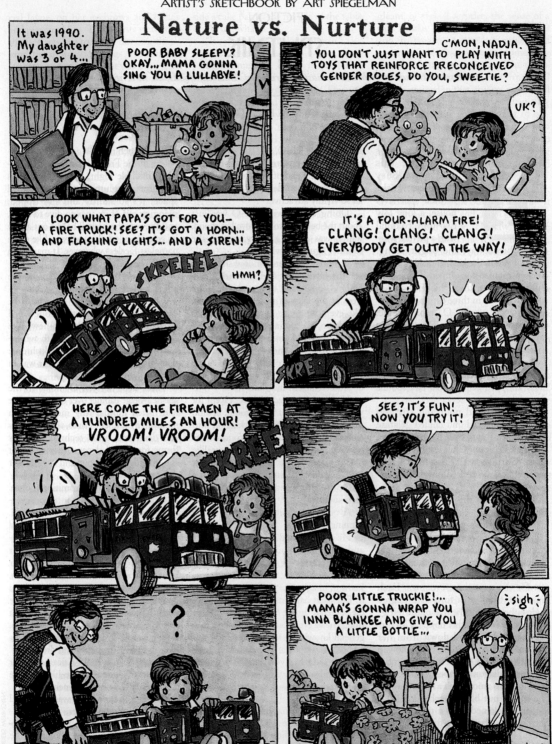

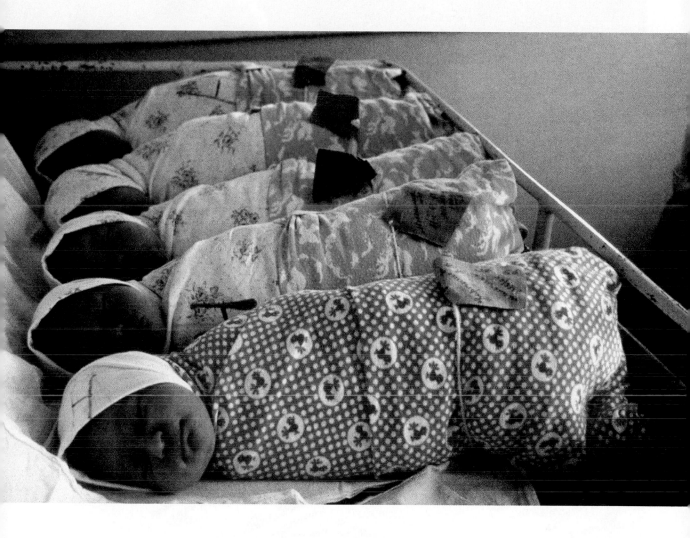

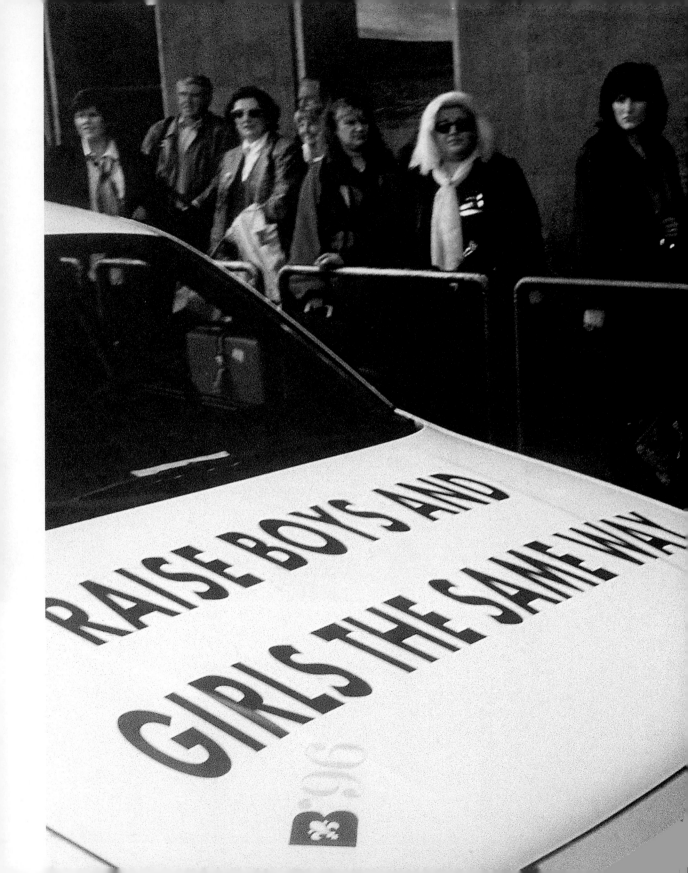

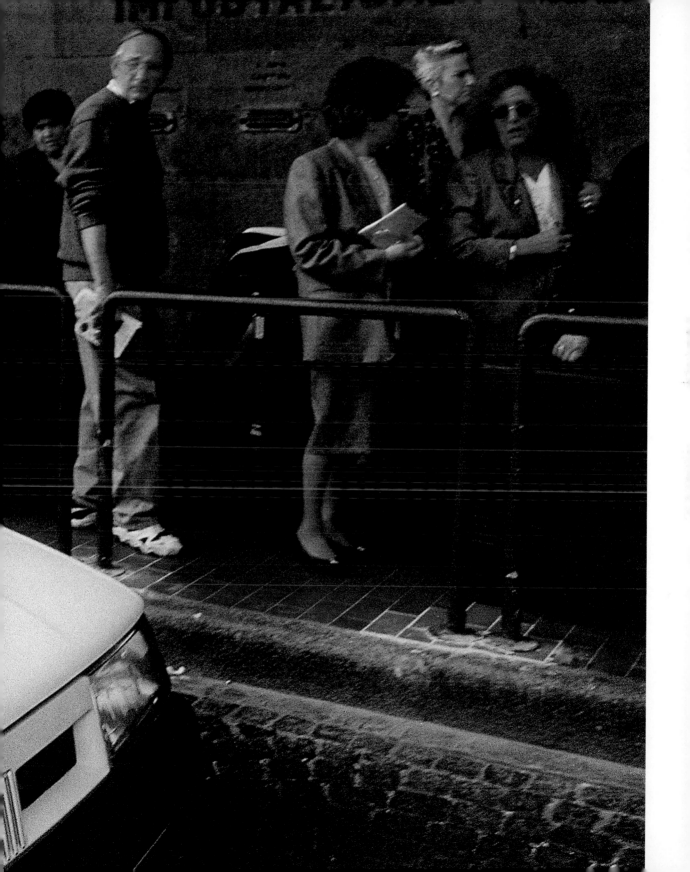

WONDER WOMAN

Wonder Woman, born on Paradise Island to Queen Hippolyte, was brought to public view through the hand of cartoonist William Moulton in the early 1940s. Hailed as a modern-day incarnation of the Roman goddess Diana (the huntress), Wonder Woman has fought the Duke of Deception and other foes of Democracy with her telepathically controlled lasso and invisible jet for more than forty years. Dressed always in her star-spangled blue shorts and red bustier with golden breast plates, she first appeared in *Comic Cavalcade* in the 1940s, as a movie heroine in the 1960s, and in 1976 in a television series starring Lynda Carter (pictured here).

DANA LIXENBERG

Photographer Dana Lixenberg often finds beauty where others see hardship. Whether photographing the young women who inhabit the housing projects of urban New Jersey for her award-winning *Life* magazine essay "Inner Beauty" or capturing the run-down edges of Staten Island for *New York* magazine, Lixenberg's images are direct and unadorned.

Born and raised in the Netherlands, she studied photography in Amsterdam at the Gerritt Reitveld Academy and in London before settling in New York in 1990. Among her early assignments in the United States were cover shots of Tupac Shakur and Curtis Mayfield for music industry magazines *Spin* and *Vibe;* her image of Sean Penn graced the cover of the French edition of *Vogue.* Her work has appeared in many other major publications and in exhibitions around the world.

KATHA POLLITT

Born in New York City in 1949, Katha Pollitt earned a B.A. from Radcliffe College in 1972. She is a widely published poet and essayist whose writing began appearing in the 1970s in such magazines as *The New Yorker* and *Atlantic Monthly.* Her prose was collected in *Antarctic Traveler* (1982), which won the National Book Critics Circle award in 1983. *Reasonable Creatures: Essays on Women and Feminism* appeared in 1994. Pollitt has received numerous awards, including a grant from the National Endowment for the Arts and a Guggenheim fellowship. Her essays and criticism reach a wide audience through such publications as *Mother Jones,* the *New York Times, The New Yorker,* and *The Nation,* where as an associate editor she writes a regularly featured column.

ART SPIEGELMAN

Art Spiegelman was born in Stockholm, Sweden, in 1948 and moved with his parents to the borough of Queens in New York City when he was 3 years old. By the age of 14 he had created a satire magazine, and when he was 15 he was selling drawings to the Topps Chewing Gum Company. Spiegelman is the only person to win the Pulitzer Prize for fiction for a comic book, *Maus* (1991), a World War II fable about the Holocaust. It was based on the experience of his parents, who survived the Nazi death camps. In the comic book the Germans are portrayed as cats, the Jews as mice, and the Poles as pigs. Spiegelman sees nothing odd about addressing a very weighty subject in what had been a very light medium. Comics are his form of communication—the only way, he says, that he knows how to tell a story. They are also his medium for understanding, for "trying to understand myself and trying to understand other things." In the process, he has expanded the breadth of what can be done with drawings and visual images, and he has almost single-handedly shown that comics can be of interest to serious readers. His latest book is *Open Me . . . I'm a Dog!* (1997).

DESMOND MORRIS

This photograph of Russian newborns appeared in *The Human Animal: A Personal View of the Human Species* (1994), a companion book to a television series on the role of genetic heritage in human behavior by anthropologist Desmond Morris. Noted for his exploration of the connections between contemporary human behavior and our animal past, Morris has published numerous books on such topics as the meaning of human gesture, courtship rituals, and child rearing practices.

The caption under the photograph reads, "Russian babies, swaddled and labeled, lie like a row of skittles in their hospital bed. Mothers only see them at feeding times and are allowed little free contact with them."

JENNY HOLZER

Since the early 1970s, artist Jenny Holzer has used the techniques of advertising to disseminate ideas in public spaces. She is best known for her large LCDs (liquid crystal displays), moving messages in lights that have been wrapped around the Guggenheim Museum, broadcast in Times Square, and displayed on the Pompidou Center in Paris. Utilizing compelling aphorisms, clichés, and words of wisdom, Holzer's work plays on our habitual reading of the many media messages around us to show how we ignore or accept information depending on its form.

SEEING

1. How would you summarize Katha Pollitt's analysis of "Why Boys Don't Play with Dolls"? What are the most compelling aspects of her argument? the least convincing? Please explain why. Pollitt notes, "But the thing the theories do most of all is tell adults that the *adult* world—in which moms and dads still play by many of the old rules even as they question and fidget and chafe against them—is the way it's supposed to be" (para. 12). What, exactly, is "the way it's supposed to be"?

2. How does the notion of gender training serve as a commentary on the photograph of newborn babies? the Wonder Woman, Jenny Holzer, and Dana Lixenberg photographs? the Art Spiegelman cartoon? What sort of childhood play is the father in the cartoon encouraging? Imagine the cartoon without the accompanying text. What would make us assume that the child is a girl and not a boy?

3. How would you characterize Spiegelman's rendering of the father in this cartoon? What type of person has he drawn? What details communicate his personality? Compare Holzer's approach in presenting her opinion on gender and raising children with Spiegelman's approach. Consider their choices of medium, the context in which each piece was seen, and the audience.

WRITING

1. How did toys contribute, if at all, to your childhood understanding of gender difference? What were your favorite toys or play activities? Would you describe them as typically "male" or "female"? Write a two-page recollection of a childhood toy or play activity that somehow informed your notions of masculinity and femininity.

2. Several authors in this book recall childhood experiences with superheroes. See, for example, Judith Ortiz Cofer's "The Story of My Body" (p. 208). What superhero were you fond of as a child? How did this superhero contribute to your childhood notions of what it meant to be a man or a woman? How representative is your experience of others your age? Write the first draft of an analytic essay in which you explain the nature of the appeal of superheroes.

Chapter 6

Constructing Race

"The problem of the twentieth century," wrote W. E. B. DuBois in 1903, "is the problem of the colorline." At the dawn of the new millennium, racial issues remain at the center of the nation's tensions. More than 130 years after the abolition of slavery, and despite civil rights legislation and the increasingly prominent presence of people of color in American public life, racial inequalities persist in virtually every dimension of American life and culture. In a recent essay in the *New York Times*, the Harvard sociologist Orlando Patterson calls for the abolition of race as a category on the Census Bureau survey form. "Getting rid of racial categorization," Patterson argues, "helps rid America of our biggest myth: that race is a meaningful, valid classification."

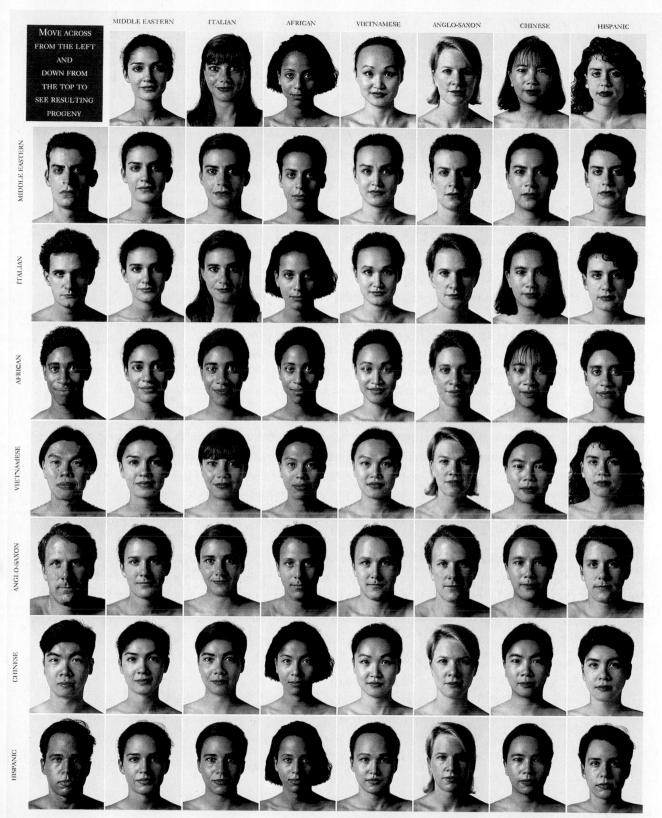

MOVE ACROSS FROM THE LEFT AND DOWN FROM THE TOP TO SEE RESULTING PROGENY

MIDDLE EASTERN ITALIAN AFRICAN VIETNAMESE ANGLO-SAXON CHINESE HISPANIC

MIDDLE EASTERN

ITALIAN

AFRICAN

VIETNAMESE

ANGLO-SAXON

CHINESE

HISPANIC

PHOTOGRAPHS BY TED THAI FOR TIME; COMPUTER MORPHING BY KIN WAH LAM; DESIGN BY WALTER BERNARD & MILTON GLASER

Americans have talked about race and racial categories for a long time, and racial issues have been—and continue to be—serious problems in our country. Yet statistical evidence suggests that most whites don't consider themselves to be prejudiced or discriminatory—perhaps because of an unspoken inclination by whites to measure all other identities by a notion of "whiteness." Here's how one white undergraduate expressed this notion:

> When Europeans, or Asians or Africans for that matter, think of America, they think of white people, because white people are mainstream, white people are general. . . . So, if you're a black person trying to assert yourself, and express your culture, there's something wrong with you, because to do that is to be diametrically opposed to everything this country stands for. And everything this country stands for is white. African Americans, Asian Americans, brown Hispanics, and Native Americans have compellingly argued that they cannot mask their color; Irish, Jewish, Italian, and other ethnic groups can. As a result, members of minority groups must learn to educate themselves about the still-dominant white population. As the playwright Angus Wilson has explained, "Blacks know more about whites in white culture and white life than whites know about blacks. We have to know because our survival depends on it. White people's survival does not depend on knowing blacks."

This student's assumptions reflect conceptions about race embedded deep within contemporary American culture. The word *black,* for example, continues to be used in a negative sense; *black sheep, black magic, blacklist, blackballed, blackmailed,* and *black hole* are but a few of many examples of linguistic prejudice. If prejudice is about ideas—unreasonable judgments or convictions, then discrimination is about behavior—unreasonable treatment based on class or category. Racism is a structural problem, a form of discrimination embedded in institutional processes of exclusion based on group identity. As such, racism is a social construction, more a cause than a product of race.

ERACISM—American slogan and bumper sticker, 1990s.

The concept of race has ancient origins that emphasized the physical, linguistic, and cultural differences among groups of people. By the mid-nineteenth century, Western science and culture used the word to classify people into groups on the basis of physical features (such as skin and hair color) as well as on the basis of mental and moral behavior. These conceptions of race depended on then-prevailing notions of heredity and superiority. In nineteenth-century language the word *Negro* suggested not only skin

color and hair texture but also other genetically inherited characteristics *and* an inferior social status—especially in cultures in which "negroes" were marked as slaves.

Color has long provided the simplest and most convenient explanation of racial differences among people. By 1805, the French comparative anatomist Georges Cuvier had divided the world into three races: white, yellow, and black. Cuvier's theory circulated for generations, not only because it told a seemingly easy-to-verify story about classifying humankind but also because his color categories implied a gradation from superior to inferior.

The publication of Charles Darwin's *Origin of Species* (1859) added the notion of natural selection to the prevailing racial theory. This principle preserved the hierarchical relationship among the races and added—under the rubric "eugenics"—the possibility of controlling racial development. This way of thinking, called Social Darwinism, provided an elaborate explanation for either dominating or marginalizing races labeled inferior as well as a moral impetus for colonizing and "civilizing" them.

By the last decades of the nineteenth century, the widely circulated phrase "white man's burden" conveyed the responsibility of whites to lift the spirits and boost the fortunes of those races designated as inferior. The efforts of anthropologists, sociologists, linguists, and other researchers to validate these claims about differences among people continued well into the twentieth century but were curtailed by World War II and the extermination of millions of people during the Holocaust.

Responding to the horrors of World War II, the United Nations endorsed the 1951 UNESCO "Statement of the Nature of Race and Racial Difference." This document declared that race, when considered in biological terms, could refer to nothing more than a group with particular genetic concentrations. The document also rejected efforts to define race in terms of intellectual and biological racial categories and underscored the importance of environment rather than genetics in shaping individual behavior and culture. A resurgence of popular interest in the relation between biology and theories of race in the 1960s repositioned race at the center of debates about human differences and led to the emergence of sociobiology in the 1970s. Its fundamental theory advocated the belief that social behavior can be transmitted genetically and is

> Light came to me when I realized that I did not have to consider any racial group as a whole. God made them duck by duck and that was the only way I could see them.
> *– Zora Neale Hurston, 1942*

subject to evolutionary processes. These debates were fueled by oversimplifications of biological speculation rather than by attention to the cultural complexities of *ethnicity,* a word used to describe human difference in terms of shared values, beliefs, culture, tradition, language, and social behavior. Ethnicity, like race, is a cultural construction rather than a biological attribute, and both terms are the products of historical processes.

Given that race has become one of the primary ways by which people identify themselves, it may well come, as the scholar Anthony Appiah has noted, as "a shock to many to learn that there is a fairly widespread consensus in the sciences of biology and anthropology that the word 'race,' at least as it is used in most unscientific discussions, refers to nothing that science should recognize as real." Appiah has also observed that scientists have rejected not only the assertions that someone's racial "essence" can explain, say, his or her intellectual and moral behavior but also such standard nineteenth-century classifications as Negroid, Caucasian, and Mongoloid. "There are simply too many people who do not fit into any such category," Appiah explains, and "even when you succeed in assigning someone to one of these categories . . . that implies very little about most of their other biological characteristics." Like a belief in ghosts, a belief in race—however inaccurate—can have serious consequences for social and cultural life.

We have to be honest, we have to be truthful and speak to the one dirty secret in American life, and that is racism.
– Henry Cisneros, 1993

Despite the discrediting of so-called objective criteria for defining race, scientific explanations—and their representations in popular culture— linger in various expressions of racist behavior and institutional practice. Racism remains, in effect, a product of attitudes.

While racial categories and the divisions between the races may never have been clearly defined, even a cursory glance at popular culture and music today reveals an unprecedented mixing of American cultures and ethnic groups. Signs of hip-hop, for example, once a grass-roots street culture and musical style of African Americans and Latinos in the South Bronx, can now be found everywhere—from MTV videos to the baggy pants of young white suburbanites across the country. "Not since pre–Civil War blackface minstrelsy has popular culture been such a racial free-for-all," writes Charles Aaron, senior editor of *Spin* magazine. The stories, essays, and images in this chapter represent different expressions of the continued existence and blurring of these racial categories.

TIME MAGAZINE

Time magazine, founded in 1923 by Henry Luce and Briton Hadden, was America's first weekly news magazine. Its name, according to the original prospectus, was selected because it was "brief, simple, easy to read and say. It is a well-known word but little used in capital letters. It is dignified for people who demand dignity and catchy enough for the general public." The first issue, dated March 3, 1923, cost 15 cents and consisted of 32 pages broken into 22 departments. It was meant to be read in a single sitting.

Time has occasionally published special issues on topics of great public interest and importance. For the special issue entitled "The New Face of America," *Time* relied on a software program called Morph 2.0, produced by Gryphon, to create, as the editors note, "the 49 combinations of progeny from the seven men and seven women featured in the *Time* picture chart.... Most of the images, or 'morphies,' on the chart are a straight 50-50 combination of the physical characteristics of their progenitors, though an entirely different image can be created by using, say, 75% of the man's eyes, or 75% of the woman's lips. After the eyes, the most important parental feature is the neck, which often determines the gender of the morph offspring."

SEEING

1. Examine carefully the composite photographs that served as the background for the cover of a special issue on race published by *Time* magazine in 1993. How does this image demonstrate the way in which the notion of race might be regarded as a social construction? What do you make of the racial categories? of the representative faces created for each category? Which groups are not shown? How does this composite portrait differ from your experience of racial and ethnic identity? What resonances do you hear in the first part of the title of the composite photograph, "Rebirth of a Nation"?

2. How "normal" does each of these faces look? What role does skin color play in your response to the images? What imperfections do you notice in each face? The computer software used to generate this grid (Morph 2.0) is used in movies and music videos. In what ways does this grid of images strike you, at first glance, as movie-like? What other responses does the image evoke in you? Please explain.

WRITING

1. This image projects a harmonious intermingling of American racial and ethnic groups. Consider an experience that conveys your attitude toward race relations on your school's campus. You might focus, for example, on an experience in which you either clashed or bonded with another ethnic or racial group. Consider the ways in which ethnic groups function and represent themselves on your school's campus. For example, do students seem to cluster by race and ethnicity in your dorm dining hall? If so, explain why. Draft a personal essay in which you recount your experience with racial or ethnic intermingling on campus.

2. Not long ago, race in America was a "black" and "white" issue. The focus of this *Time* issue on race—and of this photographic image in particular—is the intermingling of Americans of different races and ethnicities. The fact that a mainstream magazine created such a computer-generated grid—predicting the progeny of interracial marriages—reveals the extent to which the terms of the public discourse on race have changed over the past few decades. Look back through earlier issues of *Time* for a discussion of race. Draft a comparison/contrast essay in which you document—and account for—the change in attitude between that issue and the one published in 1993.

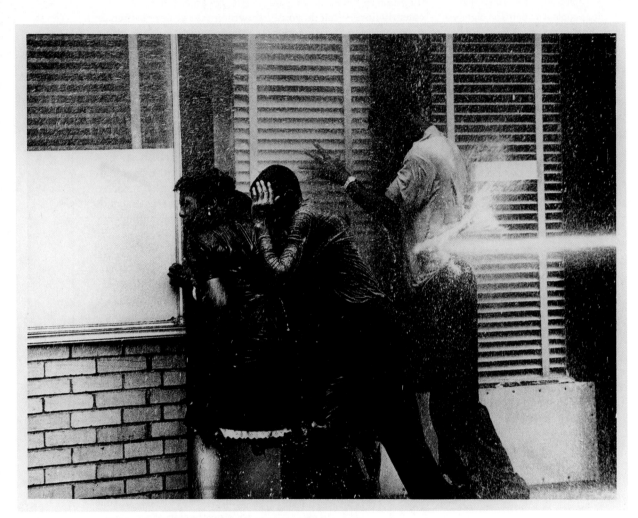

Charles Moore, **Jets of Water Blast Civil Rights Demonstrators, Birmingham, 1963**

JETS OF WATER BLAST CIVIL RIGHTS DEMONSTRATORS, BIRMINGHAM, 1963

Reverend Jesse Jackson

NO DOUBT YOU'VE SEEN THIS PHOTOGRAPH OF the children in Birmingham as the fire hoses were unleashed on them in 1963. This picture exposed the most despicable in us, and it brought the best out of us, because no one seeing this picture could be neutral. No matter how strong the water was or how armed the police were, the innocence of those children and the morality of their cause was stronger than the water from the hoses. This photograph was taken at a peaceful march. As usual, people were given three warnings before the police took action, and they did not move. Part of nonviolent resistance is to remain wherever you are. This photograph showed that the demonstrators' will was stronger than the oppressors who unleashed the hundreds of pounds of water pressure from their hoses.

These were the pictures of the spring of '63. They were commonplace, reproduced in scores of magazines and newspapers. They were important because we did not have any influence, at the time, over the pictures that got into the press or the media. White people were holding the cameras. White people were taking the pictures of us. What you see here are African-American youths fighting back for dignity, fighting against the enforcers of the old, immoral order, fighting to end the humiliating loss of dignity.

They are well-bred, well-dressed young people, college students, trained in nonviolence in workshops, who learned how to win through passive resistance. It was moral jujitsu. What seemed like a small action could have a big effect, could be very powerful. White people were embarrassed by the violence of this photograph. When a photograph like this received a lot of attention, the movement won something. A picture like this made the determination of African-Americans public.

One of the paradoxes of the time was that the poor people did not fight back; poorer people accepted their places in the back of the bus, in the kitchen, on the welfare lines. It was those who had the ambition of higher education and dreams who fought back to make America more inclusive. During the movement, there was both a sense of helplessness and a sense of power. The power was in the resolve to change things. The helplessness was in, "I can't get there now. There's a sea between us. Hold on. Help is on the way." Then it all came together. The student movement was counterculture. It was counter everything you'd been taught. It was all about fighting

back for dignities, like in this picture. Fighting to get respect. "I am a person."

I had to stand with my generation. I was in school at North Carolina A&T at that time, and I was involved in sit-ins. The sit-ins had begun on February 1, 1960, in Greensboro, and at that time, I was still at the University of Illinois. I didn't go to Greensboro until September, and by the fall, the movement had died down somewhat. Things had returned to a certain normalcy. But a few students carried it on, and there was a constant challenge to me about getting involved, for some reason that I never quite understood. By the spring of '63, when I was at A&T, the movement had heated up again. It was during this period—about when this picture was taken—that we were marching and being arrested.

One Sunday afternoon, a group of us had just left jail, and we were searching for ways to turn up the heat. About 600 or 700 of our fellow students were locked up in a senior citizens home built for 125 people. We marched two or three miles down the road to the site of the home. The National Guard had its guns and paraphernalia. They had dogs, too, and cars with flashing blue lights. I can see it as I speak. There was the element of fear. You see the police, and you know they're a threat to your life. I saw our classmates leaning out of the windows, saying, "Please get us out of here. We don't have any air." They were overjoyed because they saw us coming down the street, marching and singing like we had come to rescue them. And we had.

And as I stood there, I began to weep uncontrollably. As I wept, that water washed away any of the doubts and fears I had about participating in the movement. Something happened. I saw the system naked. I saw it without pose. I saw it face to face for all of its brutality, and its ugliness, and the depth of its venom. I saw all of it, and I was no longer afraid. I made a commitment to fight for the rest of my life. I began to speak and preach without notes, decrying the wickedness of the system. The difference that day was that I spoke with pathos, passion, directness. I spoke as well as I've ever spoken since. I

was speaking to all of them: the students, the police, the press, those behind the bars. I was speaking to all of them. I spoke with moral authority, without any fear or calculation. I was prepared to live or die. It was a transcendent moment.

I realized then that words speak pictures. With words you can stir up the imagination, and you can paint scenery. You set context. In the beginning was the word. And the word was with God. The world was spoken into existence. That's power of the word. The [civil rights] movement had its own language and rhythm. Speaking epigrammatically was at the heart of the language of the movement. Since we were so often misquoted by the media, we learned to speak in short, pithy terms—quotable terms—so the media was less able to misquote us. "Penetrate and capture order. Demonstration without hesitation. Jail without bail. Forward march." You can hardly misquote that. When people speak in rhymes, they communicate. Musicians rhyme. Poets rhyme. The same kids who cannot remember three pages of a history book can remember both sides of a double jacket album, because of how the language is put.

But words become vapor, and words blow in the wind. Except for some sticky stuff in your brain called memory, you have nothing else to go on except physical recall. That's why pictures are important. Pictures freeze a moment in time, and they can live in one's memory, just like this one lives on in mine. That becomes the power of a picture. At the time there were some films made of demonstrations or of events like this, but in many cases, it is the still picture that persists in our memories. Now there are more moving pictures, like the videotape of the beating of Rodney King, which sparked the Los Angeles riots. They are very powerful, too, but this photograph has power, even thirty years later, because it was a still photograph that the media picked up and it became symbolic. It got into history books. This is one of the photographs that sums up the entire movement.

There were times when we were about to be arrested in which the media was present. Certainly, the oppressor did not want to be seen. I remember one of

the most dramatic things I did during that period was marching one day into Morrison's Cafeteria downtown, and as I was walking toward the door, leading a group of students—CBS television had cameras there—the boy who owned Morrison's Cafeteria came out and stopped us. As I saw the cameras rolling, I said, speaking in very direct language, "I would like to eat in this restaurant." "You cannot eat here!" I knew from the inflection of his voice that he was out of control, and as a quarterback, I'm going to be under control. I had him because he was out of control. I said, "We want to eat here." "Can't eat here!" I said, "But we are Americans." "You can't eat here!" "We're hungry, we have the appetite, and we have the money." "You can't eat here!!" "We expect to be able to eat here because it's the American thing to do." I knew the contrast between stating the basic proposition—we want to eat, we have the appetite, we have the money, we are Americans—and him screaming we couldn't eat was something America had to come to grips with. And I knew I'd won that round. All of it was on film which CBS still has someplace.

You see, the media has more power than the politicians who make laws, or the bankers who make money, or the police who carry weapons. Because the media has appraisal power and it determines the worth of things. Using photographic images, the media deletes, distorts, emphasizes, and de-emphasizes. African-Americans and Hispanics are projected in photographs every day in five deadly ways. We're projected as less intelligent than we are, as less hardworking than we work, as less universal than we are, as less patriotic, and as more violent than we are. Those images are projected onto the minds of our neighbors and peers, who see those pictures everyday all day on television and in the press.

When I grew up in Greensville, no African-American's obituary was ever illustrated with a picture in the paper, no wedding pictures were ever in the paper, no cotillion pictures were ever in the paper. Only if somebody was caught murdering or stealing did they make the paper. Maybe once a year a picture of our school team ran, and we were always the state champions. The white team was featured in the paper all the time. I understood, even at that time, the media's power to project and to represent reality. What gets through becomes reality. ○

CHARLES MOORE

From his first assignment for *Life* magazine at the desegregation of the University of Mississippi in 1962, to Martin Luther King's march to Selma in 1965, photojournalist Charles Moore has created a moving and powerful record of the civil rights movement in the South.

Moore, a native of Alabama, was born into a poor white family. His father sometimes preached at black churches and took Charles with him. Later, being a "tough country kid" and an amateur boxer stood Moore in good stead as a photojournalist. Refusing to use a long lens, which would enable him to photograph from a distance, Moore would stay in the crowd to capture a dramatically candid record of events. In his book *Powerful Days: The Civil Rights Photography of Charles Moore* (1991), he comments: "For all journalists covering the civil rights story through the sixties, it was difficult, exhausting, and often very dangerous. For me it was all of the above plus troubling and emotional in a personal way because I am a Southerner too."

Moore's now-famous photograph of police dogs tearing at the leg of a black man in Birmingham, Alabama, was, according to many, influential in promoting the passage of civil rights legislation. Moore notes: "Pictures can and do make a difference. Strong images of historical events do have an impact on our society."

JESSE JACKSON

Born in 1941 in South Carolina, the Reverend Jesse Jackson began his political career as a student leader in the desegregation movements of the early 1960s. After attending the Chicago Seminary for two years, Jackson was invited by the Reverend Martin Luther King Jr. to lead Operation Breadbasket, an economic arm of King's umbrella organization, the Southern Christian Leadership Conference. In 1971 Jackson and other black leaders founded PUSH (People United to Serve Humanity), an organization that works to improve education and economic opportunities for those in need.

In 1984 Jackson became the first African American to lead a full-scale presidential campaign. Under the banner of his Rainbow Coalition, a group that seeks to give equal voice to black, brown, Native American, gay, and all disempowered people, Jackson won nearly a quarter of the votes cast in that election.

As an eloquent spokesman for the oppressed and as a talented diplomat, Jackson has earned international acclaim. Like Martin Luther King, Jackson articulates political positions deeply rooted in his religious beliefs. Racism, he says, is fundamentally a moral problem: "The resolution of the race question in this country would liberate us to liberate others around the world. For until white America is what it ought to be, black America cannot be what it ought to be."

SEEING

1. Where is your eye drawn in this photograph? How would you respond to the photograph if you could see the faces of the people being hit by jets of water? How are the effects of the photograph reinforced by the title Charles Moore gives to the image? What does he gain—or lose—by omitting from view the persons who are directing the jets of water?

2. Where—and how—does Jesse Jackson position himself in relation to this photograph in his prose account of it? to the civil rights movement more generally? Point to specific words and phrases to verify your response. What role does Jackson ascribe to education in the success of the movement? What other traditional American values does Jackson highlight? What importance does Jackson assign to the media in the civil rights story? How does he trade on the interests and "needs" of the media in promoting the civil rights movement?

3. What relationship can you articulate between Charles Moore's photograph and Jesse Jackson's account of the circumstances that led to—and the consequences of—the attack on the civil rights demonstrators in Birmingham in 1963? Which do you find more compelling? Why?

WRITING

1. Jackson observes that "words speak pictures." What, exactly, does he mean? Jackson also notes that "pictures are important. Pictures freeze a moment in time, and they can live in one's memory, just like this one lives on in mine. That becomes the power of a picture" (para. 9). Summarize the advantages and disadvantages Jackson associates with words and pictures. Drawing on Jackson and, if you like, other sources, write the first draft of an essay in which you argue that either words or pictures have a more enduring impact on the attitudes and behavior of people.

2. Jackson devotes the final few paragraphs of his essay to the influence of the media on American public opinion. Note, for example, his final line: "What gets through becomes reality." Using Jackson's assertion as a springboard, write an essay in which you analyze the influence of the media on the public's perception and understanding of reality.

GISH JEN

Born in 1956, Gish Jen grew up in Scarsdale, New York, the second of five children of immigrant Chinese parents. "We were almost the only Asian American family in town," she remembers. "People threw things at us and called us names. We thought it was normal; it was only much later that I realized it had been hard." Jen draws on her experience growing up Asian American in her two critically acclaimed novels, *Typical American* (1991) and *Mona in the Promised Land* (1996).

"I have my own definition of American," says Jen. "It is not something that you come into [and] particularly does not involve abandoning where you came from. I think of American-ness as a preoccupation with identity. It is the hallmark of the New World because we live in a society where you are not only who your parents were, and you don't already know what your children will be. That is not to say that I am blond and eat apple pie, but any definition that finds me less American—well, all I can say is that something is wrong with the definition." Jen is a regular contributor to periodicals such as *The New Yorker, Atlantic Monthly, Yale Review, Fiction International,* and *Iowa Review.*

What Means Switch

Gish Jen

THERE WE ARE, NICE CHINESE FAMILY—FATHER, mother, two born-here girls. Where should we live next? My parents slide the question back and forth like a cup of ginseng neither one wants to drink. Until finally it comes to them, what they really want is a milkshake (chocolate) and to go with it a house in Scarsdale. What else? The broker tries to hint: the neighborhood, she says. Moneyed. Many delis. Meaning rich and Jewish. But someone has sent my parents a list of the top ten schools nation-wide (based on the opinion of selected educators and others) and so *many-deli* or not we nestle into a Dutch colonial on the Bronx River Parkway. The road's windy where we are, very charming; drivers miss their turns, plow up our flower beds, then want to use our telephone. "Of course," my mom tells them, like it's no big deal, we can replant. We're the type to adjust. You know—the lady drivers weep, my mom gets out the Kleenex for them. We're a bit down the hill from the private plane set, in other words. Only in our dreams do our jacket zippers jam, what with all the lift tickets we have stapled to them, Killington on top of Sugarbush on top of Stowe, and we don't even know where the Virgin Islands are—although certain of us do know that virgins are like priests and nuns, which there were a lot more of in Yonkers, where we just moved from, than there are here.

This is my first understanding of class. In our old neighborhood everybody knew everything about virgins and non-virgins, not to say the technicalities of staying in between. Or almost everybody, I should say; in Yonkers I was the laugh-along type. Here I'm an expert.

"You mean the man . . . ?" Pig-tailed Barbara Gugelstein spits a mouthful of Coke back into her can. "That is *so* gross!"

Pretty soon I'm getting popular for a new girl. The only problem is Danielle Meyers, who wears blue mascara and has gone steady with two boys. "How do *you* know," she starts to ask, proceeding to edify us all with how she French-kissed one boyfriend and just regular kissed another. ("Because, you know, he had braces.") We hear about his rubber bands, how once one popped right into her mouth. I begin to realize I need to find somebody to kiss too. But how?

Luckily, I just about then happen to tell Barbara Gugelstein I know karate. I don't know why I tell her this. My sister Callie's the liar in the family; ask anybody. I'm the one who doesn't see why we should have to hold our heads up. But for some reason I tell Barbara Gugelstein I can make my hands like steel by thinking hard. "I'm not supposed to tell anyone," I say.

The way she backs away, blinking, I could be the burning bush.

"I can't do bricks," I say—a bit of expectation management. "But I can do your arm if you want." I set my hand in chop position.

"Uhh, it's okay," she says. "I know you can, I saw it on TV last night."

That's when I recall that I too saw it on TV last night—in fact, at her house. I rush on to tell her I know how to get pregnant with tea.

"With *tea*?"

"That's how they do it in China." 10

She agrees that China is an ancient and great civilization that ought to be known for more than spaghetti and gunpowder. I tell her I know Chinese. "*Be-yeh fa-foon,*" I say. "*Shee-veh. Ji nu.*" Meaning, "Stop acting crazy. Rice gruel. Soy sauce." She's impressed. At lunch the next day, Danielle Meyers and Amy Weinstein and Barbara's crush, Andy Kaplan, are all impressed too. Scarsdale is a liberal town, not like Yonkers, where the Whitman Road Gang used to throw crabapple mash at my sister Callie and me and tell us it would make our eyes stick shut. Here we're like permanent exchange students. In another ten years, there'll be so many Orientals we'll turn into Asians; a Japanese grocery will buy out that one deli too many. But for now, the mid-sixties, what with civil rights on TV, we're not so much accepted as embraced. Especially by the Jewish part of town—which, it turns out, is not all of town at all. That's just an idea people have, Callie says, and lots of them could take us or leave us same as the Christians, who are nice too; I shouldn't generalize. So let me not generalize except to say that pretty soon I've been to so many bar and bas mitzvahs, I can almost say myself whether the kid chants like an angel or like a train conductor, maybe they could use him on the commuter line. At seder I know to forget the bricks, get a good pile of that mortar. Also I know what is schmaltz. I know that I am a goy. This is not why people like me, though. People like me because I do not need to use deodorant, as I demonstrate in the locker room before and after gym. Also, I can explain to them, for example, what is tofu (*der-voo,* we say at home). Their mothers invite me to taste-test their Chinese cooking.

"Very authentic." I try to be reassuring. After all, they're nice people, I like them. "De-lish." I have seconds. On the question of what we eat, though, I have to admit, "Well, no, it's different than that." I have thirds. "What my mom makes is home style, it's not in the cookbooks."

Not in the cookbooks! Everyone's jealous. Meanwhile, the big deal at home is when we have turkey pot pie. My sister Callie's the one introduced them—Mrs. Wilder's, they come in this green-and-brown box—and when we have them, we both get suddenly interested in helping out in the kitchen. You know, we stand in front of the oven and help them bake. Twenty-five minutes. She and I have a deal, though, to keep it secret from school, as everybody else thinks they're gross. We think they're a big improvement over authentic Chinese home cooking. Oxtail soup—now that's gross. Stir-fried beef with tomatoes. One day I say, "You know Ma, I have never seen a stir-fried tomato in any Chinese restaurant we have ever been in, ever."

"In China," she says, real lofty, "we consider toma- 15 toes are a delicacy."

"Ma," I say. "Tomatoes are *Italian.*"

"No respect for elders." She wags her finger at me, but I can tell it's just to try and shame me into believing her. "I'm tell you, tomatoes *invented* in China."

"*Ma.*"

"Is true. Like noodles. Invented in China."

"That's not what they said in *school.*" 20

"In *China,*" my mother counters, "we also eat tomatoes uncooked, like apple. And in summertime we slice them, and put some sugar on top."

"Are you sure?"

My mom says of course she's sure, and in the end I give in, even though she once told me that China was such a long time ago, a lot of things she can hardly remember. She said sometimes she has trouble remembering her characters, that sometimes she'll be writing a letter, just writing along, and all of a sudden she won't be sure if she should put four dots or three.

"So what do you do then?"

"Oh, I just make a little sloppy." 25

"You mean you *fudge*?"

She laughed then, but another time, when she was showing me how to write my name, and I said, just kidding, "Are you sure that's the right number of dots now?" she was hurt.

"I mean, of course you know," I said. "I mean, *oy*."

Meanwhile, what *I* know is that in the eighth grade, what people want to hear does not include how Chinese people eat sliced tomatoes with sugar on top. For a gross fact, it just isn't gross enough. On the other hand, the fact that somewhere in China somebody eats or has eaten or once ate living monkey brains—now that's conversation.

"They have these special tables," I say, "kind of like 30 a giant collar. With a hole in the middle, for the monkey's neck. They put the monkey in the collar, and then they cut off the top of its head."

"Whadda they use for cutting?"

I think. "Scalpels."

"*Scalpels?*" says Andy Kaplan.

"Kaplan, don't be dense," Barbara Gugelstein says. "The Chinese *invented* scalpels."

Once a friend said to me, You know, everybody is 35 valued for something. She explained how some people resented being valued for their looks; others resented being valued for their money. Wasn't it still better to be beautiful and rich than ugly and poor, though? You should be just glad, she said, that you have something people value. It's like having a special talent, like being good at ice-skating, or opera-singing. She said, You could probably make a career out of it.

Here's the irony: I am.

Anyway. I am ad-libbing my way through eighth grade, as I've described. Until one bloomy spring day, I come in late to homeroom, and to my chagrin discover there's a new kid in class.

Chinese.

So what should I do, pretend to have to go to the girls' room, like Barbara Gugelstein the day Andy Kaplan took his ID back? I sit down; I am so cool I remind myself of Paul Newman. First thing I realize,

though, is that no one looking at me is thinking of Paul Newman. The notes fly:

"*I* think he's cute." 40

"Who?" I write back. (I am still at an age, understand, when I believe a person can be saved by aplomb.)

"I don't think he talks English too good. Writes it either."

"Who?"

"They might have to put him behind a grade, so don't worry."

"He has a crush on you already, you could tell as 45 soon as you walked in, he turned kind of orangeish."

I hope I'm not turning orangeish as I deal with my mail; I could use a secretary. The second round starts:

"What do you mean who? Don't be weird. Didn't you *see* him??? Straight back over your right shoulder!!!!"

I have to look; what else can I do? I think of certain tips I learned in Girl Scouts about poise. I cross my ankles. I hold a pen in my hand. I sit up as though I have a crown on my head. I swivel my head slowly, repeating to myself, *I* could be Miss America.

"Miss Mona Chang."

Horror raises its hoary head. 50

"Notes, please."

Mrs. Mandeville's policy is to read all notes aloud.

I try to consider what Miss America would do, and see myself, back straight, knees together, crying. Some inspiration. Cool Hand Luke, on the other hand, would, quick, eat the evidence. And why not? I should yawn as I stand up, and boom, the notes are gone. All that's left is to explain that it's an old Chinese reflex.

I shuffle up to the front of the room.

"One minute please," Mrs. Mandeville says. 55

I wait, noticing how large and plastic her mouth is.

She unfolds a piece of paper.

And I, Miss Mona Chang, who got almost straight A's her whole life except in math and conduct, am about to start crying in front of everyone.

I am delivered out of hot Egypt by the bell. General pandemonium. Mrs. Mandeville still has her hand

clamped on my shoulder, though. And the next thing I know, I'm holding the new boy's schedule. He's standing next to me like a big blank piece of paper. "This is Sherman," Mrs. Mandeville says.

"Hello," I say.

"*Non how a,*" I say. 60

I'm glad Barbara Gugelstein isn't there to see my Chinese in action.

"*Ji nu,*" I say. "*Shee veh.*"

Later I find out that his mother asked if there were any other Orientals in our grade. She had him put in my class on purpose. For now, though, he looks at me as though I'm much stranger than anything else he's seen so far. Is this because he understands I'm saying "soy sauce rice gruel" to him or because he doesn't?

"Sher-man," he says finally. 65

I look at his schedule card. Sherman Matsumoto. What kind of name is that for a nice Chinese boy?

(Later on, people ask me how I can tell Chinese from Japanese. I shrug. You just kind of know, I say. *Oy!*)

Sherman's got the sort of looks I think of as pretty-boy. Monsignor-black hair (not monk-brown like mine), bouncy. Crayola eyebrows, one with a round bald spot in the middle of it, like a golf hole. I don't know how anybody can think of him as orangeish; his skin looks white to me, with pink triangles hanging down the front of his cheeks like flags. Kind of delicate-looking, but the only truly uncool thing about him is that his spiral notebook has a picture of a kitty cat on it. A big white fluffy one, with a blue ribbon above each perky little ear. I get much opportunity to view this, as all the poor kid understands about life in junior high school is that he should follow me everywhere. It's embarrassing. On the other hand, he's obviously even more miserable than I am, so I try not to say anything. Give him a chance to adjust. We communicate by sign language, and by drawing pictures, which he's better at than I am; he puts in every last detail, even if it takes forever. I try to be patient.

A week of this. Finally I enlighten him. "You should get a new notebook."

His cheeks turn a shade of pink you mostly only 70 see in hyacinths.

"Notebook." I point to his. I show him mine, which is psychedelic, with big purple and yellow stick-on flowers. I try to explain he should have one like this, only without the flowers. He nods enigmatically, and the next day brings me a notebook just like his, except that this cat sports pink bows instead of blue.

"Pret-ty," he says. "You."

He speaks English! I'm dumbfounded. Has he spoken it all this time? I consider: Pretty. You. What does that mean? Plus actually, he's said *plit-ty*, much as my parents would; I'm assuming he means pretty, but maybe he means pity. Pity. You.

"Jeez," I say finally.

"You are wel-come," he says. 75

I decorate the back of the notebook with stick-on flowers, and hold it so that these show when I walk through the halls. In class I mostly keep my book open. After all, the kid's so new; I think I really ought to have a heart. And for a livelong day nobody notices.

Then Barbara Gugelstein sidles up. "Matching notebooks, huh?"

I'm speechless.

"First comes love, then comes marriage, and then come chappies in a baby carriage."

"Barbara!" 80

"Get it?" she says. "Chinese Japs."

"Bar-*bra,*" I say to get even.

"Just make sure he doesn't give you any *tea,*" she says.

Are Sherman and I in love? Three days later, I hazard that we are. My thinking proceeds this way: I think he's cute, and I think he thinks I'm cute. On the other hand, we don't kiss and we don't exactly have fantastic conversations. Our talks *are* getting better, though. We started out, "This is a book." "Book." "This is a chair." "Chair." Advancing to, "What is this?" "This is a book." Now, for fun, he tests me.

"What is this?" he says. 85

"This is a book," I say, as if I'm the one who has to learn how to talk.

He claps. "Good!"

Meanwhile, people ask me all about him. I could be his press agent.

"No, he doesn't eat raw fish."

"No, his father wasn't a kamikaze pilot." 90

"No, he can't do karate."

"Are you sure?" somebody asks.

Indeed he doesn't know karate, but judo he does. I am hurt I'm not the one to find this out; the guys know from gym class. They line up to be flipped, he flips them all onto the floor, and after that he doesn't eat lunch at the girls' table with me anymore. I'm more or less glad. Meaning, when he was there, I never knew what to say. Now that he's gone, though, I seem to be stuck at the "This is a chair" level of conversation. Ancient Chinese eating habits have lost their cachet; all I get are more and more questions about me and Sherman. "I dunno," I'm saying all the time. Are we going out? We do stuff, it's true. For example, I take him to the department stores, explain to him who shops in Alexander's, who shops in Saks. I tell him my family's the type that shops in Alexander's. He says he's sorry. In Saks he gets lost; either that, or else I'm the lost one. (It's true I find him calmly waiting at the front door, hands behind his back, like a guard.) I take him to the candy store. I take him to the bagel store. Sherman is crazy about bagels. I explain to him that Lender's is gross, he should get his bagels from the bagel store. He says thank you.

"Are you going steady?" people want to know.

How can we go steady when he doesn't have an ID 95 bracelet? On the other hand, he brings me more presents than I think any girl's ever gotten before. Oranges. Flowers. A little bag of bagels. But what do they mean? Do they mean thank you, I enjoyed our trip; do they mean I like you; do they mean I decided I liked the Lender's better even if they are gross, you can have these? Sometimes I think he's acting on his mother's instructions. Also I know at least a couple of the presents were supposed to go to our teachers. He told me that once and turned red. I figured it still might mean something that he didn't throw them out.

More and more now, we joke. Like, instead of "I'm thinking," he always says, "I'm sinking," which we both think is so funny, that all either one of us has to do is pretend to be drowning and the other one cracks up. And he tells me things—for example, that there are electric lights everywhere in Tokyo now.

"You mean you didn't have them before?"

"Everywhere now!" He's amazed too. "Since Olympics!"

"Olympics?"

"1960," he says proudly, and as proof, hums for 100 me the Olympic theme song. "You know?"

"Sure," I say, and hum with him happily. We could be a picture on a UNICEF poster. The only problem is that I don't really understand what the Olympics have to do with the modernization of Japan, any more than I get this other story he tells me, about that hole in his left eyebrow, which is from some time his father accidentally hit him with a lit cigarette. When Sherman was a baby. His father was drunk, having been out carousing; his mother was very mad but didn't say anything, just cleaned the whole house. Then his father was so ashamed he bowed to ask her forgiveness.

"Your mother cleaned the house?"

Sherman nods solemnly.

"And your father *bowed*?" I find this more astounding than anything I ever thought to make up. "That is so weird," I tell him.

"Weird," he agrees. "This I no forget, forever. *Fa-* 105 *ther* bow to *mother!*"

We shake our heads.

As for the things he asks me, they're not topics I ever discussed before. Do I like it here? Of course I like it here, I was born here, I say. Am I Jewish? Jewish! I laugh. *Oy!* Am I American? "Sure I'm American," I say. "Everybody who's born here is American, and also some people who convert from what they were before. You could become American." But he says no, he could never. "Sure you could," I say. "You only have to learn some rules and speeches."

"But I Japanese," he says.

"You could become American anyway," I say. "Like I *could* become Jewish, if I wanted to. I'd just have to switch, that's all."

"But you Catholic," he says.

I think maybe he doesn't get what means switch.

I introduce him to Mrs. Wilder's turkey pot pies. "Gross?" he asks. I say they are, but we like them anyway. "Don't tell anybody." He promises. We bake them, eat them. While we're eating, he's drawing me pictures.

"This American," he says, and he draws something that looks like John Wayne. "This Jewish," he says, and draws something that looks like the Wicked Witch of the West, only male.

"I don't think so," I say.

He's undeterred. "This Japanese," he says, and draws a fair rendition of himself. "This Chinese," he says, and draws what looks to be another fair rendition of himself.

"How can you tell them apart?"

"This way," he says, and he puts the picture of the Chinese so that it is looking at the pictures of the American and the Jew. The Japanese faces the wall. Then he draws another picture, of a Japanese flag, so that the Japanese has that to contemplate. "Chinese lost in department store," he says. "Japanese know how go." For fun, he then takes the Japanese flag and fastens it to the refrigerator door with magnets. "In school, in ceremony, we this way," he explains, and bows to the picture.

When my mother comes in, her face is so red that with the white wall behind her she looks a bit like the Japanese flag herself. Yet I get the feeling I better not say so. First she doesn't move. Then she snatches the flag off the refrigerator, so fast the magnets go flying. Two of them land on the stove. She crumples up the paper. She hisses at Sherman, *"This is the U.S. of A., do you hear me!"*

Sherman hears her.

"You call your mother right now, tell her come pick you up."

He understands perfectly. *I,* on the other hand, am stymied. How can two people who don't really speak English understand each other better than I can understand them? "But Ma," I say.

"Don't *Ma* me," she says.

Later on she explains that World War II was in China, too. "Hitler," I say. "Nazis. Volkswagens." I know the Japanese were on the wrong side, because they bombed Pearl Harbor. My mother explains about before that. The Napkin Massacre. *"Nan-king,"* she corrects me.

"Are you sure?" I say. "In school, they said the war was about putting the Jews in ovens."

"Also about ovens."

"About both?"

"Both."

"That's not what they said in school."

"Just forget about school."

Forget about school? "I thought we moved here for the schools."

"We moved here," she says, "for your education."

Sometimes I have no idea what she's talking about.

"I like Sherman," I say after a while.

"He's nice boy," she agrees.

Meaning what? I would ask, except that my dad's just come home, which means it's time to start talking about whether we should build a brick wall across the front of the lawn. Recently a car made it almost into our living room, which was so scary, the driver fainted and an ambulance had to come. "We should have discussion," my dad said after that. And so for about a week, every night we do.

"Are you just friends, or more than just friends?" Barbara Gugelstein is giving me the cross-ex.

"Maybe," I say.

"Come on," she says, "I told you *everything* about me and Andy."

I actually *am* trying to tell Barbara everything about Sherman, but everything turns out to be nothing. Meaning, I can't locate the conversation in what I have to say. Sherman and I go places, we talk, one time my mother threw him out of the house because of World War II.

"I think we're just friends," I say.

"You think or you're sure?"

Now that I do less of the talking at lunch, I notice more what other people talk about—cheerleading, who likes who, this place in White Plains to get earrings. On none of these topics am I an expert. Of course, I'm still friends with Barbara Gugelstein, but I notice Danielle Meyers has spun away to other groups.

Barbara's analysis goes this way: To be popular, you have to have big boobs, a note from your mother that lets you use her Lord & Taylor credit card, and a boyfriend. On the other hand, what's so wrong with being unpopular? "We'll get them in the end," she says. It's what her dad tells her. "Like they'll turn out too dumb to do their own investing, and then they'll get killed in fees and then they'll have to move to towns where the schools stink. And my dad should know," she winds up. "He's a broker."

"I guess," I say.

But the next thing I know, I have a true crush on Sherman Matsumoto. *Mister* Judo, the guys call him now, with real respect; and the more they call him that, the more I don't care that he carries a notebook with a cat on it.

I sigh. "Sherman."

"I thought you were just friends," says Barbara Gugelstein.

"We were," I say mysteriously. This, I've noticed, is how Danielle Meyers talks; everything's secret, she only lets out so much, it's like she didn't grow up with everybody telling her she had to share.

And here's the funny thing: The more I intimate that Sherman and I are more than just friends, the more it seems we actually are. It's the old imagination giving reality a nudge. When I start to blush; he starts to blush; we reach a point where we can hardly talk at all.

"Well, there's first base with tongue, and first base without," I tell Barbara Gugelstein.

In fact, Sherman and I have brushed shoulders, which was equivalent to first base I was sure, maybe even second. I felt as though I'd turned into one huge shoulder; that's all I was, one huge shoulder. We not only didn't talk, we didn't breathe. But how can I tell Barbara Gugelstein that? So instead I say, "Well there's second base and second base."

Danielle Meyers is my friend again. She says, "I know exactly what you mean," just to make Barbara Gugelstein feel bad.

"Like *what* do I mean?" I say.

Danielle Meyers can't answer.

"You know what I think?" I tell Barbara the next day. "I think Danielle's giving us a line."

Barbara pulls thoughtfully on one of her pigtails.

If Sherman Matsumoto is never going to give me an ID to wear, he should at least get up the nerve to hold my hand. I don't think he sees this. I think of the story he told me about his parents, and in a synaptic firestorm realize we don't see the same things at all.

So one day, when we happen to brush shoulders again, I don't move away. He doesn't move away either. There we are. Like a pair of bleachers, pushed together but not quite matched up. After a while, I have to breathe, I can't help it. I breathe in such a way that our elbows start to touch too. We are in a crowd, waiting for a bus. I crane my neck to look at the sign that says where the bus is going; now our wrists are touching. Then it happens: He links his pinky around mine.

Is that holding hands? Later, in bed, I wonder all night. One finger, and not even the biggest one.

Sherman is leaving in a month. Already! I think, well, I suppose he will leave and we'll never even kiss. I guess that's all right. Just when I've resigned myself to it, though, we hold hands all five fingers. Once when we are at the bagel shop, then again in my parents' kitchen. Then, when we are at the playground, he kisses the back of my hand.

He does it again not too long after that, in White Plains.

I invest in a bottle of mouthwash.

Instead of moving on, though, he kisses the back of my hand again. And again. I try raising my hand, hoping he'll make the jump from my hand to my

cheek. It's like trying to wheedle an inchworm out the window. You know, *This way, this way.*

All over the world, people have their own cultures. That's what we learned in social studies.

If we never kiss, I'm not going to take it personally. 165

It is the end of the school year. We've had parties. We've turned in our textbooks. Hooray! Outside the asphalt already steams if you spit on it. Sherman isn't leaving for another couple of days, though, and he comes to visit every morning, staying until the afternoon, when Callie comes home from her big-deal job as a bank teller. We drink Kool-Aid in the backyard and hold hands until they are sweaty and make smacking noises coming apart. He tells me how busy his parents are, getting ready for the move. His mother, particularly, is very tired. Mostly we are mournful.

The very last day we hold hands and do not let go. Our palms fill up with water like a blister. We do not care. We talk more than usual. How much airmail is to Japan, that kind of thing. Then suddenly he asks, will I marry him?

I'm only thirteen.

But when old? Sixteen?

If you come back to get me. 170

I come. Or you can come to Japan, be Japanese.

How can I be Japanese?

Like you become American. Switch.

He kisses me on the cheek, again and again and again.

His mother calls to say she's coming to get him. I 175 cry. I tell him how I've saved every present he's ever given me—the ruler, the pencils, the bags from the bagels, all the flower petals. I even have the orange peels from the oranges.

All?

I put them in a jar.

I'd show him, except that we're not allowed to go upstairs to my room. Anyway, something about the orange peels seems to choke him up too. *Mis*ter Judo, but I've gotten him in a soft spot. We are going together to the bathroom to get some toilet paper to wipe our eyes when poor tired Mrs. Matsumoto, driving a shiny new station wagon, skids up onto our lawn.

"Very sorry!"

We race outside. 180

"Very sorry!"

Mrs. Matsumoto is so short that about all we can see of her is a green cotton sun hat, with a big brim. It's tied on. The brim is trembling.

I hope my mom's not going to start yelling about World War II.

"Is all right, no trouble," she says, materializing on the steps behind me and Sherman. She's propped the screen door wide open; when I turn I see she's waving. "No trouble, no trouble!"

"No trouble, no trouble!" I echo, twirling a few 185 times with relief.

Mrs. Matsumoto keeps apologizing; my mom keeps insisting she shouldn't feel bad, it was only some grass and a small tree. Crossing the lawn, she insists Mrs. Matsumoto get out of the car, even though it means trampling some lilies-of-the-valley. She insists that Mrs. Matsumoto come in for a cup of tea. Then she will not talk about anything unless Mrs. Matsumoto sits down, and unless she lets my mom prepare her a small snack. The coming in and the tea and the sitting down are settled pretty quickly, but they negotiate ferociously over the small snack, which Mrs. Matsumoto will not eat unless she can call Mr. Matsumoto. She makes the mistake of linking Mr. Matsumoto with a reparation of some sort, which my mom will not hear of.

"Please!"

"No no no no."

Back and forth it goes: "No no no no." "No no no no." "No no no no." What kind of conversation is that? I look at Sherman, who shrugs. Finally Mr. Matsumoto calls on his own, wondering where his wife is. He comes over in a taxi. He's a heavy-browed businessman, friendly but brisk—not at all a type you could imagine bowing to a lady with a taste for tie-on sun hats. My mom invites him in as if it's an idea she just this moment thought of. And would he maybe have some tea and a small snack?

Sherman and I sneak back outside for another 190 farewell, by the side of the house, behind the forsythia bushes. We hold hands. He kisses me on the cheek again, and then—just when I think he's finally going to kiss me on the lips—he kisses me on the neck.

Is this first base?

He does it more. Up and down, up and down. First it tickles, and then it doesn't. He has his eyes closed. I close my eyes too. He's hugging me. Up and down. Then down.

He's at my collarbone.

Still at my collarbone. Now his hand's on my ribs. So much for first base. More ribs. The idea of second base would probably make me nervous if he weren't on his way back to Japan and if I really thought we were going to get there. As it is, though, I'm not in much danger of wrecking my life on the shoals of passion; his unmoving hand feels more like a growth than a boyfriend. He has his whole face pressed to my neck skin so I can't tell his mouth from his nose. I think he may be licking me.

From indoors, a burst of adult laughter. My eyelids 195 flutter. I start to try and wiggle such that his hand will maybe budge upward.

Do I mean for my top blouse button to come accidentally undone?

He clenches his jaw, and when he opens his eyes, they're fixed on that button like it's a gnat that's been bothering him for far too long. He mutters in Japanese. If later in life he were to describe this as a pivotal moment in his youth, I would not be surprised. Holding the material as far from my body as possible, he buttons the button. Somehow we've landed up too close to the bushes.

What to tell Barbara Gugelstein? She says, "Tell me what were his last words. He must have said something last."

"I don't want to talk about it."

"Maybe he said, Good-bye?" she suggests. "Say- 200 onara?" She means well.

"I don't want to talk about it."

"Aw, come on, I told you everything about—"

I say, "Because it's private, excuse me."

She stops, squints at me as though at a far-off face she's trying to make out. Then she nods and very lightly places her hand on my forearm.

The forsythia seemed to be stabbing us in the eyes. 205 Sherman said, more or less, *You will need to study how to switch.*

And I said, *I think you should switch. The way you do everything is weird.*

And he said, *You just want to tell everything to your friends. You just want to have boyfriend to become popular.*

Then he flipped me. Two swift moves, and I went sprawling through the air, a flailing confusion of soft human parts such as had no idea where the ground was.

It is the fall, and I am in high school, and still he hasn't written, so finally I write him.

I still have all your gifts, I write. *I don't talk so much* 210 *as I used to. Although I am not exactly a mouse either. I don't care about being popular anymore. I swear. Are you happy to be back in Japan? I know I ruined everything. I was just trying to be entertaining. I miss you with all my heart, and hope I didn't ruin everything.*

He writes back, *You will never be Japanese.*

I throw all the orange peels out that day. Some of them, it turns out, were moldy anyway. I tell my mother I want to move to Chinatown.

"Chinatown!" she says.

I don't know why I suggested it.

"What's the matter?" she says. "Still boy-crazy? 215 That Sherman?"

"No."

"Too much homework?"

I don't answer.

"Forget about school."

Later she tells me if I don't like school, I don't have 220 to go every day. Some days I can stay home.

"Stay home?" In Yonkers, Callie and I used to stay home all the time, but that was because the schools there were *waste of time.*

"No good for a girl be too smart anyway."

For a long time I think about Sherman. But after a while I don't think about him so much as I just keep seeing myself flipped onto the ground, lying there shocked as the Matsumotos get ready to leave. My head has hit a rock; my brain aches as though it's been shoved to some new place in my skull. Otherwise I am okay. I see the forsythia, all those whippy branches, and can't believe how many leaves there are on a bush—every one green and perky and durably itself. And past them, real sky. I try to remember about why the sky's blue, even though this one's gone the kind of indescribable gray you associate with the insides of old shoes. I smell grass. Probably I have grass stains all over my back. I hear my mother calling through the back door, "Mon-a! Everyone leaving now," and "Not coming to say good-bye?" I hear Mr. and Mrs. Matsumoto bowing as they leave—or at least I hear the embarrassment in my mother's voice as they bow. I hear their car start. I hear Mrs. Matsumoto directing Mr. Matsumoto how to back off the lawn so as not to rip any more of it up. I feel the back of my head for blood—just a little. I hear their chug-chug grow fainter and fainter, until it has faded into the whuzz-whuzz of all the other cars. I hear my mom singing, *"Mon-a! Mon-a!"* until my dad comes home. Doors open and shut. I see myself standing up, brushing myself off so I'll have less explaining to do if she comes out to look for me. Grass stains—just like I thought. I see myself walking around the house, going over to have a look at our churned-up yard. It looks pretty sad, two big brown tracks, right through the irises and the lilies-of-the-valley, and that was a new dogwood we'd just planted. Lying there like that. I hear myself thinking about my father, having to go dig it up all over again. Adjusting. I think how we probably ought to put up that brick wall. And sure enough, when I go inside, no one's thinking about me, or that little bit of blood at the back of my head, or the grass stains. That's what they're talking about—that wall. Again. My mom doesn't think it'll do any good, but my dad thinks we should give it a try. Should we or shouldn't we? How high? How thick? What will the neighbors say? I plop myself down on a hard chair. And all I can think is, we are the only complete family that has to worry about this. If I could, I'd switch everything to be different. But since I can't, I might as well sit here at the table for a while, discussing what I know how to discuss. I nod and listen to the rest. ○

SEEING

1. What does Mona mean when she refers to herself as "ad-libbing" her "way through eighth grade"? How does Gish Jen play with chronology in her narrative? When—and with what effect(s)—does she switch back and forth between childhood and adult perspectives? How does she signal that switch through tone of voice and word choice? Please point to specific examples to verify your reading.

2. Comment on Jen's use of metaphor and analogy in her story, such as "My parents slide the question back and forth like a cup of ginseng neither one wants to drink" (para. 1). What connections does Jen establish among food, class, and ethnicity?

Delivering spontaneously; saying or performing without preparation.

WRITING

1. Recall an experience you've had with stereotypes: either your own incorrect assumption about someone or someone's incorrect assumption about you. Write the first draft of a narrative essay in which you recount the incident, the circumstances that prompted it, and the consequences and lessons you might reasonably draw from it.

2. How do you interpret Jen's title, "What Means Switch"? When and with what effects does she use the word *switch* throughout the piece? Write an essay in which you analyze the meanings of the word *switch* within Mona's experiences with race and class issues. As you consider the use of *switch* within Jen's story, you might want to speculate about the extent to which each of us can "switch" race, class, and nationality as Americans.

TIBOR KALMAN ›

Born in Budapest, Tibor Kalman (1949–1999) moved to the United States at the age of 7. He grew up in Poughkeepsie, New York, and attended New York University. In 1979 he founded the design firm M&Co and attracted clients ranging from MTV and the Talking Heads to the Museum of Modern Art. M&Co's aesthetic was in direct opposition to the "slick" corporate styles of the day, and Kalman is widely known for establishing an offbeat and often humorous design vocabulary that critiques the dishonesty and superficiality of most corporate public relations and advertising. Kalman left M&Co to edit *Colors*, a magazine launched by Benetton, and he used this platform to engage in new forms of media activism, especially concerning racism.

Kalman critiques modern society because, as he explains, our economic system "tries to make everything look right. . . . But . . . when you make something no one hates, no one loves it." Thus Kalman is "interested in imperfections, quirkiness, insanity, and unpredictability. That's what we really pay attention to anyway." Since leaving *Colors* in 1995 Kalman has worked on a number of projects, including designing and curating exhibitions at the Whitney Museum of American Art in New York. A retrospective monograph, *Tibor Kalman: Perverse Optimist* (1998), is what he calls an "almanac of oddities." His other books include *Chairman* (1997).

From *Colors* magazine, Issue 4, *Race.*

SEEING

1. How did you respond to the altered images of Michael Jackson, Arnold Schwarzenegger, Spike Lee, and Queen Elizabeth? What response does each photograph elicit from you? How does each photograph challenge your assumptions about what familiar public figures should look like? Which image do you find most—and least—plausible? Explain why.

2. Comment on Tibor Kalman's choices in manipulating the skin color, hair style, and eyes of each public figure. In what ways does each of these images seem more striking, more contrived, or more realistic than others you've seen of public figures? Do you find Kalman's images humorous? satiric? ironic? some combination of these? Please clarify and explain. What, in effect, do you think he is trying to accomplish? Explain the extent to which you think he is successful.

WRITING

1. Kalman has employed computer technology to "switch" the racial identity of these public figures. Imagine that you were able to assume a different racial identity. Which would you choose? Why? What would be the consequences of doing so? How might your daily life be different as a result? Write the first draft of a comparison/contrast essay in which you imagine the impact such a change would have on the spirit and substance of your daily life—on campus or beyond.

2. Choose one of these photographs and write an essay in which you explain what Kalman's manipulation of the image of this public figure suggests about the role of race in that person's public life. How much does the public identity of each person portrayed here depend on his or her racial identity?

PATRICIA J. WILLIAMS

"I remember being 3 years old so well," Patricia Williams writes in *Seeing a Color-Blind Future* (1998). "Three was the age when I learned that I was black, the colored kid, monkey-child, different. What made me so angry and wordless ... later was the realization that none of the little white children who taught me to see my blackness as a mark probably ever learned to see themselves as white. In our culture, whiteness is rarely marked in the indicative there! there! sense of my bracketed blackness. And the majoritarian privilege of never noticing oneself was the beginning of an imbalance from which so much, so much else flowed."

Williams has established herself as an outspoken public intellectual and advocate for social justice. A graduate of Wellesley College and Harvard Law School and currently professor of law at Columbia University School of Law, she lectures widely and is the author of numerous scholarly articles. Williams also writes for a general audience and is a contributing editor of *The Nation*. She has published three books: *The Alchemy of Race and Rights* (1991), *The Rooster's Egg* (1995), and *Seeing a Color-Blind Future: The Paradox of Race* (1998). "Ethnic Hash" appeared in the 1998 issue of *Transitions*, an international journal published by Duke University Press.

Ethnic Hash

Patricia J. Williams

Recently, I was invited to a book party. The book was about pluralism. "Bring an hors d'oeuvre representing your ethnic heritage," said the hostess, innocently enough. Her request threw me into a panic. Do I even have an ethnicity? I wondered. It was like suddenly discovering you might not have a belly button. I tell you, I had to go to the dictionary. What were the flavors, accents, and linguistic trills that were passed down to me over the ages? What are the habits, customs, and common traits of the social group by which I have been guided in life—and how do I cook them? >

My last name is from a presumably Welsh plantation owner. My mother chose my first name from a dictionary of girls' names. "It didn't sound like Edna or Myrtle," she says, as though that explains anything. I have two mostly Cherokee grandparents. There's a Scottish great grandfather, a French-Canadian great uncle, and a bunch of other relations no one ever talks about. Not one of them left recipes. Of course the ancestors who have had the most tangible influence on my place in the world were probably the West Africans, and I can tell you right off that I haven't the faintest idea what they do for hors d'oeuvres in West Africa (although I have this Senegalese friend who always serves the loveliest, poufiest little fish mousse things in puff pastries that look, well, totally French).

Ethnic recipes throw me into the same sort of quandary as that proposed "interracial" box on the census form: the concept seems so historically vague, so cheerfully open-ended, as to be virtually meaningless. Everyone I know has at least three different kinds of cheese in their fondue. I suppose I could serve myself up as something like Tragic Mulatta Soufflé, except that I've never gotten the hang of soufflés. (Too much fussing, too little reward.) So as far as this world's concerned, I've always thought of myself as just plain black. Let's face it: however much my categories get jumbled when I hang out at my favorite kosher sushi spot, it's the little black core of me that moves through the brave new world of Manhattan as I hail a cab, rent an apartment, and apply for a job.

Although it's true, I never have tried hailing a cab as an *ethnic* . . .

So let me see. My father is from the state of Georgia. When he cooks, which is not often, the results are distinctly Southern. His specialties are pork chops and pies; he makes the good-luck black-eyed peas on New Year's. His recipes are definitely black in a regional sense, since most blacks in the United States until recently lived in the Southeast. He loves pig. He uses lard.

My mother's family is also black, but relentlessly steeped in the New England tradition of hard-winter cuisine. One of my earliest memories is of my mother borrowing my father's screwdriver so she could pry open a box of salt cod. In those days, cod came in wooden boxes, nailed shut, and you really had to hack around the edges to loosen the lid. Cod-from-a-box had to be soaked overnight. The next day you mixed it with boiled potatoes and fried it in Crisco. Then you served it with baked beans in a little brown pot, with salt pork and molasses. There was usually some shredded cabbage as well, with carrots for color. And of course there was piccalilli—every good homemaker had piccalilli on hand. Oh, and hot rolls served with homemade Concord grape jelly. Or maybe just brown bread and butter. These were the staples of Saturday night supper.

We had baked chicken on Sundays, boiled chicken other days. My mother has recipes for how to boil a chicken: a whole range of them, with and without bay leaf, onions, potatoes, carrots. With boiled chicken, life can never be dull.

The truth is we liked watermelon in our family. But the only times we ate it—well, those were secret moments, private moments, guilty, even shameful moments, never unburdened by the thought of what might happen if our white neighbors saw us enjoying the primeval fruit. We were always on display when it came to things stereotypical. Fortunately, my mother was never handier in the kitchen than when under political pressure. She would take that odd, thin-necked implement known as a melon-baller and gouge out innocent pink circlets and serve them to us, like little mounds of faux sorbet, in fluted crystal goblets. The only time we used those goblets was to disguise watermelon, in case someone was peering idly through the windows, lurking about in racial judgment.

I don't remember my parents having many dinner parties, but for those special occasions requiring actual hors d'oeuvres, there were crackers and cream cheese, small sandwiches with the crusts cut off, Red Devil deviled ham with mayonnaise and chopped dill pickles. And where there were hors d'oeuvres, there had to be dessert on the other end to balance things out. Slices of home-made cake and punch. "Will you take coffee or tea?" my mother would ask shyly, at the proud culmination of such a meal.

the icebox

There is a plate with two little leftover lamb chops in my refrigerator. They look lonely and cold, with those ridiculous frilly paper socks dressing the ends of their elegant arches of bone. Their presence reminds me of a TV program I saw about hunger and homelessness in New York City. They interviewed lots of middle-class New Yorkers who didn't want to look at the homeless; who wanted them removed from the bus stations, from the parks, from the streets, from the common view; who gave reasons such as: they're unsightly, they defecate in public, they smell, they might attack young children. Then came interviews with policy analysts about why the homeless should be permitted to stay. They gave reasons such as: they have a right, where else can they go, it has always been thus, and besides, they perform an ecological function by scavenging through garbage cans for recyclables, like aluminum cans.

The one time a reporter talked to a homeless person, the exchange was direct. "Why would you rather sleep on the street than go to a city shelter?" asked the reporter. The old man snapped back: "Don't put words in my mouth! I don't want to sleep on the street; I'd rather be sleeping in a penthouse on Fifth Avenue overlooking the park with a maid and a chauffeur and a cook who could make me a dinner of lamb chops. What's your address?" The program closed with some observations about how "aggressive" these homeless can be toward vulnerable middle-class citizens, who were urged to Act Now to prevent their own slaughter.

Anyway, those chops have been lying at the back of my refrigerator ever since, like a moldy existential offering.

I have a big rattling vault of a refrigerator. It's quite new, actually—my industrial strength investment in culinary self-gratification, with the handy-dandy freezer drawer down on the bottom. It came with a Refrigerator Installation Person who is supposed to install it and fasten it to a bracing system up against the kitchen wall, so that when the children swing on the door, as he tells me they will surely grow to do ("not mine," I say, he rolls his eyes), the thing won't heave forward and crush them beneath an avalanche of Dean and Deluca delectables. So there he is, my Refrigerator Installation Person, bolting and banging things into the wall, when his beeper goes off. 911, it flashes.

"What sort of refrigerator emergency rates a '911'?" I ask. He runs to my telephone to call Refrigerator Central. Turns out Itzhak Perlman's[1] fridge is on the blink. He must fly, later for now, same time tomorrow, try not to lean on the door, OK?

Go, I say. Go, I pray. I am awed. I am honored, overwhelmed with an unseemly pride. To think that Itzhak Perlman and I share the very same refrigerator repairman. I am filled with happy musings about what he must be having for dinner. Oh, the humanity. Six degrees of separation and all that.

the melting pot

For years, my mother's father worked as the solemn, brown-faced maître d' at one of Boston's finer eating

1. Itzhak Perlman is an internationally acclaimed violinist [ed.].

establishments. By all accounts, my grandfather was a gentle steward and tireless "race-man," quietly devoted to the cause of social equality.

Long after he died, the civil rights movement swept the nation, and my family set out to dine at places whose thresholds we had never quite dared to imagine crossing before. Dressed up and slicked down, we were a determined little band of gastronomical integrationists. Our favorite place to go on special occasions was a wonderful seafood restaurant. The newspapers always crowed about the clam chowder, but the restaurant's real draw as far as I was concerned was the lobster—baked or steamed, the best anywhere. If my sister and I had been very good, my parents would take us there to celebrate birthdays—or, some years later, graduations from high school, college, and law school.

Eating lobster was a kind of class sabotage in Boston. It was hard not to be inclined toward some notion of human equality when besmirched by the splattered devastation generally wrought by the arduousness of the endeavor. This particular restaurant was quite formal, yet the lobsters were served whole, gloriously encased in those pretty red shells—so impenetrable, so resistant, so hard—the sweet lobster meat quivering within. The restaurant armed Boston's finest citizens with all the implements of attack: linen napkins, starched bibs, slender forks with cruel little tines, elegant silver tongs, exquisitely wrought nut-crackery things designed to twist and snap and crush.

I always envied the ladder-backed calm of the old-fashioned "proper Bostonian," so imperturbably self-confident amid even his self-induced turmoil: the flying lobster bits, the splashing butter, the badly spotted bib, the impossible heap of crustacean parts sliding from the plate; the public struggle like some wet and salty version of mud wrestling. I marveled at the apparent lack of tension between the sloppiness of the enterprise and the prerogative of being unflappably highborn.

I have never been able to relax while eating lobster [20] in public. I am afraid that the world will see me as the sort who is always soiled after a good meal, it being my nature to roll in the trough. I suppose this anxiety about propriety and place, race and class, marks me as hopelessly bourgeois. The quest for acceptance is a kind of escape; the borders of oneself are patrolled so closely that one is always looking outward, looking toward a home beyond where one is.

I wonder if the real privilege of high status is freedom from such anxiety.

quadroon surprise

Some have said that too much salt cod too early in life hobbles the culinary senses forever. I have faith that this is not the case, and that any disadvantage can be overcome with time and a little help from Williams-Sonoma. Having grown up and learned that you are what you eat, I have worked to broaden my horizons and cultivate my tastes. I entertain global gastronomic aspirations, and my palate knows no bounds. After all, if Aunt Jemima and Uncle Ben can Just Get Over It, who am I to cling to the limitations of the past? Yes, I have learned to love my inner ethnic child. And so, I leave you with a recipe for the Twenty-first Century:

Chicken with Spanish Rice and Not-Just-Black Beans
 Boil the chicken
 Boil the rice
 Boil the beans

Throw in as many exotic-sounding spices and mysterious roots as you can lay your hands on—go on, use your imagination!—and garnish with those fashionable little wedges of lime that make everything look vaguely Thai. Watch those taxis screech to a halt! A guaranteed crowd-pleaser that can be reheated or rehashed generation after generation.

Coffee? Tea? ○

1. Patricia Williams writes, "Let's face it: however much my categories get jumbled when I hang out at my favorite kosher sushi spot, it's the little black core of me that moves through the brave new world of Manhattan as I hail a cab, rent an apartment, and apply for a job. Although it's true, I never have tried hailing a cab as an *ethnic* . . ." (paras. 3, 4). What does she mean by *ethnic* here? What distinction does she draw, however implicitly, between race and ethnicity?

2. Locate the instances in which Williams uses the phrase "coffee? tea?" throughout the essay. What meanings are suggested for this phrase in each instance? What are the effects of ending the essay with this phrase? What do you make of the "recipe for the Twenty-first Century" with which Williams concludes the essay?

1. At the outset of the essay, Williams recounts the moment when she suddenly became aware of her ethnicity—when she was encouraged to bring to a party "an hors d'oeuvre representing [her] ethnic heritage." Think of your own early experiences, and especially those that helped you to understand your own identity in ethnic or racial terms. Write the first draft of an essay in which you present an account of a moment—or perhaps a scene—when you first became aware of ethnic or racial categories.

2. Patricia Williams and Gish Jen (see "What Means Switch," p. 339) sprinkle in food references with their discussion of race, ethnicity, and class. Write an essay in which you account for the comparative significance of watermelon for Williams and turkey pot pie for Jen. In what ways are their childhood recollections similar? different? You might find it helpful in developing a response to reread Larry Woiwode's youthfully exuberant portrayal of his relationship with oranges (see "Ode to an Orange," p. 12).

BENETTON

The sweater company founded by the Benetton family in Venice, Italy, in 1965 now constitutes one of the largest textile/clothing companies in the world. The Benetton Group employs over 30,000 people in 120 countries and operates 7,000 stores; the company uses 6 million kilograms of wool, 60 million kilometers of thread, and 52 million meters of cloth yearly to manufacture various lines of sportswear and casual clothing.

Photographs used in The United Colors of Benetton advertising campaigns, featuring people of all races and colors joined in various activities, have become cultural icons for the age of global communication. These images, according to company literature, "promote issues and not clothes." Some photographs have featured victims of AIDS, famine, and war. Controversy has arisen over the ethics of using human tragedy to sell products, but Benetton states that its interests are humanitarian. The United Colors of Benetton photographer Oliviero Toscani comments that "I try to make my images personal, to reach people, everything we do is about impulse and guts." Toscani's powerful images have themselves "crossed the border" from advertising into art, and exhibits of his Benetton photographs have been held in a number of international fine arts venues.

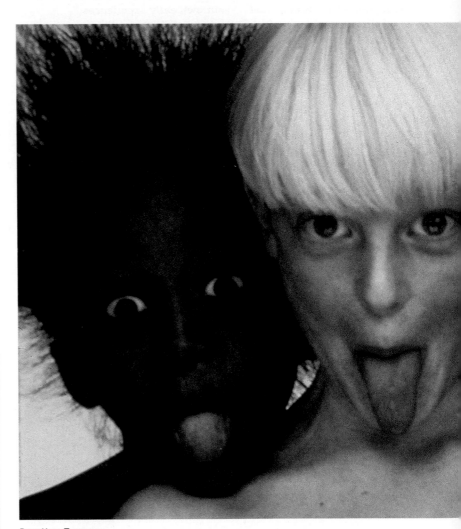

Benetton, **Tongues**

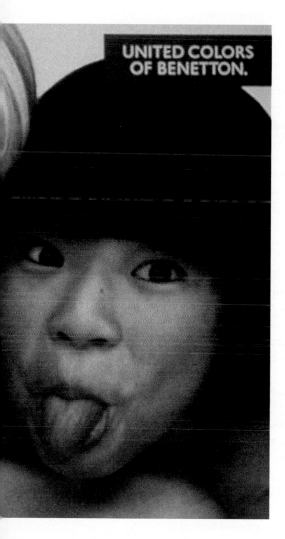

UNITED COLORS
OF BENETTON.

SEEING

1. Benetton is widely known as a company that relies on racial diversity to promote its products. In what specific ways might these three children represent diversity? And to whom? To what extent are each of these three figures stereotypes? In what ways does the hair style of each child reinforce—or subvert—a racial stereotype? Does the hair of the middle child look natural? Bleached? Why might this matter? Point to evidence to verify your response.

2. What are the effects of posing these three children with their tongues sticking out? What inferences about race relations might you draw from the relative position of the heads in this photograph? What are the effects of having the two children rest their heads on the shoulders of the middle figure? What do you notice about the alignment of the heads in this photograph? What reasonable inferences might you draw from the spacing and positioning of the heads in the photograph? How does the background of the photo accentuate its effects? What other features of this advertisement make it recognizable as an ad for Benetton?

WRITING

1. Benetton publishes a multilingual magazine, *Colors*, which focuses on sociocultural issues and such worldwide concerns as racism and AIDS. Tibor Kalman (see p. 349), the most prominent editor/designer of *Colors*, described it as "the first magazine for the global village . . . aimed at an audience of flexible minds, young people from 14 to 20, or curious people of any age." In a summer 1993 issue focused on racism, Kalman claims that "race is not the real issue here. Power and sex are the dominant forces in the world." What do you think Kalman means by this statement? Write an essay in which you draw on evidence from contemporary popular culture to argue in support of—or against—Kalman's proposition.

2. Choose an article in an issue of your favorite magazine. What do you notice about how the writer of that article handles issues of race and racial identity? Now do the same for an advertisement printed in that issue. Write the first draft of an essay in which you compare and contrast the ways in which racial identities and issues are handled by the writer and the advertiser. Who do you think has a more enlightened view of these matters? Explain why.

ROBERTO FERNANDEZ

Bilingual writer Roberto Fernandez has been described as a "Cuban William Burroughs" for the fantastic and surreal qualities of much of his fiction. His first two novels, *La Vida es un Special* (1982) and *La Montana Rusa* (1985), were written in Spanish. His more recent works, *Raining Backwards* (1988) and *Holy Radishes* (1995), are in English. This shift reflects the author's increasing interest in Cuban American culture. The collision of languages and temperaments that is characteristic of the immigrant experience makes for the inexplicable plot twists and inevitable humor that careens through Fernandez's work.

Fernandez earned his Ph.D. at Florida State University and returned to teach there in 1981, where he is a professor in the Department of Modern Languages and a specialist in Caribbean literature.

Writer William Burroughs (1914–1997) was a member of the "Beat Generation" of writers and an example to such younger Beats as Jack Kerouac and Alan Ginsberg.

WRONG CHANNEL
Roberto Fernandez

BARBARITA WAITED IMPATIENTLY FOR HER RIDE AS BEADS of sweat dripped from her eyebrows into her third cup of cold syrupy espresso. She was headed for the toilet when she heard the knocking sounds of Mima's old Impala. "About time you got here," yelled Barbarita from the Florida room.

"It wouldn't start this morning."

Barbarita got in, tilted the rearview mirror, and applied enough rouge to her face for a healthier look. She wanted to make a good impression on the doctor who would approve her medical records for her green card. On the way to Jackson Memorial, Mima talked about her grandchildren.

Barbarita knocked down all the Bibles and *Reader's Digests* on the table when the nurse finally called her name.

"Sorry, ma'am, but you can't come in," the nurse said to Mima. 5

"I'm her interpreter," replied the polyglot.

"No bueno," said the doctor grimly as he walked in with Barbarita's X-rays. He told Mima, "Ask her if she had TB."

Mima turned to Barbarita. "He says, if you have a television?"

"Tell him yes, but in Havana. Not in Miami. But my daughter has a television here."

Mima told the doctor, "She says she had TV in Cuba, not in 10 Miami, but her daughter has TV here."

"In that case we need to test her daughter for TB too."

Mima translated, "He says he needs to test your daughter's television to make sure it works, otherwise you cannot get your green card."

"Why the television?" asked a puzzled Barbarita.

"How many times did I tell you you needed to buy one? Don't you know, Barbarita? This is America." ○

SEEING

1. In a few short paragraphs, Roberto Fernandez offers a compelling account of some of the anxieties and complexities of the immigrant experience. What issues does this piece raise about the importance of language in establishing an American identity? What role does familiarity with language, schooling, cuisine, and popular culture play in "becoming an American"? Please validate each point you make with specific examples.

2. Notice the final phrase in this story, "This is America." What assumptions are embedded in this statement? In what ways does the phrase serve as a commentary on American experience? Consider all the different circumstances in which you've heard this statement. How does its meaning change when you hear it in different contexts? What associations does this phrase conjure in your own experience? Are these associations principally negative? positive? In either case, explain why.

WRITING

1. Write the first draft of an analytical essay in which you account—in specific terms— for how Fernandez's story plays with the almost iconic status of television in American culture. In what ways is television a quintessentially American object and "experience"? More specifically, what role does it play in introducing American culture to recent arrivals? In what ways does one become an American, and what role does television play in securing one's identity as an American? What's more important—having a TB (tuberculosis) test or owning a TV?

2. The narrator's account of Barbarita's experience with miscommunication and language mix-up raises the issue that questions about "health" are often preceded by questions about wealth. Such questions raise others: In what ways do immigrants need to "buy into" being "truly American"? Our answers depend on the extent to which Americans believe immigrants should be required to speak—and to be educated—in English. By 1999 nearly twenty-five states had passed "English Only" laws, requiring that students be instructed exclusively in the English language. Write the first draft of an essay in which you argue for—or against—adopting an "English Only" policy in teaching the children in your state.

Retrospect:
Reel Native Americans

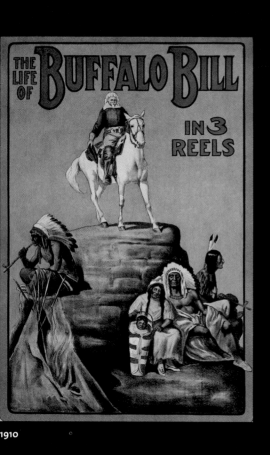

THE LIFE OF BUFFALO BILL
IN 3 REELS

1910

ANTHONY J. XYDIAS
presents
"WITH
GENERAL CUSTER
AT THE LITTLE BIG HORN"
featuring
ROY STEWART
HELEN LYNCH – EDMUND COBB · JOHN BECK
AND A CAST OF 3000
Directed by HARRY L. FRASER

1926

1990

1998

 Talking Pictures

In response to the criticism of stereo-
typical portrayals of Jewish women on
television, Fran Drescher, the star of
Nanny, said in a recent interview, "I'm
the first Jewish woman in decades
who is playing a Jewish woman on TV.
My character does not try to assimi-
late to a WASP ethic in appearance or
speech. I speak Yiddish and celebrate
'the Jewish holidays' on the series."

"There are no perfect ethnic ex-
amples," Drescher continued. "There
are a million different types of Jewish
women. She doesn't have to be edu-
cated, but she can be. She doesn't
have to speak the King's English, but
some of us do. To even think there's
one thing that's politically acceptable
is naive and rooted in a fearful
post–World War II mentality that a
good Jew is an assimilated one."

From the caricatures of blacks on
Amos 'n' Andy to the portrayals of
angst-ridden Jewish mothers on *Sein-
feld* and *Mad About You*, racial and
ethnic stereotyping has long been a
staple of television and movie humor.
From one of these media, choose a
character or scene that relies on ethnic
or racial identity as a source of humor.
What is the nature of the stereotype,
and on what does the humor rely?
Write an essay in which you discuss
the relation of humor to matters of
ethnicity and race.

DONNELL ALEXANDER
Donnell Alexander (b. 1967) is a
staff writer for ESPN online mag-
azine, where his work explores
the intersections of popular cul-
ture, sports, and entertainment.
He says, "Because sports is such a
huge money-making industry in
this country, the press rarely goes
below the surface to explore the
very rich cultural phenomena
that are at work here. Sports is
treated as a product, not as a
subject worthy of real intellectual
attention. There are not only
overt racial issues to explore, but
sexuality issues, such as gay foot-
ball players in the NFL. A lot of
people know these issues exist
but you're just not going to hear
about it."

Throughout his career,
Alexander has examined topics
ranging from what suit to wear
on NBA draft day to the life of
security guards. As a former staff
writer for *LA Weekly*, he covered
that city's booming hip-hop
music scene as well as the O.J.
Simpson trial.

Alexander's work confronts
head-on the preconceptions read-
ers have of topics associated with
the culture of African American
men. Speaking with an insider's
ease, Alexander has developed a
style that is at once articulate,
rigorous, and richly colored with
the slang and verbal music of
the streets.

Cool Like Me

Donnell Alexander

I'M COOL LIKE THIS:

I read fashion magazines like they're warning labels telling me what not to do.

When I was a kid, Arthur Fonzarelli seemed a garden-variety dork.

I got my own speed limit.

I come when I want to. 5

I maintain like an ice cube in the remote part of the freezer.

Cooler than a polar bear's toenails.

Cooler than the other side of the pillow.

Cool like me.

Know this while understanding that I am in 10 essence a humble guy.

I'm the kinda nigga who's so cool that my neighbor bursts into hysterical tears whenever I ring her doorbell after dark. She is a new immigrant who has chosen to live with her two roommates in our majority-black Los Angeles neighborhood so that, I'm told, she can "learn about all American cultures." But her real experience of us is limited to the space between her Honda and her front gate; thus, much of what she has to go on is the vibe of the surroundings and the images emanating from the television set that gives her living room a minty cathode glow. As such, I'm a cop-show menace and a shoe commercial demigod—one of the rough boys from our 'hood and the living, breathing embodiment of hip hop flava. And if

I can't fulfill the prevailing stereotype, the kids en route to the nearby high school can. The woman is scared in a cool world. She smiles as I pass her way in the light of day, unloading my groceries or shlepping my infant son up the stairs. But at night, when my face is visible through the window of her door lit only by the bulb that brightens the vestibule, I, at once familiar and threatening, am just too much.

Thus being cool has its drawbacks. With cool come assumptions and fears, expectations and intrigue. My neighbor wants to live near cool, but she's not sure about cool walking past her door after dark. During the day, she sees a black man; at night what she sees in the shadow gliding across her patio is a nigga.

Once upon a time, little need existed for making the distinction between a nigga and a black—at least not in this country, the place where niggas were invented. We were just about all slaves, so we were all niggas. Then we became free on paper yet oppressed still. Today, with as many as a third of us a generation or two removed from living poor (depending on who's counting), niggadom isn't innate to every black child born. But with the poverty rate still hovering at around 30 percent, black people still got niggas in the family, even when they themselves aren't niggas. Folks who don't know niggas can watch them on TV, existing in worlds almost always removed from blacks. Grant Hill is black, Allen Iverson is a

nigga. Oprah interviewing the celebrity du jour is a black woman; the woman being hand-cuffed on that reality TV show is a nigga.

The question of whether black people are cooler than white people is a dumb one, and one that I imagine a lot of people will find offensive. But we know what we're talking about, right? We're talking about style and spirit and the innovations that those things spawn. It's on TV; it's in the movies, sports and clothes and language and gestures and music.

See, black cool is cool as we know it. I could name names—Michael Jordan and Chris Rock and Me'shell Ndegeocello and Will Smith and bell hooks and Li'l Kim—but cool goes way back, much further than today's superstars. Their antecedents go back past blaxploitation cinema, past Ike Turner to Muddy Waters, beyond even the old jazz players and blues singers whose names you'll never know. Cool has a history and cool has a meaning. We all know cool when we see it, and now, more than at any other time in this country's history, when mainstream America looks for cool we look to black culture. Countless new developments can be called great, nifty, even keen. But, cool? That's a black thang, baby.

And I should know. My being cool is not a matter of subjectivity or season. Having lived as a nigga has made me cool. Let me explain. Cool was born when the first plantation nigga figured out how to make animal innards—massa's garbage, hog maws and chitlins—taste good enough to eat. That inclination to make something out of nothing and then to make that something special articulated itself first in the work chants that slaves sang in the field and then in the hymns that rose out of their churches. It would later reveal itself in the music made from cast-off Civil War marching-band instruments (jazz); physical exercise turned to public spectacle (sports); and street life styling, from pimps' silky handshakes to the corner crack dealer's baggy pants.

Cool is all about trying to make a dollar out of 15 cents. It's about living on the cusp, on the periphery, diving for scraps. Essential to cool is being outside looking in. Others—Indians, immigrants, women, gays—have been "othered," but until the past 15 percent of America's history, niggas in real terms have been treated by the country's majority as, at best, subhuman and, at worst, an abomination. So in the days when they were still literally on the plantation they devised a coping strategy called cool, an elusive mellowing strategy designed to master time and space. Cool, the basic reason blacks remain in the American cultural mix, is an industry of style that everyone in the world can use. It's finding the essential soul while being essentially lost. It's the nigga metaphor. And the nigga metaphor is the genius of America.

Gradually over the course of this century, as there came to be a growing chasm of privilege between black people and niggas, the nature of cool began to shift. The romantic and now-popular image of the pasty Caucasian who hung out in a jazz club was one small subplot. Cool became a promise—the reward to any soul hardy enough to pierce the inner sanctum of black life and not only live to tell about it but also live to live for it. Slowly, watered-down versions of this very specific strain of cool became the primary means of defining American cool. But it wasn't until Elvis that cool was brought down from Olympus (or Memphis) to majority-white culture. Mass media did the rest. Next stop: high fives, chest bumps, and "Go girl!"; Air Jordans, Tupac, and low-riding pants.

White folks began to try to make the primary point of cool—recognition of the need to go with the flow—a part of their lives. But cool was only an avocational interest for them. It could never be the necessity it was for their colored co-occupants. Some worked harder at it than others. And as they came to understand coolness as being of almost elemental importance, they began obsessing on it, asking themselves, in a variety of clumsy, indirect ways: Are black people cooler than white people and, if so, why?

The answer is, of course, yes. And if you, the reader, had to ask some stupid shit like that, you're probably white. It's hard to imagine a black person even asking

the question, and a nigga might not even know what you mean. Any nigga who'd ask that question certainly isn't much of one; niggas invented the shit.

Humans put cool on a pedestal because life at large is a challenge, and in that challenge we're trying to cram in as much as we can—as much fine loving, fat eating, dope sleeping, mellow walking, and substantive working as possible. We need spiritual assistance in the matter. That's where cool comes in. At its core, cool is useful. Cool gave bass to 20th-century American culture, but I think that if the culture had needed more on the high end, cool would have given that, because cool closely resembles the human spirit. It's about completing the task of living with enough spontaneity to splurge some of it on bystanders, to share with others working through their own travails a little of your bonus life. Cool is about turning desire into deed with a surplus of ease.

Some white people are cool in their own varied ways. I married a white girl who was cooler than she ever knew. And you can't tell me Jim Jarmusch and Ron Athey and Delbert McClinton ain't smooth.

There's a gang of cool white folks, all of whom exist that way because they've found their essential selves amid the abundant and ultimately numbing media replications of the coolness vibe and the richness of real life. And there's a whole slew more of them ready to sign up if you tell 'em where. But your average wigger in the rap section of Sam Goody ain't gone nowhere; she or he hasn't necessarily learned shit about the depth and breadth of cool, about making a dollar out of 15 cents. The problem with mainstream American culture, the reason why irony's been elevated to raison d'être status and neurosis increasingly gets fetishized, is its twisted approach to cool. Most think cool is something you can put on and take off at will (like a strap-on goatee). They think it's some shit you go shopping for. And that taints cool, giving the mutant thing it becomes a deservedly bad name. Such strains aren't even cool anymore, but an evil ersatz-cool, one that fights real cool at every turn. Advertising agencies, record-company artist-development departments, and over-art-directed bars are where ersatz-cool dwells. What passes for cool to the white-guy passerby might be—is probably—just rote duplication without an ounce of inspiration.

The acceptance of clone cool by so many is what makes hip hop necessary. It's what negates the hopelessness of the postmodern sensibility at its most cynical. The hard road of getting by on metaphorical chitlins kept the sons and daughters of Africa in touch with life's essential physicality, more in touch with the world and what it takes to get over in it: People are moved, not convinced; things get done, they don't just happen. Real life doesn't allow for much fronting, as it were. And neither does hip hop. Hip hop allows for little deviation between who one is and what one can ultimately represent.

Rap—the most familiar, and therefore the most emblematic, example of hip hop expression—is about the power of conveying through speech the world beyond words. Language is placed on a par with sound and, ultimately, vibes. Huston Smith, a dope white guy, wrote: "Speech is alive—literally alive because speaking is the speaker. It's not the whole of the speaker, but it is the speaker in one of his or her living modes. This shows speech to be alive by definition. . . . It possesses in principle life's qualities, for its very nature is to change, adapt, and invent. Indissolubly contextual, speaking adapts itself to speaker, listener, and situation alike. This gives it an immediacy, range, and versatility that is, well, miraculous."

Which is why hip hop has become the most insidiously influential music of our time. Like rock, hip hop in its later years will have a legacy of renegade youth to look back upon fondly. But hip hop will insist that its early marginalization be recognized as an integral part of what it comes to be. When the day comes that grandmothers are rapping and beatboxing as they might aerobicize now, and samplers and turntables are as much an accepted part of leisure time as channel surfing, niggas will be glad. Their expression will have proven ascendant.

But that day's not here yet. If white people were really cool with black cool, they'd put their stuff with our stuff more often to work shit out. I don't mean shooting hoops together in the school-yard as much as white cultural institutions like college radio, indie film, and must-see TV. Black cool is banished to music videos, sports channels, and UPN so whites can visit us whenever they want without having us live right next door in the media mix. Most of the time, white folks really don't want to be part of black cool. They just like to see the boys do a jig every once in a while.

At the same time, everyday life in black America is not all Duke Ellington and Rakim Allah. Only a few black folks are responsible for cool. The rest copy and recycle. At the historical core of black lives in this country is a clear understanding that deviation from society's assigned limitations results in punitive sanctions: lynching, hunger, homelessness. The fear of departing from the familiar is where the inclination to make chitlins becomes a downside. It's where the shoeshine-boy reflex to grin and bear it was born. Black rebellion in America from slave days onward was never based on abstract, existentialist grounds. A bird in the hand, no matter how small, was damn near everything.

Today, when deviation from normalcy not only goes unpunished but is also damn near demanded to guarantee visibility in our fast-moving world, blacks remain woefully wedded to the bowed head and blinders. Instead of bowing to massa, they slavishly bow to trend and marketplace. And this creates a hemming-in of cool, an inability to control the cool one makes. By virtue of their status as undereducated bottom feeders, many niggas will never overcome this way of being. But, paradoxically, black people—who exist at a greater distance from cool than niggas—can and will. That's the perplexity of the cool impulse. As long as some black people have to live like niggas, cool, as contemporarily defined, will live on. As long as white people know what niggas are up to, cool will continue to exist, with all of its baggage passed on like, uh, luggage. The question "Are black people cooler than white people?" is not the important one. "How do I gain proximity to cool, and do I want it?" is much better. The real secret weapon of cool is that it's about synthesis. Just about every important black cultural invention of this century has been about synthesizing elements previously considered antithetical. MLK merged Eastern thought and cotton-field religious faith into the civil rights movement. Chuck Berry merged blues and country music into rock 'n' roll. Michael Jordan incorporated the old school ball of Jerry West into his black game. Talk about making a dollar out of 15 cents.

Out in the netherworld of advertising, they tell us 30 we're all Tiger Woods. He plays the emblematic white man's game as good as anyone. Well, only one nigga on this planet gets to be that motherfucker, but we all swing the same cool, to whatever distant ends. The coolness construct might tell us otherwise, but we're all handed the same basic tools at birth; it's up to us as individuals to work on our game. Some of us have sweet strokes, and some of us press too hard, but everybody who drops outta their mama has the same capacity to take a shot. ○

SEEING

1. Donnell Alexander states that "Cool has a history and cool has a meaning" (para. 15). Sketch out the history that Alexander presents for "cool." How does he define the term? According to Alexander, what is the difference between "nigga" and "black"? What does he mean when he talks of the "nigga metaphor"? Outline the logical steps Alexander takes in constructing his argument about making "hip hop necessary."

2. Consider the list with which Alexander begins this piece. What does he gain—and lose—by opening the essay in this manner? How would you characterize his tone at the beginning of the essay? Does it remain consistent throughout the piece? If not, when does it change, and with what effects? Comment on his diction as well.

WRITING

1. Alexander claims that evidence of "cool" is everywhere evident in American popular culture. "We all know cool when we see it, and now, more than at any other time in this country's history, when mainstream America looks for cool we look to black culture" (para. 15). Choose an example of cool—a musician, a celebrity, an athlete, or a style of dress, to name a few possibilities—or something that passes for cool (what Alexander calls "cool clone") in mainstream American culture. Write an essay in which you use his explanation of the relationship between black culture and cool. Explain why you think your subject is "authentic" cool or a "wanna-be."

2. Early in the essay Alexander claims he is "a cop-show menace and a shoe commercial demi-god" (para. 11). This observation underscores the impression that African Americans are usually regarded as falling within one of these two categories. Consider your own experience with media representations of African Americans. Do you agree with Alexander's claim? Can you identify well-known African Americans who transcend these categories? Where, for example, would you place someone such as Bill Cosby? In what ways does someone like Cosby satisfy Alexander's definition of cool? Write an essay in which you assess the media representations of African Americans. Who among these figures can be said to be cool, and why?

Cool Like Me

Donnell Alexander

LARRY FISHER

For over twenty years Larry Fisher (b. 1948) has been capturing the ordinary and extraordinary events in the American heartland as staff photographer for the *Quad City Times*, a newspaper that serves Davenport, Iowa, and other communities straddling the Mississippi River between Iowa and Illinois. A native of Davenport and a graduate of Kansas City Art Institute, Fisher views the Midwest as a lively and vital crossroads: "We are not, contrary to popular opinion, a bunch of farmers out standing in their field."

SEEING

1. Make as many detailed observations about this photograph as you can. What, specifically, do you notice about it? about each of the people present in it? Comment on their facial expressions and body language. How, for example, are these students communicating with their hands?

2. If you didn't know what prompted this photograph, what might your guess be? The original caption for this photograph read: "October 3, 1995, Rock Island IL. While some black students at Augustana College celebrated the acquittal, their white classmates watched in silence." How accurate a characterization of the photograph do you think this is? What can you infer from the fact that these students are crowded into a small space, watching the verdict together? What different impact would such a photograph have if different racial groups were watching the verdict separately?

WRITING

1. This photograph records the reactions of undergraduates immediately after the announcement of the "not guilty" verdict in the O.J. Simpson trial. Choose two of the students and write the first draft of a dialogue between them, before and after the verdict. What, in effect, was going on—and being said—immediately before and after this photograph was taken?

2. Photographs are one of the most compelling forms of evidence that capture memorable moments in our lives. Compare the nature and effects of Larry Fisher's photograph to the reaction photographs Andrew Savulich took immediately following an extraordinary moment in other people's lives. Choose one of the photographs in the Savulich portfolio on pp. 166–67. Write an essay in which you compare and contrast this photograph by Fisher with one by Savulich. Which do you find more powerful and effective? Explain why.

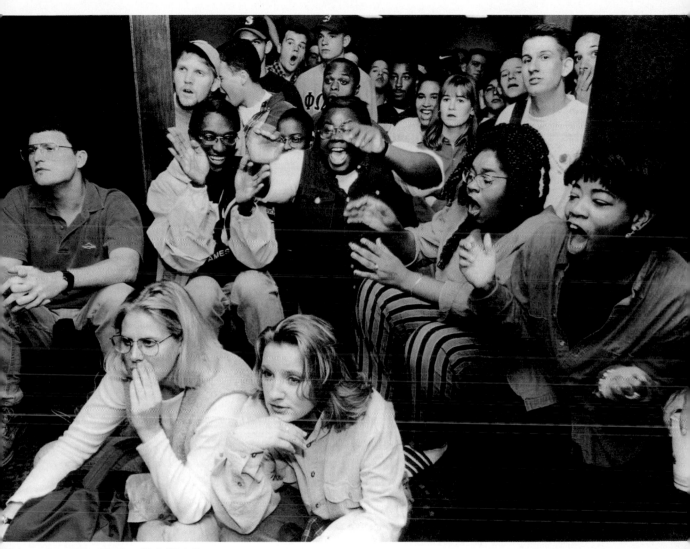

Larry Fisher, **The Acquittal of O.J. Simpson**

DEFINING WHITE

Naomi Shihab Nye

On the telephone no one knows what white is.
My husband knows, he takes pictures.
He has whole notebooks defining
how white is white, is black,
and all the gray neighborhoods in between. 5

The telephone is blind.
Cream-white? Off-white?
I want a white, he says,
that is white-white,
that tends in no direction 10
other than itself.

Now this is getting complex.
Every white I see is tending
toward something else.
The house was white, but it is peeling. 15
People are none of these colors.

In the sky white sentences form and detach.
Who speaks here? What breath
scrawls itself endlessly,
white on white, without being heard? 20
Is wind a noun or a verb?

NAOMI SHIHAB NYE

Poet, essayist, and translator Naomi Shihab Nye was born in 1952 in St. Louis to a Palestinian father and an American mother. Because she spent part of her childhood in Jerusalem, which at that time was in Jordan, the cultural tensions between Muslim and Jew, American and Arab that she experienced there have informed much of her work. Such issues were at the heart of her award-winning poetry collection *Different Ways to Pray* (1980). "For me the primary source of poetry has always been local life, random characters met on the streets, our own ancestry sifting down to us through small essential daily tasks." Recently she noted, "I believe poetry is as basic to our lives and to education as anything else there could possibly be."

Although Shihab Nye's poems address intimate matters of everyday life, her vision is international in scope and reference. She has authored eleven books of poetry; produced fiction for children as well as poetry and song recordings; and edited the popular children's anthology *This Same Sky: A Collection of Poems from around the World* (1992).

Shihab Nye has lived for many years with her family in San Antonio, Texas, and the Tex/Mex culture so prominent there finds its way into many of her poems.

SEEING

1. What definitions of *white* does Naomi Shihab Nye provide in this poem? What range of associations with the word *white* does she include? For example, to what extent does Shihab Nye play with notions of whiteness in such fields as art? design? fashion? photography? cultural traditions? race? What differences would it make to the impact of the poem if Shihab Nye had entitled it *Definitions of White* rather than *Defining White*?

2. Examine carefully the first stanza (lines 1–5). What shift in frame of reference does line 5 articulate in the poet's understanding of the term *white*? In a similar vein, what does Shihab Nye mean when she says, "People are none of these colors" (line 16)? What words and phrases has she previously introduced to prepare her readers for this assertion? What relationship does she establish between whiteness and the wind in the final stanza? What importance does this connection bear for understanding the poem? Please be as specific as possible in responding.

WRITING

1. Shihab Nye has written a powerful poem about the changing meaning of *white* in different contexts. In one context, for example, white might be used to celebrate marriage; in another, it might signal death and mourning. Shihab Nye's poem also raises issues of perception and communication. Who is to say what white is? what black is? Make a list of all the associations you can muster with the word *black*. Then do the same for the word *white*. At what point—and to what extent—did racial connotations surface as you compiled the two lists? Write an essay in which you discuss the nature and extent of racial over tones in everyday language in the United States.

2. Reread the final stanza of the poem several times until you feel comfortable with what it says and how it works. In the final line the speaker asks, "Is wind a noun or a verb?" Consider the contexts within which the word *white*, in addition to being an adjective, might also be read as a noun. How might the word also be read as a verb? Draft an essay in which you explore the changing meanings of *white* in different contexts. How and when does it function as an adjective, as a verb, and as a noun?

 Re: Searching the Web

The World Wide Web is often heralded as a great equalizer, a virtual reality free of color and class consciousness. Yet research institutions and journalists have recently called attention to the disproportionately low use of the web by minority and low-income Americans and their lack of representation on the web.

Concurrently an increasing number of sites are addressed to particular ethnic groups. NetNoir (www.netnoir.com) aims "to be the #1 Black interactive online community in the world" by providing a space for black-oriented news, social interaction, and links to black businesses. LatinoNet (www.latinoweb.com) promises a Latino Cyber Space Community in order to "empower the Latino community."

Choose a web site devoted to an ethnic or racial group. What are its announced—or implied—aims? How does it cater to this particular audience? What visual and verbal techniques does it use to address this audience? Comment on its effectiveness.

Now consider the ways in which you can compare entering this ethnic web site to the experience of entering an ethnic neighborhood in a city or a town. Describe the experience of entering an ethnic neighborhood—as either an insider or an outsider. Write an essay in which you compare and contrast the ways in which entering a web site devoted to a particular ethnic group is similar to—or different from—actually walking into an ethnic neighborhood.

BONNIE KAE GROVER

Social activist Bonnie Kae Grover grew up on a farm in rural northeastern Colorado, where "the nearest paved road was 90 miles away." There she discovered the importance of race among her schoolmates: "There were many people who were incredibly poor, poverty stricken for generations, but they were white. And they used that like a badge of honor."

Active in the civil rights and antiwar movements of the 1960s, Grover taught in the public schools from 1966 to 1968. After completing a master's degree in psychology and counseling from the University of Colorado, she served the rural population of Colorado as a social worker administering child protection services, family welfare, and related services for almost 20 years. These experiences inspired Grover to earn a law degree in order to examine the roots of the inequalities she encountered. "I was never interested in practicing law, but I am very interested in how the legal system upholds or undermines social inequality."

After earning her law degree, Grover was a lecturer in the ethnic studies department at the University of Colorado, Boulder. She has written and lectured on topics related to ethnic studies and race theory, including Vietnamese Amerasian resettlement, diversity within corporate law, and affirmative action.

GROWING UP *WHITE* IN AMERICA?

Bonnie Kae Grover

GROWING UP *WHITE* IN AMERICA. HOW DO YOU do that? I mean, lots of folks grow up Italian in America, lots more grow up capitalist in America, and legions of us have grown up middle class, working class, poor, or even rich in America. But *white?*

White is transparent. That's the point of being the dominant race. Sure, the whiteness is there, but you never think of it. If you're white, you never *have* to think of it. Sometimes when folks make a point of thinking of it, some (not all) of them run the risk of being either sappy in the eyes of other whites or of being dangerous to nonwhites. And if white folks remind each other about being white, too often the reminder is about threats by outsiders—nonwhites—who steal white entitlements like good jobs, a fine education, nice neighborhoods, and the good life.

And now, in an instant, it comes to me—the burr I've been feeling since I started getting a nasty itch from this idea. It's this—Is "white culture" really *white* culture? Or is it just American culture, nothing more, and the white folks who think it's white culture have just moved in like they've discovered it, like the white Europeans decided they'd discovered America and just moved in and took it over like they were entitled to it, never mind that five hundred nations already lived and worshipped in America, or the Land between the Great Waters, they just moved in and said they had God on their side and the Indians weren't much anyway but a few of them could work for them sometimes if they behaved themselves, and the rest were lined up for disposal.

Maybe I'm uncomfortable extolling white culture especially if it replaces other folks' culture, like prayer in the schools and boarding schools for Indian children and English Only and the Ku Klux Klan. It seems to me that too much of white culture is built on stamping out culture that isn't white, or culture that isn't white enough, or even culture that just doesn't happen to be the correct brand or shade of white.

No, I'm not ashamed of being white. But I sure am ashamed of what being white can mean to some folks who *are* proud of being white. And I'm ashamed of what it can mean to be white when that whiteness can so easily be used to hurt people who aren't white. I definitely *am* ashamed of that part of whiteness. Because in America, whiteness means being dominant, and it stands to reason that if somebody's dominant, somebody else is down. It's delightful to be able to mindlessly enjoy "white" culture. But is it really white? Or did white folks just apply the Discovery Doctrine like the white Europeans did when they took over this continent? And did somebody else or at least their culture get stamped out in the bargain one more time?

If one is going to get all sentimental over being white, be careful. With your white privilege, there ought to be one or two white responsibilities. Like, take the cleats off. They're in your genes. I realize it's tough having to be responsible about your whiteness. But blacks and Indians and Asians have to handle their own racial and ethnic selves with some level of awareness whites are not used to, even when they're celebrating who they are. When they celebrate ethnicity, they still have to be aware of themselves in the context of a larger society that is just not like them, and it won't hurt to become aware of ourselves in the context of all people, not just white ones. Whiteness is only one possible part—your part—of the greater wonder of being alive in this world. Make that awareness part of your celebration.

And make a point of seeing what you can find in your family's heritage and traditions that goes beyond the color of your skin. How did your parents meet? How did your grandparents meet? Anybody in your family come to America in steerage? Or chains? ○

SEEING

1. At the outset of paragraph 2, Bonnie Kae Grover states that "white is transparent." What does she mean? Explore all the possible meanings of this phrase. What does she mean when she says that whites "never *have* to think of" their whiteness? What, for example, are the consequences of never needing to define yourself if you are a member of the dominant race? What assumptions are embedded in Grover's title—and in the fact that the title is phrased as a question?

2. What does Grover mean when she advises white Americans to "take the cleats off. They're in your genes" (para. 6)? To what extent do you agree—or disagree—with Grover's notions of white privilege and responsibility? What do *you* see as white privilege and responsibility?

WRITING

1. Consider the ways in which "whiteness" is reflected in not only racial terms but also in class differences. List the range of associations you make between whiteness and different socioeconomic groups. Such idiomatic expressions as "White trash" and "trailer trash" are but a few obvious examples. Write the first draft of an essay in which you explore the socioeconomic, cultural, and regional differences in defining "white" in contemporary American society.

2. Grover observes that "blacks and Indians and Asians have to handle their own racial and ethnic selves with some level of awareness whites are not used to, even when they're celebrating who they are" (para. 6). Write an essay in which you agree or disagree with Grover's assertion. To what extent do you think that white Americans are aware of their whiteness? And if they are, how would they define it?

CONSUELO KANAGA

Of photography Consuelo Kanaga has written, "Most people try to be striking to catch the eye. I think the thing is not to catch the eye but catch the spirit."

Kanaga (1894–1978) herself was a woman of unusual spirit. In 1915 she became a reporter for the San Francisco *Chronicle*, a rare profession for a woman at the time. A few years later she began a career as a newspaper photographer. Covering the city for the *Chronicle*, Kanaga photographed society events as well as longshoremen's strikes. According to one co-worker, "Consuelo would go anywhere."

Kanaga traveled widely—in Europe as well as America—and often turned her camera on the faces of the poor and suffering. She was among the first photographers to portray African Americans in personal portraits that differed radically from the anonymous documentary style in which they were usually pictured. A lifelong champion of integration, she joined the Civil Rights Peace Marchers in Albany, Georgia, when she was well into her seventies.

Among her friends were the eminent photographers Alfred Stieglitz and Edward Weston. In 1992 a retrospective exhibit of Kanaga's work at the Brooklyn Museum, and the accompanying publication of *Consuelo Kanaga: An American Photographer* by Sarah Lowe and Barbara Millstein, helped place Kanaga's groundbreaking work in the public eye once again.

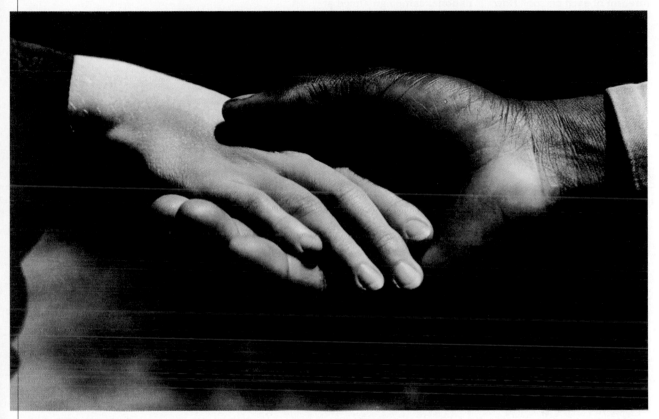

Consuelo Kanaga, **Hands**

SEEING

1. Examine this image carefully. What do you notice about each hand? How would you describe the hands? What do you notice about the forearm of each person? How would you characterize the relationship of the hands? the contact between them? What shape do the two hands form? What metaphors might you create to characterize the relationship of the hands? What associations does the image elicit from you? What conventional expectations surface when we see a white and black hand together? How does this image satisfy—or subvert—these expectations? In what ways does the photograph seem familiar to you and remind you of other images you have seen?

2. What cultural assumptions, stereotypes, and myths about race relations does this image evoke in you? What makes the seemingly simple image so emotionally charged? How would this photograph read differently—and its meaning change—if the smaller hand were black and the larger one white? both black? both white? one white and one brown or yellow? This photograph was taken in 1930. How does this fact influence your response to these questions? How would you read the photograph differently if it had been taken in 1960? in 1990? in 2000? How might the photograph be read differently in each period?

WRITING

1. Imagine that you are the creative director of a major American advertising agency. You have been hired by a civil rights group to design a national campaign aimed at eliminating bigotry and racism in our communities. Draft a proposal to this group in which you envision the beneficial effects of using this photograph as a symbol for that public service campaign.

2. After viewing this image, Henry Geldzahler, the former curator of twentieth-century art at New York's Metropolitan Museum of Art, wrote: "A photograph makes you nervous because there's less room to shrink from it. A painting gives you a wobble somehow, a tiny bit of space to move around in. It's less exact, mechanically less enhanced. With a photograph, you feel it incumbent upon you to have an opinion. If you don't give one, it may appear as if you don't have one." Write an essay in which you agree—or disagree—with the fundamental distinction Geldzahler draws between the relationship of painting and photography to the viewers of each. Use Kanaga's photograph as the basis for your argument, along with a twentieth-century American painting of your choice.

Looking Closer:
Double Consciousness

Double Consciousness
W. E. B. DuBois

In **"Double Consciousness,"** an excerpt from *The Souls of Black Folk* (1903), W. E. B. DuBois provides a deeply compelling account of the consequences of the segregated identity and the restrictions (legal, social, educational, political, and psychological) African Americans encounter in their daily experience in this nation. This identity pits "two souls, two thoughts, two unreconciled strivings; two warring ideals in one dark body" (para. 2). This "double consciousness," DuBois argues, denies any "true self-consciousness" to African Americans and requires that they define themselves primarily through "the revelation of the other world."

Seeing oneself in terms of "the eyes of others" remains an ongoing problem for virtually every nonwhite racial group in the United States. The material in this section, including a 1921 ad for **Cream of Wheat,** Guillermo Gómez-Peña's photograph **"Authentic Cuban Santera,"** George Catlin' painting *Pigeon's Egg Head (The Light),* James McBride's memoir **"What Color Is Jesus?",** and a **Charlie Chan** poster, all present graphic historical as well as contemporary evidence of the ways in which this two-ness continues to surface.

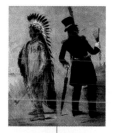

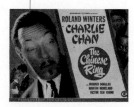

What Color Is Jesus?
James McBride

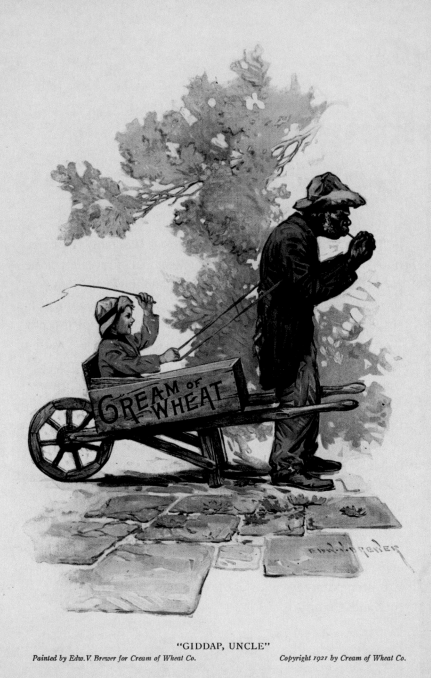

"GIDDAP, UNCLE"

Painted by Edw. V. Brewer for Cream of Wheat Co. Copyright 1921 by Cream of Wheat Co.

Double Consciousness

W. E. B. DuBois

... THE PROBLEM OF THE TWENTIETH CENTURY is the problem of the colorline. . . .

After the Egyptian and Indian, the Greek and Roman, the Teuton and Mongolian, the Negro is a sort of seventh son, born with a veil, and gifted with second-sight in this American world—a world which yields him no true self-consciousness, but only lets him see himself through the revelation of the other world. It is a peculiar sensation, this double-consciousness, this sense of always looking at one's self through the eyes of others, of measuring one's soul by the tape of a world that looks on in amused contempt and pity. One ever feels his two-ness,—an American, a Negro; two souls, two thoughts, two unreconciled strivings; two warring ideals in one dark body, whose dogged strength alone keeps it from being torn asunder.

The history of the American Negro is the history of this strife,—this longing to attain self-conscious manhood, to merge his double self into a better and truer self. In this merging he wishes neither of the older selves to be lost. He would not Africanize America, for America has too much to teach the world and Africa. He would not bleach his Negro soul in a flood of white Americanism, for he knows that Negro blood has a message for the world. He simply wishes to make it possible for a man to be both a Negro and an American, without being cursed and spit upon by his fellows, without having the doors of Opportunity closed roughly in his face.

Work, culture, liberty,—all these we need, not singly but together, not successively but together, each growing and aiding each, and all striving toward that vaster ideal that swims before the Negro people, the ideal of human brotherhood, gained through the unifying ideal of Race; the ideal of fostering and developing the traits and talents of the Negro, not in opposition to or contempt for other races, but rather in large conformity to the greater ideals of the American Republic, in order that some day on American soil two world-races may give each to each those characteristics both so sadly lack. We the darker ones come even now not altogether empty-handed: there are to-day no truer exponents of the pure human spirit of the Declaration of Independence than the American Negroes; there is no true American music but the wild sweet melodies of the Negro slave; the American fairy tales and folk-lore are Indian and African; and, all in all, we black men seem the sole oasis of simple faith and reverence in a dusty desert of dollars and smartness. ○

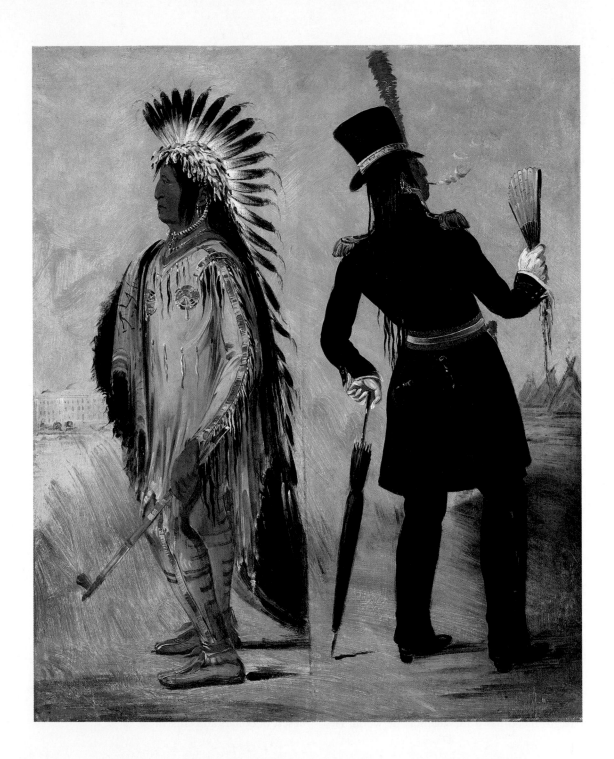

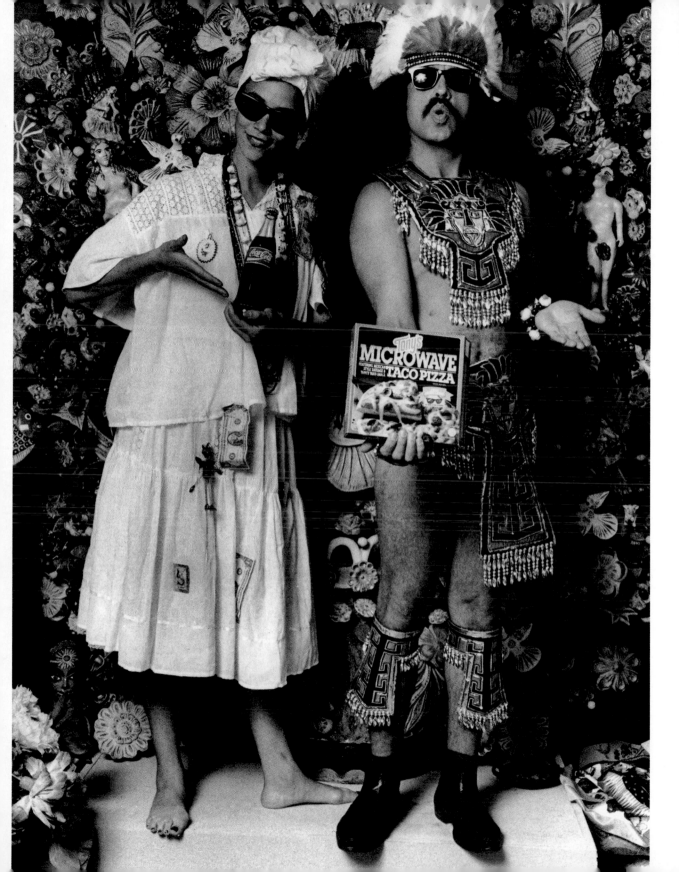

What Color Is Jesus?

James McBride

JUST BEFORE I QUIT MY LAST JOB IN WASHINGTON, I drove down into Virginia to see my stepfather's grave for the first time. He was buried in a little country graveyard in Henrico County, near Richmond, about a hundred yards from the schoolhouse where he learned to read. It's one of those old "colored" graveyards, a lonely, remote backwoods place where the wind blows through the trees and the graves are marked by lopsided tombstones. It was so remote I couldn't find it by myself. I had to get my aunt Maggie to show me where it was. We drove down a dirt road and then parked and walked down a little dusty path the rest of the way. Once we found his grave, I stood over it for a long time.

I was fourteen when my stepfather died. One minute he was there, the next—boom—gone. A stroke. Back then I thought a stroke was something you got from the sun. I didn't know it could kill you. His funeral was the first I had ever attended. I didn't know they opened coffins at funerals. When the funeral director, a woman with white gloves, unlatched the coffin, I was horrified. I couldn't believe she was going to open it up. I begged her in my mind not to open it up—please—but she did, and there he was.

The whole place broke up. Even the funeral director cried. I thought I would lose my mind.

Afterward, they took him out of the church, put him in a car, and flew him down to Virginia. My mother and older brother and little sister went, but I'd seen enough. I didn't want to see him anymore. As a kid growing up in New York, I'd been embarrassed by him because he wasn't like the other guys' fathers, who drove hot rods, flew model airplanes with their sons, and talked about the Mets and civil rights. My father was solitary, gruff, busy. He worked as a furnace fireman for the New York City Housing Authority for thirty-six years, fixing oil burners and shoveling coal into big furnaces that heated the housing projects where my family lived. He drove a Pontiac, a solid, clean, quiet car. He liked to dress dapper and drink Rheingold beer and play pool with his brother Walter and their old-timey friends who wore fedoras and smoked filterless Pall Malls and called liquor "likka" and called me "boy." They were weathered Southern black men, quiet and humorous and never bitter about white people, which was out of my line completely. I was a modern-day black man who didn't

like the white man too much, even if the white man was my mother.

My mother was born Jewish in Poland, the eldest daughter of an Orthodox rabbi. She married my natural father, a black man, in 1941. He died in 1957, at forty-eight, while she was pregnant with me. She married my stepfather, Hunter L. Jordan, Sr., when I was about a year old. He raised me and my seven brothers and sisters as his own—we considered him to be our father—and he and my mother added four more kids to the bunch to make it an even twelve.

My parents were unique. As unique as any parents I have known, which I suppose makes their children unique. However, being unique can spin you off in strange directions. For years I searched for a kind of peace. I vacillated between being the black part of me that I accept and the white part of me that I could not accept. Part writer, part musician, part black man, part white man. Running, running, always running. Even professionally I sprinted, from jazz musician to reporter and back again. Bounding from one life to the other—the safety and prestige of a journalism job to the poverty and fulfillment of the musician's life.

Standing over my stepfather's grave, thinking about quitting my gig to move back to New York to be a musician and freelance writer, I was nervous. He would never approve of this jive. He would say: "You got a good job and you quit that? For what? To play jazz? To write? Write what? You need a job." Those were almost the exact words my mother always used.

My aunt Maggie, who's about seventy-two, was standing there as I waged this war in my mind. She came up behind me and said, "He was a good man. I know y'all miss him so much."

"Yep," I said, but as we walked up the dusty little path to my car to go to the florist to get flowers, I was thinking, "Man, I'm sure glad he's not here to see me now."

I'm a black man and I've been running all my life. Sometimes I feel like my soul just wants to jump out of my skin and run off, things get that mixed up. But it doesn't matter, because what's inside is there to stay no matter how fast you sprint. Being mixed feels like that tingly feeling you have in your nose when you have to sneeze—you're hanging on there waiting for it to happen, but it never does. You feel completely misunderstood by the rest of the world, which is probably how any sixteen-year-old feels, except that if you're brown-skinned like me, the feeling lasts for the rest of your life. "Don't you sometime feel like just beating up the white man?" a white guy at work once asked me. I hate it when people see my brown skin and assume that all I care about is gospel music and fried chicken and beating up the white man. I could care less. I'm too busy trying to live.

Once a mulatto, always a mulatto, is what I say, and you have to be happy with what you have, though in this world some places are more conducive to the survival of a black white man like me than others. Europe is okay, Philly works, and in New York you can at least run and hide and get lost in the sauce; but Washington is a town split straight down the middle—between white and black, haves and have-nots, light-skinned and dark-skinned—and full of jive-talkers of both colors. The blacks are embittered and expect you to love Marion Barry unconditionally. The whites expect you to be either grateful for their liberal sensibilities or a raging militant. There's no middle ground. No place for a guy like me to stand. Your politics is in the color of your face, and nothing else counts in Washington, which is why I had to get out of there.

All of my brothers and sisters—six boys, five girls, wildly successful by conventional standards (doctors, teachers, professors, musicians)—have had to learn to plow the middle ground. Music is my escape, because when I pick up the saxophone and play, the horn doesn't care what color I am. Whatever's inside comes out, and I feel free.

My family was big, private, close, poor, fun, and always slightly confused. We were fueled by the race question and also befuddled by it. Everyone sought their own private means of escape. When he was little, my older brother Richie, a better sax player than I and

the guy from whom I took all my cues, decided he was neither black nor white, but green, like the comic book character the Hulk. His imagination went wild with it, and he would sometimes lie on our bed facedown and make me bounce on him until he turned green.

"Do I look green yet?" he'd ask.

"Naw . . ."

"Jump some more." 15

I'd bounce some more.

"How about now?"

"Well, a little bit."

"RRRrrrrr . . . I'm the Hulk!" And he'd rise to attack me like a zombie.

Richard had a lot of heart. One morning in Sunday 20 school, he raised his hand and asked our Sunday school teacher, Reverend Owens, "Is Jesus white?"

Reverend Owens said no.

"Then why is he white in this picture?" and he held up our Sunday school Bible.

Reverend Owens said, "Well, Jesus is all colors."

"Then why is he white? This looks like a white man to me." Richie held up the picture high so everyone in the class could see it. "Don't he look white to you?" he asked. Nobody said anything.

Reverend Owens was a nice man and also a barber 25 who tore my head up about once a month. But he wasn't that sharp. I could read better than he could, and I was only twelve.

So he kind of stood there, wiping his face with his handkerchief and making the same noise he made when he preached. "Well . . . ahhh . . . well . . . ahhh . . ."

I was embarrassed. The rest of the kids stared at Richie like he was crazy. "Richie, forget it," I mumbled.

"Naw. If they put Jesus in this picture here, and he ain't white, and he ain't black, they should make him gray. Jesus should be gray."

Richie stopped going to Sunday School after that, although he never stopped believing in God. My mother tried to make him go back, but he wouldn't.

When we were little, we used to make fun of our 30 mother singing in church. My mother can't sing a lick. She makes a shrill kind of sound, a cross between a fire engine and Curly of the Three Stooges. Every Sunday morning, she'd stand in church, as she does today, the only white person there, and the whole congregation going, "Leaannnnning, ohhh, leaaning on the crossss, ohhhhh Laaawwwd!" and her going, "Leeeeeaaannnning, ohhh, clank! bang! @*%$@*!," rattling happily along like an old Maytag washer. She wasn't born with the gift for gospel music, I suppose

My mother, Ruth McBride Jordan, who today lives near Trenton, is the best movie I've ever seen. She's seventy-six, pretty, about five three, bowlegged, with curly dark hair and pretty dark eyes. She and my father and stepfather raised twelve children and sent them to college and graduate school, and at age sixty-five she obtained her own college degree in social welfare from Temple University. She's a whirlwind, so it's better to test the wind before you fly the kite. When I began writing my book about her, she said, "Ask me anything. I'll help you as much as I can." Then I asked her a few questions and she snapped: "Don't be so nosy. Don't tell all your business. If you work too much, your mind will be like a brick. My pot's burning on the stove. I gotta go."

When we were growing up, she never discussed race. When we asked whether we were black or white, she'd say, "You're a human being. Educate your mind!" She insisted on excellent grades and privacy. She didn't encourage us to mingle with others of any color too much. We were taught to mind our own business, and the less people knew about us, the better.

When we'd ask if she was white, she'd say, "I'm light-skinned," and change the subject. But we knew she was white, and I was embarrassed by her. I was ten years old when Martin Luther King, Jr., was killed, and I feared for her life because it seemed like all of New York was going to burn. She worked as a night clerk-typist at a Manhattan bank and got home every night about 2 A.M. My father would often be unavailable, and one of the older kids would meet her at the bus stop while the rest of us lay awake,

waiting for the sound of the door to open. Black militants scared me. So did the Ku Klux Klan. I thought either group might try to kill her.

I always knew my mother was different, knew my siblings and I were different. My mother hid the truth from her children as long as she could. I was a grown man before I knew where she was born.

She was born Ruchele Dwajra Sylska in a town 35 called Dobryn, near Gdansk, Poland. Her father was an Orthodox rabbi who lived in Russia. He escaped the Red Army by sneaking over the border into Poland. He married my grandmother, Hudis, in what my mother says was an arranged marriage, emigrated to America in the early 1920s, changed his name, and sent for his family. My mother landed on Ellis Island like thousands of other European immigrants.

The family settled in Suffolk, Virginia, and operated a grocery store on the black side of town. Her father also ran a local synagogue. Theirs was the only store in town open on Sundays.

He was feared within the family, my mother says. His wife, who suffered from polio, was close to her three children—a son and two daughters—but could not keep the tyranny of the father from driving them off. The oldest child, my mother's brother, left home early, joined the army, and was killed in World War II. The remaining two girls worked from sunup to sundown in the store. "My only freedom was to go out and buy little romance novels," my mother recalls. "They cost a dime." In school, they called her "Jew-baby."

When she was seventeen, she went to New York to visit relatives for the summer and worked in a Bronx factory owned by her aunt. At the factory, there was a young black employee named Andrew McBride, from High Point, North Carolina. They struck up a friendship and a romance. "He was the first man who was ever kind to me," my mother says. "I didn't care what color he was."

Her father did, though. When she returned home to finish her senior year of high school, her father arranged for her to marry a Jewish man after graduation. She had other plans. The day after she graduated,

she packed her bags and left. After floating between New York and Suffolk for a while, she finally decided to marry my father in New York City. Her father caught up to her at the bus station the last time she left home. He knew that she was in love with a black man. The year was 1941.

"If you leave now, don't ever come back," he said. 40
"I won't," she said.

She gave up Judaism, married Andrew McBride, and moved to a one-room flat in Harlem where she proceeded to have baby after baby. Her husband later became a minister, and together they started New Brown Memorial Baptist Church in Red Hook, Brooklyn, which still exists. The mixed marriage caused them a lot of trouble—they got chased up Eighth Avenue by a group of whites and endured blacks murmuring under their breadth, and she was pushed around in the hallway of the Harlem building by a black woman one day. But she never went home. She tried to see her mother after she married, when she found out her mother was ill and dying. When she called, she was told the family had sat shiva for her, as if she had died. "You've been out; stay out," she was told. She always carried that guilt in her heart, that she left her mother with her cruel father and never saw her again.

In 1957, Andrew McBride, Sr., died of cancer. My mother was thirty-six at the time, distraught after visiting him in the hospital, where doctors stared and the nurses snickered. At the time, she was living in the Red Hook project in Brooklyn with seven small kids. She was pregnant with me. In desperation, she searched out her aunt, who was living in Manhattan. She went to her aunt's house and knocked on the door. Her aunt opened the door, then slammed it in her face.

She told me that story only once, a few years ago. It made me sick to hear it, and I said so.

"Leave them alone," she said, waving her hand. 45 "You don't understand Orthodox Jews. I'm happy. I'm a Christian. I'm free. Listen to me: When I got home from your daddy's funeral, I opened our mailbox, and it was full of checks. People dropped off

boxes of food—oranges, meat, chickens. Our friends, Daddy's relatives, the people from the church, the people you never go see, they gave us so much money. I'll never forget that for as long as I live. And don't you forget it, either."

A number of years ago, after I had bugged her for months about details of her early life, my mother sat down and drew me a map of where she had lived in Suffolk. She talked as she drew: "The highway goes here, and the jailhouse is down this road, and the slaughterhouse is over here. . . ."

I drove several hours straight, and was tired and hungry once I hit Suffolk, so I parked myself in a local McDonald's and unfolded the little map. I checked it, looked out the window, then checked it again, looked out the window again. I was sitting right where the store used to be.

I went outside and looked around. There was an old house behind the McDonald's. I knocked on the door, and an old black man answered.

"Excuse me . . ." and I told him my story: Mother used to live here. Her father was a rabbi. Jews. A little store. He fingered his glasses and looked at me for a long time. Then he said, "C'mon in here."

He sat me down and brought me a soda. Then he asked me to tell my story one more time. So I did.

He nodded and listened closely. Then his face broke into a smile. "That means you the ol' rabbi's grandson?"

"Yep."

First he chuckled, then he laughed. The he laughed some more. He tried to control his laughing, but he couldn't, so he stopped, took off his glasses, and wiped his eyes. I started to get angry, so he apologized. His name was Eddie Thompson. He was sixty-six. He had lived in that house all his life. It took him a minute to get himself together.

"I knew your mother," he said. "We used to call her Rachel."

I had never heard that name before. Her name is Ruth, but he knew her as Rachel, which was close to Ruchele, the Yiddish name her family called her.

"I knew that whole family," Thompson said. "The ol' rabbi, boy, he was something. Rachel was the nice one. She was kindhearted. Everybody liked her. She used to walk right up and down the road here with her mother. The mother used to limp. They would say hello to the people, y'know? Old man, though . . ." and he shrugged. "Well, personally, I never had no problem with him."

He talked for a long time, chuckling, disbelieving. "Rachel just left one day. I'm telling you she left, and we thought she was dead. That whole family is long gone. We didn't think we'd ever see none of them again till we got to the other side. And now you pop up. Lord knows it's a great day."

He asked if we could call her. I picked up the phone and dialed Philadelphia, got my mother on the line, and told her I had somebody who wanted to talk to her. I handed the phone to him.

"Rachel? Yeah. Rachel. This is Eddie Thompson. From down in Suffolk. Remember me? We used to live right be—yeaaaaah, that's right." Pause. "No, I was one of the little ones. Well, I'll be! The Lord touched me today.

"Rachel!? That ain't you crying now, is it? This is old Eddie Thompson. You remember me? Don't cry now."

I went and got some flowers for my stepfather's grave and laid them across it. My mother wanted me to make sure the new tombstone she got him was in place, and it was. It said OUR BELOVED DADDY, HUNTER L. JORDAN, AUGUST 11, 1900, TO MAY 14, 1972.

He was old when he died and a relatively old fifty-eight when he married my mother. They met in a courtyard of the Red Hook housing project where we lived, while she was selling church dinners on a Saturday to help make ends meet. He strolled by and bought some ribs, came back the next Saturday and bought some more. He ended up buying the whole nine yards—eight kids and a wife. He used to joke that he had enough for a baseball team.

I never heard him complain about it, and it never even occurred to me to ask him how he felt about

white and black. He was quiet and busy. He dealt with solid things. Cars. Plumbing. Tricycles. Work. He used to joke about how he had run away from Richmond when he was a young man because Jim Crow was tough, but racism to him was a detail that you stepped over, like you'd step over a crack in the sidewalk. He worked in the stockyards in Chicago for a while, then in a barbershop in Detroit, where, among other things, he shined Henry Ford's shoes. He went to New York in the 1920s. He never told me those things; his brother Walter did. He didn't find those kinds of facts interesting. All he wanted to talk about was my grades.

He was strong for his age, full and robust, with brown eyes and handsome American Indian features. One night, he had a headache, and the next day he was in the hospital with a stroke. After a couple of weeks, he came home. Then two days later, he asked me to come out to the garage with him. I was one of the older kids living at home; most were away at college or already living on their own. He could barely walk and had difficulty speaking, but we went out there, and we got inside his Pontiac. "I was thinking of maybe driving home one more time," he said. He was talking about Henrico County, where we spent summer vacations.

He started the engine, then shut it off. He was too 65 weak to drive. So he sat there, staring out the windshield, looking at the garage wall, his hand on the steering wheel. He was wearing his old-timey cap and his peacoat, though it was May and warm outside. Sitting there, staring straight ahead, he started talking, and I listened closely because he never gave speeches.

He said he had some money saved up and a little land in Virginia, but it wasn't enough. He was worried about my mother and his children. He said I should always mind her and look out for my younger brothers and sisters, because we were special. "Special people," he said, "And just so special to me." It was the only time I ever heard him refer to race, however vaguely, but it didn't matter because right then I knew he was going to die, and I had to blink back my tears. Two days later, he was gone.

Standing over his grave—it seemed so lonely and cold, with the wind blowing through the trees—part of me wanted to throw myself on the ground to cover and warm him. We arranged the flowers. Plastic ones, because, as Aunt Maggie said, they lasted longer. I took one last look and thought, Maybe he would understand me now. Maybe not. I turned and left.

I suppose I didn't look too happy, because as I started up the little road toward my car, Aunt Maggie put her arm in mine. I'd known her since I was a boy, just like I'd known these woods as a boy when he took us down here, but I'd blanked her and these woods out of my mind over the years, just like you'd blank out the words of a book by covering them with a piece of paper. She didn't judge me, which is what I always appreciated most about our friends and relatives over the years, the white and the black. They never judged, just accepted us as we were. Maybe that's what a black white man has to do. Maybe a black white man will never be content. Maybe a black white man will never fit. But a black white man can't judge anybody.

I remember when I was ten years old, when I pondered my own race and asked my mother, as she was attempting to fix our dinner table that had deteriorated to three-legged status, whether I was white or black. She paused a moment, then responded thoughtfully: "Pliers."

"Huh?" 70

"Hand me the pliers out of the kitchen drawer."

I handed her the pliers and she promptly went to work on the kitchen table, hammering the legs and tops until dents and gouges appeared on all sides. When the table finally stood shakily on all fours, she set the pliers down, stood up and said, "Pliers can fix anything."

"What about me being black?" I asked.

"What about it?" she said. "Forget about black. You are a human being."

"But what do I check on the form at school that 75 says White, Black, Other?"

"Don't check nothing. Get a hundred on your school tests and they won't care what color you are."

"But they do care."

"I don't," she said, and off she went.

Perturbed, I picked up the pliers and sought out my father, hammering at the fuel pump of his 1969 Pontiac. "Am I black or white?" I asked.

"Where'd you get my pliers?" he asked.

"I got 'em from Ma."

"I been looking for 'em all day." He took them and immediately put them to work.

"Am I black or white, Daddy?"

He grabbed a hose in his hand and said, "Hold this." I held it. He went inside the car and cranked the engine. Fuel shot out of the line and spilled all over me. "You all right?" he asked. I shook my head. He took me inside, cleaned me up, put the hose in the car, and took me out for ice cream. I forgot about my color for a while.

But the question plagued me for many years, even after my father's death, and I never did find out the answer because neither he nor my mother ever gave any. I was effectively on my own. I searched for years to find the truth, to find myself as a black white man. I went to Africa, got VD, came home with no answers. I went to Europe, sipped café and smoked in Paris for months, came home empty. Last year, while working on my '53 Chevy at my home in Nyack, while my four-year-old son rolled around in the leaves and ate mud, it hit me. I asked him to hand me the pliers, and as he did so, he asked me, "What color is Grandma?"

"She's white," I said.

"Why isn't she like me?"

"She is like you, she's just whiter."

"Why is she whiter?"

"I don't know. God made her that way."

"Why?"

"I don't know. Would you like her better if she looked more like you?"

"No. I like her the way she is."

It occurred to me then that I was not put on this earth to become a leader of mixed-race people, wielding my race like a baseball bat, determined to force white people to accept me as I am. I realized then that I did not want to be known as Mr. Mulatto, whose children try to be every race in the world, proudly proclaiming Indian blood, African blood, Jewish blood, singing Peter, Paul, and Mary songs at phony private schools where yuppie parents arrive each morning hopping out of Chevy Suburban tanks with bumper stickers that read "Question Authority." I want the same thing every parent wants—a good home for my wife and children, good schools, peace and quiet, a good set of wrenches, and a son big enough to hand them to me. And when he gets big enough to have his own tools and work on his own car, maybe he will understand that you can't change someone's opinion about you no matter how many boxes you check, no matter how many focus groups you join, no matter how much legislation you pass, no matter how much consciousness raising you do. It's a real simple answer. Give 'em God. Give 'em pliers. Give 'em math. Give 'em discipline. Give 'em love, and let the chips fall where they may. Pontificating about it is okay. Passing laws is important, but I never once in my life woke up not knowing whether I should eat matzo ball or fried chicken. I never once felt I'd be able to play the sax better if my mom had been black, or that I'd have been better at math if my father were Jewish. I like me, and I like me because my parents liked me. ○

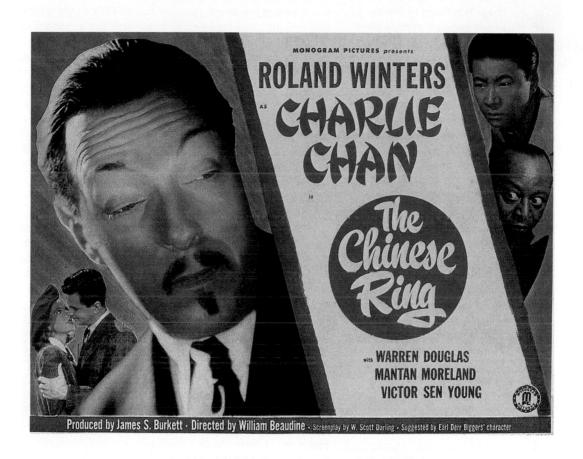

CREAM OF WHEAT

Cream of Wheat breakfast porridge was developed by a group of grain millers in Grand Forks, North Dakota, in 1893. Pressed for cash, the millers hand-made the first boxes for Cream of Wheat, decorating them with an image they found by chance among some old printing plates. The image of a black waiter carrying a steaming bowl over his shoulder remains on the carton to this day. During the 1920s a series of color magazine advertisements for Cream of Wheat was created, many of which became very popular and increased sales of the cereal.

Double Consciousness
W.E.B. DuBois

W. E. B. DUBOIS

William Edward Burghardt DuBois, born in Massachusetts in 1868, was the guiding intellectual light behind the establishment of the modern movement for the rights of African Americans. He was the first African American to earn a doctorate from Harvard University, and in 1909 he co-founded the National Association for the Advancement of Colored People (NAACP). He was the author of many works on slavery and "color," including *The Souls of Black Folk* (1903) and *Color and Democracy* (1945). He championed radical political activism as a method of social change. He joined the Communist Party in 1961 and at the age of 91 moved to Ghana, where he died in 1963 after becoming a naturalized citizen.

GEORGE CATLIN

When the painter George Catlin traveled up the Missouri River in 1832, he carefully recorded the "Indian life" he saw along the route. The drawings and paintings he returned with portrayed native peoples with dignity and accuracy, and they were among the first realistic images many Americans ever saw of the people who lived in what ultimately became the western United States. Between 1832 and 1840 Catlin painted over 470 full-length portraits and landscapes, which he collected in his two-volume *Manners of the North American Indians* (1841). The paintings and artifacts collected during his travels were assembled in "Indian Gallery," a cultural archive he hoped to sell to the government. Rebuffed, Catlin took his collection to London, where it became part of one of the first Wild West shows. In 1879 the "Indian Gallery" collection was given to the Smithsonian Institution.

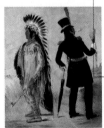

GUILLERMO GÓMEZ-PEÑA

Among the most popular performance artists of his generation, Guillermo Gómez-Peña has made the shifting border between Mexico and the United States his native land. Raised in Mexico City, where he was born in 1955, Gómez-Peña emigrated to the United States in 1978 and lived for many years in the Tijuana/San Diego area. It was here that his eclectic "border sensibility," expressed in English, Spanish, Spanglish, journalism, radio, poetry, and live mixed-media performance, first captured public attention. Challenging the traditional folkloric icons of Mexican culture as well as contemporary Chicano political forms, Gómez-Peña exposes the stereotypes in every culture. A frequent contributor to National Public Radio as well as to Latino Radio USA, he received a MacArthur fellowship in 1991.

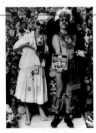

JAMES McBRIDE

Born in 1957, James McBride is a writer, composer, and musician. He received an M.A. in journalism from Columbia University and studied composition at the Oberlin Conservatory of Music. In *The Color of Water: A Black Man's Tribute to His White Mother* (1996), McBride tells the story of his Polish mother's marriage to a black Baptist minister—and her efforts to raise twelve children in the housing projects of Brooklyn, New York. Growing up the child of an interracial marriage is treated more briefly in the memoir McBride first published in 1988, "What Color Is Jesus?"

What Color Is Jesus?

James McBride

CHARLIE CHAN

Charlie Chan, a clever and subtle detective from the Honolulu police department, was the central character in a popular series of Hollywood films made in the 1930s and 1940s. Chan was created by Earl Derr Biggers, a writer from Ohio, and was played originally by the actor Warner Oland, a native of Sweden. Despite these origins, the exotic "Asian" qualities of Charlie Chan movies helped make them highly successful. Famous for reciting Chinese proverbs as he solved murder mysteries, and for succeeding against the bumbling antics of his number 1 and number 2 sons, Charlie Chan reflected America's fear of, and fascination with, "the Orient."

SEEING

1. Examine carefully the George Catlin painting, the Cream of Wheat advertisement, the Charlie Chan film poster, and the Gómez-Peña photograph. In what ways does each image illustrate W. E. B. DuBois's definition of "double consciousness"? In what ways does each image complicate that definition? Consider, for example, the ad for Cream of Wheat cereal. What image of African Americans is depicted here? How does the ad complicate our understanding of simplicity and innocence? Analyze each of the other images with similar questions in mind.

2. Create a list of the ways in which James McBride's memoir addresses W. E. B. DuBois's idea of "double consciousness." Summarize the major points McBride makes and outline the structure of his essay. What incidents and experiences were pivotal in the formation of his own racial and ethnic identity growing up? How has learning about his mother's past informed him of his own identity and cultural history? As half African American and half Polish American, McBride explains that he and his siblings "have had to learn to plow the middle ground." What do you think McBride means by "the middle ground" in his own life?

WRITING

1. Reread the excerpt from W. E. B. DuBois's *The Souls of Black Folk* (p. 383). Summarize (in one paragraph) the features of his vision of racial equality. Then choose a more recent document (a speech by Martin Luther King or some other civil rights leader, a legislative act, or a presidential address, for example). Write an essay comparing and contrasting—in specific terms—the ways in which DuBois's vision of racial equality is similar to or different from the one we strive to achieve today.

2. "But what do I check on the form at school that says White, Black, or Other?" James McBride recalls asking his mother. Labeling bears important implications for thinking about self-identity in American culture. Consider the ethnic labels McBride applies to his own identity in "What Color Is Jesus?" As students we are all faced with a moment in which we must label our ethnic identities by checking a box on a form. How many different identities might you apply to yourself? Have you always identified with one? Never felt comfortable with any? How does this categorization differ from your personal experience of ethnic identity? What informal labels never make it onto standardized forms? Write an essay in which you examine your experiences with labeling and then reflect in general terms on the cultural significance of standardized ethnic and racial labels.

Reading Icons

The peace sign. The happy face. The four-leaf clover.

Glimpse at them for a split second, and you know exactly what they mean. Because right behind every powerful icon lies a powerful idea.

A little over a century ago, we set out with what we considered to be some pretty powerful ideas:

Build cars to be fast. (We set land speed records that would last for half a century.)

Safe. (Developments in crumple zones, antilock brakes, and restraint systems have helped make all cars safer.)

Innovative. (The pioneering spirit that drove Karl Benz to patent the first three-wheel motor carriage still guides everything we do today.)

And, just as important, beautiful. (Museums throughout the world have placed our cars in their permanent collections.)

Our symbol has stood for all of these things for over a hundred years.

We look forward to the next.

What makes a symbol endure?

Mercedes-Benz, **What Makes a Symbol Endure?**

Open any newspaper or magazine, or simply turn on the television, and you will immediately encounter everything and everyone heralded as an *icon*—from blue jeans, Tupperware, the Nike swoosh, and pickup trucks to Michael Jordan, Barbie, and Martin Luther King. The cultural commentator Russell Baker complains that the current overuse of the term has escalated to "epidemic" proportions. If we casually assign great leaders, celebrities, clothing labels, and automobiles iconic status, what then might we say the term *icon* has come to mean? And what reasonable inferences might we draw from our fascination with the term?

Perhaps the oldest association of the word is with the religious representation of a sacred figure. The word has also been used historically in natural history to refer to an illustration of a plant or animal, and in rhetoric to indicate a simile. This range in the use of the term—from the sacred and religious to the scientific and technical—has not only endured but expanded to the secular and the mundane.

At its most mundane, the word icon suggests a recognizable image or representation—something that stands for something else. In this sense, one thing acts as a substitute or symbol for another. The signs for men and women on

doors to public restrooms (see p. 258), for example, are pictorial symbols that convey or represent information about which door to use, in the same way that thumbnail graphics on our computer screens tell us how to quickly open certain programs or files. In such instances, icons communicate specific meanings.

Icon is also used to identify certain individuals who are the objects of attention and devotion, people who have taken on the status of an idol. Michael Jordan has been elevated to this status for basketball, as has Elvis Presley for rock and roll. When we say that Michael Jordan is an icon, we suggest that his image has worked its way into American culture so deeply that it now represents not only all the excitement of watching professional basketball but also the American values of working hard, succeeding, and reaping the rewards.

Cultural commentators such as Aaron Betsky (p. 426) look at objects, people, and events as lenses through which to examine American culture. He sees much in the new proliferation of icons, calling them "magnets of meaning onto which we can project our memories, our hopes, and our sense of self," and observing that "part of our twentieth-century loss of faith has been a loss of the kind of icons that are unapproachable, semi-divine apparitions, and yet icons are all around us."

Corporate logos everywhere—in advertisements and on designer clothing—have extended the range of associations for the word icon. Perhaps without even knowing it, we are quite versed—and invested—in the vocabulary of corporate icons: We immediately recognize the McDonald's arches, the Nike swoosh, and the Mercedes-Benz symbol. American advertising agencies want consumers to grant iconic status to the products they promote for their corporate clients. Market research conducted by these ad agencies suggests that when their creative efforts succeed, commercial icons can and do sell products.

In the selections that follow, you will encounter a wide range of American icons. If icons are "short-hand signs" (as Aaron Betsky refers to them) or "sound bites" (to use Holly Brubach's term), then what is lost and gained in the process of representing complicated ideas through streamlined symbols? As you continue to develop your skills of seeing and writing, consider the ways in which each of the following writers and artists provides a double take on the nature and the meaning of the term icon. How do these multiple perspectives differ from, alter, or contribute to your own understanding of— and experience with—icons in contemporary American culture?

Most people tell us, "Don't touch the icon," but we're taking a calculated risk to contemporize our products.
– Marty Thrasher, president of Campbell Soup, on the redesign of the Campbell Soup can, 1995

MERCEDES-BENZ

Carl Benz assembled his first automobile in Mannheim, Germany, in 1886, and Gottlieb Daimler, maker of the Mercedes (a car named for his young daughter), assembled his a few years later. In the economic slump following World War I the companies were forced to merge, creating in 1927 the company known as Mercedes-Benz. Having manufactured "The Car with the Star" for more than 100 years (with temporary forays into military aircraft design), Mercedes-Benz is known for its engineering innovations and high-quality construction. With its headquarters today in Stuttgart, Germany, Mercedes-Benz is a division of the Daimler-Chrysler Group, Europe's largest industrial manufacturer. The company employs over 199,000 people at more than 50 production and assembly plants.

SEEING

1. Review each of the twenty-nine images depicted in this advertisement. How many can you identify immediately? Which ones do you consider to be icons? Why? Why not? What do the images have in common? In what ways do they differ? What aspects of contemporary American life do they represent? Are any significant aspects omitted? If so, please identify those and explore the possible reasons for their omission.

2. Consider the ad copy that accompanies the images. After identifying three of the icons, the speaker in the advertisement reassures us not only that we can identify the images in "a split second" but also that we "know exactly what they mean. Because right behind every powerful icon lies a powerful idea." What is the powerful idea behind each of the icons shown? What reasonable inferences about the Mercedes-Benz automobile might you draw from the "powerful ideas" the copy claims are associated with the symbol that represents the car?

WRITING

1. The advertisement says: "Our symbol has stood for all of these things for over a hundred years." Does it seem reasonable to infer that the speaker seems to equate the word *symbol* with the word *icon*? If so, why? If not, why not? How does the final line of the advertisement—"What makes a symbol endure?"—influence your reasoning? To what extent is your response a reaction to the layout of the ad, which places this question alongside the ornament that appears on the hoods of Mercedes-Benz cars? Does the text of the ad suggest a distinction between the icon (the Mercedes-Benz automobile) and the symbol (the hood ornament) chosen to represent it?

List all the meanings of *icon* that you can think of. Draft an essay in which you assert that *icon* and *symbol* are (or aren't) terms that can be used interchangeably when talking about the images represented in contemporary culture.

2. In a 1996 article, *Investor's Business Daily* observed "that the automobile is a presence in our lives from birth until death, and the car has become a subject second only to love in our popular culture." Do you agree that the car serves as an icon for America? Write an essay in which you identify *the* American icon and explain why you've chosen it, giving specific cultural examples.

THE DEATH OF MARILYN MONROE

Sharon Olds

The ambulance man touched her cold
body, lifted it, heavy as iron,
onto the stretcher, tried to close the
mouth, close the eyes, tied the
arms to the side, moved a caught 5
strand of hair, as if it mattered,
saw the shape of her breasts, flattened by
gravity, under the sheet,
carried her, as if it were she,
down the steps. 10

These men were never the same. They went out
afterwards, as they always did,
for a drink or two, but they could not meet
each other's eyes.

Their lives took 15
a turn—one had nightmares, strange
pains, impotence, depression. One did not
like his work, his wife looked
different, his kids. Even death
seemed different to him—a place where she 20
would be waiting,
And one found himself standing at night
in the doorway to a room of sleep, listening to
a woman breathing, just an ordinary
woman 25
breathing.

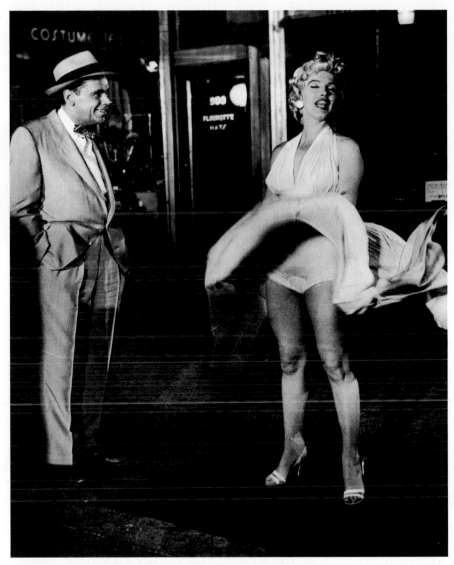

Sam Shaw, **Marilyn Monroe and Tom Ewell in *The Seven Year Itch*, 1955**

SHARON OLDS

Born in San Francisco in 1942, Sharon Olds attended Stanford and Columbia Universities. In 1980 she published her first book of poems, *Satan Says*, which won the first award given by the San Francisco Poetry Center. Her second book of poems, *The Dead and the Living* (1983), was the Lamont Poetry Selection for that year and also won the National Book Critics Circle Award. Since then, Olds has authored five books of poetry and has contributed to numerous literary journals and magazines.

Olds recently named Lucille Clifton, Brenda Hillman, Seamus Heaney, and Rita Dove among the writers who have influenced her. "It's just wonderful," Olds explained, "that every writer is shaped, and the poems are shaped, by so many things: by the life, by the mind and the spirit of the writer, so that you read a poem and know who wrote it. By where they're from, by being right here, to hear people's voices in the sense of their style as well as their physical region of the country."

Olds teaches poetry workshops at New York University and in the University's program at Goldwater Hospital on Roosevelt Island in New York. Named New York State poet in 1998, she is currently working on a new collection of poems.

MARILYN MONROE

Hundreds of onlookers, including her husband, Joe DiMaggio, gathered to watch the effects of an enormous electric fan on Marilyn Monroe's skirt as photo-journalist Sam Shaw snapped the image that was to become more famous than the film it was meant to promote, *The Seven Year Itch* (1955). DiMaggio was outraged by the poster, but the male lead in the film, Tom Ewell, was delighted—as were thousands of movie-goers who were eager for a glimpse of Monroe's famous legs.

The mid-1950s were the height of Monroe's career, which took her from wartime factory girl to magazine model, and then on to become one of the most desired and admired performers of her era. In over thirty films she defined the meaning of the "sex symbol" in American popular culture. Among her most notable films are *Some Like It Hot, Gentlemen Prefer Blondes*, and *Bus Stop*.

Marilyn Monroe was born Norma Jean Baker in 1926 in Los Angeles; her mentally unstable mother was institutionalized when Norma Jean was a young child, leaving her to the care of foster parents and orphanages. In 1962 she was found dead in her apartment from an apparent drug overdose. "Oh I just want to be wonderful," she once said, and the tragedy of both her childhood and death have helped create the mythology of Marilyn Monroe.

THE DEATH OF MARILYN MONROE
Sharon Olds

The ambulance men touched her cold
body, lifted it, heavy as iron,
onto the stretcher, tried to close the
mouth, closed the eyes, tied the
arms to the side, turned a sought
strand of hair, as if it mattered,
saw the shape of her breasts, flattened by
gravity, under the sheet,
carried her, as if it were she,
down the steps.

These men were never the same. They went out
afterwards, as they always did,
for a drink or two, but they could not meet
each other's eyes.

Their lives took
a turn—one had nightmares, strange
pains, impotence, depression. One did not
like his work, his wife looked
different, his kids. Even death
seemed different to him—a place where she
would be waiting,

And one found himself standing at night
in the doorway to a room of sleep, listening to
a woman breathing, just an ordinary
woman
breathing.

SEEING

1. What are the implied effects of Marilyn Monroe's death on the men in the poem? How do you interpret the last sentence of Sharon Olds's poem? What do you make of the phrase "just an ordinary/woman/breathing"? What is the effect of the line breaks in the final three lines of the poem?

2. You may already be familiar with this classic image of Marilyn Monroe. Even if you are, try to consider the image as if you're seeing it for the first time. What type of public persona does she display here? What aspects of femininity or sexuality can you find in the photo?

3. Both the Olds poem and the photograph involve representations of the intersection of ordinary people and celebrities. How do the Olds poem and the photograph remind us of the ways in which we turn celebrities into icons?

WRITING

1. Consider carefully the title of Sharon Olds's poem, *The Death of Marilyn Monroe.* We immortalize icons and celebrities through images, songs, and stories. But does a celebrity ever really die? Periodically we hear people proclaim that Elvis is not dead, and in fact in the public arena he may be more alive than ever. Do celebrities achieve greater iconic status in death? Choose a celebrity who died recently. (Princess Diana, Frank Sinatra, and Kurt Cobain might serve as examples.) Write an essay in which you argue for—or against—the proposition that celebrities are granted an even greater iconic status after they die.

2. Both Olds's poem and Shaw's photograph of Marilyn Monroe from *The Seven Year Itch* include men reacting to and looking at Marilyn Monroe. Write an essay in which you compare these two different reactions and try to account for those differences.

RUSSELL BAKER

"I began working in journalism when I was eight years old," Russell Baker wrote in his Pulitzer Prize–winning autobiography, *Growing Up* (1982). "It was my mother's idea. She wanted me to 'make something' of myself and, after a levelheaded appraisal of my strengths, decided I had better start young if I was to have a chance of keeping up with the competition."

Baker, who was born in Baltimore in 1925, has indeed made something of himself in a distinguished career in journalism and letters. The Pulitzer Prize for his autobiography was his second—he had won one for commentary four years earlier. From 1962 to 1999 Baker was an opinion columnist at the *New York Times,* and his comments were reprinted in hundreds of other newspapers in the United States. More recently he has been the host of public television's *Masterpiece Theatre.*

Baker's written work is usually described as humor, which means that he writes in a wry, less reverential way than most opinion writers do. But his points are no less pointed. In the piece that follows (one of Baker's columns from the *New York Times*) notice how effectively his simple, matter-of-fact style skewers what he calls "icon epidemic."

SEEING

1. Summarize Russell Baker's argument. What does he point to as the source for the "icon epidemic" raging in contemporary American culture? How does he organize his case against the continued application of the term *icon?* What standard(s) does he establish for determining whether a person or object can be called an icon?

2. Characterize Baker's tone. Point to specific words and phrases in support of your reading. What effects does Baker achieve by choosing this tone of voice? Which of his examples do you find the most—and the least—convincing? Why?

A *logo* is (1) an identifying statement or motto; (2) a letter, symbol, or sign used to represent an entire word, also called *logogram;* or (3) an identifying symbol (as for advertising), also called a *logotype.*

WRITING

1. Review the celebrities, historical documents, authors, and logos Baker speaks about in his essay. Compare and contrast these icons with those in the advertisement for Mercedes-Benz (see p. 398). To what extent does each icon in Baker's essay fit the criteria outlined by the Mercedes-Benz ad? Explain why. To what extent would Baker consider the images pictured in the Mercedes-Benz ad worthy of the term *icon?* Write an essay in which you adopt the tone of voice and line of argument espoused by Baker in arguing for—or against—the importance of icons in contemporary American culture. What contributions do they make to American life? What cultural liabilities do they present?

2. With the substance and spirit of Baker's essay in mind, consider carefully what evidence you can find to substantiate—or refute—his claim that an "icon epidemic" is raging in contemporary American culture. Gather your evidence by reviewing a broad sample of the newspapers and magazines published within, say, the past two months. Also consider books published on the subject. Write the first draft of an essay in which you argue in support of—or against—Baker's assertions.

ICON EPIDEMIC RAGES

Russell Baker

Disaster! That's what my campaign against icons has ended in. The defeat is not as catastrophic as Custer's at the Little Big Horn, but it is just as total.

I am routed in every newspaper, every magazine, every book. Despite my attacks American writers on all flanks are pelting me senseless with icons.

Wherever you turn another writer is hurling icons. Even the sports page, that sanctuary of good old plain talk, is no longer icon-free. Reading happily along in an essay on corked baseball bats the other day, I was frozen in mid-column to see George Brett being called "an icon of the game."

Why belittle Brett with namby-pamby icon talk? George Brett was one of the best hitters ever; reducing him to an icon cheats him of the high praise he deserves.

Look: Do you think Gale Hayman is in a class with George Brett? When you're two runs behind with two men on base and two out in the ninth inning, whom do you want to see coming to the plate? Gale Hayman or George Brett?

Yet she's an icon too. "Gale Hayman is a beauty icon," reports Update, a publication of the New York Times Syndicate.

So I open a book, a heavy book, a serious book, and what do you suppose leaps off Page 3 before the author has even warmed up? Yep. Icons.

Documents like the Declaration of Independence, the Supreme Court's motto ("Equal Justice Under Law") and even Murphy's and Parkinson's Laws, according to this book, "have become cultural icons."

I drop the book in a fit of icon revulsion and turn to another book. It is good, deep, thoughtful, wise and totally satisfying until the author refers to Theda Bara as "an early icon of cinematic otherness."

And what do you think Barbra Streisand is? "She's kind of like a gay icon," a museum visitor tells a Washington Post writer reporting from the Barbra Streisand Museum in San Francisco.

Vanity Fair takes a look at a guy so rich that his pile tops David Geffen's by a factor of three. For the past two years he had been "eyeing" guess what. Right the first time: an icon. Specifically, the "famed but faltering industry icon," Apple Computer.

But what is this I see on the cover of the *New York Times Book Review?* It is news of yet another book about Virginia Woolf, "an icon and a beacon for most of a century." (Also a writer of considerable talent, maybe not quite the literary equivalent of George Brett, but pretty good.)

There may be an infectious icon epidemic raging at the *Times.* The week after the iconning of Virginia Woolf, a *Times Magazine* story about the Long Island Congresswoman Carolyn McCarthy was headlined, "An Icon Goes to Washington."

Two Sundays earlier the *Week in Review* section referred to Frank Sinatra, Dean Martin and Sammy Davis Jr. as "three icons of swank."

An art review classifies painters like Marsden Hartley, John Marin and Arthur Dove as "historical icons."

Poor dead Che Guevara cannot reappear in the *Times* these days without being iconned. Interviewed by the Magazine, his biographer says Che is "a marketing icon." The *Week in Review* of the same day agrees about his mercantile iconhood:

"When it comes to marketing icons, there is an unmistakable difference between being dead and being alive."

A merchant running a Guevara lookalike contest to sell skis tells the *Times* he "wanted the Che image—just the icon and not the man's doings" for sales promotion.

"They had plundered all the other icons of the 60's," a Guevara biographer tells the *Times.*"

Always competitive with the *Times,* the *Washington Post* has kept the iconic pace. A recent headline converted the old Volkswagen Beetle into "a 60's icon." Its Style section reviewed "three discs of iconic songs." These were not songs about icons, but supposedly about gay culture.

From the *Cincinnati Enquirer* comes grim news for friends of the 1970's. "A Cincinnati icon for that very era" is dying.

That icon is Lucy's in the Sky, a saloon on the glass-walled 12th floor of the Holiday Inn downtown. It's closed.

Will no one save America from iconicization? Anyone who does will become an anti-iconicization icon. ○

ANDY WARHOL

Born Andrew Warhola to Czech immigrant parents in Pittsburgh, Pennsylvania, the artist now known simply as "Warhol" (1928–1987) began collecting movie-star photographs and autographs as a young child. This fascination with all things glamorous helped fuel his successful career as a commercial fashion artist in New York in the 1950s.

By 1963 Warhol was at the center of the American pop art movement, which sought to erase the boundary between fine art and popular culture. By painting Campbell's Soup can labels on canvas and installing a sculpture of Brillo boxes, Warhol proposed an aesthetic in which the machine-made image competed with the hand-made for significance, and "image" very often was the subject itself. This was especially explicit in his paintings of Marilyn Monroe, which were based on a publicity "headshot." Warhol reproduced, altered, and transformed her face into a series of brightly colored semi-abstract icons.

Warhol's studio loft in Greenwich Village became known as "The Factory," a meeting place for New York's avant-garde. Here Warhol created experimental films such as *Sleep* (1963) and *Chelsea Girls* (1966). Of this work he said, "All my films are artificial, but then everything is sort of artificial. I don't know where the artificial stops and the real starts."

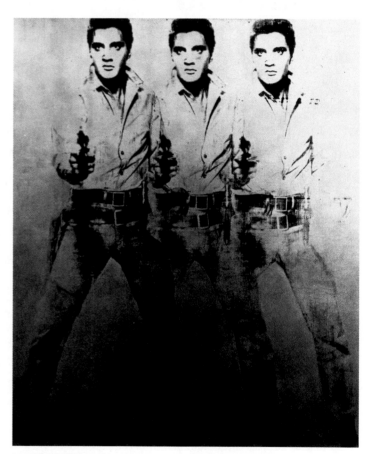

Large Triple Elvis, 1963

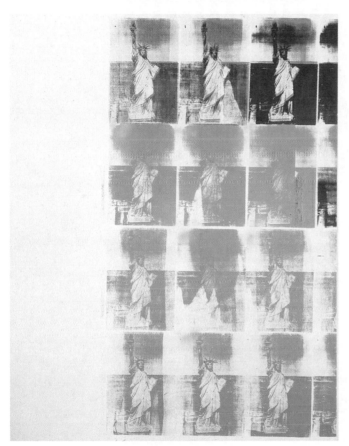

Statue of Liberty, 1963

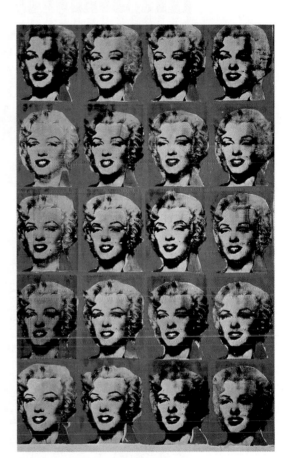

The Twenty Marilyns, 1962

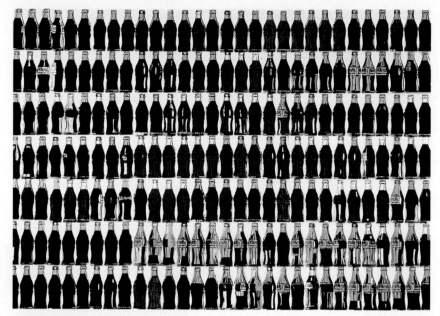

210 Coca-Cola Bottles, 1962

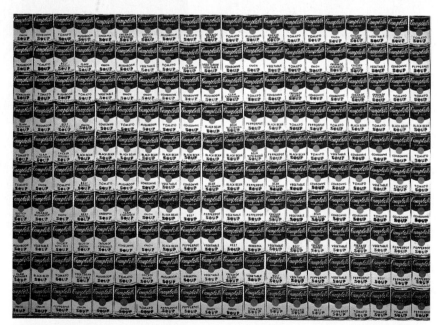

Two Hundred Campbell's Soup Cans, 1962

SEEING

1. What shared characteristics can you identify among these Andy Warhol paintings? What does he gain—and lose—by repeating images: Elvis, Marilyn, soup cans, Coca-Cola bottles, the Statue of Liberty? How does Warhol use color in each of these paintings? What is the overall effect of putting these separate paintings together on a page?

2. What is unique about each of these paintings? What features of the advertising success of Campbell Soup, for example, does Warhol emphasize? Why do you think he chooses to show Elvis as a pistol-packing cowboy? What role does repetition play in each painting? Please remember to point to specific aspects of each painting when formulating your response. For each painting, try to identify a distinct message that you see Warhol making—along with any cultural values you can read in the paintings as a group.

WRITING

1. Given what you have observed in these paintings, what role do you think originality and uniqueness play in Warhol's aesthetics? What cultural virtues and values seem to be privileged in his art? Draft an essay in which you explicate the relationship between the subjects and techniques of Warhol's paintings and the rise of American mass production in the decades following World War II. What role does duplication play in Warhol's painting and in that culture?

2. Compare and contrast Warhol's depiction of Marilyn Monroe with the other renditions of her as an American icon in this chapter. (See, for example, the poem by Sharon Olds and the poster photograph for *The Seven Year Itch* on pp. 402 and 403, respectively.) Draft an essay in which you argue that one of these "images" of Monroe is more memorable than the others. Please be sure to validate each of your assertions by pointing to specific evidence in the texts you choose to discuss.

HOLLY BRUBACH >

A former style editor for the *New York Times Magazine,* Holly Brubach has written on topics as diverse as luggage and architecture. According to one critic, she is "a writer who could make a safety pin sound interesting."

Brubach's writing on the style scene goes far beyond fashion predictions to analyze the advertising strategies behind such phenomena as "heroin chic" or to examine the changing images of feminine identity—from both academic and popular perspectives.

In her book *Girlfriend: Men, Women, and Drag* (1999) with photographer Michael James O'Brien, Brubach examines drag (men dressing in women's clothing) as a conjunction of many issues concerning sex and gender. The book surveys the various "drag scenes" in major cities around the world. Brubach writes, "Drag is a subject capable of triggering ferocious responses in a wide variety of people. There are men (both straight and gay) who abhor drag for its flamboyant display, who find it alarming that the transition from masculine to feminine can be made so easily."

Brubach has won numerous awards for her journalism, and she has worked as staff writer for the *Atlanta Times* and the *New York Times,* as a fashion columnist, and as a style editor for the *New York Times Magazine.* A native of Pittsburgh, she now divides her time between New York and Milan.

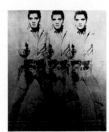 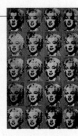

Holly Brubach

Heroine

It's the 90's, and the pantheon we've built to house the women in our minds is getting crowded. **Elizabeth Taylor, Eleanor Roosevelt, Oprah Winfrey, Alanis Morissette, Indira Gandhi, Claudia Schiffer, Coco Chanel, Doris Day, Aretha Franklin, Jackie Onassis, Rosa Parks**—they're all there, the dead and the living side by side, contemporaneous in our imaginations. On television and in the movies, in advertising and magazines, their images are scattered across the landscape of our everyday lives.

Their presence is sometimes decorative, sometimes uplifting, occasionally infuriating. The criteria for appointment to this ad hoc hall of fame that takes up so much space in our thoughts and in our culture may at first glance appear to be utterly random. In fact, irrespective of their achievements, most of these women have been apotheosized primarily on the basis of their ability to appeal to our fantasies.

An icon is a human sound bite, an individual reduced to a name, a face and an idea; Dale Evans, the compassionate cowgirl. In some cases, just the name and an idea suffice. Few people would recognize Helen Keller in a photograph, but her name has become synonymous with being blind and deaf to such an extent that she has inspired an entire category of jokes. Greta Garbo has gone down in collective memory as an exalted enigma with a slogan about being alone. Asking a man if that's a gun in his pocket is all it takes to invoke Mae West. Catherine Deneuve's face, pictured on a stamp, is the emblem of France. Virginia Woolf has her own T-shirt. Naomi Campbell has her own doll. Celebrity being the engine that drives our culture, these women have been taken up by the

Worship
the age of the female icon

media and made famous, packaged as commodities and marketed to a public eager for novelty and easily bored.

Many worthy women are acknowledged for their accomplishments but never take on the status of an icon. Many women are acknowledged as icons but for one reason or another are absent from the pages of this special issue, which is by no means comprehensive. The sheer number of icons now in circulation makes any attempt to catalogue them all impossible. Of the women included here, who they are—or were—is in some respects not nearly as significant as what they've come to stand for. Kate Axelrod, the 11-year-old on our cover, stands not only for the girls of her generation, whose identities are in the formative stages, but for women of all ages, who tend to regard themselves as works in progress.

Our icons are by no means exclusively female, but the male ones are perhaps less ubiquitous and more accessible. The pedestals we put them on are lower; the service they are called on to perform is somewhat different.

Like women, men presumably look to icons for tips that they can take away and apply to their lives. The men who are elevated to the status of icons are the ones who are eminently cool, whose moves the average guy can steal. They do not prompt a fit of introspection (much less of self-recrimination), as female icons often do in women. What a male icon inspires in other men is not so much the desire to be him as the desire to be accepted by him—to be buddies, to shoot pool together, to go drinking. I have all this on good authority from a man of my acquaintance who insists that, though regular guys may envy, say, Robert Redford for his ability to knock women dead, what they're thinking as they watch him in a movie is not "Hey, I wonder if I have what it takes to do that, too," but "I wonder if Redford would like to hang out with me."

Whereas women may look at an icon like Raquel Welch, whose appeal is clearly to the male half of humanity, and ask themselves, "If that's what's required to appeal to a man, have I got it, or can I get it?" (The thought of hanging out with

Welch—going shopping together or talking about boyfriends—would, I think it's safe to say, never cross most women's minds.)

An entire industry, called fashion, has grown up around the business of convincing women that they need to remake themselves in someone else's image: makeup and clothes and other products are presented not as alterations but as improvements. The notion of appearance and personality as a project to be undertaken is inculcated early on. A man may choose to ignore certain male icons; a woman has no such luxury where the great majority of female icons are concerned. She must come to terms with them, defining herself in relation to them—emulating some, rejecting others. In certain cases, a single icon may exist for her as both an example and a reproach.

Our male icons are simply the latest entries in a tradition of long standing, broad enough in any given era to encompass any number of prominent men. But the current array of female icons is a recent phenomenon, the outgrowth of aspirations many of which date back no more than 100 years.

What were the images of women that informed 10 the life of a girl growing up 200 years ago? It's hard for us to imagine the world before it was wallpapered with ads, before it was inundated with all the visual "information" that comes our way in the course of an average day and competes with real people and events for our attention. There were no magazines, no photographs. In church, a girl would have seen renderings of the Virgin Mary and the saints. She may have encountered portraits of royalty, whose station, unless she'd been born an aristocrat, must have seemed even more unattainable than that of the saints. There were picturesque genre paintings depicting peasants and chambermaids, to be seen at the public salons, if anyone thought to bring a girl to them. But the most ambitious artists concentrated on pagan goddesses and mythological women, who, being Olympian, inhabited a plane so lofty that they were presumably immune to quotidian concerns. History and fiction, for the girl who had access to them, contained tales of women whose lives had been somewhat more enterprising and action-packed than those of the women she saw around her, but her knowledge of most women's exploits in her own time would have been limited to hearsay: a woman had written a novel, a woman had played hostess to one of the greatest philosophers of the age and discussed ideas with him, a woman had disguised herself as a man and gone to war. Most likely, a girl would have modeled herself on a female relative, or on a woman in her community. The great beauty who set the standard by which others were measured would have been the one in their midst—the prettiest girl in town, whose fame was local.

Nineteenth-century icons like Sarah Bernhardt and George Sand would have imparted no more in the way of inspiration; their careers were predicated on their talents, which had been bestowed by God. It was Florence Nightingale who finally provided an example that was practicable, one to which well-born girls could aspire, and hundreds of women followed her into nursing.

Today, the images of women confronting a girl growing up in our culture are far more diverse, though not all of them can be interpreted as signs of progress. A woman who in former times might have served as the model for some painter's rendering of one or another pagan goddess is now deployed to sell us cars and soap. The great beauty has been chosen from an international field of contenders. At the movies, we see the stories of fictional women brought to life by real actresses whose own lives have become the stuff of fiction. In the news, we read about women running countries, directing corporations and venturing into outer space.

The conditions that in our century have made possible this proliferation of female icons were of course brought on by the convergence of advances in women's rights and the growth of the media into an industry. As women accomplished the unprecedented, the press took them up and made them famous, trafficking in their accomplishments, their opinions, their fates. If, compared with the male icons of our time, our female icons seem to loom larger in our culture and to cast a longer shadow, perhaps it's because in so many cases their stories have had the urgency of history in the making.

When it comes to looking at women, we're all voyeurs, men and women alike. Does our urge to study the contours of their flesh and the changes in their faces stem from some primal longing to be reunited with the body that gave us life? Women have been the immemorial repository of male fantasies—a lonesome role that many are nonetheless loath to relinquish, given the power it confers and the oblique satisfaction it brings. The curiosity and desire inherent in the so-called male gaze, deplored for the way it has objectified women in art and in films, are matched on women's part by the need to assess our own potential to be found beautiful and by the pleasure in putting ourselves in the position of the woman being admired.

Our contemporary images of women are descended from a centuries-old tradition and, inevitably, they are seen in its light. Women have often been universalized, made allegorical. The figure who represents Liberty, or Justice, to say nothing of Lust or Wrath, is a woman, not a man— a tradition that persists: there is no Mr. America. The unidentified woman in innumerable paintings—landscapes, genre scenes, mythological scenes—transcends her circumstances and becomes Woman. It's the particular that is customarily celebrated in men, and the general in woman. Even our collective notions of beauty reflect this: a man's idiosyncrasies enhance his looks; a woman's detract from hers.

"I'm every woman, it's all in me," Chaka Khan sings, and the chords in the bass modulate optimistically upward, in a surge of possibility. Not all that long ago, the notion that any woman could be every woman would have been dismissed as blatantly absurd, but to our minds it makes evident sense, in keeping with the logic that we can be anything we want to be—the cardinal rule of the human-potential movement and an assumption that in America today is so widely accepted and dearly held that it might as well be written into the Constitution. Our icons are at this point sufficiently plentiful that to model ourselves on only one of them would seem arbitrary and limiting, when in fact we can take charge in the manner of Katharine Hepburn, strut in the way we learned by watching Tina Turner, flirt in the tradition of Rita Hayworth, grow old with dignity in the style of Georgia O'Keeffe. In the spirit of post-modernism, we piece our selves together, assembling the examples of several women in a single personality— a process that makes for some unprecedented combinations, like Madonna: the siren who lifts weights and becomes a mother. We contemplate the women who have been singled out in our culture and the permutations of femininity they represent. About to move on to the next century, we call on various aspects of them as we reconfigure our lives, deciding which aspects of our selves we want to take with us and which aspects we want to leave behind. ○

SEEING

1. Holly Brubach defines the modern icon as a "human sound bite, an individual reduced to a name, a face and an idea" (para. 3). How does she argue that the nature and impact of human icons have changed over time? What other definitions of the term *icon* does she work with in this essay? What sources does she draw on? What evidence does she use to substantiate each of her claims? Where, in your judgment, does her reasoning seem to fall short?

2. What distinctions does Brubach draw between the ways in which women and men relate to female and male icons, respectively? How do her assertions resonate with—or differ from—your own experience with male and female icons? Choose a particular cultural icon to illustrate your point. The editors of the *New York Times Magazine* had to choose certain female icons to include as illustrations for Brubach's article (not shown here). Which ones would you choose to illustrate "Heroine Worship"? Explain why.

WRITING

1. Reread the following passage several times, until you feel comfortable dealing with its substance and implications for self-identity: "we piece our selves together, assembling the examples of several women in a single personality—a process that makes for some unprecedented combinations, like Madonna: the siren who lifts weights and becomes a mother" (para. 16). Consider carefully the ways in which you "piece [yourself] together" and especially the ways in which you rely in this process on connecting your identity to the role model(s) and heroes/heroines in your own life. Draft an essay in which you account for the role of male or female icons in establishing your identity.

2. Over 200 years ago, Brubach argues, a young woman most likely "would have modeled herself on a female relative, or on a woman in her community" (para. 10). Explain how the current era of "visual information" has changed our relationship to the role of icons, models, and celebrities in American culture, citing as examples the male and female icons *you* find most important.

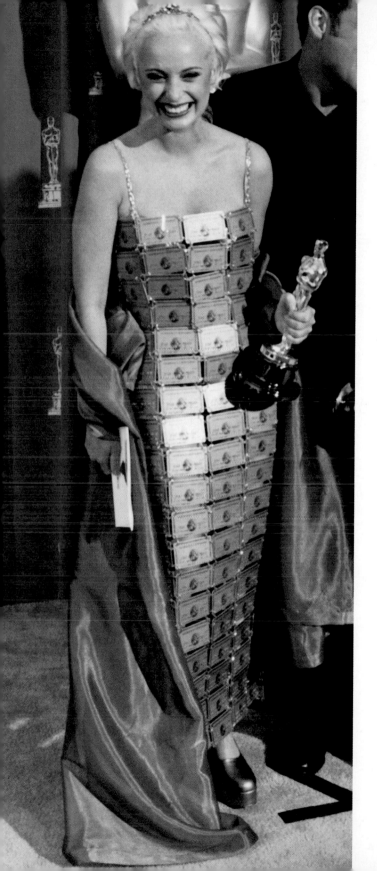

I was looking for an American symbol. A Coca-Cola bottle or a Mickey Mouse would have been ridiculous, doing anything with the American flag would have been insulting, and Cadillac hubcaps were just too uncomfortable.

– Lizzy Gardiner on her choice of the American Express gold card to wear to the 1995 Academy Awards, where she accepted an Oscar for best costume design.

Tony Zajkowski, **Lotion Logos, 1991**

PAUL RAND

Paul Rand was one of the most influential graphic designers of the twentieth century. He was a seminal figure in applying modern design and in developing the idea that meaning could be conveyed by visual images and not simply by words. Before he began working in the 1930s, advertising was cluttered with hard-sell text and small, realistic pictures. Rand began using white space, clean modern typefaces, imaginative layout, and logos—simple graphic devices that were intended to capture and convey the essence of a company's product or service. He is perhaps best known for designing the corporate logos of IBM (1956), Westinghouse (1960), United Parcel Service (1961), ABC (1962), and Next computers (1986).

Rand grew up and went to art school in New York, and he did most of his work there. From 1956 to 1993 he was a professor of graphic design at Yale University. He wrote several books, including *Thoughts on Design* (1946), which influenced generations of designers, and *Design, Form and Chaos* (1994), in which he complained that "The absence of restraint, the equation of simplicity with shallowness, complexity with depth of understanding and obscurity with innovations, distinguishes the work of these times." Rand died in 1996 at the age of 82.

LOGOS, FLAGS, AND ESCUTCHEONS
Paul Rand

"IT REMINDS ME OF THE GEORGIA CHAIN GANG," quipped the IBM executive, when he first eyed the striped logo. When the Westinghouse insignia (1960) was first seen, it was greeted similarly with such gibes as "this looks like a pawnbroker's sign." How many exemplary works have gone down the drain, because of such pedestrian fault-finding? Bad design is frequently the consequence of mindless dabbling, and the difficulty is not confined merely to the design of logos. This lack of understanding pervades all visual design.

There is no accounting for people's perceptions. Some see a logo, or anything else that's seeable, the way they see a Rorschach inkblot. Others look without seeing either the meaning or even the function of a logo. It is perhaps, this sort of problem that prompted ABC TV to toy with the idea of "updating" their logo (1962). They realized the folly only after a market survey revealed high audience recognition. This is to say nothing of the intrinsic value of a well-established symbol. *When* a logo is designed is irrelevant; *quality*, not *vintage* nor *vanity*, is the determining factor.

There are as many reasons for designing a new logo, or updating an old one, as there are opinions. The belief that a new or updated design will be some kind of charm that will magically transform any business, is not uncommon. A redesigned logo may have the advantage of implying something new, something improved—but this is short-lived if a company doesn't live up to its claims. Sometimes a logo is redesigned because it really needs redesigning—because it's ugly, old fashioned, or inappropriate. But many times, it is merely to feed someone's ego, to

satisfy a CEO who doesn't wish to be linked with the past, or often because it's the thing to do.

Opposed to the idea of arbitrarily changing a logo, there's the "let's leave it alone" school—sometimes wise, more often superstitious, occasionally nostalgic or, at times, even trepidatious. Not long ago, I offered to make some minor adjustments to the UPS (1961) logo. This offer was unceremoniously turned down, even though compensation played no role. If a design can be refined, without disturbing its image, it seems reasonable to do so. A logo, after all, is an instrument of pride and should be shown at its best.

If, in the business of communications, "image is king," the essence of this image, the logo, is a jewel in its crown. [5]

Here's what a logo is and does:

A logo is a flag, a signature, an escutcheon.

A logo doesn't sell (directly), it *identifies.*

A logo is rarely a description of a business.

A logo derives its *meaning* from the quality of the thing it symbolizes, not the other way around. [10]

A logo is *less* important than the product it signifies; what it means is more important than what it looks like.

A logo appears in many guises: a signature is a kind of logo, so is a flag. The French flag, for example, or the flag of Saudi Arabia, are aesthetically pleasing symbols. One happens to be pure geometry, the other a combination of Arabic script, together with an elegant saber—two diametrically opposed visual concepts; yet both function effectively. Their appeal, however, is more than a matter of aesthetics. In battle, a flag can be a friend or foe. The ugliest flag is beautiful if it happens to be on your side. "Beauty,"

they say, "is in the eye of the beholder," in peace or in war, in flags or in logos. We all believe *our* flag the most beautiful; this tells us something about logos.

Should a logo be self-explanatory? It is only by association with a product, a service, a business, or a corporation that a logo takes on any real meaning. It derives its meaning and usefulness from the quality of that which it symbolizes. If a company is second rate, the logo will eventually be perceived as second rate. It is foolhardy to believe that a logo will do its job right off, before an audience has been properly conditioned. Only after it becomes familiar does a logo function as intended; and only when the product or service has been judged effective or ineffective, suitable or unsuitable, does it become truly representative.

Logos may also be designed to deceive; and deception assumes many forms, from imitating some peculiarity to outright copying. Design is a two-faced monster. One of the most benign symbols, the swastika, lost its place in the pantheon of the civilized when it was linked to evil, but its intrinsic quality remains indisputable. This explains the tenacity of good design.

The role of the logo is to point, to designate—in as 15 simple a manner as possible. A design that is complex, like a fussy illustration or an arcane abstraction, harbors a self-destruct mechanism. Simple ideas, as well as simple designs are, ironically, the products of circuitous mental purposes. Simplicity is difficult to achieve, yet worth the effort.

The effectiveness of a logo depends on:
 a. distinctiveness
 b. visibility
 c. useability
 d. memorability
 e. universality
 f. durability
 g. timelessness

Most of us believe that the subject matter of a logo depends on the kind of business or service involved. Who is the audience? How is it marketed? What is the media? These are some of the considerations. An animal might suit one category, at the same time that it would be anathema in another. Numerals are possible candidates: 747, 7-Up, 7-11, and so are letters, which are not only possible but most common. However, the subject matter of a logo is of relatively little importance; nor, it seems, does appropriateness always play a significant role. This does not imply that appropriateness is undesirable. It merely indicates that a one-to-one relationship, between a symbol and what is symbolized, is very often impossible to achieve and, under certain conditions, may even be objectionable. Ultimately, the only thing mandatory, it seems, is that a logo be attractive, reproducible in one color, and in exceedingly small sizes.

The Mercedes symbol, for example, has nothing to do with automobiles; yet it is a great symbol, not because its design is great, but because it stands for a great product. The same can be said about apples and computers. Few people realize that a *bat* is the symbol of authenticity for Bacardi Rum; yet Bacardi is still being imbibed. Lacoste sportswear, for example, has nothing to do with alligators (or crocodiles), and yet the little green reptile is a memorable and profitable symbol. What makes the Rolls Royce emblem so distinguished is *not* its design (which is commonplace), but the *quality* of the automobile for which it stands. Similarly, the signature of George Washington is distinguished not only for its calligraphy, but because Washington was Washington. Who cares how badly the signature is scribbled on a check, if the check doesn't bounce? Likes or dislikes should play no part in the problem of identification; nor should they have anything to do with approval or disapproval. Utopia!

All this seems to imply that good design is superfluous. Design, good or bad, is a vehicle of memory. Good design adds value of some kind and, incidentally, could be sheer pleasure; it respects the viewer—his sensibilities—and rewards the entrepreneur. It is easier to remember a well designed image than one that is muddled. A well designed logo, in the end, is a reflection of the business it symbolizes. It connotes a thoughtful and purposeful enterprise, and mirrors the *quality* of its products and services. It is good public relations—a harbinger of good will.

It says "We care." ○ 20

SEEING

1. What, according to Paul Rand, are the most important factors in determining the effectiveness of a logo? What does he mean when he says, "We all believe *our* flag the most beautiful; this tells us something about logos" (para. 12)? What, for Rand, is the difference between "looking" and "seeing"? Do you agree with Rand's seven criteria for effectiveness, based on your own experience with corporate logos? Explain why.

2. Musician Tony Zajkowski manipulated a set of logos for his band, Lotion, and pasted them on fences and walls around New York City (see p. 418). Which of these "Lotion" brand names can you identify with a specific product? How might these images have caught your attention if you saw one while you were walking down the street? What aspect of Zajkowski's approach might make it an effective advertising campaign for a band?

WRITING

1. Choose a corporate logo that has been redesigned at least once. Make detailed notes on the different versions. Write an essay in which you compare and contrast the effectiveness of the original and revised versions of the corporate logo. Which one do you prefer? Why?

2. Imagine that you work for a marketing firm and that you and your colleagues are in charge of designing a new logo for an important corporate client. Decide which company you have as a client, and prepare at least a rough sketch of the new logo. Then write a draft of the statement that will persuade your client to adopt this logo as an image of its corporate public identity.

 Talking Pictures

One of the most important aspects of extending and enriching the marketing success of any product is developing a widely recognized and well-respected corporate logo, what Paul Rand in "Logos, Flags, and Escutcheons" (p. 419) calls "a two-faced monster" (para. 14). Review carefully the criteria Rand lists for measuring the effectiveness of a logo (see para. 16). Now turn your attention to any readily recognized logo you have seen on television recently. What do you notice about the design of this logo that strikes you as especially effective? Why? Measure the success of this logo against Rand's criteria.

As you work your way through each of these criteria, please be sure to validate every assertion you make about the logo's effectiveness by pointing to specific evidence in the nature—and implied significance—of the logo. Write an analytical essay in which you use Rand's criteria to assess the effectiveness of the logo you have chosen to discuss.

BRANDING

by ADBUSTERS

With so many school districts strapped for cash, the monetary void is increasingly being filled by corporate sponsorships. The newest program implemented in secondary and even elementary schools has been the Tattoo You Too! program. In exchange for a fixed fee (based on the number of participants) students "volunteer" to receive a stylized and updated tattoo of common and famous corporate logos.

"It's a win-win situation" said Christopher Simmons, principal of Applegate High School, in Akron, Ohio. "With the current tattooing fad, kids get a chance to look 'hip' while earning money for the school. It only takes four tattoos to purchase a new computer. We've been overwhelmed by its success."

Those opposed to the program are outraged by this new trend. Angry parents have attacked the program, after seeing their sons and daughters arrive home sporting the Nike "swoosh" or a grinning Joe Camel tattoo. The lack of consent forms has bothered many.

However, most participants in the program echo principal Simmons' sentiments. Stevie Beecher, a student at Applegate, commented, "I never thought high school could be this enjoyable. I mean it's hard work, trying to balance studying and partying, but now that I'm getting free tattoos, I'm almost glad I have to go to school. It makes it all worthwhile somehow, and it's a permanent keepsake of my formative years."

Besides raising much needed money for their schools, participating students receive a 20% discount on the products for which they have tattoos. Beecher enthused, "I'd cover my entire body with tattoos if they'd let me."

The companies themselves are also very pleased with the response. Said Brad Randolph, industry insider, "This is wonderful. It delights me to see that so many people's lives are being enriched by such an innovative program."

Fortunately (or unfortunately according to Beecher), students are limited to three tattoos each. "We wanted to keep some reasonable limits on the number and size of these tattoos. I mean, the last thing we want is our students to become walking billboards," concluded Simmons.

Reprinted with permission from the New York Times, *Dec. 12, 1999.*

ADBUSTERS

"We want a new media environment, one without a commercial heart and soul," asserts the Media Foundation, and producing *Adbusters*, a nonprofit magazine, is one of their core tactics. This Canadian magazine boasts an international circulation of 40,000, and two-thirds of its subscribers live in the United States. *Adbusters* is perhaps best known for its "spoof ads" in which designers manipulate corporate advertisements in subtle but humorous ways, provoking us to rethink the messages and assumptions of the ads we encounter every day.

The magazine also features criticism of corporate advertising campaigns and reports on international activist campaigns, as well as its own annual campaigns such as "Buy Nothing Day" and "TV Turnoff Week." "Ultimately," say the editors, "*Adbusters* is an ecological magazine, dedicated to examining the relationship between human beings and their physical and mental environment. We want a world in which the economy and ecology resonate in balance. We try to coax people from spectator to participant in this quest. We want folks to get mad about corporate disinformation, injustices in the global economy, and any industry that pollutes our physical or mental commons." In this spoof article from spring 1997, *Adbusters* created a "report" on a fictional "Tattoo You Too!" corporate sponsorship in schools program.

SEEING

1. As you examine this image, identify which aspects of the photograph your eye is drawn to—and in roughly what sequence. Are you first drawn, for example, to the faces of the young people depicted? to the tattoos they are displaying? to something else? (If so, please identify.) What evidence can you identify in support of your estimate of the age of these young people? How would you characterize each one's expression? Focus your attention for a few moments on the corporate logos presented in the image. What do they have in common? (You might consider, for example, their design as well as the intended audience of each.) In what ways are the logos different? similar?

2. *Adbusters* printed this image as an illustration to accompany a spoof *New York Times* article summarizing this recent (fictional) trend in corporate sponsorship. What's the apparent joke here? How effective do you think it is? Why might the idea of students tattooing logos on their bodies strike you as shocking (or not)? How is tattooing different from displaying logos on clothing or accessories?

WRITING

1. Choose any issue of a widely distributed and popular magazine aimed at a young audience (*Teen People*, *Spin*, or *Sassy*, for example). Review the advertisements in the magazine carefully, and select one as the focal point of your effort to prepare a "subvertisement." After you have literally sketched out what this subvertisement might look like, write a detailed description of particular visual aspects of the original advertisement you sought to subvert, and how doing so undermined the cultural values projected in the original advertisement.

2. Given the aspirations announced by the editors of *Adbusters*, write an essay in which you assess the effectiveness of the spoof reprinted here. Which strategies do you judge the most—and least—effective in creating the spoof? Explain why.

Retrospect:
Betty Crocker

1936

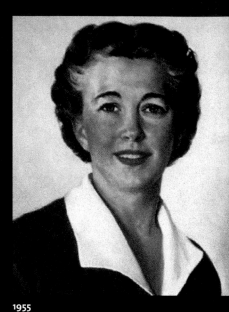

1955

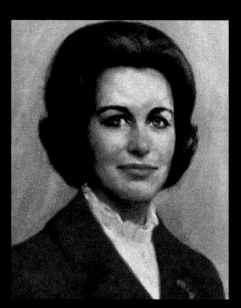

1972

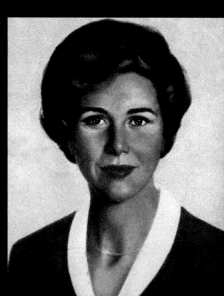

1980

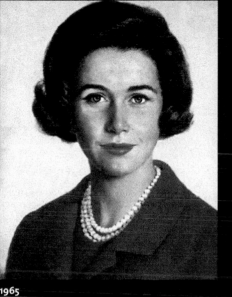

1965

1968

1986

1996

AARON BETSKY

Aaron Betsky, the curator of architecture and design at the San Francisco Museum of Modern Art, has a special interest in images and their meanings. In 1997 he mounted an exhibition called "Icons: Magnets of Meaning," which contained a large number of familiar, mass-produced objects and underscored the idea that everyday things can have cultural significance. Betsky is also a teacher and writer who has published articles on design in leading magazines. He has written eight books as well, most recently *Queer Space: Architecture and Same-Sex Desire* (1997).

Betsky was born in Missoula, Montana, in 1958, but went to grade school and high school in the Netherlands. He earned bachelor of arts and master of architecture degrees at Yale University, taught briefly at the University of Cincinnati, and then moved to Los Angeles, where he worked with the architect Frank Gehry before starting his own design practice. He joined the San Francisco Museum of Modern Art in 1995.

AN EMBLEM OF CRISIS MADE THE WORLD SEE THE BODY ANEW

Aaron Betsky

The ribbon is everywhere. Draped from dresses and T-shirts, it reminds us of runaway children, breast cancer and, most of all, AIDS. It started as a red sign to remind us of those lost to AIDS. It has since appeared as a string of rubies in a Tiffany version and as a thong, the only thing covering otherwise naked men in parades. It has become the shorthand sign for loss, suffering, anger, disease and a commitment not to just let things happen to us.

The first version of the AIDS ribbon was the 1991 invention of the artist Frank Moore and the New York advocacy group Visual Aids. "What we did was to take something that people tied around trees and put it on the body," Mr. Moore says. "My neighbors in upstate New York had a daughter in the Gulf War, and they tied a yellow ribbon around a tree in their yard. It wasn't a political thing, just a gesture of support for their child. I took that idea and suggested we turn it into something you could wear."

Few other emblems in our society are as succinct and as recognizable as the AIDS ribbon. It has all the power of a good advertising gimmick and all the immediacy of a cry in the streets, wrapped in a little curl attached to the body. It shows us how good artists and de-signers have become at honing a message and how versatile signs have become in our society. The ribbon is art as both advertising and as a political statement. And because of it, we now have a new form of art: an icon of and on the body.

On Thursday, Mr. Moore and Barbara Hunt, the director of Visual Aids, will discuss the history and significance of this little loop of fabric at a program at the Cooper-Hewitt National Design Museum in Manhattan. The enduring presence of the ribbon and its power as a graphic image is a reminder not only of the still raging AIDS epidemic but also of how the responses to the crisis changed the face of art and design.

Gay men, who were the most visible and media-savvy group to face the epidemic, responded to it with art and design of a particularly powerful kind. The AIDS crisis brought them back to simple gestures. In the late 1980's and early 1990's, Americans in our cities were confronted with both the ribbon and the pink triangle that the Nazis had used to designate homosexuals, the latter accompanied by the reductive statement "Silence = Death." They were also exposed to slogans like "Men use condoms or beat it" and photographs of men kissing ("Kissing doesn't kill: Greed and indifference do.").

Activist artists used such strong words and images because, as the Los Angeles graphic designer and educator Lorraine Wild puts it, to get their message across "they had to compete in the same arena as Pepsi and Nike." To do that, she says, they had to be "conventional in form and subversive in content." This was a deliberate decision. Douglas Crimp, an art historian and critic who was the guiding force behind many such campaigns, says: "The esthetic values of the traditional art world are of little consequence to AIDS activists. What counts in activist art is its propaganda effect."

Borrowing techniques from Madison Avenue and political propaganda and using a visual shorthand learned from the pop artists of the 1960's and 1970's, these designers made AIDS famous. Ultimately, the crisis also brought both them and art back to the body—the body as something that we inhabit and that makes us mortal, the body as an object of sexual desire or a vehicle for advertising, and the body as something real that stands against the otherworldly and precious objects that are usually graced with the name of art. The AIDS crisis put the hot body back into the cool medium of mass communication.

"It brought modern art back to its roots," says Robert Atkins, a New York art historian who is working on a book about the relationship between art and AIDS. He draws a parallel between the focus on the body in the art and graphics of the AIDS crisis and the paintings of the French Revolution. Painters like Jacques Louis David, Mr. Atkins says, tried to paint real people who rose in crisis to heroic action. Stripped almost naked, they stood

as the focal point of history, "neither idealized nor allegorized." The emphasis on the body also referred to the 16th- and 17th-century tradition of the "memento mori," in which paintings of such emblematic figures as skulls or rotting fruit reminded viewers that they, too, would die.

The AIDS crisis gave that tradition new life. It is prominent in the work of Matthew Barney, whose "Cremaster 1," a Busby Berkeley–like video work, is an allegory on H.I.V. and its progression. It is also present in the work of artists like Cindy Sherman, Noland Blake and Andres Serrano, who allude directly to the blood and mucus of the body as reminders of its reality.

Such blood-and-guts forms of art 10 became a staple of AIDS activism as a result of a series of controversial

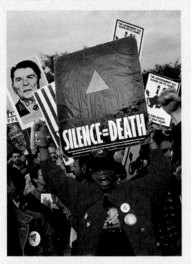

Silence = Death

exhibitions organized by Mr. Crimp and the American Foundation for AIDS Research. One storm arose, for example, over Mr. Serrano's infamous photograph of a crucifix submerged in a jar of urine, produced with the help of money from the National Endowment for the Arts. This was not art that hid its message in a closet of high art: it had all the directness of an advertisement or a police photograph.

Paradoxically, the epidemic was also a reminder of the beauty of the body and how it awakes desires. The history of art is filled with seductive figures, but the notion of portraying subjects as sex objects had lost favor after Picasso's erotic paintings of his wives and mistresses. The eroticized body in art was alive and well, however, in the realm of fashion photography, and artists like Steve Meisel brought it into the world of AIDS activism with such posters as his 1990 "Safe sex is hot sex" image of two naked men in an intimate pose.

Artists like Keith Haring delighted in showing men exploring sexuality with abandon, as if in defiance of the disease. Such an emphasis on the continued importance of the joy of sex was a mainstay of many AIDS-awareness campaigns. Advocacy groups like the Gay Men's Health Crisis in New York and foreign information agencies presented posters of men having safe sex in sensual and attractive poses. Sex, these images were saying, could and should still be fun, and the body could and should still be beautiful.

Since then, naked men have become a staple of the world of advertising. They climb up Abercrombie & Fitch posters and slither across Calvin Klein billboards. They have also become part of the world of high art, whether in the work of Robert Mapplethorpe or, in a more hidden form, in Steven Barker's grainy, only partly decipherable photographs of men having or waiting for sex in clubs—pictures shown recently at the Morris Healy Gallery in Chelsea. Thus the question of whether something was art or advertising was posed in galleries and museums. Such highly sexualized work is, more than anything else, a shorthand for desire and a defiant statement by gay men that, despite the epidemic, they have something to show.

The style of many of the posters, handbills and symbols created by the activists, especially those associated with Act Up, was rough, its shapes deliberately cut-off. It was as if the designers were looking at posters as they hung in the streets rather than as they were designed on clean white tables.

The street, where many gay men 15 had to find their culture and their social relations, was the scene for the crisis and the reaction against it. Thus the work of design collectives like Gran Fury brought the messy urgency, sexuality and urbanity of the cruising grounds and the dance clubs to the world of design.

Urban reality "gave the work its elegance and its harshness, its passionate and fearful nature," says Tom Sokalowski, director of the Andy Warhol Museum in Pittsburgh. Posters that advised men to be careful while having sex took the form of the personal ads and dance-party invitations that invited them to display their bodies. Suffused with the grittiness and immediacy of the real places people inhabit rather than with the cleanliness of the white walls and skylights of a studio, this work made the issue of how to stay healthy not only clear but visceral, immediate and real.

Some of the best of these works are currently on display at the Brooklyn Museum of Art as part of the exhibition "Graphic Alert: AIDS Posters From the Collection of Dr. Edward C. Atwater," which runs through Feb. 8. The exhibition broadens the discussion by including posters produced by gov-

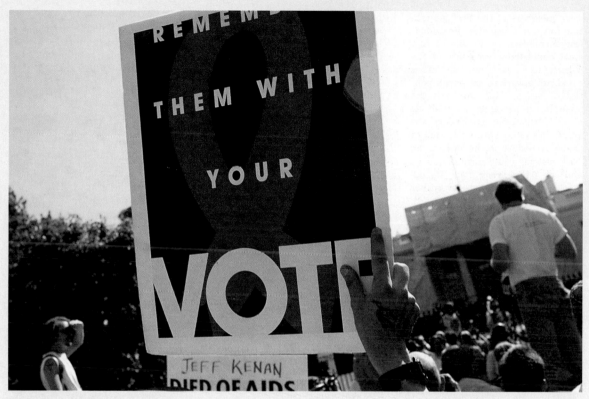

AIDS Ribbon

ernment agencies in third-world countries and in Europe, where taboos against the public display of sexuality are not nearly as great as they are in the United States.

The body as mortal vessel, object of desire and actor in the street had been the subject of art before the AIDS crisis, but it had not been present in all of its raw, sexy and dangerous potential. The body re-entered the scene of activist art because these artists weren't making art. Indeed, they did not see themselves as artists who made work to be hung on museum walls but as people faced with a life-threatening crisis to which they had to respond.

That is why they turned to advertising and propaganda. They looked at Russian constructivist posters, at the cynical and pornographic images that George Grosz and John Heartfield produced during the Weimar Republic, and at the antiwar posters of the 1960's. They looked at Vogue and Playboy but also at the New York tabloids. They imitated the bold advertising style of the firm Doyle Dane Bernbach and of movie posters, mining popular culture for its consumer appeal and turning the glare of advertising techniques on a disease that had until then been ignored by the mass media.

There was also an immediate precedent for this fusion of art and commerce: the work of artists who had learned from Pop Art but who had also had jobs in advertising. "Their work comes directly out of that of Barbara Kruger and Jenny Holzer," says Ms. Wild, the educator. Theoreticians like Roland Barthes and artists like Warhol had for two decades been preaching the victory of what Barthes called "the empire of the sign," the pure, succinct carrier of information, over the musty and more vague domain of art. Now these artists were proclaiming the victory of that sign.

Designs like the red ribbon brought theory and message down to a simple pop art moment. Most of the activist artists and designers

were members of the first generation to come of age after Post-Modernism made it acceptable to beg, steal and borrow any part of the culture to make what the artist could call a work of art—or of politics or design. Not only was the medium the message, but the idea of an identifiable profession was passé. Post-Modernism also taught that our body was the only thing "the system" could not take away, and the AIDS crisis made its defense an issue of necessity rather than theory.

"It was all ephemeral work that just came together at one particular time and could only be sustained for a moment," says Mr. Sokalowski, the museum director. And certainly the moment of creative intensity did not last long. Gran Fury disbanded, Act Up disintegrated and government agencies took over many of their functions, though in a much tempered form.

Yet the impact remained. Artists like Felix Gonzalez-Torres, who died of AIDS-related diseases last year, continued to play on the edge between art and commerce. In an early victory, he convinced the Museum of Modern Art to rent out a billboard displaying a photograph of the empty bed where his dead lover had recently slept. Mapplethorpe, Mr. Noland and Mr. Serrano kept on creating controversy, forcing the public to ask what art was good for, what good art was and why they had to look at body parts in places they thought displayed only beauty.

———

Graphic designers, meanwhile, found that their computers allowed them to create street graphics with amazing speed. Just as quickly, large advertising firms appropriated their styles, so that Nike, Budweiser and American Express all ran ad campaigns based on the ground-breaking work of designers like the members of Gran Fury. The graphic design produced in response to the AIDS crisis made the style of the street part of the world of Madison Avenue.

It was the ability of innovations made in the heat of the moment to be assimilated into the mainstream that was the most lasting achievement of the many designers and artists who contributed to public awareness about the crisis. "That was the whole point of the ribbon," recalls Mr. Moore, the ribbon's creator. "We wanted to reach the thousands and thousands who had lost friends to AIDS, who weren't part of our culture. It was sublimated into the wider culture, and that is great."

The AIDS crisis brought the body, the street and the politics that connect them back into art and design, making it more difficult to define what art is. The performance artist Ron Atthey, who is H.I.V.-positive, presents his own scarification as art. Bruce Weber's photographs of nearly naked preppy ideals are sold in galleries. Mr. Barney stages operas. Keith Haring's Pop Shop continues to do brisk business retailing his perverse figures that are graffiti, icons, advertising figures and art all rolled into one. The ribbon keeps proliferating and changing colors to identify with different diseases or losses.

In our society it seems that politics repeats itself not as farce but as advertising. As soon as a shout is heard on the street, it is sold. As soon as somebody figures out how to present the body in a more seductive fashion, some other body turns that image into a way in which it can resist its disappearance into nothing but a slick image. Graphic design composes, confronts and comports, making it all available to us, the readers, the users, the victims and the buyers of a message.

The red ribbon reminds us not only of what is lost but of how easy it is to mark a body with an emblem that changes meaning as fast as the H.I.V. virus seems to change its defenses against our attempts to frustrate its spread. ○

SEEING

1. What does Aaron Betsky mean when he asserts that the red ribbon provoked a new form of art: "an icon of and on the body"? How, according to Betsky, did artist activists and designers responding to the AIDS crisis make it "more difficult to define what art is" (para. 26)? What does Betsky imply when he says: "The ribbon is art as both advertising and as a political statement. And because of it, we now have a new form of art: an icon of and on the body" (para. 3)? How, according to Betsky, is the ribbon "a reminder not only of the still-raging AIDS epidemic but also of how the responses to the crisis changed the face of art and design" (para. 4)?

2. Comment on Betsky's use of historical examples to support his argument. To what extent do you agree, for example, with his generalizations about the role of the body in art history? What other sources might he explore to find evidence that would support—or refute—his claims?

WRITING

1. Betsky notes: "Ultimately, the [AIDS] crisis also brought both them [designers] and art back to the body—the body as something that we inhabit and that makes us mortal, the body as an object of sexual desire or a vehicle for advertising, and the body as something real that stands against the otherworldly and precious objects that are usually graced with the name of art. The AIDS crisis put the hot body back into the cool medium of mass communication" (para. 7). Write an essay in which you support—or refute—Betsky's proposition. Please validate each of your assertions with a detailed analysis of specific passages.

2. To what extent do you agree with Betsky's assertion that ever since the sexually explicit work of artists such as Keith Haring and the AIDS awareness campaigns, "naked men have become a staple of the world of advertising" (para 13)? What evidence of this trend do you see in newspapers and magazines, and on television? Write an essay in which you document the extent to which this trend has surfaced in contemporary American commercial culture. What are the benefits and liabilities of encouraging and supporting the use of some/any/ all forms of sexually explicit material in advertising?

MADONNA, 1982–1999

"Who do I think I am, trying to pull this off?" jokes Madonna in her 1991 documentary about her "Blonde Ambition" tour, *Truth or Dare*. Indeed few would have predicted that the pop artist whose singing and acting talents have never been highly praised would become one of the most enduring and controversial female icons of our time. Madonna (born Madonna Louise Veronica Ciccone in 1958) has transformed her public image dozens of times. In each incarnation, she has positioned herself as the producer and subject of public controversy—whether battling the Vatican over her artistic freedom to expose herself in videos like "Justify My Love" or being the topic of feminist debates. As she has noted: "People have always had this obsession with me, about my reinvention of myself. I just feel like I'm shedding layers. I'm slowly revealing who I am."

Madonna is considered by many a barometer of—and by others a shaping force in—popular culture. Music critic Ann Powers has written, "If a deity can be defined as a force illuminating the world, then she is a secular goddess, designated by her audience and pundits alike as the human face of social change. Intellectuals have described her as embodying sex, capitalism, and celebrity itself." Madonna's recent productions include the album *Ray of Light* (1998) and another role, that of mother: She gave birth to Lourdes Maria Ciccone Leon in 1996.

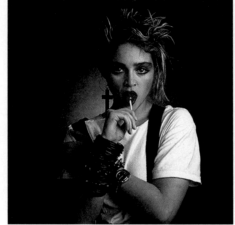

1982

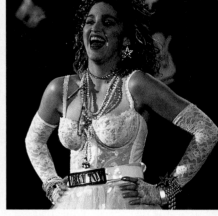

1985

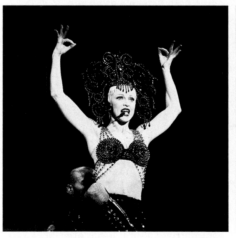

1993

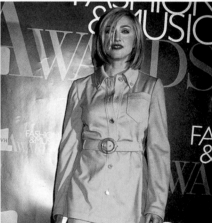

1995

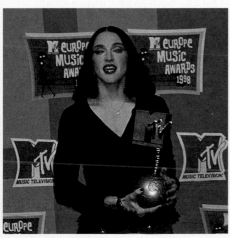

1990

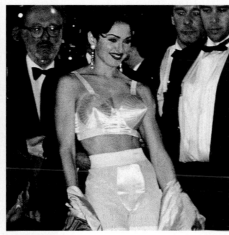

1991

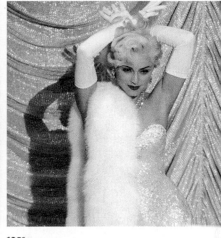

1991

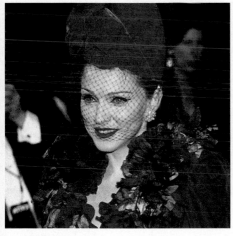

1996

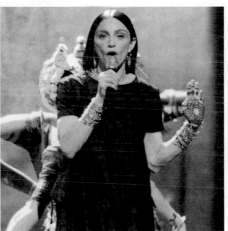

1998

1999

SEEING

1. Examine carefully the photographic sequence of Madonna's public persona—from her earliest public appearances through 1999. What identity does she project in each image? For example, in what ways is the image of her sucking on a lollypop similar to—and different from—that of her as a "Boy Toy"? Follow this pattern in observing the similarities and differences between one image and the next in this sequence. What overall pattern of observations emerges from your analysis? What reasonable inferences can you draw from these observations about Madonna's status as an American icon?

2. Choose one of the later, more recent, images in the sequence. What changes do you notice in the ways Madonna presents herself to the public? in the shape of her body? in the appearance of her face? Which Madonna do you find most—and least—engaging? Please explain why.

WRITING

1. In what ways—and to what extent—do you think the changing images of Madonna reflect the changes in American popular culture throughout the last twenty years? Draft an essay in which you use Madonna's changing public image to chart shifts in popular culture during the 1980s and 1990s.

2. Compare and contrast the image of Marilyn Monroe presented by Madonna in the fifth image in this sequence with that of Marilyn in either the poster for *The Seven Year Itch* or the poem by Sharon Olds (see pp. 402 and 403). Draft an essay in which you establish a convincing and compelling case for the effectiveness of one of these images in rendering Marilyn as one of the most popular female icons of the twentieth century.

Re: Searching the Web

The Citizens Flag Alliance is an organization devoted to a single purpose: "to persuade the Congress of the United States to propose a constitutional amendment to protect the American flag from physical desecration, and send it to the states for ratification"; its web site can be found at http://www.cfa-inc.org/index.htm. The author of The Flag-Burning Page <http://www.indirect.com/www/warren/flag.html>, on the other hand, describes his site as "a standing protest to any amendment to the U.S. Constitution which would allow Congress or the States to pass laws against flag-burning laws that the Supreme Court has already said are unconstitutional."

Spend some time exploring the substance and spirit of what is presented at each of these web sites. Which aspects of the debate on desecration of the flag does each web site emphasize? Consider the evidence each presents to support a particular point of view. Does each rely more on visual or verbal texts to make the case for—or against—laws banning flag-burning activities? To what extent does each site provide new evidence—or angles—on the debate?

Use an Internet search engine to explore other web sites devoted to the debate about representations of the flag. In what ways do these other sites extend, complicate, or enrich your understanding of the public debate surrounding the flag-burning issue?

DILLER + SCOFIDIO

Diller + Scofidio is a studio "at the intersection of art, architecture, and the performing arts." The members of the design team are both professors of architecture: Elizabeth Diller at Princeton University, and Ricardo Scofidio at the Cooper Union. They have collaborated on experimental projects in many different mediums.

The logos on this page were designed by Diller + Scofidio as part of an interactive video performance, *Indigestion,* that plays with cultural stereotypes about perceived differences between masculine and feminine, male and female, high class and low class, and fact and fiction. The video shows a dining room table that the viewer can join as a guest, choosing companions by using a touch screen and selecting two icons that stand for gender and class stereotypes. The story is always the same, although the vocabulary the characters use and the details of the plot are shaded by cultural assumptions about how a person of a given class, gender, or sexual preference might act and talk. *Indigestion* and other installations by Diller + Scofidio have been exhibited all over the world. Among other projects, they have created *Jump Cuts,* a permanent video marquee at the world's biggest Cineplex theater in San Jose, California, and *The American Lawn: Surface of Everyday Life* at the Canadian Center for Architecture in Montreal.

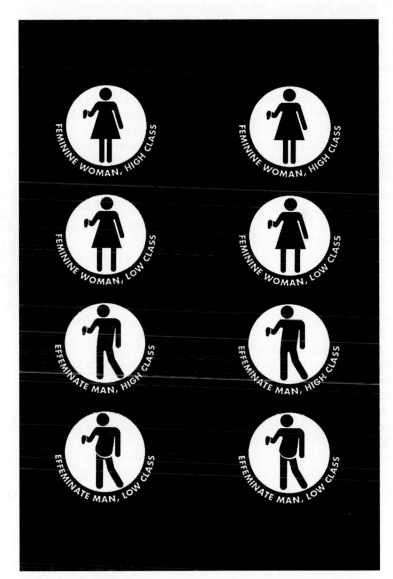

Diller + Scofidio, **Indigestion**

SEEING

1. Examine carefully the images presented here by Diller + Scofidio. Compare and contrast these representations with the traditional international symbols for "male" and "female" (p. 258). What variations on the international symbols has Diller + Scofidio introduced in this illustration? What cultural stereotypes do they suggest about the difference between "high" and "low" class? between and among masculine, feminine, and "effeminate"? How do you respond to these images? Why?

2. Diller + Scofidio designed these logos as part of an interactive video to help viewer-participants explore their assumptions about differences among people. What cultural assumptions and beliefs seem to be evoked in each of the images represented in this grid? After you have responded to this question, consider the ways in which Daniel Harris defines "effeminacy" in his essay (see p. 303). How is Harris's definition similar to—and different from—Diller + Scofidio's? Point to specific examples to verify your reading.

WRITING

1. Diller + Scofidio has played with embedded assumptions about gender and class. What other stereotypes about gender or class identity can you think of in American popular culture? For example, what signals in clothing, behavior, and attitude do we "read" as signaling a certain gender or class? Write an essay in which you characterize your assumptions about the ways people "wear" a certain gender or class identity. As you develop this draft, please be sure to mention specific aspects of Diller + Scofidio's visual representations of gender or class. Explain whether these signs represent real differences among people.

2. We invite you to think of this as an exercise in creative autobiography. Create your own altered version of the international symbol for "male" or "female"—an image that indicates something about how you define yourself. After you have drawn that image, write a brief essay in which you discuss the process by which you changed the traditional symbol—and how it made you feel to try to represent yourself with an icon.

Looking Closer:
The Stars and Stripes

Few symbols are as recognizable as the American flag, and few stir emotions as strong. The flag is ubiquitous. It flies on government buildings, but it also decorates front lawns, T-shirts, and bumper stickers. Americans encounter the flag not only in official ceremonies and at sports events, but in all kinds of "everyday" situations—in advertisements for weekend sales, on doormats, as well as on clothing and commercial packaging. Indeed, it is difficult to spend a day in this country without seeing the flag.

The Stars and Stripes evokes passionate responses—from patriotism to violence to tears—and the feelings about our right to burn this symbol are no less passionate. The **Majority Opinion** of the United States Supreme Court, by Justice William Brennan Jr., and the **Dissenting Opinion** by Chief Justice William Rehnquist articulate the two sides of this complicated issue; and a range of images—paintings such as David Hammons's ***African-American Flag;*** Matt Groening's cartoon **"Pledging the Flag";** a **Plateau Indian bag;** and the Gordon Parks photograph **"American Gothic"**—suggests how central this symbol is in American life.

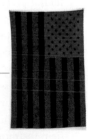

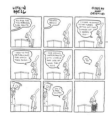

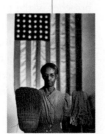

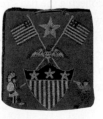

MAJORITY OPINION OF THE U.S. SUPREME COURT IN *TEXAS V. JOHNSON* (1989)

Justice William J. Brennan Jr.

AFTER PUBLICLY BURNING AN AMERICAN FLAG as a means of political protest, Gregory Lee Johnson was convicted of desecrating a flag in violation of Texas law. This case presents the question whether his conviction is consistent with the First Amendment. We hold that it is not.

While the Republican National Convention was taking place in Dallas in 1984, respondent Johnson participated in a political demonstration dubbed the "Republican War Chest Tour." . . .

The demonstration ended in front of Dallas City Hall, where Johnson unfurled the American flag, doused it with kerosene and set it on fire. While the flag burned, the protestors chanted, "America, the red, white, and blue, we spit on you." After the demonstrators dispersed, a witness to the flag burning collected the flag's remains and buried them in his backyard. No one was physically injured or threatened with injury, though several witnesses testified that they had been seriously offended by the flag burning.

Of the approximately 100 demonstrators, Johnson alone was charged with a crime. The only criminal offense with which he was charged was the desecration of a venerated object in violation of Texas Penal Code Ann. Sec. 42.09 (a)(3) (1989) ["Desecration of a Venerated Object"]. After a trial, he was convicted, sentenced to one year in prison and fined $2,000. The Court of Appeals for the Fifth District of Texas at Dallas affirmed Johnson's conviction, but the Texas Court of Criminal Appeals reversed, holding that the State could not, consistent with the First Amendment, punish Johnson for burning the flag in these circumstances. . . .

STATE ASSERTED TWO INTERESTS

To justify Johnson's conviction for engaging in symbolic speech, the State asserted two interests: preserving the flag as a symbol of national unity and preventing breaches of the peace. The Court of Criminal Appeals held that neither interest supported his conviction.

Acknowledging that this Court had not yet decided whether the Government may criminally sanction flag desecration in order to preserve the flag's symbolic value, the Texas court nevertheless

concluded that our decision in West Virginia Board of Education v. Barnette, 319 U.S. 624 (1943), suggested that furthering this interest by curtailing speech was impermissible.

The First Amendment literally forbids the abridgement only of "speech," but we have long recognized that its protection does not end at the spoken or written word. . . .

Especially pertinent to this case are our decisions recognizing the communicative nature of conduct relating to flags. Attaching a peace sign to the flag, Spence v. Washington, 1974; saluting the flag, Barnette, and displaying a red flag, Stromberg v. California (1931), we have held, all may find shelter under the First Amendment. . . . That we have had little difficulty identifying an expressive element in conduct relating to flags should not be surprising. The very purpose of a national flag is to serve as a symbol of our country; it is, one might say, "the one visible manifestation of two hundred years of nationhood." . . .

Pregnant with expressive content, the flag as readily signifies this nation as does the combination of letters found in "America."

The Government generally has a freer hand in re- 10 stricting expressive conduct than it has in restricting the written or spoken word. . . . It may not, however, proscribe particular conduct because it has expressive elements. . . . It is, in short, not simply the verbal or nonverbal nature of the expression, but the governmental interest at stake, that helps to determine whether a restriction on that expression is valid.

The State offers two separate interests to justify this conviction: preventing breaches of the peace, and preserving the flag as a symbol of nationhood and national unity. We hold that the first interest is not implicated on this record and that the second is related to the suppression of expression. . . .

We thus conclude that the State's interest in maintaining order is not implicated on these facts. The State need not worry that our holding will disable it from preserving the peace. We do not suggest that the First Amendment forbids a state to prevent "imminent lawless action." And, in fact, Texas already has a statute specifically prohibiting breaches of the peace, Texas Penal Code Ann. Sec. 42.01 (1989), which tends to confirm that Texas need not punish this flag desecration in order to keep the peace.

If there is a bedrock principle underlying the First Amendment, it is that the Government may not prohibit the expression of an idea simply because society finds the idea itself offensive or disagreeable. . . .

We have not recognized an exception to this principle even where our flag has been involved. In Street v. New York, 394 U.S. 576 (1969), we held that a state may not criminally punish a person for uttering words critical of the flag. . . .

Nor may the Government, we have held, compel 15 conduct that would evince respect for the flag. . . .

We never before have held that the Government may insure that a symbol be used to express only one view of that symbol or its referents. . . . To conclude that the Government may permit designated symbols to be used to communicate only a limited set of messages would be to enter territory having no discernible or defensible boundaries.

WHICH SYMBOLS WARRANT UNIQUE STATUS?

Could the Government, on this theory, prohibit the burning of state flags? Of copies of the Presidential seal? Of the Constitution? In evaluating these choices under the First Amendment, how would we decide which symbols were sufficiently special to warrant this unique status? To do so, we would be forced to consult our own political preferences, and impose them on the citizenry, in the very way that the First Amendment forbids us to do.

There is, moreover, no indication—either in the text of the Constitution or in our cases interpreting— that a separate juridical category exists for the American flag alone. Indeed, we would not be surprised to learn that the persons who framed our Constitution and wrote the Amendment that we now construe were not known for their reverence for the Union Jack.

The First Amendment does not guarantee that other concepts virtually sacred to our nation as a

whole—such as the principle that discrimination on the basis of race is odious and destructive—will go unquestioned in the marketplace of ideas. We decline, therefore, to create for the flag an exception to the joust of principles protected by the First Amendment.

We are fortified in today's conclusion by our conviction that forbidding criminal punishment for conduct such as Johnson's will not endanger the special role played by our flag or the feelings it inspires. . . . [20]

A REAFFIRMATION OF PRINCIPLES

We are tempted to say, in fact, that the flag's deservedly cherished place in our community will be strengthened, not weakened, by our holding today. Our decision is a reaffirmation of the principles of freedom and inclusiveness that the flag best reflects, and of the conviction that our toleration of criticism such as Johnson's is a sign and source of our strength.

The way to preserve the flag's special role is not to punish those who feel differently about these matters. It is to persuade them that they are wrong. . . .

We can imagine no more appropriate response to burning a flag than waving one's own, no better way to counter a flag-burner's message than by saluting the flag that burns, no surer means of preserving the dignity even of the flag that burned than by—as one witness here did—according its remains a respectful burial. We do not consecrate the flag by punishing its desecration, for in doing so we dilute the freedom that this cherished emblem represents. ○

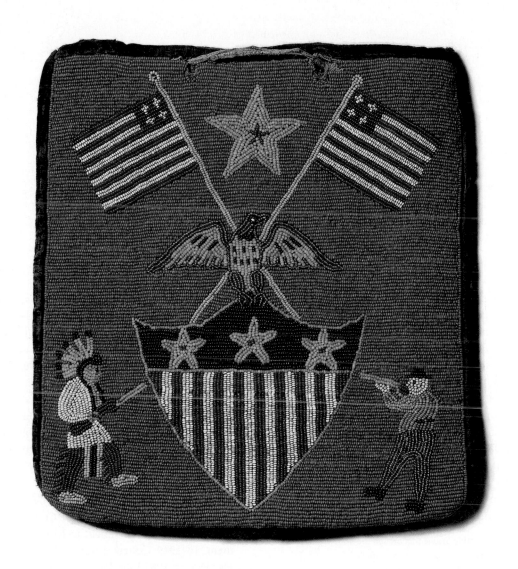

DISSENTING OPINION
IN *TEXAS V. JOHNSON* (1989)

Chief Justice William H. Rehnquist

IN HOLDING THIS TEXAS STATUTE UNCONSTITU-tional, the Court ignores Justice Holmes's familiar aphorism that "a page of history is worth a volume of logic." For more than 200 years, the American flag has occupied a unique position as the symbol of our nation, a uniqueness that justifies a governmental prohibition against flag burning in the way respondent Johnson did here.

At the time of the American Revolution, the flag served to unify the 13 colonies at home while obtaining recognition of national sovereignty abroad. Ralph Waldo Emerson's Concord Hymn describes the first skirmishes of the Revolutionary War in these lines:

> By the rude bridge that arched the flood,
> Their flag to April's breeze unfurled,
> Here once the embattled farmers stood,
> And fired the shot heard round the world.

In the First and Second World Wars, thousands of our countrymen died on foreign soil fighting for the American cause. At Iwo Jima in the Second World War, United States Marines fought hand to hand against thousands of Japanese. By the time the marines reached the top of Mount Suribachi, they raised a piece of pipe upright and from one end fluttered a flag. That ascent had cost nearly 6,000 American lives. . . .

The flag symbolizes the nation in peace as well as in war. It signifies our national presence on battleships, airplanes, military installations and public buildings from the United States Capitol to the thousands of county courthouses and city halls throughout the country. . . .

No other American symbol has been as universally honored as the flag. In 1931 Congress declared "The Star Spangled Banner" to be our national anthem. In 1949 Congress declared June 14th to be Flag Day. In 1987 John Philip Sousa's "The Stars and Stripes Forever" was designated as the national march. Congress has also established "The Pledge of Allegiance to the Flag" and the manner of its deliverance. . . . all of the states now have statutes prohibiting the burning of the flag. . . .

The result of the Texas statute is obviously to deny one in Johnson's frame of mind one of many means of "symbolic speech." Far from being a case of "one picture being worth a thousand words," flag burning is the equivalent of an inarticulate grunt or roar that, it seems fair to say, is most likely to be indulged in not to express any particular idea, but to antagonize others. . . .

The Texas statute deprived Johnson of only one rather inarticulate symbolic form of protest—a form of protest that was profoundly offensive to many—and left him with a full panoply of other symbols and every conceivable form of verbal expression to express his deep disapproval of national policy. . . .

But the Court today will have none of this. The uniquely deep awe and respect for our flag felt by virtually all of us are bundled off under the rubric of "designated symbols" that the First Amendment prohibits the Government from "establishing." But the Government has not "established" this feeling; 200 years of history have done that. The Government is simply recognizing as a fact the profound regard for the American flag created by that history when it enacts statutes prohibiting the disrespectful public burning of the flag.

The Court concludes its opinion with a regrettably patronizing civics lecture, presumably addressed to the members of both houses of Congress, the members of the 48 state legislatures that enacted prohibitions against flag burning, and the troops fighting under that flag in Vietnam who objected to its being burned: "The way to preserve the flag's special role is not to punish those who feel differently about these matters. It is to persuade them that they are wrong."

The Court's role as the final expositor of the Constitution is well established, but its role as a platonic guardian admonishing those responsible to public opinion as if they were truant school children has no similar place in our system of government. . . .

Even if flag burning could be considered just another species of symbolic speech under the logical application of the rules that the Court has developed in its interpretation of the First Amendment in other contexts, this case has an intangible dimension that makes those rules inapplicable.

A country's flag is a symbol of more than "nationhood and national unity." It also signifies the ideas that characterize the society that has chosen that emblem, as well as the special history that has animated the growth and power of those ideas. . . .

So it is with the American flag. It is more than a proud symbol of the courage, the determination and the gifts of nature that transformed 13 fledgling colonies into a world power. It is a symbol of freedom, of equal opportunity, of religious tolerance and of good will for other peoples who share our aspirations. . . .

The value of the flag as a symbol cannot be measured. Even so, I have no doubt that the interest in preserving that value for the future is both significant and legitimate. . . . The creation of a Federal right to post bulletin boards and graffiti on the Washington Monument might enlarge the market for free expression, but at a cost I would not pay.

Similarly, in my considered judgment, sanctioning the public desecration of the flag will tarnish its value—both for those who cherish the ideas for which it waves and for those who desire to don the robes of martyrdom by burning it. That tarnish is not justified by the trivial burden on free expression occasioned by requiring that an available, alternative mode of expression—including uttering words critical of the flag—be employed.

The ideas of liberty and equality have been an irresistible force in motivating leaders like Patrick Henry, Susan B. Anthony, and Abraham Lincoln, schoolteachers like Nathan Hale and Booker T. Washington, the Philippine Scouts who fought at Bataan, and the soldiers who scaled the bluff at Omaha Beach. If those ideas are worth fighting for—and our history demonstrates that they are—it cannot be true that the flag that uniquely symbolizes their power is not itself worthy of protection from unnecessary desecration. ○

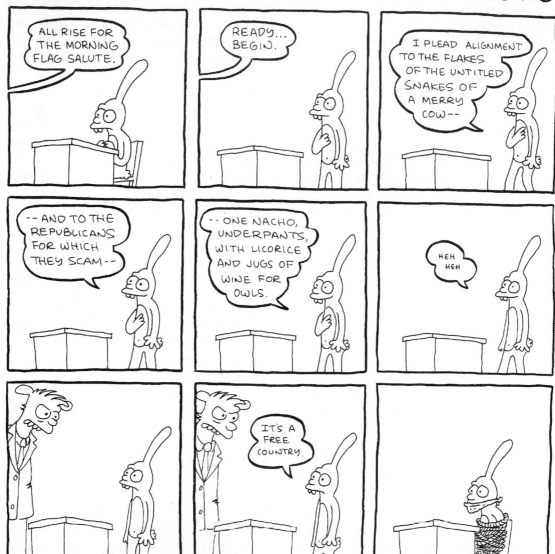

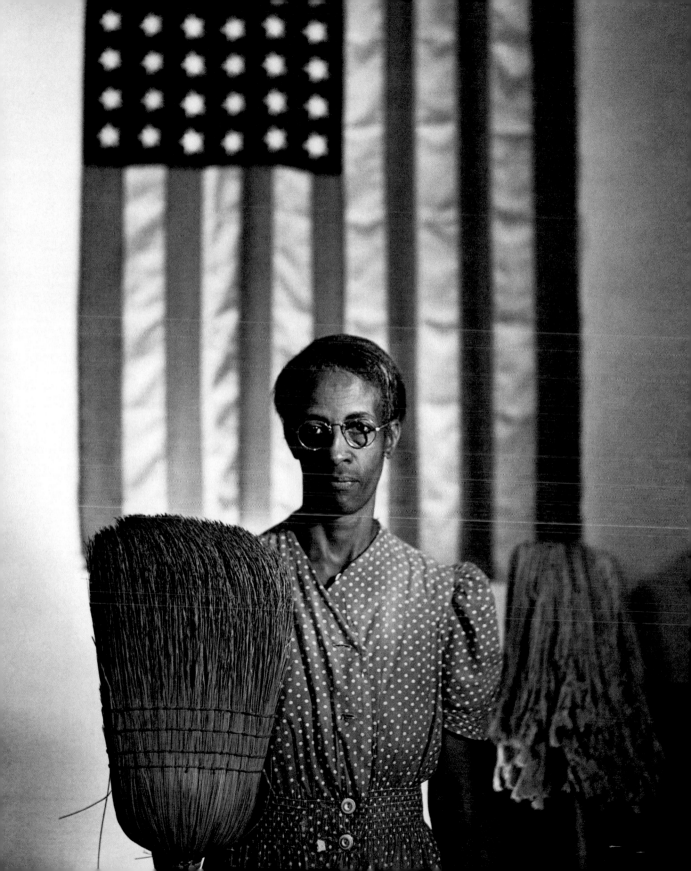

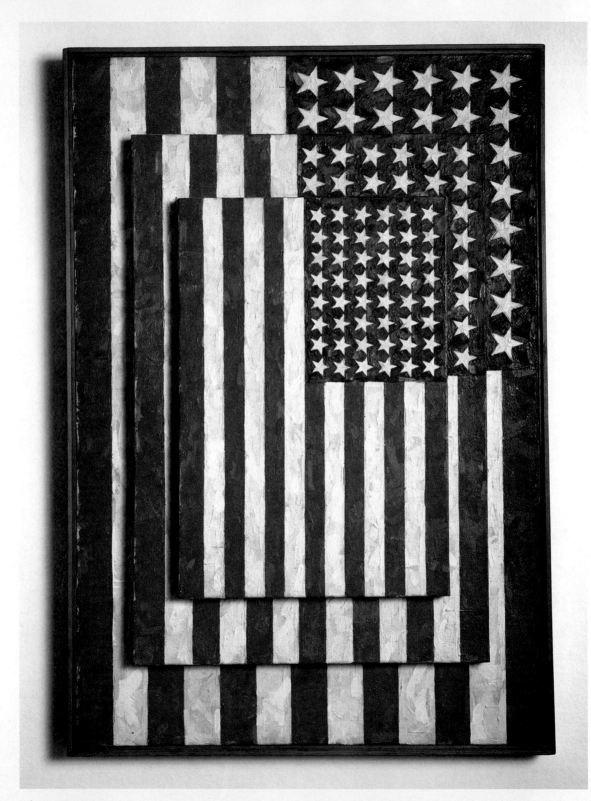

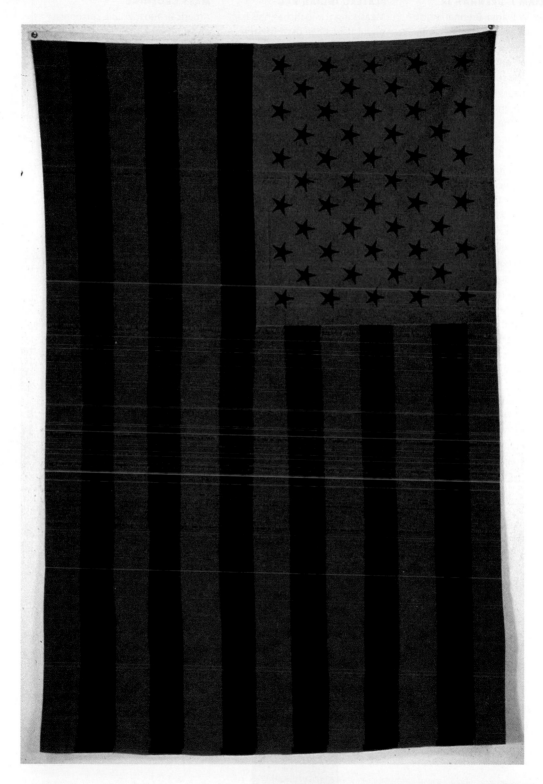

WILLIAM J. BRENNAN JR.

Justice William J. Brennan (1906–1997) was one of the most influential justices of the United States Supreme Court in the twentieth century. He served on the nation's highest court for thirty-three years, from 1956 until he retired in 1990 at the age of 84. Justice Brennan often fashioned the legal arguments that persuaded a majority of justices in difficult and controversial cases.

The *Texas v. Johnson* case is an excellent example. In 1984, while the Republican National Convention was taking place in Dallas, Gregory Lee Johnson burned an American flag as a statement of protest against the policies of the Reagan administration. He was arrested and convicted under a Texas law that made it a crime to desecrate the flag. The case reached the Supreme Court in 1989, and Justice Brennan wrote for a bare 5-to-4 majority overturning Johnson's conviction and upholding his right to burn the American flag as an exercise of his constitutionally protected freedom of speech.

PLATEAU INDIAN BAG

Measuring 11 × 10 inches, this bag might have been used to carry tools, personal items, or sacred objects in the late-nineteenth- or early-twentieth-century by the Plateau Indians, who inhabited eastern Washington, Oregon, and Idaho. The bag was most likely made from Native tanned hide, glass beads, and commercial cloth binding acquired through trading with Europeans. The bag is pictured in *The Flag in American Indian Art* (1993) by Toby Herbst and Joel Kopp with the following caption: "The tableau of cowboys/settlers versus Indians was acted out innumerable times in real life as well as in Wild West shows, frontier days, fairs, and rodeos, and would have been a well-known scene to the native craftworker."

WILLIAM H. REHNQUIST

Chief Justice William H. Rehnquist has been a member of the Supreme Court since 1971 and Chief Justice of the United States since 1986. He served with the Army Air Corps during World War II, and then graduated from Stanford Law School in 1952. President Richard Nixon appointed him assistant attorney general in 1969. Two years later he joined the Supreme Court.

For nearly thirty years Chief Justice Rehnquist has anchored the Court's conservative wing. In the Texas flag-burning case he voted with the minority to uphold the constitutionality of the law and wrote a dissenting opinion.

MATT GROENING

America's most visible cartoonist and animator, Matt Groening (rhymes with "complaining") was born in Portland, Oregon, in 1954. He worked in a sewage treatment plant, as a chauffeur, and as a ghostwriter before his "Life in Hell" comic strip (featuring two rabbits because, as he says, "they are easy to draw") earned him international acclaim as a cartoonist. In 1990 Groening launched *The Simpsons* on the Fox network; it soon became the most successful animated prime-time series in television history.

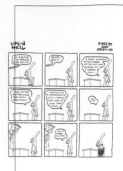

GORDON PARKS

An internationally renowned photojournalist, filmmaker, composer, and author, Gordon Parks was born in Fort Scott, Kansas, in 1912. His autobiographical novel *The Learning Tree* (1963) recounts his childhood. After an early career as an admired fashion photographer, he documented during the Depression the economic plight of average people as well as social and cultural conditions. During World War II, Parks photographed the 332nd Fighter Group, the first black air corps. After the war, he became the first black photographer at *Life* magazine, where his assignments included photo essays on Harlem, segregation in the South, crime in the United States, and the civil rights movement during the 1960s. His writing ranges from several volumes of memoirs to artful blendings of poetry and photography, most notably *A Poet and His Camera* (1968). He has also directed several popular motion pictures, including *Shaft* (1971) and *Leadbelly* (1976).

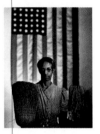

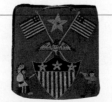

JASPER JOHNS

In a career that spans pop art, minimalism, figurative abstractions, and autobiography, Johns has been a highly influential presence on the American art scene since his first solo exhibition in 1958. Working in collage, painting, sculpture, and printmaking, his work often incorporates letters, numbers, and most recently fragments of other artists' work.

Born in Augusta, Georgia, in 1930, he has lived and worked in New York since the early 1950s. This painting of the American flag was completed in 1954 and is in the collection of the Museum of Modern Art in New York.

DAVID HAMMONS

Born in Springfield, Illinois, Hammons was an active voice in the civil rights movement, creating pieces such as *The Door* (1969), a critique of the racially slanted admissions policies of colleges at that time. His vast body of work in painting and sculpture is often described as "funk" and incorporates many icons of African American culture, such as fried chicken, drums, trains, and gold gilt. Hammons writes, "We should look to these images and see how positive they are, how strong, how powerful. . . . It all depends on who is seeing and we've been depending on someone else's sight. . . . We need to look and decide."

SEEING

1. **What do you notice about each of the images in this section? Explain how the flag is appropriated and/or represented in each. Compare and contrast, for example, the way in which the flag is used in the photograph by Gordon Parks with its use in the cartoon by Matt Groening. In what respects might the creator of each image be said to engage in an act of persuasion—to prompt readers to a particular course of action? How might these actions be fundamentally different? How are the strategies used in each instance fundamentally similar? different?**

2. **In his account of the majority decision in *Texas v. Johnson* (1989), Supreme Court justice William J. Brennan Jr. wrote, "Pregnant with expressive content, the flag as readily signifies this nation as does the combination of letters found in 'America'" (para. 9). Many representations of and discussions about the flag in this section comment on what the flag "stands for" in American culture. Choose two of these renditions of the American flag in contemporary popular culture. What social, cultural, and/or historical versions of America does each suggest? How do they speak to each other?**

WRITING

1. Since 1989, when the United States Supreme Court ruled that a person may not be prosecuted for burning the American flag as a peaceful political protest, the issue of whether the flag should receive special protection under the law has remained hotly debated. Write an essay in which you build an argument to determine whether the American flag should be protected, and to what extent and under what circumstances. Draw on the essays and images in the preceding pages to support your argument.

2. The debate over the legality of flag burning involves one of the most precious rights of Americans: freedom of speech. Go to the annual index of a local or national newspaper, and identify another controversy that focuses on interpreting the rights guaranteed under the First Amendment to the Constitution (such as the right to protest outside an abortion clinic or the right to buy pornography). Write an essay in which you account for the ways in which the nature and extent of this issue is similar to—or different from—the debate over burning the American flag.

Writing in the Age of the Image

In the battle between words and images, images seem to be winning, or so media pundits would have us believe. Images dominate more public space—on the front pages of newspapers and the covers of magazines, as well as on television, movie, and computer screens, and on roadside signs and sides and tops of buildings—than ever before.

Images play an increasingly important role in what we know—and how we learn—about current events. In fact, more Americans get their news from TV than from a newspaper, with each televised story accompanied by a stream of moving images on the screen: a child fleeing a napalm attack in Vietnam, a student dissident halting a line of tanks outside Beijing's Tiananmen Square, a phalanx of police

Barbara Kruger, **Untitled**

cars following O.J. Simpson along LA freeways. The list of such enduring images grows longer each year. As media critic Neil Postman has observed, "We are now a culture whose information, ideas, and epistemology are given form by television, not by the printed word."

You have come of age at a time when images play a prominent role in determining American values and assumptions. More of us spend our leisure time, for example, visually engaged by flipping through TV channels, watching movies, or surfing the web. Even when we are not looking at images in the public media, we record and sometimes even plan significant personal and private events around the photographs and home videos they will yield.

In a similar vein, an unprecedented influx of information, data, news, and stories is pouring into our lives at an incredible rate. Rapidly advancing computer and digital technologies now making copying, sending, and disseminating images increasingly speedy and accessible. Just as the invention of the printing press facilitated the widespread distribution of print and required people to develop verbal literacy, today more and more people have to demonstrate another kind of literacy, a visual literacy—the ability to read, understand, and act on the information conveyed in powerful contemporary images.

The language of constructing images has infused itself in the public consciousness. We hear of politicians who hire consultants to perfect their public "images." We speak of improving our own "self-image." We might even say that Americans now have become more accustomed to looking at—and thinking about— images of things than the things themselves. For example, we can now walk through a replica of the streets of downtown New York City in Las Vegas, encounter "virtual" friends on the web, or watch a war being conducted "live" on television, whether that war is being fought on the other side of the globe or down the street.

Differentiating between image and reality has never been easy, but the question now is whether it's even possible. Cultural commentators such as Neal Gabler argue that it isn't: "Everywhere the fabricated, the inauthentic and the theatrical have gradually driven out the natural, the genuine and

The impact of television on our culture is indescribable. There's a certain sense in which it is nearly as important as the invention of printing.
— Carl Sandburg, 1955

Images show us a world but not the world itself. Images are not the things shown but are representations thereof: representations.
— Richard Leppert, 1996

the spontaneous until there is no distinction between real life and stage-craft. In fact, one could argue that the theatricalization of American life is the major cultural transformation of this century. Devoured by artifice, life is a movie." The "real" events we watch on TV are what the social historian Daniel Boorstin calls "pseudo-events," events that have been crafted or framed solely for media presentation—and audience reception. At the same time that Americans are arguably more removed from real experience, we are nonetheless more obsessed with determining whether something is real or fake. Advertisers capitalize on the desire for the "authentic": authentic "stonewashed jeans" and "Coke: the real thing," for example.

More often we accept the image as our medium of choice. One example of the way in which we're becoming accustomed to working with a representation of reality in our daily lives involves the computer. When we sit in front of a monitor screen, mouse in hand, navigating a piece of software, what we're working with is a designed interface—an image, a representation of the workings of the computer. In fact, computer salespeople join cultural commentators in questioning whether computer screens will ultimately replace books as the principal format by which we read. Already book sales are decreasing, and students are demonstrating only marginal progress in reading and writing proficiency.

Meanwhile we channel surf, rapidly scanning dozens of images in a few seconds, or we click from icon to icon. How do those processes differ from reading from left to right on a page? Computers have given new meaning to the term *multitasking* for millions of workers who must shift back and forth among windows on their computer screen or simultaneously talk on the phone, type, and wait for a web page to download. How does multitasking change the way in which we can be expected to read? and the ways in which we think and write?

Today writers must think like designers and designers like writers. If you're writing text for a web page, how do the visual aspects of text design—your ability to use hypertext—change the way you write as well as the content itself? If you are writing an article for a magazine or newspaper, how do space and design constraints affect your writing style and content?

The assumption that seeing is believing makes us susceptible to visual deception.
– Kathleen Hall Jamieson, 1992

How might you write an article differently if you knew a photograph or illustration were to accompany it? In more general terms, how—and to what extent—should university curricula adjust to the changing nature of reading and writing to help students become more confident and articulate readers and writers?

Some scholars have noted that rather than simply propelling us forward in a linear way, rapidly advancing computer technology is also drawing on past ideas. Voice recognition software, for example, might allow us to return to the oral tradition of using our voices to create and record. And Scott McCloud reminds us (see p. 526) that ancient civilizations have long integrated the visual and verbal in their communication systems—think of Mandarin or Arabic characters. What consequences do you think the new "age of the image" has for writing and reading? We invite you to explore this question, and to form and revise your own judgments, as you critically read the authors and artists in this chapter.

BARBARA KRUGER

Barbara Kruger has been making cultural and political statements with her bold graphic images for over three decades. Combining black and white "found" photographs with powerful red-letter slogans, Kruger appropriates the techniques of advertising and circulates her work on billboards, posters, matchboxes, and postcards.

More than a dozen years as a designer and photo editor for Condé Nast publications gave Kruger an insider's view of how the media can manipulate the public. "To those who understand how pictures and words shape consensus," she writes, "we are unmoving targets waiting to be turned on and off."

In the early 1980s Kruger focused on feminist issues, as in one work that combines the phrase "We don't need another hero" with an image of a little boy showing his muscles. Most recently, Kruger's concerns have focused on the media.

Her writing is collected in *Remote Control: Power, Cultures and the World of Appearances* (1993), and her graphic work can be seen in *Love for Sale: The Words and Pictures of Barbara Kruger* (1996). Of her work as an artist, she writes, "I want to be on the side of pleasure and laughter and to disrupt the dour certainties of pictures, property, and power."

SEEING

1. What exactly do you think Barbara Kruger is trying to say in this piece? The copy gives us one message—does the image reinforce or subvert the words? How does Kruger manipulate the saying "a picture is worth a thousand words"? How do you interpret "worth" in this phrase? What might "worth" mean? to whom? in what context? What importance do you attach to "more" here? What significance does Kruger attach to it? How would you characterize the relationship of words to illustration in this image?

2. How would you describe Kruger's style? Comment on the effects of the choices she has made in type face and size, the position of language in relation to illustration, and the use of color. How many different images within an image can you identify here? From where does Kruger draw these images? More generally, what cultural references does she evoke? How might this image be read as a product of the culture of the 1990s?

WRITING

1. Think carefully about the phrase "a picture is worth more than a thousand words." With what experiences do you associate this expression? What patterns can you identify between and among these experiences? Are they, for example, personal experiences? more public in nature? something else? Explain. Write the first draft of an essay in which you argue for—or against—the applicability of this phrase to the circumstances of your own life.

2. Having studied Kruger's image carefully, please turn now to Andrew Savulich's news photographs (p. 166). Examine the role Savulich's brief descriptive titles play in establishing the impact of his photos. How do even these brief descriptions affect your understanding of his photographs? How might you interpret Savulich's photographs if the titles were worded differently? Draft an essay in which you compare and contrast the different impact of combining images and text in the work of Barbara Kruger and Andrew Savulich.

ON TELEVISION

Robert Pinsky

Not a "window on the world"
But as we call you,
A box a tube

Terrarium of dreams and wonders.
Coffer of shades, ordained 5
Cotillion of phosphors
Or liquid crystal

Homey miracle, tub
Of acquiescence, vein of defiance.
Your patron in the pantheon would be Hermes 10

Raster dance,
Quick one, little thief, escort
Of the dying and comfort of the sick,

In a blue glow my father and little sister sat
Snuggled in one chair watching you 15
Their wife and mother was sick in the head
I scorned you and them as I scorned so much

Now I like you best in a hotel room,
Maybe minutes
Before I have to face an audience: behind 20
The doors of the armoire, box
Within a box—Tom & Jerry, or also brilliant
And reassuring, Oprah Winfrey.

Thank you, for I watched, I watched
Sid Caesar speaking French and Japanese not 25
Through knowledge but imagination,
His quickness, and Thank You, I watched live
Jackie Robinson stealing

Home, the image—O strung shell—enduring
Fleeter than light like these words we 30
Remember in, they too winged
At the helmet and ankles.

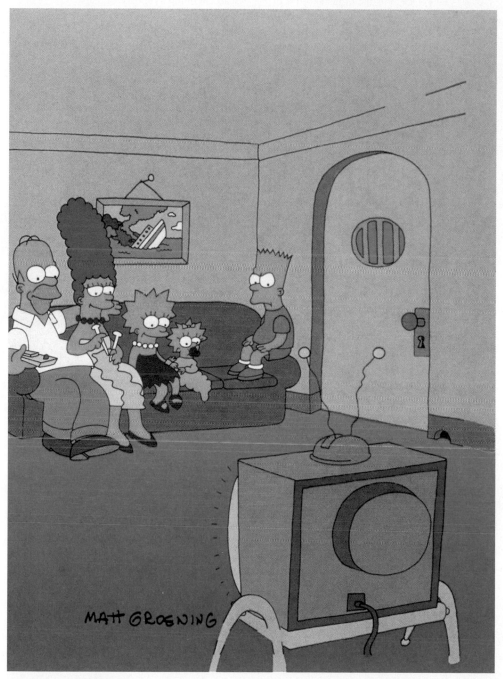

Matt Groening, **The Simpsons**

ROBERT PINSKY

Poet laureate, acclaimed translator, and distinguished critic of contemporary American verse, Robert Pinsky is committed to poetic diction while addressing a wide range of experience. "I would like to write a poetry which could contain every kind of thing, while keeping all the excitement of poetry."

Born in Long Branch, New Jersey (1940), Pinsky earned a B.A. from Rutgers University and a Ph.D. from Stanford. He has taught at the University of Chicago, Wellesley College, the University of California, Berkeley, and for the past decade at Boston University. He has won numerous fellowships and awards. His poetry has been collected most recently in *The Figured Wheel: New and Collected Poems, 1966–1996* (1996). His criticism spans three decades and includes his widely celebrated *The Sounds of Poetry* (1997).

Pinsky once called poetry "a technology for remembering," and in a recent interview on why he likes *The Simpsons* he noted that "the most powerful television of my lifetime has been broadcast live, what the book industry would call 'nonfiction': sports events, trials, assassinations, funerals, wars, missions into space. What all of these spectacles have in common is that they are unpredictable.... Television has a unique power to bring the dynamic, potentially startling event into the viewer's private, intimate space, immediately."

THE SIMPSONS

Originally created by cartoonist Matt Groening as shorts for television's *The Tracey Ullman Show* in 1987, *The Simpsons* was granted full status as a series on the Fox network in 1990. Known for its pop culture allusions, good-humored social satire, and famous guest voices, the show today enjoys the longest prime-time run of any animated television sitcom. The family—Homer, Marge, Bart, Lisa, and Maggie—lives in an "Anywhere, USA" town called Springfield where they spend their lives in close proximity to the television set; in fact, the opening "credits" of the show culminate with an always-different collision of the characters on the couch in front of the TV.

The Simpson family may be stereotypically "American," but their personalities and behaviors either exaggerate these stereotypes or reverse them in unexpected ways. The mother, Marge, is a housewife with an enormous blue "beehive" hairdo and a feminist sensibility; the father, Homer, is a nuclear safety technician who is more concerned with donuts and beer than with safety. The children, Bart, Lisa, and Maggie (ages 10, 8, and 1), usually seem smarter than their parents. The humor these characters create is slapstick, but the jokes also address current social issues, and the writing often conceals sophisticated social commentary—so the show is popular with both children and adults.

In Greek mythology Hermes brings messages; leads gods, heroes, and mortals; and guides souls to the Underworld. He is considered the god of travelers, businessmen, thieves, game-players, and storytellers. He wears wings on his hat and sandals and carries a staff with snakes entwined around it.

SEEING

1. Consider the phrases Robert Pinsky uses to refer to television in the first sentence of *On Television*: "window on the world," "box," "tube," "terrarium of dreams and wonders." Identify the differences among these metaphors. What cultural functions do they suggest about television? In what ways is the Greek god Hermes an appropriate "patron" of television? In stanza 5, Pinsky begins to explore the importance of television in his own life. How do these anecdotes anticipate the final stanza? What comparison between words and images does Pinsky draw there? With what effect(s)?

2. What role is imagined for television in the domestic lives of the Simpsons? Does television bring the family closer together or move them farther apart? How does each member of the family feel about television? In what ways can you compare (or would you resist comparing) this scene with the moments and events in Pinsky's poem?

3. How do you think Pinsky's view of television differs from that of Matt Groening, creator of *The Simpsons*? For yet another view, see Alfred Leslie's painting *Television Moon* (p. 36). How is the television as a physical object represented in these three texts: poem, cartoon still, and painting? What role do you think the different media play in these different representations?

WRITING

1. On a simple level, Pinsky's poem is about one person's relationship to television. Consider carefully your associations with television: How much time do you devote to watching it? What role(s) did it play in your family life as you were growing up? When and how did you watch it as a youngster? Did you view it primarily as a means of entertainment? as a source of information? as an occasion for relaxing? as "background noise"? as a backdrop for studying? as a social, group, or solitary activity? as something else? Draft an essay in which you draw on personal anecdotes to analyze the role(s) television has played in your personal and intellectual development.

2. Rather than simply representing the issue of writing in the age of the image, these two selections also address the issue of living in the age of the image. In this sense, television has become a focal point—as well as a vehicle— for analyzing contemporary American culture. Because people often watch television programs together, they can serve as social events. They also serve as shared cultural references. Draft an essay in which you analyze not only how but also the extent to which television shows— and the television itself—have become part of our cultural landscape.

TODD GITLIN

Born in 1943 in New York City, Todd Gitlin received a B.A. from Harvard in 1963 and an M.A. from the University of Michigan. After earning a Ph.D. from the University of California, Berkeley, he stayed on to teach courses in sociology and mass communications from 1978 to 1994. He currently teaches at New York University.

Gitlin has published nearly a dozen books, including two novels and a book of poems. He is best known for his social commentaries, particularly *The Sixties: Years of Hope, Days of Rage* (1987) and *The Whole World Is Watching: Mass Media in the Making and Unmaking of the New Left* (1980), in which he examined the effect of news coverage, or the lack of it, on the radical student movement of the 1960s. As an active leader of Students for a Democratic Society (SDS), Gitlin was able to write about the 1960s with the experience of an insider and the perspective of a scholar.

An influential commentator on media and cultural issues and a recipient of numerous grants and awards, Gitlin has published other popular studies of mass media, including *Inside Prime Time* (1983) and *The Twilight of Common Dreams: Why America Is Wracked by Culture Wars* (1995). These books explore the ways in which television networks and other media corporations influence American life.

The Liberal Arts in an Age of Info-Glut

Todd Gitlin

The culture wars over the curriculum may have been fought to a standstill, but the liberal arts are hardly free from crisis. In fact, we might as well program a computer "smart key" to print the words *liberal arts* and *crisis* together. The terms are inseparable because while the liberal arts seek to cultivate knowledge, reason, aptitude, and taste for what endures, we live in a society devoted to relentless cultural change.

Colleges and universities are tempted to swing in whatever direction consumers seem to want them to swing, and students today come to higher education largely for vocational reasons. A diploma is seen as a meal ticket. More and more students work their way through school and graduate in debt. Society preaches to them about the overpowering value of money. They see little evidence that philosophy, literature, history, foreign languages, aesthetics, or even coherent expression are valued. They arrive at the university immersed in high-technology media, with only the sketchiest command of history or Western literature, let alone experience in thinking about similarities and differences among diverse histories and literatures. Increasingly, their professors tell them that their education must be multicultural, but their grasp of any culture at all is slight. Few can write cogently, but they find little to help them do so in the ever more abstruse humanities.

On both sides of the canon wars—and in all the positions in between—little attention has been paid to the strongest reason to cultivate knowledge that is relatively enduring: to anchor a high-velocity, reckless, and lightweight culture whose main value is marketability. In a society prodigiously successful at producing material wealth, much of which goes toward affirming that anything goes, we need institutions that stand by values independent of the market. If not universities, what shall those institutions be? And because the liberal arts seek to

understand what the world is and teach who we are and how we should think, how could they not be embattled?

Of the many challenges to the liberal arts that commentators have cited—vocationalism, canon wars, identity politics—the glut of images, stories, and facts in which young people are immersed has come in for little attention. We are frequently told that we live in a golden age—no, a silicon age—of information, with silicon worth more than gold. The conventional terms, such as "superhighway," are superlative. A computer in every classroom is touted as the means to general enlightenment. Students arrive in the university already wired and hyperlinked, able to connect to global networks that afford almost instantaneous access to more "information" (the quotation marks are deliberate) in one hour than Aristotle could obtain in his lifetime. Our culture is swamped by a digital tsunami.

Thanks to photography, movies, 5 billboards, mass-circulation magazines, radio, recorded music, television, and computers, the flood of information and images surrounds and penetrates everyday life. For the young in particular, the sum of all the information that bombards us amounts to a daily curriculum purporting to tell how things go, have gone, and will go in our lives. The amalgam of images and bits of information, most of them evanescent, adds up to a culture that cultivates the hot pursuit of the new.

To our students, a great deal of everyday life feels like a carnival of mass-manufactured stories, or snippets of stories, circulating along with other snippets. Day in and day out, they are awash in images, actors, dramas. Young people are pressed to build their identities from shared fantasies of self-transformation, villainy, and rescue. The world they have in common is peopled with celebrities. Images of some of these celebrities endure, as Diana, "the people's princess," has. Most come and go—they must turn over to make way for marketing the next season's new style, the latest hot item.

The glut of images is, in many respects, unprecedented, and so is the challenge it poses for education and the arts. On average, Americans watch television, or are in its presence, for more than four hours a day—half the waking hours that are not taken up with work (and sometimes even then). For the sake of argument, let us suppose that, during those hours of watching television, the representative American tunes in to six fictional programs. Those might include half-hour comedies, hour-long dramas, and two-hour movies. (Actually, thanks to remote-control devices, many viewers see more than one program at a time. More than two-thirds of cable subscribers surf channels, and the younger they are, the more they surf.)

For simplicity's sake, assume 16 minutes of commercials per hour on commercial channels—say, 40 distinct commercials per hour. That gives us roughly 160 more short units of mass-mediated message per day. For viewers who watch news shows, throw in, as a conservative estimate, 30 separate news items every day. Add trailers for upcoming shows and trivia quizzes. Add sporting events. Add videocassettes. Add billboards along the highway, on street corners, on buses. Add newspaper and magazine stories and advertisements, video and computer games, books—especially light-weight fiction. Add the photo-studded displays of wiggling, potentially meaningful units of information and disinformation that flood into millions of households and offices through the Internet. Read me! Notice me! Click on me! All told, we are exposed to thousands of mass-produced stories a month, not counting thousands more free-standing images and labels that flash into the corners of our consciousness.

Note, too, that this imagescape has a sound track—the vast quantities of performed music and other auditory stimuli, including songs, sound effects, tapes, compact disks, voice-mail filler—all the currents and ejaculations of organized sound that have become the background of our lives.

Now, it is true that no one but 10 impressionable psychotics could be held in thrall for long by most of the minuscule dramas and depictions we find in popular culture. We experience most of the messages minimally, as sensations of the moment. But some part of the imagescape is nearly always clamoring for attention. Caught in the cross hairs of what the comedy writer Larry Gelbart has called "weapons of mass distraction," how shall we know, deeply, who we are? How shall we find still points in a turning world? How shall we learn to govern ourselves?

What does it mean, this information for which we are to be grateful and upgrade our facilities? When a neo-Nazi creates a World-Wide Web site that maintains that Auschwitz was not a death camp, he is, technically, adding as much "information" to the gross informational product as when someone posts an analysis of global warming. Garbage in, garbage sloshing around. When people "chat" about the weather in Phoenix or Paris, they are circulating information, but this does not mean they are either deepening their sensibilities or improving their democratic capacity

to govern themselves. Long before Hollywood or computers, the French observer Alexis de Tocqueville wrote of America: "What is generally sought in the productions of mind is easy pleasure and information without labor." Toward that very end, the genius of our consumer-oriented marketplace has been to produce the Walkman, the remote-control device, and the computer mouse.

When information piles up higgledy-piggledy—when information becomes the noise of our culture—the need to teach the lessons of the liberal arts is urgent. Students need "chaff detectors." They need some orientation to philosophy, history, language, literature, music, and arts that have lasted more than 15 minutes. In a high-velocity culture, the liberal arts have to say, "Take your time." They have to tell students, "Trends are fine, but you need to learn about what endures."

Faculty members in the liberal arts need to say: "We don't want to add to your information glut, we want to offer some ground from which to perceive the rest of what you will see. Amid the weightless fluff of a culture of obsolescence, here is Jane Austen on psychological complication, Balzac on the pecuniary squeeze. Here is Dostoyevsky wrestling with God, Melville with nothingness, Douglass with slavery. Here is Rembrandt's religious inwardness, Mozart's exuberance, Beethoven's longing. In a culture of chaff, here is wheat."

The point is not simply to help us find our deepest individual beings. It is also to help new generations discover that they are not that different from the common run of humanity. Common concerns about life and death, right and wrong, beauty and ugliness persist throughout the vicissitudes of individual life, throughout our American restlessness, global instabilities, the multiple livelihoods that we must shape in an age of retraining, downsizing, and resizing. We badly need continuities to counteract vertigo as we shift identities, careen through careers and cultural changes.

Finally, we need to cultivate the liberal arts in a democratic spirit— not necessarily for the sake of piety before the past (though that spirit is hardly ruled out), but to pry us out of parochialism. In preparation for citizenship, the liberal arts tell us that human beings have faced troubles before; they tell us how people have managed, well and badly. Access to a common, full-blooded humanities curriculum will help our students cross social boundaries in their imaginations. Studying a common core of learning will help orient them to common tasks as citizens; it will challenge or bolster—make them think through—their views and, in any case, help them understand why not everyone in the world (or in their classroom) agrees with them.

Regardless of one's views of the curricular conflicts of our time, surely no one who is intellectually serious can help but notice how students of all stripes arrive at college with shallow and scattered educations, ill-prepared to learn. They are greeted by budget pressures and shortsighted overseers. A strong liberal-arts curriculum could teach them about their history, their social condition, themselves. Today's common curriculum would not be that of 1950—any more than 1950's was that of 1900. What overlap it would have with the past would generate cultural ballast. Surely the academic left and right (and center) might find some common ground in the quest to offer a higher education that is democratically useful, citizenly, and smart. ○

SEEING

1. Summarize Todd Gitlin's account of the crisis currently facing the liberal arts. What does he view as particularly threatening about "the glut of images, stories, and facts in which young people are immersed" (para. 4)? What arguments does he muster for a "strong liberal-arts curriculum"? Why does he believe we need such a curriculum, and what would it entail? What does Gitlin mean when he talks about "information"? Where—and how—do you see the word used in similar or different manners?

2. Gitlin's essay was published in the *Chronicle of Higher Education*, a weekly professional journal primarily for faculty and staff. What features of the essay can you point to that indicate Gitlin's sensitivity to the interests and concerns of faculty and staff in American higher education? Consider, for example, his tone. How would you characterize it? How—and where—does his tone reveal his attitude toward undergraduates? What changes might Gitlin make in this essay if he were addressing undergraduates? Please verify your response by pointing to specific evidence from the text.

WRITING

1. Gitlin describes first-year undergraduates as having "only the sketchiest command of history or Western literature, let alone experience in thinking about similarities and differences among diverse histories and literatures. Increasingly, their professors tell them that their education must be multicultural, but their grasp of any culture at all is slight. Few can write cogently, but they find little to help them do so in the ever more abstruse humanities" (para. 2). What evidence of this characterization do you see among your peers? Within yourself? To what extent do you agree with Gitlin? Given your experience and that of your peers, in what areas are entering students not well prepared? Why or why not? Write a cogent essay in which you refute or support Gitlin's contention that few students enter higher education adequately prepared to deal with the intellectual richness and complexity of the curriculum.

2. Imagine that you have the opportunity to address the faculty in your college or university on the subject of educational reform. Write an essay in which you explain why you would—or would not—support the recommendation that your college or university establish a strong liberal arts curriculum. What, in your judgment, are the essential features of a college curriculum? What courses, if any, do you believe should be required? What other priorities would you recommend?

 Talking Pictures

When asked why he likes *The Simpsons* so much, Robert Pinsky explained, "Because the show is funny, brilliantly written for masterful vocal actors. But also, I think there is something about *The Simpsons* that penetrates to the nature of television itself. . . . Repeatedly, the show mocks and embraces its own genre. It even mocks disruption itself, regularly. . . . The simulation of faked live events—that's the only way to describe it—defines many episodes." For Pinsky, the appeal of *The Simpsons* and, more generally, of television, is their "absurdly paradoxical grounding in extremes of the actual and the synthetic."

Watch an episode of *The Simpsons*—either a new episode or a rerun. How does the show mock and embrace its own medium? Write an essay in which you agree or disagree with Pinsky's assertion about the appeal of *The Simpsons*. Please be sure to provide ample evidence to verify each of your assertions.

Retrospect:
Time Magazine

1969

1972

FINANCE

Hopefully Complex

Reserve Bank's Foresight

Rising Cycle of Business

Effect on Money Market

SPORT

Gene vs. Tunney

Test of the System

Firpo

New World's Records

AERONAUTICS

Chicago to New York

A Dreadnaught

Speed

A Successful Helicopter

TIME
The Weekly News-Magazine

— *the man who wants the
facts*
— *the man who wants to do
his own thinking after he
has the facts*
— *the busy man*

Is there such a man?

ROY E. LARSEN
Circulation Manager, *Time*
9 East 40th Street
New York, N. Y.

THOUGHTFUL, PENSIVE & HAPPY JOEY GALLO AS PHOTOGRAPHED BY FRIEND MARTA ORBACH

Our Friend Joey Gallo

In his final months of life, Mobster Joey Gallo developed an unusual friendship with Actor Jerry Orbach and his wife, Writer Marta Curro. Orbach had played a role entwined in part after Gallo's life in the movie version of Jimmy Breslin's The Gang That Couldn't Shoot Straight. One at the blue, the Orbachs got a call from Gallo, who wanted to meet his screen counterpart. The three saw each other almost daily after that. The Orbachs told TIME correspondents James Willwerth how they felt about Gallo. It is a picture that his rivals—and victims —would scarcely have believed.

JOEY had an intense sense of destiny," says Marta. "If he was truly marked for dying, this old-fashioned way —at style—would have been a point of honor to him. He was afraid he would choke on a piece of steak or slip in the bathroom. In a terrible way, Joey's death would have appealed to his sense of drama. He constantly told us that we might be with him when he was killed. And once he asked us if we would stay with him on a night when he knew it might happen. We would have, of course.

1997

TRIALS

No Again on the Conspiracy Law

After ten long weeks, 64 witnesses and many thousands of pages of testimony, the pivotal question in the trial of the Harrisburg Seven remained unanswered: When does chitchat become conspiracy?

PHILIP BERRIGAN RETURNING TO JAIL

SISTER ELIZABETH AFTER VERDICT

23

MUST THIS MAN DIE?

Roger Keith Coleman says he didn't kill anybody, but the courts are tired of listening. That could be a tragic mistake.

By JILL SMOLOWE

"Our procedure has always been haunted by the ghost of the innocent man convicted. It is an unreal dream."
—Judge Learned Hand, 1923

H ERE IS A STORY AS TWISTED AS THE THIN bands of highway that criss-cross the mountainous tip of southwestern Virginia, a remote pocket of mining country where the river runs black with coal dust in the spring.

467

MICHAEL ROCK

Michael Rock is one of three creative directors, writers, and designers who together form 2×4, a design firm in New York City that includes among its clients Knoll, the *New York Times*, the Whitney Museum of American Art, the Carnegie Museum, OMA/ Rem Koolhaas, and the Princeton School of Architecture.

Rock holds a B.A. in humanities from Union College and an M.F.A. in graphic design from the Rhode Island School of Design, where he was adjunct professor of graphic design from 1984 to 1991. He is currently associate professor of design at the Yale University School of Art, a visiting artist at the Jan Van Eyck Akademie in Maastricht, the Netherlands, and a contributing editor and graphic design critic at *I.D.* magazine in New York. He has lectured widely and his articles on graphic design have appeared in a variety of publications, including *Print*, *I.D.*, *AIGA* (American Institute of Graphic Artists) *Journal,* and the British journal *Eye*. Rock has received numerous awards from professional associations and publications, and in 1999 he received the Rome Prize in Design from the American Academy in Rome.

Michael Rock and his associates Katie Andresen and Alice Chung are the designers of *Seeing & Writing*.

SINCE WHEN DID *USA TODAY* BECOME THE NATIONAL DESIGN IDEAL?

Michael Rock

IN A RECENT *NEW YORK TIMES* SUNDAY MAGAZINE article on school textbooks, writer Robert Reinhold described California's new history series as ". . . filled with colorful charts, graphs, time lines, maps and photographs in a format suggestive of the newspaper *USA Today*." There it is again. Since when did *USA Today* become the national design ideal? Everywhere you look you find *USA Today* used as an analogy to describe a noteworthy design format. Making ideas "accessible" is the operative term for the information age. But too often information is drained of its significance in the name of accessibility.

Some things are designed for reading: scholarly journals, literary reviews, financial pages, and their ilk are fairly impenetrable to the casual page flipper. Other objects like *USA Today*, annual reports, fashion magazines, and so on are for looking. (Haven't you heard in the course of a design project someone say, only half in jest, "No one actually reads the copy, just make it look good.") Then there are the gray areas. These include newsmagazines and textbooks, which imply reading but are increasingly about looking. If you compare *Time* or *Newsweek* or a fifth grade schoolbook of twenty years ago to their present incarnations, the change is remarkable. The headlines are bigger, the captions are bigger, the photographs, charts, and call-outs are all bigger. Something had to go, someone must have decided, and what went was the text.

The trend in typography is clearly towards a destruction of narrative text, with images increasingly responsible for carrying the content. Running copy is being replaced with exaggerated hierarchies, charts, graphs, sidebars, boxes, captions, and call-outs that reduce the "story" to a collection of visualized pseudo-facts. It is the design equivalent of the video sound-bite, with complex ideas boiled down (in the words of Nigel Holmes, *Time*'s design director) to "manageable chunks."

HOW TO COMPETE AGAINST TV

The resulting designs often have the look of information, but without real content. Beyond its stylistic implications, this new typographic sensibility represents a change in the consumer's relationship to information, the author's authority, and the significance of the form. There is a fragmentation of communication, with the model of contemporary typography no longer being the linear argument but the simultaneous slogan. For instance, a *Newsweek* story may now open with an image that takes up as much as ninety percent of the spread, with only a small introductory paragraph of text as accompaniment. We are rapidly approaching the critical point where the graphics overtake the meaning.

The rationale behind the accessibility movement 5 is that information is easier to absorb in small pieces. Prodded along by marketing data, publishers and designers feel the need to compete with television and video for consumer attention. We have all heard that newspaper readership is down and that television has surpassed reading as the information source-of-choice for the majority of Americans. In response, publishers seem inclined to apply the TV info-tainment format to newspapers, and magazines. The logic is something along the lines of "TV is fast, vapid, and unbelievably successful. Publications should employ the same techniques as TV."

This perhaps makes sense in mass market magazines like *Entertainment Weekly* or *Spy* or even in corporate annual reports, where the message is not necessarily crucial; those products are not intended to challenge your intellect. When the same stylistic formats are applied to newsmagazines, newspapers, and schoolbooks, the implication may be more troubling. The distinction between what is news, opinion, entertainment, and propaganda is blurry enough. The turn toward graphic oversimplification may make the boundaries even more obscure. U.S. Education Secretary T. H. Bell referred to this phenomenon as part of the "dumbing down" of American textbooks that removes all complex information in [an] attempt to capture the reader's attention. But if students are unable to read and to grasp complex subjects, is the problem in the book? Is simplifying the content to fit into "exciting" *USA Today* formats going to solve the problem?

DESIGNING FICTIONAL FACTS

Publications made for looking rather than for reading can suggest entire themes with carefully composed photographs or coded design forms that avoid the kind of supporting evidence demanded in expository writing. (Consider the photograph from *People* of November 1991 showing Clarence and Virginia Thomas curled up on their couch reading the Bible. How can you respond to that image? How can you reason against it?) These formats emphasize the incredible power of the art-directed image, buttressed by the decontextualized quotation, the boldface caption, the "scientific" diagram, and the brightly colored map. Charts and diagrams are certainly useful for offering general, relational explications of an issue but they necessarily shave away the ambiguous, nuanced, or obscure aspects of any idea. The information has been preprocessed, prechewed; it can only lead to one conclusion. And so the design of these pages controls the reading, siphoning off all complexity and presenting a slyly fictional "fact."

At the most fundamental level, the spread of the *USA Today* style represents a destruction of traditional narrative ideals. Narrative implies an author as well as a reader. The reader negotiates the process of the rational argument, checking any specific point

against the entire premise. The credibility of the content is measured against the author's authority. The argument set forth is understood to be limited by the perspective inherently implied in the narrative voice. But images and charts seem to not imply an inherent point-of-view. They radiate a kind of false objectivity because the concept of the image-as-opinion is difficult for most people to grasp.

Cultural critics may see this shift toward the fragmented layout as an example of the continuing decline of textual authority, with the author's intention giving way to the reader's interpretation. They may praise this impulse. "Design becomes a provocation to the audience to construct meaning, consider new ideas, and reconsider preconceptions," says Cranbrook's Katherine McCoy. The philosophy of deconstruction may indeed serve as a tool to describe the original move toward fragmentation. But when the concept becomes codified and adopted as mainstream style, when the devices of mass culture adopt "deconstructed" typographic mannerisms, you can be sure it is not done to put greater interpretive power into the hands of the audience.

Fighting to grab one second from the harried, 10 over-informed consumer, the makers of the mass media have concluded that messages must be instantaneous, offering about the same content level as a fifteen-second television commercial. (As Nigel Holmes puts it, ". . . the dentist may well get through his first appointment sooner than you thought.") If a chart with a picture of Uncle Sam and a Russian bear on a seesaw balanced over an oil barrel can replace several paragraphs of text, all the better. No one has time to think about a rational argument; it takes too long, it's too boring. A sharp image and a few well chosen words can produce the same idea without the nuances but with a kind of prefabricated logic.

LOW-CAL READING

Setting aside the more sinister interpretations of this trend, one could argue that it actually relates to basic shifts in the way typography and design are produced. The Macintosh opened up to designers a vast array of new graphic possibilities, giving them access to what is the equivalent of sophisticated typesetting terminals. Intricate settings, overlapping or run-around type, complex charts and graphs that were once too costly and time consuming to design are now within the scope of even the smallest studio. Similarly, book and magazine publishers have greater digital composition possibilities and more four-color printing forms.

Or maybe the best explanation for the spread of *USA Today* look-alikes is that it is an inevitable extension of the LITE phenomenon. If beer or mayonnaise or individually wrapped slices of American cheese make you fat, then: a) stop eating and drinking so much; or b) remanufacture the products with fewer calories. We are more comfortable with the idea of changing our products than with changing our habits. Maybe publication design is under the same pressure. Maybe we want the "experience" of reading without all that heavy, annoying thinking. Maybe it's LITE design; it tastes great and it's less filling. ○

SEEING

1. What is the nature of the distinction Michael Rock draws between "reading" and "looking" (para. 2) as he responds to the question posed in his title? How is this distinction related to his assertion that "Making ideas 'accessible' is the operative term for the information age" (para. 1)? What does "accessible" mean here? Accessible to whom? How does the look of *USA Today* shift the emphasis from narrative to image in conveying content, and how does this shift produce what Rock calls "the design equivalent of the video sound-bite" (para. 3)? In what ways, then, does reading *USA Today* resemble watching television?

2. Outline the sequence of points Rock makes in building his case against what he sees as the current national design ideal. What makes his argument compelling? convincing? What other examples can you identify to support the substance and direction of his argument? What examples can you identify that might weaken or contradict his central claim?

WRITING

1. Rock claims that the new designs of newspapers, magazines, and textbooks "often have the look of information, but without real content. . . . this new typographic sensibility represents a change in the consumer's relationship to information, the author's authority, and the significance of the form. . . . We are rapidly approaching the critical point where the graphics overtake the meaning" (para. 4). Rock made this observation in 1992. Given what you observe in today's newspapers, magazines, and textbooks, to what extent is his concern relevant now?

Examine the language/image balance of the front page of a local or national newspaper. How do the editors use language and images differently to convey content—and in what proportion? Do they employ "slyly fictional 'fact'" (para. 7) and "a kind of prefabricated logic" (para. 10)? Write an essay in which you assess the extent to which the front page of this newspaper depends on "the new typographic sensibility" and images to convey meaning.

2. Rock argues that the design of *USA Today* affects content and "represents a destruction of traditional narrative ideals" (para. 8). What are these ideals, and how are they being destroyed by trends in typography? Write an essay in which you defend or challenge Rock's assertion that the trend in typography "is clearly towards a destruction of narrative text, with images increasingly responsible for carrying the content" (para. 3).

DAVID CARSON >

One of America's most innovative designers, David Carson was a competitive surfer and a high school teacher before he turned to graphic art. Characterized in 1996 by *Newsweek* as the person who "changed the public face of graphic design," Carson challenges the relationship between subject and style, typography and meaning. *Print* magazine judged his work "brilliant," and *USA Today* described it as "visually stunning" and suggested that his graphics might encourage more young people to take up reading again. Carson began his career in graphic design as a freelance designer for *Surfer* magazine. He and the editor transformed the magazine into a highly innovative, widely admired (it earned nearly 150 design awards), and yet financially only modestly successful magazine entitled *Beach Culture*.

Its successor, *Ray Gun,* has been described as "an essential guide to music and popular culture for trend-conscious men and women between 18 and 34 years old." It reflects Carson's penchant for presenting confusing typography, which renders type into a purely visual document.

The list of Carson's corporate clients includes Mercedes-Benz, MGM Studios, Kodak, Lucent Technologies, Microsoft, Armani, Nissan, Toyota, Pepsi, Cuervo Gold, MTV, and Nike. He also published *The End of Print* (1996). The following pages all come from *The End of Print* and were originally printed in *Ray Gun*.

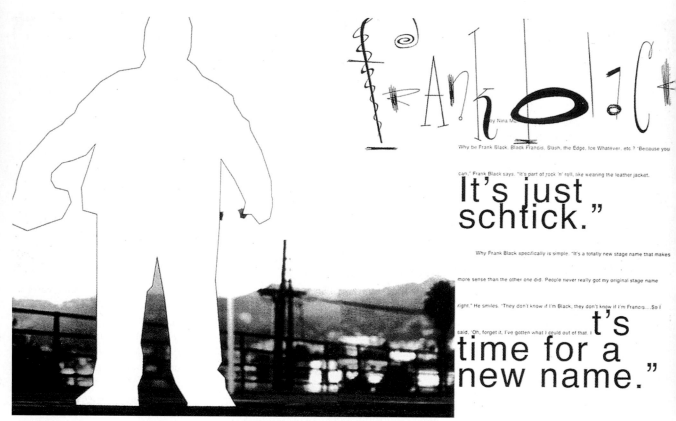

FRANK BLACK

by Nina M...

Why be Frank Black, Black Francis, Slash, the Edge, Ice Whatever, etc.? "Because you can," Frank Black says. "It's part of rock 'n' roll, like wearing the leather jacket.

It's just schtick."

Why Frank Black specifically is simple. "It's a totally new stage name that makes more sense than the other one did. People never really got my original stage name right." He smiles. "They don't know if I'm Black, they don't know if I'm Francis....So I said, 'Oh, forget it, I've gotten what I could out of that. I

t's time for a new name."

Frank Black

the case of the LA Shamen show they lost

Avalon Attractions Les Boursans had originally booked this Shamen show for the Shrine Auditorium capacity 6300 Last year he did the Spruce Goose extravaganza and was hoping to go it one bigger But when ticket sales failed to break the 100 mark he understandably wanted out

Promoter Philip Blaine of Kingfish now Moveable Feast Inc. picked up the show moved it to a smaller venue It was left with only seven days to promote it

"I've been doing raves for a long time, and the Shamen show wasn't really a rave," he admits. "If I knew I was going to do that gig a month ago it would have been in a warehouse There would have been 5,000 people there and tons of extracurricular stuff going on besides the band. But a full scale rave takes a lot of production and promotion Usually when you confirm a show you put an ad in the LA Weekly you put heavy promotion on KROQ you give away a bunch of tickets You do a lot. Boursans did a little, but he didn't really get behind it with a really good backstage type of anything like that.

"It was okay," says C of the gig the next day as he and Colin sit in their San Francisco hotel room awaiting soundcheck. "America's just really behind. Everything here is just rock and roll now. It's really backward.

It's exactly this "backward" mentality — the brainless, beer-swilling "five men waving their fists, slam dancing, stage diving and all the other macho posturing that accompanies a rock concert — that Colin and C strive to transcend

"There is definitely a shamanic tradition on rock and roll," Colin says. "Some performers were being deal, especially in the 60's with Morrison and Hendrix and all that But those kinds of performers were being poetry and virtuosity and information in the music, and that was shamanic. Most rock and roll is just an ego thing, with everyone just focusing on the person up there.'

"There's no drawing in the people so that it is a unified thing with rock because it's all me, me, me," C picks up. "What we're creating here is happening for everyone. There's not a head performer because that is a domination type thing, We're not like that. We're more an influence than the leader. We're just part of the whole experience.'

The band is the first to admit that not every American audience is openminded enough to receive the Shamen message. Even in supposedly hip New York City, the band found themselves halfway through the set before the audience caught on. "After a while," C smiles, "they can't help but be empowered by the rhythms.'

"But there are concerts where they're into it from the first beat," says Colin. "They're ready for it. They've come for it. They know they're going on a journey and they're ready.'

Increasingly, says Blaine, these cities are smaller, like

Curved Column

DANCE

Survival Research Laboratories, Only Uppercase

Overlapping, Repeated Type

SEEING

1. A critic of Carson's book, *The End of Print*, recently observed that his text "seems to have been sprayed into the book with a garden hose. It spills over images; doubles up on itself; jumps columns, lines, and pages; changes fonts and type sizes without warning; and generally does everything it can to avoid being taken prisoner." How accurate do you find this description of Carson's work? Are his layouts actually impossible to read? In what ways do they reflect the fragmented, nonlinear, multimedia, and technological ways in which meaning is communicated in contemporary culture? Point to specific examples to verify each point you make.

2. What does Carson gain—and lose—by seeming to violate every rule and convention of graphic design? How do you account for the enormous appeal of his designs among readers described as members of so-called Generation X? Would Carson's approach to typography work as effectively in, say, the magazine section of your local or national Sunday newspaper? Explain why or why not.

WRITING

1. Carson chose *The End of Print* as the title of his book, and the headline in a recent online magazine on graphic arts read: "Are Words Dead?" Consider this question carefully, and, using Carson's work as a focal point for your thinking and writing, prepare the first draft of an essay in which you answer this question. To what extent—and in what ways—do Carson's designs reflect or predict "the end of print"?

2. In a recent interview, Carson explained that "just because something is legible doesn't mean it communicates; it could be communicating completely the wrong thing. . . . You may be legible, but what is the emotion contained in the message?" More often than not, Carson suggests that this emotion is boredom. His work has prompted strong—and often divergent—responses. Some readers celebrate him as a "master of typography," others as "the king of noncommunication." Drawing on the sample of his work provided here, write the first draft of an essay in which you articulate and then defend your own views either of the special attractions of Carson's work or of your resistance to it.

Portfolio: David Carson 475

STEVE WOLFE

Born in Italy in 1955, Steve Wolfe graduated from Virginia Commonwealth University in 1977 with a fine arts degree and moved to New York City soon after. Wolfe supported himself by creating department store window displays and waiting tables. When he decided to focus on his own painting in 1982, he became interested in the words that appeared on the objects—such as book spines and cigarette cartons—that he was rendering in still lifes. "For some reason I found reading those words to be exciting," Wolfe explains, "and I had to figure out how to zero in on that. Eventually, I made one book and then another and then another."

Wolfe has since become well known for his strikingly realistic sculptural renditions of books, LP records, and cardboard boxes, using a variety of materials including stretched canvas, paper, board, paste, paint and lacquer. Wolfe's meticulous replication of these objects, complete with the inclusion of tattered edges and torn covers, often fools viewers into believing he has simply arranged a set of old things on a gallery wall. "Wolfe's medium is simulation," writes art critic Amy Stafford. Wolfe's work has been exhibited in solo and group shows in galleries and museums in New York and California.

SEEING

1. Did you characterize what you first saw here as a photograph, a painting, a sculpture, or something else? Is your response the same after a second, more careful look? Point to specific evidence to verify your response. How does the knowledge that Steve Wolfe created this artwork out of various materials and displayed it on a wall alter its effect on you? How would you read this image differently if it were a photograph? What overall response does this image evoke in you?

2. Comment on Wolfe's choice of books. What do they have in common? How would the impact of this image change if a different set of books were represented? In responding to this image, one student said that the objects depicted looked like packaging for videos. Do you agree or disagree? What, in effect, makes the objects look like books or like something else?

WRITING

1. Inevitably, at some point in your career as a student, you have discovered some "unread books" on your shelf. What do these books say about you—about your interests, aspirations, and perhaps even your anxieties? Draft an essay in which you explain how these unread books help to define who you are or the kind of person you desire to be.

As an alternative exercise, you might choose three books you have not read but would like to read. Draft an essay in which you use these three books as a group to define who you are or seek to be.

2. Despite the old saying, "You can't judge a book by its cover," bookstores are filled with increasingly alluring cover designs for hardcover and paperback volumes. Choose one of your favorite works of literature. What ideas would you suggest for designing a cover for this book? What aspects of the book would you emphasize in its cover design? Write a two-page proposal to the publisher in which you seek to convince the publisher to adopt your design in future printings of the book.

SVEN BIRKERTS

Born in Pontiac, Michigan (1951), Sven Birkerts earned a B.A. at the University of Michigan and, while in Ann Arbor, worked at the first bookstore owned by Tom and Louis Borders. Birkerts soon decided that he wanted to write books, not sell them, and he moved to Massachusetts to pursue fiction.

In 1994, Birkerts published *The Gutenberg Elegies: The Fate of Reading in an Electronic Age*, in which he warned about the damage being done by word processors and thinking on screen and online. More recently, he edited *Tolstoy's Dictaphone: Technology and the Muse* (1998), a collection of writers' comments about technological marvels. "If I could wind history back," Birkerts says, "I'd wind it back to the rotary phone and stick with that. I'd wind the television back to three channels."

Birkerts argues that writing on paper is fundamentally different from writing on screen and that a printed book is fundamentally different from anything a computer can display. To Birkerts, print on paper represents civilization's soul. "People ask me why I refuse to use a word processor," he once told an interviewer. "I tell them because it feels like a typewriter with a condom over it."

The Fate of the Book

Sven Birkerts

I WOULD NEED THE FINGERS OF BOTH HANDS TO track how many times this past year I have been asked to give my thoughts on something called "the fate of the book." I have sat on symposia, perched on panels, opined on-line and rattled away on the radio—not once, it seems, addressing the fate of reading, or literacy, or imagination, but always that other thing: THE FATE OF THE BOOK. Which would be fine, really, except that the host or moderator never really wants to talk about the book—the artifact, the bundle of bound pages—or even much about the class of things to which it belongs. That class of things is of interest to people mainly insofar as it is bound up with innumerable cultural institutions and practices. In asking about the fate of the book, most askers really want to talk about the fate of a way of life. But no one ever just comes out and says so. This confirms my general intuition about Americans, even—or especially—American intellectuals. We want to talk about the big things but we just can't let ourselves admit it.

I begin with this observation because I am, paradoxically, always encountering intelligent people who argue that if we were to leave the book behind, replacing pages with screen displays, we would not be changing very much finally; that people would still read and write, only more efficiently; and that the outlook for education would be very likely improved.

There are many people out there who don't make a strong connection between the book and the idea, or culture, of the book. I would say that this connection is everything.

My position in the matter is fairly simple. The fate of the book must be considered side by side with the fate of electronic chip and screen-based technologies. It is only by asking about both that we can see what is happening around us, and *to* us. Which is, I insist, a total redrawing of the map. Here are changes so fundamental as to force us to redraft our hitherto sacred articles of faith about public and private life.

We make a mistake if we view books and screen technologies as competing for popularity or acknowledged superiority. These are not two approaches to the same thing, but two different things. Books cannot—and should not have to—compete with chip-powered implements.

Nor is there a war going on. It is not as if we are waiting to see what the battlefield will look like once the musket smoke has blown off. No, screens and circuits are here to stay—their empery is growing daily—and the only real question is whether the book will remain, and in what form, and to what end? And: what will it mean when the functions of the book have been superseded, or rewritten as new functions that no longer require paged things, only databases and screen displays?

New functions. That is, in a way, what it all comes down to. The book will disappear, if it does, because the functions and habits for which it is ideally suited will themselves disappear. And what will the world be like then? How will people act toward one another?

Many questions—and here is another: is technology driving the change of functions and habits, or is it the other way around? Could it be that *we* are changing, evolving, and beckoning that future toward us? The light-bulb was invented, it has been said, when the world was clamoring, like the dying Goethe, for more light. Inventions don't just initiate change—they are themselves responses to changed needs and circumstances.

Maybe we are ready to embrace the pain of leaving the book behind; maybe we are shedding a skin; maybe the meaning and purpose of being human is itself undergoing metamorphosis. I fully accept that my grandchildren will hear me tell of people sitting in rooms quietly turning the pages of books with the same disbelief with which I listened to my grandfather tell of riding in carriages or pitching hay. These images trigger a deep nostalgia in many of us, and we will have a similar nostalgia for the idea of solitary reading and everything it represents.

But evolution is evolution, and no amount of nostalgia can temper its inexorability. We need to look past the accrued associations and longings and to see the book in a historical light, as a technology. A need was felt, and the ingenuity arose to meet the need. And so happy was the result that we have great difficulty in letting it go, in facing the fact that the new imperatives now dictate new solutions. These new imperatives do not yet define us, but they may come to. To understand what they are, we need to look closely at both the old technology and the new. For the technology takes the print of our needs and our desires.

How *do* books and screen technologies differ? [10] Or—and—how will a dominantly electronic culture differ from the print-centered culture we have known these past few centuries? The basic oppositions, we will find, give lie to the claim that screen technologies are only modifications and improvements of the pre-existing.

I. CLOSURE VERSUS OPEN-ENDEDNESS

Whether scholarly or non-, the book has always represented the ideal of completion. The printed text has strived to be standardized, authorized, a summa. Indeed, we may notice that when new materials are added, requiring a "new" or "expanded" edition, the effect is often to compromise the original edition, suggesting retrospectively that its original appearance of authoritativeness was ill founded, its completion spurious, and making us wonder if all such appearances should not be considered skeptically. Similarly, an erratum is like a pimple on an otherwise creamy complexion. The fixity of the word imprinted on the page, and our awareness of the enormous editorial and institutional pressure behind that fixity, send the message that here is a formulation, an expression, that must be attended to. The array of bound volumes on the library shelves communicates that knowledge and understanding are themselves a kind of structure assembled from these parts. The societal imprimatur is manifest in the physical characteristics: the lettering on the spine, the publisher's colophon embossed on the title page. . . .

Screen technologies undo these cultural assumptions implicitly. Stripping the work of its proud material trappings, its solid three-dimensionality, they further subject it to fragmentation. That a work comes to us by way of a circuit means that we think of it as being open—available—in various ways, whether or not we avail ourselves of those ways. We can enter cleanly and strategically at any number of points; we can elide passages or chapters with an elastic ease that allows us to forget the surrounding textual tissue. With a book, the pages we thumb past are a palpable reproach. Whereas the new texts, or texts of the future, those that come via screen, already advertise (many of them) features that fly in the face of definitive closure. The medium not only allows—it all but cries out for—links, glosses, supplements, and the like.

Suddenly it appears that the deconstructionists were the hierophants[1] of the new dispensation. Their questioning of closure, of authority, of the univocal nature of texts, heralded the arrival of a new kind of text—a text made possible by a technology that was only beginning to unfold its possibilities when the first deconstructionist writings were published. How odd, then, to see that the temper of the academy is turning against the theoreticians of the decentered, the polysemous,[2] just as what was indirectly prophecied is coming to pass.

Already we find the idea of boundlessness encapsulated in the technically finite CD-ROM packages that are coming on the market. The structure—the referentiality—is such that one never reads or uses them with the totality in view. One uses them open-endedly, always with the awareness that the options have scarcely been exhausted. This would be true, in a sense, of a print encyclopedia—except, of course, that the material orientation is such that as a user, you never forget exactly where you have landed and where that situates you with reference to the whole body of text. Fittingly, encyclopedias and compendious reference works have been first in line for transfer onto CD-ROM.

II. HIERARCHY VERSUS THE LEVELING OF HIERARCHY

With finality, with closure, there follows ineluctably the idea of canonicity, that great bugbear of the deconstructionists. Where texts are deemed closed and where expressions are seen to strive for finality, it is unavoidable that vertical ranking systems will result. The push to finality, to closure, is also the push for the last word; which is another term for the struggle for vertical ascendancy. If intellectual culture is seen as the product, or benefit, of book learning, then it is the marketplace of ideas that decides which books will shape our thinking and our values. The battle of the books.

But now substitute circuit-driven screen textuality, put mutability and open-endedness in the place of definitiveness, and it's easy to see that notions of hierarchy will be very hard to sustain. In the theoretically infinite database, all work is present and available—and, in a way, equal. Where discourse is seen to be woven and, technologically speaking, collective, the idea of ranking dissipates. New systems of search and access will eventually render the notion of the enclosed work antiquated. Without a system of rigorously closed and definitive authored works the whole concept of hierarchy is useless.

III. HISTORICAL LAYERING VERSUS SIMULTANEITY

The system of print textuality has always promoted the idea of culture as a matter of tradition and succession, with printed works leading back into time like so many footprints. The library or special collections department gives this notion concrete embodiment. Tracking an idea, an influence, we literally go from newer to older physical texts. The scholar's finger brushes the actual molecules of bygone eras. And historical depth is one of our most powerful metaphors—for centuries it has been our way of figuring the idea of time, of past receding from recent to ancient.

Screen technologies, circuited to their truly mind-boggling databases, work implicitly against the sedimentary paradigm. To plunder the analogy, they are metamorphic: they have the power to transpose the layered recession of texts into a single, vast collection of cross-referenced materials; they change the standard diachronic[3] approach to history to one that is—in the absence of the material markers that are books—synchronic.[4] And in this they further promote the postmodern suspicion of the historical time line or the notion of narrative. The picture of history that database and screen unscroll is of webs

1. *hierophants:* priests in ancient Greece; advocates [ed.].
2. *polysemous:* having multiple meanings [ed.].
3. *diachronic:* of, relating to, or dealing with phenomena (as of language or culture) as they change over time [ed.].

4. *synchronic:* concerned with events existing in a limited time period and not considering history [ed.]

and "trees," a field of relations and connections that eluded earlier historical projections, and that submerges any notion of story (and recall that the etymological root of history is "storia," meaning story), submerges it in vast informational complexity.

But the impact of such a paradigm change is less upon scholars and historians, who certainly don't need to be reminded that historical time is a kind of depth; rather, it will be the generations of students who learn about the past from these connection-rich databases who will, over time, internalize a very different understanding of the past than was held by the many generations preceding them. Is this good, bad, or neither? I naturally incline to the view that while we can never really *know* the past, or grasp history except fleetingly in the comprehended detail, time past is a powerful Other, a mystery that we never stop trying to solve, one which is closely bound up with our somewhat poetic conception of depth.

IV. THE PRIVATE SPHERE VERSUS THE PUBLIC SPACE

Although the technology of the book originally evolved to preserve and transmit information outside the intimate space of the geographical community—a fact which can be understood as giving the word a much larger public—it is also true that book reading is essentially private in character. This is not only because of the need for self-possessed concentration on the part of the reader, but also because the medium itself—the book—is opaque. The word signifies against the dead-endedness of the paper it is printed on, and in the process of signifying it incessantly enforces the awareness that that word is a missive from an individual sensibility, that its inscription originated in a privacy. Whatever one reads, the act is understood to be a one-to-one communication: Henry David Thoreau or Roland Barthes to myself. In this, reading has always been the verso[5] of writing; the two acts are more intimately bound than we usually imagine them to be.

Reading from a screen invokes, automatically, the circuit system that underwrites all screen transmissions. Again, on a subliminal level the traditional assumptions are modified, undone. The words on the screen, although very possibly the same as the words on the page, are not felt to dead-end in their transmitting element. Rather, they keep us actively aware of the quasi-public transparency out of which they emerge. These words are not *found* in the way that one can thumb forward in a printed text and locate the words one will be reading. No, they emerge; they are arriving, and from a place, moreover, that carries complex collective associations. To read from a screen—even if one *is* simply scrolling *Walden*—is to occupy a cognitive environment that is very different from that which you occupy when reading a book. On a small scale this does not amount to much. But when the majority of reading acts take place at the screen, then we might argue that a blow of some sort has been dealt to solitary subjectivity. Especially as the book has always been more than a carrier of information or entertainment—it has traditionally represented a redoubt[6] against the pressures of public life, a retreat wherein one can regroup the scattered elements of the self.

The other obvious difference between printed and screen-delivered text derives from the fact that chip-driven systems not only allow but encourage collaborative and interactive operations. Texts programmed for CD-ROM are the obvious instance of this, but there is little doubt that we will see more and more of these applications, especially in classroom settings. Which suggests once again that the developments which may strike those of us who are children of the book as exotic will seem perfectly natural to the generation now carrying out its first exploratory mouse clicks. And who will doubt that when reading CD-ROM is normal, reading the linear, missionary-position way will seem just a little bit strange. Moreover, as more and more texts get

5. *verso:* a left-hand page [ed.].

6. *redoubt:* a secure position [ed.].

written on the computer, we will probably see writers experimenting with the new presentation options that the medium accommodates. Though conservatively minded critics may question the aesthetic validity of collaborative hypertext ventures, these ventures will certainly flourish and further undercut the old paradigm of the lone reader turning the pages of some one author's book. Again, this is not just a change in reading modes; it is at the same time a major alteration of our cognitive environment. By degrees we will see much of our intellectual and artistic enterprise move away from strictly private exchange and in the direction of the collective. Maybe the day will come when most of our thought—and its expression—is carried out by teams. The lone creator or thinker will be a figure in our nostalgia banks, a memory preserved on commemorative postage stamps—although the odds are that postage stamps, too, will have vanished into that museum of images that will be the past.

We are moving, then, toward Roland Barthes's "Death of the Author," and toward his idea that texts are not bounded entities, but weavings ("textus" means weaving). The idea that the individual can be a carrier of some relevant vision or message will give way to a suspicion of the individual producer as atavistic[7] romantic. Indeed, the "romantic," bound up as it is with notions about the symbolic agon[8] of the solitary self, is already something of a category of derision. To call somebody a "romantic" nowadays is like calling them a "hippie"—a term that signifies as unambiguously in the cultural sphere as Edsel does in the automotive.

This may seem like a wild extrapolation—and I hope it is—but if one spends some time factoring tendencies, it's hard to get a significantly different outcome. The point is that subjective individualism is on the wane, and that, given the larger dynamics of a circuit-driven mass society, the tendency is more likely to intensify than to abate. Of course, the transition

from book to screen that I've been speculating about is not the driving force behind the change—there is no one culprit to finger—but it is certainly part of the system of changes; it stands as yet another instance of what in the larger view has begun to assume an evolutionary character.

V. EXPRESSIVE VERSUS FUNCTIONAL USES OF LANGUAGE

Hand in hand with the shifts noted above—and abetting the move toward the collective/collaborative configuration of our intellectual culture—will be the redefinition of our expressive ideals. That is, our very usage of language will change—as it is already changing—and literary style will be the obvious casualty. This makes perfect sense. Style has always been predicated upon absence and distance. A writer refines a style in order to compensate for the fact that she has nothing but words on the page with which to transmit her thoughts and emotions. Style is, in a sense, the injection of personality into communication, the attempt to leap the gap of time and space using the wings of expressiveness. But as any habitué of the Internet or e-mail user will tell you, style is not of the essence in screen-to-screen communication. For the very premise of this communication is near immediacy. The more we are linked up, the more available we are to each other, the less we need to ponder what Flaubert called the "mot juste." We don't slave over our sentences when we are face-to-face—don't because we can use gesture and inflection, and because we are present to supplement or amend our point if we detect that our listener has not gotten it right. In this respect, screen communications are closer to conversation than to, say, letters, even though they use the written word as their means of delivery.

So long as we take the view that style is merely an adornment—a superfluous extra—this may not seem like a great loss. There is even a bias in certain quarters that style is some kind of corruption or

7. *atavistic*: reminiscent or recurrence of a past style, manner, outlook, or approach [ed.].

8. *agon*: the dramatic conflict between the chief characters in a literary work [ed.].

affectation, that we should prefer Hemingway to Fitzgerald, or Orwell to Nabokov, because less is more and plain speaking is both a virtue and the high road to truth. But this is a narrow and reductive perspective. For not all truths can be sent through the telegraph, and not all insights find a home in the declarative sentence. To represent experience as a shaded spectrum, we need the subtle shading instruments of language—which is to say that we need the myriad refinements of verbal style. This is my fear: that if the screen becomes the dominant mode of communication, and if the effective use of that mode requires a banishing of whatever is not plain or direct, then we may condition ourselves into a kind of low-definition consciousness. There may result an atrophy, a gradual loss of expressions that are provisional, poetic, or subjectively nuanced. We should worry, then, not just about the "dumbing down" that is fast becoming the buzzword for this possibility, but also about the loss of subjective reach. If there is one line of defense against the coming of the herd mentality, it is the private intransigence of individuals, and that intransigence feeds on particularity as a plant feeds on sunlight.

If I am right about these tendencies, about the shift from page-centered to screen-centered communication, then we will be driven either to acquiesce in or to resist what amounts to a significant modification of our patterns of living. Those who assent will either do so passively, because it is easier to move with what appears to be the current of the times, or else they will forge on with zeal because they believe in the promise of the new. Resisters will have to take an active stance—to go against the current, you must use paddles. In both contingents, upstreamers and downstreamers, we will find a small number of people who recognize what is truly at stake, who understand that page and screen are really just an arena where a larger contest of forces is being played out.

Though I class myself as one of the resisters, I think I can see how certain tendencies that I deplore might seem seductive to others. Is there anything intrinsically *wrong* with viewing the work of culture as fundamentally collaborative rather than as an individual-based enterprise? Have we not made too great a fetish of the book, and too large a cult of the author? Aren't we ready for a change, a new set of possibilities?

Mired as I am in the romance of subjective individualism, in the Emersonian mythos of self-reliance, I cannot concede it. I have my reasons.

Let me begin by appropriating Nicholas Negroponte's now familiar distinction between *atoms* and *bits*. A simple definition should suffice. Atoms, though invisible to the naked eye, exist in space; they are the foundation stones of the material order. Bits, by contrast, are digits; they are coded information—arrangements of zeros and ones—and while they pass through appliances made of atoms, they do not themselves have any materiality. They weigh literally nothing. Atoms are like bodies and bits are like the thoughts and impulses that instruct them in their motions. Indeed, we can assert that ideas and the language that expresses them are bits; books are atoms, the bodies that sustain them.

Mr. Negroponte and I agree that we are but in the first flushes of the much-ballyhooed Information Age, and that by the time the gathering momentum has expended itself—a decade or two hence—the world will look and feel and *be* utterly different from the more slowly evolving place we all grew up in. Atoms will, of course, still exist—after all, we are significantly atoms, and computers themselves are atoms. But the determining transactions in our lives will happen mainly by way of bits. Images, impulses, codes, and data. Screen events and exchanges that will, except for those who refuse—and some will—comprise an incessant agitation through one whole layer of the implicated self. For many this will bring a comforting sense of connectedness—they will be saying good-bye to the primal solitude that all but defined selfhood down through the millennia. The citizen of the not-so-distant future will always be, in a sense, on-line; she will live inside an envelope of impulses. And to be on-line thus is to no longer be

alone. This will be less and less a world hospitable to old-style individualism; that will be seen to have been an evolutionary phase, not a human given.

The relevance of this admittedly grand projection to the fate of the book should be starting to come clear. The book as we know it now—the printed artifact that holds in its pages the writer's unique vision of the world, or some aspect of it—is the emblem par excellence of our threatened subjectivity. The book represents the efforts of the private self both at the point of origin, in the writer, and at the point of arrival, in the reader. That these are words on a page and not a screen has enormous symbolic significance. As I have suggested, the opaque silence of the page is the habitat, the nesting place, of the deeper self.

This is a bit abstract, and I will have to get more abstract still before coming around full circle. The book, you see, the tangible paper item, the very ink shapes of the words on the page—these are things. Atoms. But what the atoms are configured to convey—what gives value to the book—is the intangible element. The bit. In this way alone the book is a primitive computer, or an analogue to brain and mind. Visions and thoughts and their expression in language have never been atomic. They are *about* the atomic, the material, at least in very large part. Though they are without dimension or gravity, bits refer mainly to entities that have both.

Well, you might say, if this is true, then what is all the fuss about? What's the difference whether the content of these bits comes across on the page or on the screen? How can I argue that the digital future threatens anything that really matters?

I have two thoughts on this. 35

On a micro scale, I would propose that a significant, if highly elusive, part of the reading operation is marked by the transfer from atom to bit. The eye motion converts the former to the latter. The printed word becomes a figment in the mind much as water becomes vapor. There is a change of state, one that is a subthreshold part of the reading transaction. Words on a screen, already part of the order of bits, are not made to undergo this same fundamental translation.

There is a difference in process. When we read from a screen, or write directly onto a screen (without printing out), we in fact never cross the border from atom to bit, or bit to atom. There is a slight, but somehow consequential, loss of gravity; the word is denied its landing place in the order of material things, and its impact on the reader is subtly lessened.

"Ridiculous!" you say. To which I can only reply that outwardly nothing about our fiscal processes changed when we went off the gold standard (nobody but tourists ever saw the vaults at Fort Knox), but that an untethered dollar feels different, spends differently, than one secured by its minim of bullion.

On a macro scale, I am also preoccupied with the shifting of the ground of value. By moving increasingly from A to B—from atom toward bit—we are severing the ancient connection between things and their value. Or if not that, then we are certainly tipping the sacred ontological scales. Bits are steadily supplanting atoms. Meaning what? Meaning that our living has gradually less to do with things, places, and human presence, and more to do with messages, mediated exchanges, ersatz environments, and virtual engagements of all descriptions. It is hard to catch hold of this by looking only at the present. But try a different focal adjustment. Think about life in America in the 1950s in terms of these fundamentals and then project forward to the millennium, now less than five years away. You cannot fail to note how that balance has shifted—from the thing to its representation, from presence to mediation. And if this is the case, then life, the age-old subject matter of all art, cannot be rendered in the same way anymore. The ground premises of literature—indeed of all written content—are altered, or need to be, for everything is altered. Instead of bits referring simply to atoms, we find more and more that bits refer to other bits. If the book is a mirror moving alongside our common reality, then the future of the book— and of writer and reader—is tied to that reality.

When we ask about the future—the fate—of the book, I interpret this to mean not just the artifact, but a whole kind of sensibility. Questions about that

future are, really, larger questions about ourselves. How will we live? Who will we be? What will be the place of the private self in the emergent new scheme of things?

Myself, I see no shame in the label "romantic" and I will not accept that it is now unfashionable to be tilting at windmills. The idea that the book has a "fate" implies, in some way, the *fait accompli*. And while I believe that there is a strong evolutionary tendency underlying our moment-to-moment dealings and decisions, I don't believe that it is pointless to counter or protest that tendency. My instinct, signaling from some vestigial part of the psyche, tells me to avoid placing all my faith in the coming of the chip-driven future. It bids me to question the consequences of the myriad promised simplifications and streamlinings and to stall somehow the rush to interconnectivity, that comes—as all interconnectivity must—at the expense of the here and now. Certainly the survival of that archaic entity called the soul depends on resistance. And soul or not, our remaining individuals depends on our keeping the atom to bit ratio weighted, as it ever has been, toward the atom. Otherwise we are in danger of falling into a dream that is not ours or anybody else's, that spreads inexorably on the legs of its ones and zeroes. ○

1. Sven Birkerts argues that the book and the screen "are not two approaches to the same thing, but two different things" (para. 4). Make as extensive a list as you can of the different words he associates with each. What personal and cultural consequences does he associate with the evolving change from the book to the screen? What, for example, does he view as the consequences for individuality, authorship, and reading, and especially for matters of style? In this respect, you might want to compare Birkerts's discussion of the effects of information technologies with the conclusions Todd Gitlin reaches in his essay entitled "The Liberal Arts in an Age of Info-Glut" (p. 462).

2. Outline the sequence of points Birkerts makes as he builds his argument, encouraging his readers to resist the change from book to screen. What evidence does he provide to validate each claim? Which of his points do you find yourself agreeing with or rejecting? Explain why. What would you describe as the strengths— and the weaknesses—of his argument? Finally, how convinced are you by it?

1. Writing e-mail is one of the most popular and pervasive forms of communication in the contemporary world. It has done much to change the quantity and quality of everyday communication, be it personal or professional. Birkerts even claims that screen communications are closer to conversation than to something as informal as letters (para. 25). Write an essay in which you compare and contrast the similarities and differences between writing e-mail and writing a letter. What features are similar to each kind of writing? What features distinguish writing e-mail from writing letters? Which kind of writing do you prefer? Explain why.

2. One of Birkerts's more contentious assertions involves the cultural implications of what he calls "the shifting of the ground of value. . . . from atom toward bit. . . . Bits are steadily supplanting atoms. . . . Meaning that our living has gradually less to do with things, places, and human presence, and more to do with messages, mediated exchanges, ersatz environments, and virtual engagements of all descriptions" (para. 38). Write an essay in which you support—or challenge—Birkerts's claim that "You cannot fail to note how that balance has shifted— from the thing to its representation, from presence to mediation" (para. 38).

The Fate of the Book

Sven Birkerts

POP-UP VIDEO

Created by Spin The Bottle, Inc., *Pop-Up Video* is a music video show that has helped popularize cable channel VH1 since 1996. In each of the five music videos featured in a half-hour show, Spin The Bottle researches a series of "pop-ups," short pieces of trivia or humorous facts superimposed in bubble-shaped graphics during the course of the music video. Whether providing random facts related to song lyrics, poking fun at artists, or giving a behind-the-scenes look at the music video industry, these graphics, along with the accompanying signature popping noise, fundamentally alter the aesthetic of the original video.

Tad Low and Woody Thompson, co-founders of Spin The Bottle, pitched the idea as "the first show that gives you background information about a video while you're actually watching it. Whether through on-screen icons, telestrated handwriting or a lower-third crawl, more information comes at you than you can even handle. It's hypertext television."

Capitalizing on the current fascination with retro-hip, *Pop-Up Video* replays old hits in a humorous manner. Despite the occasional controversy with "artists who take themselves way too seriously," Spin The Bottle pledges to "continue . . . exposing the pompous, revealing the ugly truth, goofing on the freaks, and making embarrassing noises— until someone shuts us down, or the Y2K bug sends civilization back to the Planet of the Apes."

 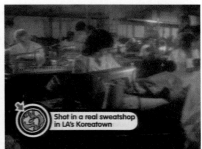

Pop-Up Video, **Donna Summer, "She Works Hard for the Money"**

Links

Steven Johnson

IF THE MID-NINETIES BATTLE OVER EBONICS[1] taught us anything, it's that the lexicon of popular idiom and slang is never quite what it appears to be on the surface. Colloquial speech gets a bad rap, but more often than not slang is where language happens. The influx of new terms and intonations keeps the word-world lively. (Think of the way Yiddish has enlivened urban American conversation.) But slang doesn't necessarily rely on phonetic innovation. Sometimes the most influential buzz-words come into popularity as crossover hits, appropriations— the way NASA jargon infiltrated the national vocabulary after the moon landing. Popular slang has borrowed heavily from the digital idiom in recent years: the ubiquitous "cyber-" prefix, the broad assault of "spamming." (I've heard more than a few friends punctuate an especially profound statement with the exclamation, "Click on *that!*") It's only fitting that Silicon Valley should serve up these new turns of phrase; having borrowed a handful of metaphors from the analog provinces, the digital idiom is now returning the favor.

But not all slang translations do justice to their new environments. Like the desktop metaphors of the graphic interface, colloquial phrases that hop from one context to another run the risk of confusing matters. The familiarity of the phrase has an initial value, the way the desktop helped millions of users acclimate to the idea of information-space. But the analogy invariably has its limits. There are always threshold points and variations that separate the metaphor from the thing itself. Sometimes the gap is so wide that the translation obscures more than it reveals—like a desktop metaphor so convincing that we neglect the computer's miraculous aptitude for shape-shifting. In both interface design and popular slang, some migrations from one context to another just aren't worth the trip.

So it is with the verb *to surf* and all its variations: Web surfer, cybersurf, surfing the digital waves, silicon surfer. Not only are the iterations inane, but the concept of "surfing" does a terrible injustice to what it means to navigate around the Web. In this case, it's not the allusion to literal surfing that leads us astray—though the laid-back, Jeff Spicoli 'tude of most real surfers hardly corresponds to the caffeinated twitch of your average Webhead. What makes the idea of cybersurf so infuriating is the im-

1. *Ebonics:* Another name for African American vernacular English or vernacular Black English, a systematic and rule-governed natural speech variety of American English [ed.].

plicit connection drawn to television. Web surfing, after all, is a derivation of channel surfing—the term thrust upon the world by the rise of remote controls and cable panoply in the mid-eighties. Those aimless excursions across the landscape of contemporary TV—roaming from infomercial to C-SPAN to news bulletin to cartoon—were so unlike anything that had come before that a new term had to be invented to describe them. Applied to the boob tube, of course, the term was not altogether inappropriate. Surfing at least implied that channel-hopping was more dynamic, more involved, than the old routine of passive consumption. Just as a real-world surfer's enjoyment depended on the waves delivered up by the ocean, the channel surfer was at the mercy of the programmers and network executives. The analogy took off because it worked well in the one-to-many system of cable TV, where your navigational options were limited to the available channels.

But when the term crossed over to the bustling new world of the Web, it lost a great deal of precision. Web surfing naturally came to be seen as an extension of the television variety, the old routine of channel surfing dressed up in high-tech drag. With that one link of association, a whole batch of corollary attributes wrapped themselves around the hapless Web surfer. We knew from countless pop-psychological treatises and op-ed pieces that channel surfers suffered from many ailments: they were prone to attention deficit disorder and ill-inclined to perceive causal relationships; they valued images over text, but rarely watched anything for more than a few minutes at a time. These were the pathologies of the channel surfer, and they were dutifully transferred to the channel surfer's Web-based kindred as soon as the phrase was coined. Thereafter, the two activities—roaming through the mediasphere via remote control and following links through cyberspace—became variations on the same theme. Neo-Luddites like Sven Birkerts and Kirkpatrick Sale offered up lamentations on the new generation of surf-addled zombies, bewitched by the disassociative powers of the remote control

and hypertext, oblivious to the ordered, moral universe of linear narrative. Gen X advocates like Doug Rushkoff built up successful consulting careers by championing the improvisational skills of today's media-savvy "screenagers."

But both the Luddites and the GenXers were seriously misguided. Web surfing and channel surfing are genuinely different pursuits; to imagine them as equivalents is to ignore the defining characteristics of each medium. Or at least that's what happens in theory. In practice, the Web takes on the greater burden. The television imagery casts the online surfer in the random, anesthetic shadow of TV programming, roaming from site to site like a CD player set on shuffle play. But what makes the online world so revolutionary is the fact that there *are* connections between each stop on a Web itinerant's journey. The links that join those various destinations are links of association, not randomness. A channel surfer hops back and forth between different channels because she's bored. A Web surfer clicks on a link because she's interested. That alone suggests a world of difference between the two senses of "surfing"—a difference that contemporary media critics would do well to acknowledge.

Unfortunately, the media critics are only half the problem. Silicon Valley itself has proved to be just as inept when it comes to the new explorations of hypertext, most egregiously in recent start-ups like Netscape and Excite that owe their billions to the Web's overnight success. That success is a direct measure of the power and the promise of hypertext—all those links of association scattered across the infosphere—and yet most Web specific start-ups have studiously ignored hypertext, focusing instead on the more television-like bells and whistles of grainy video feeds and twirling animations. There is no little irony in this state of affairs: companies that rose to prominence on the shoulders of hypertext ignore the links as soon as they go public, as though hypertext were just an afterthought, a passing fancy. You can see this strange neglect as yet another case of Silicon Valley striving for the Next Big Thing, its

dialectical quest for ever more enthralling technologies. But you can also see it as a case of sawing off the branch you're sitting on.

This indifference to hypertext stems in part from the ill-suited adaptation of the "surf" idiom. The allusion to TV flattened out the more engaged, nuanced sensation of pursuing links, made it harder to see the real significance of the experience, which then made it harder to imagine ways in which it could be improved. That neglect is no small matter. Consider just this one statistic: near the middle of 1996, Netscape and Microsoft released new versions of their respective Web browsers, setting some sort of informal record for the most rapid-fire software upgrades in history. These new versions between them unleashed more than a hundred new features, according to the press materials that accompanied them. There were upgrades for Java support, new animation types, sound plug-ins, e-mail filters, and so on. But not one of these new features—not one—enhanced the basic gesture of clicking on a text link. The very cornerstone of the World Wide Web had been completely ignored under a blizzard of other, gratuitous additions. For those of us who spend a great deal of time "surfing" online, the oversight was maddening. Ask any Web user to recall what first lured him into cyberspace; you're not likely to hear rhapsodic descriptions of a twirling animated graphic or a thin, distorted sound clip. No, the eureka moment for most of us came when we first clicked on a link, and found ourselves jettisoned across the planet. The freedom and immediacy of that movement—shuttling from site to site across the infosphere, following trails of thought wherever they led us—was genuinely unlike anything before it. We'd seen more lively cartoon animations on Saturday-morning television; we'd heard more compelling audio piped out of our home stereos. But nothing could compare to that first link.

What we glimpsed in that first encounter was something profound happening at the level of language. The link is the first significant new form of punctuation to emerge in centuries, but it is only a hint of things to come. Hypertext, in fact, suggests a whole new grammar of possibilities, a new way of writing and telling stories. But to make that new frontier accessible, we need more than one type of link. Microsoft and Netscape may be content with the simple, one-dimensional links of the Web's current incarnation. But for the rest of us, it's like trying to write a novel where the words are separated only by semicolons. (It might make for an intriguing avant-garde experiment, but you're not going to build a new medium out of it.) Fortunately, the world of hypertext has a long history of low-level innovation. More than any other interface element, the link belongs to the cultural peripheries and not to the high-tech conglomerates. Even as the Netscapes of the world ignore hypertext, the novelists and site designers and digital artists are busy conjuring up the new grammar and syntax of linking.

As the word suggests, a link is a way of drawing connections between things, a way of forging semantic relationships. In the terminology of linguistics, the link plays a conjunctive role, binding together disparate ideas in digital prose. This seems self-evident enough, and yet for some reason the critical response to hypertext prose has always fixated on the *disassociative* powers of the link. In the world of hypertext fiction, the emphasis on fragmentation has its merits. But as a general interface convention, the link should usually be understood as a *synthetic* device, a tool that brings multifarious elements together into some kind of orderly unit. . . .

Although the hypertext soothsayers were right to [10] sense something significant brewing in the new grammar of links, most of them were thinking on the wrong scale. Hypertext was supposed to revolutionize the way we tell stories, but it ended up transforming our *sentences* instead. Nowhere is this more apparent than in the World Wide Web itself—now the great breeding ground for hypertext innovation. The Web first drifted into prominence near the end of 1994, just as the public fascination with nonlinear fiction was hitting a high point. Joyce had been

named to *Newsweek*'s list of digital savants; the *New York Times Book Review* had run several extended essays on hypertext novels, laced with the obligatory references to Cortázar and Calvino; Sven Birkerts had published his assault on the forking paths of nonlinear narrative, *The Gutenberg Elegies*. The Web was seen as a logical continuation of this trend: a global medium for hypertext narrative. Soon we'd all be navigating through elaborate storyspaces on our desktop PCs, stitching our own tailor-made plots together with each mouse click. Journalists would file stories in a more three-dimensional format—as an array of possible combinations rather than a unified piece. The links would transform our most fundamental expectations about traditional narrative. We'd come to value environment over argument, shape-shifting over consistency.

But looking back now, after a few years of press releases and vaporware, what strikes you is how little of this came to pass. The great preponderance of Web-based writing is unapologetically linear. Almost all journalistic stories are single, one-dimensional pieces, articles that would be exactly the same were they built out of ink and paper instead of zeros and ones. (Many of them, of course, are simply digital versions of print originals.) If there is reader-centric navigation, it comes from hopping from article to article and from site to site. The individual articles themselves rarely offer any navigational options at all. Links do appear in some articles, but they're usually pointing to the Web sites of companies that happen to be mentioned in the piece—yet another way of accentuating brand identity, like a registered trademark or a logo. This is a particularly mindless use of hypertext. Illuminating a passing reference to Apple Computer with a link to "www.apple.com" might create the appearance of hypertext prose, but in actuality it's gratuitous, yet another case of digital window dressing. Finding a corporate Web site is one of the easiest tasks on the Web: it usually involves tacking a ".com" suffix onto the company's name and punching that into your browser. Reading an article about Apple Computer doesn't make

you want to check out its home page; it makes you want to read other, related articles on the same topic, or zoom in on one particularly tantalizing idea, or click over to a reader discussion about the company's future.

To be fair, a handful of Web publishers have integrated "related reading" pointers into their articles, though there is a strange compulsion to keep those links separated from the primary text. (Slate, for instance, trots out its links at the end of each article.) Other, community-driven sites—like HotWired and Electric Minds—feature excerpts from reader commentary in the margins of the top-level articles. But even the more adventurous, envelope-pushing sites like Word seem more preoccupied with multimedia frills than with associative links. When Stefanie Syman and I first designed FEED, we included two sections—Document and Dialog—that relied extensively on the new dimensions of hypertext. Document allowed readers and contributors to attach their own commentary to a primary text, like birds perched on the backs of lumbering elephants. Dialog deposited a panel of critics in a "conversation space," where each written remark led off in several directions; one sentence might generate a string of rebuttals and counterrebuttals, while another sentence might lead off to a mild clarification from the original author; or to a missive sent in by a reader: You didn't read so much as *explore* the Dialog, and like most interesting spaces, you'd stumble across a new passageway every time you went back to it. This was journalism for trailblazers, we thought, and we assumed that other Web publications would soon adopt similar journalistic storyspaces.

But two years later, the FEED Dialog remains one of the Web's most complex hypertext environments, at least among the mainstream publications. (More serpentine structures have been built on the margins of avant-garde fiction by hypertext trailblazers like Carolyn Guyer and Mark Amerika.) It may be that readers genuinely prefer the ordered, author-centric direction of traditional storytelling, and so more complex structures will remain the exception to the

rule. But my hunch is that the appetite for nonlinear prose will grow as we acclimate ourselves to these new environments—and to the strange new habits of reading that they require. Here again the legacy of channel surfing has done the Web a great disservice. The metaphor suggests a certain agitated indifference, zapping randomly from source to source. But moving through a hypertext space, following links of association, is an intensely focused activity. Channel surfing is all about the thrill of surfaces. Web surfing is about depth, about wanting to know *more*. But if you can't see that distinction, if you imagine the mouse as the poor cousin of the remote control, then of course you're not going to create documents that fully exploit the power of hypertext. There's plenty of programming designed for trigger-happy surfers on MTV; why bother lowering yourself to that common denominator on the Web?

Fortunately, ill-advised metaphors can't possibly curtail *all* innovation, particularly with a medium as democratic as the Web. As it turns out, the most interesting advances have taken place on the micro level of syntax, rather than the macro level of storytelling. This is one of those wonderful occasions—frequent in high-tech history—when the pundits and trendspotters have us looking in one direction and the exciting stuff ends up happening somewhere else. Hypertext links were supposed to be a storytelling device, but their most intriguing use has proved to be more syntactical, closer to the way we use adjectives and adverbs in our written language. The link was going to engender a whole new way of telling stories. It turned out to be an element of style.

Nowhere is this more apparent than in the irony-[15] drenched column of Suck. Launched anonymously by a pair of Unix hackers in the HotWired basement, Suck is now generally regarded as the ultimate do-it-yourself, self-publishing success story in the Web's short history. The daily column took aim at the Web's relentless march toward the commercial mainstream (this was still news at the time), riffing caustically on the bloated, straining-to-be-visionary pronouncements of the "digital elite" or the inane

online brochures of most corporate Web sites. The Sucksters liked to play themselves off as slackers and malcontents, lacing their columns with crack-smoking jokes and references to their being "postliterate." But the bad-boy posturing couldn't mask the intelligence and inventiveness of the prose, with its elliptical phrasing and penchant for extended metaphors. This onscreen style was both a curse and a blessing. The columns invariably sounded wonderful on first reading, but the layering of rhetoric made it difficult to pin down exactly what it was they were saying. Despite all the Budweiser jokes, what came to mind reading Suck was the cagey, intricate language of literary theory, the willed evasiveness of someone trying to use language to talk about how language doesn't work.

For a long time, I was puzzled by my return visits to Suck. Too many times the prose had seemed deliberately obscure, as if it were actively trying to repel its audience, inundating them with in-jokes, pop-culture references, French theory, and bathroom humor. Certain sentences had a kind of elusive, shimmering quality to them, as if you were seeing them at a great distance. You sensed that a tangible meaning lurked in the mix—if only you had the time to disentangle all the subsidiary clauses, parse out all the throwaway references. Consider this obtuse, but representative, example:

> In the new infomockracy, the cafe tables have been overturned. The stiffs chained to hollowed-out terminals are now on the bleeding edge, while the most observed of old-line cultural observers are merely blunted. No more reheeling your Manolo mules every three weeks—a lack of mobility confers an advantage. Though boxed into cubicles, the new counterparts of Whether Overground footsoldiers have freer, faster access to the entrails and tea leaves of hipster life.

Normally, of course, I'd have little patience with the onslaught of mixed-metaphor allusions, particularly on a Web site. But I found myself returning to the Sucksters, not so much to read what they had to say, but to figure out how they were saying it. After a few weeks of study, I began to realize that the uncanny, ethereal quality of the prose—particularly uncanny given the earthiness of the words themselves—was a side effect of the links. Like the passing resemblances of *Great Expectations,* the links triggered that sense of mystery, the sense of a code half-deciphered.

Suck's great rhetorical sleight of hand was this: whereas every other Web site conceived hypertext as a way of *augmenting* the reading experience, Suck saw it as an opportunity to withhold information, to keep the reader at bay. Even the sophisticated Web auteurs offered up their links the way a waiter offers up fresh-ground pepper: as a supplement to the main course, a spice. (Want more? Just click here.) The articles themselves were unaffected by the "further readings" they pointed to. The links were just addenda, extensions of the primary argument. The Sucksters took the opposite tack. They used hypertext to condense their prose, not expand it. The benefits were clear: they could move faster through their sentences if they linked out strategically to other documents. They didn't need to spell out their allusions; they could just *point* to them and leave it up to the reader to follow along. So they left things out, and let the trails do the work. They buried their links mid-sentence, like riddles, like clues. You had to trek out after them to make the sentence cohere.

The rest of the Web saw hypertext as an electrified table of contents, or a supply of steroid-addled footnotes. The Sucksters saw it as a way of phrasing a thought. They stitched links into the fabric of their sentence, like an adjective vamping up a noun, or a parenthetical clause that conveys a sense of unease with the main premise of the sentence. They didn't bother with the usual conventions of "further reading"; they weren't linking to the interactive discussions among their readers; and they certainly weren't building hypertext "environments." (Each Suck article took the resolutely one-dimensional form of a thin column snaking down an austere white page.) Instead, they used links like modifiers, like punctuation—something hardwired into the sentence itself. Most hypertext follows a centrifugal path, forcing its readers outward. The links encourage you to go somewhere else. They say, in effect: When you're done with this piece, you might want to check out these other sites. More sophisticated hypertext storyspaces say: Now that you've enjoyed this particular block of text, where would you like to go next? Suck, on the other hand, pointed its readers outward only to pull them back in, like Pacino's tragic dance with the Mob in the *Godfather* trilogy. The links were a way of cracking the code of the sentences; the more you knew about the site on the other end of the link, the more meaningful the sentence became.

In its simplest form, Suck's hyperlinks worked the way "scarequotes" work in slacker idiom. They labored in the service of irony, undermining the seriousness of the statement, like a defense mechanism or a nervous twitch. Suck was notorious for linking to *itself* at any mention of crass commercialism or degeneracy. You'd see *sellout* or *jaded* highlighted in electric blue, and you'd click dutifully on the link—only to find yourself dropped back into the very page you were originally reading. The first time it happened, you were likely to think it was a mistake, a programmer's error. But after a while, the significance of the device sank in. By linking to itself, Suck broke with the traditional, outer-directed conventions of hypertext: what made the link interesting was not the information at the other end—there was no "other end"—but rather the way the link insinuated itself into the sentence. Modifying "sellout" with a link back to themselves was shorthand for "we know we're just as guilty of commercialism as the next guy"—in the same way that scarequotes around a word is shorthand for "I'm using this term but I don't really believe in it." The link added another *dimension* to the language, but not in the storyspace sense of the word. You never felt that you

were exploring a Suck piece or navigating through an environment. You were just reading, but the sentences that scrolled down the screen had a strange vitality to them. They were more resonant somehow, and the hypertext shorthand allowed them to do much more with less.

The self-referential links were actually the easiest codes to decipher. Other combinations took more effort. Consider this sentence from an end-of-the-year column. It read, at first, like a seasonal good tidings from one Web publication to another; but once you unraveled all the links, the words took on a darker, more cutting tone. "We are pleased to see that FEED is still worth the effort, though occasionally extraneous." It's an intelligible enough phrase, if a little vague. But reading the sentence through the lens of hypertext sharpened the image noticeably. The word *effort* pointed to an article we had run at FEED critiquing the WebTV product by Sony and Philips; the word *occasionally* linked to a Suck piece, penned months earlier, on the same topic. *Extraneous* pointed to another Suck article that predated ours—this one less critical of WebTV. When you added it all up, the "meaning" of the sentence was a good deal more complicated than the original formulation. Like one of Freud's dream studies, the sentence had a manifest and a latent content. The former was clear-cut, straightforward: "We are pleased to see that FEED is still worth the effort, though occasionally extraneous." The latter was more oblique, something like: "We're still fans of FEED, though they tend to be about two months behind us, and they tend to rip off our ideas when they finally catch up—like this WebTV travesty." As in the dream work of psychoanalysis, the latent content had a way of infecting the manifest content. After you deciphered the links, the phrase *worth the effort* began to sound more and more derogatory, as though the readers were laboring under the "effort" rather than being rewarded for it.

It may sound like an unlikely comparison, given Suck's postliterate pretensions, but what these passages remind me of are the famous lines from Wallace Stevens's "Thirteen Ways of Looking at a Blackbird":

> I do not know which to prefer,
> The beauty of inflections
> Or the beauty of innuendoes.

Stevens describes the gap between literal language ("the beauty of inflections") and those subtle but still meaningful silences *between* words, their resonance, their beautiful innuendo. Suck's hypertext links seem to me to straddle that gap. They hover over the language, shadow it, part inflection and part innuendo. Who can say where the literal meaning lies? You can read the sentence straight, ignoring the links altogether; and it will indeed make sense, though you can't help but feel that something has been lost in the translation. But it's just as hard to imagine the links as an integral part of the sentence's meaning, as integral as the words themselves. Wouldn't that be a whole new way of writing? And even if we *are* witnessing the birth of a new type of language, surely it's not the offspring of a bunch of postliterate hackers?

Suck's use of hypertext is actually a bit less momentous in its implications, and a bit more encouraging. Making sense of those links brings us full circle, all the way back to the restricting language of Web surfing. What you can see in Suck's oblique syntax is not the birth of a new language, but rather the birth of a new type of *slang.* It's a jargon, but it's not built out of words or phrases. It's the slang of associations, of relationships between words. The slang evolves out of the way you string together information, the way you make your references, and not the words you use. If punctuation can become an element of slang (think scarequotes again), then why not links? ○

SEEING

1. How did hypertext (links to other sites on the web) revolutionize the use of computers and the organization and dissemination of information? What does Steven Johnson mean when he says, "The link is the first significant new form of punctuation to emerge in centuries, but it is only a hint of things to come. Hypertext, in fact, suggests a whole new grammar of possibilities, a new way of writing and telling stories" (para. 8)? How did hypertext, which was "supposed to revolutionize the way we tell stories," end up instead "transforming our *sentences*" (para. 10)?

2. Summarize Johnson's argument about the effects on American vocabulary of the language of Silicon Valley. What new "turns of phrase" and "digital idioms" (para. 1) emerge from cyberspace? Which of these colloquial phrases does Johnson view as least—and most—enduring? What reasons does he present to support his argument? How convincing do you find it?

WRITING

1. Johnson reports that if we were to "Ask any Web user to recall what first lured him into cyberspace," we'd not only hear "rhapsodic descriptions of a twirling animated graphic or a thin, distorted sound clip. No, the eureka moment for most of us came when we first clicked on a link, and found ourselves jettisoned across the planet" (para. 7). Draft an essay in which you recount your earliest experiences working with the web. What, more specifically, did you find revolutionary about the web? What impact has working on the web had on the ways in which you think and write?

2. Johnson mentions Sven Birkerts twice during the course of "Links." Read Birkerts's essay "The Fate of the Book" (p. 479). What would Johnson and Birkerts each say about the nature and fate of reading in the wake of the fast-paced improvements in computer technology? What conclusions, however tentative, have you made as you consider this question? Draft an essay in which you create a convincing argument about the fate of reading in an age of computers.

 Re:Searching the Web

In his essay entitled "Links" (p. 490), Steven Johnson observes that "Popular slang has borrowed heavily from the digital idiom" (para. 1), and he cites "the ubiquitous 'cyber-' prefix" and "the broad assault of 'spamming'" as two of the most prominent examples. What other expressions, turns of phrase, and metaphors can you identify whose origins can be traced to the Internet? Using a search engine, explore the web for essays on the subject of the influence of Silicon Valley on American popular idiom. As you conduct this research, identify as many examples of these terms as possible and focus on three or four that you regard as most widespread in use. Draft an essay in which you argue for—or against—defining these terms in the next edition of the *American Heritage Dictionary*.

Looking Closer:
The Ethics of
Representation

Is seeing really believing? Photographs may never have been the documents of "truth" that they initially were assumed to be, and now the growing accessibility of digital technology has made it possible for even home-computer users to alter the look of a holiday portrait. Doctoring family snapshots may seem benign, but what are the ethics of enhancing or altering news photographs?

As Mitchell Stephens describes in **"Expanding the Language of Photographs,"** magazines and advertisers have a history of enhancing and manipulating photographs. George Hunt's **"Doctoring Reality"** is evidence that photo-doctoring has long been a staple of government propaganda. And *Newsweek* magazine's enhancement of **"Bobbi and Kenny McCaughey"** and the U.S. Postal Service's revision of a 1920 photograph of **"William Hopson"** provoked new occasions for this debate.

What standards should be used for the images designed to report news and information? What role do words and captions play in the debate? To what extent should such images be labeled? And in what manner? These and other complicated ethical questions surround the use of technologies to enhance, store, and recombine information.

Expanding the Language
of Photographs

Expanding the Language of Photographs

Mitchell Stephens

A PHOTO ON THE FRONT PAGE OF *NEW YORK Newsday* on Feb. 16, 1994, showed two well-known Olympic ice skaters, Tonya Harding and Nancy Kerrigan, practicing together. By the standards of the tabloid war then raging in New York City (a war *New York Newsday* would not survive), this shot of Harding and the fellow skater she had been accused of plotting to assault did not seem particularly incendiary. But there was something extraordinary about this photograph: The scene it depicted had not yet taken place. Harding and Kerrigan, as the paper admitted in the caption, had not in fact practiced together. A computer had stitched together two separate images to make it appear as if they already had.

Newsday was certainly not the first publication to have taken advantage of techniques that allow for the digital manipulation of photographs. In 1982, for example, a *National Geographic* computer had nudged two pyramids closer together so that they might more comfortably fit the magazine's cover. In July 1992, *Texas Monthly* had used a computer to place the head of then-Gov. Ann Richards on top of the body of a model riding a Harley-Davidson motorcycle. But you had to be an expert on pyramids to

figure out what *National Geographic* had done, and you had to miss a fairly broad joke to take umbrage with *Texas Monthly*. *New York Newsday*'s editors had fiddled with photos featuring two of the most talked-about individuals of the day, and they weren't joking. The results of their efforts were clearly visible on newsstands all over Manhattan.

Defenders of journalism's accuracy and reliability quickly grabbed their lances and mounted their steeds: "A composite photograph is not the truth," Stephen D. Isaacs, then acting dean of the Columbia Graduate School of Journalism, thundered. "It is a lie and, therefore, a great danger to the standards and integrity of what we do." The dean of the S. I. Newhouse School of Public Communication at Syracuse University, David M. Rubin, concluded that "*New York Newsday* has taken leave of its ethical moorings."

This front-page photo in a major daily seemed to announce that craven journalists had found a powerful new way to debase themselves: computer reworkings of photographs.

Others of us, however, heard a different announcement on that winter day in 1994: *Newsday*'s rather ordinary-looking attempt to further exploit an

unpleasant, mostly unimportant story, we believed, was an early indication that news images might finally be coming of age.

To understand the significance of *New York Newsday*'s digital manipulation of this photograph, it is first necessary to acknowledge all the other ways photographs are manipulated. Photographers choose angles, making sure, for example, that the crowd of reporters isn't in the shot. They use filters, adjust contrast and vary depth of field. They frame and crop, and routinely transform reds, blues and yellows into blacks, grays and whites. Aren't these distortions of sorts?

It is also necessary to acknowledge the ways in which we manipulate language. Words are routinely arranged so that they describe events that are not currently occurring, as in the sentence: "Nancy Kerrigan and Tonya Harding will practice together." Words are even deployed in tenses that describe events that likely will not or definitely will not occur: "She might have won the gold medal." And words frequently speak of one thing as if it were another: Despite its proximity to New York harbor, *New York Newsday* did not literally possess "ethical moorings." Deans Isaacs and Rubin, for all their devotion to journalistic integrity, probably did not grab lances or mount steeds. In their efforts to approach the truth, words regularly depart from the literal truth.

In fact, words have gained much of their strength through speculation, negation, hypothesizing and metaphor through what, by Dean Isaacs's definition, might qualify as lies. In the first century and a half of their existence, photographic images, on the other hand, have been held back by their inability to speak of what will be, what might be and what won't be; their inability to present something as if it were something else. "Pictures," the theorist Sol Worth wrote dismissively in 1975, "cannot depict conditionals, counter-factuals, negatives or past future tenses." Well, now they can. Alert observers of journalism learned that on Feb. 16, 1994.

The above-board computer manipulation of photographs will give responsible journalists—those with their ethical moorings intact—a powerful new tool. Sometimes the results will be fanciful: an image of Bill Clinton and Newt Gingrich arm wrestling, perhaps. Sometimes such computer-altered photographs will be instructive: They might picture, for example, how that plane should have landed. Such reworked photos will allow us to peek, however hazily, into the future: showing not just how Harding and Kerrigan might look together on the ice but how that new building might change the neighborhood. They will also allow us to peek into the past: portraying, with photographic realism (not, as in TV reenactments, with clumsy actors), how a crime might have been committed. The idea should be to clarify, not to pretend.

For news photographs will not come of age by 10 hoodwinking those who look at them. That must be emphasized. Before digital editing and digital photography, harried photographers occasionally rearranged backgrounds or restaged scenes; adept photo editors, armed with a thick black pencil, occasionally added hair where there was too little or subtracted a chin where there were too many. Computers make such attempts to deceive much easier but no more conscionable. There is no doubt that they have been used for such purposes already. *Time* magazine's surreptitious digital darkening of O.J. Simpson's face on its cover later in 1994 may qualify as an example. But *New York Newsday*'s Harding-Kerrigan photo was labeled as a "composite." "Tomorrow, they'll really take to the ice together" the paper explained on that front page, though not in as large type as we journalism professors would have liked.

Here is a standard journalism deans might more reasonably champion: Digitally manipulated photographs must not be used as a tool for deceiving. They must be labeled, clearly, as what they are. (Let's take a hard line on this, initially at least: no lightening of a shadow, no blurring of an inconvenient background without some sort of acknowledgment.) But the potential these photographs offer as a tool for communicating honestly must not be suppressed.

With the aid of computers, photographic images will be able to show us much more than just what might present itself at any one time to a well-situated lens, as words tell us about much more than just what is, at any one time, literally the case. And computers will be able to work this magic on moving as well as still photographic images, on television news video as well as newspaper and magazine photographs.

None of this should be that hard to imagine. The computer-produced graphics that increasingly illustrate print and television news stories have been perpetrating clever and effective reimaginings of reality for many years now: politicians' faces matched with piles of dollar bills, the affected states jumping out of maps, items flying in and out of shopping carts. And all this has been happening without attracting the ire of the defenders of journalism's integrity.

The notion that news photographs themselves—not just cartoon-like graphics—are subject to these new types of alteration will take some getting used to. The labels will have to be very clear, their type very large—particularly at the start. For we have been in the habit of accepting photography as what one of its inventors, William Henry Fox Talbot, called "the pencil of nature." That was always something of a misperception. Now, if we are to take advantage of the great promise of digital technology, we'll have to wise up.

For computers are going to expand our control 15 over this pencil dramatically. Journalists will have unprecedented ability to shape the meanings their photographs, not just their sentences, can communicate. Their pictures will approach issues from many new directions. The language of photojournalism will grow. And that is good news for those who struggle to report with images. ○

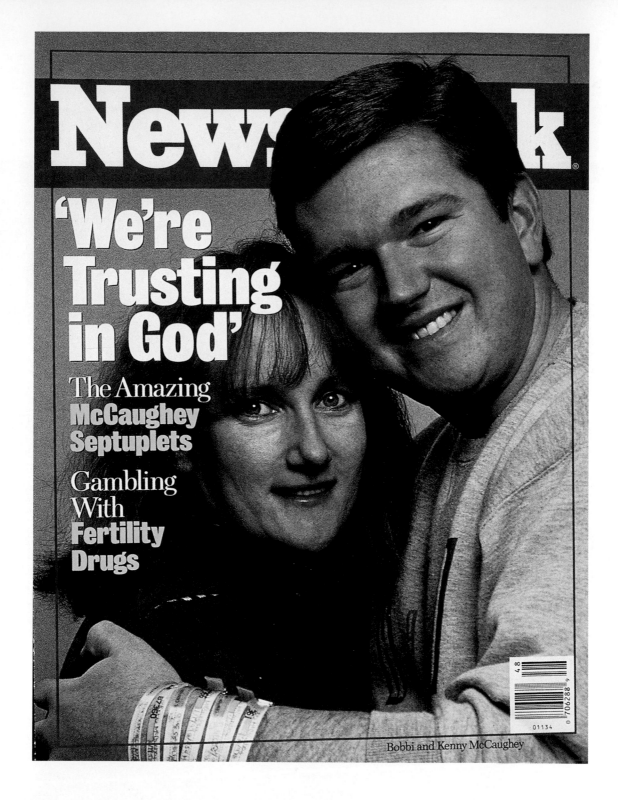

Newsweek

'We're Trusting in God'

The Amazing McCaughey Septuplets

Gambling With Fertility Drugs

Bobbi and Kenny McCaughey

We live in a world ruled by fictions of every kind—mass merchandising, advertising, politics conducted as a branch of advertising, the instant translation of science and technology into popular imagery, the increasing blurring and intermingling of identities within the realm of consumer goods, the preempting of any free or original imaginative response to experience by the television screen. We live inside an enormous novel. For the writer in particular it is less and less necessary for him to invent the fictional content of his novel. The fiction is already there. The writer's task is to invent the reality.

– J. G. Ballard

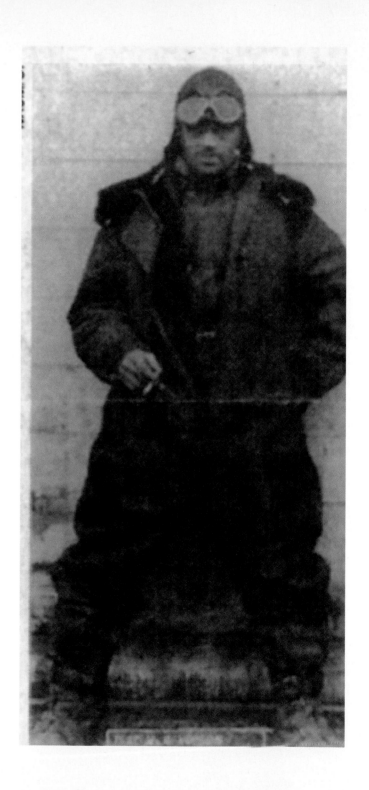

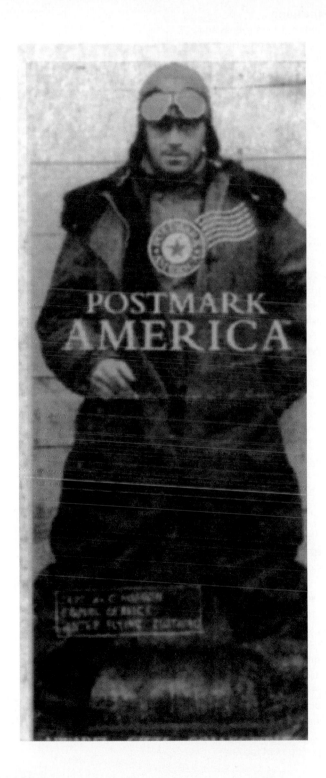

MITCHELL STEPHENS

Mitchell Stephens teaches journalism and mass communications at New York University. An acclaimed commentator on both the history and practice of journalism, he has written on the topic for various newspapers and has also published several journalism textbooks. His general-interest publications include *A History of the News* (1996) and *The Rise of the Image and the Fall of the Word* (1998). In the latter work he challenges the belief that "visual" information is eroding the intelligence of the news audience, arguing instead that future viewers will become as adept at reading the subtleties of moving pictures and images as they now are at understanding the nuances of language.

Expanding the Language
of Photographs

Mitchell Stephens

GEORGE HUNT

Anthropologist Franz Boas and photographer George Hunt were members of a late-nineteenth-century expedition designed to study and record indigenous cultures of the North Pacific, which were facing increasing westernization. While cameras provided an ideal tool for capturing daily life and cultural practices, the still-cumbersome technology created ample opportunities for staging or manipulating "authentic" culture. This photograph, featured in an American Museum of Natural History exhibition, shows Boas (left) and Hunt (right) preparing a backdrop for a photograph of a cedar bark weaving by a Kwakiutl woman.

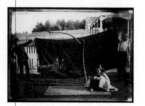

NEWSWEEK

Bobbi and Kenny McCaughey were thrust into the national spotlight when they became the parents of septuplets in 1997. When *Newsweek* touched up its cover photograph of the couple, making Mrs. McCaughey's teeth appear straighter and whiter, it furthered the national debate on the ethics of altering photographs. *Newsweek*'s enhancement became glaring when *Time* printed a similar, unaltered image of the couple on its cover the very same week. "You want to get the best possible picture out of the image that was out there," explained Richard M. Smith, *Newsweek*'s president and editor in chief. "The photo we decided to use had a considerable shadow over her mouth. The editors decided to lighten and improve the picture. In the process of doing that, the technical people went too far."

U.S. POSTAL SERVICE

William "Big Bill" Hopson served as an air-mail pilot in the 1920s. Before his death in a plane crash in 1928, he submitted a photograph of himself for Postal Service records. "Enclosed please find photo of bum pilot," he wrote. The U.S. Postal Service recently featured his photograph on the cover of a Postmark America brochure (a catalog of apparel, gifts, and collectibles) as well as on an Air Mail sweatshirt. The Postal Service chose to make one change to the original image: a cigarette has been airbrushed out of Hopson's right hand. Seen by some as a valuable contribution to antismoking campaigns and others as an example of dangerous tampering with an historical document, the choice remains controversial.

SEEING

1. In "Expanding the Language of Photographs," Mitchell Stephens draws a distinction between *Time*'s manipulation of Simpson's image and *Newsday*'s composite image of Harding and Kerrigan. The former, Stephens argues, is unethical and the latter is not. To what extent do you agree with Stephens? What are the ethics involved in each case? What was manipulated in each instance, and how? Did the editors act ethically in each instance? Why or why not? In your view, is an image used as "cover art" not subject to the same standards as a news photograph?

2. Here is what one critic said after the Kerrigan/Harding photo was printed: "Different standards applied to photographic and textual evidence, indicating that photographs have a lower status in the editorial hierarchy. Whereas *Time*'s editors would presumably never consider rewriting a quotation from O.J. Simpson, attempting to say it better for him, they evidently felt fewer qualms about altering the police photograph in order to lift . . . 'a common police mug shot to the level of art, with no sacrifice to the truth.'"

Do you agree with this distinction—and with its implications? To what extent do you think *Newsweek*'s enhancement of the McCaugheys' photograph was unethical? Should *Newsweek* have labeled the image as a "photo-illustration"?

WRITING

1. Stephens makes a comparison between manipulating photographs and words in journalism. Like photographs, words are equally subject to being shaped and edited.

Compare and contrast a news photo and a written report of the same event. How is the event framed visually and verbally? What did the photo-grapher and writer/editor choose to include? to omit? How would you compare the overall point of view and tone of a photograph with the same aspects of a verbal description of the same event? Draft an essay in which you argue for—or against—the assertion that visual and verbal material are held to the same standards of evidence in journalism.

2. To what extent do news organizations have a responsibility to inform their audiences of photo manipulation practices? What might such a labeling system look like? Based on what criteria? Where would the labels be printed (on the photo, on a table of contents page)?

3. Draft an argumentative essay in which you agree or disagree with Stephens's proposed standard for labeling manipulated news photos: "Digitally manipulated photographs must not be used as a tool for deceiving. They must be labeled, clearly, as what they are. (Let's take a hard line on this, initially at least: no lightening of a shadow, no blurring of an inconvenient background without some sort of acknowledgment.)" (para. 11).

Appendix

On the Theory and Practice of Seeing

As visual images have become increasingly integrated into our lives, the call to define the term *visual literacy* has grown louder. What does it mean to be visually literate? How exactly do we see? How should we train ourselves to see clearly and read images analytically? How do images affect us? How are images different from or similar to words? How are visual images products of their cultural contexts? Scholars and cultural commentators in the fields of art history, science, social history, design, and literary and cultural studies have responded to these questions in dozens of studies.

This appendix presents two fundamental theoretical works: the first essay in John Berger's *Ways of Seeing,* and the sixth chapter (entitled "Show and Tell") in Scott McCloud's *Understanding Comics: The Invisible Art.*

Of his book *Ways of Seeing,* John Berger writes in a note to the reader, "The form of the book has as much to do with our purpose as the arguments contained within it." The same might be said of Scott McCloud's illustrated "essay."

Each of these selections uses text and images to present theories on both *how we see* and *how visual images have been seen* throughout history. You are encouraged to use these texts to re-examine any of the visual and verbal selections presented in *Seeing & Writing.*

JOHN BERGER

John Berger was born in 1926 in London, where he attended Central School of Art and Chelsea School of Art. Known primarily as an art critic and social historian, Berger is also a distinguished novelist, artist, poet, essayist, Marxist critic, screenwriter, translator, and actor. He has published more than eight works of fiction and fifteen works of nonfiction, along with numerous articles and screenplays, during a remarkably prolific career. His novel *G: A Novel* won the Booker Prize in 1972.

Berger began his career as an artist and drawing teacher. While exhibiting his work at local galleries in London, he also wrote art criticism for British journals. Beginning with *Permanent Red: Essays in Seeing* (1960), Berger focused his criticism on the broad issues of seeing as a social and historical act. He introduced a mixed-media approach—combining poetry, photography, essays, and criticism—to the field of art criticism in books such as *Ways of Seeing* (1972), *About Looking* (1980), and *Another Way of Telling* (1982). His most recent work, *Photocopies* (1995), offers a series of personal vignettes from the past several decades. Berger currently lives and works in a small French peasant community.

The selection printed here is the first essay in *Ways of Seeing*, which was based on a BBC television series.

Ways of Seeing

John Berger

The Key of Dreams by Magritte (1898–1967).

SEEING COMES BEFORE WORDS. THE CHILD LOOKS and recognizes before it can speak.

But there is also another sense in which seeing comes before words. It is seeing which establishes our place in the surrounding world; we explain that world with words, but words can never undo the fact that we are surrounded by it. The relation between what we see and what we know is never settled. Each evening we *see* the sun set. We *know* that the earth is turning away from it. Yet the knowledge, the explanation, never quite fits the sight. The Surrealist painter Magritte commented on this always-present gap between words and seeing in a painting called *The Key of Dreams*.

The way we see things is affected by what we know or what we believe. In the Middle Ages when men believed in the physical existence of Hell the sight of fire must have meant something different from what it means today. Nevertheless their idea of Hell owed a lot to the sight of fire consuming and the ashes remaining—as well as to their experience of the pain of burns.

When in love, the sight of the beloved has a completeness which no words and no embrace can match: a completeness which only the act of making love can temporarily accommodate.

Yet this seeing which comes before words, and can never be quite covered by them, is not a question of mechanically reacting to stimuli. (It can only be

thought of in this way if one isolates the small part of the process which concerns the eye's retina.) We only see what we look at. To look is an act of choice. As a result of this act, what we see is brought within our reach—though not necessarily within arm's reach. To touch something is to situate oneself in relation to it. (Close your eyes, move round the room and notice how the faculty of touch is like a static, limited form of sight.) We never look at just one thing; we are always looking at the relation between things and ourselves. Our vision is continually active, continually moving, continually holding things in a circle around itself, constituting what is present to us as we are.

Soon after we can see, we are aware that we can also be seen. The eye of the other combines with our own eye to make it fully credible that we are part of the visible world.

If we accept that we can see that hill over there, we propose that from that hill we can be seen. The reciprocal nature of vision is more fundamental than that of spoken dialogue. And often dialogue is an attempt to verbalize this—an attempt to explain how, either metaphorically or literally, "you see things," and an attempt to discover how "he sees things."

In the sense in which we use the word in this book, all images are manmade [see below]. An image is a sight which has been recreated or reproduced. It is an appearance, or a set of appearances, which has been detached from the place and time in which it first

made its appearance and preserved—for a few moments or a few centuries. Every image embodies a way of seeing. Even a photograph. For photographs are not, as is often assumed, a mechanical record. Every time we look at a photograph, we are aware, however slightly, of the photographer selecting that sight from an infinity of other possible sights. This is true even in the most casual family snapshot. The photographer's way of seeing is reflected in his choice of subject. The painter's way of seeing is reconstituted by the marks he makes on the canvas or paper. Yet, although every image embodies a way of seeing, our perception or appreciation of an image depends also upon our own way of seeing. (It may be, for example, that Sheila is one figure among twenty; but for our own reasons she is the one we have eyes for.)

Images were first made to conjure up the appearance of something that was absent. Gradually it became evident that an image could outlast what it represented; it then showed how something or somebody had once looked—and thus by implication how the subject had once been seen by other people. Later still the specific vision of the image-maker was also recognized as part of the record. An image became a record of how X had seen Y. This was the result of an increasing consciousness of individuality, accompanying an increasing awareness of history. It would be rash to try to date this last development precisely. But certainly in Europe such consciousness has existed since the beginning of the Renaissance.

No other kind of relic or text from the past can 10 offer such a direct testimony about the world which surrounded other people at other times. In this respect images are more precise and richer than literature. To say this is not to deny the expressive or imaginative quality of art, treating it as mere documentary evidence; the more imaginative the work, the more profoundly it allows us to share the artist's experience of the visible.

Yet when an image is presented as a work of art, the way people look at it is affected by a whole series of learnt assumptions about art. Assumptions concerning:

Beauty
Truth
Genius
Civilization
Form
Status
Taste, etc.

Many of these assumptions no longer accord with the world as it is. (The world-as-it-is is more than pure objective fact, it includes consciousness.) Out of true with the present, these assumptions obscure the past. They mystify rather than clarify. The past is never there waiting to be discovered, to be recognized for exactly what it is. History always constitutes the relation between a present and its past. Consequently fear of the present leads to mystification of

Regents of the Old Men's Alms House by Hals (1580–1666).

Regentesses of the Old Men's Alms House by Hals (1580–1666).

the past. The past is not for living in; it is a well of conclusions from which we draw in order to act. Cultural mystification of the past entails a double loss. Works of art are made unnecessarily remote. And the past offers us fewer conclusions to complete in action.

When we "see" a landscape, we situate ourselves in it. If we "saw" the art of the past, we would situate ourselves in history. When we are prevented from seeing it, we are being deprived of the history which belongs to us. Who benefits from this deprivation? In the end, the art of the past is being mystified because a privileged minority is striving to invent a history which can retrospectively justify the role of the ruling classes, and such a justification can no longer make sense in modern terms. And so, inevitably, it mystifies.

Let us consider a typical example of such mystification. A two-volume study was recently published on Frans Hals.[1] It is the authoritative work to date on this painter. As a book of specialized art history it is no better and no worse than the average.

The last two great paintings by Frans Hals portray 15 the Governors and the Governesses of an Alms House for old paupers in the Dutch seventeenth-century city of Haarlem. They were officially commissioned portraits. Hals, an old man of over eighty, was destitute. Most of his life he had been in debt. During the winter of 1664, the year he began painting these pictures, he obtained three loads of peat on public charity, otherwise he would have frozen to death. Those who now sat for him were administrators of such public charity.

The author records these facts and then explicitly says that it would be incorrect to read into the paintings any criticism of the sitters. There is no evidence, he says, that Hals painted them in a spirit of bitterness. The author considers them, however, remarkable works of art and explains why. Here he writes of the Regentesses:

> Each woman speaks to us of the human condition with equal importance. Each woman stands out with equal

clarity against the *enormous* dark surface, yet they are linked by a firm rhythmical arrangement and the subdued diagonal pattern formed by their heads and hands. Subtle modulations of the *deep*, glowing blacks contribute to the *harmonious fusion* of the whole and form an *unforgettable* contrast with the *powerful* whites and vivid flesh tones where the detached strokes reach a *a peak of breadth and strength*. [Berger's italics]

The compositional unity of a painting contributes fundamentally to the power of its image. It is reasonable to consider a painting's composition. But here the composition is written about as though it were in itself the emotional charge of the painting. Terms like *harmonious fusion, unforgettable contrast,* reaching *a peak of breadth and strength* transfer the emotion provoked by the image from the plane of lived experience, to that of disinterested "art appreciation." All conflict disappears. One is left with the unchanging "human condition," and the painting considered as a marvellously made object.

Very little is known about Hals or the Regents who commissioned him. It is not possible to produce circumstantial evidence to establish what their relations were. But there is the evidence of the paintings themselves: the evidence of a group of men and a group of women as seen by another man, the painter. Study this evidence and judge for yourself.

1. Seymour Slive, *Frans Hals* (Phaidon, London).

The art historian fears such direct judgement:

> As in so many other pictures by Hals, the penetrating characterizations almost seduce us into believing that we know the personality traits and even the habits of the men and women portrayed.

What is this "seduction" he writes of? It is nothing less than the paintings working upon us. They work upon us because we accept the way Hals saw his sitters. We do not accept this innocently. We accept it in so far as it corresponds to our own observation of people, gestures, faces, institutions. This is possible because we still live in a society of comparable social relations and moral values. And it is precisely this which gives the paintings their psychological and social urgency. It is this—not the painter's skill as a "seducer"—which convinces us that we *can* know the people portrayed.

The author continues:

> In the case of some critics the seduction has been a total success. It has, for example, been asserted that the Regent in the tipped slouch hat, which hardly covers any of his long, lank hair, and whose curiously set eyes do not focus, was shown in a drunken state. [below]

This, he suggests, is a libel. He argues that it was a fashion at that time to wear hats on the side of the head. He cites medical opinion to prove that the Regent's expression could well be the result of a facial paralysis. He insists that the painting would have been unacceptable to the Regents if one of them had been portrayed drunk. One might go on discussing each of these points for pages. (Men in seventeenth-century Holland wore their hats on the side of their heads in order to be thought of as adventurous and pleasure-loving. Heavy drinking was an approved practice. Etcetera.) But such a discussion would take us even farther away from the only con-frontation which matters and which the author is determined to evade.

In this confrontation the Regents and Regentesses stare at Hals, a destitute old painter who has lost his reputation and lives off public charity; he examines them through the eyes of a pauper who must nevertheless try to be objective; i.e., must try to surmount the way he sees as a pauper. This is the drama of these paintings. A drama of an "unforgettable contrast."

Mystification has little to do with the vocabulary used. Mystification is the process of explaining away what might otherwise be evident. Hals was the first portraitist to paint the new characters and expressions created by capitalism. He did in pictorial terms what Balzac did two centuries later in literature. Yet the author of the authoritative work on these paintings sums up the artist's achievement by referring to

> Hals's unwavering commitment to his personal vision, which enriches our consciousness of our fellow men and heightens our awe for the ever-increasing power of the mighty impulses that enabled him to give us a close view of life's vital forces.

That is mystification.

In order to avoid mystifying the past (which can equally well suffer pseudo-Marxist mystification) let us now examine the particular relation which now exists, so far as pictorial images are concerned, between the present and the past. If we can see the present clearly enough, we shall ask the right questions of the past.

Today we see the art of the past as nobody saw it before. We actually perceive it in a different way.

This difference can be illustrated in terms of what was thought of as perspective. The convention of perspective, which is unique to European art and which was first established in the early Renaissance, centres everything on the eye of the beholder. It is like a beam from a lighthouse—only instead of light travelling outwards, appearances travel in. The conventions called those appearances *reality*. Perspective makes the single eye the centre of the visible world. Everything converges on to the eye as to the vanishing point of infinity. The visible world is arranged for

the spectator as the universe was once thought to be arranged for God.

According to the convention of perspective there is no visual reciprocity. There is no need for God to

situate himself in relation to others: he is himself the situation. The inherent contradiction in perspective was that it structured all images of reality to address a single spectator who, unlike God, could only be in one place at a time.

After the invention of the camera this contradiction 30 gradually became apparent.

> I'm an eye. A mechanical eye. I, the machine, show you a world the way only I can see it. I free myself for today and forever from human immobility. I'm in constant movement. I approach and pull away from objects. I creep under them. I move alongside a running horse's mouth. I fall and rise with the falling and rising bodies. This is I, the machine, manoeuvring in the chaotic movements, recording one movement after another in the most complex combinations.
>
> Freed from the boundaries of time and space, I coordinate any and all points of the universe, wherever I want them to be. My way leads towards the creation of a fresh perception of the world. Thus I explain in a new way the world unknown to you.[2]

The camera isolated momentary appearances and in so doing destroyed the idea that images were timeless. Or, to put it another way, the camera showed that the notion of time passing was inseparable from the experience of the visual (except in paintings). What you saw depended upon where you were when. What you saw was relative to your position in time and space. It was no longer possible to imagine everything converging on the human eye as on the vanishing point of infinity.

This is not to say that before the invention of the camera men believed that everyone could see every-

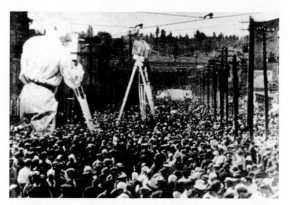

Still from *Man with a Movie Camera* by Vertov (1895–1954).

thing. But perspective organized the visual field as though that were indeed the ideal. Every drawing or painting that used perspective proposed to the spectator that he was the unique centre of the world. The camera—and more particularly the movie camera—demonstrated that there was no centre.

The invention of the camera changed the way men saw. The visible came to mean something different to them. This was immediately reflected in painting.

For the Impressionists the visible no longer presented itself to man in order to be seen. On the contrary, the visible, in continual flux, became fugitive. For the Cubists the visible was no longer what con-

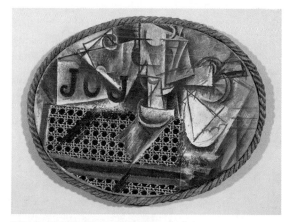

Still Life with Wicker Chair by Picasso (1881–1973).

2. This quotation is from an article written in 1923 by Dziga Vertov, the revolutionary Soviet film director.

fronted the single eye, but the totality of possible views taken from points all round the object (or person) being depicted [*Still Life with Wicker Chair*, p. 517].

The invention of the camera also changed the way in which men saw paintings painted long before the camera was invented. Originally paintings were an integral part of the building for which they were designed. Sometimes in an early Renaissance church or

chapel one has the feeling that the images on the wall are records of the building's interior life, that together they make up the building's memory—so much are they part of the particularity of the building [below].

The uniqueness of every ₃₅ painting was once part of the uniqueness of the place where it resided. Sometimes the painting was transportable. But it could never be seen in two places at the same time. When the camera reproduces a painting, it destroys the uniqueness of its image. As a result its meaning changes. Or, more exactly, its meaning multiplies and fragments into many meanings.

This is vividly illustrated by what happens when a painting is shown on a television screen. The painting enters each viewer's house. There it is surrounded by his wallpaper, his furniture, his mementos. It enters the atmosphere of his family. It becomes their talking point. It lends its meaning to their meaning. At the same time it enters a million other houses and, in each of them, is seen in a different context. Because of the camera, the painting now travels to the spectator rather than the spectator to the painting. In its travels, its meaning is diversified.

One might argue that all reproductions more or less distort, and that therefore the original painting is still in a sense unique. Here [right] is a reproduction of the *Virgin of the Rocks* by Leonardo da Vinci.

Having seen this reproduction, one can go to the National Gallery to look at the original and there discover what the reproduction lacks. Alternatively one can forget about the quality of the reproduction and simply be reminded, when one sees the original, that it is a famous painting of which somewhere one has already seen a reproduction. But in either case the uniqueness of the original now lies in it being *the original of a reproduction*. It is no longer what its image shows that strikes one as unique; its first meaning is no longer to be found in what it says, but in what it is.

This new status of the original work is the perfectly rational consequence of the new means of reproduction. But it is at this point that a process of mystification again enters. The meaning of the original work no longer lies in what it uniquely says but in what it uniquely is. How is its unique existence evaluated and defined in our present culture? It is defined as an object whose value depends upon its rarity. This market is affirmed and gauged by the price it fetches on the market. But because it is nevertheless "a work

Church of St. Francis of Assisi.

Virgin of the Rocks by Leonardo da Vinci (1452–1519). Reproduced by courtesy of the Trustees, The National Gallery, London.

Before the *Virgin of the Rocks* the visitor to the National Gallery would be encouraged by nearly everything he might have heard and read about the painting to feel something like this: "I am in front of it. I can see it. This painting by Leonardo is unlike any other in the world. The National Gallery has the real one. If I look at this painting hard enough, I should somehow be able to feel its authenticity. The *Virgin of the Rocks* by Leonardo da Vinci: it is authentic and therefore it is beautiful."

To dismiss such feelings as naive would be quite wrong. They accord perfectly with the sophisticated culture of art experts for whom the National Gallery catalogue is written. The entry on the *Virgin of the Rocks* is one of the longest entries. It consists of fourteen closely printed pages. They do not deal with the meaning of the image. They deal with who commissioned the painting, legal squabbles, who owned it, its likely date, the families of its owners. Behind this information lie years of research. The aim of

Virgin of the Rocks by Leonardo da Vinci (1452–1519). Louvre Museum.

of art"—and art is thought to be greater than commerce—its market price is said to be a reflection of its spiritual value. Yet the spiritual value of an object, as distinct from a message or an example, can only be explained in terms of magic or religion. And since in modern society neither of these is a living force, the art object, the "work of art," is enveloped in an atmosphere of entirely bogus religiosity. Works of art are discussed and presented as though they were holy relics: relics which are first and foremost evidence of their own survival. The past in which they originated is studied in order to prove their survival genuine. They are declared art when their line of descent can be certified.

The Virgin and Child with St. Anne and St. John the Baptist by Leonardo da Vinci (1452–1519). Reproduced by courtesy of the Trustees, The National Gallery, London.

the research is to prove beyond any shadow of doubt that the painting is a genuine Leonardo. The secondary aim is to prove that an almost identical painting in the Louvre is a replica of the National Gallery version [see bottom, p. 519].

French art historians try to prove the opposite.

The National Gallery sells more reproductions of Leonardo's cartoon of *The Virgin and Child with St. Anne and St. John the Baptist* [above] than any other picture in their collection. A few years ago it was known only to scholars. It became famous because an American wanted to buy it for two and a half million pounds.

Now it hangs in a room by itself. The room is like a chapel. The drawing is behind bullet-proof perspex. It has acquired a new kind of impressiveness. Not because of what it shows—not because of the meaning of its image. It has become impressive, mysterious, because of its market value.

The bogus religiosity which now surrounds original 45 works of art, and which is ultimately dependent upon their market value, has become the substitute for what paintings lost when the camera made them reproducible. Its function is nostalgic. It is the final empty claim for the continuing values of an oligarchic, undemocratic culture. If the image is no longer unique and exclusive, the art object, the thing, must be made mysteriously so.

The majority of the population do not visit art museums. The following table [right] shows how closely an interest in art is related to privileged education.

The majority take it as axiomatic that the museums are full of holy relics which refer to a mystery which excludes them: the mystery of unaccountable wealth. Or, to put this another way, they believe that original masterpieces belong to the preserve (both materially and spiritually) of the rich. Another table indicates what the idea of an art gallery suggests to each social class.

Venus and Mars by Botticelli (1445–1510). Reproduced by courtesy of the Trustees, The National Gallery, London.

In the age of pictorial reproduction the meaning of paintings is no longer attached to them; their meaning becomes transmittable: that is to say it becomes information of a sort, and, like all information, it is either put to use or ignored; information carries no special authority within itself. When a painting is put to use, its meaning is either modified or totally changed. One should be quite clear about what this involves. It is not a question of reproduction failing to reproduce certain aspects of an image faithfully; it is a question of reproduction making it possible, even inevitable, that an image will be used for many different purposes and that the reproduced image, unlike an original work, can lend itself to them all. Let us examine some of the ways in which the reproduced image lends itself to such usage.

Reproduction isolates a detail of a painting from the whole. The detail is transformed. An allegorical figure becomes a portrait of a girl [see left].

When a painting is reproduced by a film camera it inevitably becomes material for the film-maker's argument.

National proportion of art museum visitors according to level of education: Percentage of each educational category who visit art museums

	Greece	Poland	France	Holland
With no educational qualification	0.02	0.12	0.15	—
Only primary education	0.30	1.50	0.45	0.50
Only secondary education	0.5	10.4	10	20
Further and higher education	11.5	11.7	12.5	17.3

Source: Pierre Bourdieu and Alain Darbel, *L'Amour de l'art*, Editions de Minuit, Paris 1969, Appendix 5, table 4.

Of the places listed below which does a museum remind you of most?

	Manual workers	Skilled and white collar	Professional and upper managerial
	%	%	%
Church	66	45	30.5
Library	9	34	28
Lecture hall	—	4	4.5
Department store or entrance hall in public building	—	7	2
Church and library	9	2	4.5
Church and lecture hall	4	2	—
Library and lecture hall	—	—	2
None of these	4	2	19.5
No reply	8	4	9
	100 (n = 53)	100 (n = 98)	100 (n = 99)

Source: As left, Appendix 4, table 8.

Procession to Calvary by Breughel (1525–1569).

A film which reproduces images of a painting leads the spectator, through the painting, to the film-maker's own conclusions. The painting lends authority to the film-maker. This is because a film unfolds in time and a painting does not. In a film the way one image follows another, their succession, constructs an argument which becomes irreversible. In a painting all its elements are there to be seen simultaneously.

The spectator may need time to examine each element of the painting but whenever he reaches a conclusion, the simultaneity of the whole painting is there to reverse or qualify his conclusion. The painting maintains its own authority.

Paintings are often reproduced with words around them.

Wheatfield with Crows by Van Gogh (1853–1890).

This is a landscape of a cornfield with birds flying out of it. Look at it for a moment. Then see the painting below.

This is the last picture that Van Gogh painted before he killed himself.

It is hard to define exactly how the words have changed the image but undoubtedly they have. The image now illustrates the sentence.

In this essay each image reproduced has become part of an argument which has little or nothing to do with the painting's original independent meaning. The words have quoted the paintings to confirm their own verbal authority. . . .

Reproduced paintings, like all information, have to hold their own against all the other information being continually transmitted [see top, p. 523].

Subject and significance in
Titian's *Death of Actaeon*

Heritage exploits the authority of art to glorify the present social system and its priorities.

The means of reproduction are used politically and commercially to disguise or deny what their existence makes possible. But sometimes individuals use them differently [see top, p. 524].

Adults and children sometimes have boards in their bedrooms or living-rooms on which they pin pieces of paper: letters, snapshots, reproductions of paintings, newspaper cuttings, original drawings, postcards. On each board all the images belong to the same language and all are more or less equal within it, because they have been chosen in a highly personal way to match and express the experience of the room's inhabitant. Logically, these boards should replace museums.

What are we saying by that? Let us first be sure about what we are not saying.

We are not saying that there is nothing left to experience before original works of art except a sense of awe because they have survived. The way original works of art are usually approached—through museum catalogues, guides, hired cassettes, etc.—is not the only way they might be approached. When the art of the past ceases to be viewed nostalgically, the

Consequently a reproduction, as well as making its own references to the image of its original, becomes itself the reference point for other images. The meaning of an image is changed according to what one sees immediately beside it or what comes immediately after it. Such authority as it retains, is distributed over the whole context in which it appears [below].

Because works of art are reproducible, they can, theoretically, be used by anybody. Yet mostly—in art books, magazines, films, or within gilt frames in living-rooms—reproductions are still used to bolster the illusion that nothing has changed, that art, with its unique undiminished authority, justifies most other forms of authority, that art makes inequality seem noble and hierarchies seem thrilling. For example, the whole concept of the National Cultural

EVERY JACKET CARRIES A GOVERNMENT HEALTH WARNING.

If women knew then... what they know now.

works will cease to be holy relics—although they will never re-become what they were before the age of reproduction. We are not saying original works of art are now useless.

Original paintings are silent and still in a sense that information never is. Even a reproduction hung on a wall is not comparable in this respect for in the original the silence and stillness permeate the actual material, the paint, in which one follows the traces of the painter's immediate gestures. This has the effect of closing the distance in time between the painting of the picture and one's own act of looking at it. In this special sense all paintings are contemporary. Hence the immediacy of their testimony. Their historical moment is literally there before our eyes. Cézanne made a similar observation from the painter's point of view. "A minute in the world's life passes! To paint it in its reality, and forget everything for that! To become that minute, to be the sensitive plate . . . give the image of what we see, forgetting everything that has appeared before our time . . ." What we make of that painted moment when it is before our eyes depends upon what we expect of art, and that in turn depends today upon how we have already experienced the meaning of paintings through reproductions.

Nor are we saying that all art can be understood spontaneously. We are not claiming that to cut out a magazine reproduction of an archaic Greek head, because it is reminiscent of some personal experience, and to pin it to a board beside other disparate images, is to come to terms with the full meaning of that head.

The idea of innocence faces two ways. By refusing to enter a conspiracy, one remains innocent of that conspiracy. But to remain innocent may also be to remain ignorant. The issue is not between innocence and knowledge (or between the natural and the cultural) but between a total approach to art which attempts to relate it to every aspect of experience and the esoteric approach of a few specialized experts who are the clerks of the nostalgia of a ruling class in decline. (In decline, not before the proletariat, but before the new power of the corporation and the state.) The real question is: to whom does the meaning of the art of the past properly belong? To those who can apply it to their own lives, or to a cultural hierarchy of relic specialists?

Woman Pouring Milk by Vermeer (1632–1675).

The visual arts have always existed within a certain preserve; originally this preserve was magical or sacred. But it was also physical: it was the place, the cave, the building, in which, or for which, the work was made. The experience of art, which at first was the experience of ritual, was set apart from the rest of life—precisely in order to be able to exercise power over it. Later the preserve of art became a social one. It entered the culture of the ruling class, whilst physically it was set apart and isolated in their palaces and houses. During all this history the authority of art was inseparable from the particular authority of the preserve.

What the modern means of reproduction have done is to destroy the authority of art and to remove it—or, rather, to remove its images which they reproduce—from any preserve. For the first time ever, images of art have become ephemeral, ubiquitous, insubstantial, available, valueless, free. They surround us in the same way as a language surrounds us. They have entered the mainstream of life over which they no longer, in themselves, have power.

Yet very few people are aware of what has happened because the means of reproduction are used nearly all the time to promote the illusion that nothing has changed except that the masses, thanks to reproductions, can now begin to appreciate art as the cultured minority once did. Understandably, the masses remain uninterested and sceptical.

If the new language of images were used differently, it would, through its use, confer a new kind of power. Within it we could begin to define our experiences more precisely in areas where words are inadequate. (Seeing comes before words.) Not only personal experience, but also the essential historical experience of our relation to the past: that is to say the experience of seeking to give meaning to our lives, of trying to understand the history of which we can become the active agents.

The art of the past no longer exists as it once did. 70 Its authority is lost. In its place there is a language of images. What matters now is who uses that language for what purpose. This touches upon questions of copyright for reproduction, the ownership of art presses and publishers, the total policy of public art galleries and museums. As usually presented, these are narrow professional matters. One of the aims of this essay has been to show that what is really at stake is much larger. A people or a class which is cut off from its own past is far less free to choose and to act as a people or class than one that has been able to situate itself in history. This is why—and this is the only reason why—the entire art of the past has now become a political issue. ○

Many of the ideas in the preceding essay have been taken from another, written over forty years ago by the German critic and philosopher Walter Benjamin.*

His essay was entitled The Work of Art in the Age of Mechanical Reproduction. *This essay is available in English in a collection called* Illuminations *(Cape, London, 1970).*

* Now over seventy years ago [eds.].

SCOTT MCCLOUD

"When I was a little kid I knew exactly what comics were," Scott McCloud writes in his book *Understanding Comics: The Invisible Art* (1993). "Comics were those bright, colorful magazines filled with bad art, stupid stories and guys in tights." But after looking at a friend's comic book collection, McCloud became "totally obsessed with comics" and in the tenth grade decided to become a comics artist.

In 1982, McCloud graduated with a degree in illustration from Syracuse University. "I wanted to have a good background in writing and art and also just liberal arts in general because I thought that just about anything can be brought to bear in making comics." Later McCloud worked in the production department of DC Comics until he began publishing his two comic series, "Zot!" (1984) and later "Destroy!!"

In *Understanding Comics*, a caricature of McCloud leads readers through an insightful study of the nature of sequential art by tracing the history of the relationship between words and images. "Most readers will find it difficult to look at comics in quite the same way ever again," wrote cartoonist Garry Trudeau of McCloud's work. Recently McCloud has been working with comics in the digital environment. His web site is at <http://www.scott mccloud.com>. "Show and Tell" is the sixth chapter in *Understanding Comics*.

SHOW AND TELL

Scott McCloud

CHAPTER SIX

SHOW AND TELL.

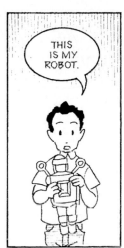

THIS IS MY ROBOT.

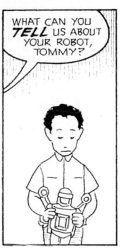

WHAT CAN YOU *TELL* US ABOUT YOUR ROBOT, TOMMY?

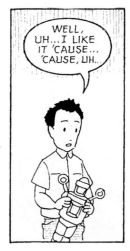

WELL, UH...I LIKE IT 'CAUSE... 'CAUSE, UH..

IT'S GOT ONE OF *THESE* THINGS.

WHAT IS *THAT,* TOMMY?

138

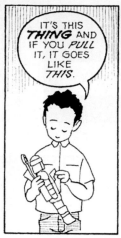
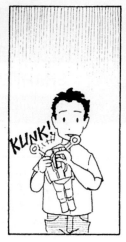
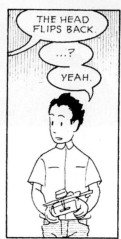
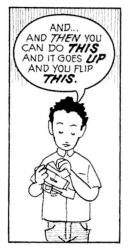
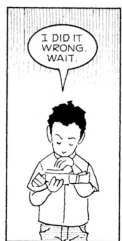
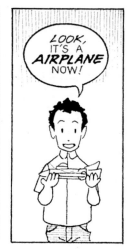
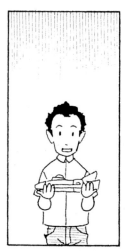
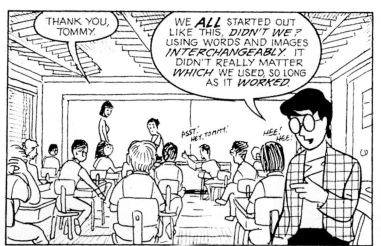
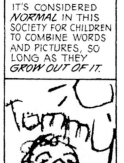

139

As children, our first books had PICTURES GALORE and very few WORDS because that was "EASIER."

Then, as we grew, we were expected to graduate to books with much MORE text and only OCCASIONAL pictures --

-- And finally to arrive at "REAL" books -- those with no pictures AT ALL.

Or perhaps, as is sadly the case these days, to no BOOKS at all.

140

MEANWHILE, WORDS AND *MOVING* PICTURES HAVE HALF THE WORLD IN THRALL TO THEIR CHARMS, BUT MUST STRUGGLE TO MAKE *THEIR* POTENTIAL UNDERSTOOD.

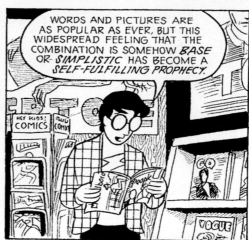

WORDS AND PICTURES ARE AS POPULAR AS EVER, BUT THIS WIDESPREAD FEELING THAT THE COMBINATION IS SOMEHOW *BASE* OR *SIMPLISTIC* HAS BECOME A *SELF-FULFILLING PROPHECY.*

THE ROOTS OF THIS ATTITUDE RUN PRETTY *DEEP.*

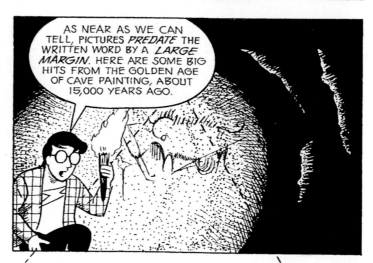

AS NEAR AS WE CAN TELL, PICTURES *PREDATE* THE WRITTEN WORD BY A *LARGE MARGIN.* HERE ARE SOME BIG HITS FROM THE GOLDEN AGE OF CAVE PAINTING, ABOUT 15,000 YEARS AGO.

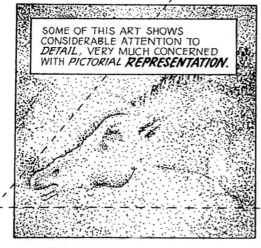

SOME OF THIS ART SHOWS CONSIDERABLE ATTENTION TO *DETAIL,* VERY MUCH CONCERNED WITH PICTORIAL **REPRESENTATION.**

BUT OTHERS WERE VERY *ICONIC,* ACTING AS *SYMBOLS* RATHER THAN PICTURES-- MORE LIKE A *PRIMITIVE LANGUAGE!*

141

AS MENTIONED IN OUR *LAST CHAPTER*,* THE EARLIEST *WORDS* WERE, IN FACT, *STYLIZED PICTURES*.

AS SEEN, MOST OF THESE EARLY WORDS STAYED *CLOSE BY* THEIR PARENTS, THE *PICTURES!*

IT DIDN'T TAKE *LONG,* THOUGH-- RELATIVELY SPEAKING -- BEFORE ANCIENT WRITING STARTED TO BECOME MORE *ABSTRACT.*

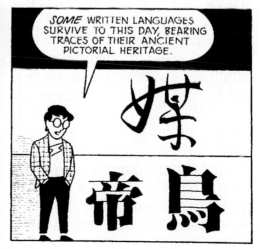

SOME WRITTEN LANGUAGES SURVIVE TO THIS DAY, BEARING TRACES OF THEIR ANCIENT PICTORIAL HERITAGE.

* SEE PAGE 129.

142

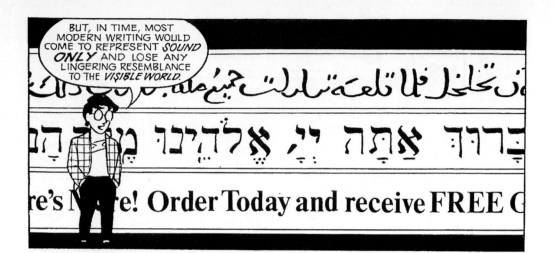

BUT, IN TIME, MOST MODERN WRITING WOULD COME TO REPRESENT *SOUND ONLY* AND LOSE ANY LINGERING RESEMBLANCE TO THE *VISIBLE WORLD.*

BUT WHERE HAD THE *PICTURES* ALL GONE?

WITH THE INVENTION OF *PRINTING*, THE WRITTEN WORD TOOK A GREAT LEAP *FORWARD--*

--AND ALL OF HUMANITY WITH IT.

WORDS AND PICTURES DID STILL *COEXIST* AT THIS STAGE IN WESTERN CIVILIZATION.*

BUT *THOSE* INSTANCES WERE BECOMING THE *EXCEPTION,* NOT THE *RULE.*

143

*IN ILLUMINATED MANUSCRIPTS, FOR EXAMPLE.

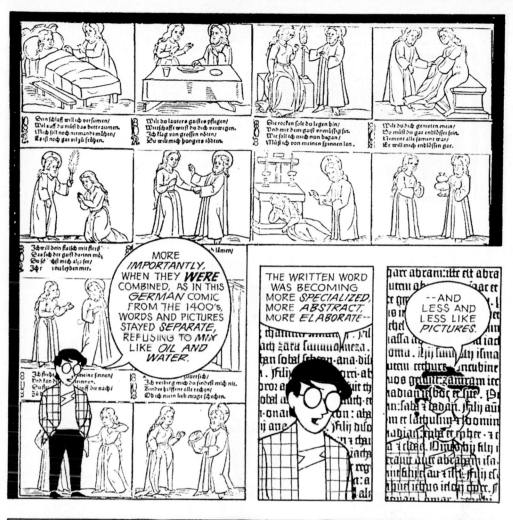

MORE *IMPORTANTLY*, WHEN THEY *WERE* COMBINED, AS IN THIS *GERMAN* COMIC FROM THE 1400's, WORDS AND PICTURES STAYED *SEPARATE*, REFUSING TO *MIX* LIKE *OIL AND WATER*.

THE WRITTEN WORD WAS BECOMING MORE *SPECIALIZED*, MORE *ABSTRACT*, MORE *ELABORATE*--

--AND LESS AND LESS LIKE *PICTURES*.

PICTURES, MEANWHILE, BEGAN TO GROW IN THE *OPPOSITE* DIRECTION: LESS *ABSTRACT* OR *SYMBOLIC*, MORE *REPRESENTATIONAL* AND *SPECIFIC*.

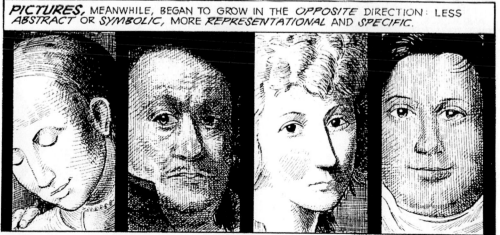

FACSIMILE DETAILS OF PORTRAITS BY DURER (1519) REMBRANDT (1660) DAVID (1788) AND INGRES (1810-15).

144

John Keats 1819
Ode on a Grecian Urn

1

Thou still unravish'd bride of quietness,
 Thou foster-child of silence and slow time,
Sylvan historian, who canst thus express
A flowery tale more sweetly than our rhyme:
What leaf fring'd legend haunts about thy shape
 Of deities or mortals, or of both,
 In Tempe or the dales of Arcady?
 What men or gods are these? What maidens loth?
What mad pursuit? What struggle to escape?
 What pipes and timbrels? What wild ecstasy?

BY THE EARLY 1800's, WESTERN ART AND WRITING HAD DRIFTED ABOUT AS FAR APART AS WAS *POSSIBLE.*

ONE WAS OBSESSED WITH *RESEMBLANCE, LIGHT* AND *COLOR,* ALL THINGS *VISIBLE...*

...THE *OTHER* RICH IN *INVISIBLE* TREASURES, SENSES, EMOTIONS, SPIRITUALITY, PHILOSOPHY...

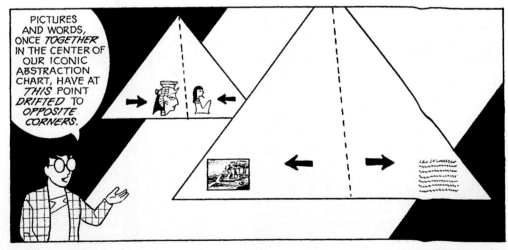

PICTURES AND WORDS, ONCE *TOGETHER* IN THE CENTER OF OUR ICONIC ABSTRACTION CHART, HAVE AT *THIS* POINT *DRIFTED* TO *OPPOSITE* CORNERS.

145

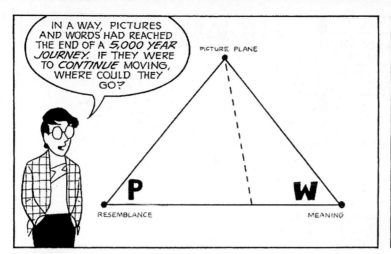

IN A WAY, PICTURES AND WORDS HAD REACHED THE END OF A *5,000 YEAR JOURNEY.* IF THEY WERE TO *CONTINUE* MOVING, WHERE COULD THEY GO?

PICTURE PLANE

P W

RESEMBLANCE MEANING

FOR *PICTURES*, THERE WAS ONLY *UP!*

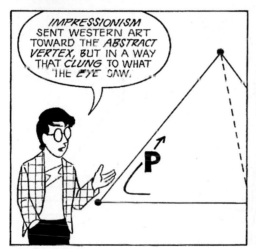

IMPRESSIONISM SENT WESTERN ART TOWARD THE *ABSTRACT VERTEX*, BUT IN A WAY THAT *CLUNG* TO WHAT THE *EYE* SAW.

P

IMPRESSIONISM, WHILE IT COULD BE THOUGHT OF AS THE FIRST *MODERN* MOVEMENT, WAS MORE A *CULMINATION* OF THE *OLD*, THE *ULTIMATE STUDY* OF *LIGHT AND COLOR.*

FACSIMILE DETAIL OF "A SUNDAY AFTERNOON ON THE ISLAND OF LA GRANDE JATTE" BY GEORGES SEURAT.

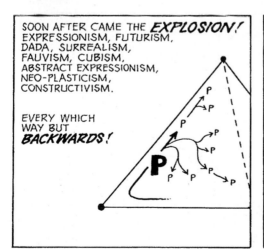

SOON AFTER CAME THE *EXPLOSION!* EXPRESSIONISM, FUTURISM, DADA, SURREALISM, FAUVISM, CUBISM, ABSTRACT EXPRESSIONISM, NEO-PLASTICISM, CONSTRUCTIVISM.

EVERY WHICH WAY BUT *BACKWARDS!*

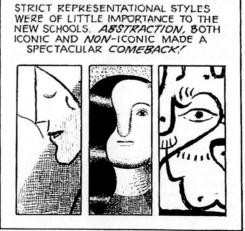

STRICT REPRESENTATIONAL STYLES WERE OF LITTLE IMPORTANCE TO THE NEW SCHOOLS. *ABSTRACTION*, BOTH ICONIC AND *NON*-ICONIC MADE A SPECTACULAR *COMEBACK!*

FACSIMILE DETAILS OF PORTRAITS BY PICASSO, LEGER AND KLEE.

146

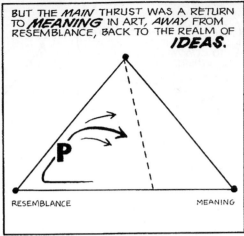

147

DADA POSTER FOR THE PLAY "THE BEARDED HEART"

Portrait de TRISTAN TZARA
par
FRANCIS PICABIA

THE WORK OF *DADAISTS, FUTURISTS* AND VARIOUS *INDIVIDUAL* ARTISTS OF THE MODERN ERA BREACHED THE FRONTIER BETWEEN *APPEARANCE* AND *MEANING!*

FACSIMILE OF "ORIENTAL SWEETNESS" (1938) BY PAUL KLEE.

PAINTINGS INCREASINGLY TOOK ON *SYMBOLIC,* EVEN *CALLIGRAPHIC,* MEANINGS...

WHILE SOME ARTISTS ADDRESSED THE IRONIES OF WORDS AND PICTURES *HEAD-ON!*

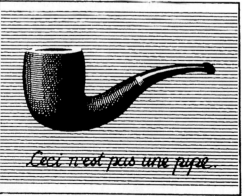

Ceci n'est pas une pipe.

148

AND IN *POPULAR* CULTURE THE TWO FORMS COLLIDED *AGAIN AND AGAIN* WITHOUT ANY PRETENSES OF *"HIGH"* ART.

NOWHERE IS THIS COLLISION MORE THOROUGHLY EXPLORED THAN THE MODERN COMIC. AND IT'S NOT A RECENT OBSESSION.

LET'S GO BACK TO THE EARLY 1800's BEFORE ANY OF THIS HAPPENED, WHEN WORDS AND PICTURES HAD DRIFTED AS FAR APART AS *POSSIBLE*.

UP TO THAT POINT, *EUROPEAN BROADSHEETS* HAD OFFERED *REMINDERS* OF WHAT WORDS AND PICTURES COULD DO WHEN COMBINED.

BUT AGAIN IT WAS *RODOLPHE TÖPFFER* WHO FORESAW THEIR *INTERDEPENDENCY* AND BROUGHT THE FAMILY *BACK TOGETHER* AT LAST.

M. CRÉPIN ADVERTISES FOR A TUTOR, AND MANY APPLY FOR THE JOB.

TRANSLATION BY E. WIESE.

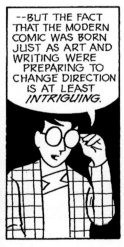

I'M SURE THAT THESE IDEAS WERE THE *FURTHEST* THING FROM TÖPFFER'S MIND WHEN HE PUT *PEN TO PAPER*--

--BUT THE FACT THAT THE MODERN COMIC WAS BORN JUST AS ART AND WRITING WERE PREPARING TO CHANGE DIRECTION IS AT LEAST *INTRIGUING.*

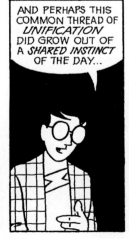

AND PERHAPS THIS COMMON THREAD OF *UNIFICATION* DID GROW OUT OF A *SHARED INSTINCT* OF THE DAY...

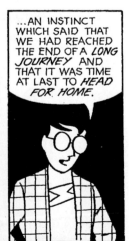

...AN INSTINCT WHICH SAID THAT WE HAD REACHED THE END OF A *LONG JOURNEY* AND THAT IT WAS TIME AT LAST TO *HEAD FOR HOME.*

149

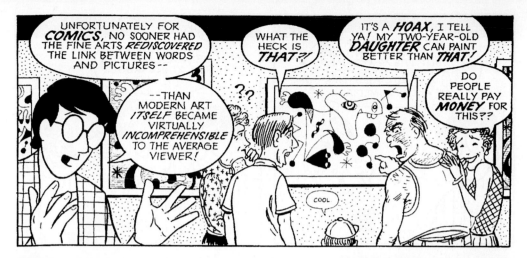

UNFORTUNATELY FOR *COMICS*, NO SOONER HAD THE FINE ARTS *REDISCOVERED* THE LINK BETWEEN WORDS AND PICTURES --

--THAN MODERN ART *ITSELF* BECAME VIRTUALLY *INCOMPREHENSIBLE* TO THE AVERAGE VIEWER!

WHAT THE HECK IS *THAT?!*

IT'S A *HOAX*, I TELL YA! MY TWO-YEAR-OLD *DAUGHTER* CAN PAINT BETTER THAN *THAT!*

DO PEOPLE REALLY PAY *MONEY* FOR THIS??

COOL

IN FACT, THE GENERAL PUBLIC'S PERCEPTIONS OF "GREAT" ART AND "GREAT" WRITING HASN'T CHANGED MUCH IN 150 YEARS.* ANY ARTIST WISHING TO DO GREAT WORK IN A MEDIUM *USING* WORDS AND PICTURES WILL HAVE TO *CONTEND* WITH THIS ATTITUDE.

Thou still unravish'd bride
Thou foster-child of siler
Sylvan historian, who cans
A flowery tale more sweetl
What leaf fring'd legend he
Of deities or mortals, or
In Tempe or the dales
What men or gods are th
What mad pursuit? What
What pipes and timbrels

IN OTHERS *AND* IN *THEMSELVES...*

...BECAUSE, DEEP DOWN INSIDE, MANY COMICS CREATORS STILL MEASURE ART AND WRITING BY *DIFFERENT STANDARDS* AND ACT ON THE FAITH THAT "GREAT" ART AND "GREAT" WRITING WILL COMBINE HARMONIOUSLY BY VIRTUE OF *QUALITY ALONE.*

 FACE

TWO EYES, ONE NOSE, ONE MOUTH.

Thy youth's proud livery, so gaz'd on now...

* NOT AS MUCH AS WE LIKE TO *THINK* IT HAS, ANYWAY.

150

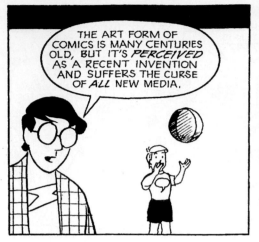

THE ART FORM OF COMICS IS MANY CENTURIES OLD, BUT IT'S *PERCEIVED* AS A RECENT INVENTION AND SUFFERS THE CURSE OF *ALL* NEW MEDIA,

THE CURSE OF BEING JUDGED BY THE STANDARDS OF THE OLD.

EVER SINCE THE INVENTION OF THE WRITTEN WORD, NEW MEDIA HAVE BEEN *MISUNDERSTOOD.*

CAREFUL, JACOB! IF YOU KEEP DOING THIS, YOU'LL STOP USING YOUR *MEMORY!*

EACH NEW MEDIUM BEGINS ITS LIFE BY IMITATING ITS *PREDECESSORS.* MANY EARLY MOVIES WERE LIKE FILMED *STAGE PLAYS,* MUCH EARLY *TELEVISION* WAS LIKE *RADIO WITH PICTURES* OR *REDUCED MOVIES.*

FAR TOO MANY COMICS CREATORS HAVE NO HIGHER GOAL THAN TO MATCH THE ACHIEVEMENTS OF OTHER MEDIA, AND VIEW ANY CHANCE TO *WORK* IN OTHER MEDIA AS A *STEP UP.*

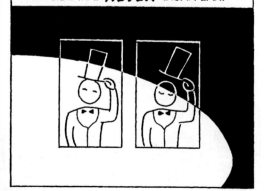

AND *AGAIN,* AS LONG AS WE VIEW COMICS AS A *GENRE* OF WRITING OR A *STYLE* OF GRAPHIC ART THIS ATTITUDE MAY *NEVER* DISAPPEAR.

151

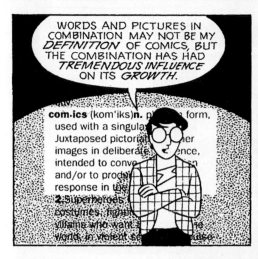

WORDS AND PICTURES IN COMBINATION MAY NOT BE MY *DEFINITION* OF COMICS, BUT THE COMBINATION HAS HAD *TREMENDOUS INFLUENCE* ON ITS *GROWTH.*

com·ics (kom'iks)n. ... form, used with a singular ... Juxtaposed pictorial ... other images in deliberate ... ence, intended to conve... ... and/or to produ... ... response in th... **2.**Superheroes ... costumes, fight... ... villains who want ... the world in violent se...use ...

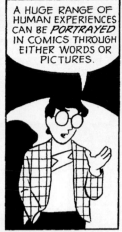

A HUGE RANGE OF HUMAN EXPERIENCES CAN BE *PORTRAYED* IN COMICS THROUGH EITHER WORDS OR PICTURES.

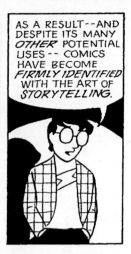

AS A RESULT--AND DESPITE ITS MANY *OTHER* POTENTIAL USES -- COMICS HAVE BECOME *FIRMLY IDENTIFIED* WITH THE ART OF *STORYTELLING.*

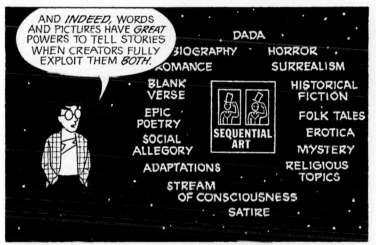

AND *INDEED,* WORDS AND PICTURES HAVE *GREAT* POWERS TO TELL STORIES WHEN CREATORS FULLY EXPLOIT THEM *BOTH.*

DADA

BIOGRAPHY HORROR

ROMANCE SURREALISM

BLANK VERSE HISTORICAL FICTION

EPIC POETRY FOLK TALES

SEQUENTIAL ART EROTICA

SOCIAL ALLEGORY MYSTERY

ADAPTATIONS RELIGIOUS TOPICS

STREAM OF CONSCIOUSNESS

SATIRE

AND SO FAR, WE'VE ONLY SEEN THE *TIP OF THE ICEBERG!*

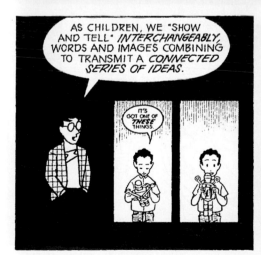

AS CHILDREN, WE "SHOW AND TELL" *INTERCHANGEABLY,* WORDS AND IMAGES COMBINING TO TRANSMIT A *CONNECTED SERIES OF IDEAS.*

IT'S GOT ONE OF *THESE* THINGS

THE DIFFERENT WAYS IN WHICH WORDS AND PICTURES CAN *COMBINE* IN COMICS IS VIRTUALLY *UNLIMITED.*

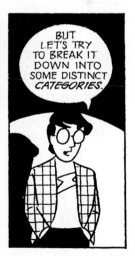

BUT LET'S TRY TO BREAK IT DOWN INTO SOME DISTINCT *CATEGORIES.*

152

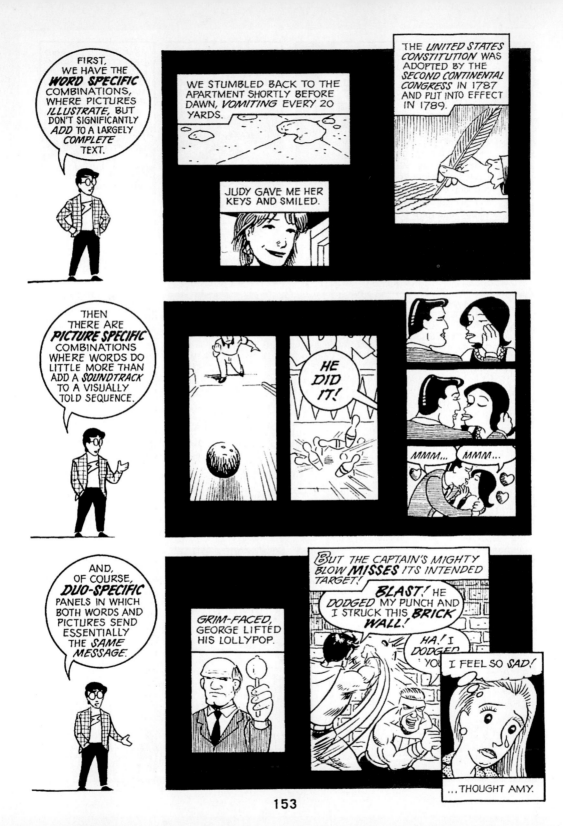

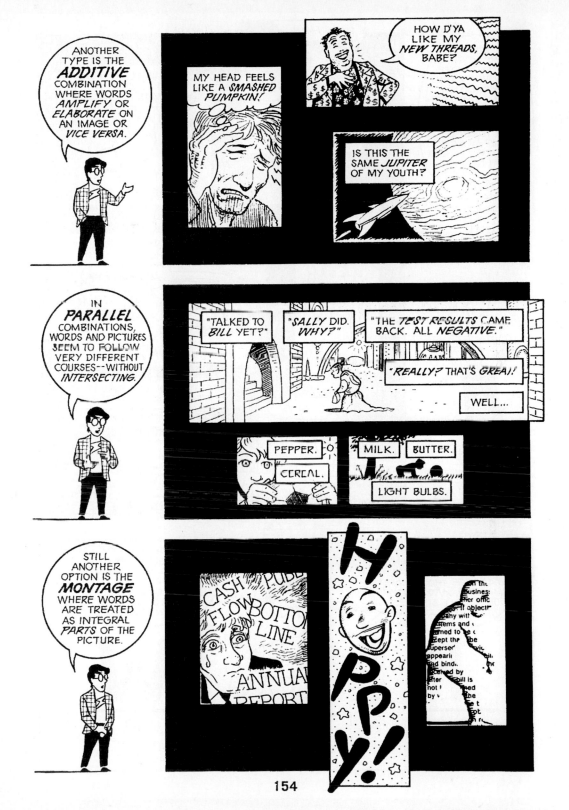

154

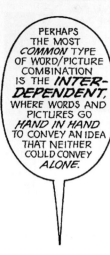
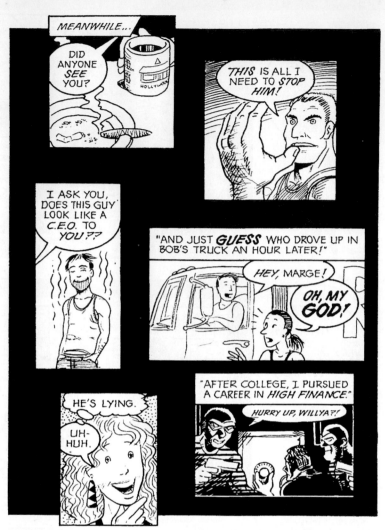

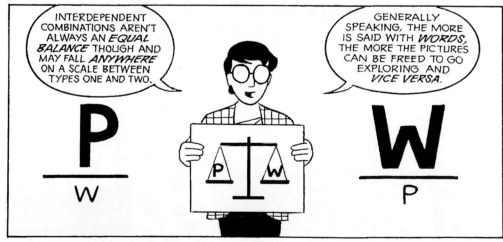

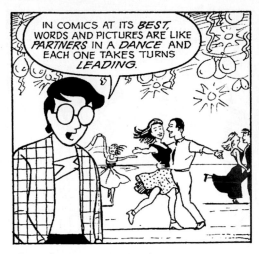

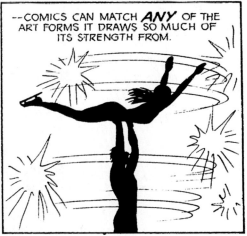

156

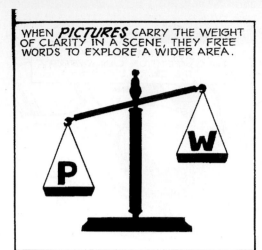

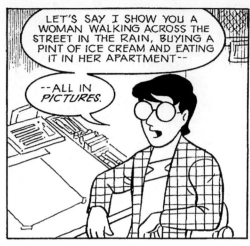

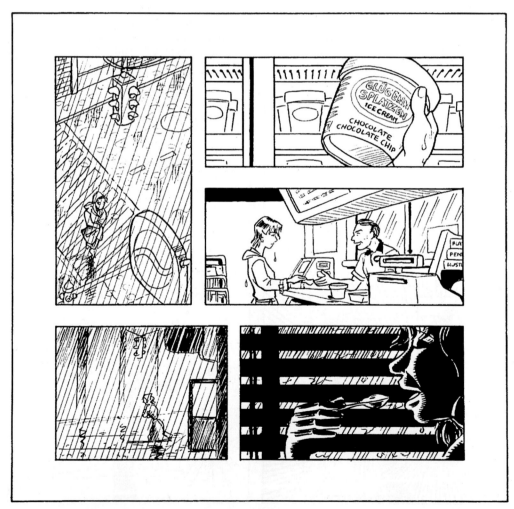

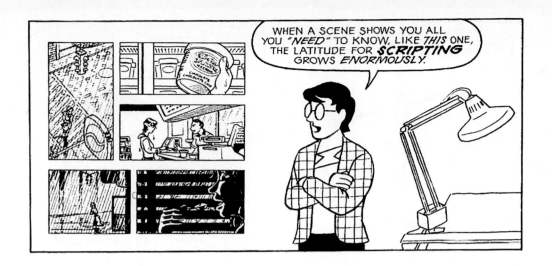

WHEN A SCENE SHOWS YOU ALL YOU *"NEED"* TO KNOW, LIKE *THIS* ONE, THE LATITUDE FOR *SCRIPTING* GROWS *ENORMOUSLY.*

IT COULD BECOME AN *INTERNAL MONOLOGUE.*

(INTERDEPENDENT)

PERHAPS SOMETHING WILDLY *INCONGRUOUS*

(PARALLEL)

MAYBE IT'S ALL JUST A BIG *ADVERTISEMENT!*

(INTERDEPENDENT)

OR A CHANCE TO RUMINATE ON *BROADER TOPICS.*

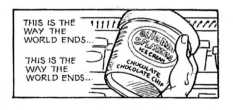

(INTERDEPENDENT)

158

ON THE *OTHER* HAND, IF THE *WORDS* LOCK IN THE *"MEANING"* OF A SEQUENCE, THEN THE *PICTURES* CAN REALLY TAKE OFF.

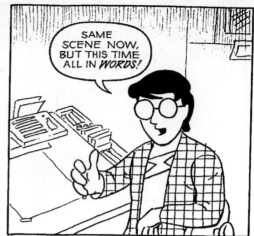

SAME SCENE NOW, BUT THIS TIME ALL IN *WORDS!*

I CROSSED THE STREET TO THE CONVENIENCE STORE. THE RAIN SOAKED INTO MY BOOTS.

I FOUND THE LAST PINT OF CHOCOLATE CHOCOLATE CHIP IN THE FREEZER.

THE CLERK TRIED TO PICK ME UP. I SAID *NO THANKS.* HE GAVE ME THIS CREEPY LOOK...

I WENT BACK TO THE APARTMENT--

--AND FINISHED IT ALL IN AN HOUR.

ALONE AT LAST.

159

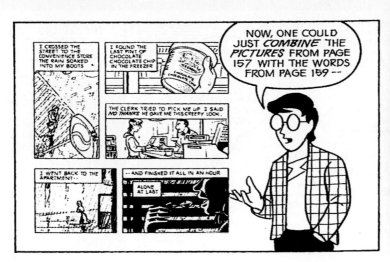

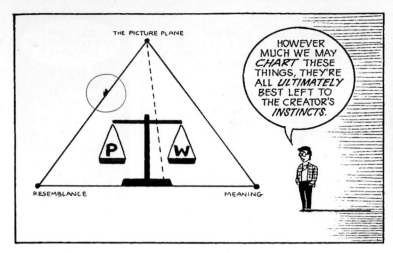

THE PICTURE PLANE

RESEMBLANCE

MEANING

P W

HOWEVER MUCH WE MAY *CHART* THESE THINGS, THEY'RE ALL *ULTIMATELY* BEST LEFT TO THE CREATOR'S *INSTINCTS.*

THE MIXING OF WORDS AND PICTURES IS MORE *ALCHEMY* THAN SCIENCE.

SOME OF THE SECRETS OF THOSE *FIRST* ALCHEMISTS MAY HAVE BEEN LOST IN THE ANCIENT PAST.

BUT WE HAVE SOME POWERFUL MAGIC RIGHT HERE IN THE *20TH CENTURY,* TOO!

THE RICHNESS OF MODERN LANGUAGE IS AN *IRREPLACEABLE COMMODITY!*

THIS IS AN *EXCITING TIME* TO BE MAKING COMICS, AND IN MANY WAYS I FEEL VERY *LUCKY* TO HAVE BEEN BORN WHEN I WAS.

STILL, I DO FEEL A CERTAIN *VAGUE LONGING* FOR THAT TIME OVER *50 CENTURIES AGO* --

-- WHEN TO TELL WAS TO *SHOW* --

-- AND TO SHOW WAS TO *TELL.*

161

ACKNOWLEDGMENTS (continued from copyright page)

Listerine Bottle. Photograph by Jody Dole. From *The New York Times*, April 6, 1997. Copyright © 1997 by The New York Times Company. Reprinted by permission.

Milk drop coronet. © Harold & Esther Edgerton Foundation, 1999. Courtesy of Palm Press, Inc.

Under the Bed. Courtesy William Eggleston.

Tears of Wine. Photo courtesy Felice Frankel.

Ride a Bicycle. Courtesy Gaslight Ad Archives, Commack, NY.

New Hoover Convertible, 1980. Courtesy Jeff Koons Productions.

Television Moon. © Alfred Leslie. Reprinted by permission.

500 magnification of Post-It Note. Courtesy of 3M.

Specialized Bicycles. Courtesy Robert Mizono, Photographer.

Columbia Bicycles. © Collection of The New York Historical Society.

A kitchen scouring pad. David Scharf, © Photo Researchers, Inc.

Ordinary Objects. Courtesy Wolfgang Tillmans.

Homage to Outerbridge, 1988. 40 Cibachrome photographs Neil Winokur. Courtesy Janet Borden, Inc.

Chapter 2
Verbal Texts

Lucille Clifton. "When I Go Home." From *A Place Called Home: Twenty Writing Women Remember* by Mickey Pearlman, editor. © Lucille Clifton. Reprinted by permission of the author.

Richard Ford. "I Must Be Going." Copyright © 1992 by *Harper's Magazine*. All rights reserved. Reproduced from the February issue by special permission.

David Gutterson. "No Place Like Home: On the Manicured Streets of a Master-Planned Community." Originally appeared in *Harper's Magazine*, November 1992. Copyright © 1992 by David Gutterson. Reprinted by permission of Georges Borchardt, Inc. for the author.

Edward Hirsch. "Edward Hopper and the House by the Railroad." From *Wild Gratitude* by Edward Hirsch. Copyright © 1985 by Edward Hirsch. Reprinted by permission of Alfred A. Knopf, Inc.

Chang-rae Lee. "Home Again." Originally published in *The New Yorker*, 1996. Copyright © 1996 by Chang-rae Lee. Reprinted by permission of International Creative Management, Inc.

Scott Russell Sanders. "Homeplace." From "Settling Down" in *Hunting for Hope* by Scott Russell Sanders. Copyright © 1998 by Scott Russell Sanders. Reprinted by permission of Beacon Press, Boston.

Eudora Welty. "The Little Store." From *The Eye of the Story: Selected Essays and Reviews* by Eudora Welty. Copyright © 1975 by Eudora Welty. Reprinted by permission of Random House, Inc.

Visual Texts

AT & T ad. Courtesy AT & T and Tony Stone Images.

Family in Kitchen. Photo by Tina Barney. Courtesy Janet Borden, Inc.

Among the Sierra Mountains, 1868. Photo by Albert Bierstadt, National Museum of American Art, Washington, DC/Art Resource, N.Y.

Tamalada. Artist: Carmen Lopez Garza. Photo: Wolfgang Dietze. Collection of Lenoila Ramierz, Don Ramon's Restaurant, San Francisco, CA. Reprinted by permission.

Matthew Demo, Elridge, NY. © 1985 David Graham. Reprinted by permission.

Gary Larson cartoon. *The Far Side* © 1991 Farworks, Inc. Used by permission. All Rights Reserved.

Richard Misrach portfolio. Courtesy Curt Marcus Gallery and Robert Mann Gallery, New York.

House by the Railroad, 1925. The Museum of Modern Art, New York. Given annonymously. Photograph © 2000 The Museum of Modern Art, New York. Reprinted by permission.

Untitled #20. From *The Freeway Series*, 1994 by Catherine Opie. Courtesy Regen Projects, Los Angeles.

Homeless. Photo courtesy Mark Peterson.

Rancho Seco Nuclear Plant, Sacramento, CA 1983. Photo John Pfahl. Courtesy Janet Borden, Inc.

American Prospects Lake Oswego, Oregon, June 1979. Copyright © Joel Sternfeld. Courtesy PaceWildensteinMacGill, New York.

60 West 125th Street, Harlem. Courtesy Camilo Jose Vergara.

Storekeeper. Eudora Welty Collection, Mississippi Department of Archives & History. Reprinted by permission.

Chapter 3
Verbal Texts

Isabel Allende. "Omayra Sanchez." Reprinted by permission of Agencia Literaria Carmen Balcells for Isabel Allende.

Dorothy Allison. "This Is Our World." From *DoubleTake Magazine*, Summer, 1998. Copyright © 1998 by Dorothy Allison. Reprinted by permission of Frances Goldin Literary Agency, Inc.

Judy Budnitz. "Park Bench." From *Flying Leap* by Judy Budnitz. Copyright © 1998 by Judy Budnitz. Reprinted by permission of the author.

Ethan Canin. "Viewfinder." First published in *DoubleTake Magazine*. Copyright © 1998 by Ethan Canin. Reprinted by permission of the author.

Don DeLillo. "Videotape." From *Underworld* by Don DeLillo. Copyright © 1997 by Don DeLillo. Reprinted with the permission of Scribner, a Division of Simon & Schuster.

N. Scott Momaday. "The Photograph." From *The Man Made of Words* by N. Scott Momaday. Copyright © 1997 by N. Scott Momaday. Reprinted by permission of St. Martin's Press, Incorporated.

Visual Texts

The Man/The Shot. Michael Jordan *Sports Illustrated* cover, June 22, 1998. © John F. Biever/Sports Illustrated. Reprinted by permission. All rights reserved.

Omayna Sanchez. © Frank Fournier/Contact Press Images. Reprinted by permission.

Ashleigh, 13, with her friend and parents, Santa Monica. Courtesy Lauren Greenfield Photography.

Tourists. Photo by Duane Hanson. Courtesy National Galleries of Scotland.

Rodney King. © K.T.L.A./SYGMA. Reprinted by permission.

Kim Phuc and child. © Joe McNally, *Life* magazine/© Time, Inc. Reprinted by permission. All rights reserved.

The New York Times, April 21, 1999 front page. Copyright © 1999 by The New York Times Company. Reprinted by permission.

People-Tourists, Kalkan, Turkey. © Martin Parr/Magnum Photos, Inc. Reprinted by permission.

JFK in motorcade, Dallas, November 1963. © Dave Powers/*Life* magazine. Reprinted by permission.

Damage from the L.A. Riot, Baldwin Hills, California. © 1992, Eli Reed/Magnum Photos. Reprinted by permission.

Untitled. (Woman Behind Plants, 1940s). Gift of Gordon L. Bennett. Courtesy San Francisco Museum of Modern Art.

Andrew Savulich portfolio. Courtesy Andrew Savulich.

Children Fleeing a Napalm Strike, Viet Nam 1972. © Nick Ut, AP/Wide World Photos. Reprinted by permission.

Monica and Jack P., Mill Valley, California. © Catherine Wagner, 1990. Courtesy Catherine Wagner.

Dallas, November 1963. Zapruder film, Copyright 1967 (renewed 1995) LME Co. c/o James Lorin Silverberg, Esq., Washington, D.C. 202-466-2787. All rights reserved. Reprinted by permission.

Chapter 4
Verbal Texts

Susan Bordo. "Never Just Pictures." From *Twilight Zones: The Hidden Life of Cultural Images from Plato to O.J.* by Susan Bordo. Copyright © 1997 by The Regents of the University of California Press. Reprinted by permission of the author and University of California Press.

Bruce Bower. "Average Attractions." From *Science News* 12, May 1990, pp. 298–99. Reprinted with permission from Science Service, the weekly newsmagazine of science, copyright 1998.

Judith Ortiz Cofer. "The Story of My Body." From *The Latin Deli: Prose & Poetry* by Judith Ortiz Cofer. Copyright © 1993 by Judith Ortiz Cofer. Reprinted by permission of The University of Georgia Press.

Natalie Kusz. "Ring Leader." First published in *Allure*, February 1996. All rights reserved. Copyright © 1996 by Natalie Kusz. Reprinted by permission of Brandt & Brandt Literary Agents, Inc.

Philip Lopate. "Portrait of My Body." Copyright © 1996 by Philip Lopate. First appeared in the Michigan Quarterly. From *Portrait of My Body* by Philip Lopate. Used by permission of Doubleday, a division of Random House, Inc.

Marge Piercy. "Imaging." From *Mars and Her Children* by Marge Piercy. Copyright © 1992 by Middlemarsh, Inc. Reprinted by permission of Alfred A. Knopf, Inc.

Visual Texts

Bill Clinton's Dress Codes. AP/Wide World Photos. Reprinted by permission.

Asics ad. © Asics Tiger Corporation, 1998. Reprinted by permission.

Charles Atlas ad. TM © 1999 Charles Atlas, Ltd. Licensed by CMG Worldwide Inc., Indianapolis, Indiana, 46256 USA www.cmgww.com. Reprinted by permission.

© The Body Shop International PLC 1998. This material is reproduced with the permission of The Body Shop International PLC.

Self-Portrait: Back with Arms Above, 1984. John Coplans, Photographer. Courtesy John Coplans.

Relax-a-Cizor ad. Courtesy Gaslight Ad Archives, Commack, NY.

Cindy Jackson. All photos © Cindy Jackson. Reprinted by permission.

Nose Piercing. Courtesy Lynn Johnson, photographer.

Your body is a battleground, 1989. Photo by Barbara Kruger. Collection: Eli Broad Family Foundation, Santa Monica. Courtesy: Mary Boone Gallery, New York.

Average attractions. Courtesy, Judith Langlois, Dean of Psychology, University of Texas.

Olympic Portraits—Photographs by Annie Liebowitz/Contact Press Images.

Physical Culture cover, No. 6, September 1900. Copyright © 1900 B.A. MacFadden.

Born in the USA album cover collage, 1991. Courtesy Christian Marclay.

Transformers, Madonna and Michael Jackson. Courtesy Yasumasa Morimura/Luhring Agustine Gallery, NY.

Lilith, 1995. Sculpture by Kiki Smith. Photograph by Ellen Page.

Wilson. Courtesy of PaceWildenstein. © 1999 Museum of Fine Arts, Boston. Reprinted by permission. All Rights Reserved.

Shalom and Linda, Paris & Doubles, Lima. Reprinted with permission by Mario Testino/Art Partner, NY; Elite Model Agency (Linda Evanglista) and IMG (Shalom Harlow). Photos from *Any Objections* by Mario Testino, Phaidon Press, Ltd., 1998.

Chapter 5
Verbal Texts

Natalie Angier. "Men, Women, Sex and Darwin" adapted from *Woman: An Intimate Geography* by Natalie Angier. Copyright © 1999 by Natalie Angier. Reprinted by permission of Houghton Mifflin Company. All rights reserved. This article was first published February 2, 1999 in *The New York Times*. Copyright © 1999 by The New York Times Company. Reprinted by permission.

Mavis Hara. "Carnival Queen" from *Sister Stew: Fiction and Poetry by Women* edited by Juliet S. Kano and Cathy Song, Cambridge University Press. © 1991 by Mavis Hara. Reprinted by permission of the author.

Daniel R. Harris. "Effeminacy." First published in *Michigan Quarterly Review.* Reprinted by permission of the author.

Jamaica Kincaid. "Girl." From *At the Bottom of the River* by Jamaica Kincaid. Copyright © 1983 by Jamaica Kincaid. Reprinted by permission of Farrar, Straus & Giroux, Inc.

Katha Pollitt. "Why Boys Don't Play with Dolls." From *The New York Times*, October 8, 1995. Copyright © 1995 by The New York Times Company. Reprinted by permission.

Daphne Scholinski–Jane Meredith. Excerpt from *The Last Time I Wore A Dress.* Copyright © 1997 by Daphne Scholinski–Jane Meredith. Used by permission of Putnam Berkley, a division of Penguin Putnam, Inc.

Visual Texts

Molly Pitcher, 1944. Courtesy American Premium Underwriters, Inc. for Pennsylvania Railroad.

Untitled Images. From the *He/She Series.* Copyright © 1996–97 by Nancy Burson.

Linda Carter as Wonder Woman. Archive Films, Archive Photos. Reprinted by permission.

Operation Desert Storm, 1991. Copyright © 1998 Donna Ferrato. Reprinted by permission.

Palmolive ad. Courtesy Gaslight Ad Archives, Commack, NY.

Raise Boys and Girls the Same Way. © Jenny Holzer. Courtesy of Jenny Holzer.

Li'l Sis, 1944. William H. Johnson, National Museum of American Art, Washington, DC/Art Resource, NY.

Practice Makes Perfect. © Dana Lixenberg. Courtesy of Z Photographic and International Marketing Inc.

Robert Mankoff cartoon. © The New Yorker Collection 1999 Robert Mankoff from cartoonbank.com. All Rights Reserved.

Self-Portrait, 1980 (masculine/feminine). Copyright © The Estate of Robert Mapplethorpe. Used by permission.

Mechanical Animals CD cover. Reprinted by permission.

Uncompromise Rockport RuPaul ad. Reprinted with permission of RuPaul, The Rockport Company, Inc., and Lorenzo Agius, Photographer.

Nature vs. Nuture cartoon. Copyright © 1997 Art Spiegelman. Originally published by *The New Yorker*, September 8, 1997. Reprinted by permission.

U.S. Army ad. Army materials courtesy of the U.S. Government.

The Human Animal. Martin Weitz/Everett Collection. Reprinted by permission.

Chapter 6
Verbal Texts

Donnell Alexander. "Are Black People Cooler than White People?" Appeared in *Utne Reader*, November/December 1997. Reprinted by permission of the author.

W. E. B. DuBois. "Social Consciousness." From *The Souls of Black Folk* by W. E. B. DuBois. Reprinted by permission of David DuBois.

Roberto Fernandez. "Wrong Channel." Reprinted by permission of the author.

Bonnie Kae Grover. "Growing Up White in America?" Copyright © 1996 by Bonnie Kae Grover. Reprinted by permission of the author.

Jesse Jackson. "Jets of Water Blast Civil Rights Demonstrators." Excerpt from essay by Jesse Jackson. Reprinted from pages 174, 176–77 in *Talking Pictures* by Marvin Heiferman & Carole Kismaric. Chronicle Books, 1994. Courtesy of D. Michael Cheers,The Rainbow/PUSH Coalition, Washington, D.C.

Gish Jen. "What Means Switch." Copyright © 1990 by Gish Jen. First published in the *Atlantic Monthly*. Reprinted by permission of the author.

James McBride. "What Color Is Jesus?" From *The Washington Post* magazine, 1988. © 1988. The Washington Post. Reprinted with permission.

Naomi Shihab Nye. "Defining White." From *Words Under the Words: Selected Poems* by Naomi Shihab Nye. © 1995. Used by permission of Far Corner Books.

Patricia Williams. "Ethnic Hash." From *Transitions*, 1998. Reprinted by permission of the author.

Visual Texts

The Life of Buffalo Bill & With General Custer at the Little Big Horn film posters. Autry Museum of Western Heritage, Los Angeles.

Tongues ad. Concept: O. Toscani. Courtesy of United Colors of Bennetton.

Pigeon's Egg Head painting by George Catlin. National Museum of American Art, Smithsonian Institution, Washington, DC, Art Resource, NY.

Tibor Kalman portfolio. From *Colors Magazine*, #4, "Race." Reprinted by permission.

Pocahontas and John Smith film still. © Disney Enterprises, Inc.

Charlie Chan & The Chinese Ring film poster. Everett Collection. Reprinted by permission.

Reaction to O.J. Simpson verdict. Larry Fisher/Quad City Times/Sygma. Reprinted by permission.

Hands, 1930. Gift of Wallace B. Putnam from the Estate of Consuelo Kanaga. Courtesy of The Brooklyn Museum.

Smoke Signals film still. © Miramax Films. Jill Sabella/Everett Collection. Screenplay by Sherman Alexie, Chris Eyre, director. Actors: Adam Beach and Evan Adams. Reprinted by permission.

Civil Rights Demonstrators Being Hosed. Charles Moore/Black Star. Reprinted by permission.

Guillermo Gómez Pēna with Coco. Photo courtesy of Cristina Taccone. From *Warrior for Gringostroika: Essays, Performance, Text and Poetry* by Guillermo Gómez Pēna. © 1993 Guillermo Gómez Pēna. Published by Graywolf Press. Reprinted by permission.

Rebirth of a Nation, Computer-Style. Ted Thai/Time Magazine. © 1993 Time, Inc. Reprinted by permission. All rights reserved.

Chapter 7
Verbal Texts

Russell Baker. "Icon Epidemic Rages." From *The New York Times*, June 24, 1997. Copyright © 1997 by The New York Times Company, Inc. Reprinted by permission.

Aaron Betsky. "An Emblem of Crisis Made the World See the Body Anew." From *The New York Times*, November 30, 1997. Copyright © 1997 by The New York Times Company. Reprinted by permission.

Holly Brubach. "Heroine Worship." From *The New York Times magazine*, November 24, 1996. Copyright © 1996 by The New York Times Company, Inc. Reprinted by permission.

Sharon Olds. "The Death of Marilyn Monroe." From *The Living and the Dead* by Sharon Olds. Copyright © 1983 by Sharon Olds. Reprinted by permission of Alfred A. Knopf, a Division of Random House, Inc.

Paul Rand. "Logos, Flags and Escutcheons." From *AIGA Journal Of Graphic Design*, Vol. 9, No. 3, 1991. © 1991 Paul Rand. Reprinted by permission of Mrs. Paul Rand.

Visual Texts

American Indian Beaded Bag: Flags, Eagle & Shield. Courtesy Joel & Kate Kopp, American Hurrah Archive, NY.

Lizzy Gardiner, 1995 Academy Awards. Photo © Dan Groshong/SYGMA. Courtesy American Express/Sandra Marsh Management.

Indigestion. Reprinted by permission of Elizabeth Diller and Diller and Ricardo Scofidio.

Branding. Reprinted by permission of The Media Foundation.

Betty Crocker photos. Betty Crocker is a registered trademark of General Mills, Inc. and is used with the permission of General Mills.

Pledging of the Flag cartoon. From *Love Is Hell* © 1986 by Matt Groening. All Rights Reserved. Reprinted by permission of Pantheon Books, A division of Random House, Inc.

African-American Flag, 1990. Courtesy David Hammons.

American Gothic. Courtesy Gordon Parks/Corbis.

Three Flags. © Jasper Johns/Licensed by VAGA, New York, NY. Copyright © 1999: Whitney Museum of American Art. Reprinted by permission.

Madonna 1982–1998. AP Photo; Archive Photos; Corbis; Los Angeles Daily News. Reprinted by permission.

Mercedes-Benz ad. Courtesy of Mercedes-Benz USA, Inc. Montvale, NJ., A Daimler Chrysler Company. www.mbusa.com.

Aids ribbon & *Silence=Death* photos. Courtesy Impact Visuals.

Andy Warhol Portfolio. © 2000 Andy Warhol Foundation for the Visual Arts/ARS, New York and The Andy Warhol Foundation, Inc./Art Resource, NY.

Lotions Logos. Designed by Tony Zajkowski, Bill Ferguson, Jim Ferguson and Rob Youngberg.

Tom Ewell and Marilyn Monroe photo. George Zeno Collection.

Chapter 8

Verbal Texts

Sven Birkerts. "The Fate of the Book." Copyright © 1996 by the *Antioch Review*, Vol. 54, No. 3. Reprinted by permission of the Editors.

Todd Gitlin. "The Liberal Arts in an Age of Info-Glut." From *The Chronicle of Higher Education*, March 1998. Reprinted by permission of the author.

Steven Johnson. "Links." From *Interface Culture: How New Technology Transforms the Way We Create and Communicate* by Steven Johnson. © 1997 by Steven Johnson. Reprinted by permission of HarperCollins Publishers, Inc.

Robert Pinsky. "On Television." Reprinted by permission of the author.

Michael Rock, "When Did *USA TODAY* Become the National Design Ideal?" Reprinted by permission of the author.

Mitchell Stephens. "Expanding the Language of Photographs." From *Media Studies Journal*, Spring 1997. © 1997 Media Studies Journal. Reprinted by permission.

Wallace Stevens. "Thirteen Ways of Looking at a Blackbird." From *Collected Poems* by Wallace Stevens. Copyright © 1923 and renewed 1951 by Wallace Stevens. Reprinted by permission of Alfred A. Knopf, a Division of Random House, Inc.

Time Magazine. Excerpts from pp. 20–21, March 3, 1923, Vol. 1, No. 1. "Our Friend Joey Gallo." pp. 22–23, April 17, 1972. "Must This Man Die?" pp. 40–41, May 18, 1992. © 1923, 1972, 1992 Time, Inc. Reprinted by permission.

Visual Texts

Cedar bark weaving by Kwakiutl woman. Courtesy Dept. of Library Services. American Museum of Natural History.

David Carson Portfolio. From *The End of Print: The Graphic Design of David Carson* by Lewis Blackwell & David Carson. © 1995 David CARSON design, inc. Reprinted by permission of David Carson.

The Simpsons, Matt Groening. Courtesy Everett Collection.

Untitled. "A picture is worth more than a thousand words." Barbara Kruger, 1992. Courtesy: Mary Boone Gallery, New York.

William "Big Bill" Hopson (unretouched). United States Postal Service.

Newsweek cover, December 1, 1997. Bobbie & Ken McCaughey. © 1997 Newsweek, Inc. All rights reserved. Reprinted by permission.

From *Pop-Up Video* on VH1. Created by Spin the Bottle, Inc. Reproduced with permission.

Untitled (Unread Books #1). Steven Wolfe, 1990. Courtesy of Steven Wolfe and Luhring Augustine, NY.

Appendix

Verbal Texts

John Berger. "Chapter 1" from *Ways of Seeing* by John Berger. Copyright © 1972 by Penguin Books Ltd. Used by permission of Viking Penguin, a division of Penguin Putnam, Inc.

Visual Texts

"Mars, Venus, and Satyrs." Sandro Botticelli. National Gallery, London, Great Britain. Alinari/Art Resource, NY.

"Jesus Carrying the Cross, 1564," Pieter the Elder Brueghel. Kunsthistorisches Museum, Vienna, Austria. Erich Lessing/Art Resource, NY.

"St. Luigi dei Francesi." Caravaggio. Scala/Art Resource, NY.

"Key of Dreams, 1927." Rene Magritte. © ARS, NY. Collections Wormland, Munich, Germany. Giraudon/Art Resource, NY.

"Still life with chair caning, 1912." Pablo Picasso. © ARS, NY. Musee Picasso, Paris, France. Giraudon/Art Resource, NY.

"The Milkmaid" by Vermeer. CORBIS/Raymond V. Schoder.

"Wheatfield with Crows, 1890." Vincent van Gogh. Van Gogh Museum, Amsterdam, The Netherlands. Art Resource/NY.

"Virgin and Child with St. Anne and St. John the Baptist. National Gallery, London, GB. Art Resource/NY

"The Virgin of the Rocks." Leonardo da Vinci. CORBIS/National Gallery Collection; By kind permission of the Trustees of the National Gallery.

"The Virgin of the Rocks." Leonardo da Vinci. Louvre, Paris, France. Art Resource, NY.

Scott McCloud. "Show and Tell" (Chapter 6) from *Understanding Comics* by Scott McCloud. Copyright © 1993 by Scott McCloud. Reprinted by permission of HarperCollins Publishers, Inc.

Index of Verbal and Visual Texts

A NOTE ON THE TYPE

Seeing & Writing was designed by Michael Rock, Katie Andresen, and Alice Chung of 2x4, New York City, using a mixture of historical and contemporary typefonts. Chapter heads are set in *Leviathan* (1992), which was designed originally for *Rolling Stone* magazine by Jonathan Hoefler. The headnotes and questions appear in two Dutch faces: Lucas de Groot's *TheSans* (1994); and *Caecilia* (1990), a slab serif by Peter Matthias Noordzij. Heads for the text selections are set in *Electra* (1935–49), which was drawn by the great American designer William Addison Dwiggins. The primary text font is *Minion* (1989) by Robert Slimbach.